Bernard Shaw on the London Art Scene
1885–1950

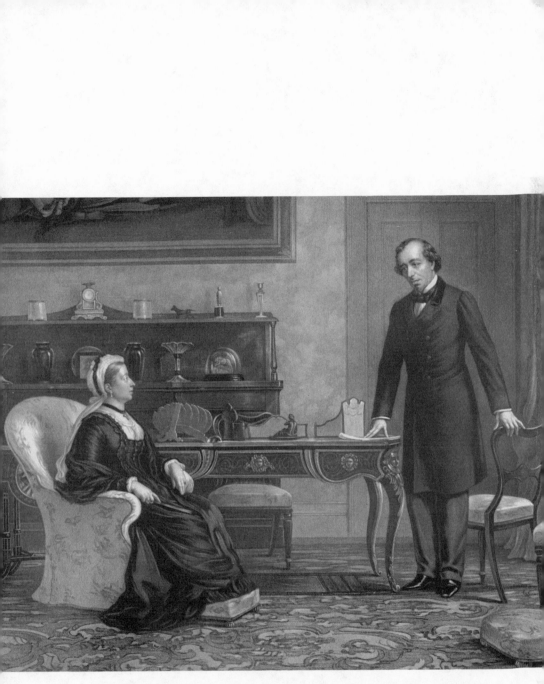

Theodore Blake Wirgman, "Peace with Honour" (Victoria and Disraeli), 1886. Reviewed by G.B.S. in an unsigned notice, *The World*, 23 March 1887. Reproduced by permission of The Prince of Wales Hotel, Niagara-on-the-Lake, Ontario, Canada.

Bernard Shaw

on the
London Art Scene
1885 ~ 1950

Edited with an Introduction
by

Stanley Weintraub

THE PENNSYLVANIA STATE UNIVERSITY PRESS
University Park and London

Library of Congress Cataloging-in-Publication Data

Bernard Shaw on the London art scene, 1885–1950.

 1. Shaw, Bernard, 1885–1950—Knowledge—Art.
2. Art criticism—England—London. 3. Art—
England—London. 4. Art, English. I. Weintraub,
Stanley, 1929– .
PR5368.A75B47 1989 822′.912 88–43442
ISBN 0-271-00665-X

For MaryAlison. Her first book.

Contents

viii Contents

Introduction:
In the Victorian Picture Galleries

In a music review—for nearly a decade Bernard Shaw conducted parallel careers as music critic and art critic, adding to them several others, including that of playwright—he emphasized the negative aspects of his encounters with art. His musical notice was "disjointed," he apologized. "The fact is, I have been at the Royal Academy all day, 'Press-viewing' it; and my mind is unhinged by the contemplation of so much emptiness and so much bungling" (2 May 1890).

Shaw did not dislike pictures, but he had little respect for what many of his fellow Englishmen were producing at a time when he needed so badly to earn a few pounds a week by his pen as to sell his soul alive by writing about it. "I am not a critic of Art," he insisted then to J. Stanley Little (26 August 1889): "I hate the whole confounded cultus, which is only a huge sponge to sop up the energies of men who are divinely discontented. If the [striking] dockhands came to me tomorrow and said that they were going to start burning and demolishing, but could not make up their minds what to start on, I should recommend them to go for the works of art first. . . . " Yet he wrote about art even when he did not have to, and continued to write about it into his nineties. Toward the end of his long life he even planned to collect his myriad writings on art, preparing a preface for the never-published book.

Very likely Shaw never knew how much he had written on art and artists, even during the Victorian heyday of his attention to the subject. Some anonymously published pieces are not in his cutting books; some appeared in other guises, as music or drama reviews and essays; some were never published at all. Brought together, they illuminate

and they entertain. Shaw could not help but be readable, and quotable lines leap from obscure paragraphs in forgotten and forlorn newspapers and magazines. In the process the vanished world of Victorian art reemerges, and after it the new era of international art which Shaw was quick to appreciate. Writing to a friend in 1912 about Post-Impressionism, Shaw called it "the only live art now going. You can't look at ordinary stuff after it."[1] But his days as a regular critic were then long over. Whatever the interest of his occasional later forays into writing about art, Shaw would always dismiss them, observing in one of his 1919 pieces that he would always be an old Victorian, and it was in that guise, his up-to-date sympathies notwithstanding, that he continued to write occasionally about art the rest of his professional life.

Shaw's real art education came years after he began learning on the job. His friends in the Art Workers' Guild, Walter Crane and Emery Walker, took Shaw along on Guild tours, from a day at the National Gallery to have his "mind improved" (11 September 1891), to a trip to Italy, where Shaw was exposed to the art of Milan, Verona, Venice, Padua, Mantua, and Pavia. A long letter to William Morris (23 September 1891) is full of Shaw's impatient impressions of Italian architecture ("inferior"), cathedral decoration ("piffling pictures like illustrations out of Cassell's Illustrated Family Bible"), and the paintings of masters like Tintoretto and Veronese ("magnificent"). But Shaw felt then, and continued to believe, that a "permanent, living art" had to emanate from conditions other than "Venetian splendor," which implied the existence of its opposite, on which splendor fed. "The best art of all will come when we are rid of splendor and everything else in the glorious line."

Shaw's writing in general had already begun appropriating metaphors from art in ways that could not have happened had he not spent so many prentice years as art critic. His music criticism was an early example. In counterpoint Handel was "left behind by comparatively commonplace men, much as Raphael was outdone by Pietro de Cortona in anatomy and perspective."[2] Contemporary English oratorios were "sham classics . . . worth no more than the forgotten pictures of [William] Hilton . . . "—whose *Christ Crowned with Thorns* of nearly a century earlier, to Shaw's disgust, had been purchased for the Royal Academy from the Chantrey bequest (14 October 1891). Charles Gounod was "almost as hard to dispraise as the President of the Royal Academy. Both produce works so graceful, so harmonious, so smooth, so delicate, so refined, and so handsomely sentimental that it is difficult to convey, without appearing ungracious or insensible, the exact measure of disparagement needed to prevent the reader from concluding that M. Gounod is another Handel, or Sir Frederick Leighton an-

other Raphael."[3] Unenthusiastic about French music of his day, Shaw claimed also (II, 155) that Jules Massenet's *Hérodiade* "bears about the same relation to what is usually understood by classical music as Mr. Pettie's pictures do to Raphael's or Mr Lewis Morris's poetry does to Goethe's." John Pettie (1839–93), a Scottish artist, painted sentimental subjects often based on Walter Scott's novels.

On the positive side, Shaw suggested that D'Oyly Carte-managed musical comedies—such as the Gilbert and Sullivan "Savoy operas"— were "as recognizable by the style alone as a picture by Watteau or Monticelli" (28 September 1892). But Franz Liszt's "devotion to serious composition seems as hopeless a struggle against natural incapacity as was Benjamin Haydon's determination to be a great painter."[4] And, Shaw thought, elevating painting above music, that if a painter "copied the design and the light and shade on canvas" from a photograph of Holman Hunt's *Flight into Egypt,* "and exercised his invention in the coloring only, his claim to have produced an original work would be scoffed at by the most superficial amateur. To score a pianoforte arrangement is a precisely analogous operation, although it is easier beyond comparison to fill in a score than to color a design with oil paint."[5]

A "stupendous helmet" in *Lohengrin* reminded Shaw (29 April 1891) "of the headdress of the Indian in [Benjamin] West's picture of the death of [General] Wolfe," and proved to Shaw the willingness of the tenor, like the painter, "for any sacrifice of tradition to accuracy." A performance of *Mefistofele* prompted Shaw to write (5 August 1891) that the scene designer should have taken his suggestions from Hendrik Willem Mesdag's *Sunrise* "in the Museum at Amsterdam," rather than retain the dingy old backcloths of past productions. Mesdag (1831–1915) was known for his romantic marinescapes. Shaw had not only seen them in Amsterdam but remembered seeing them. Similarly, in noting (5 April 1890) that Belgian composer Edgar Tinel's "barren" oratorio *Franciscus* had "created a great sensation in Brussels," Shaw downplayed that reaction with the remark that the city which created "as a temple of Miltonic genius" a municipal museum of the studio of Antoine-Joseph Wertz (1806–65), to house his elephantine historical canvases, and regarded its own Léon Gallait (1810–87) "as a great painter . . . is capable of admiring anything that has nothing in it." Shaw had encountered the work of both men in Belgium, and their mediocrity was not lost on him. Even much later, disputing a critic's claim, in downgrading Wagner, that Meyerbeer has "never been equaled among men," Shaw would add (5 April 1890) that it quite took his breath away, "as if someone had said that [G.F.] Watts was a greater draughtsman than Mantegna." And, Shaw noted, one did

not need a "modern scientific basis" for accomplishment in the arts: "Sir Joshua Reynolds painted none the worse for believing that there were three primary colors, and that the human eye was one of the most exquisite and perfect instruments ever designed for the use of man; nor have his successors painted any the better since [physicist and physician Thomas] Young exploded the three primary colors for ever [in 1807], and [physiologist and physicist Hermann von] Helmholtz [in 1850] scandalized Europe by informing his pupils that if an optician were to send him an instrument with so many easily avoidable and remediable defects as the human eye, he would feel bound to censure him severely" (16 November 1892).

Shaw's facetious justification for writing prefaces to his plays, rather than letting them speak for themselves, was to put the question, "What is a Royal Academy catalogue but a series of statements that This is The Vale of Rest, This the Shaving of Samson, This Chill October, This H.R.H. the Prince of Wales, and so on?"[6] Like his prose, Shaw's play-writing was filled with echoes from art. Thus the Devil in *Don Juan in Hell* (1903) moans that Juan's departure is a "a political defeat" on a level with Rembrandt's exit: "This is the greatest loss I have had since that Dutch painter went—a fellow who would paint a hag of 70 with as much enjoyment as a Venus of 20." In 1910, at a benefit for the Irish National Theatre at which Shaw introduced W. B. Yeats, he identified his compatriot's genius with the same metaphor. Like Yeats, he observed, Rembrandt did not settle for empty beauty, but was interested in life in all its manifestations. "You will find that [Adolphe] Bouguereau has an extreme interest in beautiful women. He tries to make their flesh look like ivory. [laughter] But if you study the paintings of Rembrandt you will find that he took as much interest in old women as in young. That is always the sign of a great man. [laughter] I have always been interested in old women myself. [loud laughter] . . . Bouguereau wants his pretty women with skin like a visiting-card" [laughter].[7]

Words, he would point out, were not always adequate to convey the impact of the senses—not even when allied to the composer's art. "The words spoil the music. Michael Angelo wrote reams of sonnets; but what are they beside the speechless prophets and sibyls in the Sistine Chapel? Is there any written or writable description," he argued to Margaret Wheeler (22 July 1948), "that makes you see the Venus of Milo or the Hermes of Praxiteles? Do the gardeners' catalogues with which Milton padded Paradise Lost do for you what Turner and Monet did with a few dabs of paint?"

In Shaw's letters we find such figures of speech from art as his dismissal (26 December 1902) of his German translator Siegfried Trebitsch's "unashamed, intentional crimes—of a classically educated

Viennese litterateur. If you took to painting & made a portrait of me, you would give me the leg of Apollo and the torso of the Farnese Hercules, and if I complained you would think me an ignorant Philistine." He told engraver John Farleigh (6 July 1932) that "consistency is the enemy of enterprise just as symmetry is the enemy of art." To artist J. M. Strudwick (13 June 1922), Shaw compared strategies in playwriting to those in painting, writing, "And remember that though there is no chiaroscuro in the Rossetti school, and ought not to be, and not much more movement than in heaven, drama requires conflict in tragedy, contrast in comedy, and continual movement."[8] Even in prefacing Frank Harris's semi-scurrilous 1931 biography of him (some of it written by the subject himself and all of it read by Shaw in proof), Shaw, in putting some distance between the portrayal and any suggestion that it was authorized, declared, "No man is a good judge of his own portrait; and if it be well painted he has no right to prevent the artist exhibiting it, or even, when the artist is a deceased friend, to refuse to varnish it before the show opens." And from Cape Town the next year he wrote of the enchanting Dutch gardens and "Peter de Hooghe interiors" and their dramatic contrast with the seemingly insoluble social problems of South Africa.[9] On hundreds of occasions like these, Shaw spoke in the language he learned from his years as art critic.

In the days of Shaw's boyhood, when English painting was still suffering from the blight of the sentimental academic subject picture and Ireland lagged culturally at least a generation behind, the young Shaw could have been guaranteed a surfeit of such "story" paintings in Dublin, pictures he later (21 April 1886) condemned as so lacking in invention that it would take a thousand of them "to furnish a single shilling dreadful." What the galleries wanted, and painters provided, were "sentimentalities meant to be tragic" and "good natured imbecilities that are offered to be humorous."

An index to the London situation in the fifth decade of Queen Victoria's reign was the fate of Whistler's "Mother"—the *Arrangement in Grey and Black, No. 1,* which had been exhibited in London in 1874 and, being unsold and unsalable, was immured most of the following eighteen years in pawn, until the government of France purchased it for the Luxembourg Museum, for living painters then the "vestibule to the Louvre."

The later years of that portrait's purgatory were Shaw's years as an art critic in London. Shaw had no ambitions to be an art critic, although as a boy in Ireland he had once dreamed of being an artist. Economics intervened; he dropped out of school to develop a copperplate hand as a bookkeeper in a land agent's office rather than learn to etch a plate or paint a picture. Then he wanted to write, but until he

left for London, at twenty, in 1876, his writing was largely confined to account books; and even after he was able to sell very little from his pen.

In his tenth year in London, after five manuscript novels which no publisher wanted, and some occasional journalism, Shaw was still dependent, at twenty-nine, upon his mother's income as a music teacher. Then the unanticipated writing career opened. His friend William Archer, who was dramatic critic of the *World* in 1885, had found himself suddenly compelled to double as art critic. He invited Shaw to accompany him. London galleries and studios had long been familiar places. Shaw had already written two unpublished novels in which art played a major role. In *Immaturity* and *Love Among the Artists,* the artists of some worth had been influenced by Pre-Raphaelitism and Whistler, while the Philistine painters believed in society portraits, anecdotal pictures, and making money. Wandering the galleries and offering comments as he went was not work to Shaw, who was surprised when Archer sent him a check for £1.6.8—half the fee. Shaw returned it; Archer sent it back; Shaw then "re-returned" it on December 14, 1885, claiming that he had been under no "external compulsion" to go, while Archer had been under the orders of his editor, Edmund Yates.

"As it is," Shaw explained (14 December 1885), "I have the advantage of seeing the galleries for nothing without the drudgery of writing the articles. I do not like to lose the record of the art life, and yet going to a gallery by myself bores me so much that I let the [Royal] Academy itself slip last year, and should have done so this year but for your bearing me thither. . . . " Archer solved the problem. Pointing out that Shaw had done the work, he persuaded Yates to name his friend as art critic, a post Shaw held, often concurrently with half a dozen other responsibilities, from February 1886 until January 1890. One of the more short-lived of the parallel posts was that of arts critic for Annie Besant's socialist organ *Our Corner,* in which several of his stillborn novels were being resurrected in serial form as padding; by no coincidence, the first time Shaw produced an "Art Corner" column about art (rather than music or theater) was for the February 1886 issue. If he were doing the gallery beat for Yates, there was no reason why he could not provide a sampling for Mrs. Besant, who would permit him to propagandize more freely.

The better his uncommercial novels had become, the more they had turned away the conventional-minded professional readers at the publishing houses; but as a critic, he boasted, "I came to the top irresistibly, whilst contemporary well-schooled literary beginners, brought up in artless British homes, could make no such mark." As a result, he felt, his weekly columns "On all the fine arts in succession"—since he

went on from art to music and theater—remained readable. He had a
critical strategy, he exaggerated in the *World* (6 July 1892):

> I was capable of looking at a picture then, and, if it dis-
> pleased me, immediately considering whether the figures
> formed a pyramid, so that, if they did not, I could prove the
> picture defective because the composition was wrong. And if I
> saw a picture of a man foreshortened at me in such a way that
> I could see nothing but the soles of his feet and his eyes
> looking out between his toes, I marveled at it and almost re-
> vered the painter, though veneration was at no time one of my
> strong points. . . . I can only thank my stars that my sense of
> what was real in works of art somehow did survive my burst of
> interest in irrelevant critical conventions and the pretensions
> of this or that technical method to be absolute.
>
> When I was more among pictures than I am at present, cer-
> tain reforms in painting which I desired were advocated by the
> Impressionist party, and resisted by the Academic party. Until
> those reforms had been effectually wrought I fought for the
> Impressionists—backed up by men who could not draw a nose
> differently from an elbow against Leighton and Bouguereau—
> did everything I could to make the public conscious of the ugly
> unreality of studio-lit landscapes and the inanity of second-hand
> classicism. . . .
>
> I am always electioneering. . . . I make every notable perfor-
> mance an example of the want of them, knowing that in the
> long run these defects will seem as ridiculous as Monet has
> already made Bouguereau's backgrounds, or Ibsen the "poetical
> justice" of Tom Taylor. Never in my life have I penned an impar-
> tial criticism; and I hope I never may. As long as I have a want, I
> am necessarily partial to the fulfilment of that want, with a view
> to which I must strive with all my wit to infect everyone else
> with it.

Shaw's refusal to accept the commercial perspective quickly made
him a target for dealers—not for bribes but for special flatteries. At his
first appearance at an advance "Press View"—he was twenty-nine and
unknown—a dealer described to him "rapturously" the extraordinary
qualities of what were even to the novice critic only "half a dozen
respectable but quite ordinary sketches in watercolor by an unknown
painter." He listened and then said, "How can you talk such nonsense
to me? You know better." Thereupon, Shaw was escorted to a private
room in which the dealer kept "a few real treasures by old masters:
mostly primitives."

Another dealer invited Shaw to see the latest work by a well-known painter and then pretended disgust with the popular taste which it represented. "Oh!" he said, "you've come to see this. Here it is. Pish! It is what you people like; and we have to provide it for you. Now here," he suggested, pointing to an inconspicuously hung canvas, "is a picture to my taste worth ten of it. But it means nothing to you: you wouldn't know the painter's name if I told it to you. Look at his handling! Look at that sky. But you gentlemen of the Press pass it by without a glance."

Shaw guessed that few would fall for the "neglected genius" ploy, but he "had not the heart to spoil the old man's comedy by telling him so." Yet editors employed newsmen "who were ignorant of art and impatient of the convention that obliged their papers to notice it. They sent their worst and wordiest reporters to the galleries, the theatre and the opera, reserving their best for political meetings and the criminal courts."[10] For Shaw the Victorian galleries helped complete his education.

One of his earliest campaigns as a critic was fought after the war was over. Pre-Raphaelite painting had already made an impact upon contemporary art and had itself either faded into commercialism or been transmuted into new conventions. Still, Shaw (to the end a follower of Ruskin) regularly praised Dante Gabriel Rossetti, who had died in 1881; but he tempered his appreciation of Rossetti's later work by noting that although he had dazzled with his "wealth of color [and] poetic conception, . . . our eyes are now used to the sun; and . . . Rossetti's want of thoroughness as a draughtsman, and the extent to which his favorite types of beauty began to reappear as mere . . . conventions, with impossible lips and mechanically designed eyebrows, came as something of a shock upon many who had previously fancied him almost flawless."[11] He also continued to admire the earlier art of Rossetti's confreres Millais, Hunt, and Burne-Jones, all of whom had long since done their best work. The sheer labor they evidenced, of which Ruskin would have approved, led Shaw—ever the social critic— into observing that intended didacticism often had an improving effect, if not the one which the artist may have intended. The Holman Hunt works he approved of in one of his earliest "In the Picture-Galleries" columns were

> elaborated beyond the point at which elaboration ceases to be improvement in the eyes of the normal Londoner. . . . Mr. Holman Hunt, the catalogue tells us, . . . painted *The Hireling Shepherd* "in rebuke of the sectarian vanities and vital negligences of the nation." The seriousness of the painter's aim

probably did not bring a single Sandemanian into the fold of the Established Church, or induce one woman of fashion to give up tight-lacing (the most familiar form of "vital negligence"); but it is the secret of the perseverance and conscientiousness which has made this small picture one of the most extraordinary units of a collection that does not contain one square inch of commonplace handiwork.

Spencer Stanhope, he wrote in the *World* in 1886, "has imitated Mr Burne-Jones quite long enough. If he would imitate Hogarth for a season or two, and then look out of the window and imitate Nature, we might gain some adequate return from his praiseworthy industry." Conscientious industry was not enough, nor imitation of Burne-Jones, although Edward Burne-Jones remained to Shaw the one contemporary with "the power to change the character of an entire exhibition by contributing or withholding his work." It was not that he was more technically gifted, but that he had more imagination, while others who displayed similar wares in Bond Street were "venal, ambitious, time-serving and vulgar." The "least sincere pictures" he observed in one show were by Burne-Jones's son, Philip, "who seems to have abandoned any designs he may have entertained of doing serious work as a painter." (Similarly, as we shall see, Shaw did not let his awe of Robert Browning's poetry obscure his doubts about young "Pen" Browning's skills with a brush.) Of the Pre-Raphaelite Brotherhood survivors he found least to admire in John Millais, who was making more money and producing less art than ever before. His *Forlorn,* Shaw thought, reviewing an 1888 exhibition, "ought surely to have been called *Abandoned.* She is an arrant pot-boiler as ever was painted: her upper lip dripping vermillion, and her ill-made flaunting theatrical red sleeves, are intolerable to contemplate."

Once a P.R.B. crony, Whistler years later was still on the outside, as uncommercial as ever; and if only as rebel and wit, he was bound to receive Shavian support. However, Shaw was not merely playing critical politics, for he even felt, from his own visual experience, that Whistler's artistic perceptions were easily validated. Writing for his "Art Corner" in March 1886, he observed, "That our foggy atmosphere often produces poetic landscapes in the midst of bricks and mortar will hardly be denied by anyone who has watched the network of bare twigs lacing the mist in Lincoln's-Inn-Fields." Yet Shaw praised Whistler's art while warning imitators against it, and when he felt that Whistler was displaying work not up to his abilities, as in the cleverly mounted Dowdeswell show of Venice etchings in 1886, he hoped— with some skepticism—for more formidable later results:

Mr. Whistler's Notes, Harmonies, and Nocturnes are arranged in brown and gold, in a brown and gold room, beneath a brown and gold velarium, in charge of a brown and gold porter. . . . He has the public about him; and he not only humours their nonsense, but keeps it in countenance by a dash of nonsensical eccentricity on his own part, and by not standing too stiffly on his dignity as an artist, which is saved finally by the fact that his "notes" are well framed, well hung, well lighted, suitably set forth, and exquisitely right so far as they go, except a failure or two which he unblushingly amuses himself by exhibiting as gravely as he might his very masterpieces. The "Chelsea Fish Shop," the Hoxton street scene, and Dutch seaside sketch (No. 47), are a few out of many examples of accurate and methodical note-taking, which is just the reverse of what the rasher spectators suppose them to be. As Mr. Whistler presumably takes notes with a view to subsequent pictures, it is to be hoped that something will soon come of them.

In the same vein, Shaw employed his characteristic Dickensian "signature"—his constant attempt to make his paragraphs readable by using metaphors from Dickens—to excoriate Whistler's minimalist sketches. Using Joe Gargery, Pip's laconic but blunt brother-in-law in *Great Expectations,* and Jaggers, the secretive, overbearing London lawyer who negotiates Pip's gentlemanly upbringing and meets his match in the country blacksmith, Shaw wrote (30 November 1887), "In much the same spirit as that in which Joseph Gargery met the supersubtleties of Mr. Jaggers, I ask Mr. Whistler if so be as he can draw a girl reading, to up and draw her; if not, let her alone." To Shaw, Whistler remained a great artist, but his genius did not give him license to thrust anything with his butterfly mark before the public. His portrait of Lady Colin Campbell, Shaw wrote sharply in the *World* (8 December 1886), "being unfinished, has no business in the gallery." Admiring a John Singer Sargent work, he nevertheless refused to ignore what he felt was half-hearted effort displayed elsewhere. "Mr Sargent," he wrote (*World,* 8 May 1889), "who has put the Academy off with a couple of amusing slapdash caricatures of Mr Henschel and Mr Henry Irving, has given the New Gallery his *Lady Macbeth,* a superb portrait of Miss Ellen Terry, more like she, except in rare inspired moments, is like herself."

Shaw was never to be satisfied, as literary critic, art critic, music critic, or theater critic, with the work of an artist who was performing at less than his potential. As he put it in a music column in 1890, "A criticism written without personal feeling is not worth reading. It is the

capacity for making good or bad art a personal matter that makes a man a critic. The artist who accounts for my disparagement by alleging personal animosity on my part is quite right: when people do less than their best, and do that less at once badly and selfcomplacently, I hate them, loathe them, detest them, long to tear them limb from limb. . . . " Unintimidated by the politics of picture placement and other deceptions meant to mask inadequacy of performance, he could write, as he did in a 20 March 1889 review, that A. H. Enock was "to be congratulated for getting a large and frankly bad picture hung by calling it 'that Beautiful Dartmouth (Queen's Diary).' "

Finding himself once, in the *World,* speaking "contemptuously" of the "elderly school," he confessed as much and then went on to observe that it was "not a time to be just to it. Its principle of giving a precise pictorial account of what it knew to be before it, led it to paint a great deal that it did not see, and to omit a great deal that it did see. It is now getting a tremendous lesson from the men [of the Impressionist school] who are trying to paint no more and no less than they see; and I am more disposed to help to rub that lesson in than to make untimely excuses for people who for many years outraged my taste for nature until I positively hated the sight of an ordinary picture." As a result, although he could not reconcile himself "to the occasional prevalence of a ghastly lilac-coloured fog," still, "looking at the more elderly British wall-ornaments," he found it hard "to admit that such airless, lightless, sunless crudities, coloured in the taste of a third-rate toymaker, and full of absurd shadows put in *a priori* as a matter of applied physics, could ever have seemed satisfactory pictures."

Shaw's concern, he wrote later in the *Sanity of Art* (1908), was that when "Whistler and his party" forced the dealers and art societies to exhibit their work, and by doing so, to accustom the public to tolerate, if not appreciate, what at first appeared to be absurdities, "the door was necessarily opened to real absurdities. Artists of doubtful or incomplete vocation find it difficult to draw or paint well; but it is easy for them to smudge paper or canvas so as to suggest a picture just as the stains on an old ceiling or the dark spots in a glowing coal-fire do. Plenty of rubbish of this kind was exhibited, and tolerated at the time when people could not see the difference between any daub in which there were aniline shadows and a landscape by Monet. Not that they thought the daub as good as the Monet: they thought the Monet as ridiculous as the daub; but they were afraid to say so. . . . "[12]

Among the early Impressionists, Claude Monet was a particular hero of Shaw's picture-gallery period, and he regularly attempted to separate the daubers from such new masters. "Impressionism, or the misfortune of having indefinite impressions, which can happily be cured

by attentive observation and a suitable pair of spectacles," he wrote (28 April 1886), "is responsible for Mr. Sydney Starr's nebulous *St John's Wood.*" The British gallerygoer, he cautioned, would find such pictures very different from the usual Bond Street fare and very uneven in quality, but "nobody with more than half an eye will need more than a glance . . . to convince him that Monet, his apparently extravagant violets and poppy reds notwithstanding, is one of the most vividly faithful landscapists living." Still, Shaw responded coolly to innovation which seemed to him not fraudulent but lacking range, much as he criticized Whistler for working on a minimalist scale. "As to the 'New English Art' reformers," he wrote, "they are, for the most part, honest as well as adroit; but so far they lack the constructive imagination to make pictures out of their studies." He had his doubts as to where the newness would lead:

> These gentlemen are painting shortsightedly in more senses than one. The trick of drawing and colouring badly as if you did it on purpose is easily acquired; and the market will be swamped with "new English art," and the public tired of it, in a year or two. . . . The "new" fashion may be capital fun for Mr. Whistler, Mr. Sargent, and a few others who can swim on any tide; but for the feebler folk it means at best a short life. . . .

"As to my line in criticism," Shaw wrote to his first biographer, Archibald Henderson (15 July 1905),

> the only controversial question up in my time was raised by the Impressionists, of whom, in England, Whistler was the chief. People accustomed to see the "good north light" of a St. John's Wood studio represented at exhibitions as sunlight in the open air were naturally amazed by the pictures of Monet. I backed up the Impressionists strongly; refused to call Whistler "Jimmy" instead of Mr. Whistler; boomed the Dutch school vigorously and tried to persuade the public that James* Maris was a great painter; stood up for Von Uhde not only in defence of his pictures of Christ surrounded by people in tall hats and frock coats, but also of his excellent painting of light in a dry crisp diffused way then quite unfashionable; and, on the whole, picked out my men and supported movements with fairly good judgment as far as subsequent events enable one to say. And of course I did not fall into the Philistine trap & talk "greenery yallery" nonsense about Burne Jones & the pre-Raphaelite school.

*Dutch landscape painter Jacob Maris (1837–99).

The artistic direction which Shaw saw as most fruitful was one to which he had been converted first by Ruskin and then by William Morris, who had put his theories of decorative art to use well beyond the fresco and the frame. There was important art needed in the world, Shaw prophesied, that not only did not require brushes and an easel but could be effected by craftsmen who were more useful and more accomplished with other tools than the conventional ones:

> It has been for a long time past evident that first step towards making our picture-galleries endurable is to get rid of the pictures—the detestable pictures—the silly British pictures, the vicious foreign pictures, the venal popular pictures, the pig-headed academic pictures, signboards all of them of the wasted talent and perverted ambition of men who might have been passably useful as architects, engineers, potters, cabinet-makers, smiths, or bookbinders. But there comes an end to all things; and perhaps the beginning of the end of the easel-picture despotism is the appearance in the New Gallery of the handicrafts-man with his pots and pans, textiles and fictiles, and things in general that have some other use than to hang on a nail and collect bacteria. . . .

One would not expect Shaw to be anything less than Shavian in his art columns, and they do not disappoint. In a May 1886 "Art Corner" he noted a new piece of commercial art by Millais, *Ruddier Than the Cherry,* "representing a ragged flower girl in whose cheeks rosiness is complicated by sunburn, and who is likely to prove more interesting to the dealers than to knowers of pictures." In the *World* in 1887 he reported that William Stott of Oldham "exhibits a nymph; and she, basking in the sun on a couch formed by her own red hair, exhibits herself freely and not gracefully. The red hair is ill painted." In another "Art Corner"—in perhaps his strongest condemnation of establishment art—he brought up the "painful subject" that "Art has suffered an usually severe blow at the hands of the Royal Academy by the opening of the [Academy's] annual exhibition at Burlington House." And in the *World* he noted that Harry Quilter (*The Times*'s critic, who was equally mediocre as an artist) was "progressing in his studies as a landscape painter." Unafraid of other critics, he was equally unintimidated by the galleries which disapproved of his honesty. When he had condemned the annual photography show in Pall Mall for its gold medals "stuck on the most fraudulent examples of retouching or picture-faking," his "public spirit," he confessed (9 October 1889), cost him, all told, "A capital sum of thirty shillings, through the cutting off of my invitations to the press views. I now perforce pay at the turnstile, and buy my

catalogue like any ordinary unit of the mob; but when I look around and see the reformation I have wrought, I bear my chastening stoically, and even laugh a little in my sleeve."

As season followed season, Shaw continued to turn out his columns on art, at the same time writing book reviews for the *Pall Mall Gazette,* music reviews for the *Dramatic Review,* and political and economic journalism for myriad radical publications in London. By early 1889, his music columns, now written for the *Star* under the playful *nom de plume* "Corno di Bassetto," were undermining his loyalties to the galleries. Winding down his columns on art for the *World,* he wrote in the issue of 23 October 1889, "I cannot guarantee my very favourable impression of the Hanover Gallery as I only saw it by gaslight. That was the fault of Sarasate, who played the Ancient Mariner with me. He fixed me with his violin on my way to Bond Street, and though, like the wedding guest, I tried my best, I could not choose but hear." The concert hall had won out.

To Archibald Henderson he explained (15 July 1905) that once he took to music criticism, he began to examine whether the "very hard work of plodding through all the picture exhibitions" was worth continuing. Counting his printed paragraphs, most of them anonymously published, for which he received fivepence a line, he discovered that he had been earning less than forty pounds a year for columns he felt were worth two hundred. Edmund Yates professed to be as staggered by the revelation as Shaw had been and proposed that Lady Colin Campbell, who was Shaw's suggestion as his replacement, and who wrote a "Woman's Walks" column, share the duties, with Shaw taking the major shows at a higher fee plus a £52 annual retainer. Instead Shaw used the opportunity to relinquish the entire responsibility. He claimed that he was too busy, and it was true, although he always found time for what he wanted to do. He was delivering lectures two or three times a week for such organizations as the West London Social and Political Reform Association, the Plumstead Radical Club, the Finsbury Radical Club, the Fabian Society, the Socialist League, the Upper Chelsea Institute, the Chiswick Liberal Club, and the South Place Religious Society. And he was already trying his hand at playwriting, beginning and then discarding or putting aside a number of experiments for the stage. In Whistlerian terms, *The Star* (17 December 1889), in its "Mainly About People" column, regretted in advance "the absence of the famous harmony in snuff-color with which Mr. Shaw used to enliven Academy picture shows."

Shaw's final withdrawal as art critic (he had needed the income and hung on) did not occur until 1891. First he applied unsuccessfully to become art critic for a new journal about to begin publication that

January, the *Speaker*. Then he signed on with Henry Labouchere's feisty *Truth* to write art criticism with his left hand while doing music columns elsewhere. When, however, Labouchere's editor, Horace Voules, insisted that Shaw admire the painting of Frederick Goodall, a Royal Academician whose work he thought mediocre, Shaw wrote a friend (16 May 1890) that his "connection with the paper may not survive the language I have used in consequence." It was the end of G.B.S. the art critic in the sense of a regular commitment to a column. He did write an article on the next Academy show (April 1891) for the *Observer,* then as well as now a Sunday paper, but it appeared "with profuse interpolations" and unsigned on 3 May 1891. Shaw quickly resigned. His copy had gone to the proprietor, who (Shaw wrote his friend Emery Walker on 7 May 1891) "proceeded to mutilate it, interpolate scraps of insufferable private view smalltalk, break it into paragraphs in the wrong places, season it with obvious little puffs of . . . private friends, and generally reduce its commercial value (not to speak of its artistic value) about 1800%. If you look at the article you will see at a glance the broken fragments of Shaw sticking ridiculously in the proprietary mud."

Despite his claim that he immediately gave up going to the picture galleries, his diaries in the 1890s are full of references to press views and private views, and as late as December 1893 he was still helping his successor on the *World,* Lady Colin Campbell, by writing notices for her while she was away from London. Even as late as 13 March 1897, one of his theater columns for the *Saturday Review* is titled with the names of two artists and a playwright: "Madox Brown, Watts, and Ibsen." Art was still a point of reference.

Although painting had palled for him, Shaw's on-the-job art education would prove to be useful for a working playwright in ways he could never have anticipated. The experience had also convinced him of the effectiveness of art as an instrument of culture, a subject he wrote about explicitly in the influential *The Sanity of Art* and in prefaces to *Misalliance* and *Back to Methuselah* and implicitly wherever he put his pen to paper. "We all grow stupid and mad," he concluded in the *Misalliance* preface, "to just the extent to which we have not been artistically educated." Earlier, in *The Sanity of Art,* still under the powerful influences of Ruskin and Morris, he had made as wide-ranging a claim for the importance of art in human life as he ever enunciated:

> The claim of art to our respect must stand or fall with the validity of its pretension to cultivate and refine our senses and faculties until seeing, hearing, feeling, smelling, and tasting become

highly conscious and critical acts with us, protesting vehemently against ugliness, noise, discordant speech, frowsy clothing, and foul air, and taking keen interest and pleasure in beauty, in music, and in the open air, besides making us insist, as necessary for comfort and decency, on clean, wholesome, handsome fabrics to wear, and utensils of fine material and elegant workmanship to handle. Further, art should refine our sense of character and conduct, of justice and sympathy, greatly heightening our self-knowledge, self-control, precision of action, and considerateness, and making us intolerant of baseness, cruelty, injustice, and intellectual superficiality or vulgarity. The worthy artist or craftsman is he who responds to this cultivation of the physical and moral senses by feeding them with pictures, musical compositions, pleasant houses and gardens, good clothes and fine implements, poems, fictions, essays, and dramas which call the heightened senses and ennobled faculties into pleasurable activity. The great artist is he who goes a step beyond the demand, and, by supplying works of a higher beauty and a higher interest than have yet been perceived, succeeds, after a brief struggle with its strangeness, in adding this fresh extension of sense to the heritage of the race. This is why we value art; this is why we feel that the iconoclast and the Puritan are attacking something made holier, by solid usefulness, than their own theories of purity. . . .

Shaw's early dramatic settings could not help but be influenced, even when he intended to construct a scene ironically, by what English eyes were accustomed to encountering in art. One can visualize what Shaw himself saw, as he tramped through Bond Street and Burlington House and the art clubs and societies in the 1890s, in his earliest plays. In the final stage directions in *Candida* (1894), for example, young Marchbanks, spurned, turns to Candida and her husband for the last time, and "*She takes his face in her hands; and he divines her intention and falls on his knees, she kisses his forehead.*" In his tableau Shaw was parodying the sentimental Victorian anecdote in painting, although his first audience, aware only of the artistic genre, took it straight. (In *The Devil's Disciple*, the first act includes a reading of the will—an obvious grouping of people for a Royal Academy set piece, and in fact a painting of that name by David Wilkie was famous.) In the last act, the scene of Dick Dudgeon mounting the scaffold owes much, as Shaw freely confessed, to dramatizations of Dickens's *A Tale of Two Cities* but perhaps even more to Frederick Barnard's popular painting *Sydney Carton. "A Tale of Two Cities,"* exhibited at the Royal

Academy in 1882 and much reproduced.[13] "Mr. Fred Barnard's studies from Thackeray," Shaw once noted (6 July 1887), "are by no means so happy as his Dickens pictures."

When Vivie Warren, in *Mrs Warren's Profession,* draws aside the curtains of her window and proclaims, "What a beautiful night!" Shaw's stage directions add, *"The landscape is seen bathed in the radiance of the harvest moon rising over Blackdown."* It may be no coincidence that Frederick Leighton's *Summer Moon*—which fits the description—was exhibited in London shortly before Shaw wrote the play. The New England Puritan interiors of *The Devil's Disciple* suggest Dutch genre painting, although no special subject can be pointed to. Rather, a Shaw letter to the actor Ian Robertson (23 May 1900) complains that classic actor Johnston Forbes-Robertson (Ian's distinguished brother) would become interested in the play only after asking "whether I could not alter the last act . . . so as to make it like the Delaroche picture." Shaw sometimes conceived his plays in painterly images. Paul Delaroche had produced smoothly finished, sentimental depictions of historical scenes, engravings of which decorated thousands of English parlors. *The Devil's Disciple* had been written to expose the fraud rather than to perpetrate it. Yet Shaw's painterly images were not necessarily ironic. Putting the case for realistic theater in a *Saturday Review* column (17 July 1897), he declared, "The most advanced audiences today, taught by Wagner and Ibsen (not to mention Ford Madox Brown), cannot stand the drop back into decoration after the moment of earnest life. They want realistic drama of complete brainy, passional texture all through, and will not have any pictorial stuff or roulade at all. . . . " He intended to provide the intellectual realism.

G.B.S. always did his homework before writing a scene, even researching American Civil War memoirs as preparation for a comedy in which war would play a part, *Arms and the Man.* He was thus quick to respond (23 April 1894) to his critic friend William Archer, who reviewed the play unfavorably, "Do you think war is any less terrible & heroic in its reality—on its seamy side, as you would say—than it is in the visions of Raina & of the critics who know it from the engravings of Elizabeth Thompson's pictures in the Regent St. shop windows?" Elizabeth Thompson (Lady Butler) was famous for her obsessively detailed paintings of British feats of arms during the Napoleonic, Crimean, and colonial wars: Shaw's play was at least in part a response to her sentimental pictures, one of which, *The Roll Call* (1874), was purchased by Queen Victoria. But there were certainly others Shaw had in mind, as well, as he suggests in the opening stage directions of the later *Man of Destiny* (1895), in which he describes Napoleon as

having been "*trained in the artillery under the old regime. . . . Cannonading is his technical specialty . . . dignifying war with the noise and smoke of cannon, as depicted in all military portraits.*" The romanticizers of war were only slightly less numerous than its casualties.

Lady Butler's best-known works received wide and continuing distribution in the form of engravings, as Shaw observed, and several of these suggest some of Captain Bluntschli's lines in *Arms and the Man,* in particular *Scotland Forever!* (1881), with its dramatic canvas of cavalrymen charging headlong at the viewer, flank to flank. Describing a cavalry charge to the wide-eyed Raina, Bluntschli cynically pictures it as "slinging a handful of peas against a window pane" and then notes that one can tell the young horsemen "by their wildness and slashing. The old ones come bunched up under the number one guard; they know that they are mere projectiles. . . . Their wounds are mostly broken knees, from the horses cannoning together." But Raina's beloved, the blustering Major Saranoff, out of "sheer ignorance of war," according to Bluntschli, charges "like an operatic tenor," and one can see the operatic—or romantic—idealization of cavalry charges in the colorful, crowded canvases of Lady Butler. One can even wonder, since *Arms and the Man* is set in Bulgaria, during a real war with Serbia which occurred there in the 1880s, what Shaw might have remembered from "some melodramic Servian incidents by M. Joanowits," now forgotten, which he saw at McLean's Gallery and noted in his "Art Corner" in May 1886.

Sometimes in Shavian drama a painting seems displayed perfunctorily, as in Dr. Paramore's reception room in *The Philanderer* (written in 1893), where a framed reproduction of Rembrandt's *The Anatomy Lesson* is hanging on the wall above a cabinet containing "anatomical preparations." It is the obvious work for the location. But later in the scene Leonard Charteris "*strolls across to the cabinet, and pretends to study the Rembrandt . . . so as to be as far out of Julia's reach as possible.*" As the dialogue develops, he is "*still contemplating Rembrandt.*" The picture has no more than its obvious relationship to a physician's office, but it is there to provide the philanderer of the play with something innocuous upon which to temporarily fix his attention. Seldom is a work of art inserted into a Shaw play for only such mechanical purposes.

Candida was a much more complex response to art. Shaw called it his "modern Pre-Raphaelite play" and intended it on one of its many levels as an analogue to medieval religious painting. Even its curious subtitle, "A Mystery," suggests medieval associations. In the sitting room of the comfortable London parsonage in which the play is set, a single picture is seen on the wall, described in Shaw's stage directions

as "*a large autotype of the chief figure in Titian's Assumption of the Virgin*" (the upper half, showing Mary ascending into the clouds). In the original manuscript Shaw had described, instead, a reproduction of Raphael's *Sistine Madonna* ("a large photograph of the Madonna de San Sisto")[14] over the mantel, but he substituted the Titian afterward, possibly because there was in it no distracting babe in arms. But *Candida*, he wanted to make plain by a recognizable work of art, was an ironic Shavian mystery play about Madonna and Child, with the heroine of the title the Holy Mother. At Candida's first entrance, Shaw's stage directions comment, "*A wise-hearted observer, looking at her, would at once guess that whoever had placed the Assumption of the Virgin over her hearth did so because he fancied some spiritual resemblance between them, and yet would not suspect either her husband or herself of any such idea, or indeed of any concern with the art of Titian.*" For Candida's philistine father, Burgess, it is "a high class fust rate of work of ort," but the reproduction is the gift of the eighteen-year-old Eugene Marchbanks, the sensitive and emotional young poet whom the Reverend James Morell and his wife have befriended. The resemblance he perceives will vanish through the play, and with it his idealism.

In a letter to Ellen Terry, Shaw confided (6 April 1896) that Candida was "the Virgin Mother and nobody else" and that he had written "THE Mother Play." To Janet Achurch, for whom he had written it, he suggested that she make herself up for the role by recourse to examples in art, having been horrified by the idea that she would play his Madonna in frizzed, bleached-blond hair. "Send to a photograph shop," he urged (20 March 1895), "for a picture of some Roman bust—say that of Julia, daughter of Augustus and wife of Agrippa, in the Uffizi in Florence—and take that as your model, or rather as your point of departure. You must part your hair in the middle, and be sweet, sensible, comely, dignified, and Madonna like. If you condescend to the vulgarity of being a pretty woman, much less a flashy one . . . you are lost." What he wanted emphasized to desensationalize the situation was "dignity," and he found his guide to it, as he had found his initial inspiration, in Italy, having spent a few weeks in Florence in the autumn of 1894, where (as he wrote in his Preface to *Plays, Pleasant*) he occupied himself "with the religious art of the middle ages." He had hurried back from an earlier Italian visit to fulfill a music-criticism assignment in Birmingham and had discovered there that a "very remarkable collection of the works of our British 'pre-Raphaelite' painters were on view. I looked at these, and then went into Birmingham churches to see the windows of William Morris and Burne-Jones. . . . When my subsequent visit to Italy found me practising the play-

wright's craft, the time was ripe for a modern pre-Raphaelite play." That his 1927 recollection to Ashley Dukes was completely accurate can be seen in the letter he wrote to Florence Farr, then his mistress, from Birmingham (7 October 1891), after seeing Rossetti's beatific, Italianate women. "This is to certify," he wrote effusively, "that you are my best and dearest love, the regenerator of my heart, the holiest joy of my soul, my treasure, my salvation, my rest, my reward . . . my secret glimpse of heaven, my angel of the Annunciation, not yet herself awake, but rousing me from a long sleep with the beat of her uncon- scious wings, and shining upon me with her beautiful eyes that are still blind." The enraptured Eugene Marchbanks would not do better in Shaw's 1894 play.

Observing that his feminine lead was a composite of influences from art, Shaw suggested to Dukes that Titian's *Assumption of the Virgin* in the Accademia in Venice and Correggio's less famous Virgin in the dome of the cathedral at Parma had been "boiled down into cockney Candida."[15] By then he had forgotten the Madonnas of Raphael, Murillo, and others he had seen in Italy and the special effort he made in July 1894 to see the *Madonna* of Hans Holbein in Darmstadt; but no matter, the point was clear.

Ellen Terry had wanted to play Candida, but Shaw offered her as consolation prize a role for an even more mature woman. When Lady Cicely Waynflete in *Captain Brassbound's Conversion* failed at first to interest her, Shaw appealed (5 August 1899), "I try to shew you fearing nobody and managing them all. . . . Here then is your portrait painted on a map of the world—and you prefer Sargent's Lady Macbeth!" He persuaded, as he wrote, in images from art. But it took a half-dozen more years and a dearth of alternative roles before Ellen Terry played Lady Cicely.

Shaw's fascination with the Virgin figure failed to be satisfied by the completion of *Candida* or even by the creation of the more matronly and asexual (yet still attractively marriageable) Lady Cicely. Later he found a Virgin figure at the Reims cathedral that impressed him so much that he "intended some day to put [her, too] in a play."[16] But he did not, although he did not forget her, writing of Reims in the preface (1919) to *Heartbreak House* that "no actress could rival its Virgin beauty." No play thereafter suggests what he might have done.*

*Even before Shaw's playwriting career began in earnest, and even before he had written the earliest of his jejune novels, he had toyed with a Passion play and had written several scenes of one in blank verse. The 1878 script suggests the setting and allegedly irreverent realism of John Millais's early and once-controversial Pre-Raphaelite painting of the Holy Family, *Christ in the House of His Parents* (1850), which remained well known in Shaw's early years in London.

The extent of artistic influence on Shaw's Napoleonic drama *The Man of Destiny* (written August-September 1895) seems considerable from the first page, which observes how melodramatic military portraits give a spurious dignity to war. The short play depicts a very young Napoleon, a twenty-six-year-old who had barely begun the dazzling military campaigns which were to establish his power. Most artistic portrayals of Napoleon represent the later triumphs, after the young general had become "*l'Empereur.*" However, Shaw reminds the reader in his first stage directions that these "*Napoleonic pictures of Delaroche and Meissonier*" were yet to be produced at the early point in the general's career which the play dramatizes. He was recalling such well-known paintings as Meissonier's *Napoleon in 1814* (1863) and *Campaign of France* (1864) and Delaroche's *Napoleon at Fontainebleau* (1845), *Napoleon Crossing the Alps* (1848), and *Napoleon at Saint Helena* (1852). All were exhibited in London shortly after they were first painted and in subsequent retrospective exhibitions, and three of them were owned by British collectors in Shaw's time. They were also widely reproduced in England during the late 1880s, for Delaroche and Meissonier were highly esteemed artists, and Napoleon was a popular artistic subject.

Of the period of Napoleon's life which Shaw depicts in *Man of Destiny*, few artistic works were accessible to him. One work exists, however, which may have touched off the very episode Shaw invents; although there is no evidence that Shaw saw it or a reproduction, he well might have. The opening stage directions read, "*The twelfth of May, 1796, in north Italy, at Tavazzano, on the road from Lodi to Milan. . . . Two days before, at Lodi, the Austrians tried to prevent the French from crossing the river by the narrow bridge there; but . . . Napoleon Bonaparte, who does not respect the rules of war, rushed the fireswept bridge, supported by a tremendous cannonade. . . .* " The Milanese Andrea Appiani's *Napoleon after the Battle of Lodi* (c. 1797), commissioned by the victor himself and well known thereafter from engravings, shows that very Napoleon, unsheathed sword in hand and the gunfire-raked bridge at Lodi in the background. And did the attractive and allegorical young woman in the foreground who appears to be the Muse of History, inscribing the event for posterity on a golden plaque, provide the inspiration for the young woman who confronts Napoleon in the play? We can only guess.

The opening scene of *The Man of Destiny*, which reveals Napoleon, immersed in his work, seated at a table littered with writing materials and dishes, seems inspired by a painting by the Parisian historical artist François Flameng. This untitled work, completed sometime between 1875 and 1885, portrays a youthful, long-haired Napoleon who

also works at a table cluttered with books and papers. His discarded boots lie in a heap on the floor, and his jacket hangs on a peg behind him, as in the play the young Napoleon's hat, sword, and riding whip are *"lying on the couch."* The similarities between Flameng's picture and Shaw's opening scene are striking, and it is no surprise to find that Shaw's diary for 31 March 1894—little more than a year before he began the play—notes the opening of a show of Flameng's "Napoleon pictures" at the Goupil Gallery. Shaw missed the opening, having to review a concert at the Crystal Palace, but he was at the Goupil later and remembered what he saw.

The impact of the visual arts upon *Caesar and Cleopatra*, written in 1898, is even more clear. As he insisted (16 August 1903) to his German translator Siegfried Trebitsch, in sending him some crude sketches for the play:

> Barbarous as my drawings of the scenery are, a great deal depends on them. Even an ordinary modern play like Es Lebe das Leben, with drawingroom scenes throughout, depends a good deal on the author writing his dialogue with a clear plan of stage action in his head; but in a play like Caesar it is absolutely necessary: the staging is just as much a part of the play as the dialogue. It will not do to let a scenepainter & a sculptor loose on the play without a specification of the conditions with which their scenery must comply. Will you therefore tell the Neues manager that we will supply sketches. I will not inflict my own draughtsmanship on him; but I will engage a capable artist to make presentable pictures.

Shaw was taking no chances. Ancient Egypt had tremendous appeal for a precinematic, Bible-familiar public, and cheap color lithographs were a popular commodity. Society painter Edward Poynter (later president of the Royal Academy) even achieved his first successes with enormous scenes from the times of the pharaohs, with one crowded and carefully researched ten-foot panorama, *Israel in Egypt* (1867), being typical of the genre. There was no end to Victorian visual opportunities for exposure to pre-Cleopatra Egypt.

At least two paintings seem to have inspired specific Shavian scenes. Luc Olivier Merson's 1879 painting *Répos en Egypte* is cited in a Shaw letter to Hesketh Pearson in 1918 which establishes the source of the famous tableau.

> The Sphinx scene was suggested by a French painter of the Flight Into Egypt. I never can remember the painter's name, but the engraving, which I saw in a shop window when I was a

boy, of the Virgin and child asleep in the lap of a colossal Sphinx staring over a desert, so intensely still that the smoke of Joseph's fire close by went straight up like a stick, remained in the rummage basket of my memory for thirty years before I took it out and exploited it on the stage.

The "relevance of the new god in the arms of the old" is implicit in the scene, whether or not the influence of the Merson painting is known, but the suggestive relevance is more than a matter of scenery, for knowledge of the artistic source of the scene opens up a new avenue of interpretation. Shaw places Caesar in the Sphinx's lap, the position occupied by Christ and the Virgin in the Merson painting. Thus, Caesar "explicitly equates himself with his successor, the unborn Christ."[17] Likewise, the young and barely nubile Cleopatra is equated with the Virgin, already a familiar figure in Shaw.

The so-called "rug scene" in Act II of *Caesar and Cleopatra*, in which Cleopatra, wrapped in a rug, is delivered to Caesar, is also traced to a painting. The incident itself is described in Plutarch's life of Caesar, but Jean-Léon Gérôme's painting *Cleopatra Apportée à Caesar dans un Tapis* (1866) may have influenced Shaw's rendering of the scene.[18] The picture focuses upon a more mature and nubile Cleopatra than Shaw's child-woman, standing amid the folds of the carpet from which she has just emerged and turning toward Caesar, who is seated at a table. An apprehensive Apollodorus (having just unwound the rug) kneels behind her, and several male Romans in the background look on curiously. Gérôme's Caesar is younger and less bald than Shaw's or history's; also, the details differ from Shaw's exterior conception of the scene. However, Gérôme's conception is one of its rare evocations in art, and Shaw declared in a letter to Trebitsch (15 December 1898) that his handling of the incident would give considerable pause to the French painters who were so fond of her.

Shaw's familiarity with Gérôme's work came from both exhibitions at the London showrooms of the Goupil Gallery, and from reproductions. Gérôme had prudently married Marie Goupil, daughter of the influential Paris art dealer and publisher and benefited enormously from the worldwide distribution of Goupil photogravures of his paintings, which although in black and white emphasized their wealth of archaeological detail. Through Goupil's and via reproductions, Shaw saw not only several Gérôme-depicted Caesars and Cleopatras but also Roman gladiator and martyr scenes, which enriched *Androcles and the Lion* (1913). Unquestionably the most important source for the dramatization of the fable was the familiar Victorian Christmas pantomime; however, Gérôme had painted the popular and widely reproduced *The Gladiators*

(1874) and *Ave Caesar, Morituri Te Salutant* (1859), both of which depicted, from the perspective of the Coliseum floor, gladiators looking up from the arena toward the audience. Perhaps more important, Gérôme had also painted, in muted colors, *The Christian Martyrs' Last Prayer* (1883), showing a noble lion moving slowly across the arena of the Circus Maximus toward a group of huddled, ragged Christians. Of such works Shaw wrote, reviewing an opera (18 May 1892) that suggested some of the elements of *Androcles,* that the hero of George Fox's *Nydia* "shared his cell with a Nazarene, who strove hard, not without some partial success, to make him see the beauty of being eaten by a lion in the arena. Next came the amphitheatre, with a gladiator fight which needed only a gallery full of shrieking vestals with their thumbs turned down to be perfectly *a la* Gérôme."

In *Caesar and Cleopatra* itself were the opportunities for Shaw to illustrate the play from the art of his near contemporaries, for mid-Victorian painters loved Roman scenes, and Shaw good-naturedly satirizes his own Pre-Raphaelite sympathies. Apollodorus the Sicilian is a young purveyor of decorative art transplanted in time, "*handsome and debonair; dressed with deliberate aestheticism in the most delicate purples and dove greys, with ornaments of bronze, oxydized silver, and stones of jade and agate. His sword, designed as carefully as a medieval cross, had a blued blade shewing through an openwork scabbard of purple leather and filagree.*" He does not "keep a shop," he explains to a sentinel as he arrives fortuitously with rugs for Cleopatra. "Mine is a temple of the arts. I am a worshipper of beauty. My calling is to choose beautiful things for beautiful queens. My motto is Art for Art's sake." If Pre-Raphaelitism had become Aestheticism and been weakened and debased as the century came to a close, Shaw nevertheless defended its values against allegations of insanity and "degeneration" in *The Sanity of Art*; and Apollodorus is sane indeed, and tough and brave although an admitted "votary of art." At the close of the play, Shaw mocks the flabbiness of conventional English art and England's willingness to expend some of its imperial wealth to compensate for its flagging creativity. "I leave the art of Egypt in your charge," Caesar informs Apollodorus. "Remember: Rome loves art and will encourage it ungrudgingly."

"I understand, Caesar," says Apollodorus—and for Rome, read England—"Rome will produce no art itself; but it will buy up and take away whatever the other nations produce."

"What!" exclaims the conqueror. "Rome produce no art! Is peace not an art? is war not an art? is government not an art? is civilization not an art? All these we give you in exchange for a few ornaments. You will have the best of the bargain."

Earlier, in *Mrs Warren's Profession*, Shaw had mildly satirized Aestheticism not with a work of art but with a weaker representative of the movement than the shrewd Apollodorus—the sensitive and naive architect Praed, who responds to Vivie Warren's description of her practical, masculine tastes, "I am an artist; and I can't believe it." Later Praed adds, unaware of what is happening around him, except that people are unhappy, "The Gospel of Art is the only one I can preach," and urges Vivie, as might a proper inheritor of Pre-Raphaelitism, to "come with me to Verona and on to Venice. You will cry with delight at living in such a beautiful world." The dialogue which follows will turn the invitation into an irony, but the setting is already remote from Praed's escapist Pre-Raphaelite dreams, for it is the cold, ultrabusinesslike Chancery Lane office of Vivie and her professional partner, "*with a plate-glass window, distempered walls, electric light, and a patent stove.*"

Man and Superman (written 1901–2) owes at least one element both to popular nineteenth-century art and to a favorite and archetypal eighteenth-century image—that of the collector in his gallery or study surrounded by the acquisitions which reflect the personality he wanted to evoke. Thus Johann Zoffany painted his famous *Charles Townley in His Gallery* (1782) in the sanctum of Townley's house in Westminster, amid a clutter of the works of art—from paintings to portrait busts— which were to establish his client's neoclassical tastes. The canvas remained well known in Shaw's day.

Roebuck Ramsden's study, described in the opening scene of *Man and Superman*, might be another Zoffany. It contains, in addition to busts and portraits of famous contemporaries, "*autotypes of allegories by Mr. G. F. Watts . . . and an impression of Dupont's engraving of Delaroche's Beaux Arts hemicycle, representing the great men of all ages.*" (Shaw two pages of notes labeled "Look up at Museum &c. for Superman" include, in the list, "Title of Delaroche's Beaux Arts painting. . . . ")[19] Shaw's selection of the works he describes helps to establish both the atmosphere of the scene and Ramsden's personality. George Frederick Watts, the fashionable Victorian painter referred to in the description, painted portraits, classical scenes, and biblical settings in addition to his allegorical works, but it is significant that Shaw chose the latter category with which to decorate Ramsden's study. Watt's idealized representations fit into Ramsden's thinking, as when he and Octavius call each other "the soul of honor." Allegorical representations such as Watts's *Time, Death, and Judgment, Love and Death* and *Hope* possess a very literal, uncomplicated quality, and they would appeal to the relatively unimaginative mind—to Ramsden's conservative point of view, for example, for he "believes in the fine arts

with all the earnestness of a man who does not understand them,"
according to Shaw's description of him. The choice of the Beaux-Arts
hemicycle engraving is Shaw's commentary on the pompous Ramsden
and on the cluttered atmosphere of his study, with its assemblage of
"great men" (and one great woman—George Eliot's picture also graces
the "gallery"). Paul Delaroche's *Hemicycle* (1837–41), so named be-
cause it occupies the semicircular frieze of the Palais de Beaux-Arts
amphitheater, depicts Appelles, enthroned within the portico of an
Ionic temple, flanked by Ictinus and Phidias. Near them are five alle-
gorical figures (reminiscent of Watts's allegories in Ramsden's study):
Fame, Greek Art, Gothic Art, Roman Art, and Renaissance Art. At each
side of this ideal group sit and stand seventy-five colossal figures of the
great artists of the world, a complement to Ramsden's own miniature
collection of Victorian celebrities. Ramsden's study, then, is in effect a
"Hemicycle" in miniature.

Little if anything of Shaw's description of Ramsden's study is percep-
tible to the stage audience, only the reader thus being "in" on Shaw's
satirical treatment of the ultrarespectable, well-to-do Englishman of
liberal persuasion whose views have not changed in a generation. But
the studied clutter is itself Victorian, and the suggestion that change
has passed Ramsden by is thus palpable to people in the furthermost
seats.

To Max Beerbohm, in his critic's role, the play was "not a play at all"
and had no flesh-and-blood characters. "In vain," Shaw wrote to him
on 15 September 1903, "do I give you a whole gallery of perfectly
miraculous life studies. . . . They are reduced, for you, to the same
barren Shavian formula by the fact that they are not Italian prima
donnas. The chauffeur, the Irishman & his American son are positively
labeled for you as Hogarthian life studies—in vain. . . . " Earlier, Shaw
had written to actress Gertrude Knight (20 June 1900) about the part
of the militant Reverend Anthony Anderson in a production of *The
Devil's Disciple* that he was worried about the casting. Anderson "must
be a *very* good man." She was to tell her husband, Ian Robertson, who
was directing the play, "to look up Hogarth's portrait of Captain Coram,
and get me a man like that. . . . " Despite the bows to William Hogarth,
whose art Shaw admired unstintingly and seemed often to have at the
back of his mind, and the denial to Beerbohm of any indebtedness to
Verdi and Puccini, most of the stage images in *Man and Superman*
come from music rather than art, Mozart rather than Hogarth. With
the first dialogue of the play, its indebtedness to nineteenth-century art
ends.

Although one can sometimes point to a direct precursor for a Sha-
vian scene or character, the larger work of which it forms a part is

usually the product of myriad subtle influences. In 1901 Max Beer-bohm may have contributed to the critical mass of inspiration for two plays when he exhibited among his caricatures at Robert Ross's Carfax Gallery (in which Shaw held shares) a mock frontispiece for a "second edition" of Shaw's *Three Plays for Puritans*. In it a girl of the streets with "DRAMA" written on her hat is being summoned to redemption by G.B.S. in Salvation Army uniform, with a pamphlet labeled "The Shaw Cry" sticking out of his pocket. (The Salvation Army's periodical was the *War Cry*.) Beerbohm's "Miss Tolty Drama" answers Shaw with "Garn! 'Ow should I earn my livin'?" Shaw's Salvation Army play, *Major Barbara*, would emerge from incubation in 1905, while in 1912 he would create his own Cockney guttersnipe who needed redemption and began sentences with "Garn!"—Eliza Doolittle of *Pygmalion*. Had Shaw seen it? "The Salvation caricature had come out of its box," he wrote Beerbohm on 17 December 1901, "& was flaunting itself un-ashamed on the walls."

When Shaw came to *The Doctor's Dilemma* (1906), a number of artistic temptations affected his dramaturgy. His scamp of a hero, who dies operatically with an artist's credo on his lips, must evoke the tensions of ambiguity about his supposed genius in order to leave the weight of guilt at his death unresolved. "I believe in Michael Angelo, Velasquez, and Rembrandt," he declares, and "in the might of design, the mystery of color, the redemption of all things by Beauty everlast-ing, and the message of Art that has made these hands blessed. Amen. Amen." But the chief believers in his genius—aside from his ultraloyal wife—are a group of physicians who buy his work and bicker about his medical treatment. Shaw notes early in the play, as he works his spell upon his doctors, that *"his artist's power of appealing to the imagina-tion gains him credit for all sorts of qualities and powers, whether he possesses them or not."* Based upon Aubrey Beardsley, from whom he inherited his mortal disease, and Dante Gabriel Rossetti, from whom he acquired his unscrupulousness in mulcting patrons, Louis Dubedat (his surname is suggestive of double-dealing) is seen sketching during the play, although none of his drawings is seen by the audience.* But in the fifth act—an epilogue following Dubedat's death—Shaw suc-cumbs to a self-defeating dramatic device. He portrays a posthumous show of the artist's work and displays the art itself.

Stage directions for Act V note that the setting is *"one of the smaller*

*Another personality whose more vicious unscrupulousness went into Dubedat's char-acter (including bigamy) was the common-law husband of Shaw's friend Eleanor Marx, Edward Aveling, a chemist and amateur playwright.

Bond Street Picture Galleries. . . . the walls . . . are covered with Dubedat's works. Two screens, also covered with drawings, stand near the corners right and left of the entrance." For the first production at the Court Theatre, Shaw borrowed representative contemporary drawings from the Carfax Gallery, compounding his failure to leave the problem of the artist's genius to audience imagination, for the gallery attendant asks the widow, "Have you seen the notices in Brush and Crayon and in the Easel?"

"Yes," says Jennifer Dubedat indignantly—"most disgraceful. They write quite patronizingly, as if they were Mr Dubedat's superiors. After all the cigars and sandwiches they had from us on press day, and all they drank. I really think it infamous that they should write like that." But the drawings on display are by Beardsley, William Rothenstein, Augustus John, Charles Ricketts, and Charles Shannon, creating not ambiguity but confusion. The ex-art critic in Shaw had pressed himself too convincingly upon the playwright. As Max Beerbohm (who doubled as artist himself) observed in the *Saturday Review* dramatic column he had inherited from Shaw,

> Dubedat seems to have caught, in his brief lifetime, the various styles of *all* the young lions of the Carfax Gallery. . . . We are asked to accept him as a soon-to-be-recognised master. Of course, it is not Mr. Shaw's fault that the proper proofs are not forthcoming. But it certainly is a fault in Mr. Shaw that he wished proper proofs to forthcome. He ought to have known that even if actual masterpieces by one unknown man could have been collected by the property-master, we should yet have wondered whether Dubedat was so remarkable after all. Masterpieces of painting must be left to an audience's imagination. And Mr. Shaw's infringement of so obvious a rule is the sign of a certain radical lack of sensitiveness in matters of art. Only by suggestion can these masterpieces be made real to us.[20]

Shaw might have countered that it was safer to portray artistic genius in the pages of a novel and that he might be given credit for his daring, but he never attempted such a characterization again on stage. His next several plays (but for *Androcles*) eschewed echoes of the arts altogether; however, in *Pygmalion* (1914)—also the subject of a Gérôme canvas—he returned to a less hazardous dramatic formula. As with Roebuck Ramsden's study in *Man and Superman,* the art in Henry Higgins's laboratory and in his mother's Chelsea drawing room helps establish their personalities both to readers of the printed play and the theater audience. On the walls of the "laboratory" are engravings—"mostly Piranesis and mezzotint portraits." Giambattista

Piranesi remains best known for his architectural drawings and theatrical perspectives, and Higgins's interest in them suggests the mechanical nature of his mind. Visitors to Mrs. Higgins's at-home can expect a warmer personality:

> *Mrs Higgins was brought up on Morris and Burne Jones; and her room, which is very unlike her son's room in Wimpole Street, is not crowded with furniture and little tables and nicknacks. In the middle of the room there is a big ottoman; and this, with the carpet, the Morris wall-papers, and the Morris chintz window curtains and brocade covers of the ottoman and its cushions, supply all the ornament, and are much too handsome to be hidden by odds and ends of useless things. A few good oil-paintings from the exhibitions in the Grosvenor Gallery thirty years ago (the Burne Jones, not the Whistler side of them) are on the walls. The only landscape is a Cecil Lawson on the scale of a Rubens. There is a portrait of Mrs. Higgins as she was when she defied the fashion in her youth in one of the beautiful Rossettian costumes which, when caricatured by people who did not understand, led to the absurdities of popular aestheticism in the eighteen-seventies.*

Again the once-advanced taste of the occupant is immediately apparent, although the Cecil Lawson landscape is a private Shavian memorial to a long-dead young friend. In 1879 an unemployed young Irishman, resident in London only three years, who spent his evenings at free public meetings or in wandering the artists' sectors of Chelsea off the King's Road or the Embankment, wrote his first novel, titled ("with merciless fitness," Shaw confessed later) *Immaturity*. It was set partly in the gallerylike Richmond mansion of the wealthy art patron Halket Grosvenor, Shaw's transmutation of the Grosvenor Gallery and its proprietor, the patron of Aesthetic art Sir Coutts Lindsay. Ambitious and utterly unknown at twenty-three, Shaw first acquired his ideas of Aesthetic art—and no artistic movement was ever as social as the Aesthetic movement—from the one family associated with it whose Sunday evening at-homes he had the courage to attend, the Lawsons. He wrote, fifty years afterward:

> When I lived at Victoria Grove [in Fulham], the Lawsons: father, mother, Malcolm and two sisters, lived in one of the handsome old houses in Cheyne Walk, Chelsea. Cecil and another brother, being married, boarded out. Malcolm was a musician; and the sisters sang. One, a soprano, dark, quick, plump and bright, sang joyously. The other, a contralto, sang with heart-

> breaking intensity of expression, which she deepened by dress-
> ing esthetically, as it was called then, meaning in the Rossettian
> taste . . . so that when she sang . . . she produced a picture as
> well as a tone poem.

Only the landscape-artist brother is important in the novel: "Cecil,
who had just acquired a position by the few masterpieces [of his]
which remain to us, was very much 'in the movement' at the old
Grosvenor Gallery, then new, and passing through the sensational
vogue achieved by its revelations of Burne-Jones and Whistler."[21] The
Cyril Scott of the novel was Cecil Lawson, who painted the pictur-
esque, pre-Embankment Thames, and died at thirty, in 1882, only four
years after his Grosvenor Gallery show had created such a demand for
his few canvases that they brought great prices while still on the easel.
Preparing an etching from another man's picture was for Whistler,
who generally ignored other contemporaries' work, including that of
his closest followers, the rarest kind of tribute. For a memorial volume,
Whistler produced an etching from an unfinished composition by Law-
son of a swan startled under Old Battersea Bridge.

Giving the place of honor in the eminently sensible Mrs. Higgins's
drawing room to an oversized Cecil Lawson canvas was Shaw's tribute
to his old friend, as well as a symbol of the good taste of the professor's
tough-minded mother. "The Rossettian Mrs Higgins in her Burne
Jones costume and Morrisian drawingroom" was Shaw's description to
Feliks Topolski on a 1940 postcard, but again, although a general
impression of her personality can be derived by the theater audience
from her drawing-room decor, the subtleties (she prudently purchased
Burne-Jones but not the radical Whistler) are available only to the
reader, through that extra dimension derived from Shaw's use of art.

Victorians were obsessed with the Pygmalion legend not only in
poetry (as with Shaw's master William Morris's "Pygmalion and the
Image" in *The Earthly Paradise*) and in drama (as with W. S. Gilbert's
Pygmalion and Galatea) but in art. It would have been impossible for
Shaw to escape some of the emotionally prurient examples to which
his coolly ironic comedy of manners seems an antidote, in particular
Burne-Jones's four canvases, *Pygmalion and the Image* (1868), in-
tended for an edition of Morris's book. Shaw not only read Morris but
was a regular at the Grosvenor Gallery in London when the gallery
exhibited the group in 1879. More important, perhaps, he was in Lon-
don when the Tate Gallery showed them again in 1911–12. Burne-
Jones's treatments were typically mid-Victorian in their sexual repres-
sion. The second, with the pining sculptor adoring the virgin marble
(or the virgin in the marble), was captioned *The Hand Refrains*. In the

third, *The Godhead Fires,* the statue plasticizes into womanly flesh, while in the fourth, Pygmalion kneels before his nubile creation, a placid lady whose breasts he surveys with an apprehensive devotion while touching only her fingertips. The picture is titled *The Soul Attains.* Perhaps the lubricious fantasy lay in the unpainted but hardly unimagined (at least by the viewer) fifth panel, in which the hand attained. Shaw's unsentimental and antiromantic version would defy such daydreams.

With all the literary forebears available to him and suggested since by generations of scholars, he hardly needed the impetus of the Tate exhibition of 1911–12 with Burne-Jones's reminder of the legend in its most saccharine form. But it was there. And Shaw began his play on 7 March 1912.

The milieu out of which came Lawson and Whistler and Burne-Jones also inspired a scene in Shaw's next major play after *Pygmalion, Heartbreak House* (written in 1916–17), although it was many years later that he revealed his indebtedness. In his 1949 puppet play *Shakes versus Shav,* written when Shaw was ninety-three, "Shakespeare" taunts the puppet G.B.S., "Where is thy Hamlet? Couldst thou write King Lear?" Shav counters, "Aye, with his daughters all complete. Couldst thou have written Heartbreak House? Behold my Lear." And in Shaw's stage directions, "*A transparency is suddenly lit up, shewing Captain Shotover seated, as in Millais' picture called North-West Passage, with a young woman of virginal beauty.*" The captain raises his hand and intones lines from Act II of *Heartbreak House,* and the young woman responds with lines of Ellie Dunn's, after which the captain warns, "Enough. Enough. Let the heart break in silence." The picture then vanishes, but the revelation is clear.

John Millais's 1874 painting parallels Shaw's scene in other respects than the two seated figures, for the setting is a room with a nautical flavor, as is Shotover's house, and visible are a logbook, flags, maps, and telescopes. The young woman in *Northwest Passage* is more idealized than Shaw's Ellie, whom life's insecurities only too quickly cause to become hard; but her youth and beauty and affection for the old captain make the scene a dramatic representation of Millais's once-famous work. Pre-Raphaelite art and that of the Aesthetic movement which emerged from it clearly had a profound and continuing impact upon Shaw the playwright.

A brief and literally pre-Raphael reference in Shaw's long dramatic cycle *Back to Methuselah* (written 1918–20) suggests a more familiar use of art in Shaw. Savvy, in *The Gospel of the Brothers Barnabas,* the second play, is described as a "vigorous sun-burnt young lady with hazel hair cut to the level of her neck, like an Italian youth in a Gozzoli

picture." Thus the fifteenth-century Italian master is utilized to pro-
vide a more precise image of Shaw's character. But later in the cycle, in
the futuristic parable *As Far as Thought Can Reach,* the scorn of art
("pretty-pretty confectionery" and "vapid emptiness") by the inhabi-
tants of the world of A.D. 31,920 is utilized to reflect the coldness and
soullessness of an earth in which the physical body and its needs have
been reduced to an ever-diminishing minimum, and the pleasures of
the intellect take precedence, intimating a condition in which the body
might eventually disappear altogether. People quickly outgrow an ado-
lescence which is the only period of life in which the business of art is
thought to be the creation of beauty. Only the reflection of "intensity of
mind"—a superrealism—is important thereafter, and art is condemned
as "dead" because only the creation of life (or pseudo-life, as in the
inventor Pygmalion's stimulus-responding human substitutes) has
practical value. The sculptor Arjillax reflects the prevailing vision in
retelling the "legend of a supernatural being called the Archangel Mi-
chael" who was

> a mighty sculptor and painter. He found in the centre of the world
> a temple . . . full of silly pictures of pretty children. . . . He began
> by painting on the ceiling the newly born in all their childish
> beauty. But when he had done this he was not satisfied, for the
> temple was no more impressive than it had been before. . . . So he
> painted all around these newly born a company of ancients, who
> were in those days called prophets and sybils, whose majesty was
> that of the mind alone at its intensest. And this painting was
> acknowledged through ages and ages to be the summit and mas-
> terpiece of art. Of course we cannot believe such a tale literally. It
> is only a legend. We do not believe in archangels; and the notion
> that thirty thousand years ago sculpture and painting existed,
> and had even reached the glorious perfection they have reached
> with us, is absurd. But what men cannot realize they can at least
> aspire to. They please themselves by pretending that it was real-
> ized in a gold age of the past. This splendid legend endured
> because it lived as a desire in the hearts of the greatest artists.
> The temple of Mediterranea never was built in the past, nor did
> Michael the Archangel exist. . . .

But Arjillax, having matured from abbreviated adolescence, "cannot
pretend to be satisfied now with modelling pretty children," although
the immature Ecrasia maintains with the steadfastness of youth, "With-
out art, the crudeness of reality would make the world unbearable." To
her the She-Ancient suggests better wisdom. "Yes, child: art is the
magic mirror you make to reflect your invisible dreams in visible pic-

tures. You use a glass mirror to see your face: you use works of art to see your soul. But we who are older use neither glass mirrors nor works of art. We have a direct sense of life. When you gain that you will put aside your mirrors and statues, your toys and your dolls." Yet the art-starved Ancients are unhappy and bored, their lives long but bleak, their brave new world gained at great price.

The writing of *Back to Methuselah* seemed to burn Shaw out. He saw no likelihood of another play. Yet in 1913, when he was touring what he referred to as "the Joan of Arc country," he had seen at Orleans a bust "of a helmeted young woman with a face that is unique in art [of the period] in point of being evidently not an ideal face but a portrait, and yet so uncommon as to be unlike any real woman one has ever seen." It was "yet stranger in its impressiveness and the spacing of its features than any ideal head, that it can be accounted for only as an image of a very singular woman; and no other such woman than Joan is discoverable."[22] The discovery was a slow-burning fuse, but from Orleans Shaw did write to Mrs. Patrick Campbell—his Eliza in Pygmalion—that he would do a Joan play "some day,"[23] and he described his proposed epilogue for it, complete to English soldier rewarded in heaven for the two sticks he tied together and gave Joan for a cross as she went to the stake. Ten years later he wrote the play which was preface to that epilogue.

The helmeted head, once in the Church of St. Maurice and attributed to the fifteenth century, is reputed to have been inspired by Joan. According to tradition, when Joan entered Orleans in triumph with the relieving force, a sculptor modeled the head of his statue of St. Maurice from Joan herself. When the church was demolished in 1850, the head of the statue was preserved. After Shaw saw it, he declared that although no proof existed, "those extraordinarily spaced eyes raised so powerfully the question 'If this woman not be Joan, who is she?' that I dispense with further evidence, and challenge those who disagree with me to prove a negative."[24] The eyes do cast a spell; one can imagine the woman beneath them as capable of Joan's visionary uniqueness.

Throughout France images of Joan on tapestry and canvas, in relief and statuary, in manuscript illuminations and contemporary woodcuts, and even on medals and coins, proliferate. Her legend has invited artistic representation, but most of the events in which she is depicted defy stage dramatization—the panoply of the coronation at Reims, the sieges and battles, Joan's capture and her burning. Shaw handled each of these on stage indirectly, but his indebtedness to the visual art of Joan's period is strong nevertheless. His description of the immature twenty-six-year-old Dauphin is memorable. The future Charles VII is "*a poor creature physically; and the current fashion of shaving closely and*

hiding carefully every scrap of hair under the head covering or head-dress . . . makes the worst of his appearance. He has little narrow eyes, near together, a long and pendulous nose that droops over his thick short upper lip, and the expression of a young dog accustomed to being kicked, yet incorrigible and irrepressible." That the Dauphin seems to have been imagined from the Jean Fouquet portrait on wood of Charles VII now in the Louvre is unquestionable, as Shaw's description is exact, from the Dauphin's glum expression to the shaven rim of skull which emerges from under a large and ugly hat. That Shaw knew Fouquet's work is clear indeed. In the epilogue to the play, Charles is discovered in bed reading—or rather looking at the pictures—in a Fouquet-illustrated Boccaccio.

How well Shaw researched his characters can be seen also from Jean Dunois, the Bastard of Orleans, for the preface to the play refers to "Dunois' face, still on record at Chateaudun," probably in a painting or engraving encountered on a Shavian exploration of the "Joan of Arc country." But not all representations of Joan he knew were contemporary or came from Lorraine. In Scene V, for example, Shaw ingeniously bypassed Charles's coronation by beginning the action with Joan alone in the cathedral afterward, "kneeling in prayer . . . beautifully dressed, but still in male attire." The image was familiar, and at least two such representations were known to Shaw: an anonymous sculpture at Domremy and a Millais painting which antedated the *Northwest Passage*, which had inspired a scene in *Heartbreak House*. Millais's *Joan of Arc*, painted in 1865, was exhibited that year at the Royal Academy and again in 1898. And Shaw came upon the Domremy statue in 1913, when he traveled through the village "for the sake of Saint Joan of Arc."

It is even possible that one picture Shaw described in a column of art criticism in the *World* in 1886 lingered in his mind as an example of how not to portray St. Joan and resulted in the third scene of the play. The mediocre Pre-Raphaelite-influenced son of famous parents, Barrett ("Pen") Browning, had taken uneasily to the brush, and "G.B.S." noted in an "In the Picture-Galleries" column that Browning had "made a careful life-school study of a nude woman; brought it into startling relief against a background of vivid verdure; labelled it 'Joan of Arc and the Kingfisher.' . . . As the face of the model is turned away, and her figure not more than ordinarily expressive, the title and quotation assigned the picture in the catalogue may be dismissed as a humorous imposture." Whether or not Shaw remembered the picture, he dramatized the scene which had been identifiable in Browning's work only by its caption.

At her trial, Shaw's heroine appears in a "page's black suit," a costume possibly suggested by *Le Depart de Vaucouleurs*, a painting by

J. E. Lenepveu which became part of his Pantheon mural in Paris. Here Joan is short-haired and dressed in a page's short black smock, stockings, and short ankle boots. Similarly, in a book Shaw knew and referred to, artist Louis-Maurice Boutet de Monvel's *Jeanne d'Arc* (1907), a too-prettified Joan is clothed in page's garb for her trial. Possibly Lenepveu lent his artistic imagination for yet another—but off-stage—scene, the priest John de Stogumber's hysterical but moving report of the burning. It, too, is in the Pantheon mural and has many of the details described by the unhappy Englishman. Like de Stogumber's description, it features English soldiers and clergymen and the French priest (Shaw's Ladvenu) who struggles to hold the cross high above the throng, while Joan, at the stake, looks imploringly up to heaven. But Lenepveu's martyr has no makeshift wooden cross in her bosom. Shaw knew of it from contemporary accounts of Joan's execution and needed no prompting from pictures to reproduce it himself, however much he otherwise adopted from art in giving flesh to the trial transcripts which were his primary source for the play.

Shaw's only wartime visit to France came four years after his exploration of Lorraine. He kept mentally busy on a dull stretch of road between Calais and Boulogne "on an evening stretch of the journey," he reported in a newspaper account in 1917, "by inventing a play on the Rodin theme of The Burgesses of Calais, which like the play about the Reims Virgin, I have never written down, and perhaps never will."[25] But he did, although it was not until 1934 that he consulted Froissart's *Chronicles* and brought the sculpture to life in a short play.

Rodin's *Les Bourgeois de Calais* (1884–86) and Shaw's *The Six of Calais* depict an event which occurred in 1346–47, when, for eleven months, Calais was besieged by the English under Edward III. Edward agreed to lift the siege on the starving city if six hostages, wearing sackcloth and halters and carrying keys, would surrender themselves at his camp outside Calais. Rodin's work commemorates the bravery and selflessness—and misery—of the six burgesses who submitted themselves to Edward's humiliating conditions and immortalizes the wretched men, half-naked and wearing halters at the moment of their surrender. Shaw's play dramatizes the group, but not with strict exactitude.[26] Neither their attitudes, names, nor physical descriptions match those of the Calais monument. For the program of the first production in 1934 Shaw noted that Rodin had "contributed the character of Peter Hardmouth; but his manner of creation was that of a sculptor and not that of a playwright. Nothing remained for me to do but correct Froissart's follies and translate Rodin into words." For his published preface he added that Peter is "the only one without a grey and white beard," while Eustache is the only Rodin burgess *with* a

beard. The differences are insignificant. Shaw was not playing Pygmalion and seeking to bring a statue directly to life, but perhaps no one else in drama brought so many artistic scenes to life on the stage as Bernard Shaw.*

Memories of the art galleries refused to fade. Explaining to Ellen Terry her son Edward Gordon Craig's set-designing deficiencies (15 May 1903), he observed that "Tedward" had a passion for moonlight and "rows of spears borrowed from Paolo Uccello, from a certain Tintoretto picture in Venice, and from the Surrender at Breda, by Velasquez. Now the first act of [Ibsen's] The Vikings should be a most lovely morning scene, all rosy mists, fresh air, virgin light and diamond dewdrops. . . . Instead of which, Signor Teduardo, not being able to manage full light and local color, turns the dawn into night. . . . " Writing in 1921 of poet and artist George Russell ("AE"), Shaw recalled first meeting him "before a lovely modern picture" in the National Gallery of Dublin. It was Shaw the art critic more than Shaw the memoirist sardonically describing the work in question. "The master who painted it," Shaw remembered, commenting on the blindness of the gallery's curators, "had suppressed his name, not in modesty, but because he found that he could get fully a hundred times as much for his work by adopting the name Correggio."27

A few years earlier, Shaw had identified English Philistines as those who "imply that Frith's Derby Day and the Christmas chromolithographs of Santa Claus are the only art for healthy souls." But he had also moved in space and time from the Grosvenor Gallery of the early 1880's to the Grafton Gallery of Georgian London, where he had admired the Post-Impressionists. Cézanne and Matisse, he realized, "Being possessed, by nature and through practice, of a distinguished mastery of their art in its latest academic form [and] . . . finding themselves intolerably hampered by so much ready-made reach-me-down thoughtstuff . . . deliberately returned to primitive conditions so as to come in at the strait

*A low relief rather than a statue had been one of Shaw's earliest dramatic inspirations from art, but the play was never completed. In an art column in the World for 24 April 1889, Shaw had praised Burne-Jones's "skill as a domestic craftsman" as displayed upon "a golden 'cassone' or ark, with a picture in gesso of the Garden of the Hesperides. The ark is the most beautiful simple object in the exhibition." Before the year was out he had begun a play he tentatively titled "The Cassone," in which Eleanor asks Ashton to design a cassone for her. "Oh!" says Ashton, "one of those chests like an altar—an ark, in fact, to hold things." "It must be," Eleanor explains, "a beautifully formed box—noble and beautiful and Grecian, and gilt all over with pure gold. The panels must have pictures in gesso, in deep, rich, heartfelt colors. . . . " It would be, we discover, "a trap for a man's soul," but the play remains a tantalizing fragment.

In the 1930s Shaw would draft the beginning of a play about the Garden of the Hesperides, perhaps an echo of the cassone. Again only a fragment exists.

gate and begin at the beginning with all the knowledge of the men who begin at the end."[28] He was still eager to acknowledge some expertise as a critic, writing a correspondent, on a printed postcard, explaining why he didn't have time to answer letters, that a reproduction he had been sent suggested that the original was not, as the owner hoped, a Rembrandt. "It seems to me that if such a picture were by Rembrandt his hand would be unmistakable. The small reproduction does not suggest him in the least. The scale, the composition, and the background and properties place it within 40 years of 1800 either way. . . . "[29] It was forty years after Shaw had given up art criticism.

By the 1930s, Shaw was no longer visiting galleries. He was too old to collect things and found problems in responding to the newest artistic fashions. To a dealer who invited him to a new show in 1932, he wrote that he was not a collector of art and was reluctant to disappoint a shopkeeper by walking out without buying anything.[30] Yet, the old Victorian pictures retained their hold upon him. When Shaw was eighty, he was asked by William Morris's daughter May, then preparing a collected edition of her father's writings, to promote the project by contributing a memoir. A once-lovely girl whom the young G.B.S. had admired, May Morris had aged unhandsomely, yet Shaw built into his recollections a flattering vignette. "Among the many beautiful things in Morris's two beautiful houses," Shaw wrote in *William Morris as I Knew Him,* "was a very beautiful daughter, then in the flower of her youth. You can see her in Burne-Jones's picture coming down the *Golden Stair,* the central figure. I was a bachelor then, and likely to remain so, for . . . I was so poor that I hardly could have supported Morris's daughter on Morris's scale for a week on my income for a year. . . . "

Although *The Golden Stairs* often languishes in the basement of the Tate Gallery, to which it had been bequeathed by Lady Battersea (Constance Rothschild), the nine-foot by four-foot canvas had been the sensation of 1880, and reproductions of it had even been used during that decade and after by Floriline Hair Tonic and Epps Cocoa. May had been the central figure of thirteen beautiful maidens on Burne-Jones's winding staircase, all daughters of late-Victorian luminaries. To remember her that way showed remarkable tact and showed as well that it was not just for his plays that Shaw extracted metaphors from art.

The rest is epilogue. To the end of his life Shaw found mental pictures for his dramatic concepts from his encounters with painting and sculpture. *In Good King Charles's Golden Days,* written when he was eighty-three, included—anachronistically by two generations—the court painter Geoffrey Kneller, as Shaw was unable to find a significant artist of Isaac Newton's own time to parallel the physicist. (He

had wanted to use Hogarth.) Yet Kneller is more a debating opponent to Newton than portraitist, insisting—with the ample charms of a royal mistress to point to as microcosm of an Einsteinean curvilinear universe—that because space is curved, "the line of beauty is a curve. My hand will not draw a straight line." Another mistress, Barbara Villiers, Duchess of Cleveland, compares Kneller unfavorably with the recently dead Peter Lilly (or Lely), who had painted her portrait for King Charles, and thus provides the director with a lens through which to see her; but all the figures of the play were oft-painted, and the play can be visualized in one sense almost as a three-dimensional composite of seventeenth-century royal portraiture.

A comedy completed when Shaw was ninety, *Buoyant Billions* (1947), had been begun some years before, but the third act, the germinal one about which the others were integrated, found its shape when Shaw, visiting a neighbor, saw a print of Leonardo's *The Last Supper*.[31] He then conceived a "last supper" for a wealthy old man who had brought his guests together to solicit their advice on how to dispose of his money. When he wrote the scene, however, he had old Bill Buoyant invite his children instead and through his solicitor warn them of the difficult future which will await them when he dies and the Buoyant billions revert largely to the state via death duties and charitable bequests. But a picture had been its impetus. And in his last year, in *Shakes versus Shav,* he summoned up for the stage his recollection of the Millais painting that had inspired the *Lear*-like scene in *Heartbreak House.* To the end, the art of his own formative years remained a catalyst for his playwriting, and his encounters with the visual arts added a unique dimension to his plays.

The last side of Shaw's involvement with art exists offstage. From his earliest public years his striking features—first set off by red hair, jutting beard, and Mephistophelean eyebrows and later metamorphosed into white-maned, white-bearded Old Testament sage—captivated artists. His vanity teased by such interest, Shaw encouraged the practice, in some cases assuming that he was engaging in art patronage rather than self-indulgence. As a result, his flats at Adelphi Terrace and then Whitehall Court and his study at Ayot St. Lawrence were narcissistic art galleries, always including a number of Shavian portraits and busts.

More than most public figures outside politics, he was also the subject of caricaturists and cartoonists, worked over by such masters as "Ruth" in *Vanity Fair,* Partridge (Bernard Gould) in the *Sketch,* "Max" (Beerbohm) in myriad publications, and Low in the *New Statesman.* As early as the 1890s he was painted by Chelsea artist Bertha Newcombe as a platform spellbinder. It was, Shaw said as an old man, "the best vision of me at that period," and it may have been the artist's best

work because she—a fellow Fabian—was in love with Shaw, and her rapture gave new impetus to her brush.

The best photographers of the day vied for the opportunity to take his portrait—not only Evans, Sarony, Coburn, and Elliott & Fry in Shaw's earlier years, but Karsh in the last years. Alvin Langdon Coburn's nude study of Shaw in the pose of Rodin's *Thinker* is the most striking and seemingly most narcissistic of all, but his subject explained that most portraits were only masks of one's reputation—in fact, disguises:

> The result is that we have hardly any portraits of men and women. We have no portraits of their legs and shoulders; only of their skirts and trousers and blouses and coats. Nobody knows what Dickens was like or what Queen Victoria was like, though their wardrobes are on record. Many people fancy they know their faces; but they are deceived: we know only the fashion mask of the distinguished novelist and of the queen. And the mask defies the camera. When Mr Alvin Langdon Coburn wanted to exhibit a full-length photographic portrait of me, I secured a faithful representation up to the neck by the trite expedient of sitting to him one morning as I got out of my bath. The portrait was duly hung before a stupefied public as a first step towards the realization of Carlyle's antidote of political idolatry: an naked parliament. But though the body was my body, the face was the face of my reputation. So much so, in fact, that the critics concluded that Mr Coburn had faked his photograph and stuck my head on somebody else's shoulders. . . . [32]

The Rodin pose resulted from Shaw's interest in having the man he regarded as the "greatest sculptor of his epoch" do his bust. To Shaw, Rodin was akin to a "river god turned plasterer," and the three busts he accomplished—in bronze, plaster, and marble—would "outlive plays." A thousand years hence, he suggested, he would be certain of a place in the biographical dictionaries as "Shaw, Bernard: subject of a bust by Rodin: otherwise unknown."[33]

Few of the many portraits and busts Shaw commissioned or encouraged resulted from anything like modesty. The playwright was offering a friend a viable subject, enabling a young artist to make his mark with a picture likely to attract notice or feeding his vanity by having a famous creative personality paint or sculpt him. "A man's interest in the world," Shaw had a character in *Heartbreak House* say, frankly, "is only the overflow from his interest in himself," and after Rodin he permitted, or abetted, busts of himself by Kathleen Bruce (afterward Lady Scott), Jacob Epstein, Jo Davidson, and such fashionable Continental sculptors, in their time, as the Russian Prince Paul Trou-

betskoy, the Yogoslav Sava Botzaris, and the Hungarian Sigmund de Strobl, provoking H. G. Wells's remark that it was impossible to move in Europe without being confronted by an effigy of Shaw.

Only Epstein's bust resulted in a troublesome aftermath for the sitter. Shaw had been an outspoken champion of the American expatriate's work in days when the artistic establishment had attempted to shut the sculptor out. The sitting had even been arranged because Shaw thought that Epstein could "benefit materially"[34] from it, and he praised the sculptor's primitivism and his rejection of classicism, admiring the way he "broke up the brassy surfaces of his busts in his determination to make them flesh."[35] Epstein's actual intentions suggested a different sort of iconoclasm. "I neither looked for nor found the gentleman in him," he told art dealer René Gimpel, "for I saw only the diabolical being." He was not alone in his vision, for Charlotte Shaw, so G.B.S. wrote to Epstein, threatened "that if that bust came into our house she would walk out of it."[36] Defending the work—without admitting it to the house—Shaw described Epstein's "atavism" as essential to his appeal as a sculptor, and saw it as a "Neanderthal Shaw, not a XX century one."[37] Perhaps the most powerful image inspired by Shaw's person, it was never to reside at a Shavian address.

Shavian portraits abound, ranging from the curious one by the third Earl of Lytton in 1905, showing a robed G.B.S. on a golden throne, orb in one hand and red skull cap on his head, like some mysterious pope, and the quizzical one by John Collier strangely rejected by the Royal Academy Hanging Committee, to more conventional pictures like the shaggy-browed pixie by Dame Laura Knight, the puckish drawings of Feliks Topolski, and the celebrity poster by Augustus John. Laura Knight's experience belied her canvas. "The trouble I've had with that portrait!" she sighed to Conrad Aiken's wife, Clarissa. "He's so changeable and so difficult, one minute a tired old man of seventy-six, the next an absolute devil." He sang operatic airs as she tried to keep him still, and told tall tales. "My nurse used to hold the back of my petticoats," he said, recalling Victorian children's dress, "so they wouldn't act like sails and carry me away. . . . And have you noticed the projection [of my ears] at the base of my skull? Catherine the Great had the same. I'm told it means excessive sexual development."[38]

Invited to Lady Gregory's home in Ireland at Coole Park in 1915 specifically to do Shaw's portrait, Augustus John produced three— actually six, Shaw suggested, but "as he kept painting them on top of one another until our protests became overwhelming, only three portraits have survived." One showed the subject with eyes closed, apparently asleep, which he described to Mrs. Patrick Campbell as "Shaw Listening to Someone Else Talking." He purchased the two more vigor-

ous representations (the Queen Mother now owns the third), giving one to the Fitzwilliam Museum and keeping the other at Ayot St. Lawrence, where he described the breezy, posterish picture as the "portrait of my great reputation."[39]

In one way or another, all the drawings, paintings, and busts he commissioned or inspired were portraits of his reputation. When Sir Harold Nicolson traveled to Ayot the month after Shaw's death to assess the property's possibilities for the National Trust, he noted in his diary with amazement, "The pictures, apart from one of Samuel Butler and two of Stalin and one of Gandhi, are exclusively of himself. Even the door-knocker is an image of himself."[40] (He was wrong. There was also a large pastel portrait of Charlotte as a young woman.) But Shaw would have seen nothing wrong in art as a celebration of self. As is written in Ecclesiastes, a book he knew well, "Wherefore I perceive that there is nothing better, than that a man should rejoice in his own works; for that is his portion: for who shall bring him to see what shall be after him?"

Shaw's last, and vicarious, encounter with the Victorian art galleries had nothing narcissistic about it. The very aged live largely within their memories, and on his ninety-fourth and last birthday, 26 July 1950, while his lane was blocked by photographers, messengers staggered to the front door at Ayot St. Lawrence loaded with birthday greetings which Shaw ignored, and delivery vans from Piccadilly brought, he wrote to Sydney Cockerell (27 July 1950), "giant cakes, gorgeous and uneatable," from Fortnum and Mason. The long-retired art critic ignored as much of the fuss as he could by immersing himself in the autobiography and journals of Benjamin R. Haydon. Despondent over commissions unreceived and pictures unsold, the once-famous nineteenth-century historical painter had committed suicide in 1846. William Morris—whom Shaw venerated all his life—"was wrong for once," Shaw insisted to Cockerell, in claiming that Haydon had killed himself because he "found himself out." Rather, Morris had given up painting when *he* had "found himself out as a Rossettian painter. Haydon was the most extraordinary genius of them all." More at the end than in the beginning, Shaw was "an old Victorian."

A NOTE ON THE TEXTS

Unlike G.B.S.'s music and drama criticism—and he was the best critic of his time in both categories—his art criticism, aside from two or three

pieces, is mostly unsigned, never reprinted, and largely unknown. Of the 181 pieces on art collected in this volume, three appear here, from the original manuscripts, for the first time, and 170 have never before been reprinted after their first, often anonymous, publication. Even some of these appear for the first time in accurate form.

Although it is impractical to measure up Shaw's writings on art against all the images which inspired them, many of the more familiar works are available in easily accessible art books, and even the rare, inaccessible, or lost works have their parallels in other art of their time.

All texts are taken from their original sources of publication as noted at the end of each essay or paragraph. Code references are to the Laurence *Bernard Shaw. A Bibliography* (1983). Where a work is published from manuscript for the first time, no code is given; where it is identified for the first time, and thus not in Laurence, it is coded as NIL.

All works have their original Shavian titles; those published untitled or as part of a group of anonymous paragraphs are given bracketed titles. Since he collected many of his press cuttings in scrapbooks now in the British Library's Shaw Archive, and noted on some cuttings his corrections where editors altered his prose, or where he caught printer's errors, these texts have been corrected to reflect Shaw's original intentions. A number of obvious yet minor typographical errors not picked up by Shaw have been made silently.

First references in the prefatory notes to identifications of people in Shaw's art columns can be found in the index.

NOTES

References to Shaw letters in the four-volume *Collected* [actually Selected] *Letters* (1965–88) are dated parenthetically, as are references to Shaw's published music criticism (originally in *The Star* and *The World*) and published dramatic criticism (originally in the *Saturday Review*). References to the art criticism itself are from the present book.

1. Shaw to Henry Salt, 13 December 1912, Humanities Research Center, University of Texas, quoted in George Jefferson, *Edward Garnett* (London, 1982), pp. 321–22.

2. "Composers and Professors in the Coming Century," *The Musician*, 19 May 1897, *The Musician*, 19 May 1987, rept. in *Shaw's Music*, ed. Dan H. Laurence, XXXX III, 392. Earlier *Star* and *World* notices are also reprinted in *Shaw's Music*.

3. "The Redemption at the Crystal Palace," *Pall Mall Gazette*, 8 May 1886, in *Shaw's Music*, I, 461.

4. "Liszt," *The Dramatic Review*, 10 April 1886, in *Shaw's Music*, I, 457.

5. Unsigned note in *The Dramatic Review*, 3 October 1885, in *Shaw's Music*, I, 368.

6. From the "On Diabolonian Ethics" segment of Shaw's preface to *Three Plays for Puritans* (London, 1900).

7. Speech 11 March 1910, printed in *Yeats and the Theatre*, ed. Robert O'Driscoll (Toronto, 1975), p. 57.

8. Shaw to Strudwick, TLS, Burgunder Collection, Cornell University.

9. Shaw to Emery Walker, 15 January 1932, HRC, University of Texas.

10. *Everybody's Political What's What* (London, 1944), pp. 179–80.

11. "Art Corner," *Our Corner*, May 1886, p. 310.

12. *The Sanity of Art,* written 1907, was Shaw's expansion of his review of Max Nordau's *Degeneration,* originally published in the form of a letter to editor Benjamin Tucker, *Liberty* (New York), 27 July 1895, pp. 2–10. Its first title was "A Degenerate's View of Nordau."

13. Barnard, known to his contemporaries as "the Charles Dickens among black-and-white artists," did many of the illustrations in the (London) Household Edition of Dickens, including *A Tale of Two Cities*. He also published three sets of six-lithograph depictions of Dickensian characters as "Character Sketches from Dickens," each afterward issued as a 20 by 14½-inch one-guinea photogravure. The first set (1879) included a Sydney Carton.

14. British Library Ms. 50603.

15. Shaw to Ashley Dukes, 6 April 1927. ALS, Burgunder Collection, Cornell University Library.

16. Shaw in the *Daily Chronicle* (London), 5 March 1917. Reprinted as "Joy Riding at the Front," in *What I Wrote About the War* (London, 1931), p. 255.

17. Martin Meisel, "Cleopatra and 'The Flight into Egypt,'" *Shaw Review* (1964), 62–63.

18. George W. Whiting, "The Cleopatra Rug Scene: Another Source," *Shaw Review* (1960), 15–17.

19. Manuscript pages in the Humanities Research Center, University of Texas. Quoted in *Shaw: An Exhibition* by Dan H. Laurence (Austin, 1977), as catalogue item 280.

20. "Mr. Shaw's Roderick Hudson," *Saturday Review*, 24 November 1906.

21. Preface to *Immaturity* (London, 1930).

22. Preface to *Saint Joan.*

23. Shaw to Mrs. Campbell, 8 September 1931. In Alan Dent, ed., *Bernard Shaw and Mrs Patrick Campbell: Their Correspondence* (New York, 1952).

24. Preface to *Saint Joan.*

25. *Daily Chronicle*, 5 March 1917.

26. Shaw may also have known painter William Hilton's *The Citizens of Calais Delivering Their Keys to King Edward III* (1810), an early nineteenth-century favorite.

27. Shaw, "How Shaw and Russell Met," *Pearson's Magazine*, July 1921.

28. Shaw, "Chestertonism and the War," *New Statesman*, 23 January 1915.

29. Shaw to T. T. Crowe, London, 9 December 1920. Quoted in the Paul C. Richards catalogue 121 (1979) as item 46.

30. Shaw to G. S. Sandilands, London, 4 May 1932. Reproduced in facsimile in Paul Richards catalogue 121 (1979) as item 57.

31. F. R. Rattray, *Bernard Shaw: A Chronicle* (London, 1951), p. 283.

32. "Rodin," *Nation*, 9 November 1912. Reprinted in *Pen Portraits and Reviews* (London, 1931), pp. 226–31.

33. *Table Talk of George Bernard Shaw,* Archibald Henderson, ed. (London, 1925), pp. 90–91.

34. Quoted from Epstein in Richard Buckle, *Jacob Epstein, Sculptor* (London, 1963), p. 210.

35. Shaw, preface to the catalogue of the exhibition of Sigismond de Strobl's sculptures (London, 1935).

36. René Gimpel, *Diary of an Art Dealer,* entry for 3 November 1935 (New York: Farrar, Straus, 1966), p. 433; Shaw, letter to Epstein, quoted in Buckle, p. 211.

37. Shaw to Curtis Freshel, TLS, 27 November 1936, Southern Historical Collection at the University of North Carolina Library, Chapel Hill, North Carolina.

38. Clarissa M. Lorenz, *Lorelei Two: My Life with Conrad Aiken* (Athens, GA: University of Georgia Press, 1983).

39. Michael Holroyd, *Augustus John* (New York and London, 1975), p. 436.

40. Harold Nicolson, diary entry for 11 December 1950. In *Harold Nicolson: Diaries and Letters: The Later Years,* Nigel Nicolson, ed. (New York and London, 1968).

On the London Art Scene

Pictures: A Shavian Preface

[About 1947, when Shaw was well past ninety, he drafted a brief foreword intended for a volume of his writings on art which he planned to add to his Collected Edition. The articles which he had filed were never plucked from his cutting books for the purpose, and would have been incomplete in any case, as Shaw had little idea how much he had written on art, and where it had all appeared. Still, the preface validates his intentions, now fulfilled in this book. The pieces to which he refers appear in their chronological places.

William Archer (1856–1924), Scottish dramatic critic, was Shaw's closest friend in the 1880s. John William Colenso (1814–83), Bishop of Natal, earned opprobrium from his superiors for his The Pentateuch and the Book of Joshua Critically Examined *(1862, 1879), which was regarded as heretical. Edmund Yates (1831–94), editor of* Temple Bar, Tinsley's, *and other periodicals, founded* The World *in 1874 and edited it until his death. The beautiful and statuesque Lady Colin Campbell (1858–1911), born Gertrude Elizabeth Blood in County Clare, married the youngest son of the eighth Duke of Argyll and was judicially separated from him in 1884 after a notorious trial that beclouded both their reputations. She then made a living as a journalist. The other writers and artists to whom Shaw refers are all familiar names, with the possible exception of Domenichino, or Domenico Zampieri (1581–1641), a Bolognese painter whose masterpiece is* The Last Communion of St. Jerome *(1614), in the Vatican.]*

William Morris was fond of saying that no man could pass a shop window with a picture in it without stopping to look at it. This is not completely true: there are people who are picture blind just as there are people who are tone deaf; but it is true enough to be worth saying. I was certainly born with an interest in pictures: I had no literary ambitions, but wanted intensely to be a Michelangelo. As I could not remember anything that did not interest me I could not pass the simplest examination; but I never forgot that Domenichino's name was Zampier, and Raphael's Sanzio. I haunted the National Gallery in Dublin and seldom found anyone else there. When as a child I possessed as much as sixpence (usually my mother's bribe to induce me to submit to a mustard plaster on a sore throat) I bought a box of water colors with it. But though I could write by nature I could not draw nor paint presentably; and nobody ever dreamt of teaching me; so I perforce became an eminent writer instead of a mediocre painter.

Nevertheless I began as an author with years of complete and apparently hopeless failure. When from 1879 to 1893 I wrote five full dress novels no publisher would accept them. The first and longest of them did not get into print for fifty years. I was in the very trough of failure when I made the acquaintance of William Archer, a leading theatre critic on the staff of The World, then the most fashionable weekly magazine of the day. Like most of my few friends we were attracted to one another by being "infidels," the name by which at that time were described all who were at all sceptical as to the articles of the religious creeds and the absolute and final historical and scientific authority of the Bible. Voltaire, Rousseau and Tom Paine were presented to us as blasphemous scoundrels whose deathbeds were made frightful by the imminence of eternal burning in a brimstone hell; and even Bishop Colenso was excommunicated for questioning the actual occurrence of the Resurrection. Archer, piously brought up, was an irreconcilable atheist; and I called myself one publicly whenever the situation called for a stroke of bravado.

It happened that the picture critic of the World died; and the editor, Edmund Yates, asked Archer to take his place. Archer put it to me whether he could honestly undertake this duty in view of the fact that he knew nothing about pictures and could not keep awake in a gallery. I told him to take it by all means, as I knew all about pictures and would go with him to the exhibitions and tell him what to say until he picked up his job.

We tried the experiment until Archer, making no progress, found it unbearable and told Yates so, adding that his notices, with which Yates was quite satisfied, were being written by me. And so I became picture critic to The World, writing paragraphs about the exhibitions for fivepence a line, and articles on the Royal Academy on great occasions. My success led to my becoming music critic to the paper when that too, presently fell vacant; but I still wrote about pictures until I discovered that the fivepence a line was earning me only £35 a year. Yates, shocked and apologetic, handed the post over to Lady Colin Campbell. I returned briefly to the galleries as picture critic to Truth and later on to The Observer; but Truth, under a now forgotten editor, required me to praise his friends' pictures instead of criticizing them, with freedom to do the same for my own friends. I walked out; and that editor presently died, some said of shock and surprise at the refusal of what seemed to him an entirely reasonable request on a subject of no importance.

The Observer episode was even briefer. The paper had just been bought by a lady who interpolated my first [Royal]/Academy article with eulogies of painters of no account who had invited her to tea; so

again I burnt my boats and left the galleries for ever. I must add that these two magazines were passing through phases of which there is now no trace left, whilst The World has long ceased to exist.

I do not pretend that these youthful criticisms of mine are of any artistic importance; but they illustrate to some extent the evanescence of fashionable reputations in art, and also the growth of unfashionable ones; so here they are for what they are worth.

c. 1947 [BL 50664]

Art Corner

[Shaw's first column on art was as tough-minded and confident as if he were a veteran critic. The "Art Corner" department in Annie Besant's Socialist monthly Our Corner *covered all the arts; only Shaw's observations on the visual arts are extracted. Burne Jones (1833–98), soon to be Sir Edward, and to hyphenate his name, was the leader of the second phase of the Pre-Raphaelite movement, and elected ARA in 1885. Sir Frederick Leighton (1830–96), elected ARA in 1864, was among the most respected of Victorian neoclassical painters. James A. McNeill Whistler (1834–1903), American expatriate painter and etcher and a student crony of Leighton's in Paris, had quickly diverged from academic work into a pioneering Impressionism. Sir William Blake Richmond (1842–1921), best known as a portrait painter, would be an ARA in 1888. His subject Lettice Wormald was probably the daughter of Thomas Wormald, a famous surgeon at St. Bartholomew's Hospital and Governor of the Foundling Hospital. Andrew Lang (1844–1912), man of letters, was best known for his translations of Homer.*

Paolo Veronese (1528–88) was the Venetian painter and muralist. Walter Crane (1845–1915), artist and designer for books and textiles, would design the cover for Shaw's Fabian Essays *(1889). George Frederic Watts (1817–1904) was a fashionable historical, allegorical, and portrait painter then at the height of his reputation. Sir John Everett Millais (1829–96), elected ARA in 1853, was a founder of the Pre-Raphaelite Brotherhood and then a fashionable society painter. W. E. Gladstone (1809–98) would be Victoria's prime minister four times, finally passing from the political scene in 1894. Robert Barrett ("Pen") Browning (1846–1912), son of the poet Robert Browning (1812–89), was a struggling protégé of Millais. Rudolf Lehmann (1819–1905)*

was a German-born portrait and historical painter who had settled in London in 1866.

Thomas Matthews Rooke (1842–1942), a protégé of John Ruskin (1819–1900), painted architectural, biblical, and portrait subjects. George Henry Boughton (1833–1905), London-based American expatriate painter, was elected ARA in 1879. Thomas Erat Harrison, painter and sculptor, exhibited at the RA 1875–95. Charles William Mitchell, Newcastle genre painter, exhibited at the RA 1876–89. Charles Kingsley (1819–75) published his novel Hypatia *in 1853. John Melhuish Strudwick (1849–1937) was a protégé of Burne-Jones best known for his allegorical and mythological paintings. Marie Spartali Stillman (1844–1927) was a model for Whistler and for Dante Gabriel Rossetti (1828–82), who painted in the Pre-Raphaelite manner. John Roddam Spencer-Stanhope (1829–1908), who painted first in the manner of Watts and then in the late Pre-Raphaelite style of Burne-Jones, lived in Florence after 1880.]*

During the past month Art has suffered an unusually severe blow at the hands of the Royal Academy by the opening of the annual exhibition at Burlington House. But as this painful subject is dealt with in another article, it only remains, as far as pictures are concerned, to treat of the Grosvenor Gallery, which is this year distinguished negatively by nothing from Mr. Burne Jones, nothing from Mr. Whistler, and next to nothing from Sir Frederick Leighton. In their absence Mr. W. B. Richmond takes a strong lead with a large history piece, a couple of sketches of Grecian scenery, and no less than eight admirable portraits, of which those of Miss Lettice Wormald and Mr. Andrew Lang are likely to be most popular. Their delicacy, which is a charm in these portraits, reappears as a weakness in "An Audience in Athens during the representation of the *Agamemnon.*" Aerial perspective exacted in this picture that the figures should be less and less emphasized as they stand further and further from the spectator. In order to leave sufficient scope for this gradation, the front row should have been handled with the maximum of force. But Mr. Richmond, apparently led into improvident habits by his portraits, which of course impose no such conditions on him, has painted his foremost figures almost as prettily and as squeamishly as he painted Miss Lettice Wormald, and so was compelled to fill the middle distance with ghosts of Greeks, and to dilute the colors of the background until they resembled those of a print gown washed at least twice too often. It should be mentioned, however, that the front row of figures, owing to the semicircular sweep of the bench on which they are seated, are partly in the foreground, and partly in the middle distance. Paul Veronese would have made

room for depths of perspective by making the nearest man at each side a richly draped negro. Such an expedient would require some courage in these days of Christy Minstrel corner men. The fact that the centre of interest is not in the picture at all, but on the stage at which we only see the Greeks staring; and the scantiness of the audience, suggesting that the *Agamemnon* was "a frost," completes the unsatisfactory effect of the picture. Democrats will rejoice at Mr. Walter Crane's "Freedom" descending in angelic radiance upon an awakening youth, from whose limbs are falling the fetters forged by the hoary priest and leaden-eyed king who sit in the background, dozing in dull confidence that their sway is everlasting. Mr. Crane, who has not the classic regard for a safely and therefore gracefully poised figure, has given his Freedom an air of falling downstairs, and being on the point of pitching head foremost upon an alarmed youth on the mat. A kindred defect appears in another picture by him in the overdone attitude of Pandora, who sprawls like an unskilful actress upon her box, which is large enough to contain her entire wardrobe. Nevertheless Mr. Crane's work is of a higher class than that of any other exhibitor in the Grosvenor gallery except Mr. Watts, who has sent a large picture of Love and Life. Life is represented by a narrow rocky path. A young girl is painfully traversing it, helped along by Love in the shape of an agreeable youth with wings and an encouraging smile. The absence of roundness in the outline of the girl's limbs produces a cadaverous appearance which sensibly diminishes her beauty, but intensifies the impression of sadness and weakness conveyed by the whole composition. Mr. Watts also exhibits some of his incomparable portraits. Mr. Millais's Gladstone is less striking than his last portrait of the eminent statesman, but is perhaps a better picture. Portraits of Robert Browning have been contributed by Mr. R. Barrett Browning and Mr. Lehmann. Mr. Browning has certainly not flattered his illustrious father; but his portrait is more valuable than that of Mr. Lehmann, who, painting on easier terms (Mr. Barrett Browning, commissioned by Balliol College, was handicapped by the academic gown of his sitter), has turned out the smarter but less impressive picture of the two. A couple of salmon fishing sketches in oil are recognizable as Mr. Boughton's by the prodigious noses with which this artist invariably decorates his figures. Features large out of all proportion to the scale of the wearers are also prevalent in the laborious work of Mr. T. M. Rooke. Mr. T. Erat Harrison exhibits a small Danae standing erect with the shower of gold sweeping round her in a whirlwind. The cool light in which the gold rains down, and the deep green hue of the walls, carry out a delightful scheme of color. Mr. C. W. Mitchell has tried the heroic style in his martyrdom of Hypatia, who is represented, as in Kingsley's novel, meeting her death

at a Christian altar. The picture will not harrow the spectator as an adequate representation of the scene certainly would. The pursuers are invisible; and everything is left to our imagination and historical knowledge except the presence of an undraped woman, good looking, but not oppressively clever, in some embarrassing but not self-explanatory predicament in church. Mr. Alma Tadema displays his virtuosity in white marble by the familiar hemicyclium, with the usual blue sea beyond, in "Expectations." A solitary young lady has just got rid of the gentleman whom we are accustomed to see reciting Homer there, and is expecting someone else. Hence the title! "Who is it?" is a quotation from a lady who is looking over a wall. Both these pictures are unusually beautiful specimens of Mr. Alma Tadema's art. The subdued light in them veils with an imaginative air the shallowness of conception which so heavily discounts the glaring perfection of most of this painter's produce. More reflective work is that of Mr. Strudwick, whose "Golden Thread" is irreproachable so far as it goes; and Mrs. Stillman's beautifully colored and carefully finished "Love's Messenger": the texture of the flesh in which is, however, a distinct failure. Mr. Spencer Stanhope has depicted the birth of Venus, but has not elucidated what she is trying to do with her head, since there is no apparent reason why she should be trying to put it under her arm. The Grosvenor Gallery is always well provided with exhibitors who seem to have sought the most recondite sources for enlightenment in their art, but who, ignorant of the simple principle that economy of force always underlies grace of attitude and movement, perpetrate blunders in posing their figures that any professional dancer, fencer, boxer, circus athlete, or skilled actor (not to mention any intelligent observer of Greek statuary), could correct at a glance.

Our Corner, June 1885 [C114]

The French Gallery and Messrs. Tooth's

[Shaw's venture to the Bond Street galleries resulted in only a tailpiece paragraph to a column on theater matters. Karl Leopold Müller (1834–92) specialized in Middle Eastern (called "Oriental") scenes; Karl Ludwig Becker (1820–1900) painted Venetian themes, sometimes historical. Ricardo de Madrazo (1852–1917) was one of a large family of artists exhibiting in Spain, France, Britain, and Germany. The Dutch-born Lawrence Alma-Tadema (1836–1912), RA 1879, skill-

fully suggested Greco-Roman architectural and archaeological authenticity to settings of flimsily draped women.]

The foreign artists have not much to say for themselves at the French Gallery this season. Professor Leopold Muller's eastern scenes come under the head of ethnography rather than of art, though considerable artistic skill has been employed in their production. Nor is there any novelty worth remembering at Messrs. Tooth's in the Haymarket. One would indeed willingly forget M. Becker's Christian martyr, a lady who lies supine, with her tunic nailed to her breast by three arrows, and the affected smile of a ballet dancer on her half-closed lips and eyelids. Señor Madrazo's "Soubrette," and a few old works by Mr. Alma Tadema, are the most skilfully painted pictures in the exhibition. Few of the rest have even manual skill to recommend them.

Our Corner, December 1885 [C174]

The Institute of Painters in Oil Colours

[Shaw quickly discovered how difficult it would be to prevent his art columns from degenerating into lists. Frederick Barnard (1846–96) was a painter and illustrator who contributed regularly to Punch *and to the* Illustrated London News. *Horatio Sparkins is the name assumed by drapery businessman Samuel Smith to get into polite society in Dickens's* Sketches by Boz, 1836. *William Small (1843–1929) was a watercolorist for the proliferating illustrated magazines; Richard Caton Woodville (1856–1927) was a painter and illustrator, notably of military scenes from Napoleonic and Victorian colonial wars. Charles Green (1840–98), watercolorist and illustrator, was largely a contributor of black-and-white genre scenes to magazines and books. John Reinhard Weguelin (1849–1927) painted classical, biblical, and historical subjects, largely in the neoclassical style of Sir Lawrence Alma-Tadema (1836–1912). Arthur Hughes (1830–1915), Pre-Raphaelite painter notable for his delicacy of color and line, later turned to book illustration. Thomas Benjamin Kennington (1856–1916) moved from illustrating genre scenes to depicting upper-class life. The Kennington Oval is in southeast London.*

John Scott (1850–1919) was a London genre painter; Georges Montbard (?–1903) was a landscapist who painted English, French, and Middle Eastern settings. Frank William Warwick Topham (1838–

1924), genre painter and watercolorist, studied under his father, Francis William Topham. Miss Eastlake is Mary Eastlake (1856–1911), an actress whose stage career faded in the early 1890s.

Frank Dicey (?–1888) was a London painter of figure and genre subjects; Philip Richard ("Phil") Morris (1838–1902), ARA, painted domestic and historical scenes, then turned to portraits. John Charles Dollman (1851–1934), genre painter, specialized in dramatic scenes involving animals, especially dogs.

John Atkinson Grimshaw (1836–93), Leeds-born painter of landscapes and townscapes, was best known for his "moonlights"—striking moonlit night scenes. He seldom exhibited publicly, usually working on commission for patrons. Edward Frederick Brewtnall (1846–1902) was a London landscape and genre painter; Edward Sherard Kennedy exhibited genre and historical paintings in London 1863–1890. Samuel Melton Fisher (1860–1939) specialized in genre scenes with Italianate settings; Harry E. James (?–1902), Cornish painter of landscapes and boatscapes, also worked out of London. William Padgett (1851–1904) was a London landscape and genre watercolorist in the tradition of Jean François Millet (1814–75), Barbizon rustic painter. Thomas Hope McLachlan (1845–97) painted romantic, moody English landscapes peopled by Millet-like figures. Cecil Lawson (1851–82) was an early Impressionist landscapist whose premature death robbed Britain of a major painter.

Rudolf Swoboda (1819–59) was a German genre and landscape painter; Edgar Barclay (exhibited 1868–1913) was a German-trained London painter of Millet-like scenes. John MacWhirter (1839–1911), a Scottish painter, was known for his Pre-Raphaelite attention to detail. Alfred Walter Bayes (1832–1909), elected ARA 1890, was a London genre painter, etcher, and engraver. Paul Falconer Poole (1807–79), RA, a Bristol genre and history painter, left England for Geneva after being involved in a marital scandal. Alfred Sacheverel Coke exhibited largely historical subjects 1869–92; Shaw's joke at the expense of Robert Gascoyne-Cecil, third Marquis of Salisbury (1830–1903) and Conservative prime minister, refers to his patrician demeanor and full beard.

John William Waterhouse (1849–1917) painted genre scenes in a romantic, Pre-Raphaelite mood; John Thomas Hamilton Macallum (1841–96) was a Scottish painter of coastal and fishing subjects. George Stanfield Walters (1838–1924) painted Liverpool-area, Welsh, and Dutch seascapes and landscapes. Charles Edward Johnson (1832–1913) was an English genre painter; William Lionel Wyllie (1851–1931), ARA 1889, painted London-area marine and coastal scenes. Jane Dealy (Lady Lewis) exhibited genre scenes, mostly studies of

children, 1879–1903, and illustrated children's books. Charles James Lewis (1830–92) painted rustic and angling subjects as well as landscapes; Solomon Joseph Solomon (1860–1927) painted portraits and genre scenes as well as biblical subjects.

Alfred Toft (1862–1949) moved from portrait busts to figurative sculpture and then to war memorials for Cardiff and Birmingham. His subject Hugh Willoughby Sweny (?–1887) was then an art critic under the pen name of "Maulstick."]

The third exhibition of this young association is now open at Prince's Hall, Piccadilly. The average of merit is fairly high: so much so that many pictures which would be remarkable at an ordinary Academy exhibition do not stand out from the rank and file here. It must not be inferred, however, that the painters have proved themselves particularly thoughtful or observant. They are merely skilful with their hands, and seem for the most part humbly desirous of nothing more than a handsome *douceur* from an illustrated paper for the privilege of publishing their pictures in chromo-lithograph for the adornment of a Christmas number. Hence there is abundance of pretty pussy, good dog, mamma, papa, and baby. It is melancholy to have to add that the effect of this competition for shop-window popularity has so far been rather a beneficial one. It has raised Art to the level at which it will hereafter keep it nailed down.

Among the experiments in colour by famous manipulators of black and white, Mr. Barnard's are the least successful. His "Pot Boiler" (8) is a disastrous attempt to paint bright sunshine in the open air; and his "Horatio Sparkins" (647) is hardly better than the immature sketch by Dickens which it illustrates. Mr. W. Small, who has on former occasions been at an obvious disadvantage with the palette, has been rather happy in his "Critics" (395), a couple of fisherwomen scanning the work of a fascinating lady artist. Mr. Caton Woodville, who is almost too clever to be anything but a very smart draughtsman and picture maker, sends an effective picture of "Ali, a Man of Wars and Woes" (273), gorgeous in gem-like hues. The features of Mr. Charles Green's "Cinderella" (377) are merely drawn with the point of the brush on a face as flat as that of a clock. Mr. Weguelin, in "Blossoms from a Roman Garden" (344), is more like Mr. Alma Tadema than ever. The woolly tissue of the leaves and sward in Mr. Arthur Hughes's "Rest in the Wood" (357), and the stuffed and sewn-up appearance of some of the branches, do not prevent the picture from being, on the whole, a striking one. Mr. Kennington sends a study (426) of his own name, inscribed in tall poplar-like letters on a wall, presumably in the neighbourhood of the Oval. The title "Fancy Free" probably refers to a lady

who occupies a subordinate position beneath. The same painter's "Poverty" (48) is a more ambitious work, and does not refer to poverty of ideas. Mr. John Scott exhibits two unaccountable pictures of a lady who reposes in the branches of a tree on her wings, as in a hammock. No explanation is given of how she came by the wings, or of her relations with the raven, who, in the second picture, inscrutably called "The Ambassador" (285), has stolen someone's necklace. Mr. G. Montbard's "Study in a Burgundian Forest" (143) will repay inspection. Mr. Walter Crane sends two panels with female figures, Laura (718) and Fiammetta (761), painted on a golden background. Laura is the prettier. No. 499, by Mr. F. W. Topham, represents Miss Eastlake, in her Ophelia costume, posing as a candelabrum. Mr. Phil Morris's "Sisters" (388) is a sentimental composition of widow, bride, white satin in dark green shadow, and crape. It will not strike connoisseurs as the outcome of severe mental exercise. Mr. F. Dicey's "The World Forgetting" (638) might be called "The Critics Forgetting." It will not add to Mr. Dicey's reputation. In his "After the Day's Run" (338) there is nothing of merit except the representation of the winter evening's light. Mr. J. C. Dollman's "Stop Thief" (368) is one of the few attempts at humorous pictures that justify a smile. It represents a dog bolting with a goose, pursued by missile turnips, potatoes, and a hat. The lamplight is, as usual, the weak point in Mr. Atkinson Grimshaw's "Piccadilly" (784). Why does not some artist try "Portland-place by lamplight on a wet night"? Prosaic as the suggestion sounds, the reflection of the lamplight from the wet flagway produces effects of extraordinary splendour. Mr. E. F. Brewtnall's "Outlaws" (686) await their prey in the warm light of a very clear evening. Mr. E. Sherard Kennedy's "Rosalind" (711) almost makes one feel before the line at the Royal Academy. Mr. S. Melton Fisher's picture of "Three Maskers" (406) is as repulsive as realistic treatment of a vile subject can make it. The woman in Mr. Harry E. James's "A Moment's Rest" (695) is so artificially posed that pleasure in the contemplation of the picture is impossible. Mr. William Padgett, in "The Old Wife's Work" (717), follows in the footsteps of the great Millet, by seeking pathos in the stooping figure of a toil-worn old woman. Mr. T. Hope M'Lachlan's poetic landscapes recall the work of the late Cecil Lawson, especially the misty "Twilight" (649), with the flock of sheep. In Mr. Rudolf Swoboda's "Bazaar in Cairo" (633), the sunlight, dazzling as it is, seems Arctic rather than Egyptian. Mr. Edgar Barclay's "Tame Magpie" (611) is handled like a water-colour. Mr. MacWhirter's "Isle of Skye, from Loch Hourn" (456), inspires a hope that the artist will avoid the Isle of Skye in future, and keep in the neighbourhood of the beeches and birches he paints so much better. Mr. A. W. Bayes, in "Eagle's Crag" (431),

makes one fancy for a moment that a posthumous work by Falconer Poole has found its way into the gallery. Mr. A. Sacheverel Coke's "Pheidias at Olympia" (311) must not be mistaken for a portrait of Lord Salisbury. Mr. Waterhouse's "Gossip" (319) is gaudy. Mr. G. S. Walter's "Peaceful Close of a Summer's Day" (292) is an attractive study of a silvery sea. Mr. Hamilton Macallum, Mr. C. E. Johnson, and Mr. W. L. Wyllie send specimens of their usual work. Miss Jane Dealy's "Dutch Bargain"(101) shows the power of observing national characteristics in children. Mr. F. D. Millet's two pictures are among the most important works in the exhibition. "The Granddaughter" (450) will soften the British matron more than the "The Amanuensis" (7), which will, nevertheless, be preferred by the critics. Mr. C. J. Lewis's "Old Battersea Bridge" (171) gives a monstrously exaggerated idea of the width of the Thames opposite Cheyne Walk. Mr. Solomon J. Solomon's "Home Scene and Heart Study" (78) is a remarkably original and truthful representation of a *bourgeois* interior, with a vulgar, but superficially very presentable, couple "spooning"—as they would say—over some photographs in a corner by themselves.

The sculpture includes a capital portrait bust in terra cotta of Mr. Hugh Willoughby Sweny, by Mr. Albert Toft.

The Dramatic Review, 5 December 1885 [C175]

Art and Society

[On 8 December 1885 Shaw began writing, in longhand, a lecture he was to deliver two evenings later at the Bedford Debating Society, one of the many discussion groups of intellectuals in which he continued his education and involved himself with like-minded friends. Writing in essay form rather than in his usual manner for talks (a series of note-cards), he spent all of the 9th on the talk and finished it on the 10th, barely in time to deliver it. The title is editorially added. Shaw had only written in his diary on the 10th "Lecture on 'Art' at Bedford."

The Society had previously heard from veteran art critic John Ruskin (1819–1900), then in shaky mental health but always eager to present his views; poet, printer, arts-and-crafts entrepreneur and Socialist visionary William Morris (1834–96); and artist-designer Walter Crane.

Shaw's spelling of Shakespeare *as well as much else was always idiosyncratic. His intentions are followed in this text.*

Burlington House was (and is) the home of the Royal Academy of Arts, in Piccadilly. George Du Maurier (1834–96), Punch satirist and cartoonist, would be the author of the 1890s fiction best-seller Trilby. *William Hogarth (1697–1764) was the greatest English satirist in line drawing, and a painter and engraver. Francis Galton (1822–1911), scientist and sociologist, was the author of* Hereditary Genius *(1869). Laputa was the mythical land in* Gulliver's Travels *where myriad expensive experimental follies were practiced in the name of science.*

William Frith (1819–1909), ARA in 1845, became famous with huge genre canvases, one of which Ramsgate Sands *(1854), was purchased by Queen Victoria. Turner is J. M. W. Turner (1775–1851), the great master of English landscape art. Sir Francis Grant (1803–78) was a fashionable painter of portraits and hunting scenes who established his reputation with his picture of Queen Victoria and Lord Melbourne riding in Windsor Park (1840). The Venetian painter Tintoretto in actuality was Jacopo Robusti (1518–94); Shaw accepts him as on the highest possible plane of achievement in the visual arts.*

Jacques Offenbach's gallant General Rudolph Boum is a character in the comic opera The Grand Duchess of Gerolstein *(1867). Nicholas Rowe (1674–1718), dramatist of* The Fair Penitent *and* Jane Shore, *also edited an edition of Shakespeare's plays (1709). The Venetian painter Titian was actually Tiziano Vecellio (1477–1576). Francis Bacon (1561–1626) was convicted of bribe-taking when James I's attorney-general, imprisoned briefly in the Tower of London in 1621, then forced to retire. The Urbino painter Raffaelo Sanzio (1483–1520) was called Raphael. His father was the painter Giovanni Sanzio (?–1494). William Holman Hunt (1827–1910), one of the original Pre-Raphaelite painters, painted genre scenes, Middle Eastern settings, and religious pictures with grim actuality.*

Shaw's Yankee-bashing lines refer to "robber barons" Cornelius Vanderbilt (1794–1877), railway financier, and Jay Gould (1836–92), an even more rapacious bank and railway financial manipulator.]

I must begin by asking some indulgence from you in consideration of the subjects upon which I am driven by circumstances to address you. On a previous occasion, it was my misfortune to bring before you the subject of Socialism. To-night I have undertaken to deal with Art. In discussing Socialism, societies of ladies and gentlemen usually emancipate themselves from the sway of reason and humanity, and debate briskly, if not wisely. In discussing Art, they are equally untrammeled; but they unfortunately assume an attitude of superstitious approval towards Art, which they suppose to be a good thing just as they

suppose Socialism to be a bad thing. The result is that a discussion on Art has all the insane irrelevance of a debate on Socialism, without the hostilities and personalities which make the latter stimulating, if not edifying. It is therefore, from our debating-society point of view, most fortunate that Mr. Ruskin, Mr. Morris, and Mr. Walter Crane, have mixed the two subjects up in such a way that I have some hope of being able to exasperate my hearers to a debate quite as energetic and acrimonious as a paper on pure Socialism could evoke.

The word Art cannot be defined, because the majority of the people who use it do not understand the matters to which they apply it, sufficiently to determine its function with even moderate exactness. I shall deal this evening chiefly with what are called the Fine Arts— Picture making, Book making, Decoration, Music, and the like. The pursuit of these was formerly deemed frivolous: it is now regarded as serious and beneficent. Neither of these views is of any greater authority than the other. The prevalence at present of that more favorable to Art, is due to the fact that, in modern society, most of those who have leisure to cultivate Art have no other resource for killing time except Folly or Vice. We credit ladies and gentlemen who study the violin or paint in water-colours with superior characters because we have remarked that ladies and gentlemen who are not so occupied, are generally doing something worse. This is a purely accidental state of affairs. It leads our shallower philanthropists to give cheap concerts and to exhibit pictures at the East End with a vague impression that they are improving their fellow creatures; but as a matter of fact no one seriously pretends that the mental activity induced by music or painting is more healthy than any other form of serviceable work. It is impossible to admit that Art would have any peculiar power of keeping people out of mischief in a rationally ordered community. At present, when gentlemen of property are deprived by their inherited wealth of that incentive to useful work which we all set such store by; and when society compels them to be either amateur artists, butchers, gamblers, sots, or politicians, it is doubtless lest that they should become amateur artists. And whilst the workman has to choose between a dwelling room in which a well-bred horse would sicken and die; the public house; or the cheap concert, it is certainly best that he should go to the cheap concert, as often as he can stand it. But this use of Art as a palliative for the social gangrene, though it is the only apology for much of the art of the present day, is also one of the causes of the extreme need of apology in what that Art stands for. The gentleman artist ceases to have eyes for anything but his own water colours and for those sufficiently near them in merit to excite his jealousy. The spectators of these works are fatigued rather than edified by their contemplation. At the cheap con-

certs the music is for the most part calculated to reconcile the workman to the fact that he cannot afford to buy a pianoforte. Bad music may be better for the workman than gin; but from an artistic point of view it is better to have no music at all than bad music. If no music at all happens to mean gin under present arrangements, that is not an argument in favour of bad music, but an additional argument—if any were needed—in favour of fresh arrangements. Pending alterations, we may as well admit that from the social point of view a great deal of bad art is now excusable as the only alternative to greater evil. The admission being made, we can pass on to the mere artistic point of view.

There are people who talk of Pure Art, Art for Art's sake, Absolute Art, and the like. These people are usually incapable of elementary metaphysics, from which they impatiently take refuge in a pretence of transcendental metaphysics. The Arts are certain methods of seeking happiness; and they are mischievous or beneficial, moral or immoral, just as other methods of seeking happiness are. A work of Art is good or bad according to the side on which the balance appears when its total effects on human welfare for good and evil are set against one another. In many instances, the calculation is quite beyond our arithmetic. As far as I am aware, no one has as yet any means of determining even approximately the conditions of good and evil in house decoration. One man covers the walls and ceiling of his room with obliterated penny postage stamps. Another prefers oyster shells or Dutch tiles. A third takes counsel with Mr. Whistler: a fourth with Mr. Morris. Manufacturers of wall papers find that there is a certain demand for patterns with spots; patterns with leaves; patterns with stripes; and a pattern with a hunting scene recurring in every square yard of the paper. The people who buy the stripes are not discoverably inferior to the people who insist on spots; and both despise the admirers of the hunting field, though these are often healthy, honest, and cheerful citizens. Personally, I prefer plain whitewash, as being convenient for making pencil memoranda that do not get mislaid. And I challenge any man to quarrel with my taste on any stronger ground than that he likes blue better, to which I am morally justified in replying that I dont: Science will settle the question someday. It will discover the difference between the effect upon mankind of light reflected from a red wall and that reflected from a yellow wall. But until it does so, we are in a state of utter license as to the decoration of our rooms.

When we speak of an Artist as a great painter, we imply that he sees more than an average painter. For example, let us suppose that some patron of the arts and admirer of Shakspere, desiring to possess a picture of Juliet, commissions an average Burlington House exhibitor

to produce such a work. The average one, much gratified, sets to work. He has four ideas concerning Juliet. 1. She was young, because Shakspere said so. 2. She was pretty, because Romeo fell in love with her. 3. She was dark, because she was an Italian. 4. She wore a white satin dress, because she is generally painted with one on. The painter then simply hires a satin dress, and paints a portrait of the prettiest young brunette whom he can induce to put it on and sit to him. He labels the picture "Juliet," and—there you are. When the work is exhibited, thousands of people who have only two, or at most three ideas about Juliet, will be delighted with it. Those who have four ideas will be merely satisfied. Provided, that is, that the four ideas be those of the painter. A certain proportion of perfectly irrational people, who have a notion that Juliet was a fair woman in a blue dress, like Margaret in Faust, will declare that the picture is not like Juliet at all. They will apparently be supported by the contemptuous critics who happen to have five or more ideas about Juliet, and whose disapprobation is utterly incomprehensible to the three- and four-idea people. Now let us suppose another painter, decidedly above the Burlington House average, is painting the same subject. His superiority to the other will consist in his having a greater number of ideas concerning Juliet. For instance, instead of merely painting a dark haired woman, he will paint a woman with the facial characteristics of the Italian race—or, still more exactly, of the North Italian type. To the two ideas that Juliet was young and pretty, he will add that she had a strong will; that she was impatient; that she lived in some dread of her father; that she was affectionate; and that she had the patrician habit of considering herself and her family as better than other people. The question now arises: How on earth can you put all this into a painting?—into an image that neither acts nor speaks? The answer is that character is expressed by signs that can be painted as well as by speech and action. Take one of Juliet's qualities—strength of will! Bring together a hundred women, each with a will of her own—if you are sufficiently courageous—and you will find bewildering differences of height, shape, age, complexion, and even of amiability. But, corresponding to the strength of will which recurs in everyone of these different women, there will recur in all the various faces some significant trait—some ominous squeeze at the corners of the mouth, or vigilant squaring of the eyebrow, which thus becomes stamped upon our minds as the expression of a strong will. The Juliet of our superior painter will have that squeeze of the mouth, or square of the eyebrow, or whatever the sign may be; for I do not pretend to know what it actually is, nor, if I did, would I divide your attention by mentioning it, and so setting all the gentlemen present furtively seeking it in the faces of the nearest ladies instead of attend-

ing to me. In order to give the fullest expression to such a quality as strength of will, a painter must observe far more than the faces of the people he meets. The hand of an energetic person falls, when at rest, into a position quite different to that taken by the hand of a feeble person. Hands and attitudes are expressive just as faces are. It is not necessary to pursue the special subject of expression further here. Enough has been said to shew that the greater painter's ten ideas about Juliet, can be expressed in a painting, just as well as the four cruder ideas of the lesser painter; and to shew why the ordinary Academy exhibitor who makes a study of a female figure and calls it Juliet, or Margaret, or Ariadne, or Mary Queen of Scots, or Ethel Newcome, or any other fashionable heroine, is justly said not to have so much in him as, for instance, Mr. Du Maurier, who presents us with much more highly specialized types. When the ideas expressed in one of Mr. du Maurier's work are analysed into their simplest forms and counted, they are found to be much more numerous than those of the average Academy exhibitor. The difference between the two is quantitative, and therefore the phrases "great painter" and "minor painter" are quite correct. It would be easy to shew, on the same lines, that Mr. du Maurier is inferior to Raphael; but I shall not attempt it, as the majority of my audience probably prefer Mr. du Maurier to Raphael.

The reason I selected Juliet for my illustration was that she enables me to kill two birds with one stone. The difference between a great actress's representation of Juliet on the stage, and that of an average leading lady in a provincial stock company, is of the same nature as the difference between a representation of Juliet on canvas by a great painter and one by an average Academy exhibitor. Consequently I need say nothing more about the art of acting. But before leaving the graphic arts, I wish to lay stress on the fact that the process by which the painter arrives at his ideal head is one that can be performed mechanically by composite photography. I spoke of assembling one hundred strong minded women. If a photographer's plate be sensitized so as to require an exposure of fifty seconds, and, instead of placing one of the women before the camera for that time, each of the hundred be placed there for half a second, the resultant composite photograph will contain only the features which recur alike in all the hundred— that is, the expression of strong will. A composite photograph of a number of patrician ladies will mechanically ascertain that expression of pride which Mr. du Maurier has caught so successfully, and which has evoked a protest from Mr. Ruskin. Composites of the rest of the Juliet characteristics can be obtained one by one in the same way; and a final composite of the composites will be an ideal Juliet. Thus can the process which goes on in the painter's mind be mechanically verified

by the substitution of a sensitized plate for a living retina. It must not be supposed that the painter is conscious of the process. Hogarth, if he had heard Mr. Francis Galton's proposal to obtain pictures of the typical thief and the typical ruffian by composite photography, would quite possibly have set it down as the quintessence of Laputan folly. Nevertheless, Mr. Galton's thief and ruffian have been published, and will bear comparisons with Hogarth's many pictures of criminals. It is to be noted that the truth of both photographs and Hogarths is generally recognized, which proves that the process goes on in all our minds as well as in those of the Hogarths and du Mauriers. It is also to be noted that the composite photograph is distinguished from the ordinary individual photograph by that ideal character which was until recently supposed to be producible by the hand of the artist alone. Of all skilled manual labourers, the artist has hitherto considered himself safest from the competition of machinery. He will soon find that he was desperately mistaken. A two-fold benefit will ensue. He will stop painting inferior pictures; and he will turn Socialist.

Before dealing directly with the subject of Music, which is still, to most educated people, a mere superstition, I must remind you of my proposition that the value of a work of art is determined by the number of *simple* ideas it contains. But we very rarely reduce our highly compound ideas to simple ones; and a picture expressing one highly compound idea may be much greater than a picture expressing two or three dozen simple ones. The idea that Juliet wore a satin dress is obviously much simpler than the idea that she had a strong will: it might occur to any fool. Mr. Frith's Railway Station and Derby Day are pictures that express a multitude of simple ideas of sufficient variety and interest to keep a crowd always in front of them; but as the ideas are not only very simple, but are brought together with very little synthetic power, or "insight" as it is called, these crowded pictures are inferior in value to much smaller single figure pictures by greater painters, who have often expressed more in one face than Mr. Frith does in a hundred figures. But Mr. Frith in turn stands higher than the illustrator of a tailor's catalogue, the subjects of which are essentially still-life subjects, although the draughtsman occasionally depicts a head protruding from the collar of the coat which is the true subject of his pencil. The idea of a man is enormously more compound than that of a coat. Therefore an exhaustive study of a man is a greater achievement than an exhaustive study of a coat, or of a bird, beast, reptile, or landscape. It is true that Turner, though a landscape painter, was greater than Sir Francis Grant, who was a figure painter; but that was because Grant could not rise to the height of his subject, whereas Turner did rise to the height of his, and so saw more in a landscape

than Grant saw in a man. But even Mr. Ruskin has never contended that Turner was as great a painter as Tintoretto. We may take it then that the representation of humanity is the highest art, and proceed to the subject of Music, which has nearly always been a vehicle for the expression of human emotion.

As we have not yet succeeded in making composite phonographs, the music of the future still seems likely to be made by hand as hitherto. But there is no reason to doubt that the process which goes on in the ear of the musician, is analogous to that which takes place in the eye of the painter. Emotions, or states of mind, can be expressed in music with extraordinary intensity; but they cannot be as easily specialized as in the graphic arts or literature. As an example of this, Beethoven's opera Fidelio—the only opera he wrote—is very remarkable. In no opera have the emotions that arise from the action of the drama been more movingly expressed. Horror, resignation, hope, rage, resolution, affection, reluctance, relief, and rapture are all there to the life. The work is nevertheless a failure. To describe a man as angry gives you no idea of the sort of man he is. A piece of music expressing nothing but hope is as appropriate to Cleopatra as to Imogen. Beethoven's opera contains emotions but not individuals. He failed in opera as many great epic and descriptive poets have failed in drama. Bach, who was a much greater man than Beethoven, might have failed equally had he made a like attempt. Wagner has stopped short at the same point: his music-dramas are epic poems written in dialogue and set to music rather than dramas in the Shakesperean sense. It would seem impossible to specialize expression in music so highly as to express individual characters, if it were not that it has been done by Mozart as fully as by Moliere or Shakespere. Such expedients as writing gruff music for robust old men, employed by Beethoven to characterize the jailer in Fidelio, and, quite as admirably, by Offenbach to characterize General Boum, are childish in comparison with Mozart's subtle and consistent discrimination of characters so similarly circumstanced, that only a dramatist of the very highest order could maintain any essential distinction between them. Mozart therefore is entitled to rank as the greatest of musicians for the same reason that Shakespere ranks as the greatest of writers—because he gave artistic expression to the most complex subject—man, under the most complex conditions— those of human personality in a society stratified into classes of various degrees of civilization. It is worth remarking that as a hundred years after Shakspere's death, his eminence was so little understood in literary circles that Nicholas Rowe prefaced an edition of his works by an apology for him as a dramatist who worked "by a mere light of nature"; so it is the fashion now, a hundred years after Mozart's death, to claim

indulgence for him as the clever child of music. This view, however, leaves Mozart's works unaccounted for.

As the instance I took of the art of painting covered the art of acting, so what I have said about music must serve to indicate the order of merit in literature. Of executive skill, I say nothing, because it is necessary to judge artists solely by what they succeed in expressing, as it [is] impossible to know what they have failed to express. If good intentions were allowed to pass for actual achievement, Titian and Turner might have to take a back seat in this room. Those who can invent pictures, but who cannot paint them, can always turn critics. In that capacity I hope they will admit the point that I have been driving at thoughout this paper—the point that the greatest artist is also the wisest artist, and that, as a wise man, he is likely in a well-ordered community, to be a valuable teacher and a good citizen. In an ill ordered community, the wisest course may be to make friends with the Mammon of Unrighteousness, in order that wisdom may not die of starvation. Bacon was a wise man and a rascal; and it is quite an open question whether his rascality was not a proof of his wisdom, and the cause of our enjoying its fruits. Another open question—a very wide open question just now—is whether we live in a well-ordered community. I am of opinion that we do not. We divide our wealth foolishly. I occasionally hear gentlemen say "If you were to divide up all the wealth in the country today, things would be just as they are now again in six months." Whoever had made that remark has spoken—as we all do at one time or another—like an idiot. The wealth of this country is divided up every day before our eyes in our shops and markets, and distributed among us. Those who work hardest and suffer most to produce it get the smallest shares. Those who work less get more; and those who produce nothing at all get most. To call a nation which carries out this arrangement, and which rallies round it in the name of Liberty and Property, a foolish nation, is to flatter its morals at the expense of its understanding. To call it a wicked nation, is to flatter its understanding at the expense of its morals. It is too silly to extort the admiration which we cannot withhold from a clever rogue; and too dishonest to deserve the pity we accord to a well-intentioned dupe. Our immediate concern, however, is with the prospects of Art in such a nation—in England today, in fact. At first sight, they look somewhat rosy; for the fashionable portrait painter[s] can obtain sums of four figures from their patrons. Now, remote from common sense as are the extremes to which vanity will carry men, it may be asserted with the greatest confidence that no man would pay a thousand pounds for his portrait if he had to produce that thousand pounds by his own labour. It is impossible to say how much further he would see even Sir John Millais first. He

would content himself with a photograph. The ladies and gentlemen who patronize Sir John Millais for the sake of the portrait, and not of the social advertisement involved, are so rich that the payment of a thousand pounds inflicts much less deprivation on them than a cockney excursionist suffers when he pays sixpence to the itinerant photographer on Margate sands. They do not feel it at all. Having so huge a share of our wealth, it follows that they belong to the class which does not work. It follows also that they are much richer than the fashionable painter; for he has to work for the thousand pounds before they give it to him; and they have no sooner given it with one hand than they take most of it away with the other in the shape of a heavy ground rent for his house, and the cost of a carriage, servants, and entertainments which he provides ostensibly for his wife, but which are really part of his shop fittings. The painter eventually acquired a certain contempt for his profession apart from the money making side of it; and, what is of even greater importance, he sees that it is much better to make his son a stockjobber, loanmonger, banker, or other form of city man qualifying for country gentleman, than to make him an artist. Probably the young gentleman will have found that out for himself already, and have learned to despise his governor's paint pots, as comparatively unremunerative investments for a man with capital. Now if the artist of genius who has renounced high art to paint portraits of people whose features are uninteresting alike to their contemporaries and to posterity, does not think his profession good enough for his son, how can the minor artist, who has perforce renounced his efforts at high art to give drawing lessons to young ladies naturally incapable of the arts of design, think his occupation a desirable one for *his* son? It takes many generations of drawing masters and minor artists, steadily cultivating their art, to breed a Raphael. It is true that when the Raphael comes, no discouragement may be able to turn him from art; but the case was different with his father, who was perhaps only an artist because his father was one before him, and who would have taken to doctoring or shopkeeping, if that had appeared more profitable to him. But such a swerve would have spoiled the breed, and no Raphael would have resulted. It is the small artists who build up the big ones; and a nation which gives an ordinary stockbroker great advantages over an ordinary artist will have more talent in its stock exchange than in its Royal Academy, and will breed masters of what is called— euphemistically—Finance, instead of masters of painting. America has not yet produced a Raphael and a Titian; but she has produced a Vanderbilt and a Jay Gould.

But it may be said that great colourists and draughtsmen are far more likely to be developed from a race of carpet weavers and cabinet

makers than from minor painters and drawing masters. This would be so if the weavers and joiners were free men enjoying the full produce of their labour; for then they would have leisure to develop the intellectual power, without which, as I have endeavoured to show, the colourist and draughtsman, for want of ideas to express, can never become a great artist. At present the workman has no leisure, because his remuneration has nothing to do with the fruitfulness of his labour: he is expected to do a day's work of at least ten hours in return for the price of a day's subsistence. He may produce the full value of that subsistence in the first five hours of his day; but he is not free to stop then: he must go on for five hours more in order that another man may live without working at all. Consequently his class breeds quick hands and eyes, but not cultured brains, without which great artists cannot be bred. Further, as he is generally engaged by a firm which execute[s] contracts for the sake of profit, he is encouraged to do his work quickly and showily, and is often discharged for doing it patiently and thoroughly. Consequently, in the struggle for existence, the quick and thoughtless survive. The artistic qualities bred in this way are superficiality of execution, quickness of work, thoughtless imitation, and vulgarity of conception. The verification of this is to be found in all our picture galleries, and in none more strikingly than in the Grosvenor Gallery, where we find such exceptional artists as Mr. Burne Jones, Mr. Watts, and Mr. Holman Hunt gaining extraordinary distinction for qualities which, in a really flourishing condition of Art, would be looked for as a matter of course from all painters of any pretensions. But even such brainless dexterity as we abound in is being cut off at its source by machinery, which is turning the handicraftmen from whom our smart shop window artists sprang, into mere unskilled labourers from whose offspring we can expect nothing at all save mischief.

Under these circumstances it might be suggested that we should destroy all machines and make invention a capital crime. Well, we do a great many things that are far more absurd; but this we cannot do, because it is impossible. We gain from machinery an enormous saving of time. Every new machine gives us daily a few years of leisure to "divide up" among the nation. We divide it exactly as we divide the material wealth. To him that hath, much more is given; and from him that hath little, we take that which he already hath. The signalman still does his stretch of sixteen or twentyone hours, its monotony varied only by an occasional collision; and the idle shareholder is enabled to make another son-in-law independent of honest labour. If we can only make up our minds to distribute our vast national stores of leisure fairly, it is already vast enough to make us a nation of artists and thinkers. If we persist in distributing it unfairly, it is vast enough to

corrupt us to the very marrow of our national life—and would do so if we were a race of angels much less what we are. And whilst we are thinking of machinery, it should be noted that one of the chief evils which our insane method of distribution inflicts on us, is the barrier which it raises against further really high developments of machinery. Just as it useless to provide the chattel slave with any but the rudest and coarsest implements, because he is incapable of delicate handling and intelligent direction; so there are many masterpieces of machinery that remain mere useless curiosities because the working classes are too brutalized by excessive work and squalid surroundings to be able to use them. We hardly realize what excessive work and squalor really means, because the standard of comfort for the working classes is so atrociously low; and we have become so hardened by the contemplation of misery in comparison to which mere squalor is luxury, that we think a working man pretty well off when he is half as well housed, and not quite twice as hard worked as a prosperous country doctor's cob; and as to admitting that we respectable Londoners live for the most part in holes of houses much more squalid than any house need be if our arrangements were even moderately rational, we should be highly offended at any such suggestion from a candid visitor. But none the less, we find ourselves and the workmen unable to use the higher arms of precision which science could place in the hands of highly cultivated men. The ideal workman of the future is not the old handicraftsman revived and working with the old tools that machinery has supplanted, but an intelligent and artistic guider of complex machine tools that are now only dreamt of by a few experts in laboratories. Such workers would certainly breed first rate artists, though it is undeniably probable that they would discard as Tomfoolery nine tenths of what we understand by Art.

As long as artists live by the sale of their pictures, they must paint so as to please the buyers. In a society in which all are striving after the thief's ideal of living well and doing nothing—an independent position, as we call it—, and in which the only people who can afford to buy valuable pictures are those who have attained to this ideal, a great artist with anything short of compulsory powers of attraction must either be a hypocrite; paint landscapes (which have no social significance); or starve. If he attempts the highest art, which, as we have seen is necessarily the most significant with regard to humanity, he had better either inherit a property first, or else make haste to become popular whilst he is young and does not know enough to be dangerous. When he really becomes a great artist, he will be before his time, and so will not gain much more by exhibiting his picture at a shilling a head than will pay for the necessary advertisements. It takes a capital-

ist to exploit a great painter, and the painter is just as likely to catch a wealthy patron with a first rate work as a capitalist. Failing this, he will end by coming down to the selling level, and keeping there. But indeed we breed for imbecility, roguery, and drudgery, so much more successfully than for artistic skill, that the selling level pulls up more men than it drags down. This is at once its apology and its condemnation. My general conclusion is that we need look for no improvement in the beauty of our lives, and therefore for no valuable advance in Art, until we redistribute our immense Wealth and our immense Leisure so as to secure to every honest man his due share of both in return for his due share of the national labour.

[BL 50702]

[John Millais after Pre-Raphaelitism]

[Mrs. F. W. H. Myers was the former Eveleen Tennant, the youngest daughter of Charles Tennant of Codopton Lodge, Neath, Glamorganshire. Mrs. Bischoffsheim was the widow of a Paris banker; Miss Hermione Schenley, a watercolorist, lived opulently at Prince's Gate.

John Bright (1811–89), Liberal M.P. for Birmingham, served in two Gladstone cabinets. Sir James Paget (1814–99) became President of the Royal College of Physicians in 1875; Luther Holden (1815–1905), Senior Surgeon at St. Bart's, was President of the Royal College of Surgeons. Sir Henry Thompson (1820–1904) was Professor of Clinical Surgery at University Hospital, London, and was best known for having operated (unsuccessfully) upon the exiled Napoleon III.

Alessandro Botticelli (1444–1510) was the great Florentine painter; Peter de Hooghe (1629–83) was best known for his Dutch interiors with seated figures. Col. Sir William Everett (1844–1908) was an art collector. Jan Steen (1625–79) painted, primarily, Dutch peasant scenes and portraits. John Constable (1776–1837) was the painter of poetically realistic English landscapes. Claude Lorraine (1600–1682) produced large French and Italian landscapes as well as mythological and religious subjects. Sir Joshua Reynolds (1723–92), court painter to George III and first President of the Royal Academy, did a portrait of Dorothea Sinclair Duff, wife of the second Earl of Fife. Thomas Gainsborough (1727–88), one of the masters of English landscape and portraiture, painted Elizabeth Anne Linley (1754–92), beautiful first wife of playwright Richard Brinsley Sheridan.

Francisco de Zurbarán (1598–1664) was a Spanish painter of religious subjects; Paulus (Paul) Potter (1625–54) was a Dutch etcher and painter of large bucolic scenes. David Teniers the Younger (1610–90), better known than his artist painter father, was a Flemish religious and genre painter. Meyndert Hobbema (1638–1709) was one of the greatest Dutch landscape painters of his time; Aelbert Cuyp (1620–91), Dutch painter of landscape, genre, interiors, and portraits; Jan Wouvermans (1629–66), Dutch painter of hunting pictures, landscapes, and genre scenes.

Joseph Wright (1737–97), Derby painter of domestic and workshop interiors, recorded the earliest moments of the Industrial Revolution. Sir David Wilkie (1785–1841), Scottish historical and portrait painter, was court favorite of George IV. The Chelsea Pensioners were army disabled and retirees resident at the Royal Hospital, Chelsea; their successors are still much visible in their bright uniforms in the King's Road.]

The collection of the works of Sir John Millais at the Grosvenor Gallery is a timely one. The string of fashionable portraits which have of late years lucratively occupied so much of the artist's time; and the triviality of the subjects of his more imaginative work, have for some years past been discrediting the seriousness of his aims and the moral worth of his motives. That his aims and motives were of the highest when he was a pre-Raphaelite brother is never questioned; and the lamentation over him as a great genius is louder than ever now that he has stooped to accept a title. But the walls of the Grosvenor Gallery proclaim the baronet the same man as the pre-Raphaelite: that is to say, a man possessed by an intense desire for color. Pictures such as the Academy produced towards the end of the first half of our century could not satisfy this desire: real flowers and plumage, stained glasses and sunsets, could not be too rich in hue to please him. Mere draperies, such as those in which the Italian painters clothed their prophets and sybils, were nothing to him: he was hardly content when he had imitated the exact texture that makes plush and pile gorgeous beyond other fabrics. When he turned from pictures to nature with the pre-Raphaelites, it was because he found pictures too shabby and dingy in hue, not because they were unpoetically conceived; for the works which he set against them, though superior in thorough and masterly execution, and in rich color, are as empty in purely intellectual matter as "Little Miss Muffet," or the doubtful drummer boy of 1884. A color-blind poet would repudiate "Mariana," "Isabella," "Ferdinand and Ariel," and "Ophelia," as adequate interpretations of Tennyson, Keats, and Shakspere. Of the original subjects, "The Huguenot" is a fair sample. The idea is pretty: the *Family Herald* would not blush to father it. But the

Family Herald standard of sentinent is only so-so: the picture is enno-
bled, not by its poetic conception, which is commonplace; but by its
painting, which is superlative. And it is impossible to resist the conclu-
sion that the dream which the artist realized in the picture was not a
dream of the young lovers, but of a violet velvet mantle with a back-
ground of darkly glowing flowers. And it is to be noted that the return
to Nature of the pre-Raphaelites did not mean a return to the study of
natural objects. Millais showed no preference for Nature's dyes as
against manufacturers' dyes: he choose the richest. Flower-beds and
carpets, clouds and curtains, are equally interesting to him: the crav-
ing for color alone influences his choice. It has never permitted him to
rest, or to stereotype his palette. He engages in tremendous combats
with refulgent hues of which ordinary painters hardly dare allow them-
selves a cautious touch; sets square feet of canvas on fire with them;
and yet so harmonises them with their surroundings that no one
thinks of complaining of them as crude, gaudy, or forced. In one or two
instances, it is true, he has been beaten; but the few failures only prove
the arduousness of the many victories. Few of those who are now
admiring the portrait of Mrs. Myers have any suspicion of how an
average Royal Academician would recoil from the color of her dress as
from a pictorial impossibility. Nor can the ordinary Bond Street visitor
imagine for himself the blinding visions of crimson that tormented the
artist into producing the "Yeoman of the Guard," or the cold but not
less dazzling "Esther," in which blue, yellow, black, and white force
each other to their utmost splendor. Every color has haunted him in
turn until he has appeased it with a picture. Once we find him deliber-
ately going to the opposite extreme, and, in a most un-Shaksperean
"Rosalind, Celia, and Touchstone," painting a murky brown tunic and
a lacklustre indigo gown that absolutely disgust the spectator. This is
not the only freak that shows the artist's restlessness and dissatisfac-
tion with the mere repetition of past achievements. There is a conven-
tional academic picture of Hur and Aaron holding up the arms of
Moses during the fight with Amalek in Rephidim. There is an old-
fashioned historical picture of Jephthah, which, if it were to appear for
the first time in the 1886 Academy, would be mourned for as a symp-
tom of Sir John's dotage. There are Gainsboroughs out Gainsbor-
oughed, and Velasquezes out-Velasquezed. There is "The Knight Er-
rant" chivalrously releasing a lady who has been stripped and bound in
a wood by robbers. He is almost sawing her fingers off in his efforts to
cut her bonds without coming to her side of the tree. One is at a loss
which to admire most: the delicacy of the knight or that of the painter,
in whose treatment there is not the faintest stain of voluptuousness—
even in color. Yet the lady is as beautiful as the Isabella in the pre-

Raphaelite Keats picture is quaint, which is saying a great deal. Among the portraits are two of Mr. Gladstone, who seems to have interested the artist more than either Lord Salisbury or Mr. Bright, and to have impressed him more seriously than Lord Beaconsfield, whose portrait, striking as it is, has a dash of malice in it, and suggests a magnified cartoon from *Vanity Fair*. The medical profession is represented by Sir James Paget, Luther Holden, and Sir Henry Thompson; and there are the well-known portraits in which there is not a brush-stroke of flattery. The prettiest peeress in the collection has a slight moustache as faithfully represented as her other more popular charms. The portraits of Mrs. Myers, Miss Hermione Schenley, and Mrs. Bischoffsheim may be studied as representative types from contemporary polite society. Lovers of poetic landscape will miss "The Vale of Rest"; but they will be consoled by "The Deserted Garden," "Chill October," and above all, by "Autumn Leaves." In the landscapes, however, we miss the art of composition by which Turner always gave unity to his pictures, even when he had to move mountains to secure it. In the early pictures we miss the atmosphere: the scenes seem to be *in vacuo*, with only the linear perspective to guide us as to the distances represented. And even later on we find "The Deserted Garden," in which an actual mist is painted, far more satisfactory than "Over the hills and far away," in which a substantial carpet of blooming heather appears cut out and stuck upon a painted background. The painter was evidently awake to the need for atmosphere when he produced "Flowering to the Sea"; but it only hampered him in painting the figures, which are faint and unconvincing, though the river and its banks are as nearly perfect transcripts of nature as art can attain to. The rivulet to the left, with its broken ripples, is a masterpiece of water-painting. Indeed, all these landscapes are examples of those feats in color or draughtsmanship that tempt one to declare that no man has ever seen anything that Millais could not paint although many men have painted things that he cannot see. With all nature to choose from, he is far too easily pleased. He has the propensity of the mackerel to snap at anything that glows or glitters. The palette provided for, Miss Muffet is to him as welcome a subject as Moses. Perhaps his is the higher wisdom. It only remains to do justice to the knowledge of effect with which, in "Caller Herrin'," he has, by exaggerating the eyes of the figure, made an outrageous potboiler attractive to those who are "no judges, but only know what they like."

The old masters at the Academy are worth seeing, chiefly for the sake of a most beautiful Virgin, child, and rosebush by Sandro Botticelli; a delicious pair of pictures by Peter de Hooghe, only rivalled in the masterly management of the light in them by Colonel Everett's

Jan Steen (No. 86); two first-rate Constables and one first-rate Claude; several Reynoldses, of which the noblest represents the Countess of Fife (No. 159); a fascinating portrait of Mrs. Sheridan by Gainsborough, hung beside a hideous personification of religious bigotry and the fear of hell by Zurbaran; the usual sprinkling of Paul Potters, Teniers, Hobbema, Cuyp, Wouvermans and Co.; a fair assortment of second- and third-class examples of the greatest masters; an interesting selection from the works of Joseph Wright of Derby, the painter of "An Experiment with an Air Pump" in the National Gallery; Wilkie's "Chelsea Pensioners reading the Waterloo Despatch"; some good examples of the works of the early Italian painters; and a roomful of water colors by Turner, full of interest as illustrations of the modifications which his style underwent during his long life. It would be tedious to dwell on their beauty as pictures: a visit will convince any sceptic that Mr. Ruskin's praise of Turner was not excessive.

Our Corner, February 1886 [C197]

[Landscapes and Meissoniers]

[Cremorne was a popular amusement park on the Thames above Chelsea in Whistler's early years in London; the Inventions were technological exhibitions, with supplementary popular entertainments, at the Crystal Palace site in Sydenham, south of the Thames. Dowdswell's was the Bond Street gallery, Lord's the famous and still-sacred cricket grounds.

(Sir) Hubert von Herkomer (1849–1914), ARA 1879, versatile German-born artist, was Slade Professor of Fine Arts at Oxford and scene designer as well as portraitist and landscapist. Herbert Menzies Marshall(1841–1913) turned from architecture to topographical painting, which he taught at Queen's College, University of London. Charles Edward Holloway (1838–97), landscape and cityscape painter, in an Impressionist vein, was best known for his church views. James Orrock (1829–1913) practiced dentistry in Nottingham and painted landscapes in oils and in watercolors. Scott is Sir Walter Scott (1771–1832), the Scottish novelist and poet.

Jean-Louis-Ernest Meissonier (1815–91) was the eminent French painter of portraits and historical canvases.]

At the Fine Art Society, Mr. Herkomer's Tyrolese sketches have given place to Mr. Herbert Marshall's water-colour pictures of London

scenery. Ever since Cecil Lawson painted poetic landscapes from Na-
ture in Tedworth Square, Chelsea, (probably the most desperately pro-
saic enclosure within the four-mile radius), an appreciation of the
loveliness of London has ceased to be regarded as an eccentricity fruit-
ful only of such works as Turner's "Burning of the Houses of Parlia-
ment," or Mr. Whistler's Cremorne catherine-wheel. Lawson and Mr.
Whistler, however, did not satisfy the popular appetite for topographi-
cal accuracy in familiar scenes: Lawson, indeed, was probably best
pleased when his Chelsea Square was mistaken for a Yorkshire moor.
On the other hand, such works as Marshall's etchings of Paris, when
the transports of recognition pall, are dull as a petrified city on a gray
winter afternoon. Mr. Marshall, at his best, combines just enough of
the cadaverous realism of the French etcher with something of Tur-
ner's feeling for light and atmosphere, and of his exquisite lightness of
pencil in the tracery of architectural details. "Snow-time on the River"
and "Asphalters at work in the Strand" are fine pictures; "Sunrise in
Broad Sanctuary" and "The Approach to Westminster" are a shade less
striking, but not less meritorious. In the latter the painter has followed
the primrose path by his appreciative treatment of the gondola of Lon-
don: the hansom coming down Whitehall is charming. Mr. Marshall,
when he is not at his best, drops quite a surprising distance. When he
nods, his buildings nod too, and that so outrageously that another
Holloway catastrophe seems inevitable. The colour becomes crude,
incoherent, and garish, suggesting neither London, nor Italy, nor that
compromise between them which we sometimes see in Park Lane or
the north side of Hyde Park on a fine summer day. The most highly
specialised subjects in the collection are "The Fountains at the Inven-
tions" and "Lord's: the University Match, 30th June 1885." The first of
these is a failure, the only question being whether the drawing of the
illuminated spray or the colour of the sky is the worse: but "Lord's" is
capital, and is one of the strong links by which the strength of this
chain of pictures must be measured.

❖

Messrs. Dowdeswell exhibit a series of water-colours by Mr. James
Orrock, R.I., representing scenes on the English and Scottish Border.
The handiwork is not of the highest order; but they are acceptable as
illustrations to Scott's poems, which are extensively quoted in the cata-
logue. Mr. Orrock is fond of the effective device of concentrating the
light in the middle distance, and a few of his landscapes are not with-
out a certain pleasing sentimentality obtained in this way.

❖

At No. 20 Cockspur Street are exhibited Meissonier's famous "La Rixe," and the small study of a doubleted gentleman in much the same warm colour-key which was last exhibited in London a few years ago at the French Gallery. There is also the "Flute-player," the sheen of his white satin coat undimmed, and his immaculate finger-nails still perfect in their pearly finish. Comment would be superfluous.

The World, 10 February 1886 [C199]

[English Contemporaries]

[Edwin Long (1829–91), ARA 1875, was a popular painter in oils of biblical and historical subjects, deriving his style and matter—socially acceptable nudity and sex—from Alma-Tadema. His Jephtha series was based upon the judge of ancient Israel who sacrificed his daughter Iphis to fulfill a rash vow. Robert Thorne Waite (1842–1935) was primarily a watercolorist who produced careful yet evocative scenes of the wheat and hay fields of the Sussex Downs and Yorkshire. William Holman Hunt (1827–1910), veteran Pre-Raphaelite, established his reputation with overelaborate and heavily detailed oil paintings, and never altered his style significantly. Peter De Wint (1784–1849) was primarily a landscape painter and best known in his time for his vistas of the Lake Country and Wales. Edward Moxon (1801–58), London publisher, produced editions of many Victorian poets, but is still best remembered for his Illustrated Tennyson, which employed the best artists, rather than the least expensive artists, available. John Millais's "Bubbles" would become immensely popular and was featured in advertising, in magazines, and on hoardings.]

The Exhibition of Mr. Edwin Long's works at 168 New Bond Street has been enriched by a series of three pictures, representing the history of Jephtha and his daughter. In the first and largest of the three, Jephtha, surrounded by his victorious army, and by the women and children who are welcoming them back from the smiting of Ammon, stands distractedly by his chariot, his rent garment on the ground, and his doomed daughter trying to console him. The charioteer looks angrily on, wondering whether his horses are to be kept standing there all day. The rest are not greatly interested in the episode. An element of comedy is introduced by a warrior suspiciously inspecting a baby which is presented to him, on his return from the wars, by his wife.

Her forced smile and anxious eye seem to indicate that his doubts as to the authenticity of the infant are not without foundation. In the second picture, Iphis, surrounded by her maidens, is mourning in the mountains for her virginity. In the third, she is lying unbound on the fatal pyre, which is about to be set aflame. The spectator's hasty conclusion that she has been humanely chloroformed is dispelled when he perceives that her apotheosis is taking place in the left-hand corner of the sky, proving that she is already slain, though her perfectly peaceful attitude precludes all idea of violence, and suggests the lethal chamber as the means of her removal. Mr. Long has no rival in the art of rendering tragic subjects gently affecting. The lines of his composition lead the eye to corners where pretty women, with large eyes and long lashes, placidly ignore any painful transactions which may be in progress close by. Considering how terrible the subject of Jephtha would be if all the figures were made to appear conscious of his despair, the heads and hands saturated with expression, and the execution convincingly solid, one cannot help being grateful to Mr. Long for sparing the feelings of his admirers. The negative qualities of the pictures may therefore be placed to the credit of his modesty and humanity. The positive qualities are those which experience has taught us to look for in his work.

❖

Remote from the beaten way of Bond Street, at 14 Great Portland Street, is a remarkable collection of pictures and sketches in watercolour by Mr. R. Thorne Waite. The sketches are full of sunshine, and are as effective as the work of a first-rate scene-painter. The pictures, though not minutely laboured like those of William Hunt and [C. J.] Lewis, are yet highly finished. It is true that one of the best, "On the Cotswold Hills" (No. 51), has a tree represented by a few splotches that would need apology in a rough memorandum sketch, and that the rivers and a few of the skies are spoiled by the too free use of a crude bright blue; but these are the only blemishes on a vast quantity of excellent work. Mr. Thorne Waite's mastery of aerial perspective, with his power of drawing the surface of the country in every aspect, enables him to represent large expanses of plain and upland with delightful naturalness. His smooth grassy downs, growing yellow in the sun at the approach of the hay-making season, are as truthful as those of De Wint, and are painted much in his manner, though with a drier brush. He does not rearrange natural features in the Turner fashion; but he selects his point of view with a judgment that entitles him to rank as an adept in composition. There are nearly a hundred and

seventy works in the collection, which is very credibly introduced in the catalogue as the result of many years' labour.

❖

Sir John Millais' new picture, exhibited at Messrs. Tooth's in the Haymarket, is of the "Miss Muffet," not of "The Ornithologist," order. A nice little boy, with golden hair, and a sweet red and white complexion that only a confectioner could imitate with any success, sits on a rugged log in a coal-cellar, watching a gorgeous bubble which he has just wafted upwards. His velveteen tunic is of a faded green. Near him lies a common red flower-pot, upset and broken. No naughty and uproarious *gamin*, he gazes raptly up at his bubble, and sees visions in it. Yet, dramatically considered, it must be confessed that he is a pot-boiling sort of boy, with his draperies following the sweep of the brush rather than followed by it, and his upturned face made monstrously effective by a considerable license in the matter of faithful draughtsmanship. The boy, however, is not the thing in this instance. Like the "Yeoman of the Guard," he is present only to carry the colours. The green of the tunic in the murky, and yet luminous, atmosphere of golden brown, with the accessories of red flower-pot and prismatic bubble, constitutes the real picture. And a very beautiful picture it is.

A good deal of sport has been got, of a quiet sort, of the Grosvenor catalogue of Millais' works. The same kind of amusement may be obtained from the art criticism of the *Athenaeum*. The writer—or writers—of both are nearly omniscient—only not quite. For instance, after a great gush of "precious" praise of the lovely drawing of "St. Agnes' Eve," the *Athenaeum* says it has never before been shown to the public. Literally this may be true, but a reproduction of it is an illustration to the Laureate's poem of the same name, in Moxon's *Illustrated Tennyson*. probably the most lavishly executed work of the kind in existence, though now considered here and there, perhaps, to be somewhat *passé*.

The World, 17 February 1886

[English Impressionists and French Traditionalists]

[Adolphe Bouguereau (1837–1905), painter of historical and mythic subjects, was best known for his ability to paint white on white. Jean-

Joseph-Benjamin Constant (1845–1902), often confused with the earlier writer of similar name, was one of a group of fin-de-siècle French and English artists who found a public eager to feast their eyes on "barbaric oriental slavery"—usually female—made acceptable by alleged sociological or historical import. Jean Léon Gérôme (1824–1904), popular neoclassical painter with a turn for surface realism, took his subjects from antiquity. John Rogers Herbert (1810–90), ARA 1841, painted historical and biblical scenes as well as landscapes, mostly Italian. Adrien Louis Demont (1851–1928) was a French genre painter, as was Virginie Demont-Breton (1832–1917). Josef Israels (1824–1911) was a Hague-based master of genre painting, from farmer and fisherman to city dweller.]

There is an interesting collection of watercolor pictures of London scenery by Mr. Herbert Marshall at the Fine Arts Society. That our foggy atmosphere often produces poetic landscapes in the midst of bricks and mortar will hardly be denied by anyone who has watched the network of bare twigs lacing the mist in Lincoln's-Inn Fields. The tone and color that prevail in London landscapes do not prevail in Mr. Marshall's drawings; but doubtless all the effects he has painted are occasionally to be seen, though not so frequently as to be characteristic. The whole collection is topographically interesting, and three or four of the pictures are of high value as works of art.

Those who appreciate modern French painting will find at No. 20 Cockspur Street, three fine works by Meissonier; and at Goupil's Gallery several pictures by Bouguereau, the illusion of whose smooth and solid flesh-painting will endure the closest inspection. Messrs. Goupil also exhibit a vast panorama, by Benjamin Constant, of an Hispano-Moorish harem, with the wives of the proprietor lying bowstrung or brained on the marble floor, amid heaps of rich carpets. The painting is thin, and the figures are so arranged as to present no exceptional difficulties to the draughtsman; but there is all the luxurious light and color that we expect from M. Constant. The subject would be unendurably horrible if it were realistically treated, but it is so obviously fictitious that the spectators either enjoy the color with tranquil indifference, or count the slain with idle curiosity. Gérome's "La Patrie" gives the English critic a shock by reminding him strongly of the work of Mr. J. R. Herbert, R.A. Mr. Herbert certainly abuses his rights as an Academician when he hangs eight large examples of his decaying powers on the line at Burlington House: nevertheless, much of the fine quality and finish of his best period still appear in his landscape backgrounds, and this is the part of his work which M. Gérome's picture has the honor of suggesting. There is an excellent picture of a common, with

patches of sunlight through broken clouds, entitled "Stormy Weather," by Adrien Demont. Also a carefully-studied picture of fishermen, lifesize, drinking in a tavern, by Virginie Demont-Breton, and "The Old Sabot," by Josef Israels.

Sir John Millais' new picture, "Bubbles," is at Messrs. Tooth's, in the Haymarket. As all its merit is in its coloring, those who do not make its acquaintance until it is engraved will probably condemn it as a frivolous claptrap. It represents a pretty little boy in a clean frill and velveteen tunic blowing soap bubbles.

Mr. Thorne Waite's watercolor pictures and sketches, exhibited at 14 Great Portland Street, should be studied by amateurs in search of the secret of effective sketching, and by artists curious as to the degree in which that scrupulous faithfulness in detail beloved by Mr. Ruskin and the Pre-Raphaelites may be disregarded by a clever painter and good draughtsman without apparent loss of thoroughness.

Our Corner, March 1886 [C207]

[The Teesdale Collection; Art and Socialism]

[George Arthur Fripp (1813–96) was a landscape painter who worked mainly in watercolors; Henry George Hine (1811–95) painted landscapes of Sussex and Northumberland. James Holland (1799–1870) was best known for his early Victorian continental views but settled later for profitable romantic waterscapes of Venice. Girolamo Francesco Maria Mazzola (1503–40), called Parmigiano, was a Parma painter of religious works in the manner of Correggio and Raphael. Henry Maplestone (1819–84) painted country subjects in watercolor; Henry Brittan Willis (1810–84) painted picturesque localities in England and Scotland; his Highland Cattle was purchased by Queen Victoria.

G. P. R. James (1799–1860) was a London-based writer of romances; William Harrison Ainsworth (1805–82) also wrote romances largely based upon British history. John Pettie (1839–93), ARA 1866, was a Scottish historical painter; Samuel Waller (1850–1903) painted romantic genre scenes in period costume; George Cattermole (1800–1868) was an illustrator and painter of historical genre scenes.

Paul-Jacques Baudry (1828–86) was a Second Empire classicist who decorated the Paris Opera. Gustave Courbet (1819–77) was an uncompromising realist and political activist; Pierre Joseph Proudhon

(1809–65) was a radical journalist who wrote largely on economic issues. Prince Peter Kropotkine (1842–1921) was a Russian revolutionary of aristocratic birth who spent much time in French jails and English exile.

Shaw's scoffing at American clocks would find its way into a wry line given to General Burgoyne in the last scene of The Devil's Disciple *(1897).]*

The pictures of the late Frederic S. Teesdale were brought to the hammer at Christie's on Friday last. The strength of his gallery was in the water-colours: he was rich in works by Fripp, Hine, and James Holland, whose "Benediction" was one of the treasures of the collection. The oil-paintings were a very mixed lot, with an air of having been deposited fortuitously in the course of time and accident upon a nucleus consisting of a withered Parmigiano and a copy from a trivial relic of Gainsborough. The judgment that enabled Mr. Teesdale to choose his water-colours so well helped him to some good landscapes in oil—notably in the case of a sunset by Maplestone and H. B. Willis; but his taste in figure subjects only suggests that he must have been fond of the novels of G. P. R. James and Harrison Ainsworth. Still, his Petties, Wallers, and Cattermoles in this vein were not bad. The moral of the collection was—If you want pictures that will keep, buy water-colours. An American cheap clock is guaranteed to last two years. An average Academy picture is even more fleeting than an American clock.

❖

At the Hanover Gallery there is a capital specimen of the late Paul Baudry's work—a Psyche in the arms of Cupid. The textures seem woven out of air, and the flesh but just "materialized" (to borrow from the technology of spiritualism); yet the picture is quite free from flimsiness. The gallery is fairly furnished just now. There is Meissonier's "Postillon" in the place of honour. Less conspicuously placed is a good landscape by Courbet, whose friend Proudhon demonstrated that "La propriete: c'est le vol," and who became Messiah of the Anarchists, as Prince Kropotkine is their apostle. Perhaps it was Courbet's picture that induced an old gentleman in the gallery one day last week to meet a tentative remark (in the direction of business) by exclaiming, "These are not buying times, sir; they are not buying times." "They certainly are not," said the tempter, with engaging candour; "still—" "No, sir," continued the gentleman; "if you buy a picture to-day, you don't know who it will belong to this day six months." Such is the influence of Socialism on grammar and picture-dealing.

The World, 17 March 1886 [C210]

In the Picture-Galleries
The Holman Hunt Exhibition

[*Herbert Spencer (1820–1903) was a social philosopher who advocated application of scientific method to problems of human nature and human aggregation. Auguste Comte (1798–1857) was the French philosopher who founded Positivism, a system the goal of which was to organize human knowledge into a consistent, nontheological whole. Charles Darwin (1809–82) was the biologist who propounded a theory of evolution through natural selection in* The Origin of Species *(1859).*
 Vasili Vasilevich Verestschagin (1843–1904) was a Russian painter of grimly realistic military and wartime scenes. Andrea di Cione (1308?–68), called Orcagna, a corruption of Arcagnuolo, as he was known to contemporaries, was a Flemish painter and architect, mostly of altarpieces. "Isabella, or the Pot of Basil," was a grim narrative poem (1820) by Keats about an ill-starred romance. "Pre-Morrisian" refers to William Morris's Arts-and-Crafts revolution in interior decoration; the Sandemanians were fundamentalist followers of the Scot theologian Robert Sandeman (1718–71), who considered church establishments unscriptural and held that congregations should be self-governing.]

In surveying the works of a pre-Raphaelite painter, attitude—mental attitude—is everything. The normal Bond Street attitude will not do: you must become as a little child with a Ruskinised nurse if you wish to enjoy yourself genially, or to utter criticism sympathetic to the painter. If you are a dogged person, and will not attitudinize, mentally or otherwise, for any man; or if you are naturally deficient in flexibility, and simply cannot pose, you will deem the show at the Fine Arts Society exasperating or dreary, according to your case; and you will find the sympathetic criticism of the attitudinizers extremely unsympathetic to you. And if you are in the majority, have you not greater claims on the sympathy of a truly large-hearted critic than the painter, who is, after all, only one man? Willing as you are to allow every one to judge according to his lights, you cannot but feel that the so-called sympathetic critic who can at a moment's notice turn up his lights or turn them down, or surround them with green or red lamp chimneys, is no more to be depended upon for an opinion of Holman Hunt than a stage gasman is for an opinion of Turner. He has obviously no standard; no stable common measure; no tabular index, as it were, to gauge pictures or anything else. Besides, there is nothing new to be said from his point of view. He has long ago done his best on Mr.

Holman Hunt, and his worst on the inflexible among his fellow-creatures. Bear with me, then, whilst I jealously preserve my normal attitude, and record how the exhibition strikes me in this condition.

Here are two masterpieces: "The Light of the World" and "The Shadow of the Cross." Before "The Light of the World" I am a child again. In my nonage, when my Evangelical parents and pastors told me, in Scriptural metaphor, of the light and the entering in, I used to think vaguely of the stable-lantern and the garden-door. Behold my childish conception realised—the man in the white garment; the stable-lantern (a madly expensive one, but a stable-lantern still); the garden-door; and the still night, with everybody in bed! It is astonishing that a grown-up man—a contemporary of Spencer, Comte, and Darwin—should have painted that; but there it is; and, whilst England is Evangelical and children are children, it must remain a treasure of English art, faithfully copied from a picture that every English child makes for itself and never quite forgets. As an antidote to the sentiment it inspires, I turn to "The Shadow of the Cross," a picture which reflects no imagination of any human being, young or old; a destructive collision of realism with crude symbolism: a lean Syrian carpenter throwing the shadow of a god; an old Jewish housewife ransacking the regalia of the Queen of Heaven; Verestschagin with hallucid intervals of Orcagna. How is one, without dislocation of every fibre, to preserve the normal attitude, with its insistent associations and prepossessions, in the face of all this? Better take refuge at once before the secular masterpiece, "Isabella and her Basil Pot."

"The ardency of Isabella's nature," says the catalogue, "seems to be expressed in the whole and single expression of her grief, and in the abandonment of her action"—seems to be expressed in the expression of her expression, in short. But what the normal spectator sees is a magnificently vigorous woman clasping in ecstasy a generously moulded vase, from which springs exuberantly a flourishing vegetable, its thick stalks strong with much sap. The joyousness of her abounding strength and the "abandonment of her action" almost make you dodge, lest she should give vent to her energy by throwing the vase at your head in irrepressible animal spirits. Grief, quotha? Nonsense! Everything in the picture, from the dry-eyed woman herself to the fresh morning light and the gorgeous draperies, cries, "Away with melancholy!" There is only one pathetic picture in the room, and that is the poor scapegoat sinking, famished and weary, into the Dead Sea quicksand, and blinking at the setting sun with a goatishly vague prescience of his end. The catalogue expresses a doubt as to what is going to happen to him; but to a mind inflexibly normal, the half-buried camel-skeleton and other relics are conclusive.

The facial expression of Mr. Holman Hunt's men and women is not so intelligible as that of his goats and sheep. In "The Awakened Conscience," a lady—who, poor girl! is no lady—is struck with remorse on hearing her companion sing "Oft in the stilly night." The violent straining of her eyes and retraction of her lips from her teeth are certainly appropriate to a sudden and unendurable sting of some bitter memory. But they are equally appropriate to so many other causes of sudden agitation, that the story is told rather by the man's attitude than by the woman's face. The accessories are a record of house-furnishing in the pre-Morrisian stuffed bird and pierglass taste; and the man is not a masher, but an obsolete swell. A "Scene from *The Two Gentlemen of Verona*" contains an exquisite Julia and an admirable Proteus; but Sylvia is unattractive, and almost as intensely misexpressive as a desperately conscientious amateur in a *tableau vivant*. In the "Scene from *Measure for Measure*," Claudio undeniably looks bothered; but the tame little nun beside him is not the terrible Isabella of Shakespeare. As Claudio's cell has such a pretty look-out and as he is allowed to keep a dainty mandoline—the pianoforte of the period—he is presumably a first-class misdemeanant. Yet a great stress is laid on the unclean condition of his thick hair. To allow a prisoner a mandoline, and deny him a wash, seems inconsistent enough to justify the introduction, in the painter's favourite vein of symbolism, of a bundle of red tape.

The prodigious value imparted to all these pictures by sheer labour is acknowledged not less in the seriousness with which they are challenged by some than in the enthusiasm with which they are accepted by others. Most of them are elaborated beyond the point at which elaboration ceases to be improved in the eyes of the normal Londoner; but even he must admit the apparent solidity, the convincing power, and the vital glow of these pictures in comparison with the works which artists like M. Bouguereau manage to finish so highly in half as many months as Mr. Holman Hunt would spend years. The difference in the result is a tremendous practical rebuke to the doctrine of art for art's sake. Mr. Holman Hunt, the catalogue tells us (it is a mine of instruction and amusement, that catalogue), painted "The Hireling Shepherd" "in rebuke of the sectarian vanities and vital negligences of the nation." The seriousness of the painter's aim probably did not bring a single Sandemanian into the fold of the Established Church, or induce one woman of fashion to give up tight-lacing (the most familiar form of "vital negligence"); but it is the secret of the perseverance and conscientiousness which has made this small picture one of the most extraordinary units of a collection that does not contain one square inch of commonplace handiwork.

The World, 24 March 1886 [C211]

[A Bavarian Collection]

[The Brodie Gallery was unusual in being remote from the Bond Street center of art exhibition space. Salvator Rosa (1615–73), Italian painter and engraver, would have been too romantic in his Italian landscapes to have suited John Ruskin. Peter Paul Rubens (1577–1640) was the great master of Flemish painting. The Pinacothek was the venerable Munich art museum. John Opie (1761–1807) was a British portrait and histori-cal painter, whose great-nephew, Edward Opie (1810–94), was then painting historical genre scenes. Sir Edwin Landseer (1802–73), Lon-don painter and sculptor, had been a favorite of Victoria and Albert, for whom he had done portraits and sculpture, and pictures of their domes-tic animals. His animal and sporting pictures, often with a Highlands background, helped establish a vogue for Scottish subjects.

Nicholas Poussin (1594–1665) was the exemplary painter of the French baroque; his historic and religious pictures created an ideal-ized antiquity, whatever the actual time period of his subjects. Al-brecht Dürer (1471–1528), German painter and engraver, master of the late Gothic style, and of the application of perspective to human anatomy, was also a landscape painter in watercolor. Martin Schon-gauer (1440?–91), German religious painter, was also a copper-plate engraver.]

An important private collection of pictures has been sent from Bavaria into the English market by Herr Sepp of Munich, and is now in the hands of Mr. Brodie at 4 Grosvenor Mansions, Victoria Street. A large work bearing Paul Potter's signature, with the date 1642, will probably excite some discussion. Potter was only seventeen in 1642, and though he is said to have been an adept when he was fifteen, his fame does not rest on any known works of his boyhood. Herr Sepp's picture represents a sunny landscape, with Noah and his children collecting the live stock for the ark. Foremost among the animals is the familiar cow, a little dry and hard in execution, but still an unmistak-able Potter cow. If the picture was really painted in 1642, which there is no special reason to doubt, it must be assigned to Potter as the only possible painter. The "Hagar and Ishmael" by Salvator Rosa would probably sell better in a land where Mr. Ruskin is unknown. A picture by Rubens, the sketch for which is in the Pinacothek at Munich, completes an important trio of Old Masters. A good Opie, a Landseer, a lady of the Monna Lisa family, a Nicolas Poussin, and some modern works complete this instalment of the collection, part of which— including some examples of Dürer and Martin Schongauer—is still at

Munich. Herr Sepp is decidedly ill-advised in hesitating to allow his pictures to be exhibited in a suitable gallery. Victoria Street at this season may be an abode of sweetness: it is certainly not of light.

The World, 24 March 1886 [C211A]

[Minor Picture Shows]

[Carl Seiler (1846–1921) was a German painter of military subjects; Edward Allan-Schmidt, Anglo-German painter who exhibited from 1868, was a genre and hunting-scene painter. Karl Heffner (1849–89) was a German landscapist; Ludwig Munthe (1841–96) was a Norwegian landscape painter. Ricardo de Madrazo y Garreta (1852–1917), son of a Madrid portraitist, was a figure and genre painter who exhibited in Paris and London. Jean-Léon Gérôme made a specialty of Oriental scenes and Moslem subjects. Christian Ludwig Bokelmann (1844–94) was a German genre painter, here compared favorably to both William Powell Frith (1819–1909) and Paul-Gustave Doré (1832–83), was a maker of panoramic pictures. Paul (Pal) Joanowits (1859–?) was a Serb genre and historical painter; Ludwig Loefftz (or Löfftz, 1845–1910) was a German genre and historical painter then acclaimed for his technique.

Benjamin Williams Leader (1831–1923) was a Worcester-born landscape painter, largely of Welsh and Midlands scenes. The Faed brood of Scottish painters included at least six recognized artists; here Shaw refers to Thomas Faed (1826–1900), ARA 1859, painter of Scottish genre scenes and best known of the family. Keeley Halswelle (1832–91) was another Scottish genre and landscape painter. John Brett (1830–1902) was a London-based painter of landscapes and coastal scenes admired by Ruskin.

Conrad Kiesel (1846–1921) was a German painter; Salvador Barbudo-Sanchez (1857–1917) was a Spanish genre painter. Tito Conti (1842–1924) was an Italian painter in oils; Eugene de Blaas, who also called himself Eugen von Blass (1843–1932), was based in Venice, where he produced scenes of local life. Federigo Andreotti (1847–1930) was an Italian genre painter. Hermann Schneider (1847–1918) was a German artist.

John Pettie often painted literary subjects, particularly from Shakespeare; however, his Charles Surface is from Sheridan's The School for Scandal.

Vlacho (in France it became Blaise) Bukovac (1855–1923) was a Serb painter of lubricious nudes with biblical or otherwise moral titles. John Callcott Horsley (1817–1903), Kentish historical and genre painter, voiced prudish objections to the use of nude models that earned him, from Whistler, the tag of "Clothes-Horsley."]

The minor picture shows this year are full of clever and gaudy work. At the French Gallery there are minutely-finished soldiers and blacksmiths by C. Seiler and E. Allan-Schmidt; low-spirited peasants by Josef Israels; landscapes by Karl Heffner, which are to Nature as a skilful actress's "make up" is to a clean face; a brilliant little suggestion of a lady at a pianoforte by Madrazo; further supplies of the perpetual snows of Ludwig Munthe; a couple of so-so Meissoniers—a sleeper in oils and a smoker in water-colours; and a small group of pious Mussulmans by Gerôme, in very unequal preservation, one half of the surface being dry and cracked and the other apparently fresh— perhaps repainted. In L. Bokelmann's "Gambling-room at Monte Carlo" the saloon takes quite a novel aspect in the last hour of daylight on a cold and cloudy afternoon; and the composition is a great improvement on that of the panoramas of gaming-house character and incident painted aforetime by Mr. Frith and Gustave Dore. Unfamiliar names in the catalogue are those of P. Joanowits, who sends several spirited pictures of swaggering Servians, and Professor L. Loefftz, in whom we were promised a modern Peter de Hooghe. His picture of a domestic interior, with a woman sewing, shows a certain professorial moderation and mastery; but a glance at the open door in the background disposes of his claims to rival de Hooghè, whose effects of cool light he has nevertheless imitated with a degree of success which explains the comparison.

❖

The exhibition at Messrs. Tooth's, in the Haymarket, is not so deperately Continental as the French Gallery. Works by Mr. Leader, Mr. W. L. Wyllie, Mr. Keeley Halswelle, Mr. Long, Mr. Faed, Mr. Boughton, and Mr. Brett are not quite outstared by those of Eugene de Blaas, Conrad Kiesel, and S. Barbudo, in whose "Connoisseurs" the practice of painting pictures in which heaps of accessories are the real subjects is carried to a ludicrous extreme. Sir John Millais' "Bubbles" has been shifted to another wall; and this change, with the recent return of the sun, has dispelled the gloom which made the young bubble-blower appear to be taking his pastime in a dungeon.

❖

At Mr. T. McLean's the pictures are at least all new. M. de Blaas is again conspicuous, making hay while the sun shines on his Venetian lad and two lasses. Conrad Kiesel is here too, and Tito Conti, and F. Andreotti, all as glittering and as empty as the laziest and most luxurious gallery stroller could desire. Mr. Pettie sends a picture of Charles Surface; and Sir John Millais a subject entitled "Ruddier than the Cherry," a girl in a ragged jersey, of the colour of the red earthenware flower-pot so masterfully introduced in "Bubbles." "Ruddier than the Cherry" has evidently cost Sir John no very strenuous effort; but amid so many barren appeals to the eye alone from the foreign artists, it appears to great advantage. In H. Schneider's "In Love," the white marble is not so good as Mr. Alma Tadema's: it is like painted iron. Mr. Burton Barber's "Monster" is by no means so funny as his dog about to be dosed with mustard, which made us all laugh so consumedly at the Academy.

❖

Messrs. Vicars, at Eagle Place, Piccadilly, have supplemented M. Bukovac's "White Slave" by his "Potiphar's Wife." At the moment represented, Joseph has not yet arrived; but the lady has heard his footstep, and has completely unmasked her battery of seduction. The flesh-painting is very solid and brilliant; and the golden couch, the silken cushions, and other accessories might be taken for the work of Meissonier many times magnified. All the modern peep-show devices to heighten the illusion of the picture have been employed with a skill which will perhaps strike persons of Mr. Horsley's way of thinking as diabolical. The picture is a remarkable one—of its kind.

The World, 31 March 1886 [C213]

[Etchings, Engravings, and Oils]

[Richard Josey (1840?–96) was a mezzotint engraver of pictures by other hands. Jean-Baptiste Greuze (1725–1805) was a French painter who established a vogue for sentimental and moralizing anecdotes. Silvera Paladiense was proprietor of her own gallery; her manager was Octavia Campotosto, a Belgian painter, here exhibiting her own work. Louis-Émile-Felix Vauqueline debuted at the Paris Salon in 1879. Jules Ferry (1832–93), his subject, was the anticlerical mayor of Paris during the siege of 1870. Jules-Léon Montigny (1847–99) was a

Belgian painter best known for his animal paintings. Eilert (Gilbert) Adelsteen Normann (1848–1918), a Berlin-based Norwegian land- scapist, painted scenes as far away as Australia; his compatriot Morten Müller (1828–1911) painted landscapes in Sweden and Ger- many as well as Norway.]

Messrs. Dowdeswell have just published a mezzo-tint, by Mr. Rich- ard Josey, after Greuze's picture of a girl fondling a dove. Mezzo-tint is probably the only process by which the softness and silvery tones of Greuze's work can be satisfactorily reproduced in black and white, and Mr. Josey has made masterly use of it. With the exception of a few lines in the hair, put in with the dry point, the whole plate has been worked with the cradle alone. The result is charming. The picture is called "My Dove."

❖

Madame Silvera Paladiense, of 62 New Bond Street, has published an etching, by Miss Octavia Campotosto, of an Italian head, studied from life. It contains some clever work with the needle; and is intelligently designed throughout, the gradation of tone being genuine etcher's work, and not printer's artifice. This is more than can be said for much of the random scratching that is offered as etching nowadays.

❖

At the Continental Gallery politics and pictures are mixed. Hidden in a lurid recess is M. Vauquelin's "Bourreau et Vietimes—Souvenir de Tonkin," a frightful heap of skulls, from which the last remnants of decaying flesh are being picked by a carrion crow. The apex of the ghastly pyramid is recognisable as the face of M. Jules Ferry, who, by a sardonic twitch of his pale lips, manifests a demoniac delight in the destruction he has brought about. M. Vauquelin is evidently tremen- dously in earnest; but his attack is overcharged, and his picture—or rather political cartoon—is more likely to amuse than to impress us on this side of the Channel. J. L. Montigny's "Napoleon's Horse on the Battlefield of Waterloo, Twenty Years after," possesses much greater artistic merit; and it is a pity that the catalogue should insist as it does on the fact that "Napoleon and the Duke of Wellington are visible in the clouds," an absurdity which would degrade the work to the level of a transparency in a peepshow, if it were not—but for the injudicious cataloguist—so easily overlooked. There is much clever work in the gallery, and some that is interesting, notably the pictures of Norwegian scenery by A. Normann and Morten Müller.

The World, 7 April 1886 [C215]

[The Graham Collection; Tristram Ellis]

[William Graham (1817–85), Liberal M.P. for Glasgow 1865–74, had been a major patron of the Pre-Raphaelites and of Whistler. His art collection, from Rossetti to Rembrandt, was being sold as part of the dispersal of his estate. John Phillip (1817–67), known as "Spanish Phillip" because of his success with colorful Spanish subjects, was a Scottish genre painter, ARA 1857. Bernardino Luini (1481?–1532), Italian painter, was first of several generations of artists. Sir Antonio More, more properly Mor (1527?–76), born in Utrecht, painted portraits at the court of Spain, then afterward in London, Utrecht, Brussels, and Antwerp. Jacobo d'Antonio Palma il Vecchio Negreti (1480?–1528) and Masaccio, or Tomasso di Giovanni di Simone Guidi (1401–28?), were Italian portrait and religious painters.

Tristram Ellis (1844–1922), London landscape painter, traveled widely in the Middle East, the subject for many of his pictures and drawings.]

The prices at the sale of the Graham Collection show that it pays better just now to have been a pre-Raphaelite in intention than in fact. Any of the budding peoples of Eastern Europe might, by sending an agent to Christie's last week, have set up a very creditable little National Gallery for a couple of thousand guineas. Failing so much hard cash, almost as much might have been done with a modern picture. For example, the possessor of twenty-five inches by twenty of J. Phillip's work might have obtained in exchange for it a magnificently composed and painted landscape by Nicolas Poussin, a masterpiece of Luini, a fine Claude, a little gem by Sir Antonio More, a Monna Lisa to shed the radiance of that smirk which no picture-gallery should be without, very respectable examples of Rembrandt, Palma Vecchio, and Masaccio, and a hundred and fifty guineas into the bargain to pay auction-fees and travelling expenses.

Mr. Tristram Ellis's illustrations in water-colour of Channel scenery, English and French, are now exhibited at the Goupil Gallery. They are naturally somewhat unequal; but the best are very good indeed, and they all seem full of fresh air, the illusion making one almost forget the painter's difficulties. Mr. Ellis has etched his "St. Michael's Mount"; but the dank, slimy rocks at low water, admirably represented by his brush, have baffled his needle. "The Chain Pier at Brighton" is remarkable for a happy effect of a flood of silver light on the water. "Branksome Chine" is a charming little picture. Lovers of coast scenery or of water-colour painting will find in the contemplation of the whole

series—fifty-nine pictures in all—a congenial way of spending a bright spring morning.

The World, 14 April 1886 [C218]

In the Picture-Galleries
The Royal Institute

[The President of the Royal Institute of Painters in Water-Colours since 1871 had been Sir John Gilbert (1817–97), RA 1876, painter and book illustrator of Shakespeare, Scott, and Cervantes. Rawdon Crawley was a W. M. Thackeray creation in Vanity Fair. Joseph Knight (1837–1909), Manchester landscape painter, was also an editor, critic, and biographer. Joseph Arthur Severn (1842–1931), landscape and marine painter, was husband of Ruskin's niece. Henry George Hine (1811–95) painted Sussex and Northumberland landscapes and genre. Robert Walker Macbeth (1848–1910), ARA 1883 and son of painter Norman Macbeth (1821–88), was a watercolorist and etcher of scenes from country life.

Wilson Barrett (1846–1904), proprietor of the Princess's Theatre, was a well-known actor in Victorian melodramas. John Sherrin (1819–96) was a still-life and animal painter; George Goodwin Kilburne (1839–1924) was a London genre painter and engraver. Edward F. C. Clarke, London painter in oils as well as watercolors, made a specialty of Surrey scenes; Nathaniel Everett Green (1833–99) was less a figurative painter (despite the work he exhibited) than a landscape and architectural artist. Henry M. Terry (1850?–1920) was a London painter of genre and literary subjects; Henry John Stock (1853–1930) was a London painter of portraits and genre.

Sidney Prior Hall (1842–1922), illustrator and portraitist of the Royal Family, had accompanied the Prince of Wales on his visit to India; Prior's sketches of India are in Victoria's Durbar Room at Osborne House. Luigi da Rios (1844–92) was an Italian painter then resident in London; (Sir) Samuel Luke Fildes (1843–1927), ARA 1879, painter of genre and portraits, including the Royal Family, also painted Venetian scenes.

George Samuel Elgood (1851–1943) specialized in English and Italian garden settings; Edward Henry Fahey (1844–1907) painted English, French, and Italian landscapes and genre. Stanley L. Wood (?– 1903) painted genre and military subjects. Maude Goodman Scanes (?–1901) painted London genre scenes and children; Herbert Moxon

Cook (1844–1920) specialized in Welsh and Scottish views. David Carr (1847–1920) painted rustic scenes and designed country houses. Louise Rayner (1832–1924) was an architectural and topographical artist; Gertrude Martineau (?–1894) was a genre and animal painter. Charles Green's Captain Cuttle is from Dombey and Son; *his Weller family is from* Pickwick Papers. *Charles Robert Leslie (1794–1859) was a friend of Sir Walter Scott, whose books he illustrated, among others.*

William Simpson (1832–99) painted topographical and architectural subjects, as became his membership in the Geographical Society, and was an illustrator and engraver of contemporary events for the press. Charles Edward Johnson (1832–1913) was an English landscape painter; Francis S. Walker (1848–1916) an Irish genre and landscape painter. Arthur Willett was a Brighton landscape and seascape painter who exhibited in the 1880s and 1890s; Charles Potter exhibited landscapes from the 1860s into the 1890s. Carl Olof Larssen (1853–1919) was a Swedish watercolorist with whom Shaw was clearly impatient.

Edwin Austen Abbey (1852–1911) was a Philadelphia-born painter and illustrator who settled in London in 1880 and became ARA in 1894. He would paint the official Coronation picture of Edward VII in 1903–4. Frank Dadd (1851–1929) was a painter and illustrator of historical subjects; Reginald Savage was a watercolorist who exhibited briefly in the later 1880s. Charles Hazelwood Shannon (1863–1937) was a painter, illustrator, and lithographer who would be associated in artistic projects over a lifetime with Charles Ricketts (1866–1931). James Lawson Stewart exhibited views of London throughout the 1880s.

William Fraser Garden was a landscapist who exhibited into 1890, at first under his actual name, Garden William Fraser. James Ireland (?–1925) was a painter of genre; C. I. Anson was an Irish landscape and genre painter. His Aghavannagh depicted a scene in the Irish village of that name in County Wicklow; the stream is the laconically named Ow.]

This year there are one thousand and sixty-six pictures at the Royal Institute of Painters in Water-Colours. Their average excellence is such that the only alternative to noticing separately at least a thousand—producing an annotated catalogue, in short—is to revise the standard of mentionable merit, drawing the line higher up, and thereby excluding many works which, in an ordinary exhibition of paintings in oil, would claim attention as comparative masterpieces in point of execution. I say in point of execution advisedly; for, in spite of

an occasional novelty in choice of treatment of subject, painters of the British School display hardly enough invention, per thousand, to furnish a single shilling dreadful. If the sentimentalities that are meant to be tragic, and the good-natured imbecilities that are offered as humorous, were as ill painted as they are ill thought out, a painter to-day would be deservedly less esteemed than a circus athlete. This, however, is by the way. Declarations of the inanity of British art are undeniably tedious; but they should be made and read from time to time, lest the public should lose hope of improvement, and the artists forget the need of it.

The President of the Institute exhibits some of his irreproachable studies of knighthood and maidenhood. His picture of Romeo exclaiming, as he dies, "O true apothecary!" misses the intended pathos, because Romeo's gesture, though it may possibly be that of a poisoned man, is also that with which one prepares to receive a ponderous object descending from above. Romeo, therefore, suggests a Rawdon Crawley of the Renascence tossing up his infant son, and just realising that its head is about to hit the ceiling and wake mamma. Conspicuous among the landscapes are Mr. Joseph Knight's vivid representations of greensward in sunlight and cloud-shadow, and Mr. Arthur Severn's almost lurid red and blue sunsets. Mr. H. G. Hine is all in the downs, as usual. His sunset with the flock of sheep (881) is a treasure of its kind. Mr. Macbeth has sent one picture, apparently because it was not good enough to keep at home. It is called "Landing Sardines at Low Water," and it depicts two fine young fisher-maidens carrying between them a load of sardines through the swallow water to the shore—one wearing Mr. Macbeth's colours in the shape of a primrose scarf; the other attitudinising after Mr. Wilson Barrett. Will Mr. Macbeth attentively reconsider the painting of the arms and legs of these girls, and the zigzag brush-marks where their shadows should be and then explain to an astonished and outraged public what he means by it all? To Mr. Hamilton Macallum, with his emerald wavelets, his boys, and his boats, one can only say, "Something too much of this," without the least hope that the hint will be taken. Mr. J. Sherrin's "Mining Operations with a Sentry," a picture of two hares, is capital, though hares in real life are a trifle less bristly, and perhaps not so highly finished. Mr. John Scott sends mystical pictures of crows and colleens, as usual. What they mean no uninitiated spectator can tell; but they have a pleasant appearance. Mr. G. G. Kilburne's large frameful of riverside picnic includes a quite perfect cornet player, and a highly meritorious parson. Mr. E. F. C. Clarke sends "Surrey Cabbages," and such cabbages! Another success of this kind, and the dealers will keep Mr. Clarke painting vegetables during the rest of his life. If Mr. N. E.

Green had taken half as much pains with his Desert Chief's beard as
with his face, twice as much might be said for his little work. Mr.
Henry Terry's "Awakened Memories" shows that our water-colourists
cannot as yet touch the old Dutch Masters in effects of cool light
indoors. Mr. Henry J. Stock's "Sin piercing the Heart of Love" is hardly
worth the pains it must have cost. Love's attitude expresses grievous
trouble; but it is rather that of a qualmish passenger than of a fallen
Eros. Mr. Sidney P. Hall's "H.R.H. the Prince of Wales elk-shooting in
Sweden," weak from an artistic point of view, may perhaps therefore
gratify militant Republicans. "La Tombola," by Mr. L. da Rios, will be
attributed by many as a first glance to Mr. Luke Fildes, though the
handling is smoother, and the composition more artful than his. Mr. G
S. Elgood's "Compton Wynyattes," an old mansion with a great pool at
the end of the garden, might extort an elegy from a poet susceptible to
such scenes. In Mr. Fahey's "Summer Sunset, Norfolk," a straggling
row of blood-red poppies make a strange effect, as of an open wound or
a glimpse of subterranean fire, amid the dark clods of a ploughed field.
Mr. Keeley Halswelle has three pictures in different manners. "The
Pass of Brander, Loch Awe," excellent in colour, is somewhat mechani-
cal in design, as if the sloping lines of the mountain were bent, like
standing corn, by the wind. "At the Theatre of Marcellus, Rome," is
forcible with its dark shadows and its point of strong colour in the rags
of the recumbent figure at the gateway. The third picture is a scene in
Asia Minor, Turneresque in treatment. Mr. Stanley L. Wood artlessly
tempts the Radical picture-fancier by giving a small study of an agri-
cultural labourer the enterprising title, "An Applicant for Three Acres
and a Cow." The effectiveness of Miss Maude Goodman's "Parted" has
been earned by careful work. The light in Mr. Moxon Cook's Scotch
landscape is good, but the grosser details have been suggested as
cheaply as possible. In Mr. David Carr's "Selling the Catch," the reflec-
tions in the water are not convincing. Miss Louise Rayner's "Foot of
the West Bow, Edinburgh," is an honest representation of the entire
subject, and not a study of a single shop-window with the name of a
whole postal division attached. The clear, colourless light on the upper
stories of the old house-fronts up the street is especially noteworthy.
Miss Gertrude Martineau exhibits a poetic corner of a lake, in which a
bed of water-lilies, floating on the sombre water, follow the curved
margin as it receded into the shadow and mystery of the evening. Mr.
C[harles] Green sends some pictures from Dickens, and they are by no
means bad; but they are tame, and lack that native perception of the
extravagant aspects of every-day life without which Captain Cuttle and
the Weller family cannot be fully revealed. Mr. Green falls short of
Dickens, as [Charles Robert] Leslie fell short of Shakespeare and Mo-

liere. Mr. William Simpson sends, as becomes an F.R.G.S., an interesting picture of the Great Wall of China. Mr. C. E Johnson's "Clouds and Showers" has a singularly damaged appearance, as if the showers had washed away most of the landscape. Mr. F. S. Walker, from whose pictures it is hardly possible to get far enough away to blend his plasterings of pigment, has, in "The Forgotten Sheaf," insisted on two peasant women with his usual streaky emphasis. Mr. Arthur Willett, in his "Woodland Stream in Sussex—Autumn," has availed himself to good purpose of Sir John Millais' "Autumn Leaves." Mr. Carl Larssen's "First and Last Steps" shows us a centenarian and a child keeping their feet with difficulty during an earthquake or other convulsion of Nature which has deflected the floor of the room considerably from the horizontal plane. Mr. Charles Potter, R.C.A. (Royal Cumbrian Academy), sends a creditable mountain landscape, with a heavy, warm foreground contrasting with the snowy hills, shot with pink sunlight, in the distance. Mr. Abbey's "March Past" and Mr. Frank Dadd's "Foot for Power," will attract and amuse most visitors; and the merriment will be kept up by certain contributions from Mr. Reginald Savage and Mr. C. H. Shannon, whose intentions are nevertheless serious, and their manual skill not contemptible. "Companions by the Way" is an elaborate study of an old church at sunset, by Mr. J. Lawson Stewart. Mr. W. F. Garden's "In the Copse" is unluckily hung, and seems to deserve a better place. Among the best pictures in the gallery is "Easier is the Haul that's a Hearty One," by Mr. James Ireland. Three men, on a shelving strong beach, drag up a red sail, on which a little girl is sprawling. Of many other pictures, no less worthy to be described, I can only allude at one, Mr. C. I. Anson's "Aghavannagh"; and this, to confess the truth, I mention, not for its merit, which is not exceptional, but because I fell, at an early age, into the shallow river depicted in the little sketch, and so, though my critical faculty was then comparatively undeveloped, can testify to the truthfulness of the painter's observation.

The World, 21 April 1886 [C219]

The Spring Exhibitions

[Whistler's withholding his Harmony in Blue and Gold *from press view was part of his running battle with the somnolent hierarchy of the Society of British Artists, whose exhibition in its Suffolk Street building, he felt, would falter without his own work to display. When the*

SBA's President, Scottish genre painter John Burr (1831–93), decided not to stand for reelection, Whistler, in league with a younger faction, on 1 June 1886, engineered his own election to the presidency of a society he had joined only two years earlier.

Philip Calderon (1833–98) turned after 1870 from domestic and historic scenes to an emphasis upon portraiture. His St. John's Wood studio was the focal point of a London artistic group. James Peel (1811–1906) was a prolific painter of English landscapes; Vincent Philip Yglesias (?–1911) was a London painter of landscapes and riverscapes. William Lamb Picknell (1853–97) was a Boston landscape and marine painter who settled in London. Henry Fuseli (1741–1825) was born in Switzerland, studied art in Germany, settled in England where he became ARA in 1788 and later Professor of Painting at the Royal Academy. Sidney Starr (1857–1925) was an American genre, portrait, and mural painter with a transatlantic clientele. His Paddington pictured a railway station scene.

The New English Art Club was formed in 1886 as an alternative to the stuffiness of the Royal Academy, largely by artists outside Burlington House whose bent was naturalistic and impressionistic.

Leopold Rivers (1850–1905), son and pupil of an artist, was a landscape painter. Horace Henry Cauty (1846–1909) was a London genre painter and curator of the Royal Academy Schools. Alfred Joseph Woolmer (1805–1892) painted sentimental genre scenes. Both Ludwig Munthe (1841–96) and Gerhard Peter Munthe (1849–1929) were Norwegian painters of landscapes.

Hilda Montalba (1840–1919), landscape and genre painter, worked in London and Venice. Clara Montalba (1842–1929), second of four artist sisters, painted largely Venetian scenes and subjects. David Law (1831–1901) was a London-based landscape painter and etcher; Charles William Wyllie (1853–1923) painted English harbor and coastal scenes. Charles Gogin (1844–1931) painted genre and figurative subjects; William Arthur Howgate exhibited landscapes and waterscapes in London from 1884 through 1904. John Finnie was a Liverpool painter, etcher, and engraver; Thomas Bush Hardy (1842–97) was a prolific watercolorist of coastal English scenes. Nora Davison, oil painter and watercolorist of coastal scenes and landscapes, exhibited in London from 1881 until 1905.

Willem Geets (1838–1919), Belgian artist, painted in the turn-of-the-century fashion for lurid, sexually provocative antifeminism, a growing reaction to feminism itself. Frederick Brown (1851–1941), genre painter and influential teacher at the South Kensington Museum, was a founder of the New English Art Club. Israëls is Josef Israëls; Maurice Greiffenhagen (1862–1931) was a painter and illus-

*trator in the late Pre-Raphaelite allegorical manner. John Singer
Sargent (1856–1925), born in Europe of American parents, was just
beginning to establish himself in London as England's major living
portraitist. He would be elected ARA in 1894. His picture was a por-
trait of the wife of painter and illustrator Frederick Barnard.*

*Lindsey Bernard Hall (1859–1935) was a genre and portrait
painter and original member of the NEAC. (Sir) Arthur Arnold (1833–
1902), Hall's portrait subject, was a Liberal politician and writer on
London municipal government and a member of the London County
Council. (Sir) James Jebusa Shannon (1862–1923), ARA 1897, figure
painter and society portraitist, came to London from Auburn, New
York, at sixteen. Daniel Maclise (1806–1870), ARA 1835, was an Irish
portrait and historical painter resident in London. Thomas Cooper
Gotch (1854–1931), an original NEAC member, was a painter of por-
traits, landscapes, and genre. Albert Chevallier Tayler (1862–1925)
turned from genre and interiors to portraiture. Thomas F. Goodall
(1856–1944) was a London-based painter of landscapes, rustic genre,
and coastal scenes, especially of Norfolk; Henry Herbert La Thangue
(1859–1929) painted landscapes and rustic life. The Logsdail pair
were twins: brother and sister. William Logsdail (1859–1944) painted
large, realistic panoramas of London and Venice and landscapes in
France and Italy. Marian Logsdail (Mrs. Richard Bell, 1859–1944)
painted figures and street scenes.]*

The British Artists are more British than ever this year. Their exhibi-
tion is intensely mediocre and matronly; although those who look back
fondly to Mr. Calderon's Venus at the Grosvenor Gallery will find the
goddess washed ashore in the northeast room at Suffolk Street, looking
much the worse for her immersion. Her reappearance is due to Mr. A.
W. Bayes. Mr. James Peel's "Chapel Mill" recalls by its size, subject,
and treatment one of Mr. Hubert Herkomer's best works in landscape.
In Mr. V. P. Yglesias's "Moonlight at Tarbert," the looming brown ship
is good; but the clouds are distractingly ragged, as if the skyey curtains
had been rent by a boiler exposion. Mr. Picknell's "Sultry Day" glares
so, that Fuseli, if he were alive, might say "Gif me mein omprella," to
keep off the sun, which is quite as distressing as Constable's rain.
Verestschagin himself never piled up such intolerable sunlight. The
representation is, however, quite successful. Mr. Sidney Starr's "Pad-
dington" is greatly superior to his "St. John's Wood" at the New En-
glish Art Club. The terminus appears in a silver haze; and all the
values are—so to speak—expressed in terms of that haze; but the
verisimilitude of the picture is undeniable. The milk-cans, the vehi-
cles, the northern light from the outlet, are all true Paddington. Mr.

Leopold Rivers' "On the Lydd: Lydd" is certainly the very paintiest painting ever painted, and the title will but incite punsters to crime. Mr. Horace Cauty needs to go to Nature for a lesson to freshen and correct his impressions. The satiny sheen of the water in his "September Morning," and the roseate complexion of the little girl in "Sulks," are mere picture-gallery conventions, of which most of us are heartily tired. Mr. J. Fraser's "Silver Sea" is not fluid: its under edge does not fit closely to the strand, but crinkles up like a tiger-skin rug. Mr. A. J. Woolmer romances with his palette as usual. His "Winter Studio" and "Summer Studio" in the same frame rather spoil one another; but his "St. Agnes' Eve" is pretty. Mr. Whistler's "Harmony in Blue and Gold" was withheld from the press view; and its gifted author rather over-rated the attractions of the exhibition if he relied on subsequent visits from the critics. Mr. G. S. Walters is producing green seas with a facility which is becoming a little alarming; but in his "Winter Morning: Holland" he varies his programme by some snow, and incarnadines the multitudinous seas with the wintry red reflections beloved by Herr Munthe. Miss Hilda Montalba's "On Lake Sevelungen" is an enchanting trifle. Miss Clara Montalba's "Moonlight on the Thames" is a sober variation of one of her favourite themes. Mr. David Law's "Houses of Parliament" is dry and superficial; Mr. C. W. Wyllie's "Return of the S. S. Stirling Castle" quite the reverse. Mr. C. Gogin's striking power of planning and carrying out a subject, is distinguished from the ordinary practice of making a study of something and then casting about for a plausible name to label it with, appears in his "Prisoners on a Canal." Among the more notable landscapes are Mr. W. A. Howgate's "Sunlit Cumuli," Mr. John Finnie's "Welsh Hillside," Mr. T. B. Hardy's "Arrival of the first Herring Boats," and Miss Nora Davison's "Quiet Haven." Other masterpieces need not be indicated; visitors can choose for themselves.

Mr. Lefevre, of King Street, is exhibiting a collection of pictures by Professor Willem Geets, Director of the Fine Arts Academy of Malines. The *pièce de résistance* is a large work entitled "La Vengeance de Jeanne la Folle." Mad Queen Joan, it appears, became jealous of a lady of the Court, whom, having caused to be stripped and bound, she attacked with her scissors, cutting off her hair and lacerating her breasts. This subject, quite repulsive enough to attract a Belgian painter, has been treated by Professor Geets with a cool neutralism that gives the spectator a disagreeable sense of the reality of the incident. There is no attempt at lurid light, pools of gore, or any of the common horrors and weirdnesses of sensational painting. In cold, clear daylight, in a well-furnished but commonplace bedroom, the victim is being tightly bound by four strong serving-women. Her face expresses

nothing but acute terror. The Queen, a woman with meeting eyebrows and a hard, high nose, watches her, and grasps the scissors. As an exact study of a morbidly jealous woman of evil temper, this figure could hardly be surpassed. Facial expression is one of Professor Geets' strong points—by far his strongest, in fact; but his love of fine colours, and his painting of textures and brilliant fabrics such as satins and velvets, will not be lost on his lady critics.

Fifty painters, who describe themselves as "all more or less united in their art sympathies," have formed a club and opened an exhibition. Hence "The New English Art Club" and their very creditable display of work at the Marlborough Gallery, in Pall Mall. Among the fifty-eight clever pictures shown, there is none better than Mr. Frederick Brown's "Hard Times." It might be hung between a Meissonier and an Israëls without eclipse. Mr. Maurice Greiffenhagen's "Ophelia" has her mouth full of snow, which might with advantage be replaced by a set of teeth. Mr. J. S. Sargent's rococo portrait of Mrs. Barnard is not likely to revive its old fashion, but it is very clever, as is Mr. L. B. Hall's capital after-dinner portrait-study of Mr. Arthur Arnold. Mr. S. J. Solomon's brilliant "Reflections" (of a lady in a white ball-dress, and a roomful of dancers) will touch many a metropolitan man who is perfectly insensible to peasant-girls at cottage-doors, rosy, industrious, and comparatively easy to paint. Impressionism, or the misfortune of having indefinite impressions, which can happily be cured by attentive observation and a suitable pair of spectacles, is responsible for Mr. Sidney Starr's nebulous "St. John's Wood." Far better than this is Mr. J. J. Shannon's "In my Studio," which, if not exactly in the manner of Maclise, is definite enough to be a very successful example of naturalism. Mr. T. C. Gotch's "Destiny" is a canvas of considerable acreage, but only moderately fertile. A single very simple idea is too small a crop for so vast a field. The three figures in Mr. Gogin's "Soothsayer" are not sufficiently well handled to justify a high estimate of his work as a whole; but the incident is presented intelligently and inventively, and so the picture secures attention. M. La Thangue's contribution of an unfinished study is a strange proceeding. Surely public impatience to see the work could have been restrained pending its completion. Mr. Chevallier Tayler, without condescending to the buffoonery of our funny painters, supplies a touch of refined comedy by his "Latest Novelty from London," a Japanese doll seated gravely on the floor of a country alehouse amid a circle of staring village folk. The scheme of sodden straw-colour in Mr. T. F. Goodall's river scene, "The Last Load," is novel and pleasing. Mr. W. Logsdail gives fresh examples of his virtuosity in the paving-stones and bricks which were his favourite themes before he gave way to the seductions of Venetian gaiety; and Miss Marian

Logsdail follows his example with notable success. Besides these, there are "Bathers" and other pretty things in the gallery, which is one of the most interesting and least fatiguing now accessible in London. The aims and methods of the members of the new club are, of course, not essentially different from those of outsiders; but if the fifty painters fancy that they are exceptions to the rest of creation, the belief can only intensify their *esprit de corps,* and perhaps impel them to keep their work jealously up to the highest practicable standard.

<div align="right">

G.B.S.

The World, 28 April 1886 [C220]

</div>

[Pre-Raphaelite Art: Rossetti and Holman Hunt]

[Ford Madox Brown (1821–1893), father-in-law of Dante Gabriel Rossetti's brother William, was never a part of the famous Pre-Raphaelite Brotherhood, but as a painter of historical, biblical, and mythological subjects, and a realistic portrayer of contemporary town and rustic life, appears to parallel their practice. Many of the painters and pictures in the tailpiece to Shaw's review had been noticed earlier in paragraphs in the World. *Wilhelm Frey (1826–1911), who had escaped Shaw's earlier reports, was a German landscape painter.]*

Opportunities of studying the pre-Raphaelite movement in the works of its best exponents have been unusually plentiful this spring. First there was the Millais collection, described in last month's *Corner.* From this, two celebrated pictures, "Apple Blossoms" and "The Vale of Rest," were missed; but they have since been brought to light at Christie's by the sale of the Graham collection, which contained also thirty pictures by Dante Rossetti, and thirty-three by Mr. Burne Jones. When Rossetti's works were first assembled at the Fine Arts Club and, very soon afterwards, at the Academy, their wealth of color; poetic conception, and the fascination of the faces with which the canvases were crowded, dazzled all those to whom the work of Rossetti was new. But our eyes are now used to the sun; and, at Christie's, Rossetti's want of thoroughness as a draughtsman, and the extent to which his favorite types of beauty at last began to reappear as mere Rossettian conventions, with impossible lips and mechanically designed eyebrows, came with something of a shock upon many who

had previously fancied him almost flawless. Their attention, too, had just been recalled to the value of thoroughness, and of a constant reference to nature, by the exhibition at the Fine Art Society's galleries of the collected works of Mr. Holman Hunt. All that is wanted now to complete our survey of the pre-Raphaelite movement is a glimpse of the work of Mr. Ford Madox Brown. It must not be supposed, however, that the contrast between Dante Rossetti and Mr. Holman Hunt is wholly to Rossetti's disadvantage. Mr. Hunt's prodigious expenditure of elbow grease has made his pictures pre-eminent in all the qualities which depend on that ingredient, scarce as in large dose it is; and he is fortunate in having devoted himself to the art in which it goes farthest. Had he turned composer or author, and written symphonies or poems combining insight and technical thoroughness in the same proportions as his pictures, he would certainly not have become a popular favorite. Compare "Isabella and her Basil Pot," as an illustration to a poem, with Rossetti's "Blessed Damozel." Rossetti created his poem as well as his picture, and did the one as excellently as the other. Mr. Holman Hunt took a poem by Keats, and so completely missed everything in it except such of the mere objects described as he could faithfully copy from existing models, that it is impossible to believe that any technical mastery of verse would have enabled him to write the poem. "The Light of the World," his most famous picture, was meant to be symbolic; but it is really not a symbol of anything, but a picture of a symbol taken literally. If that be admitted as symbolism, charades and dumb crambo cannot be denied the same dignity. Still, "The Light of The World" presents to us the ideal Christ of pure superstition in his prettiest shape, clad in the garment without seam or stain, grave and decorous, jewelled and crowned, a perfect shepherd king in the eyes of lowly Christians, an equally faultless first gentleman in heaven to the Christian aristocrat. No wonder it gained for Mr. Hunt a popularity strong enough to bear even the blow he himself struck at his own reputation twenty years later by his "Shadow of the Cross," in which he offered an uncomprisingly realistic representation of the actual Jesus of Nazareth. Fancy our evangelical merchant princes—rich and respected men who can hardly humble themselves to brook redemption by the very Prince of Peace himself—condescending to accept as their savior a common carpenter, a lean Syrian Jew, a commodity purchasable for five shillings a day in the labor market. They scouted the proposition, and agreed that the painter's treatment of the subject was undignified and irreverent. Mr. Hunt did not regain their esteem until, in his latest masterpiece. "The Triumph of the Innocents" (unfortunately not in the collection of the Fine Arts Society), he depicted the Re-

deemer as a beautiful naked child, fit for the nursery of a duke. Mr. Hunt has earned all this attention by taking his art in earnest; by renouncing all baser objects than that of perfection of workmanship; by persistent expenditure of patient labor; by a strong sense of red, blue, yellow, and their most glowing combinations; and by the gentle exercise of an imagination which ever takes the British public out of its depth. He is a matter-of-fact painter both in his realism and in his symbolism—more remarkably so, perhaps, in the latter than in the former. "The Ship" is sentimental, and "The Scape Goat" even pathetic; but in these respects both are exceptional among his works.

Many minor picture shows are now open. At Mr. McLean's there is a new Millais called "Ruddier than the Cherry," representing a ragged flower girl in whose cheeks rosiness is complicated by sunburn, and who is likely to prove more interesting to the dealers than to knowers of pictures. At the French gallery, there is a hackneyed subject—the gambling room at Monte Carlo—treated with much freshness by M. Bokelmann. Also some melodramatic Servian incidents by M. Joanowits, a pupil of Leopold Müller; and an interior with a woman sewing, by Professor Loefftz, in the taste of Peter de Hooghe, whose consummate skill the professor is far from having attained, though his picture surpasses the modern average in such subjects. A few clever and ambitious artists have formed "The New English Art Club," and have opened a very smart exhibition at the Marlborough Gallery, near the St. James' Street end of Pall Mall. It is better worth visiting than most of the smaller galleries. Mr. Tristram Ellis has sent a charming set of water color pictures of Channel scenery to Messrs. Goupil's, where they may be profitably contemplated by anyone who wishes to be reminded of the seaside without the trouble of a trip to the coast. At the Continental Gallery, M. Vauquelin's "Souvenir de Tonkin" is a grisly caricature of M. Ferry, whose head crowns a pyramid of dead soldiers, victims of the Tonquin expedition. The freshest and most interesting landscapes in this gallery represent Norwegian scenery, of which, as it is coming into fashion, our own artists will soon give us enough and to spare. W. Frey's "Farmouse in Holland" (38) deserves more attention than it is likely to get as it is hung at present, almost on the floor.

The most interesting event of the spring season hitherto has been the sale of the McConnel and Graham collections, at which works by F. Walker and Rossetti were purchased for the National Gallery. The list of prices is full of absurdities: some comparatively commonplace modern pictures having fetched more than half a dozen fine examples of old masters of the first class.

Our Corner, May 1886 [C223]

In the Picture-Galleries
The Academy and the Grosvenor

[Burlington House was, and remains, the home of the Royal Academy of Arts in Piccadilly. Thomas Oldham Barlow was a mezzotint engraver of some of John Millais's work. Sir Frederick Leighton's picture was clearly one of his standard Hellenic subjects. Sir Edward John Poynter (1836–1919) was an old art-student crony of Whistler, Leighton, and Du Maurier who specialized in neoclassical pseudohistorical canvases but painted anything marketable. He was then at the South Kensington Museum but would move to the National Gallery as its head in 1894. Sir William Orchardson (1832–1910), ARA 1868, painted scenes from upper-class life, and would become a distinguished society portraitist. Edward Armitage (1817–96), ARA 1867, was a London painter of biblical, mythological, and historical subjects. William Frith's portraits were of one historical figure, Dr. Samuel Johnson (1709–84), and one fictional personality, from Walter Scott's The Bride of Lammermoor. Frank Holl (1845–88), ARA 1878, was a popular painter who injected dramatic social realism into his genre canvases. Queen Victoria bought one of his early pictures, of a grieving fisherman's widow. Also a portraitist, Holl was exhibiting a picture of Manchester Liberal politician Joseph Chamberlain, M.P. (1836–1914), who had recently resigned from Gladstone's Cabinet over the Prime Minister's backing of Home Rule for Ireland.

 Walter Ouless (1848–1933) was a successful society portrait painter; James Sant (1820–1916) also painted the best society, particularly from landed and noble families. George Hicks painted society portraits as well as scenes from Victorian life and historical subjects. Briton Riviere (1840–1920), ARA 1878, was a rustic genre and animal painter. Frederick Goodall (1822–1904), ARA 1852, painted contemporary and pseudoantique settings. Shaw's misquotation referring to Burne-Jones's painting is from William Cowper (1731–1800), who in The Task VI, 106 (1785), referred to "The insupportable fatigue of thought."

 The Grosvenor Gallery was managed by its founder (in 1877), Sir Coutts Lindsay (1824–1913), who was also a painter. Miss Pickering was Mrs. Evelyn de Morgan (1855–1919), Pre-Raphaelite painter and wife of potter William de Morgan, who made decorative tiles for [William] Morris & Co.]

"Is the Academy good this year?" Well, the Academy is never positively good; but the first room is usually bearable; the second raises hopes

which are dashed in the third; and the fourth contains Mr. Burne Jones's "Depths of the Sea," after which the rest of the exhibition is leather and prunella. A damaging Associate for stale Academicians is Mr. Burne Jones; and the members whose invention is still fresh enough to have left some room for hopeful doubt as to what the season would bring forth from them possibly felt it; for they have not this year divided his preeminence at Burlington House. They have, indeed, hardly challenged it; for Sir John Millais only sends a prodigiously clever likeness, which has an air of being a masterly portrait, of his fellow-Academician Mr. T. O. Barlow; Sir F. Leighton's expanse of ceiling decoration, with its graceful Muses, and its lively boy kicking up behind and before in honour of Terpsichore, makes no pretence to being a picture of anything in particular; and even Mr. Watts' "Cain," though attended by a beauteous angel, conveys little more than a disagreeable impression of a very ugly old man with apish hands and an inscrutable problem in inartistic anatomy in his supra-clavicular region. Mr. Poynter's *Chef-d'oeuvre* is a "Design for an advertisement placard of the Guardian Life and Fire Assurance Company," his other contributions to the show being two discordant portraits. First on the list of the Academicians whose pictures can be placed to the credit of their reputation is Mr. Orchardson. His "*Mariage de Convenance*: After!" is hung in the pet place on the north wall of the second room. A haggard, elderly gentleman in evening-dress sits as nearly supine as a man can stretch himself in a straight-backed chair staring into the dining-room fireplace like one conscious of having made a very paltry job of his own affairs. On the wall, dimly visible in the fading daylight, is the portrait of the lady of the house, at sight of whose proud face the sympathetic feminine spectator will exclaim, "Poor fellow!" and the stern masculine moralist, "Serve him right!" The verdict will be favourable in any case to the artist; for though a jaundiced atmosphere prevails in this as in all Mr. Orchardson's works, the composition and arrangement are masterly, the colours of carpet and the crimson chair being treated with notable skill. On the opposite wall two magnificently stalwart Highlanders, bathed in the ruddy radiance of the torches they uplife, show how Mr. Pettie has re-composed his old subject, "The Chieftain's Candlesticks." The picture is as a stove in a cold room. He who turns not aside for Mr. Orchardson or Mr. Pettie, but keeps his face steadfastly to the west, will be confronted by Mr. Edwin Long's "Finding of Moses," whose mother, from a hiding-place less logical than that to which the ostrich is said to resort, but quite as obvious, anxiously watches the daughter of Pharaoh discussing the baby with her ladies on a flight of steps bordered by lions carven out of Castile soap, or perhaps out of porphyry. In the large room a marmoreal

"Apodypterium" provokes the remark that it is now some time since Mr. Alma Tadema has had a new idea. Hard by is "A Daughter of the Lagoons," by Mr. Luke Fildes, an undeniably fine girl, but conventionally bold in her attitude, and not to be compared to the painter's irresistible flower-girl in the first room, who is perfect to the very points of her scissors. No one, seeing her, need complain of having to turn his back on the salmon-coloured radiance of Mr. P. H. Calderon's "Ruth and Naomi," an Oriental scene which bears the stamp of the N.W. postal district in every touch. In the same room, at the very doorway, and first on the line, Mr. J. R. Herbert assaults the eye with one of his eight works. Let it be confessed, however, that Mr. Herbert has behaved himself better this year than last, when the space occupied by his canvases was so outrageously disproportionate to their interest that the critics made him their butt with the full approval of the public; and, for the moment, no one questioned the statement, which was, unfortunately, very far from being true, that his pictures were the worst in the Academy. Mr. Herbert is past his prime; but some of the defects which are now pointed out as instances of his dotage are to be found in the works of his best period; and on other points he would run less risk than some of his younger colleagues if the stone-throwing became general. Of his last eight works, suffice it to say that "Daniel and the False Elders" is a disagreeable picture, but not an unskilful one, though exception might be taken to a point or two in it. Mr. Armitage, more modest or less appallingly industrious than his contemporary, sends two works of moderate size. Then there is Mr. Frith, with his Dr. Johnson and Edgar of Ravenswood as reminders of the fame of the painter of the most popular, if not quite the best, picture in the National Gallery; and Mr. Faed, with his old Scotch emigrant sitting, heavy with home-sickness, on the shores of Lake Ontario. Mr. Holl occupies yards of the line with six indigestible portraits (Mr. Holl, it seems, may steal a horse, though Mr. Herbert may not look over a hedge), prominent among which is one of Mr. Chamberlain, in a bad humour over his resignation, and not himself at all. Mr. Ouless also presents us with half a dozen counterfeit contemporaries; but they are more interesting than Mr. Holl's lot—if his sitters will excuse that expression. Mr. Sant and Mr. Hicks familiarise us with the best society, as they always do. Of Mr. Briton Riviere's four pictures, the vulgar taste will prefer "Union is Strength," in which thirty-eight fleecy sheep majestically overawe a single snarling dog. "The Exile" is less impressive than the most bashful of these sheep; and in "Rizpah" the wolves are better than the woman, but the woman is better than the lions. The subject is rather discounted by Mr. Briton Riviere's treatment of it. Mr. Goodall's chief subject is Susanna, whose normal colour would seem to

be a delicate cinnamon, though the footfall of the elders has caused her to turn pale all over. No such nudeness is to be found in the pictures of Mr. J. C. Horsley, whose exploits with his brush do not at all overshadow his fire-new fame as a moralist. Of Sir John Gilbert it need only be said that he is in full force, incurably shaggy as to his forms, incurably brave as to his colour, and incurably romantic as to his colour, and incurably romantic as to his subjects. As to the landscapists, the seascapists, the Associates, and the outsiders, there is no room here this week for any save Mr. Burne Jones, to whom it is necessary to return for a moment. What people of a jolly disposition have hitherto missed in his pictures is gaiety. Now the first thing one sees in "The Depths of the Sea" is a wonderful smile in the lips of a mermaid. She has got a treasure—a drowned man; and she is carrying him down to the bed of the sea—has indeed all but laid him there; for the flukes of her rigid tail are already turning from the touch of the sand. Her uncanny ecstasy, her dead burden, and the strangeness of the place, with the light straggling down and the bubbles straggling up, just as they appear in the glimpses of a deep dive, would make one forget the Academy if it were possible to forget anything so insistently mundane. Anyhow, it is the best picture there, and the only successful one that has cost much of what Cowper called "the intolerable fatigue of thought."

At the Grosvenor, again, Mr. Burne Jones's welcome recognition of the fact that Beauty occasionally smiles, leads him into downright comedy in "The Morning after the Resurrection," in which two gracious angels, seated on the edge of the sarcophagus, are politely hiding, with their fingers on their lips, their smiles at the mystification of Magdalen as she sees before her the Lord whom she believed dead. Mr. Spencer Stanhope, by this change of tune on the part of his leader, is left to be melancholy all by himself; for Miss Pickering is in full rebellion against the interdict of her school on vigour and purpose, to which indeed she never wholly submitted; and Mr. Strudwick, whose pictures of unhappiness were, at their worst always piteous and pathetic when even his master's were mannered and morbid, must now be regarded an an independent painter, since he follows up his enigmatical little success of last year by a work of handsome dimensions, entitled "Glaucus and Scylla," interesting as well as intelligible, impressive as well as interesting, and beautiful as well as impressive, a description which would apply to no other work in the gallery except that of Mr. Watts and Mr. Burne Jones. Both the interest and the impressiveness, for instance, would have to be subtracted in order to fit it to the contributions of Mr. Alma Tadema, who sends, besides a large portrait, one of his usual cabinet pictures, with the usual figures and

the usual accessories, the usual cunning of hand and the usual reflective indolence. Mr. Watts sends two fascinating and mystical representations of "Hope" and "The Soul's Prison," the latter illustrative of a poem by Mr. Walter Crane, who has done more, both with pen and pencil, for the publishers this year than for the galleries. Neither Sir Frederick Leighton nor Sir John Millais contributes, and Sir Coutts Lindsay has accordingly had to work vigorously to supply the deficit from his own easel. Mr. Orchardson, however, has helped with a considerable canvas; and Mr. W. B. Richmond's generosity may almost be described as boundless, no less than half a scope of portraits by his hand decorating the walls. Further particulars must be deferred until next week, lest the surfeit of the Fine Arts from which I am suffering should infect the reader.

The World 5 May 1886 [C225]

In the Picture-Galleries
The Grosvenor (Second Notice)

[Anna Alma-Tadema (?–1943) was the daughter of Sir Laurence Alma-Tadema. The Messrs. Maple sold furniture; Pears' Soap had also exploited Bubbles *in advertising to the enrichment of Sir John Millais. Philip Burne-Jones (1861–1926), son of a famous father, would not live up to his early promise. Even less so would "Pen" Browning.*

John T. Nettleship (1841–1902) was a genre and animal painter, illustrator, and literary critic. Subjects of pictures were Joseph Pyke, a London barrister, and Margaret Burne-Jones, twenty-year-old daughter of the eminent painter, and (Sir) Henry Irving (1838–1905), actor-manager. John Collier (1850–1934), portrait and landscape painter, also painted scenes of upper-class life. He would later do a portrait of Shaw which the RA hanging committee would reject. Louise Jopling (1843–1933), portrait and genre painter, exhibited as Louise Romer until the death of her first husband, Frank Romer, in 1873. Herbert Schmalz (1856–?), engraver and painter, often of Middle Eastern and biblical subjects, added Carmichael as surname in 1918 in response to anti-German feeling. George Dunlop Leslie (1835–1921), landscape and genre painter, was part of the St. John's Wood circle.

J. P. Beadle, actually James Prinsep Barnes (1863–1947), painted historical and military subjects, portraits, and landscapes. John Robertson Reid (1851–1926) was a Scottish-born genre painter who lived

in England. John Frederick Boyes (1811–79), classical scholar, was the portrait subject of Edwin Arthur Ward (?–1927). Heywood Hardy (1843–1933) was a watercolorist who specialized in sporting scenes and genre. William John Hennessy (1839–1920) was an Irish-born landscapist. Charles Edward Hallé (1846–1914), son of the musician, was a portrait painter and decorative artist. Alfred William Parsons (1847–1920), ARA 1897, was a watercolorist and illustrator known for pastoral scenes and landscapes. John Da Costa (1867–1931), largely a portrait and figure painter, was influenced by his friend J. S. Sargent. Julian Russell Story (1857–1919) was an American painter long resident abroad; Edward Robert Hughes (1851–1914) was a London landscape and genre painter. Professor Grosse was a Dresden portrait painter; Thomas Charles Farrer (1839–91) was a London landscape painter. (Sir) David Murray (1849–1933), ARA 1891, Glasgow landscape painter, left Scotland in 1882 to paint in the south of England and on the Continent. William E. F. Britten (1848–1916) was a London decorative painter in the neoclassical manner of Frederick Leighton and Albert Moore; (Sir) George Clausen (1852–1944), ARA 1895, a painter of portraits and scenes from rural life, became Professor of Painting at the Royal Academy Schools in 1904. He would be knighted at seventy-five in 1927.

Allusions include the usual Dickensian ones: Sam Weller from Pickwick Papers *and the widowed Mrs. Gummidge in* David Copperfield. *The American-born George Boughton's William the Testy of New Amsterdam (New York) was the waspish Wilhelmus Kieft, who became the Dutch governor in 1634. According to Washington Irving's* A History of New York *(1809), ostensibly by "Diedrich Knickerbocker," Kieft's surname "according to the most ingenious etymologists was a corruption of* Kyver, *that is to say a* wrangler *or* scolder, *and expressed the hereditary disposition of his family, and . . . he had scarcely been a year in the discharge of his government before he was universally known by the appellation of William the Testy." The Bequest of Sir Francis Chantrey (1781–1841) left the RA £105,000, the interest of which was to purchase new works of art executed within Great Britain. Chantrey purchases now go to the Tate Gallery.*

Strudwick's Isabella was the Keats heroine; his Scylla was changed in shape through the envious magic of Circe, who also loved Glaucus (in Ovid tale). Alphonse Marie de Lamartine (1790–1869) was a French poet.]

One of the interesting points about the Grosvenor this year is Sir Coutts Lindsay's success in exploiting our artistic stock in the second generation. Miss Anna Alma Tadema has sent him a picture of a

drawing-room which, if it were a little larger, would be as well worth its price to Messrs. Maple as Sir John Millais' "Bubbles" was worth—was it not 2000£?—to Messrs. Pears. In saying this I do not take a commercial view of Miss Alma Tadema's art, but a highly artistic view of Messrs. Maples's commerce. Then there is Mr. Philip Burne Jones, who has taken a garret flooded with sunlight for his subject, and painted it like a young Rembrandt. No conclusive opinion concerning this promising novice's powers as draughtsman can be based on the two easy figures, one of which—that of the unkempt artist—might be resented as personal by Mr. Burne Jones senior if he could feel quite sure that Mr. Holman Hunt was not the actual model. Another and more mature son of a great art-worker is Mr. Barrett Browning, who has made a careful life-school study of a nude woman; brought it into startling relief against a background of vivid verdure; labelled it "Joan of Arc and the Kingfisher"; and hurled it, all naked, at the head of Mr. Horsley. As the face of the model is turned away, and her figure no more than ordinarily expressive, the title and quotation assigned to the picture in the catalogue may be dismissed as a humorous imposture. The name of Browning naturally suggests the poet's votary, Mr. J. T. Nettleship, who paints lions as if he despised men. In its way, there is nothing grander in the gallery than his "Night in a strange land where no man comes," with its fearful creatures creeping down to lap the moonlit water, or staring with awful wonder over the waste. To turn from this to our ordinary retailers of Landseer's small beer, with their pretty pussy, good dog, and the rest, it is to realise the feelings of a grown-up man to whom some scoffer gravely presents a wooden monkey on a stick. Mr. T. Hope McLachlan, as an imaginative landscape-painter, bids for the place made vacant by the death of Cecil Lawson, something of whose manner he has caught.

Sir Henry Thompson and Sir Coutts Lindsay also exhibit landscapes of their own painting, which will startle any unsophisticated visitor who may suppose that the knighthood and the baronetcy are the rewards of high achievement at the easel. But Sir Coutts, as an amateur of the arts, may be congratulated on his "Paolo and Francesca," and still more on his portrait of Mr. Joseph Pyke. Mr. John Collier's portrait of Mr. Henry Irving is one of those opaque clayey faces in a black quagmire which Mr. Holl has made fashionable. They are generally admired (and what am I that I should object?), but I pity the children who will see them daily looming over the sideboard for years to come. A far more cheering spectacle is Mr. Richmond's portrait of Miss Burne Jones, a pleasant and natural treatment of a very attractive sitter. The same painter's "Hermes" has equally gladsome surroundings; but he is unhandsomely modelled, particularly the arm and hand with which he

props himself against the fluted column. His Pastoral in the East Gallery, when seen in warm summer light, and not examined too closely, is charming. Mrs. Louise Jopling is not at her best this year. Her "Reminiscence of Miss Norreys" is garish, as a theatrical reminiscence perhaps should be, but as a picture certainly should not be. Mr. Herbert Schmalz continues on the primrose path of portrait-painting and pretty face-making, which is a pity; for Mr. Schmalz started like a man with better stuff in him. Let us hope that he is only collecting himself for a spring. Mr. G. D. Leslie's "Garland" shows how well he knows that nothing is more effective on canvas than some flowers and maidens on an island of shadow in a sea of green lawn. The execution is irreproachable. Mr. Orchardson gives us "Master Baby," whose prevalence at our exhibitions makes us feel that there is much to be said in extenuation of the policy of Herod. On this occasion baby's victim is not mamma, but grandmamma; and she, again, is not the conventional doddering person in spectacles, but a lady just turned forty—the dark and slender sort of grandmamma, who keeps her figure and loses her temper. Mr. Walter Crane's "Cupid," apparently painted on a handkerchief, and his sketches, especially the "Corner of St. David's," with the geese and the plantation, are more interesting than his decorative "Venice, Florence, Rome," a water-colour design in three compartments, with Raphael, Michael Angelo, Dante, Giotto, and other celebrities about. Mr. T. M. Rooke's work is laboured and mannered, as usual; but few judicious lovers of earnest work will pass it inattentively. His "Rue du Bourg and Queen Bertha's Staircase" is excellent. Mr. Spencer Stanhope's "Why seek ye the living among the dead?" might have been produced by "the profeel machine" alluded to by Samuel Weller. Three persons, with exactly the same profile and exactly the same lone lorn air—as of Mrs. Gummidge thinking of the old one—thrust forward their chins at an angel, also in profile, but facing the opposite way, and in comparatively high spirits. Mr. Spencer Stanhope has imitated Mr. Burne Jones quite long enough. If he would imitate Hogarth for a season or two, and then look out of the window and imitate Nature, we might gain some adequate return from his praiseworthy industry. Mr. Boughton has a capital picture of the smokers of New Amsterdam mutely blowing a cloud of rebellion before the house of William the Testy. One week-kneed trimmer is half hiding round the corner of William's house; but the rest are as calm as Fate: they smoke like the conscious vehicles of the aroused will of the sovereign people. The Chantrey Bequest might be worse used this year—and probably will be—than in the purchase of this very interesting work. Interest, by the bye, is just what Mr. J. P. Beadle's otherwise commendable "Life Guards" lack.

Mr. Strudwick's "Isabella" is sad, but beautiful; and his Circe is terrible as she stands in the mouth of a cavern, squeezing dreadful virus into a pool, from which a whiplike serpent, maddened by the venom, springs up at her outstretched hand, whilst uncanny reptiles scramble from the margin, hissing at her in rage and panic. At a little distance Scylla comes down the bank to her doom. Miss Pickering has taken no less pains than Mr. Strudwick with her "Dawn": yet the result is ill-balanced. The heralds of the day are three splendid fellows, but their red wings and shirts of gold mail form with the pale flesh of the awakening Day chromatic discords that are nowhere resolved. The attitude of Day is a reminiscence of Michael Angelo's Medici tomb. In Mr. John R. Reid's "Calm Evening," the figures are hardly visible, although there is light enough in the picture to define them perfectly well. Mr. J. F. Boyes, not so large as life, but quite as imposing, seems to take note of the company from the canvas of Mr. E. A. Ward. Mr. Heywood Hardy's "Toast" is chiefly remarkable for the pleasing novelty of huntsmen in bottle green instead of pink. Miss Hilda Montalba's essay in portraiture is clever; but it is rather odd than elegant. Mr. W. J. Hennessy's pictures look like monochrome work beside their gorgeous neighbours. Mr. C. E. Halle, in "Rivals," has depicted two admirably contrasted types of beauty and character. He has done nothing better within my recollection. Mr. Alfred Parsons' "In Cider Country" is a reckless shedding of green paint. As to Mr. Philip Calderon, one hardly knows what to say to a painter whose mossy banks are apparently copied from long-haired hearthrugs, and whose landscape backgrounds would stagger the most irresponsible photographer in the Euston Road. His "AEnone" is not so uncompromising a life-study as Mr. Barrett Browning's so-called Joan; but she is more graceful, and has a pretty skin and complexion. Against my will, I admit that Mr. Calderon's Phrynes never fail to secure a popular verdict in his favour. Mr. Phil Morris is an even less severe master of the pretty. His pictures seem fresh from the bandbox—always excepting the breezy little landscapes with which he occasionally appeases people who know how miserable excessive soaping and excessive millinery probably make the spick and span children whose images declare the cunning of his hand. Mr. Waterhouse has a clever picture of an Italian girl stooping to smell a bunch of violets on a flower-stall in a sunny court, the plastered walls of which remind one somewhat of the white marble beloved of Mr. Alma Tadema. Giving reminders of other artists is quite a speciality with Mr. Waterhouse, except when he paints sorceresses and contribution is "Frate Francesco and Frate Sole," a panoramic landscape, in which the friar in the foreground, with his back to the spectator, salutes the sun with a world-embracing gesture. Mr. Costa has interpreted St. Francis somewhat in the spirit of Lamartine. Noteworthy

also are Mr. Julian Story's two smart works; Mr. E. R. Hughes's "Pastoral," the dusty dryness of which is refreshing amid so much paintiness; Professor Grosse's excellent cabinet portraits, which show how unnecessarily we waste space and material in his branch of art; Mr. Hamilton Macallum's lively boating incident; the rural scenes of Messrs. David Murray, Clausen, and Barclay; Mr. T. C. Farrer's "Out of the World," a cavalier trudging through a pine wood at sunset; and a couple of small works by Mr. Britten and Mr. Poynter.

<div align="right">

G.B.S.

The World, 12 May 1886 [C227]

</div>

In the Picture-Galleries
Water-Colour and Other Art Shows

[Thomas J. Watson (1847–1912) painted landscapes and genre and fishing scenes; Myles Birket Foster (1825–99) was a Surrey watercolorist of sentimental rustic scenes. Alfred Downing Fripp (1822–95), like his elder brother George Arthur Fripp (1813–96), was a painter of landscapes and rustic subjects. The elder Fripp also painted, on commission from the Queen, sketches of Balmoral and environs for the Royal collections.

The Bavarian-born Carl Haag (1820–1915), watercolorist of landscapes, portraits, and "Orientalist" subjects, became prosperous through sale of his Middle Eastern pictures. Albert Goodwin (1845–1932), painter of landscapes and biblical-allegorical subjects, often used pen-and-ink in combination with a watercolor wash. William Collingwood the elder (1819–1903), largely a watercolorist, was known for his Alpine subjects; Colin Bent Phillip (1855–1932), son of painter John Phillip, was a Scottish landscapist, principally in watercolor. William Eyre Walker (1847–1930) was a prolific painter of English and Scottish landscapes; Charles Robertson (1844–91) was an engraver and landscapist. John Frederick Lewis (1805–76), ARA 1859, painted Spanish and Middle Eastern subjects; Thomas Miles Richardson, Jr. (1813–90), painted Scottish and Continental landscapes.

The elder Telbin (father and son were painters) was William Telbin (1815–73), Victorian stage manager, landscapist, and architectural artist. Edward Radford (1831–1920) was a genre painter in watercolors; Arthur Hopkins (1848–1930), illustrator and portraitist, had a reputation for striking country scenes. Arthur Hardwick Marsh

(1842–1909), London genre painter, often used Northumberland for his settings; Frederick Smallfield (1829–1915), here with a scene from Thackeray, painted literary and genre subjects. Richard Henry Nibbs (c.1816–93) was a London and Brighton painter of marine and country scenes; Sir Hubert Medlycott (1841–1920) was a Somerset-based landscape and architectural painter.

Frederick Vezin was a London marine and cityscape painter; Dr. Frederick James Furnivall (1825–1910), editor and inveterate founder of literary societies, also founded the Hammersmith Sculling Club and the National Amateur Rowing Association. Margaret Murray Cookesley (c.1860–1927)—the gender error is Shaw's—lived in Bath and began exhibiting in London galleries in 1884. Charles Gounod (1818–93) was the composer of the opera Faust *(1859); Reginald Barbier, who exhibited in the 1880s and 1890s, was a French portraitist and genre painter; Jean Carré de Malberg (1749–1835) was a French painter and illustrator. E. P. Sanguinetti was one of an Italian family of painters; Alicia (Alice) Miller was a London painter of country and figurative subjects. William Edward Norton (1834–1916) was an American-born landscape and marine painter; Charles Collins was a Dorking painter of rustic genre and Edward Hartry a Southampton genre painter.*

Frederick William Hayes (1848–1918) was a landscape and marine painter who worked out of Liverpool and London. Francis Wollaston Moody (1824–86) was a London genre and portrait painter who also worked in decoration—ceilings, lunettes, mosaics. Charles Stuart, who exhibited in London 1880–1904, painted landscapes and marine subjects. H. V. Inglis's master was John Linnell (1792–1882), landscape painter and patron of William Blake.

Albert Bruce Joy (1842–1924), Irish-born sculptor, made his reputation with massive commemorative figures, among which were John Bright (1811–89), Radical statesman and Liberal cabinet member; W. E. Gladstone (1809–98), the four-time Liberal prime minister; and William Harvey (1578–1657), English physician and discoverer of the circulation of the blood.

Charles Albert Waltner (1846–1925) was a Dutch etcher; David Adolph Artz (1837–90) was a Dutch painter of genre scenes; Hendrik Willem Mesdag (1831–1915) was a Dutch marine painter of the Hague School. Willem Maris (1844–1910) was a Dutch Impressionist painter of bucolic scenes; his brother, Jacobus ("James") Maris (1837–99), a leader of the Hague School, also painted the Dutch countryside as well as marine subjects and portraits. Bernardus Bloomers (1845–1914) was also a Hague School painter of rustic scenes, while Antonij

Mauve (1838–88), a nephew of Vincent Van Gogh (1853–90), was a Hague genre painter.

Jules Dupré (1811–89) was a Barbizon School painter of landscapes and figures; Charles François Daubigny (1817–78) was also a Barbizon landscapist, as were Marie Chantreil and Henri-Joseph Harpignies (1819–1916). Eugène Isabey (1803–86) was a French genre painter; Jean-Baptiste-Camille Corot (1796–1875) painted idealized romantic landscapes. Rosa Bonheur (1822–99) was the premier French animal painter of her time; Etienne Prosper Berne-Bellecour (1838–1910) painted genre scenes and figures from Boulogne and Paris.

Wouterus (Walter) Verschur (1812–74) painted Dutch landscapes, marinescapes, and animals. Félix-François-Georges-Philibert Ziem (1821–1911) was a French painter of coastal scenes and genre.

Ernest Hart (1835–98) was an English physician who edited the British Medical Journal from 1866 until his death. He began collecting Japanese art and artifacts in 1884. George A. Audsley (1838–1925), Liverpool and London architect and organ designer, published pioneering books on Japanese ornamental and ceramic arts, 1872–84. Hans Holbein the Younger (c. 1497–1543) lived in England from 1532 as Court painter, limning the eminent in oils and crayon drawings.

Joshua Smallweed was the insatiably avaricious old moneylender in Dickens's Bleak House.*]*

The show of water-colours at the Royal Society is, as usual, excellent. Mr. Herbert Marshall has made some additions to his pictures of the city, among them a notable "First View of London from the Railway" as you look down the river from Cannon Street Bridge. Mr. Du Maurier's "Time's Revenge" is just a little inky; and the discomfited elderly lady has one of those wooden chins and ill-drawn mouths which are too often seen on the ugly people in *Punch.* Of Mr. T. J. Watson's admirable pictures of Ilfracombe Harbour, the smaller (No. 41) is perhaps the more attractive, though one would rather have both than be compelled to choose. The works of Mr. Birket Foster and of the Messrs. Fripp, like Mr. Carl Haag's extraordinarily luminous "Important Message," are worthy of the able hands that made them. The cool freshness of Miss Clara Montalba's "Spring—Venice" is the more welcome, since her other pictures betray a tendency to exaggerate the glow of the southern sun, and to force the effects of light and shade. Mr. Albert Goodwin's sombre "Ponte alle Grazia," with its dark piers looming above the mud, and the dull evening red just visible through its arches, is good. His "Clovelly," however, is a paltry piece of pencilling, though it is a

trustworthy "note" of colour. Mr. William Collingwood's "Jungfrau" is very fine indeed; and Mr. Colin Bent Phillip's rich golden-brown moorlands are strong and satisfying. Mr. E. F. Brewtnall shows us some crows following the plough, which at evening on a windy day has left only one narrow strip of sward unturned. Quite a bridal aspect has Mr. Eyre Walker's "May Blossom," a white tree on a pale-green hillside. Mr. Charles Robertson is minute, gorgeous, and oriental in the manner of [John Frederick] Lewis; and Mr. T. M. Richardson's elaborate pictures recall the drop-scenes of the elder Telbin. The maiden in Mr. Edward Radford's picture seems to be arranging her front teeth rather than wafting a kiss. The best figure-subject in the gallery—putting Sir John Gilbert *hors concours*—is Mr. Arthur Hopkins's "Keeper Caught," an effective picture and a thorough piece of workmanship. Sir John's "Enchanted Forest" represents two knights making their way through a tangled wood full of elves and fairies, who swarm about the warriors like bees about a couple of bewildered bears. Mr. A. H. Marsh also distinguishes himself, a little sentimentally, but not ignobly, in the figure department; and Mr. Smallfield repeats in water-colour his Academy picture of "Colonel Newcome at the Charterhouse."

Water-colours are also in the ascendant at the Nineteenth Century Gallery in Conduit Street. Romantic scenery, in the guide-book sense, has inspired less of the best work there than the town end of the Thames, upon which Mr. R. H. Nibbs and Mr. Medlycott have been at work to some purpose, Mr. Nibbs inviting our attention to the beauties of Waterloo Bridge and Somerset House; whilst Mr. Medlycott induces us to contemplate the Custom House, and to venture into the busy waters of the Pool below London Bridge. When Mr. Whistler, Mr. Herbert Marshall, and the Messrs. Wyllie have half a dozen more followers, the Cockney school will be one of the glories of English Art. The biggest of the oil pictures is Mr. Vezin's "Henley Regatta," which Dr. Furnivall, if he had the christening of it, would certainly call "Cads on the River." It revives that intolerant frame of mind in which so many of us have, at one time or another, longed to plant a torpedo in Teddington Lock and explode it during a rush of business there. Mr. Charles Gogin succeeds, as usual, in arresting attention by his small landscape with the moon risen, the sun not yet set, and a labourer finishing his day's toil. His "Amaryllis," a study of a young woman's face, is also remarkable; but the imperfection of the artist's skill in flesh-painting is still evident in the handling of the subject. Mr. Murray Cookesley's scenes from *Faust* display a grasp of the subject and a knowledge of its details, evidently derived from M. Gounod, Barbier, Carré, and the stage-manager. Mr. Murray Cookesley may still ripen considerably, both as workman and thinker, without risk of spoiling.

Mr. E. P. Sanguinetti's elopement and pursuit in postchaises is dashing, but coarse and exaggerated. Miss Alicia Miller will probably be called an Impressionist. She does not attempt a complete representation of her subject, but very cleverly places before you certain aspects of it, like Mr. Whistler, except that she does not venture to sacrifice form so much as he, and she compromises a little with conventionality in colour. Thus her "Harmony in Grey" is more than a harmony in grey: it is a distinct portrait of a lady, and, as such, it is open to the objection that the red in the lady's complexion is not natural—if a phenomenon not unknown in real life can fairly be called unnatural. There is no apparent reason why Miss Miller should pretend to limit herself to harmony when she seems so well qualified to excel too in counterpoint, which is, after all, harmony in action. The inconsiderate slovenliness with which M. Montbard's Oriental executioner has just decapitated a man on a flight of clean marble steps would provoke any British matron to demand who he expected to wash up the place after him. In Mr. William E. Norton's "Sunlight and Shadow" we see a pilot-boat just entering the shadow of a cloud from the sunny green beyond. Mr. Charles Collins's "Farmyard Pets" would be a good picture if the cow's accessories, including the woman and the farmhouse, were solidly and thoroughly executed. Mr. Hartry's "I'se found him" is remarkable only for bearing the artist's name in letters nearly as large as those inscribed on the balloon which soars above Drury Lane Theatre. Hints taken by Mr. F. W. Hayes from the works of Mr. Brett and Mr. Albert Goodwin have resulted in the unusually vivid illusion produced by his "Mussel Gatherers at Anglesea." Of the inevitable funny pictures, the funniest is Mr. F. Moody's "Familiarity breeds Contempt," a hound staring disparagingly at a tame fox, who is acutely put out of countenance. Mr. Charles Stuart has painted, in the same vein, a housemaid scrubbing a bust of his Royal namesake, who surveys the girl with fearful indignation. The face and arms of the fishermaiden in Mr. Padgett's "There's a dear, dear love on a distant shore" (misquoted—not that it matters—in the catalogue) are thinly and ineffectually painted. "A Glimpse of a Brighter Lane," by Mr. H. V. Inglis, seems to have been skied for sufficient reasons; yet it has an imaginative air, and the clouds remind one of Linnell. So perhaps there may be some promise discernible in it at close quarters.

Among the sculptors whose best work is not in the Academy this year is Mr. Bruce Joy, whose colossal statue of Mr. Bright for the Birmingham Fine Arts Gallery is ready to be made marble. When finished, it will rank with the sculptor's Harvey, and with his Gladstone. Mr. Bright is in some respects a more difficult subject than either; for his figure is less statuesque than that of the Premier, and his

costume less artistic than that of Harvey. Mr. Bruce Joy has, however, vanquished both difficulties; and has put some of his finest work into the head and hands. He has also—so as not to give to party what was meant for mankind—finished a bust of Lord Salisbury, the destination of which is not yet made public.

At the Goupil Gallery Messrs. Boussod, Valadon, & Co. exhibit an etching of Rembrandt's "Night Watch," which has cost Mr. C. Waltner four years' work, and a strong collection of Dutch pictures by Artz, Mesdag, Israels, W. and J. Maris, Bloomers, Mauve, and others. The Hollanders are still masters of effects of cool light and aerial perspective in and out of doors; but the surfaces of Jan Steen and Peter de Hooghe, smooth and luminous as the varnish on a Stradivarius fiddle, have disappeared; and the modern Dutch process of painting might more fitly be called plastering. A picture by J. Maris, with its atmospheric effects which make one almost feel the sort of weather depicted, and its peculiar old-Worcester blue here and there, seems as smooth at a distance as a Canaletto. Close at hand it is a chaos of lumps of paint. The examples of Josef Israels' work are comparatively numerous and important, and will interest those who have not worn out their interest in his wearisome trick of pathos. A comparison of the French with the Dutch landscapists may be made by going from the Goupil Gallery to Messrs. Obach's in Cockspur Street, where there are some interesting specimens of the work of Dupré, Daubigny, Chantreil, and particularly of Harpignies than whom we have no landscape painter more pastoral or less theatrical. Would that many of them were as skilful! The interest of the collection is varied by a Gérôme, a Meissonier, and a couple of works by the veteran Isabey, whose death is an occurrence of yesterday, though his vogue seems remote.

Meissonier, Dupré, Daubigny, and Isabey are also represented at the Hanover Gallery, with Gustave Doré, Corot, Millet (a pastel), Rosa Bonheur (a fine drawing), Berne Bellecour, and many others. The *Macbeth* sketch by Doré is remarkable for an effect of flame obtained by very simple means. Hard black ice is depicted with exceptional truth in W. Verschuur's sledge scene; and M. Berne Bellecour's French marines are closely observed. "Finishing Smacks," by Ziem, might pass as the work of Miss Clara Montalba, and add to her reputation.

The art record of the season would be unpardonably incomplete without a reference to Mr. Ernest Hart's astonishing Japanese collection at the rooms of the Society of Arts in John Street, Adelphi. Britons whose ideas of Japanese aesthetics are based on the sudden appearance a few years ago of sixpenny umbrellas in their fireplaces, and paper fans on their mantelpieces, will gasp when they see scores of

swords, buttons, and lacquer boxes, each of which is a separate and original miracle of such craftsmanship as seems impossible even under the most favourable feudal conditions. If Mr. Ernest Hart and Mr. Audsley had not verified their descriptions to me sword in hand, I should not have believed them. Not that either of them would have practised *hari-kari* on me if I had expressed a doubt; but that my senses could not refuse the evidence of swords which not only looked—to quote Mr. Smallweed—"awful sharp and gleaming," but which undeniably had upon pommel, guard, and the ferule of the scabbard, pictures executed in metals of wonderful colours, chased and inlaid with a cunning and patience apparently infinite, and representing scenes in the space of two thumbnails with as much energy, force of realism, and breadth of treatment as Holbein showed with twelve times as much room to turn in. No two of these pictures in metal are alike; and in no instance has the extraordinary skill they evince been applied to objects not useful in the ordinary sense. Description would be endless and inadequate. Walk up, walk up; and see the show for yourselves.

The World, 19 May 1886 [C229]

[Tissot]

[Jacques-Joseph (James) Tissot (1836–1902), born in Nantes, turned in the 1860s from costume works to Impressionist-influenced scenes of modern life. In 1871 he moved to London and began to paint the English conversation pieces for which he is best known, returning to Paris in 1882. Coup d'aeil: stroke, or flap of the wing.]

The set of pictures by M. J. J. Tissot at Messrs. Tooth's in the Haymarket is the most generally interesting of its kind in London. As in our boyhood we bought the figures of an unreal world at a penny plain and twopence coloured, so can we now obtain the figures of actual life at threepence plain from Mr. Du Maurier, or a shilling coloured from M. Tissot. I say actual life, not real, advisedly; for *la vie mondaine,* when summed up compactly by M. Tissot, and presented to us in an album, as it were, seems as unreal as any undeniable hard fact can be. The spectators do not become out-and-out pessimists as they gaze, for M. Tissot, clever as he is, is no Hogarth; but they become moralising prigs in spite of laboriously acquired and proudly cherished *savoir*

faire and *savoir vivre,* and almost resolve to refuse all their invitations, and take to philantropy or politics. In the execution of the sixteen pictures, M. Tissot has adhered to his old methods, giving you, by the steepness of the perspective, the same *coup d'aeil* which you would actually enjoy were you seven or eight feet high. The light, life, colour, and character are those of the drawing-room, the theatre, and the promenade, during the summer season. Impressionism is carried with great skill just to the right point of representing everything as we see it in Nature when our eyes are wide open. Thus the verisimilitude of the newspapers and play-bills is perfect, though they cannot be read even with a magnifying-glass. M. Tissot shows us our decorative taste exactly as the books of our upholsterers and house-furnishers prove it to exist. He does not shrink even from the yellow gaslight and crimson garniture of a circus. The "Cirque du High-life," with the herculean duke grinning at his friends from the bar of a flying trapeze, where he sits clad in a red jersey cut down the front so as to convey a futile suggestion of ordinary evening dress, is as funny as the work of M. du Maurier at his funniest.

The World, 2 June 1886 [C233]

[Marine Painting]

[Emily Mary Osborn (1838–c.1908) was a genre painter, often with an emphasis upon children; Pownoll Toker Williams, who exhibited in London from 1872 through 1897, was a landscape and genre painter.]

The collection of Dutch pictures at the Goupil Gallery has been reinforced by another Israels and a Meissonier; and Mr. Tristram Ellis's pictures have given place to a series of breezy and effective sketches of the Norfolk Broads, taken by Miss E. M. Osborn during what must have been a delightfully quiet and poetic voyage in a flat-bottomed wherry. At Mr. T. McLean's, in the Haymarket, Mr. Pownoll Williams exhibits a series of his sketches and drawings of scenery in the Riviera. They display remarkable power and striking fertility in devising novel methods of handling. The peculiarly soft, bright, and dry effects produced are only unhappy in the case of the sea and lake scenes, in which even the water is dry and sparkling—an excellent thing in champagne, but not in marine painting.

The World, 9 June 1886 [C234]

[Engravings and Watercolors]

[*Edmund Caldwell (c. 1855–1930) was a London animal painter who late in his career turned to sculpting animal figures. George H. Every (1837–1910) was a London line and mezzotint engraver who made his reputation with plates of Daumier and Gainsborough. The Ackerman firm had been purveying prints, and paper for engraving and print-making, since 1799, when it opened at 101 Strand as R. Ackerman's Repository of Arts.*

Sir James Linton (1840–1916), President of the Royal Institute of Painters in Watercolors, and Sir John Charles Robinson (1824–1913), Superintendent of the South Kensington Museum School and Keeper of the Queen's Pictures, headed fiefdoms sometimes at rivalry. Sir Arthur Herbert Church, who began exhibiting in 1854, was a London painter of landscapes and still-life.

Henry Campotosto (c. 1840–1910), Belgian painter of rustic genre who established a London atelier in 1870–71, was the brother of Octavia Campotosto, the painter who managed the Paladiense Gallery.]

Mr. E. Caldwell's picture of a puppy ingloriously worrying a fox's brush on a table within doors has been for a long time past in the hands of Mr. G. H. Every, who has engraved it, with his usual softness and delicacy, in mezzotint (with the customary adulterations). The plate is entitled "The First Draw," and is published by Mr. Arthur Ackerman.

❖

The altercation between Sir James Linton and Mr. J. C. Robinson has ended, happily for the public, in a display of priceless treasures in water-colour at the Royal Institute. As there is no possibility of comparing the last state of the pictures with the first, the exhibition settles nothing—not even the right of a free-born British subject to express a doubt of the permanence of water-colours without being summarily lectured by the President of the Royal Institute. The correspondence in the *Times* was excellent fun. Mr. Robinson irritating Sir James; Sir James provoking Professor Church; all three retorting amid a shower of *obiter dicta* from partisans and outsiders; the appeal to the oracle of Brantwood; the response, crushing the *Times*, faintly alluding to the disputants, and implying infinite disparagement of everything and everybody save only Turner's work and Mr. Ruskin's opinion of it: all this is reprinted in the catalogue without the motto, "How these artists love one another!" But as the letters are very amusing to read, and the pictures very delightful to see, the little breeze has blown good to the

world and innocent sport to the Philistines. Sir James Linton can point in triumph to the fact that none of the exhibits are "practically ruined and worn out." Nobody, in truth, expected that they would be, since the President himself had the picking of them. On the other hand, Mr. Robinson may consider it proved that there is a perceptible difference, for better or worse, between new water-colours and old ones.

❖

Madame Paladiense, of New Bond Street, has published "The Dead Lamb," an original engraving, which is interesting as an example of mixed methods, the plate being partly bitten, partly worked upon with the dry point, and partly cut with the burin. The artist-engraver, Mr. Henry Campotosto, has been remarkably successful in combining the advantages and avoiding the defects of the various methods, which supplement one another very satisfactorily.

The World, 30 June 1886 [C239]

Morris on the Aims of Art

[(Sir) William Hamo Thornycroft (1850–1925), R.A., already eminent as a sculptor, was a member of the Art Workers Guild. Thomas James Cobden-Sanderson (1840–1922), bookbinder and printer, operated the Doves Bindery at Hammersmith 1893–1921, and with (Sir) Emery Walker the Doves Press 1900–1916. Sergei Stepniak (1852–95), actually Sergyei Mikhailovich Kravchinsky, an anti-Czar revolutionary who fled to London in 1886, came to public notice the next year via an English translation of his Russia Under the Czars. *Mrs. Annie Besant (1847–1933), Radical orator and writer, was proprietress of* Our Corner, *a splinter socialist monthly to which Shaw contributed.]*

Mr. William Morris succeeded in making an audience forget the election for a couple of hours last night at South Place Chapel, where he lectured to the Fabian Society on the Aims of Art. The poet was in his best vein when he described the exquisite pleasure his first glimpses of Rouen and Oxford gave him—a pleasure, he added, that no man will ever enjoy again. He subsequently remarked, with great heartiness, that the dons of Oxford were about as well qualified to take charge of ancient monuments as a parcel of cheesemongers. Mr. Walter Crane was in the chair; and Mr. Hamo Thornycroft, Mr. [Thomas]

Cobden-Sanderson, Stepniak, Mrs. [Annie] Besant, and some of the Fabians struck up a lively debate, in which not a single allusion was made to Home Rule. One result of the discussion was to elicit from Mr. Morris, besides the "cheesemongers" comparison, a definite statement of view of machinery, the limits of his hostility to which have, it appears, been imperfectly apprehended.

Pall Mall Gazette, 3 July 1886 [C240]

[Bouguereau and Turner]

[The mythological and religious canvases of William Bouguereau (1825–1905) reached an illusionistic perfection and a mawkish eroticism much admired in his day, but his flesh tones now seem to be lifeless waxwork, and his fashionable subjects an accumulation of platitudes.]

Messrs. Boussod, Valadon & Co. have brought over some two dozen pictures from the last Salon to the Goupil Gallery. This puts us in a much better position than the Parisians as regards contemporary French art. They have to wade through the whole Salon to see these pictures. We get them unencumbered. But cannot someone hire a room—a small one will suffice—for the good things of the Academy, and spare us the weary pilgrimage which leaves us, like the king mastering the alphabet, in doubt whether it is worth while to go through so much to gain so little? The pictures at the Goupil Gallery profit greatly by their comparative isolation. "Spring," the inevitable masterpiece of ivory nakedness by M. Bouguereau, is more interesting and not less beautiful than its many forerunners.

The Nineteenth Century Arts Society have reinforced their exhibition by Turner's "Blowing up of the Orient at the Battle of the Nile." It is an eighteenth-century Turner, but a very fine one. The still depths and green shadows in the foreground, with here and there a stray swimmer or boat stealing peacefully round the great wooden walls of the three-deckers, are so out of keeping with the noise and glare of battle, that the exploding ships and flaming forts look like some gorgeous natural phenomenon, and the few visible spectators seem to be contemplatively inquiring why the nations should furiously rage together, and the people imagine a vain thing.

The World, 21 July 1886 [C242]

The Reynolds of the North

[William Raeburn St. Clair Andrew, lawyer and writer, was the great-grandson of the Scottish portrait painter Sir Henry Raeburn (1756–1823).]

Mr. Raeburn Andrew has had to make bricks with very little straw in compiling a biography of his great-grandfather, "the Reynolds of the North." Raeburn came from the hands of nature a ready-made portrait painter. He took his place at the head of his profession without a struggle; he married a rich widow, who seems to have been a very good wife to him; and thereafter occupied a distinguished position in Edinburgh society until his death. It was his happiness to leave no history except the catalog of his works. Probably so able a man could have told something worth knowing about his development as an artist and his experiences as he viewed them from the inside. From the outside, however, they were conventional, and there is no more to be learned about him now than is set forth in this modest and businesslike memoir, which can be read easily at a single sitting. As an artist he is not likely to be forgotten in these islands while his Scotch sitters, from Sir Walter Scott downward, are remembered. Some of them will be remembered for his sake, and remembered more favorably in point of personal dignity than they perhaps deserve; for Raeburn never allowed his patrons to look mean on canvas. That was at least one reason for his great popularity as a portrait painter. He was a quick workman. An exhibition of his pictures was held at Edinburgh in 1876, and though it was necessarily incomplete, the catalog gives particulars of 325 works from his hand.

Pall Mall Gazette, 23 September 1886 [C257]

[Frederick Leighton's Fresco "The Arts of Peace"]

The accomplished President of the Royal Academy has at last unveiled his fresco, "The Arts of Peace," at the South Kensington Museum. After many years spent amid an industrial system which, stained as it is with the blood and sweat of innumerable slaves, is still stupendous and full of promise to the free worker of the future, Sir Frederick Leighton has come to the conclusion that the only essential arts of peace are the arts of the toilet as practiced by rich ladies. This is

his way of expressing that the Arts of Peace are mere vanity. The pessimism of the nineteenth century philosopher and the devotion of the knightly artist to women and beautiful dresses could not be more delicately reconciled in one work.

Freedom, October 1886 [C258]

[New Pictures in Old Bond Street]

[Mihaly von Munkacsy (1846–1900) was a Hungarian who became famous for dramatic paintings of secular and religious "moments in history," particularly his Christ Before Pilate *(1881). Constant Troyon (1810–65) was a French landscape and animal painter; Jules Bastien-Lepage (1848–84) painted French rural scenes and society portraits. Sarah Bernhardt (1844–1923), one of his subjects, was the French tragedienne, born Rosine Bernard. William Mulready (1786–1863), Irish-born London genre painter in the Dutch tradition, was elected RA in 1816. Queen Victoria was one of his purchasers.*

Raphael Sanzio (1483–1520), Italian master, is seldom referred to by his surname. Carlo Maratti (1625–1713), Roman painter, was a leader of the Baroque style.]

Among the first signs of renewed life in Bond Street is the opening of the Hanover Gallery. Messrs. Hollender and Cremetti have, as usual, brought together a miscellaneous lot of pictures, not quite new and not too old, by foreign painters. There is no Meissonier this time; but Corot, Daubigny, Munkacsy, Troyon, Andreotti, and others, whose names these will suggest, are represented. M. J. Tissot's "Little Blonde," and the Bastien Lepage portrait of Sarah Bernhardt, with its vaunted cut-steel frame, are part of the exhibition. A couple of pictures of street arabs remind you of [William] Mulready; and when you turn to the catalogue, there, sure enough, though the pictures are new, is the name of the painter of "The Lion and the Lamb." The easels that usually do honour to Meissonier are occupied by pictures that could be quite worthily accommodated on the wall.

❖

Messrs. Winch & Co. of Old Bond Street are exhibiting what they call "A replica (or old copy) of the Sistine Madonna by Raphael." It is smaller than the original, and is most certainly not a replica, though it

is an old copy by a painter of considerable ability—perhaps as good as Carlo Maratti, or thereabout. He took it upon himself to correct the squint in the eyes of the Child, and had he been a wise man, he would have uncorrected it again on seeing the very tame result. The picture has enough of the sweetness and glow of the original to please unsophisticated visitors. The sophisticated will find it interesting in two or three points. At the lowest estimate, it is a noteworthy "find."

The World, 13 October 1886 [C260]

[Van Beers and Other Forgeries]

[The popular and successful William Mulready died in 1863; there were other painting Mulreadys, however, including Augustus E., genre painter and member of the Cranbrook Colony of artists, who—although there had been an erroneous report of his death in 1886—died in 1905.

Wackford Squeers was the brutal and incompetent master of a Yorkshire boarding school in Dickens's Nicholas Nickleby. *The "white feather" was a symbol of cowardice.*

Jan Van Beers (1852–1927), Belgian painter of shockers, was popular enough to be forged. According to The World, *6 February 1889, he "brought an action against a certain picture-dealer, M. Roland Beaudoin, for having sold bogus examples of Van Beers bearing his counterfeited signature. Beaudoin's reply was to produce in evidence several old pupils of Van Beers who had quarreled with him and who, to the astonishment of all, declared that it was the painter himself who, to make a market, attached his signature to paintings which he had not painted. M. Jan Van Beers, indignantly denying this, caused the matter to be pursued before a tribunal at Antwerp which, after a prolonged investigation, sustained the artist in his original action, and pronounced against Beaudoin. . . ."]*

M. Jan Van Beers is in the field again, at the Salon Parísíen, with corpses, nightmares, skeletons, peepholes, dark closets, and other devices for making British flesh creep. At the climax of the entertainment you are confronted with a notice warning you to go no further unless you are a "strong-nerved person." A commissionaire stands by to note the effect. Naturally you are not going to show the white feather before a commissionaire; so you boldly enter a sort of valley of the shadow of

death, at the end of which the king of terrors holds up a mirror, inscribed "Ecco Homo." As you advance, doubtful as to the intentions of the grisly figure, your funeral knell tolls, and a green light flashes on your face, which instantly appears reflected beneath the legend on the mirror. Unfortunately the disparaging grin which a grown-up nineteenth-century man wears when he deliberately enacts a piece of tomfoolery, robs the green light of its horrors; and you return to the light of day, with your nerves none the worse, to amuse yourself by helping the commissionaire to terrify the later comers. When this palls, you stumble about in the dark in search of the excessively inconvenient peepholes, through which you can obtain precarious glimpses of decapitated persons, "steepled in their goar," like Mr. Squeers.

❖

If the childishness of the exhibition were the natural outcome of the painter's qualities, an indulgent laugh would serve all the purposes of criticism. But M. Van Beers is no incapable: he is a man of exceptional talent, who has taken the measure of the average West End sightseer, and has set to work to fool him to the top of his bent, because it pays better to be a first-class charlatan than a second-rate Academician. At the same time, it cannot be denied that he has provided a fair shillingsworth for lovers of art, including those who absolutely refuse to look through peepholes. His own works range from a very clever and even impressive "People's Gratitude" down to audaciously worthless zanies in red and green; and he has pictures by other hands to suit romanticists and sensationalists of all grades of judgment. As for the classicists, they had better stay away; they will find nothing to please them at 160 New Bond Street.

❖

The following sentence occurred here last week in a comment on the Hanover Gallery Exhibition: "A couple of street arabs remind you of Mulready; and when you turn to the catalogue, there, sure enough, though the pictures are new, is the name of the painter of the 'Lion and the Lamb.'" Messrs. Hollender & Cremetti write to me pointing out that I may be supposed to have meant that the pictures are forgeries. There was no such stuff in my thoughts; but the passage, read by the new light of Messrs. Hollender & Cremetti's letter, certainly looks ambiguous. It was intended to convey that there was a new Mulready in the field, working on the lines of the old one. As the pictures are signed "A. E. Mulready," and dated 1886, no suspicion of an attempted deception could possibly have suggested itself to me. Hence, indeed, my incautious phrasing, for which Messrs. Hollender & Cremetti will,

perhaps, the more readily excuse me, as they have themselves fallen into a slight inadvertence in the matter at page 21, No. 73, in their printed catalogue.

The World, 20 October 1886 [C261]

[Drawings and Watercolors]

[Heinrich Hofmann (1824–1911) and Robert Beyschlag (1838–1903) were German painters; Jacques Callot (1592–1635) was a French art- ist and etcher famous for his crowd scenes with grotesque figures.

Robert Fulleylove (1847–1908) was a Leicester watercolorist and book illustrator who painted views of Greece, Italy, and the Holy Land as well as English genre scenes. Frederick Wedmore (1844– 1921) was an art critic and essayist whom Whistler considered a stodgy conservative.]

Messrs. Sampson Low & Co. have issued two sets of drawings: one representing "Scenes from the Life of our Saviour," by Herr H. Hofmann, Director of the Royal Academy of Dresden; the other enti- tled "Female Costume Pictures," by Robert Beyschlag. The Beyschlag series, twelve reproductions in photogravure of pastel-work, are of little artistic account, being merely sketches of young ladies with mon- strously fine eyes, effectively dressed in obsolete fashions. Herr Hof- mann's drawings are of a different order. Their academic sobriety and purity of taste are made interesting by a grace and artistic fancy that academies cannot guarantee. In the "Suffer Little Children" the kindly smile on the face of the chief figure will perhaps strike the Puritans as a blasphemous innovation. But the charm of the picture is undeniable. Herr Hofmann is never severe in his treatment: indeed, in the Nativity plate, the soft radiance on the face of the sleeping Virgin is almost too pretty. It is a relief to find a modern set of Scriptural pictures in black and white absolutely untainted by the spirit of Callot's "Horrors of War" and "The Dore Bible."

❖

The Fine Art Society opened its rooms yesterday with an exhibition of water-colour sketches, made by Mr. John Fulleylove in "Petrarch's coun- try." Mr. Fulleylove displays an extremely catholic taste in weather, time of day, and scenery; his drawings have all the variety of an actual season

spent in the open air. The worst of them are acceptable and effective: the best are masterly. "Petrarch's country" means, of course, not Tuscany, but the Rhone country—Avignon, Arles, Nimes, and thereabouts. Mr. Frederick Wedmore, in a preface to the catalogue, helps undecided visitors to an opinion of the exhibition.

The World, 27 October 1886 [C262]

[Millais, Moreau, and Others]

[Shakespeare's Portia, heroine of The Merchant of Venice, *was an oft-characterized figure. Georg Wilhelm Bauernfeind was a mid-eighteenth-century German painter; Ludwig Deutsch (1855–?) was a young contemporary German painter. Georges Croegaert (1848–1923) was a Belgian genre painter.*

*L. Block, London painter of still-lifes, exhibited from the 1870s into the 1890s. Lucan was the Roman poet Marcus Annaeus Lucannus (*A.D.* 39–65). Philip F. Walker, who exhibited in the 1880s and 1890s, painted harbor scenes and shipping; Wilfred H. Thompson, whose work was shown in the same decades, was a genre and landscape painter with a Hampstead studio. Robert Little (1854–1944) was a landscape and portrait painter with a Pre-Raphaelite bent.*

The oft-illustrated Fables *of Jean de la Fontaine (1621–95) were first translated into English verse in 1734, forty years after publication of the last of the 240 poems. Eugene Delacroix (1798–1863) painted dramatic scenes in vivid colors and was considered an art rebel. Richard Doyle (1824–83) was an eminent caricaturist and book illustrator, son of illustrator John Doyle (1797–1868).]*

The picture-galleries are opening in all directions. In the Haymarket, Messrs. Arthur Tooth & Sons have a very handsome show; but it is surpassed in average quality by that of their next-door neighbour, Mr. Thomas McLean, whose collection is crowned by a magnificent portrait of somebody dressed as Portia, with golden hair and crimson robe, by Sir John Millais. "The Birthday Gift," No. 8, is an excessively clever little picture by M. Van Beers; and G. Bauernfeind's gate of the Temple of Jerusalem, with its Moslem sentinels watching a group of Jews who look wistfully at the forbidden threshold, is an important work of that able and thorough painter. The chief attraction at Messrs. Tooth's is M. Meissonier's "Voyageur," a mounted soldier, who, under a cold gray

sky, with the last brown leaves of the year flying about him in the wind, is making his way wearily along a road much the worse for recent artillery operations. Hard by is a picture by L. Deutsch, "Calling to Prayer," in which the caller, minutely finished to the very grime under his fingernails, reminds one of the Meissonier of "The Flute Player." The Highlander who described the first donkey he had ever seen as "a muckle hare" probably came across the identical puss at which the artist in G. Croegaert's "Interrupted" is about to shoot. It is at least as large as a sheep.

❖

At the exhibition of the Nineteenth Century Art Society the artistic standard, like the tariff, is modest, the average price of a picture there being about eleven guineas. A water-colour by Mr. L. Block, representing with extraordinary fidelity an old edition of Lucan open at the title-page, with a few other objects, is decidedly the most complete achievement in the gallery. The frightened horses in M. Sanguinetti's "Burnt Out" are better than his swaggering runaway postchaise at the last exhibition; and Mr. William Padgett's work again makes a very distinct impression. Mr. Philip F. Walker's "Traveller's last Resting-Place," a water-logged barge in a stagnant corner, with reeds, weeds, and swans, is good. "Punch," by Mr. Wilfred H. Thompson, is very nearly successful. Miss Alice Miller's "Work" is not bad; but the rest of her contributions seem hasty and superficial. Mr. R. Little's picture of a person in heaven after a troublesome life will hit its mark with people of a mystical turn.

❖

At the Goupil Gallery, Messrs. Boussod, Valadon, & Co. have an exceptionally interesting exhibition of sixty-four water-colour drawings, made by M. Gustave Moreau to illustrate La Fontaine's Fables. Lovers of literature who have been soured and hardened against artists by the exasperating brainlessness of the common sort of illustrations to the works of great authors, need not fear the work of M. Moreau. This La Fontaine series entitles him to rank with Delacroix or Mr. Burne Jones as illustrator. He is not a consummate draughtsman, or an exceptionally dexterous manipulator of the brush—not a Leighton or a Bouguereau, for example; but he has the insight of a poet, and the true painter's faculty of mixing his colours with imagination. He uses the palette as a good composer uses the orchestra. The illustrations have humour; but they are not comic; M. Moreau does not treat his author as [Richard] Doyle would have treated him. An idea of the painter's range may be gathered from an examination of three such different

pictures as "The Two Pigeons," which is pathetic; "The Cock and the Pearl," which contains a capital pictorial study of character; and "The Man and the Adder," which has the force, breadth, and seriousness of a Rembrandt.

The World, 3 November 1886 [C263]

[Unfashionable Exhibitions]

[Founded as a memorial to philanthropist John Kyrle (1637–1724) to improve the living conditions of working people by encouraging home decoration, window gardening, and park landscaping, the society sponsored exhibits in poor districts. Shaw, often impatient with the inefficient do-gooding of its volunteers, nevertheless gave his review copies of books for sale to support the society's "bringing beauty to the people." The exhibit at 72 Cromwell Road was of work by the Society's painters and decorators; the Society's offices were at Nottingham Place.

Joshua Dixon, M.D. (?–1885) had collected pictures at Winslade Park, near Exeter. His oils, watercolors, engravings, enamel pictures, and sculptures were bequeathed to the Bethnal Green Museum in the East End, where 274 items in the collection were exhibited in 1886. A series of articles on the bequest by Walter Shaw Sparrow appeared in The Magazine of Art *in 1892; the catalogue of the exhibition itself went into a third edition by 1892. The museum, a branch of the Department of Science and Art of the London Council on Education, in time (1974) became a museum of artifacts of childhood, and a branch of the Victoria and Albert Museum, which now holds the Dixon collection in its South Kensington building.*

The professor was portraitist Sir William Blake Richmond (1843–1921), Slade Professor of Art at Oxford 1878–1883; Henry Austin Dobson (1840–1921), poet and man of letters, needed the financial security of a Board of Trade clerkship from 1856 to 1901.]

There were two picture-shows last week, one in the far east and the other in the far west: both for the benefit of unfashionable people. The Kyrle Society's little exhibition at Cromwell Road will, be it hoped, draw the attention of our clever amateurs to the fact that there are vastly populous tracts of London where they will not be regarded as nuisances—where, on the contrary, their brushes, voices, and pens are

in great demand. For the key of these uncritical regions apply at 14 Nottingham Place, W.

❖

From Cromwell Road to Bethnal Green is a far cry; but it was cried on Wednesday last by some who wished to see the Dixon collection at the Bethnal Green Museum. An evening paper recommends the authorities to reject the bequest as not worth house-room. But that evening paper evidently does not know good water-colour work when it sees it, whereas the late Joshua Dixon evidently did. There is an ebonished screen, fitted with six Japanese panels, the rejection of which would justify a revolution. As to the oil-pictures and engravings, some of them are commonplace, no doubt, and will perhaps be raffled among the East Enders some day, for the benefit of the Science and Art Department; but at present they are needed to brighten the place.

❖

English Art in the Public Galleries of London is a very handsome publication indeed, enlivened by monographs by Professor Richmond, Mr. Austin Dobson, and others. The illustrations, in photogravure, reproduce the touch of the originals as no engraving could. The relative values of the colours are occasionally upset, of course: photographic processes have their drawbacks; but it must be admitted, in the face of such work as this, that for reproductive purposes no other processes can compete with them. Messrs. Boussod, Valadon, & Co. are the publishers.

The World, 17 November 1886 [C267]

[Black and White]

[J. P. Mendoza was proprietor of the St. James's Gallery. Hugh Thomson (1860–1920) was a watercolorist and book illustrator; Randolph Caldecott (1846–86), illustrator of famous reprints of Washington Irving's fiction, was also a watercolorist and sculptor in terra-cotta and bronze. A transplanted Philadelphia Quaker, Joseph Pennell (1857–1926) was a London-based etcher and book illustrator. Napier Hemy, actually

Charles Napier (1841–1917), was a watercolorist of landscapes and seascapes; Alice Mary Havers (1850–90), genre painter and landscapist, sometimes known as Mrs. Frederick Morgan, exhibited at the Paris Salon and was considered one of the most accomplished women artists of her time. William Biscombe Gardner (1847–1919) was an engraver and landscape painter.]

Mr. J. P. Mendoza's fourth black-and-white exhibition is now open at the St. James's Gallery in King Street. It contains good specimens of all sorts of work with ink, blacklead, tint and tone, from Dante Rossetti's and Mr. Alma Tadema's to Mr. Caton Woodville's and Mr. F. Barnard's. Mr. Hugh Thomson exploits the vein discovered by Mr. Randolph Caldecott; and Mr. Dollman has added a second and third set to his tragedy of the runaway dog, besides sending a new study of crows, entitled "Don't Care was Hanged." There are drawings, old and new, by Mr. Jo Pennell, Mr. Napier Hemy, Miss Alice Havers, Mr. Macbeth, Mr. C. W. Wyllie, Mr. Hubert Herkomer, Mr. Biscombe Gardner, and other experts.

The World, 24 November 1886 [C270]

[Copley Fielding]

[Anthony Vandyke Copley Fielding (1787–1855), a marine and landscape painter in both watercolor and oils, was a fashionable depicter of Scottish, Welsh, and English scenes, admired by John Ruskin.]

Messrs. J. and W. Vokins have borrowed some six dozen examples of the work of Copley Fielding; and those who delight in the old watercolour school may study him, as they have already had an opportunity of studying De Wint, at the gallery in Great Portland Street. A complete collection of Copley Fielding's works would be a monstrosity—they would overflow Oxford Street. But enough can be seen at Messrs. Vokins' to show how truly the phrase "master of the brush" applies to the painter. The colours, except in three or four cases, seem unchanged by time. No. 11, a scene on the shore at Scarborough, contains some of the most exquisite work in the collection.

The World, 1 December 1886 [C271]

In the Picture Galleries

[Lady Colin Campbell (1858–1911), born Gertrude Elizabeth Blood in County Clare, was a statuesque beauty who married the son of the Duke of Argyll in 1881 and was judicially separated from him in 1884 after a notorious trial that beclouded both their reputations. She made her living in London as a journalist, writing as "Vera Tsaritsyn." As "Vera" she would succeed Shaw on The World *as art critic.*

There were two painters who signed themselves William Stott—the reason why the artist from Oldham often hyphenated his names and added his location to them. William-Stott of Oldham (1857–1900) was a landscape and figure painter influenced by Whistler and the early Impressionists. Alexander Hugh Fisher (1867–1945) had just begun exhibiting; the new show may have been his first London exhibition. Alice Bolingbroke Woodward (?–1900) painted figurative subjects and landscapes. The versatile George Percy Jacomb Hood (1857–1929), who often hyphenated his names, was portraitist, landscapist, genre painter, etcher, and sculptor. Thomas Millie Dow (1848–1919) was a Glasgow painter of landscape and genre influenced by Carolus Duran and Gérôme, with whom he had studied. Albert (Anthony) Ludovici, Jr. (1852–1932), was an early Impressionist much influenced by Whistler; he lived mostly in Paris.

"Wally" (Wilhelmina Walburga) Moes (1856–1918) was an Amsterdam painter of genre scenes who also exhibited in Paris and Düsseldorf. Henry Gillard Glindoni, who exhibited in London through 1893, was a prolific painter of anecdotal pictures and genre, with six pictures in the 1886 show. Jessica Hayllar (1858–1940) painted domestic scenes, children, and flowers; Harold Sutton Palmer (1854–1933) was a Surrey landscape painter and watercolorist. Norman E. Tayler (1843–1915) painted genre and flowers; Edward Duncan (1803–82) was a London marine painter and watercolorist. William Harding Collingwood Smith (1848–1922), painter of genre and historical subjects, was also a well-known collector of antiquities. Paul Jacob Naftel (1817–91) was a Guernsey landscape painter who became a London drawing master in 1870. Charles Gregory (1850–1920) exhibited historical and genre pictures in London in both oils and watercolors.

Henry Stacy Marks (1829–98), a London genre painter and watercolorist in the St. John's Wood circle, often used literary or historical subjects; later he became most successful as an animal and bird painter. Sir William Harcourt (1827–1904) was the Liberal statesman who during his early career wrote for the Saturday Review *and*

(as "Historicus") for The Times. *George Henry Andrews (1816–98) was a London landscape painter and watercolorist.*

Alnaschar is the Barber's brother, who appears in the 177th night of The Arabian Nights. *"My brother," says the Barber, "by misfortune gave such a push to his basket and crockery that they were thrown into the street and broken into a thousand pieces."]*

There has recently been much opening of winter exhibitions. The [Royal] Institute, with a display of eight hundred and seven works, proves that we have among us some twenty-five score ladies and gentlemen who will be in a position to paint pictures as soon as the necessary subjects occur to them. For the present they are occupied in producing canvases which, however conclusive one way or the other as specimens of handiwork, are inexpressibly inane to people who regard manual skill as only a means to an end. The President falls back on Sir Walter Scott for a theme. Mr. Henry J. Stock perseveres at allegory, but his naked young man, undignified, topheavy, frightened, miserable, and running away with his wings between his legs from a patriarch whose pocket he seems to have been picking, cannot for a moment be accepted as representative of "Love driven out by the World." Mr. Stock will not be Mr. Watts's successor at this rate. Mr. Alexander Fisher, by the way, has taken Mr. Watts's beautiful Diana of the "Diana and Endymion," hung her up vertically in a sky, and so contrived a capital little picture, which he calls "Selene, the Moon Goddess." Miss Evelyn Pickering also sends a "Luna," who, enviously watching from her heavenly seat the rope trick as performed at our street-corners, has tied herself up with magenta curtain cord, but has failed to get loose within the specified time. The same artist's "Sea Maidens" are five mermaids standing in a row, waist-deep in the sea, facing the spectator. One of them wears a fringe; all have the sunniest and driest hair; and they twine their arms about one another's shoulders—a mode of endearment that could never arise among an habitually wet race. The workmanship in these two pictures is of the highest quality: there is nothing else in the gallery so good of that kind. But the excess of curtain rope in the one and the artless composition of the other stick in one's enjoyment of them like flies in ointment. . . .

The Society of British Artists, though this time it is supposed to have raised its standard, and discarded all respect of persons, has, after all, taken very much what it could get. Mr. Whistler's opinion that it is better to succeed in achieving a part than fail in attempting the whole, has influenced many of the exhibitors: the rest have filled up the interspaces with well-varnished commercial furniture pictures, which would hold their own in the handsomest shop-window in Tottenham Court road. At

the end of the large room a face in bright sunlight, backed by fresh green foliage, is recognizable at first sight as the work of Mr. G. Clausen. Hung next to it is Mr. Whistler's "Harmony in Red"—not the delicate red of the rose, nor the magnificent crimson of a royal mantle, nor the stimulating vermilion of the postal-pillar; but a kitchen-flags or linoleum sort of red that does indeed harmonize with the foggy blackness in the dim lamp-light. The President's other contributions are a portrait of Lady Colin Campbell, which, being unfinished, has no business in the gallery; a fine "Nocturne in brown and gold: St. Mark's, Venice," a survival from the attack of the blue-and-opal pastel which the painter suffered last spring; and an "arrangement in black," of which one may (if naturally reverent) speak with perfect respect. Mr. William-Stott of Oldham, as the catalog insists on calling him, has painted some very naked sands, and some very naked boys bathing; and it is apparent that the artist did not take the slightest interest in the boys, or in the sands, or in the sea, except as far as they had the making of a striking picture in them. Mr. J. J. Shannon emulates Wright of Derby with indifferent success in his study of two boys stooping over a candle in a turnip ghost. There is a capital little portrait by Miss Alice B. Woodward, and a capital big one by Mr. Jacomb Hood; both of ladies in black. Mr. T. M. Dow's bird's-eye view of the Hudson river has a mildewed appearance; and the broad dull frame, with an old paper number imperfectly scraped off, gives it a neglected air. Mr. A. Ludovici junior has painted a ballet-dancer so cleverly that those who enter the saloon bear down on it, not doubting that it is by Mr. Whistler himself, and a very characteristic work too. Except that a light like that of a single tallow candle is substituted for the usual limelight, the picture is quite worthy of its subject. Two works by Miss Wally Moes appear to greater advantage in Suffolk Street than they would were the British artists as good as the Dutch artists. Mr. Sidney Starr sends nothing so interesting as his "Paddington Station" at the last exhibition; nor is there anything novel in the contributions of Mr. Yglesias, Mr. Glindoni, and other habitual exhibitors. Mr. William Padgett's "Camp Fire" and Miss Jessica Hayllar's "Apple Blossom" deserve favorable note; and the new yellow velarium, hung presumably by Mr. Whistler's direction, deserves reprobation. It was very well at Messrs. Dowdeswell's at midsummer; but on Friday last a mild-fog; the light it cut off could ill be spared.

Mention of Messrs. Dowdeswell's reminds me of their collection of water-color drawings by Mr. Sutton Palmer, which have drawn from Mr. Ruskin a declaration that they are "entirely praiseworthy and in a kind which needs no praise from me, except the attestation that every scene is absolutely true to scale and form." Now, adverbs like "entirely" and "absolutely" are not for such as I to venture upon; but I can say

without the slightest reserve that one might give all the pictures at the Institute and the British Artists'—about 1300 all told—for the six dozen at Messrs. Dowdeswell's, and consider the bargain an uncommonly good one. I am not sure that I would not throw in a dozen of the best Copley Fieldings at Messrs. Vokins's as a makeweight. For Mr. Sutton Palmer is no mere clever trickster who has found out the knack of imitating this or that on paper, but a master of his art, with a pure taste, an exacting conscience, and a great knowledge of the aspects of Nature.

There is not much to be said of the Royal Society of Painters in Water-Colors this season. As at the other societies, the ablest members have sent either nothing, or nothing remarkable. With Mr. Birket Foster, the Messrs. Fripp, Sir John Gilbert, Mr. Heywood Hardy, Mr. Arthur Hopkins, Miss Clara Montalba, Messrs. Norman Tayler, Duncan, Collingwood Smith, Thorne Waite, Carl Haag, and the rest, it is a case of old stories retold. Mr. Herbert Marshall has given up London scenery for the nonce, and taken to the Netherlands. Mr. Albert Goodwin has taken to incompleteness, and is advancing rapidly in that direction. Mr. Paul Naftel's work is very remarkable, but he uses body color in a tricky way, and repeats himself remorselessly. Mr. C. Gregory is also prominent; and Mr. Holman Hunt sends, among other things, a little black-and-white design entitled "Will o' the Wisp," ugly, but extraordinarily real and forcible. The grotesque birds in Mr. Stacy Marks's pictures are as irrelevant as the red lions in Sir William Harcourt's story, and are introduced for exactly the same reason. Mr. Charles Robertson deals elaborately with the inexhaustible incident of Alnaschar's broken crockery. Mr. Du Maurier sends, as usual, a couple of drawings which have been already engraved and published. Finally, the treasurer, Mr. George H. Andrews, exhibits a large sketch for a picture of the defeat of the Armada, and accompanies it with one of the curious pamphlets, full of out-of-the-way and interesting information, which he occasionally puts forth.

The World, 8 December 1886 [C272]

[Watercolors and Pastels]

[George Vicat Cole (1833–93), popular landscape painter, was best known for his views of the Thames; his The Pool of London *is in the Tate Gallery. Jules Lessore (1849–92) was a French watercolorist who had settled in England. Arthur Douglas Peppercorn (1847–1924) was*

a landscape painter in oils and watercolor often called "our English Corot." Henry Muhrman (1835?–90) was a London painter of landscapes and figurative subjects; William Ayerst Ingram (1855–1913) was a much-traveled landscape painter who in 1888 would become President of the Royal British Colonial Society of Artists.]

Messrs. Hogarth, in their new premises in Oxford Street, W., have Mr. Vicat Cole's "Summer Rain" to show to those who wish to see it again. Some fine water-colour work and a curious early picture, by Turner, add considerably to the attraction.

❖

The series of water-colour sketches by M. Jules Lessore, which Messrs. Buck & Reid are exhibiting at 179 New Bond Street, are clever, but inferior to good English work in the same medium, being full of untameable reds and greens, mostly introduced under pretext of roofs and barges. The pastels by Messrs. Peppercorn & Muhrman are more interesting, as the trick of them has not yet become common. At the Goupil Gallery M. Moreau's La Fontaine pictures have given place to a collection of sketches made at sea during two years' voyaging by Mr. Ayerst Ingram. They are painted with a wet sheet and a flowing palette, and seem quite unstudied in point of composition, as if the painter loved the sea and thought all aspects of it worth painting. The sunny haze in "Crabbers off Hastings" contrasts with the melancholy haunt of the Flying Dutchman in "Off of Cape of Good Hope"; and "The St. Ives Corps of the Salvation Army" is, as a "note" of colour, worthy of Mr. Whistler. A look through Mr. Ingram's work is the next best thing to an actual voyage.

The World 15 December 1886 [C273]

[The Hanover and Burlington Galleries]

[Enrico Crespi was a contemporary Italian painter; there had been two seventeeth-century painters of the same surname. Michel Angelo Merisi (1565?–1609), born at Caravaggio, was known by that name; gloomy and quarrelsome, his paintings reflect that character. Friar Laurence is the tender priest in Romeo *and* Juliet.

Walter Duncan (1845?–93) was a London painter of marine and historical subjects.]

"The proprietors of the Hanover Gallery, in bringing before the English public the celebrated picture, 'A Lesson in Anatomy,' by Signor Enrico Crespi, beg to state that they disclaim any intention of desiring to create a sensation by the exhibition of a work treating with an unquestionably morbid subject." Such are the rebukes which M. van Beers incurs by intending to desire to create a sensation by the exhibition of works treating with unquestionably morbid subjects. Such, too, is English as she is spoke in Hanover. Signor Crespi's picture is child's play in comparison with Rembrandt's great work of the same name; but it is likely to be more popular, being rather sentimental, which Rembrandt's "Lesson" certainly is not. It represents the body of a golden-haired young woman in profile—the easiest position to draw her in, but also, perhaps, the best for the artist's purpose. An elderly anatomist, intent on his scalpel, and indifferent to the pitiful aspect of the dead girl, is making a careful incision. A student looks on with eager curiosity, and with some emotion. The expressions of the two men are admirable; and the scheme of light and shadow reminds one of Caravaggio, although without any of his harshness and obscurity. The subject is made as little repulsive as it is in its nature to be; for the figure on the table is, except in colour, life-like instead of death-like; and it is as reverently and tenderly disposed as if it were Juliet, and the operator Friar Laurence.

❖

At the Burlington Gallery a number of Indian sketches by Mr. Walter Duncan are being exhibited, together with a very hopeful collection of pictures from the Colonies. We have so hackneyed our subjects in the old world that there is no more mystery or majesty left in Nature for us. The glimpses of strange lands, strange beasts, and strange hunters in the works of our Colonial painters are exceedingly refreshing to those who possess what Mr. Wedmore righteously calls a "deplorably profound" knowledge of minor picture shows.

The World, 22 December 1886 [276]

[Art in 1886]

[Shaw's original title was "Art and Music in 1886." The musical paragraphs have been edited out as irrelevant here. Richmond is Sir William Blake Richmond.]

1886 leaves us much where it found us as far as the fine arts are concerned, in spite of the unusual activity of artists of all sorts. One little knot of painters opened a gallery of their own, and announced that they were not, and did not intend to be, as other artists were. And a brilliant little gallery it was, with Mr. Sargent's and Mr. Solomon's cleverness well to the front. Then Mr. Burne-Jones relented towards the Academy, and even condenscended to be made an Associate, showing the Forty at the same time, by "The Depths of the Sea," what a very superior Associate fate had forced upon them. Except for his mermaid, the Academy exhibition was as barren of first-rate work as its worst enemies could have hoped. Mr. Orchardson and Mr. Fildes helped Mr. Alma Tadema to keep up appearances; but their works did not go very far among so many. At the Grosvenor things were better: Mr. Burne-Jones and Mr. Strudwick had good work there; Mr. Phillip Burne-Jones made a modest but promising debut: and Mr. Richmond rained elegant portraits upon Sir Coutts Lindsay. Sir John Millais did not commit himself to anything of importance: a princely pot-boiler or two at the exhibitions in the Haymarket added nothing to the impression made by the great collection of his works at the Grosvenor. At the Institute, and elsewhere, the water-colourists had the best of it. Painters in oil seemed to grow more and more conscious of the patronage of the illustrated papers which issue Christmas numbers; and babies and doggies and pussies have abounded. Indeed, the name of animal painter would be a byeword but for Mr. Briton Rivière and the incorruptible Mr. Nettleship. A tremendous attack, which our readers know all about has been led against the Academy by Mr. Walter Crane and Mr. Holman Hunt; and a rival institution has been projected with mingled threats and promises. Equally heretical, and more lively, have been the exploits of M. Jan Van Beers and Mr. Whistler, highly gifted artists, who take Carlyle's view of the population of these islands, and entertain us according to our folly. The judicious grieve, but Mssrs. Van Beers and Whistler laugh the more. A few of the minor exhibitions at the Goupil Gallery and Messrs. Dowdeswell's have been a solace to the knower at sight of good work; but his chief joy has been in Christie's, where a succession of extraordinary collections came to the hammer, with results that will seem gratifying when the superiority of Phillip to Rubens, Rossetti, Titian, Bellini, Turner, and Constable is more generally admitted. Our taste, it appeared, is for portable property in pictures. The old masters are much too big and a trifle too serious for us just now.

Pall Mall Gazette, 3 January 1887 [C278]

[MacWhirter and Macbeth]

[Leon Richeton in France was Leon Richet (1847–1907); his "Fred Archer" was a portrait of the famous jockey (1857–86). Reginald Winslow (1858–?) was a lawyer and author. Marcus Bourne Huish (1845–1921) was the longtime editor of Art Journal.*]*

Some of Mr. J. MacWhirter's hundred pictures of Scotch scenery at the Fine Art Society, New Bond Street, seem to be no better than the snowy cottages and roads on shilling Christmas cards; others are first-rate pieces of scene-painting in miniature. Trees, water, and moonshine look quite like themselves; and many pretty bits of country-side make the icebound fog from which we have to view them additionally miserable. Round the corner, at the Rembrandt's Head, in Vigo Street, Mr. Dunthorne has an etching by Mr. Macbeth, the subject of which is nothing less than Titian's "Bacchus and Ariadne," which few English people have ever seen, as it is in their National Gallery. The toning of the proof makes it resemble a boxwood block. The plate has been most skilfully etched and carefully printed. Mr. Macbeth has been at a double disadvantage from his own special inaptitude in copying faces accurately, and the utter hopelessness of dealing in black and white with such a masterly piece of colour; but for all that he may be congratulated on having made a remarkable addition to his achievements as an etcher.

❖

I have received Dr. David Law's "Windsor Castle," an etching just published by Messrs. Dowdeswells, which possesses genuine artistic qualities. M. Leon Richeton's etched portrait of Fred Archer is a rapid and clever piece of work; but the expertly rendered silkiness of the tunic seems to have got into the face also. It is published by Messrs. Dickenson of New Bond Street.

❖

The Year's Art for 1887 contains an intelligible and sufficient epitome, by Mr. Reginald Winslow, of the law of copyright in works of art. Specimens of the sort of drawing expected in our Government elementary schools from children in the various standards are also given. These and some other particulars not included in previous issues have further increased the size of this very useful three-shilling volume. It is

compiled by Mr. Marcus Huish, the editor of the *Art Journal,* and published by Messrs. Virtue & Co.

The World, 19 January 1887 [C281]

[The Queen, Larger than Life Size]

[Alexandre Bassano was an Italian society photographer who took many pictures of Victoria and her family over several decades.]

Mr. Bassano has gratified the desire of the Punjab to possess a portrait of its Sovereign, by engaging several artists to enlarge a photo to the handsome dimensions of nine feet by six. The figure is adroitly arranged, and the painting sufficiently skilful; but the camera has been as attentive to the Kohinoor, the lace, the Gothic chair, and the red casket labelled "First Lord of the Treasury," as to the Empress of India; and consequently the crown looks more like a sort of discover-handle, to lift her Majesty by, than it certainly would have looked had the picture been painted by Sir John Millais or Mr. Watts. However, the Punjabees are undeniably right in preferring Mr. Bassano's compilation to a portrait by a second-rate artist. The Institute of Lahore is the destination of this curious and by no means unsuccessful piece of work.

The World, 26 January 1887 [C282]

[Miscellany]

[Barnett Samuel Marks (1827–1916), born in Cardiff, began painting genre and portraits in London in 1867. The first Baron Rothschild in England was Nathaniel Mayer Rothschild (1840–1915), M.P. for Aylesbury 1865–85 and the first professing Jew to enter the House of Lords. Louis Cohen of West Hampstead was a journalist and Fabian Society friend of Shaw.

Rose Barton (1856–1929) was a Dublin-born genre and landscape painter in watercolors. Kate Macaulay, who lived in Wales, and exhibited in London 1872–84, was a Scottish-born painter of coastal scenes. Charles Edward Hern, sometimes spelled Herne (1848–94), a

landscape and architectural painter, taught art to some of the Royal Family. John Griffiths (1837–1918) painted Indian scenes; Robert Malcolm Lloyd, a Sussex landscape painter, exhibited in London 1897–99. Harry Goodwin (c. 1836–1932) was a Maidstone landscape and genre painter who began exhibiting in 1856; Russell Dowson, Eton landscape and marine painter, exhibited in London 1867–96.

Claude Hayes (1852–1922) was a London landscape and portrait painter; Frederick Hines exhibited landscapes in London galleries 1875–97. W. Bingham McGuinness exhibited landscapes in Dublin and London from 1882 through 1929. Walter Severn (1830–1904), largely a watercolorist, was one of the founders of the Dudley Gallery. Walter Rupert Stevens exhibited landscapes in London 1874–91.]

Mr. Frederick Goodall, R.A., has in a manner assaulted public attention by his picture, "For of such is the Kingdom of Heaven," at Messrs. Tooth's in the Haymarket. It represents a man, seated, facing the spectator, with a child standing on his knee. His eyes, which are too large, stare intensely straight forward at you. His expression is eager, but unintelligent; his hair ripples on his forehead like a wig; and his pasty flesh suggests ill-health and bad ventilation. His hands and arms, and the nervous action with which they clutch the child, are those of an anxious working-class woman. The child, too, looks anaemic; but it is excellently modelled, and is the best of the picture. Mr. Goodall is too skilful a painter to fail wholly in an obviously strenuous effort to distinguish himself; but there is neither strength, beauty, nor intelligence in the face which he has surrounded with a halo; and the general effect is one of sensational piety rather than of thoughtful artistic achievement.

❖

The first Jew who took the oath at the table of the House of Lords was Lord Rothschild, who was sworn on the 9th July 1885. A portrait of him as he appeared at that historic moment has been painted by Mr. B. S. Marks, of the Cambrian Academy, for Mr. Louis Cohen, who presents it to the United Synagogue. The odd head-gear and the crimson robe required skilful management on canvas; but Mr. Marks, quite equal to the occasion, has produced at once a successful portrait and an ably-painted picture.

❖

The Dudley Gallery Art Society has at last recognised that the great increase in the number of artists, and the raising of the standard of merit in all departments conquerable by ambition and industry, neces-

sitate the exclusion of much work which would have passed ten years ago as exceptionally good. The result is, fewer pictures at the Egyptian Hall this season, but much better ones. The clever people who used to be called the fair sex have much to do with the excellence of the exhibition. Miss Rose Barton's view of the column in Trafalgar Square, and Miss Gertrude Martineau's nameless picture of toilers in the field at evening, are unconventional as well as sound in the homelier virtues of good work. Miss Kate Macaulay's blottesque touch, excess of parallel lines, and sails that glow with somewhat too fierce an orange, have the qualities of their faults. Mr. C. E. Hern's work attracts by its novel pea-soupy tones and its delicacy; but his largest picture, "Greenwich," is spoiled by the drawing of the waves, which, with their shadows, look more like ridges of broken ground than Thames water ever does, even at Greenwich. The Society having made Mr. John Griffiths, of Bombay, a member, the Prince of Wales has sent some of his work, the Oriental character of which contrasts startlingly with the very British water-colours around. Mr. Malcolm Lloyd follows the Wyllie river-school, wisely, but not as yet too well. Mr. Harry Goodwin's work is distinguishable from that of his brother, Mr. Albert Goodwin, only by occasional crudeness and a forced note of colour here and there, as in the cloak of the woman in "Toil comes in the Morning." Pictures by Mr. Russell Dowson, Mr. Claude Hayes, Mr. Fred Hines, Mr. McGuinness, R.H.A., Mr. Hubert Medlycott, Mr. Walter Severn (the President), Mr. Rupert Stevens, and other members, need not be more particularly described.

The World, 2 February 1887 [C285]

[Mountains and Water]

[Benjamin John Merifield Donne (1831–1928) of London painted landscapes and rustic genre subjects. John Surtees (1817–1915), a Newcastle painter of landscape and genre, lived later in London and Cannes.]

When two exhibitions of sketches of Alpine and Italian scenery are opened on the same day, it is impossible—even if it were desirable—to avoid comparisions. The artists thus accidentally pitted against one another this week are Mr. B.J.M. Donne at Messrs. Dowdeswell's, and Mr. John Surtees at Mr. T. McLean's in the Haymarket. Mr. Donne's work is unequal: one or two sketches being underdone and commonplace; and a few others over done and mannered, so that the mosses

look like plush and the clouds like mildew. But most of them are delicate and fascinating representations of steep crags and misty heights, or of a thread of road winding between clusters of huts in the green valley far below the spectator. Mr. Surtees' sketches are certainly not unequal; and they are not unskilful, as far as they go; they are, however, too rapid and superficial to interest any one whose senses have been previously sharpened on Mr. Donne's subtleties.

❖

Mr. E. H. Fahey's genius for painting expanses of stagnant water doubtless suggested the commission given to him by the Fine Art Society for a series of studies of the Norfolk Broads. Some five dozen sketches, executed in the most straightforward fashion, without body-colour or fugitive pigments, are the result. Of Great Yarmouth Mr. Fahey has made a large picture in oils; but the subject of No. 50, "The Yare at Bramerton Wood End," is, from a purely artistic point of view, more worthy of that distinction.

The World, 9 February 1887 [C287]

[The Nineteenth-Century Art Society and The Goupil Gallery]

[Miss A. S. Manville Fenn was a Chiswick anecdotal painter and member of the Society of Lady Artists; Shaw did not know her and referred to her as Mr. in the review—a mistake corrected here. Walter James Shaw (1851–1933) was a Devonshire painter of coastal scenes and landscapes; Henry Scott Tuke (1858–1929) was a Cornish genre and marine painter whose canvases of naked boys often alarmed Victorian gallery goers. Charles Jones (1836–92) was a Welsh-born London animal and landscape painter; Alfred Vevier de Poncy, a London and Balham genre and landscape painter, exhibited 1870–90. Elizabeth Stone (Mrs. William) Lawson, London painter of figure subjects and flowers, exhibited 1852–88.

Herbertian appears to suggest John Rogers Herbert (see [C207]), whose historical and biblical scenes had an Italianate quality. Gaetano Cherici (1838–1921) was an Italian genre painter; José Benlliure y Gil (1855–1919) was a Spanish genre painter then enjoying wide commer-

cial success. Giovanni Battista Quadrone (1844–98) and Benjamin Eugène Fichel (1826–95) were Italian and French genre painters.]

At the spring exhibition of the Nineteenth Century Art Society the water-colourists have much the best of the show, which contains several reminders of the Dudley Gallery. There is much very raw work in oils, as, indeed, there should be; for the Conduit Street gallery is indispensable for the encouragement of tyros; and a visit is often an act of wisdom and generosity as much as—perhaps rather than—a pleasure. Odd imitations of popular painters abound, and are kept fresh by a saving salt of minor works by skilled hands. Mr. Walter J. Shaw's study of waves, made at Salcombe during the gale of the 8th December last, is good; and there is some fancy, skill, and delicacy of touch in Mr. H. S. Tuke's "Taking a Spell," a name which is to be taken as sarcastic; for the sailor hero of the piece is neglecting his spell by taking a nap. Miss Manville Fenn's impossibly blue-eyed girl, "Left Alone," and wistfully looking out of a doorway, deserves the attention of spectators in Christmas numbers and chromolithography. Mr. Charles Jones's "Gray Day" is stale and airless: it might have been called a drab day. Mr. A. V. Poncy's "Toil and Rest" is worth looking at, as one does not see such a horse twice in a lifetime. Mr. Sanguinetti is tamer than usual in his picture of a lovelorn maiden, the action of whose arm, by the bye, is hardly expressive of the emotion suggested by the quotation in the catalogue. In the corner is the welcome group of roses by Mrs. E. S. Lawson, without which no gallery would look properly furnished.

❖

The French gentleman whose pictures are at the Goupil Gallery is emphatically a collector who knows what he is about. Now that Gérôme's style is becoming comparatively Herbertian, it revives one's waning faith to see such a splendid reminder of his technical power as the "Master of the Harem." Chierici's "La Polenta," representing a whole Italian household in ecstasies at the great squab of yellow porridge turned out of the saucepan, is quite an outrageous success of its kind. Benlliure's distracting brilliancy is redeemed in "Christmas Eve— Church of Alcira" by the variety, truth, and humour of the choirboys. Quadrone's "Amusing Story" is a gem of its kind; and Fichel's "Young Clerk" is an excellent and discreet little picture. All these excessively clever painters have been caught by the collector in the happy and unfortunately rare moments when they hit on a subject worth painting, and so produced something more for our entertainment than mere examples of their own dexterity.

The World, 16 February 1887 [C288]

[Mr. Fahey's Modesty]

[Sir Francis Legatt Chantrey (1781–1841), English sculptor, left the bulk of his £150,000 estate to the Royal Academy for the continuing purchase of contemporary British art, a collection still added to and housed in the Tate Gallery.]

Mr. Edward H. Fahey writes to say that his picture of Great Yarmouth, now at the Fine Art Society among his sketches of the Norfolk Broads, was in the Academy last year, and that it was *not* purchased under the Chantrey Bequest. And to forestall the obvious retort that nobody said it was, he convicts me of having published such a statement in May last. Since the story was incorrect, I am sorry I let it pass without question; but I deny that it was improbable enough to raise suspicion, though Mr. Fahey's modesty leads him to differ from me on this point.

The World, 23 February 1887 [C290]

[Campotosto, Alken, and Haig]

[One detects irony in Shaw's comments about the courage involved in hanging Henry Campotosto's work, since he knew that the Paladiense Gallery was managed by Campotosto's sister, Octavia. Henry Alken (1785–1851) and his son were painters of sporting scenes in watercolors, made popular through prints and engravings. John Leech (1817–64) was a witty critic of Victorian life in illustrations and caricatures. Axel Herman Haig (1835–1921), a London and Surrey painter of English, Italian, German, and Spanish views, changed his name to Hägg.]

Mr. Henry Campotosto's ingenious work in crayon, charcoal, and pastel is in force at Paladiense's, in New Bond Street. Mr. Campotosto may be congratulated on Madame Paladiense's indifference to the unfashionableness of the medium in which he works, and on her apparent faith in the approach of a craze for pastel and crayon work, in which not unlikely event he will score heavily for a season or two. A curious collection of drawings by old Henry Alken, whose hunting sketches are still familiar, shows that artist's really fine touch at its best. His pencilling is not so delicate as Leech's; but it is not too far

inferior to remind one of the illustrator of the *Comic History of England*, some of whose finest qualities as a draughtsman, by the bye, were never even suggested by his engravers.

❖

At Dunthorne's, in Vigo Street, Mr. Macbeth's etching after Titian's "Bacchus" has been succeeded by Mr. A. H. Haig's "Cathedral of St. George, Limburg on the Lahn." Mr. Haig's treatment of towering buildings on steep crags does not vary much. This time he is, perhaps, a little more cheerful—a few hours earlier in the afternoon than usual: otherwise the plate is like other successful plates on kindred subjects from his hand. It has been very skilfully printed.

The World, 2 March 1887 [C292]

Spring Picture Exhibitions

[Professor Holmberg is August Johann Holmberg (1851–1911); Walther Firle (1859–1929) and Leopold Karl Muller (1834–92) were also German artists. George Adolphus Storey (1834–1919) was a genre painter in the St. John's Wood circle. Franz Roubaud (1856–1928) was a Russian illustrator; the "our special artist" reference referred to newspaper depictions of battle scenes purportedly by an on-the-scene observer. Henry Wallis (1830–1916) was a historical and genre painter much influenced by the Pre-Raphaelites; he opened his first gallery in 1853 and was then proprietor of the French Gallery.

Peter Graham (1836–1921) was a Scottish painter of landscapes and coastal scenes; Henry Moore (1831–95), elder brother of a more famous artist, Albert Moore, was best known for his marine painting. José Jiminez y Aranda (1853–1903) was one of a prolific family of Spanish painters; Giacomo Favretto (1849–87) was an Italian artist, as were Francesco Bergamini and Antonio Rotta (1828–1903). Jean Henri Zuber (1844–1909) was French, as was Pierre Celestin Billet (1837–1922); José Gallegos y Arnosa (1859–1917) was a Spanish artist.

Theodore Blake Wirgman (1848–1925), a portrait and historical painter, would never paint a more successful picture than his representation of Disraeli being received by Queen Victoria on returning home after concluding the Berlin Treaty in 1878.

Goodall is Frederick Goodall (see [C225]); Martin is John Martin

(1789–1854), painter of grandiose biblical and historical scenes. Edmund Morison Wimperis (1835–1900) was a London landscape painter, largely in watercolors; William Wordsworth (1770–1850), the Romantic poet, is referred to in the "Wordsworthese" coinage.]

The French Gallery does not glitter this season as it did formerly. Peter de Hooghe might look at some of the best work there without gasping for fresh air. Professor Holmberg's pictures, though they show us princes of the Church in their cabinets, are cool in tone as well as rich in colour. M. W. Firle favours the Dutch school, and yet reminds us of the British, as if Josef Israels had got mixed up with Mr. Leslie, or Mr. Storey, or Mr. Phil Morris. Professor Muller's Cairo camel-market glares aridly enough; but there is relief on either hand in a couple of Corots. His Coptic girl as a live Sphinx is striking. The quiet mastery of expression and breadth of handling in Meissonier's water-colour study for the smoker in the "Sign Painter" puts out of countenance the laborious manipulation of C. Seiler and E. Allan Schmidt, who, in his "Village Forge," has, as usual, caught the glow of the hot iron, but missed the grime of the smithy. Joanowits's petticoated Servian gamblers are as spirited as ever, but a little mellower and better harmonised in point of colour. Though Herr Karl Heffner's landscapes still differ considerably in texture from these of Nature, his "On the Road to Ostia" is in some respects an admirable picture. The inevitable battle-piece in the manner of "our special artist" is by F. Roubaud. Mr. Wallis, however, having, it seems, happily found the market for miniature clerical and military subjects growing dull, has made a clean sweep of the old tiresome outposts and cuirassiers and buglers and scandal-mongering gormandising abbes who used to infest his sofas and worry his judicious visitors into all but forswearing French art.

Mr. T. McLean, in the Haymarket, again stiffens his exhibition with a Millais. It is a sort of Lenten exercise in colour; for the painter has abstained from the magnificent hues he ordinarily delights in. There are gold in the hair and red in the cheek of "The Fern Gatherer," but all beside is dank straw colour and faded green. She is a girl with an unfashionable figure and an earnest and nobly beautiful face, most skilfully wrought with the brush. In "Winter and Autumn" Mr. G. H. Boughton's mannerism is free from the coarseness of outline and exaggeration of feature which sometimes made it unwelcome. There is a certain flavour of Bedford Park about the scheme of colour; but the association is complimentary to Bedford Park rather than disparaging to Mr. Boughton. Mr. Peter Graham deals in his ordinary fashion with cattle and seagulls. Mr. Pettie's "Tiff" is of the nature of a pot-boiler. The two tiffsters have turned their backs on one another in such a way

that they seem bound to a great invisible wheel trundling along the road. Rosa Bonheur's boars in the forest of Fontainebleau are said to be exhibited here for the first time. There are, besides, homemade pictures by Mr. Thomas Faed, Mr. Leader, Mr. Herbert Schmalz, and Mr. H. Moore; and imports by Messrs. Madrazo, Jimenez, De Blaas, Andreotti, Favretto, Bergamini, Rotta, Tito Conti, Zuber, Bauernfeind, and others.

Mr. T. Blake Wirgman's "Peace with Honour," now being exhibited at Messrs. Dickinson's in Bond Street, is a *pièce d'occasion* which will serve its turn. Her Majesty, mildly self-conscious, sits at one end of a table, and Lord Beaconsfield condescends to her from the other, in a "genteel apartment" pervaded by peace with honour. The old-fashioned furniture helps to give the picture an air of being a family portrait. If it survive to be an "old master," it may find itself described as such in a dealer's catalogue. No one will guess that two such unassuming personages are Empress and Earl.

The Spring Exhibition at Messrs. Tooth's, in the Haymarket, contains plenty of brilliant work, and the brilliancy is not so barren as it used to be. Our English monopoly of good intention, and the Continental monopoly of manual skill, are happily breaking down as the public grows more and more impatient of mere dexterity, and less and less tolerant of clumsiness. M. Eugene de Blaas has had the ill-luck to paint a garish flower-girl who is all but the twin of Mr. Luke Fildes's "Lily among Flowers" in last year's Academy. The words of Mercury are harsh after the songs of Apollo. Rosa Bonheur's "Picnic Party" consists of foxes looking rather too conscious of standing for their portraits. Mr. Vicat Cole sends a cornfield and Mr. Leader a gloaming, in their most approved manners. Mr. Waller has a carefully-painted horse, a perfunctorily added rider, a maiden thrown in anyhow, and a background that deserves a sentence of pre-Raphaelite hard labour. Mr. Heywood Hardy is less slovenly; but he, too, is beginning to paint without conviction. "Rehearsing the Easter Anthem," by José Gallegos, contains some capital studies of facial expression. In Mr. Keeley Halswelle's "Where lilies float for many of a rood," the drawing is mannered out of all naturalness. Mr. Goodall's young lady in white was originally called Miriam or Minerva; an erasure in the catalogue has changed her to Calypso. She might be anybody. Mr. L. Deutsch's minute finish is conspicuous in the finger-nails of his two Arabs discussing "News from the Soudan"; but their toes are comparatively neglected. M. Pierre Billet's "Weary Wait" has a gorgeous sky, as imaginary as one of Martin's. There are many other interesting pictures, more than can be conveniently mentioned here.

The harvest of Mr. E. M. Wimperis's quiet eye (Wordsworthese for a collection of sketches made in the neighbourhood of the New Forest) is to be seen at Messrs. Dowdeswell's in New Bond Street, and a very fair harvest it is. His quiet eye is an eye for landscapes, not for "bits," as holes and corners are usually called by the people who paint them. His sketches are strong, breezy, full of incidents of colour, and rich with broken lights, broken ground, broken clouds, and everything that can be scumbled, dragged, and touched without too smooth a hand or too flowing a brush. When the spring sunshine gets the better of the fog which prevailed at the private view, then will be the time to visit Messrs. Dowdeswell, and see Mr. Wimperis's work in all its glory.

The World, 23 March 1887 [C296]

[Landscapes]

[Alphonse Marie Adolphe de Neuville (1835–85) was a French historical painter; Frederick Arthur Bridgman (1847–1927) was an American historical and landscape painter who had studied with Gérôme in Paris and exhibited his influence.]

Mr. Koekkoek has half a dozen Munkacsys, a Meissonier, and De Neuville's "Tel el Kebir," at his gallery, 72 Piccadilly. "An Avenue in the Forest of Fontainebleau" shows that M. de Munkacsy can deal with landscape to as much advantage as with rich interiors. The scramble up the earthworks in the darkness of very early morning is admirably shown in De Neuville's picture.

❖

Mr. Frederick A. Bridgman exhibits at the Fine Art society two hundred and thirty sketches made by him in Egypt and Algeria. Executed with a rapidity and success only possible as the result of great knowledge and practice, they are just what working sketches should be. In many of them the scheme of light is so masterly as to be quite fit for transfer to a picture without further consideration or composition. Outside the general run of the series are some sketches of the sea, which are not quite so successful as the rest, and some capital studies of horses.

The World, 6 April 1887 [C303]

Picture Shows

[Frank Bramley (1857–1915), genre painter, was a member of the Newlyn (Cornwall) School with Henry Tuke and Stanhope Forbes. William Lionel Wyllie (1851–1931) of London occupied himself largely with English and French harbor and coastal scenes. Isabella Milbanke-Huskisson (?–1923) was the wife of Conservative M.P. Mark Lockwood (1847–1928), later the First Baron Lambourne. Sargent's portrait of Robert Louis Stevenson (1850–94) showed the gaunt novelist standing, with his wife, Fanny (Frances Osbourne), seated in a corner nearly out of the picture. Stevenson had written a friend about it, "Sargent . . . painted a portrait of me walking about in my own dining-room, in my own velveteen jacket, and twisting as I go my own moustache; at one corner a glimpse of my wife, in an Indian dress, and seated in a chair that was once my grandfather's. . . . "

Edward Stott (1859–1918), ARA 1906, was a painter of landscape and rustic genre. William-Stott of Oldham's nude model was very likely Maud Franklin, soon-to-be-discarded mistress of Whistler (who was very prudish, as well as involved with another woman—whom he would later marry). Mrs. Maxse was the wife of Admiral Frederick Augustus Maxse (1833–1900); the portrait was a small watercolor.

Charles William Wyllie (1853–1923), the brother of W. L. Wyllie, painted, as did his brother, river and coastal scenes.

Theodore Roussel (1847–1926) was a Sussex portrait and genre painter; Mortimer Menpes (1860–1938), his subject, watercolorist and etcher, was a follower of Whistler. Shaw was wrong about Whistler's own Chelsea in Ice, which was "true" in the sense of its realism, but even that was because it was an early work, painted in 1864.

Louis Edouard Dubufe, portrait and figure painter, lived and worked in both Paris and London, as did genre painter Paul Albert Besnard. Louis-Maurice Boutet de Monvel (1851–1913) was primarily an illustrator; Kate Greenaway (1846–1901) was the most famous children's book illustrator in England. Jean-Charles Meissonier (1848–1917) was a French genre painter, as was Gaston Bethune (1857–97). Jean-Baptiste-Edouard Detaille (1848–1912) was known for his realistic battle scenes; Eugène-Edouard Morand (1855–?) was a genre and figure painter. (For Harpignies, see C229.)

Annie Louisa Robinson (1844–1933), who was Mrs. Joseph William Swynnerton, ARA 1922—the first woman so honored in her time— lived and worked in Rome after 1883. Kate Dickens Perugini (1839– 1929), daughter of the novelist, was a genre and portrait painter; Katherine D. M. Bywater was a London genre painter. Blanche Jen-

kins was a London figure and genre painter; Mariquita (Mrs. H. G.) Moberly was a Surrey painter of figures, animals, and landscapes; Miss Freeman Kempson painted landscapes in watercolor. Mildred Anne Butler (1858–1941) was an Irish painter and watercolorist, largely of landscapes and genre; Clara Savile Clarke (wife of the playwright H. Savile Clarke), London landscape painter and book editor, was a friend of Aubrey Beardsley.]

Many of the art-critics who passed on Friday last from the exhibition of the New Art Club at the Dudley Gallery to that of the British Artists in Suffolk Street must have bethought them that it was the first of April, and that perhaps most of the "impressionist" pictures submitted to them would be spirited away during the night, and replaced by more sensible ones in time for the private view on Saturday. Truly, if some of them were spirited away and not replaced at all, the public would not be the losers. The value of impressionism depends on the accuracy of the impressions. Mr. Whistler, for instance, fixes for us an impression which, though incomplete, is exquisitely accurate as far as it goes. But the same subtlety of sense which enables him to do this must also compel him to recognize that there is not half-a-crown's worth of successful or even honest effort in some of the works conspicuously hung in the vinegar and brown paper bower he has made for his followers in Suffolk Street. These gentlemen are painting short-sightedly in more senses than one. The trick of drawing and colouring badly as if you did it on purpose is easily acquired; and the market will be swamped with "new English art," and the public tired of it, in a year or two. Then there will be vain lamenting over lost ground to recover, bad habits to correct, and association of names with unsaleability to be lived down. The "new" fashion may be capital fun for Mr. Whistler, Mr. Sargent, and a few others who can swim on any tide; but for the feebler folk it means at best a short life and a merry one.

Among the pictures at the New Art [English] Club mentionable without unkindness, Mr. F. Bramley's "But thou and I" is the most promising. If the lady's face were quite equal to the rest the success of the painter's effort would be complete. Mr. W. L. Wyllie has taken a new departure inland, and gives us hills, hares, and crows instead of steamers and barges. In Mr. J. J. Shannon's portrait of Mrs. Mark Lockwood the light is too cold for lamplight, and not diffused enough for daylight. It is clever; but cleverness is a drug, and rather a nauseating one, at the Dudley Gallery now. In a similar work by Mr. Sargent, the distant sunlit side of the room is capital; but the young lady's complexion is pasty. A portrait of Mr. R. L. Stevenson and his wife, by the same painter, is humorous and interesting: one cannot help wondering what the author

of *Kidnapped* is chuckling over. Mr. H. S. Tuke's "First Boat In," an unaffected piece of work gains by contrast with its competitors. There is some very ingenious manipulation in "The Ferry," by Mr. Edward Stott (Not Mr. William Stott, please). Mr. T. B. Kennington has tried his hand at a version of "Hard Times," the subject with which Mr. Frederick Brown did so well at the last exhibition. Mr. T. Hope McLachlan's "Orion" is like a dance of will-o'-the-wisps escaped from earth; and Mr. Jacomb Hood's portrait of Mrs. Maxse is done well, but just in the fashion to tempt a less skilful painter to go and paint another one badly. He has an equally effective but larger portrait at the British Artists. Here Mr. Ludovici again shows us unsubstantial ballet-girls twirling in an atmosphere of cobwebs. Mr. William Stott (not Mr. Edward Stott, pray) exhibits a nymph; and she, basking in the sun on a couch formed by her own red hair, exhibits herself freely and not gracefully. The red hair is ill painted. The nymph, the sunshine, and the flowers and leaves are, on the contrary, carefully studied and well executed; but the desirability of the picture as a whole, estimated by the artist at a thousand guineas, is a matter of taste. Mr. C. W. Wyllie's "Approach to London" is a river-picture of his best brand. In Mr. A. F. Grace's "Harvest Moon" the landscape and horses are good; but the moon itself is like the top of an oil-barrel with a red-lead stain on it: a defect happily not irremediable. Mr. Leslie Thomson still works successfully in the strong Dutch style. M. Theodore Roussel's contribution, coloured in street-hoarding style, so as to make sure of catching the eye, is a portrait inscribed "MORTI-MER MENPES. ESQUIRE." Mr. Whistler's arrangements and noc-turnes are repetitions of former successful exploits of his, with the ex-ception of the "Harmony in Grey: Chelsea in Ice," which is new and true. Visitors overpowered by the pictures in the large gallery will find welcome relief in the water-colour room.

At the Goupil Gallery, the Société d'Aquarellistes Français show us that Frenchmen can do with water-colours quite enough to make them think rather poorly of our boasted English school, and yet not enough to shake our insular conceit for a moment. They are, as might be expected, gayer and more dashing, fonder of figure subjects and body colour. In an English exhibition, M. Dubufe's brilliant follies would stir no competitor to rivalry; and M. A. Besnard's outrageously unobser-vant impressionism might sober even the New English Art Club or the British Artists. M. B. de Monvel's quaintly beautiful drawings of chil-dren would be the despair of Miss Kate Greenaway. But our Fripps, Hines, and Fosters might rest safely on their oars, leaving MM. Charles Meissonier and Bethune to be dealt with by Mr. Gregory and Miss Clara Montalba. M. Detaille is great as a limner of soldiers rather than as a water-colourist, though he handles the brush like a master.

The work of MM. Harpignies and Eugène Morand will probably prove most attractive to lovers of our own school.

The Society of Lady Artists is rather pressed for wall-space in the drawing-room at the Egyptian Hall, although there are hardly half a dozen pictures in the exhibition which had better have been left unhung. Miss Annie L. Robinson takes a strong lead with her two girls in a garden, and her "Danaë," who is not *the* Danaë, but a girl in a sunbonnet carrying a bundle of sticks, and surrounded by golden blossoms. Miss Robinson seems to have striven with considerable success to attain something of Mr. Burne Jones's quality without catching his manner. The light in "Danaë" is just a little too violent: it would not have pleased that professor who, when the little girl asked him to draw her a white cat, replied, "Child, in the great school all cats are gray." Mrs. Perugini opposes a mild Millais to a crude Frank Holl by Miss Katherine Bywater (for most of these ladies imitate some favoured gentleman). Miss Hilda Montalba is original and productive; but Miss Clara Montalba is now only *re*productive of old work. And it is time to ask Miss Kate Macaulay whether the universe is really made up of fishing luggers with tawny sails, and planks floating in weak gray water. Miss Blanche Jenkins's portrait of a lady is one of the most cunning pieces of brushwork in the exhibition. Mrs. H. G. Moberly's handling is firm and clean; but her conception of Little Nell as a rather dark, determined girl, and of Nell's grandfather as something like Mr. Ruskin in a heroic mood, is certainly not Dickensian. Miss Freeman Kempson improves, in point of variety of hue, on Miss Macaulay's favourite subjects. Miss Mildred Butler, Mrs. Savile Clarke, and others, exhibit works which succeed in arresting attention amidst a collection of very creditable average merit.

The World, 13 April 1887 [C307]

In the Picture-Galleries

[John William North (1842–1924), ARA 1893, was a genre and landscape painter, illustrator, and wood engraver. Edward Matthew Hale (1852–1924), genre painter and artist for the Illustrated London News, *actually titled his burial ground picture* Dead. *Robert Weir Allan (1852–1942) was a Glasgow painter of Scottish outdoor scenes who settled in London in 1881. William Telbin (1815–73) was a Victorian stage designer as well as a landscape and architectural*

artist. Thomas James Lloyd (1849–1910) was a genre and landscape painter.

Thomas, Cardinal Wolsey (1475?–1530), English statesman under Henry VIII, was John Gilbert's subject; Seth Pecksniff is the unctuous Wiltshire hypocrite who receives Martin Chuzzlewit as architectural apprentice in Dickens's novel; Julia Mannering is Guy Mannering's daughter in Walter Scott's 1815 novel.

Alfred William Hunt (1830–96) was a Liverpool landscape painter and watercolorist; Federico del Campo was a Peruvian-born artist who exhibited in European galleries 1880–1912; Canaletto was the name adopted by Venetian artist Giovanni Antonio Canale (1697–1768). José Frappa (1854–1904) was a French anecdotal painter; his subject, General Charles ("Chinese") Gordon (1833–85), was killed while vainly defending the Sudanese capital of Khartoum.

Martin Henry Colnaghi (1821–1908), art dealer and collector, took over Flatou's Gallery at 11 Haymarket in 1877 and renamed it the Guardi Gallery after two pictures he had purchased by the Italian master Francesco Guardi (1712–93). In 1888 he would move to the former quarters of the Royal Institute of Painters in Water Colours at 53 Pall Mall and rename his establishment the Marlborough Gallery.

Giuseppe de Nittis (1846–84) was a French portraitist and genre painter; Ferdinand-Victor-Léon Roybet (1840–1920) was a French genre painter. Karl Kuhl (1850–1915) was a Dresden portrait and genre painter who exhibited in Paris and London; Bernardus Johannes Bloomers (1845–1914) was a Dutch genre painter.]

The Royal Society of Painters in Water-Colours have, as usual, an excellent collection of pictures, about which there is little to be said which would not go without saying to all who know the old society. Of Messrs. Fripp, Mr. Hine, Mr. Birket Foster, and Mr. Thorne Waite, for instance, what can one possibly say that has not been said before, except that Mr. Thorne Waite has been busier than any of the rest, and that his downs are not quite so pleasing, because muddier, than Mr. Hine's? His "Trundling the Cheese" will rank among his more important works. Newer, but not better, methods have been turned to good account by Mr. J. W. North in his "Early Spring." Concerning Mr. Poynter's "Difference of Opinion," with its expanse of closely-clipped grass glittering in the sun, one can only suggest, not disrespectfully, that it would make a capital advertisement for a lawn-mower. On Mr. Matthew Hale's "Old Celtic Burial Ground" the colour has broken out (or gone in) in a kind of rash which makes the scene too spotty to be thoroughly impressive. Mr. R. W. Allan commends his recent election by strong, wet, breezy pictures, with plenty of good work in them. Mr.

T. M. Richardson displays his familiar taste for oleographic greens, and Alpine compositions in the style of Telbin's drop-scenes. Mr. Holman Hunt is a painter in finding fault with whom it behoves a critic to tread warily; but were he fifty Mr. Holman Hunts, his "Jesus among the Doctors" is ugly. The murder being out on that point, it is easy to lecture Mr. Albert Goodwin on the self-indulgent caprice which threatens to become a new and, on the whole, objectionable development of his manner. We cannot afford to see one of our few really imaginative painters lapsing into luxurious cleverness. Mr. Tom Lloyd, in his ambitious "Responsive to the Sprightly Pipe," has not quite caught the mellow, equably diffused radiance of the evening sun. The glow upon the figures is almost that of a lamp with a red shade. Mr. John Gilbert gives us Cardinal Wolsey and his retinue, all very brave and scarlet and shaggy. Mr. C. Gregory harps on the ups and downs of San Remo, as Mr. Pecksniff's pupils harped on Salisbury Cathedral. Mr. Herbert Marshall still exploits London. Mr. David Murray, like Mr. Paul Naftel, is clever, but un-English—a real reproach to a water-colourist. Mr. Edward Radford's figures show progress. Mr. Charles Robertson's "Oriental Bazaar" is elaborate, and would be splendid if the figures were only solid enough to convince the eye. Mr. Eyre Walker's best subject is "In Chancery"—a dilapidated windmill swamped in a pool choked by bulrushes. The stormy sea in Mr. A. W. Hunt's little sketch, "A Stiff North-Easter," is perfect, if one may use such a wild word for once. Mr. Arthur Hopkins's "Fuel-Gatherers" may be accepted as some slight atonement for his "Reindeer Sleigh" and "Maid of the Mill," which are themselves, in a sense, fuel-gatherers. Besides these pictures are many others from contributors of established fame.

Messrs. Dowdeswell, in arranging at their Whistleresque room a second series of sketches of Scotch scenery by Mr. James Orrock, have had the happy thought of relieving it by a set of characters from Scott's novels, painted by the President of the Royal Institute. Mr. Orrock, when drawing stones, grass, and foreground detail, never quite succeeds in keeping his strokes from running into pothooks and hangers. His very colours somehow get inky. But his touch with a full brush is often wonderfully happy: witness the "Solway from Burgh Marsh," which you can hardly look at without forgetting that you are in 133 Bond Street; and in his composition and his treatment of the play of sunlight and cloud-shadow, especially in middle distance, he shows himself a master. Sir James Linton, though out of the question as an illustrator of Scott (a traction engine would not have dragged his "Marmion" within a league of Flodden Field), sends several nobly-painted pictures of men and women in costumes which afford full play for his patience, thoroughness, and skill. Julia Mannering is the pleas-

antest of them. The *technique* and treatment of both artists would perhaps prove monotonous if either had the room to himself; but, as Mr. Dowdeswell has arranged matters, each saves the other from this pitfall.

At Messrs. Tooth's Gallery some pictures in oil, of Venice, the Gulf of Naples, Capri, &c., by Signor F. del Campo, have been added to the exhibition. They are very bright and pretty. Perhaps somebody with a few spare Canalettos would like to exchange them for newer and smarter-looking articles. If so, Messrs. Tooth may safely deal, brilliant as Signor del Campo's palette is.

M. José Frappa's big picture of the assassination of Gordon at Khartoum bears witness to considerable skill and industry on the part of the painter. As much may be said for his other pictures exhibited at 48 Pall Mall. But they contain somewhat too much of that hackneyed and indecorous person, the monk distracted from pious contemplation by a glimpse of a pretty woman. If M. Frappa will weed this subject out of his exhibition, he will find himself on all the better terms with the British public.

At the Guardi Gallery in the Haymarket, Mr. Colnaghi has brought together for his spring exhibition a number of works by Benlliure, De Nittis, Seiler, Roybet, Heffner, Kuhl, Joanowits, Chierici, Tissot, Munkacsy, Israels, Bloomers—in short, by the painters whose acquaintance we have made at the French Gallery. Most, if not all, of the pictures have already been exhibited elsewhere in London, some of them, Mr. Gogin's "Soothsayer," for example, as lately as last year. Under these circumstances there is nothing new to be said about them, except that they bear a second inspection quite as well—or, in one or two instances, as ill—as they bore the first.

The World, 20 April 1887 [C309]

In the Picture-Galleries

[Thomas W. Couldery was a London painter of domestic and rustic subjects who exhibited 1883–93. Walter Langley (1852–1922), a genre painter largely of Cornish fisherfolk life, was a member of the Newlyn School. Frederick Walker (1840–75), ARA 1871, was a London genre painter in oils and watercolors. Highly regarded at an early age for his poetic evocations of pastoral life, he died of tuberculosis at the height of his powers. Edward Henry Corbould (1815–1905) was a

watercolor painter and illustrator who taught painting to the Royal
children from 1851 to 1876. Victoria and Albert acquired some of his
work. Mrs. Stillman was Marie Spartali; Mrs. de Morgan was Evelyn
Pickering (see C225).

Linton's subject was the ill-fated Emperor Maximilian of Mexico
(1832–67), a Hapsburg prince imposed unsuccessfully upon the Mexi-
cans by Napoleon III of France in 1864. Charles Green's Dickens sub-
jects from Little Dorrit *were Fanny Dorrit, snobbish elder sister of*
Amy, the title figure; and Edmund Sparkler, Fanny's husband—the
vacuous son of the swindling financier Mr. Merdle.

A. J. Staniland is unknown but for his "Little Nell" picture, first
exhibited as "Little Nellie" in 1865 at the British Institution; the artist
may well be C. J. (Charles Joseph) Staniland (1838–1916), a well-
known genre painter and graphic artist who contributed to the Illus-
trated London News. *William Barnes Wollen (1857–1936) was best*
known as a painter of military and sporting scenes; Henry Reynolds
Steer (1858–1928) was a landscape and genre painter both in oils and
watercolors. Henry Ryland (1856–1924) was a watercolorist, decora-
tor, and designer in the Pre-Raphaelite manner. Harry T. Hine
(1845–1941) was a watercolorist of landscape and church architec-
ture. Mary Reeves painted Irish scenes from her home in Cork, and
exhibited in London 1871–87. Josiah Wood Whymper (1813–1903),
London engraver and watercolorist, specialized in English landscapes;
Alfred William Strutt (1856–1924) was a New Zealand-born animal,
genre, and portrait painter.

Joshua Anderson Hague (1850–1916) was a Welsh painter and wa-
tercolorist. Allan Duncan (1830–87), London painter of landscapes
and waterscapes, was the son of artist Edward Duncan. Edmund
George Warren (1834–1909) painted landscapes in watercolors and
in the Pre-Raphaelite manner; he was the son of the better-known
watercolorist Henry Warren. (Sir) Alfred East (1849–1913), ARA
1899, landscape painter in oils and watercolors, worked in a style
influenced by the Barbizon School. Luis Riccardo Faléro (1851–96)
was a Spanish figure and landscape painter. Sir Oswald Walters
Brierly (1817–94) was a London marine painter and watercolorist
who at various times accompanied royal English princes on their trav-
els as official artist. The Pall Mall Gallery exhibition was the first full-
scale show of his work after his knighthood.]

The Royal Institute, through its secondary position and the levelling
effect of water-colour, is a rather barren subject for description or dis-
cussion. Its best pictures are never so aggressively good, or its worst so
abjectly bad, as those which the Grosvenor and the Academy can show

when fairly on their mettle in either direction. This season it has very few distinguished pictures indeed. Mr. Thomas W. Couldery has, however, set himself well apart by his "Legitimate Drama," a representation of a crowd witnessing a Punch and Judy performance. If street-corner audiences were in the habit of arranging themselves with due regard to pictorial composition, Mr. Couldery might be suspected of having simply copied an instantaneous photograph. As it is, he must be credited with an astonishingly observant and faithful piece of work, important enough to deserve a somewhat better position than it actually occupies. Mr. Walter Langley's best picture is "Betrayed." The subject—a village girl gone astray—is a little worn; but Mr. Langley's version might hang beside "The Harbour of Refuge" in a collection of Fred Walker's works, without losing countenance. Mr. E. H. Corbould's figure subjects show earnestness and unsparing diligence, much of which is unfortunately wasted on a system of hatching and stippling which never produces satisfactory results as to texture. Mrs. Stillman's work suffers from the same cause. Miss Pickeri—that is, Mrs. de Morgan—sends a "Hero watching for Leander," which is hardly as good as she could have made it. Hero's right arm, mathematically a right angle, is artistically a wrong one; and the rock which supports her is too obviously a mere piece of furniture to kneel on. Sir James Linton has painted, with the hand of an artist and the sympathies of a costumier, his 1885 *tableau vivant* of Maximilian in the studio of Albert Dürer. Has the President no feeling for his fellow-men, that he persistently treats them as mere clothes-horses to pile armour and fur upon? This year Mr. Macbeth's contribution, "A Cambridgeshire Ferry," is not unworthy of him, though the collie in the corner is perhaps more pigeon-breasted than these useful animals commonly are in real life. Mr. Charles Green's "Fanny Dorrit" is not like her: Mr. Sparkler would never have accepted such a person as his ideal well-educated woman, with no nonsense about her. Mr. Henry J. Stock's pictures are smaller than usual, and show some gain in grace; but his drop into poetry is alarming—"O sea, I sing, A nymph to bring From far within Thy caverns dim," &c. Who is the author of these unfamiliar lines? Mr. Staniland's girl surrounded by curios is, of course, dubbed "Little Nell." Mr. Wollen, in the pictorial war department, has acquitted himself effectively, without swaggering. Mr. H. R. Steer has been busy with figures, and contributes presentable conversation pieces. Mr. Frank Dadd, by trying to suggest the colour of his faces, as he does with black and white when working for the engraver, spoils them. Why, one would ask, suggest colour when you have it at hand on your palette? Mr. Cattermole's illustration of a Boccaccio tale has the good quality of telling its own story. Mr. Henry Ryland's "Vision of the Holy Sangreal" shows that love of Arthurian legend, though debilitating

in comparison to study of the real life, still makes very painstaking votaries.

The landscapes are, of course, more numerous and more successful than the figure-subjects. Mr. Arthur Severn's "Brighton and Back for Three-and sixpence," in which the holiday-makers flit about the sands in a haze which the sun cannot dispel, is more interesting than his "Sunlight on Clouds and Sea," dazzling as that certainly looks at a sufficient distance to hide the touches of aniline colour in the waves. Mr. Harry Hine's attractive array of works includes a remarkable sketch of Canterbury Cathedral from the Allotment Garden. The foreground, in contrast with the building, is blotted on in the roughest impressionist style, forcing you to retreat until the clumps of colour become intelligible, when you find that the carefully pencilled tracery of the Cathedral outlines produces an enchantingly airy and delicate effect. Mr. Joseph Knight sends a "Brown Autumn" which looks rather blue, and a portrait study called "The Ship's Carpenter," as well as a supply of green pastures in his familiar manner. Miss M. Reeves has made an effective mid-Channel study of the wake of a steamer making an opal path between the green waves and the shadow of the dense cloud-trail of smoke. But it must be added that she has led the eye to her signature so successfully that the illusion of the painting is destroyed by it. Hard by is Mr. J. W. Whymper's "Stream and Ford at Brockenhurst," showing the country fresh and clear under a rainy and lowering sky,—the sort of day that persuades you to take a walk, and gives you a thorough wetting when it has lured you a mile or so out of the reach of shelter. Sunnier weather prevails in Mr. Alfred W. Strutt's happy "Noon in a Kentish Hop Garden." Miss Rose Barton has recorded her "impression" of an Irish bog cleverly; and Mr. Anderson Hague has not only recorded, but in a striking fashion conveyed, one made on him by a hayfield with workers. Mr. Fahey is still all in the Broads: his "Martham Broad," Mr. Orrock's "Blenkensop Castle," and Mr. Allan Duncan's "Welsh Coast Scene" form a notable group of pictures in the east gallery. Mr. William Simpson, whose pictures always have something of the fascination of travellers' tales, sends a view of the Sakrah, or summit of Mount Moriah. Mr. Edmund G. Warren's "Splendid Solitude," though not a specially ambitious work, bears the weight of its title handsomely. Mr. Hamilton Macallum's "Amsterdam" has actually no boy bathers in it, and does very well without them. Mr. Alfred East's "New Neighbourhood" and Mr. Ayerst Ingram's "Passing Showers" are noteworthy, though not more so than many other pictures which must be included in a general acknowledgment of the high average quality of the mass of undistinguished work in the exhibition.

Mr. F. Goodall has followed up his pietistic picture at Messrs. Tooth's by an Andromeda—not pietistic—at Messrs. Harper & Graves'. Andromeda, much larger than life, and undeniably "a fine figure of a woman," lies, bound by two slender chains at wrist and ankle, on a sea-bound rock, and is so pleased with herself, with the jocund morn, the lapping waves, the warm newly-risen sun, and the cheerful look of things generally, that she does not worry about the monster, and indeed seems to know all about Perseus beforehand. Tragedy and drapery are alike discarded: we have the beauty of the woman unmarred by pain or terror, and the pleasant scene made a significant part of the subject instead of a mere background. The seascape is apparently drawn to a smaller scale than the figure; but it is well imagined and conscientiously painted. The figure is admirably modelled, and being natural in the face of Nature, is perfect in point of dignity and propriety.

Hardly so much can be said of M. Faléro's "Marriage of a Comet," personified as a handsome young gentleman with streaming locks of cold white fire, who, in a steely-blue night, embraces a young lady in every way worthy of him, the two forming a group which balances itself like a parachute in the empyrean. Mr. J. P. Mendoza, who exhibits the picture at his gallery in King Street, has also a collection of works by British and foreign artists. Most of them are old friends, but Mr. Heywood Hardy exhibits some bearing this year's date.

Sir Oswald Brierly has worked for many decades on the high seas with sufficient artistic success to make him independent of the somewhat disturbing parade of Royal, aristocratic, and plutocratic patronage at the Pall Mall Gallery, where an extensive collection of his works, borrowed for the occasion, is to be seen. They are in all styles, from tinted drawings which might have been made when Turner was a boy, to brilliant notes of colour reminding one of the New English Art Club. Sir Oswald's study of the sea has never ceased: he rarely repeats himself either in treatment or in method. As might be expected, he was fond of the old wooden man-of-war, and has painted shy of the Navy since ironclads began to devastate the coast. Sometimes, the sailor in him overpowering the artist, he insists on minute details of rigging at distance which would obscure them to the keenest eye. His drawing has been a little hard all through, and his touch is naturally less solid now than it was when he was younger. It is, however, impossible to examine this selection from his life's work without admitting that he has gained his distinction by remarkable merit as a painter of shipping and marine scenery no less than by courtly favour.

The World, 27 April 1887 [C311]

At the Academy

[Among the absentees Shaw mentions Thomas Woolner (1825–92), ARA 1871, Pre-Raphaelite sculptor and poet. Sargent's Mrs. Playfair was Emily Kitson Playfair, wife of William S. Playfair, M.D. (In 1883 he had exhibited a portrait of Edith Russell Playfair, wife of Sir Lyon Playfair.) "The President" was Sir Frederick Leighton; the facetious comparison of his subject to Dorothy Dene (1830?–99) was to the comic actress. Charles Edward Perugini (1839–1918), genre and portrait painter in London from 1863, had been a studio assistant and protegé of Leighton. William Teulon Blandford Fletcher (1858–1936) was a genre painter originally in the Newlyn group but in London after 1879. Stanhope Alexander Forbes (1857–1947) was a Dublin-born realist genre painter who joined the Newlyn group in Cornwall; his wife was the painter Elizabeth Armstrong. Another Newlyn artist was Henry E. Detmold (1854–98), rustic genre and figure painter who painted North African and French scenes as well as Cornish settings.

Charles Coborn was the stage name of Scottish music hall singer-comedian Colin Whitton McCallum (1852–1945), whose immortality was assured after he first sang "The Man Who Broke the Bank at Monte Carlo" in 1890. He was then doing a Golden Jubilee number. Henry Tanworth Wells (1828–1903), ARA 1866, was known for his portrait groups of distinguished Victorians. John Aubrey (1626–97) was a biographer, bibliophile, and gossip, author of the influential Brief Lives, *not published except in extracts until 1813.*

Andrew Gow (1848–1920), ARA 1880, was best known at the time for his paintings of historical and military subjects; he would depict, in 1897, Victoria before St. Paul's on Diamond Jubilee day. Frederick Richard Pickersgill (1820–1900), ARA 1847, was also a historical painter. Archibald Philip Primrose, fifth Earl of Rosebery (1847–1929), a subject of Millais, was a longtime Liberal cabinet minister and briefly Prime Minister 1894–95. Another Millais subject, Spencer Compton Cavendish, Marquis of Hartington (1833–1908), Liberal leader and cabinet minister, would become the eighth Duke of Devonshire in 1891.

William Frederick Yeames (1835–1918), ARA 1866, was a historical painter and member of the St. John's Wood group. Arthur Dampier May exhibited genre scenes and portraits, largely of children, 1872–1900. William James Laidlay (1846–1912), landscape painter indebted to the Impressionists, was a founder of the New English Art Club. Albert

Joseph Moore (1841–93), despite close ties to the Pre-Raphaelites and to Whistler, was largely a Neo-Classic painter of nude or draped figures or figure groups. The Herkomers were Hubert Herkomer (1849–1914), ARA 1879, genre and portrait painter, who added a "von" prefix to his name after honors from Germany in 1899, and was knighted in England in 1907; and his nephew Herman G. Herkomer (1863-?), American expatriate portrait painter transplanted to Hertfordshire.

Carl Bernhard Schloesser (1832–1914), born in Darmstadt, exhibited figurative and historical subjects throughout Western Europe. Frederick Vigers, a Surrey genre painter, exhibited 1884–97. Émile Bernard (1868–1941), French symbolist painter, can be excused for "ineptitude" in his works based upon stained-glass techniques: this was his first major show and he was only nineteen. Arthur Wasse, Manchester painter of genre and flowers, exhibited in London 1879– 95. Emile Auguste Carolus Duran (1838–1917), a Parisian portraitist in the tradition of Velázquez, had been the teacher of Sargent. Kate Hayllar, painter of flowers and still-life, and a daughter of James Hayllar, after exhibiting 1883–98, gave up art for nursing. Charles William Campbell (1855–87), born in Tottenham, had been a promising engraver and painter in the Pre-Raphaelite style.]

In this year's Academy five pictures, by Mr. Orchardson, Mr. Alma Tadema, Mr. Waterhouse, Mr. S. J. Solomon, and Mr. Nettleship, stand out most notably from a background of fourteen hundred and thirteen. "The First Cloud" has come upon the wedded life of a couple who thinly inhabit a spacious room, decorated and furnished by Mr. Orchardson in his well-known manner, with yellow walls, faded crimson chairs, and Eastern carpet. The gentleman, getting on in years, and a little the worse for wear, stands on the hearthrug with his back to the fire, furtively watching his wife, who is leaving the room. His hanging head, hands thrust in pockets, and heavily-planted heels are sufficiently expressive of the failure of the lady to meet his views in the interview just concluded. Her feelings are better hidden: she might be going on the most indifferent business: probably she cares less for him than he for her, and so has got the better of him. Effective arrangement, expressive design, harmony of colour, exquisitely finished detail—all the beauties, in short, that have a place in drawing-room comedy, are here in rare excellence. Mr. Alma Tadema's subject is "The Women of Amphissa." The catalogue explains copiously how the Chyades, women sacred to Dionysos, strayed into the market-place of hostile Amphissa, and went to sleep there. Also how the married ladies of the town came to their aid; allowed them to sleep their fill; fed them (chiefly on cucumbers, according to Mr. Alma Tadema); and saw them

safely out of harm's way. What the marketplace and the girls are like may be guessed; but the disposition, apparently unstudied, of these figures lying in all directions on the marble flags is pleasant and novel. The next two of the superlative five are less beautiful, but more ambitious. Mr. Waterhouse shows us "Mariamne, wife of King Herod the Great, going forth to execution after her trial for the false charges brought against her by the jealousy of Salome, the King's sister." Mariamne, a white-robed figure in the middle of the picture, is descending a stair that leads nearly straightforward out of the frame, so that she is prominent and close upon you as she turns her head to look a last reproach at Herod, who, cowering in his judgment-seat to the right, at some distance behind, needs Salome's eager grip of his arm to keep his resolution firmly screwed. Mariamne has evidently been studied as a nude figure: her drapery, flat and fresh from the wardrobe, hardly looks as if it had been worn by a woman of passionate temperament during her trial on a capital charge. Mr. Waterhouse conceives the situation as a commonplace historical romancer might; but the exceptional knowledge and skill he has shown in the manual work makes the picture striking and important. As for Mr. Solomon, he bids boldly for high place as a nineteenth-century Rubens by a Samson in the old-fashioned magnificent style. Some stamp of modern Paris is upon Delilah, a little black-haired, raven-eyed witch, who, from a safe distance, shakes Samson's shorn locks in his face in frantic devilment. He, infuriated by her laughter, struggles in an immensely brawny fashion as the Philistines drag at him with ropes, like a team of bullocks. Altogether a brilliant and spirited achievement, and a severe abashing to the countenance in which the namby-pamby pictures used to keep each other whilst they had the field all to themselves. The appearance of so odd a picture as Mr. Nettleship's "Caliban upon Setebos" on the line may make it a bait for unwary scoffers. But the hangers have done wisely in taking good care of a grotesque so rich in humour and significance. Caliban is squatting in a cool cave, with a leopard-like substitute for Miranda at his side, a strange and gorgeous bird on his shoulder, and a sea-horse (enjoying the novelty of a hot climate) turning a bland blind face to his master from the sunny sea without. All these creatures seem happy, elate, basking in Caliban's favour; but he, poring over a green book "of broad leaves, arrow-shaped," is in desperate perplexity, pretending to read, trying to think, struggling hopelessly upwards from a puzzle-headed monster to a serenely wise Prospero. In short, he is Mr. Browning's tragically ludicrous Caliban to the life. The picture is unique in its way.

Between these five and the mass of clever or pretentious works which next claim attention may be placed Mr. Andrew Gow's picture of

the garrison of Lille as it marched out with the honours of war when, after a steadfast resistance, the fortress-town surrendered to Marlborough and Prince Eugene. In this, as in his picture of last year, Mr. Gow has hit the dramatic moment in a historical episode. He shows us the column of starved-out French soldiers trudging through the puddles on a wretched road and in miserable weather, woefully enough, but still carrying their arms and colours doggedly upright. On a bank to the right, the officers of the victorious army, as the colours are borne past them, salute their brave and unfortunate enemy with genuine respect and sympathy.

Besides these, the Academy contains nothing to be devoutly thankful for. The list of absentees is surprisingly strong: it concludes Mr. Burne Jones, Mr. Watts, Mr. Woolner, Mr. Poynter, Mr. Vicat Cole, Mr. P. H. Calderon, and Mr. Pickersgill. Sir John Millais, perhaps with some vague intention of giving the rein to his imagination, has produced a life-size group, somewhat in the manner of his "Drummer Boy," consisting of a man rushing, in the attitude of a toy theatre bandit, to the massacre of St. Bartholomew; a monk beckoning to him; and a sister of mercy clinging to his knees. Then there are portraits of Lord Rosebery and Lord Hartington, and two pretty child-pictures of the usual kind. Mr. Yeames tries to make up for the absence of Mr. Watts by a huge St. Christopher bearing across a river an intelligent but priggish young gentleman, evidently bred in a London nursery. Mr. Fildes sends an irresistible portrait of Mrs. Fildes; and Mr. Solomon—who takes this important domestic subject more seriously—one of Mrs. Solomon. Mr. Sargent's portrait of Mrs. Playfair is almost disrespectfully clever. His "Carnation, lily, lily, rose," is a brilliant extravaganza in children and Chinese lanterns, the peculiar illumination of which is most ingeniously imitated. Mr. Goodall's "Misery and Mercy" (Christ and the adulterous woman) is too big to be passed in silence. The chief figure is posing with sham impressiveness at the spectator, and not paying the least heed to the woman, who is unexpressive and uninteresting. Mr. Armitage has spoiled Room VIII. with a canvas as large as a stage flat, and remarkable for nothing but its acreage. The President gives us "The Jealousy of Simaetha the Sorceress" (not unlike Miss Dorothy Dene in one of her tragic moments), and Hero looking from her window for Leander. Practice in sculpture and fresco, and perhaps widening wisdom and disillusion, are making another man of Sir Frederick. Pretty ladies who wish to be portrayed with waxen cheeks and jellied ear tips may now transfer their patronage to Mr. C. E. Perugini (see for a dainty sample his "Peonies," No. 138); for the presidential touch with women grows stern: they come from his hand terrible and sibylline. Mr. Macbeth, in his less dignified way, has

made a successful experiment on a larger scale and in a broader and
freer style than of yore, in his "Ambrosia"—that is, oysters! The good
side of the influence of Mr. Whistler and the new English Art Club in
leading artists to the study of out-of-door light and atmosphere, and in
securing to its best results due recognition from the Hanging Commit-
tee, may be seen in Mr. Blandford Fletcher's "Evicted," Mr. Stanhope
Forbes' "Their ever-shifting Home," Mr. Detmold's "On the Cornish
Coast," and Mr. Bramley's "Eyes and no Eyes." Mr. Bramley's picture,
by the bye, might as appropriately be called "Teeth and no Teeth." Mr.
Bramley and Mr. Sargent may be unable to distinguish a row of teeth
from foam at the mouth, but I always can, and so must declare them
wrong according to my powers of vision, however right they may be
according to their own. Mr. J. J. Shannon and Mr. Chevallier Tayler
also help to sustain the credit of the new school, and Mr. Dampier May
has been allotted a good place for his "Little Pink Girl," who is too pink
to be interesting. Mr. H. T. Wells, following the example of a brother
artist in another walk (Mr. Charles Coborn), turns the Jubilee to ac-
count in a manner that will give only a subdued pleasure to the loyal,
whilst it will certainly embitter the disaffected tenfold. Mr. Briton
Riviere again exhibits the dog as the friend of man; but his largest
work represents a young Greek landing on a dogless and desolate
shore. The birds, unaware of the dangerous nature of the strange
animal, cluster fearlessly and inquisitively about him. In Mr. Brett's
"Ardentrive Bay," on the contrary, the birds "sit sullenly on the rocks,
and seem too low-spirited to notice passing strangers." This, the cata-
logue further explains, is because the barometer being very low, "their
relative gravity is increased," a statement which at once upsets the
relative gravity of the Academy visitor, though he cannot deny that Mr.
Brett's little present of information is much more pertinent and interest-
ing than most catalogue explanations. Besides Mr. Brett's landscapes,
there are Mr. Leader's, Mr. East's, Mr. Laidlay's, and Mr. Alfred W.
Hunt's, all of high rank among the landscapes of the year. Mr. Picknell
sends a landscape too, besides the familiar scene with one figure—in
this instance a young fisherman standing in a boat at sea—in which he
loves to sum up his strength and versatility. Mr. Herbert, having re-
tired, sends only one picture. It represents Columbus on a white don-
key, overtaken by a Persian nobleman mounted on a mouse-coloured
steed with an exceptionally massive head. It is certainly not so good as
the painter's fresco in the House of Lords; but worse pictures have
been hung and applauded at Burlington House within the memory of
young men. In Mr. Boughton's "Dancing down the Hay" the sea-fog is
good; but the features of the dancers!—"Lord warrant us, what fea-
tures!" as Aubrey says. Mr. Pettie has much unmemorable bravado in

fabrics and flesh, with impossible white high lights. The charm of Mr. Anderson Hague's field of ripening corn in the shadow of a hill on a shimmeringly hot day baffles literary expression. Mr. Albert Moore's experiment with bright orange against a leaden background scorches the unseasoned eye. Portraits by Mr. Holl and the Messrs. Herkomer are here, there, and everywhere. Mr. C. L. Bokelman's "Fire in a Village" is a very honest and sensible piece of work. Beethoven, in Mr. Carl Schloesser's latest edition, is far too respectably dressed, and his room too tidy. Mr. Albert Goodwin harks back to Sinbad the Sailor in a desert of seaweed. Mr. Frederick Vigers has changed the costume of Mr. Burne Jones's Angel of the Annunciation, and reintroduced her as Diana—of all people. Mr. Bernard's ineptitude with the brush is fatal to his "Corin and Touchstone." Mr. Arthur Wasse has chosen a capital subject in "Lancashire Pit Lasses at Work." You cannot choose but look at Mr. Carolus Duran's portraits, with their distinction of pose, and peculiar delicacy and splendour of colour. Mr. Logsdail, modest this year, contents himself with a couple of studies of London street traffic, which show that he has not yet worn the gaudy hues of Venice out of his eyes. The water-colour room is full of excellent work, of which I have only space to point out an exquisitely finished study of some furniture and shooting apparatus by Miss Kate Hayllar, whose work is as thorough as that of her sister, Miss Jessica Hayllar. In the black and white room the "Pan and Psyche" after Mr. Burne Jones, by Mr. C. W. Campbell, proves what a loss has been sustained in the recent death of this young master of pure mezzotint. The sculpture I must pass over, and the Grosvenor Gallery chronicle must perforce wait another week.

The World, 4 May 1887 [C314]

The Grosvenor Gallery

[Daniel Maclise (1806–70), ARA 1835, was the Irish portrait and historical painter. Henry John Yeend King (1855–1924) was a London rustic genre and landscape painter; William Hughes was a London genre and still-life painter. John Collier's subject was John Lawrence Toole (1830–1906), English actor and theatrical manager. Hubert Herkomer's portrait subject was Henry Fawcett (1833–84), economist, Liberal M.P., and Postmaster General in 1880. Arthur Hacker (1858–1919), historical and genre painter, would become a popular

society portraitist. *Hippolyte Paul Delaroche (1797–1856) was an École des Beaux-Arts professor and a master of historical painting.*

Mrs. Laura Epps Alma Tadema (1852–1909), painter of children and domestic subjects, and Dutch-born like her husband (Sir) Laurence, was his second wife and the mother of Anna Alma Tadema (1864?–1943), landscape, genre, and flower painter.

Harry Furniss (1854–1925), Irish-born caricaturist for Punch, *went to school in Dublin with Shaw; he was a successful book illustrator but failed with his* Furniss's Christmas Annual. *Archibald Stuart Wortley (1849–1905) was a painter of portraits and sporting subjects. De Maris is the Dutch landscape and waterscape painter Jacob Maris (1837–99), who on 20 June 1888 Shaw would anglicize into James Maris (C452). Edwin Roscoe Mullins (1848–1907), sculptor, would be author of* A Primer of Sculpture *(1890). (Sir) Henry W. Lucy (1843–1924) was a journalist who wrote on parliamentary matters for London papers 1881–1916. William H. Bartlett (1858–1932) was a London painter of genre and sporting scenes; Arthur A. Lemon (1852–1912) was a genre painter born on the Isle of Man who lived and painted in Italy.*

Francis Wilfred Lawson (1842–1935) was a painter and illustrator of sentimental genre scenes; Arnold Helcke, a Guernsey landscape and seascape painter, exhibited in London 1865–98. (Sir) Ernest Albert Waterlow (1850–1919), ARA 1890, was landscape and animal painter in oils and in watercolors. Dorothy Tennant (1855?–1926), genre painter and illustrator, married explorer and journalist (Sir) Henry Morton Stanley in 1890.]

It is said that Mr. Burne Jones has already been recommended to the public, by a critic rather struck with some of his work, as "the father of that rising young artist Mr. Philip Burne Jones." This view of the case is premature; but Mr. Philip is undoubtedly a very promising aspirant, with a pleasant talent for representing floods of light. Thus, last year he gave us the radiance of the sun in a garret; and this year he shows us the radiance of the moon in a street, with a quaint incident to give point to it. Two schoolgirls, returning from a party, are startled by a funny shadow, and rather a puzzling one; for though it seems at the first glance to be a simple matter of a sweep emerging from a funnel-shaped chimney, further examination proves that the sweep is naked, has no brush, and is in the attitude of a bell-ringer. Turning to the catalogue, and finding, not without astonishment, that the supposed bell-ringer is St. Simeon Stylites praying on his pillar, one cannot wholly approve of so venerable an artistic tradition being made fun of in this fashion. But when an appended sonnet makes it clear that the

treatment is intended to be impressive, and that the two girls are exhibited as having "on their face" (*sic*) "the terror of the Lord," it is clearly time to tell Mr. Philip Burne Jones that he cannot, by sonnets or otherwise, obtain credit for anything that is not expressed by this own hand. It is barely possible that the picture delicately conveys an opinion that his friend's sonnet is moonshine: if so, it only remains to say that painting is one thing, and literary criticism another.

In Mr. Burne Jones's "Garden of Pan," the man and woman who are listening to the god's pipings form a group that will tempt every sculptor and metal-worker to reproduce it. It is a triumph of high draughtsmanship: no other achievement of the year can compare with it. To Pan, on the other hand, I take exception. He is playing the flageolet, an instrument with an easily mastered embouchure. Further, he must be supposed to have been an exceptionally skilful performer. Yet his distorted face is that of a novice receiving a first lesson on the clarionet. The background of green hillside, though indispensable to the decorative plan of the work, is a little dry; and the sober colours of the little rushy pool come with almost ascetic effect from the painter of "The Mill." The Perseus picture shows us Andromeda, in a plain gown and shawl, bending over a jasper font, in which, by a slight cocking of the perspective, not only her face, but Perseus's and Medusa's, are visible to the spectator. Medusa's complexion is anaemic, but not appallingly baleful: Andromeda, indeed, seems to consider it overrated. The picture is very fine; but the excessive artificiality of the arrangement—the composition, as it used to be called—will not please everybody. The portrait in blue deserves all the pretty things that have already been said of it, but the elfish "Katie" opposite the door is an unattractive freak of domestic portraiture. Hard by the "Garden of Pan," and at certain hours almost invisible to a careless eye amid the glitter of the frames, is Mr. Strudwick's "Love Story," quietly beautiful, without vulgar thought or a hasty stroke, the track of the brush concealed by perfect finish and the painter's patient contriving by perfect distribution of his wealth of detail. In an auctioneer's catalogue the subject would be described as "Room, with Two Girls": but no catalogue could tell how beautiful a room can be, and how pure the charm of the presence of two girls, on the canvas of a painter who works and feels for his work as Mr. Strudwick does. Not that it is to be expected—rents being what they are in Kensington and St. John's Avenue—that every painter shall work in this fashion. No: *c'est magnifique; mais ce n'est pas la guerre.* Mr. Spencer Stanhope does not spare labour; but he misapplies it. Would he but take one lesson in boxing or fencing, one walk through the Greek statues at the British Museum, or one glance at any well-instructed actor or actress, he would learn enough of the

law of grace and gravitation to set his figures properly on their legs and their heads reasonably on their shoulders. And may I say, whilst in a plaintive strain, that I doubt whether Mrs. Stillman shows any real appreciation of a strong man like Dante by repeatedly painting him as a limp, sprawling, moping, mediaeval Mrs. Gummidge? It is a relief to turn from him to the whirl of life and movement in Mr. Walter Crane's thoroughly virile "Chariots of the Hours."

A graceful link between the poetic figure-painters and such very prosaic ones as Mr. John Collier and Mr. C. W. Mitchell is Mr. W. B. Richmond, whose "Icarus," if used as a poster by one of our "flying man" athletes, would make art critics of all the town, and whose rapidly turned-out portraits are astonishingly dainty and refined. Mr. Herbert Schmalz's omission of the atmosphere from his "Blondine" has produced the harshest results. He has nothing at the Grosvenor so respectable as his "Widowed" at the Academy, a large composition in which the men and women are evidently treated as mere material for a luxuriously melancholy pageant. Its low tones recall Maclise's colouring; and it is chiefly interesting as a pledge that Mr. Schmalz is not really going to waste the stuff that is in him upon the trivial branch of portraiture he has lately been exploiting. Mr. C. W. Mitchell has expended much care and blue paint on the text, "And many bodies of the saints which slept arose and came out of the graves." His saint, a young middle-class Englishwoman, has, to the consternation of her parents, come straight home. The arrangement is theatrical, and the scheme of colour—if it can be called a scheme—wrecked by the huge patch of blue and cream. Mr. Yeend King spares from the Academy one of his exercises in metallic verdure, which I cannot identify with any hue of foliage or herbage known to me. Mr. Nettleship contributes one of his "Zoo" pictures. In it, with characteristic independence, he represents tigers and antelopes among the *fauna* of what seems to me to be the Isle of Wight. Mr. William Hughes' delicate gray-brown "Cygnets" are an acceptable departure from the staring white swan of commerce. Mr. John Collier does himself more credit as an idealist in his portrait of Mr. J. L. Toole than in his "Lilith," a fine, impudent, matter-of-fact naked woman, worlds apart from the Lilith of Rossetti. In Mr. Hallé's work, as usual, the picture cannot be seen for the figures. Mr. Herkomer's portrait of Henry Fawcett, though in his finest manner, will not supplant his "self-oblivious" lady at the Academy as first favourite among his works of the year. The messes of green into which Mr. Alfred Parsons has been of late suffering his landscapes to run grow tiresome. Mr. Arthur Hacker gives us a variation in dustcolour of Delaroche's Christian Martyr theme. Mr. Poynter must have painted his "Corner of the Market Place" to keep his hand in: there is

certainly no other point or purpose discernible in it. "The Judgment of Paris" is in Mr. Watts's chalkiest manner. Hera is magnificently tall, Athene mortally spiteful, and Aphrodite enchantingly lovely. Miss Anna Alma Tadema has, with devoted exactitude, given us the truth, the whole truth, and nothing but the truth concerning the drawing-room at No. 1A Holland Park. In Mrs. Alma Tadema's "Always Welcome" the accessories are solidly and handsomely painted; but I confess to a doubt whether the figure seated on the bed is a child or a doll. The brilliant effects in Mr. Biscombe Gardner's "Brook Hill" are forced: the specimen of his work with the graver in the black and white room at the Academy surpasses anything that he has done this year with the brush. Mr. Jacomb Hood's "Spring" is pretty, and entirely unnatural. Mr. G. D. Leslie's "Visitors" is summery and up-the-rivery. Mr. Philip H. Calderon's "In Forest-deeps Unseen" is a sample of the sort of thing Mr. Harry Furniss may perhaps laugh out of our galleries some day. The gigantic red and green insects running up and down the heathery hillside in Mr. Stuart Wortley's "Big Pack" turn out on close inspection to be cartridge-cases. Mr. J. W. North sends two pictures, neither of them quite so successful as his "Early Spring" at the Water-Colour Society. Mr. Barrett Browning has painted a woman in a black shawl and skirt, from beneath which a large white-stockinged foot peeps, or rather stares, all in the coldest, most prosaic light. The subject seems to have engaged the artist because it was not pretty and not easy: Mr. Calderon, for instance, would have seen it further—if that is a proper expression for a critic to use—before meddling with it. In Mr. J. J. Shannon's portraits here, as in those at the Academy, his individuality begins to insist more and more on attention. Mrs. Jopling's big and crudely-coloured "Funeral of a Priest in Venice" is conclusive as to her need for some hard study. Surely so bright a talent as hers could with due industry produce better hands and faces than these. Mr. Tuke's boys are still bathing in shine and shadow; and Mr. C. H. Shannon struggles, in his peculiar fashion, for a power which has not come yet, but may be on the way. Mr. Holman Hunt's two pictures seem to be portrait studies, and present no novel features, except that one of them—a boy seen through a window—owes its effect to the real glass in the frame. Mr. H. H. La Thangue's "Runaway," a girl lying in a cornfield, is blocked out in a number of short straight lines, which can hardly rank as drawing. The tint in the girl's gown is curiously effective, and the picture altogether remarkable. Mr. Henry Moore, as usual, repeats his favourite blue sea, reminding us of one side of a greater painter, De Maris. Mr. Alfred Hunt is fortunate in having such a work as his "Rose Red Village" to spare for the Grosvenor, after dealing so generously with the Water-Colour Society and Burlington

House. Mr. Roscoe Mullins, in his marble statuette, "Morn," shows that he can handle a chisel with some feeling. Mrs. Swynnerton (Miss A. L. Robinson) has loyally sent her best work to the Ladies' Exhibition at the Egyptian Hall. The face of her "Dreamer" will not bear scrutiny. Mr. Edwin Ward sends effective little portraits of Mr. and Mrs. H. W. Lucy; and W. H. Bartlett has been hard at work among the seaside folk in Connemara. Mr. Phil Morris has a good cloudy landscape with figures. There are also effective contributions by Messrs. Albert Moore, A. Lemon, G. H. Boughton, David Murray, J. R. Reid, Albert Goodwin, William Padgett, Frank Holl, F. W. Lawson, Keeley Halswelle, Fahey, Napier Hemy, Helcké, Waterhouse, Waterlow, Miss Dorothy Tennant, and others.

The World 11 May 1887 [C317]

[Pictures, Foreign and Domestic]

[A Shaw paragraph on photography this date is omitted. Franck Kirchbach (1859–1912), who painted in Munich and Berlin, sometimes anglicized his name to Frank Kirkbach. George Robert Canning, fourth Baron Harris (1851–1932), a member of several Liberal cabinets, was a great figure in the cricket world, captain at times of the Kent and England elevens. Frederick Robert Spofforth (1853–1926), Australian cricketer, was considered one of the great bowlers in the history of the sport. Carl Friedrich Deiker (1836–92) and Franz von Defregger (1835–1921) were German artists; Franz Hals (c. 1580–1666) was a Dutch portrait and genre painter, as was his similarly named son. Alfred George Stevens (1817–75), designer and decorator, produced nude studies in red chalk (to which Shaw refers) that were highly praised.]

Mr. Frank Kirkbach, the young Munich artist whose huge "Expulsion of the Money-changers from the Temple" is now at the Egyptian Hall, is a painter of remarkable promise, though he has not yet attained the full measure of subtlety, variety, and power which distinguishes the highest work on the large scale he has adopted. The principal group in the picture contains some beautiful and expressive figures, and there is character and incident enough in the crowd to make it interesting through-out. The picture is quite untainted by sensationalism or affectation, and produces a favourable impression of the indus-

try and educated taste of Mr. Kirkbach, whose career ought to be a highly distinguished one.

❖

At the Goupil Gallery, Messrs. Boussod, Valadon, & Co. exhibit a set of forty pictures by Mr. A. D. Peppercorn, an imaginative landscape painter, who loves to paint Nature when she is veiled in mist and twilight—when she would most completely disconcert Mr. Brett, for instance. His successful pictures are very good indeed: the "Hay-cart," "The Evening Star," the scene at the edge of the wood in autumn with the felled trees, and the "Golden Sunset," are poems on canvas. On the other hand, the unsuccessful ones, such as "Silvery Leaves," are as bad as the bitterest foe to impressionism could desire.

❖

At the Goupil Gallery, Messrs. Boussod, Valadon, & Co. also exhibit for a few days a picture destined for the Colonies, entitled "An Ideal Cricket-Match at Lord's." The elevens engaged were picked by Lord Harris and Mr. Spofforth; and their portraits, in twenty-two separate compartments in the base of the frame, form a predella "in the mode," says the very quaint prospectus, "frequently adopted by the early Italian Masters." Sir Coutts Lindsay it was who suggested the application of the early Italian fashion to a modern cricket-match. "The animated appearance of the scene," we are told, "is completed by the charming toilettes of the ladies, among whom will be recognized many of our popular beauties. Thus in a manner not before attempted, will be shown this thoroughly English game, as much esteemed in the Colonies as in the picture with considerable dexterity.

❖

Just a note concerning some exhibitions of foreign pictures. At the Continental Gallery Mr. Deiker's collection, which, terribly miscellaneous as it always is, is seldom without a few notable works, has been reinforced by Professor Defregger's "To your health," a large composition of half-length figures seated at a table, those with their backs to the spectator looking over their shoulders with glasses uplifted in the old Flemish fashion. The genial colouring, the broad, solid execution, and the cunning and spirited painting of the faces, remind us in a worthier way of Rubens and Franz Hals. The Hanover Gallery contains four Meissoniers, one being a sketch in water colour of the artist by himself. Two full-length portrait studies in pastel, by M. de Nittis and Mr. A. Stevens, show how much of our most characteristic modern work can be done with the crayon alone. A third collection, small, but

very select, is to be seen at Messrs. Obachs', 20 Cockspur Street. Two out of the three Corots exhibited are exquisite examples of that master's work. Eugene Delacroix, Meissonier, Israels, Daubigny, Harpignies, Mesdag, Mauve, and Troyon are also represented by works which will help to explain their reputation to the unskilled in foreign art. Let it be added gratefully that there are no tedious wallfuls of second and third rate work to be wearily searched through for the good things. A pleasant refuge for jaded gallery-trampers in Messrs. Obachs'.

The World, 8 June 1887 [C323]

[Watercolors and Drawings]

[Frederic Tucker, landscape painter who exhibited 1873–89, painted almost entirely in watercolors. William Heysham (1851–98), London marine painter and illustrator, worked for The Illustrated London News. *Amedée Forestier (1854–1930), Belgian-born, came to England in 1882 to work for* The Illustrated London News, *where he was Special Artist for ceremonial occasions at home and on the Continent until 1899. Georges Pilotell (1845–1918) left France after the 1871 Commune, in which he participated, to become fashion illustrator to the* Lady's Pictorial, *and free-lance caricaturist. Robert Barnes (1840–95) was a genre painter, illustrator and caricaturist; Samuel Begg, educated in France, contributed to* The Illustrated London News *and other English periodicals 1886–1916. Herbert Gandy (1855?–1920) was a genre and figure painter who exhibited, and contributed to English publications like* The Illustrated London News, *1881–1911. Walter Daniel Batley (1850–1919) was an engraver and a landscape painter in oils and watercolors.]*

At the Goupil Gallery the Jubilee has broken out in the shape of several dozens of water-colour pictures of Balmoral and thereabouts by Mr. Frederic Tucker. A little more sensitiveness in the painter's drawing would have made the set independent of the extraneous interest of "The Queen's Highland Home"; for the sketches are carefully and ably wrought, and reproduce much of the charm of the Grampian scenery.

❖

Messrs. Clifford & Co. have opened a new gallery in Piccadilly with an exhibition of drawings in black-and-white. Messrs. Caton Wood-

ville, Overend, Forestier, Pilotell, Barnes, Yglesias, Samuel Begg, Herbert Gandy, and many others contribute characteristic works. Mr. Gandy's "Sunday Evening," now made familiar by Mr. Batley's delicate mezzotint, is perhaps the prettiest picture in the gallery.

The World, 22 June 1887 [C327]

[Americans and Others]

[John Sartain (1808–97), London-born, emigrated to the United States in 1830, where he became a prolific engraver and illustrator for magazines and late for separate editions of historical works. He was art director of the Centennial Exposition in Philadelphia in 1876. Peter Rothermel (1817–95) was a Pennsylvania painter of historical and religious scenes who lived in Rome in the 1850s. Albert Bierstadt (1830–1902) emigrated from Germany as a boy and returned to Düsseldorf to study. In 1857 he returned and went West, becoming the great panoramic painter of the American Rockies. Sarah Paxton Ball Dodson (1847–1906) had become an expatriate, moving from Pennsylvania to Paris for further study, then settling in Brighton to paint biblical and historical scenes. Thomas Sully (1783–1872) came to Philadelphia from Lincolnshire as a boy, and became the leading portraitist of his generation. His coronation picture of Queen Victoria capped his career.

Marceli Suchorowski (1840–1908) was a Russian painter best known for his nudes, one of which here disturbed the critic.

George Tinworth (1843–1913), a sculptor who worked chiefly in terra-cotta, was known for his decorative panels in churches and other public buildings. From 1867 until his death he was employed at Doulton's Pottery Works in Lambeth.

Percy Tarrant was a London genre and figure painter who exhibited 1883–1904. Alice Mary Havers (1850–90), wife of artist Frederick Morgan, was a genre and landscape painter; Elizabeth (Mrs. Robert E.) Mack worked with her husband to write and illustrate such children's books as A Christmas Tree Fairy *(1887). Edmund Blair Leighton (1853–1922), son of a painter, produced Tissot-like pictures of elegant ladies in period settings, and historical scenes.]*

Mr. John Sartain has at last got the collection of pictures by "exclusively American artists" into order at Earl's Court. Under the interna-

tional circumstances, it is hard to know exactly what to say. If the collection were really representative, some unbiased foreigner might sum the matter up in an indictment of Providence for giving all the subjects to America and all the painters to us. Fortunately, we know better here than to form an opinion of American art from Mr. Rothermel, Mr. Bierstadt, and Miss Sarah Dodson, in the absence of Mr. Whistler, Mr. Abbey, and Mr. Boughton, and Mr. Hennessy. Still, it had better be said explicitly that but for the two pictures by Mr. W. L. Picknell, from the Walker Art Gallery in Liverpool, the galleries would convey to otherwise uninformed visitors an impression that the United States must be a century behind-hand in art. Much more entertaining is the room containing the stuffed bears and mountain goats, the aspect of the latter fully justifying Shakespeare's prophetic description of them as "dammed and luxurious." Thomas Sully's 1837 portrait of the Queen is chiefly remarkable for the ingenuity with which the artist, by a special effort to conceal the short stature of his august sitter, emphasized it quite startlingly.

❖

In Mr. M. Suchorowski's "Dream of Delight," now being exhibited in New Bond Street, the velvet curtain and the piece of tapestry may be regarded leniently as successful examples if imitative painting under circumstances of no special difficulty. With the unpleasant person on the couch the art-critic declines to concern himself.

❖

Messrs. Doulton are exhibiting a new terra-cotta work by Mr. George Tinworth. This "panel" is twenty-three feet long and nine feet high: and the figures are life-size—a scale to which it has been evident for some years that Mr. Tinworth must come at last. As might have been expected from his former achievements, the change is a change for the better. The admirable group to the right is one of the best in point of character and expression—both carried out to the very finger-tips— that Mr. Tinworth has done. One of the faults of the artist's qualities appears in the head of Christ, which is too small in proportion to the features to be perfectly dignified. The subject is "Christ before Herod."

❖

At Messrs. Cassell's exhibition of black-and-white work at the Memorial Hall, Farringdon Street, some clever and pretty drawings are offered at very modest prices. Mr. Percy Tarrant's work is remarkably effective; and Miss Alice Havers is in her element. Miss Dorothy Tennant and Mrs. Mack send graceful studies of children; and Mr.

Blair Leighton and Mr. Paget do what they can with popular illustration to history in monthly parts. Mr. Fred Barnard's studies from Thackeray are by no means so happy as his Dickens pictures.

The World, 6 July 1887 [C331]

[Du Maurier, Moore, Menpes, and Wyllie]

[George Marks was a landscape painter of the Kent and Surrey coasts; he exhibited from 1876 to 1922. Ettore (Franz) Roesler (1845–1907) was an Italian landscapist in watercolors. Charles G. Danford was a Hertfordshire landscape painter who exhibited in the 1880s.

Mortimer Menpes (1860–1938) had sent his Whistlerian scenes of Japanese life from Yokohama, where he was studying Japanese art firsthand.]

The water-colourists at the Dudley Gallery this summer display a thoroughness, delicacy of perception, and sincere feeling for Nature not common among the workers in oil. Messrs. Walter Severn and Joseph Knight have hit on some fairly fresh and interesting subjects; and Mr. A. F. Grace, Miss Mary Reeves, Messrs. George Marks, Rupert Stevens, Franz Roesler, C. G. Danford, and others exhibit noteworthy works. Mr. Hubert Medlycott still exploits the river; but Miss Kate Macaulay has abandoned her orange-tawny sails and floating boards for herons and old churches.

❖

Mr. du Maurier's "London Society" exhibition at the Fine Art Society contains his last two hundred contributions to *Punch,* and a few new drawing-room and staircase studies, from all of which, be it noted, the aesthete has entirely disappeared. The work of a fine penman like Mr. Du Maurier bears engraving and printing—even on the paper used by *Punch*—much better than the exquisite pencil draughtsmanship of Leech, of whose touch those who have only seen the published prints can have no idea. Fortunately for Mr. du Maurier, the difference between his actual handiwork and the familiar reproductions is comparatively trifling. We all know from *Punch* the tact with which he groups his figures and arranges his masses of black and white, the refinement and expressiveness of his drawing, the purity of his taste, the acuteness of his observation, and the variety of even his typical figures. What some of us do not know is, that he occasionally takes such liberties as palming off

a figure ten feet high as a lady or gentleman of ordinary stature. Of the general effect of the series it can only be said wearily that the season would be much more endurable if London society were as graceful or interesting as Mr. Du Maurier represents it. In contrast to his pen-and-ink work are the ninety pictures and drawings in the adjoining room by Mr. Henry Moore, whose range as a painter is hardly appreciated by the younger generation, which knows him chiefly as a student of one particular indigo aspect of the sea. They should go to Bond Street and have a look at his landscapes, and at his capital pictures, painted some years ago, of craft waterlogged in brackish drab waves.

❖

Mr. Mortimer Menpes, making sketches in Yokohama for next season's exhibition at Messrs. Dowdeswells', finds himself the only European painter in Japan, and writes home describing that country concisely as "full of lovely children and shops." He works, it appears, with exemplary diligence, "except on special occasions, such as the Mikado's garden-party." He has given the first Whistleresque "Ten o'Clock" ever held in Japan, and at the close thereof each painter present made a sketch on paper, and, prostrating himself, presented it to the apostle of New English Art. No wonder Mr. Mempes thinks them "a charming people." One would like to know what they—especially the artists—think of Mr. Menpes.

❖

Mr. Dunthorne, who has touched up "The Rembrandt Head" in Vigo Street gaily for the season, exhibits there a series of spirited and dainty sea-sketches by Mr. W. L. Wyllie, whose eye for craft of all shapes and sizes, from ironclads to luggers and barges, can always be depended on to make shipping interesting. One or two of the minuter studies of the sea (No. 33, for example) suggest that Mr. Wyllie has gained a hint from instantaneous photography. Despite the gloom of an occasional night-scene, the effect of the whole is bright, breezy, and generally happy.

The World, 13 July 1887 [C333]

[Painting and Pottery]

[Frederic Albert Slocombe (1847–1920), landscape and genre painter as well as etcher, was one of a large family of artists.

Maria Longworth Storer (1849–1932) worked in pottery at this time, later in bronze. She was founder of the Rookwood Pottery in Cincinnati and a patron of the arts.

Shaw had earlier deplored Bukovac's using biblical names in order to pander female flesh.]

The Nineteenth Century Art Society seems to be gaining ground. At its summer exhibition, I observe with relief that the weakly pretentious figure subjects, which used to look as if they had been refused everywhere else, have at last been refused here, and replaced by fairly presentable landscapes. Miss Alice Miller's "Isabel" shows a marked advance in power; and Mr. William Padgett's "Winter Moonrise" is one of the best "nocturnes" of the year, so far. Some of the water-colour work is excellent; and Mr. Slocombe's clever adaptations of mezzo-tinting give interest to the black-and-white corner.

❖

The exhibition of pastel work by lady amateurs and artists at Howell & James's will give a fresh impetus to the "boom" which dry colours are certain to have as soon as their scope becomes as well known as their permanence. No tone or texture seems to come amiss from them in skilled hands. Mr. Stacy Marks, who has helped Mr. Goodall to award the prizes, sends a few works which he could have done no better in oils. The Rookwood pottery, the result of Mrs. Maria Longworth Storer's experiments at Cincinnati, is admirable in form and colour: some of the glazed pieces are of most satisfying delicacy and richness of hue. If the work on china continues to advance in freedom of style and variety of method, we shall soon have Corots and Constables on tiles. It would not be easy to find, even among genuine old ware, pieces finer than one or two of the best prize-takers.

❖

Messrs. Vicars, of Eagle Place, Piccadilly, have a new picture from M. Bukovac, whose "Potiphar's Wife," like Mr. Goodall's cinnamon-coloured "Susannah," some time ago set the provincial British Matron strenuously and publicly blushing. M. Bukovac, whose former works have been nothing more than elaborate studies of the nude figure from the most beautiful models he could obtain, has, in his "Adam and Eve," taken a genuine subject, and treated it with some originality and great technical skill, still taking care to give us a very lovely Eve, and a handsome and ingenuous Adam—so young that one can hardly identify him with the traditional old Adam. If the picture were in daylight, apart from the glamour of the Messrs. Vicars's artful arrangements, it

would be easier to pronounce confidently on the solidity of the flesh-painting and the relation of its tones to the sunshine and greenery of the carefully-studied landscape. Under the circumstances, one can only say that the treatment of the subject is novel, the effect dazzling, and the picture quite void of offence.

❖

The plan of holding an exhibition of bad new pictures, helped out with a few tolerable old ones, annually in the gallery of the Albert Hall, has given an opportunity to say many modest artists, that, merit not being regarded as an absolute disqualification, the bad pictures are beginning to be crowded out by better ones. Some capital work of this year's date catches the eye during a walk round the gallery. The entertainment can be varied by tea and fossils, the latter on view down-stairs among "a private collection of Indian archaic remains, mostly prehistoric, illustrative of the earliest arts of man in the Stone Age."

The World, 20 July 1887 [C340]

[Robertson and Campbell]

[Charles Kay Robertson was an Edinburgh painter who exhibited from 1892 through 1902 with little distinction.

Shaw's efforts to assist C. W. Campbell's widow belie the picture of him as curmudgeon, as these were usually undertaken privately. But here too his paragraph is anonymous.]

The Constitutional Club has had a Jubilee gift in the shape of a huge picture, or rather a row of portraits on one canvas of some two dozen leading Conservatives. It would perhaps be unkind to say merely that that they are all very fine and large; but that is the only comment that suggested itself after ten minutes' contemplation of the twenty-six noblemen and gentlemen in question. The painter is Mr. C. Kay Robertson, ex-student at the Royal Academy in Edinburgh. Scotch artists seem to have a taste for commissions of this class. The picture is exhibited at present at the Haymarket by Mr. T. McLean, who will publish the inevitable photogravure.

❖

The late C. W. Campbell lived just long enough to show us what a fine art pure mezzotinting is, and how unwisely we have neglected it of

late years in our craze for etchings, nine-tenths of which are scratchy absurdities. His plates, "Venus and Galatea" and "Pan," after Mr. Burne Jones, are amongst the most beautiful published in recent years. It is late in the day to sing his praises now that he has joined the majority; but not too late, perhaps, to help Mrs. Campbell to get justice done to the work he left behind. Her name appears as the publisher of a masterly study in mezzotint of a sleeping girl with strong comely features and coarse black hair, wrapped in a plaid. As Mrs. Campbell lives at Tottenham, it seems probable that she would have had this little masterpiece published in Bond Street if "the trade" had appreciated it. Perhaps they were afraid that the method was too unfashionable; but that will soon be remedied if work like Campbell's be kept to the front. The plate, called "After Stormy Seas," is enough by itself to turn the tide.

The World, 27 July 1887 [C344]

[English Sculptors and Continental Painters]

[George Saul's native city of Carlisle was not interested in a statue of Aristodemus. He was not a native son, but rather the Greek hero of the First Messenian War (c.735–15 B.C.), who offered his daughter as a sacrifice to the gods in response to a Delphic oracle, defeated the Spartans, was elected king, then slew himself upon his daughter's grave.

M. P. Fleischer (1861–1930) was later known as Max Fleischer-Weimans; he exhibited widely on the Continent. Eugène Chaperon (1857–?) was a Paris painter and illustrator, especially of military scenes.]

Mr. Martin Colnaghi has got Mr. George Saul's fine statue of Aristodemus at the Marlborough Gallery. It would be a great pity to leave it there, unless we wish to teach Mr. Saul that the sole business of an English sculptor is to raise monuments, on commission, to Indian veterans, politicians, and chairmen of railway companies, who will generally be found willing to appear in marble without tall hats, as a concession to high art. Mr. Saul is a Carlisle man. Has not Carlisle got a town-hall or some other appropriate hiding-place for an imaginative statue by one of her sons? Aristodemus really deserves it.

❖

Among the latest importations at the Continental Gallery is M. P. Fleischer's "St. Gotthard," a huge picture of the *Illustrated London News* school. The excavators are trooping out of the tunnel, having presumably just finished the great work by knocking a hole right through. The picture is a good one of its kind; but the company of tired men, and the gray and cheerless light and colour, with everything unfinished and at sixes and sevens, is not exhilarating. The background is very perfunctory. M. Chaperon's "Regimental Bath" is an amusing and thoroughly studied picture of French soldiers, without defensive armour of any kind, facing a terrific *mitraille* from the regimental hose. The hero who has turned his back to the enemy is a capital life-study.

The World, 7 September 1887 [C354]

Notes by Ignotus

[John Bagnold Burgess (1830–97) painted Spanish and North African genre subjects; Percy Thomas Macquoid (1852–1925), genre painter and watercolorist, was also a decorator and furniture designer. John Absolon (1815–95), landscape, seascape, and genre painter, was also a book illustrator and theatrical scene designer. Charles Napier Kennedy (1852–98) painted portraits and domestic scenes at first, then turned to mythological and imaginative subjects.

Shaw does not make clear why 1887 was also the year of the "phonetic Jubilee"; however, he seems not to mean the book so influential for his Professor Henry Higgins of Pygmalion, *Alexander Melville Bell's* Visible Speech *(1867), as that would have been only a twenty-year anniversary. He may be referring, rather, to Bell's 1837 edition of the New Testament, with his phonetic markings, as this appeared in the year of the Queen's accession and brought Bell wide recognition.]*

I hear, with the sympathy born of experience, that the art of painting in water colours is hard up. Consequently, when the Royal Institute of Painters of that persuasion resolved to raffle their unsold stock, and invited me to inspect the prizes, I hastened to support them by my presence at their exhibition. Although I do not habitually intrude myself on the public as an art critic, I can consistently say that I have had

many years' experience of my own opinion as to the merits of pictures, and that I am as well satisfied with it now as when I first entertained it.

No less than fifty-four painters who have promised contributions had not sent them in when I arrived. I respectfully urge Sir John Millais, Mr. Alma Tadema, Mr. Abbey, Mr. Burgess, Mr. Gow, Mr. Herkomer, Mr. Stacy Marks, and Mr. Waterhouse to hurry up. Mr. Goodall, Mr. Caton Woodville, Mr. Blair Leighton, and Mr. Percy Macquoid must also be kept to their word. But Mr. Herbert and Sir Coutts Lindsay may take their time.

Before definitely making up my mind to subscribe a guinea for a photogravure of Sir James Linton's "Declaration of War" and a chance in the ballot for the pictures, I should like to know whether, if I win, I can be legally compelled to remove my prize. Suppose, for instance, that I win Mr. John Absolon's "Storm Brewing," or Mr. Macbeth's "Early Morning in the Fens," must I take them home with me? Because, if so, I had rather not face the risk, being unlucky in such matters.

On the other hand, I should make no such difficulty about Mr. Keeley Halswelle's "Wittenham Clumps," or one of Mr. Alfred East's pictures, or that water-colour trifle by Mr. Boughton, "A Moment's Rest Up-Hill." Instead, I would take my chance cheerfully with most of the water-colours, especially as Fate might allot me Mr. Wyllie's "Gabriel's Wharf." Among the oil paintings, Mr. Waterlow's "Bathers" strikes me as a novel combination of the styles of Salvator Rosa and Corot. But it I can do without.

There is one picture, however, which I greatly covet to hang up in the office of the *Dramatic Review*. I allude to Mr. C. N. Kennedy's "Row in the Gallery." As this is the phonetic Jubilee, perhaps I had better spell it "The Rou in the Gallery," lest I be taken to mean a row of seats. A soldier and a civilian are coming to blows, and a young woman is hanging on to the red coat, as young women do when a man must either have his eyes blacked or his hands free. The gaslight and the murky shadow of the theatre ceiling are painted with a creditable degree of success; and the faces are capital, except the sentimental young lady on the right, with her alabaster cheeks in a false light. If I win the picture, I shall paste a piece of brown paper over that maiden, and touch up the cheeks of the belligerents with a little white chalk. I find that when I fight soldiers in the gallery on first nights they become paler than their neighbours; and I have been told that close observers can detect a certain pallor in my own complexion on such occasions. This is not due to any want of self possession on my part, as it is my custom to request a policeman to conduct the final stages of the combat.

Dramatic Review, 8 October 1887 [C360]

[Vassili Verestschagin's Realism]

[The scenes of Osman Pasha's five months' defense against the Czar's forces in 1877 was Plevna, a small town in Bulgaria. Russians and Rumanians superior in numbers to the Turks botched the campaign, succeeding only when Plevna's supplies gave out that December. Expecting an easy victory, the Russians at first gave an imaginary importance to the capture of Plevna, which proved embarrassing.

The gallery of wax models of Madame Marie Tussaud (1761–1850) at the time was in Baker Street; when the exhibition of lifelike heroes and rogues burned down in 1925 it was reopened in the Marylebone Road.]

Eight years ago people could hardly be induced to go as far as Prince's Gate to see Vassili Verestschagin's pictures at the old India Museum. At present their shillings are pouring into Sir Coutts Lindsay's turnstiles, and the works of "the painter-soldier-traveller" are the wonder of the winter season. Those who go expecting to find in the Grosvenor Gallery what they usually find there are being disappointed: those who prefer a museum and panorama to any picture-gallery are being delighted. For Verestschagin, judged by the standard at which Mr. Burne Jones, for example, aims, is no artist at all. In no discoverable stroke of his brush is there more artistic feeling or purpose than there is in ordinary penmanship. "What a relief!" the realists will say. Well, perhaps so; but no one who goes conscientiously through this collection will ever thereafter deny that realism can be quite as tiresome as the other thing. Verestschagin is a prodigiously able painter of the *Illustrated London News* school, special-at-the-seat-of-war department. He can paint anything he sees—fire, air, snow, blood, mountains, trees, telegraph-poles, temples, princes, peasants, officers, soldiers, civilians, anything you please, and all in their appropriate lights, indoor, outdoor, morning, noon, or night. The ease with which he throws crowds of figures, living and dead, upon his canvas without the slightest confusion, is amazing. His favourite subject is homicide. "Observing life through all my various travels," he says, "I have been particularly struck by the fact that even in our time people kill one another everywhere under all possible pretexts, and by every possible means." Accordingly, we have such works as "Blowing from the Guns in British India," on the lines of drawings in the basement of Madame Tussaud's, as well as the coolly realistic Plevna pictures, with the starving, rotting, freezing soldiers on one wall, and on the other the Czar seated on a hill far away enjoying the excitement of battle in perfect safety and comfort. "Hanging in Russia," and "Crucifixion by the Ancient Romans,"

are really pictures of *the* Crucifixion and *the* hanging (of the conspirators who killed Alexander II.), hung so as to suggest a parallel between the two events. "The Holy Family," which horrified the pious Viennese, will attract no attention here, Sir John Millais and Mr. Holman Hunt having accustomed us to naturalistic treatment of the subject. There are many minor works representing Eastern scenes, some full of interest, but all void of charm. The larger ones have a panoramic spaciousness which may be studied as the realism of grandeur of style. Their force and vividness has been obtained chiefly by heaping solid white on the lights, and painting the shadows thinly and transparently. On the whole, the show is a curious and instructive one, and its moral is well driven home; but it is not beautiful. Everybody will go once: few will go twice: no one will ask the price of any of the pictures.

The World, 12 October 1887 [C363]

[Harry Furniss's Drawings]

[Benjamin Disraeli, Earl of Beaconsfield (1804–81), made his last visit to the House of Lords on 15 March 1881 in very failing health. He died on the morning of 19 April.

George Cruikshank (1792–1878), illustrator and cartoonist, remains best known for his illustrations of Charles Dickens, beginning with the novelist's first book, Sketches by Boz.*]*

Mr. Harry Furniss has collected upwards of four hundred of his drawings at the Gainsborough Gallery, where you can purchase the original of any of the marginal portraits from *Punch's* "Essence of Parliament" for five guineas, the "House of Commons" scenes for twenty, the "Interiors and Exteriors" for twenty-five, or "Lord Beaconsfield's Last Visit to the House," for one hundred. Nowadays he sells twice who sells to the illustrated papers. The drawings are very clever and very funny, and a development towards beauty and wit is apparent in the later ones; but the artist's extraordinary powers are not yet ripe. If his hard-studied Parliamentary work shews knowledge as well as fancy, his book illustrations and other ideal works shew the same fancy, with much less study and knowledge. The figures are posturing, stooping, swaggering, sprawling, tumbling, playing practical jokes, and doing what they can to avoid the difficulties of straightforward drawing. The shoulders of some of the men are humps hanging half-way down their backs: the torsos of

most of the girls something between a corset-maker's advertisement and a ham turned upside down. The old lady with the queer right shoulder in No. 1, the ungainly young man stooping over the table in No. 32, the beau in "Old Vauxhall," No. 96 (recalling by contrast one of Cruikshank's happiest etchings in that style), the outrageous back of the man in No. 229, and such repulsive and unsympathetic caricatures of working-class humanity as No. 382, mark the point at which Mr. Furniss falls short of Leech and Mr. Du Maurier, who have shown us that a draughtsman can get abundant fun out of society without forgetting the artistic impulse towards beauty, or overstepping the line between ridicule and insult which divides the satirist from the street-boy. However, in one of the designs for *The Comic Blackstone* (84), the chief female figure is upright, tranquil, and almost as dignified as one of Mr. Du Maurier's. 163 and 167 also mark a distinct gain in power. Even the characteristic overflow of buffoonery is growing more and more serious in intention—and after all, seriousness of intention and width of sympathy are the qualities that make the great humourist. *Pickwick* is a very funny book; but it is not of *Pickwick* that we think when we make large claims for the author of the *Little Dorrit* and *Great Expectations*. Mr. Furniss must be satisfied for the present with the compliment implied in illustrating his case by that of Dickens. It only remains to say that the drawings are much better in the original than in the engraved version; and that the darkness of the Gainsborough Gallery serves to render the electric light visible.

The World, 19 October 1887 [C366]

[Watercolors]

[Francis Bret Harte (1836–1902) was the American expatriate author of short stories and verse, much of it written from his rooms in Lancaster Gate. "Grinnich" was his idea of Cockney pronunciation of the London suburb.

Johannes Albert Neuhuys (1844–1914) was a Rotterdam genre and townscape painter; Albert Edelfelt (1854–1905) was a painter in watercolors and pastel. Johannes Bosboom (1817–91) was a Hague painter and lithographer.]

The Dutch Water-Colour Society's exhibition at the Goupil Gallery would make our famous water-colour school ashamed—if anything

could—of that inveterate British prettiness and sentimentality which made Bret Harte describe the cockney ideal of pastoral loveliness as "somethink that reminds you of Grinnich." The dignity of the Dutch painters, their sober colouring, breadth of style, sense of the poetry of light and shade, and their deep feeling for nature, which does not desert them, British fashion, the moment the weather puts a trip to Burnham Beeches out of the question, are all admirable, and help to maintain that respect for the painter's calling which a long course of Bond Street is apt to sap. The works signed Mesdag, Maris, Blommers, and Josef Israels need no recommendation; but a note of admiration is due to J. Bosboom's church interiors, to J. Neuhuys's street in Rotterdam, and, for its truthful effect of indoor light, to trifle by A. Edelfelt, called "At the Piano." The pictures of D. A. C. Artz will please the public, especially the very naturally composed troop of girls mending nets (No. 10); but his successes are cheap compared with some of the others. A. Mauve's sheep are decidedly tricky; and Josef Israel's baby (No. 40) is shockingly ill-drawn. That is about all that reasonable fault-finding can bring against a very good exhibition.

❖

Messrs. Dowdeswells' new gallery at 160 New Bond Street divides the interest of the accustomed amateur with Mr. Charles Gregory's water-colours. The little room at No. 133, in which Mr. Whistler's vinegar and brown paper decorations were perennial, has been abandoned for a handsome suite of galleries, with hangings of sombre green, the effect of which is very pleasant after the shabby gorgeousness of many another picture show. Mr. Gregory's sketches concentrate all the joys of the seaside tripper—the sunny awards and foliage, the red-brick chimneys, the yellow gorse, the apple blossom, the ruddy-cheeked maidens in straw hats and print gowns, the red fishing-nets, the boat by the hour, the rippling sea, the smiling sky, and—and so on, in short. It is all very pretty, and very dexterously done, if without much *finesse*. No. 15, "Polperro at Sundown," is the best piece of work in the collection.

The World 26 October 1887 [C367]

Winter Art Exhibitions

[John Seymour Lucas (1849–1923) was a London genre and portrait painter; Charles Wilda (1854–1907) was a German genre painter.

*Jakob Emanuel Gaisser (1825–99) and Wilhelm Menzler (1846–?)
were German painters; Remi van Haanen (1812–94) was a Dutch
landscape painter known for his moody winter scenes. Cesare Lau-
renti (1854–1936) was an Italian landscape and genre painter; Léon
Augustin Lhermitte (1844–1925) was a French painter and engraver
who first exhibited at the Salon at twenty, in 1864. Francisque Noailly
was a French genre painter who specialized in North African Arab
scenes. Salvador Barbudo-Sanchez (1857–1917) was a Spanish genre
and historical painter.*

*Raffaelo Sorbi (1844–1931) painted Italian genre settings; Brussels-
born Thomas Blinks (1860–1912) painted sporting and animal sub-
jects. Gilbert Davis Munger (1837–1903) was an American engraver
and painter; Aime Perret (1847–1927) was a French genre painter.
Émile Adelard Breton (1831–1902) painted landscapes in the Barbizon
manner; Gabriel Cornelius Ritter von Max (1840–1915) was a Czech-
born German genre painter whose later works became increasingly
symbolic. Antonietta Brandeis (1849–?) was also of Czech origin, but
painted in Italy. Richard Elmore, Surrey landscape and genre painter,
exhibited 1852–87. John Thomson Dunning (1851–1931) was a Mid-
dlesbrough landscape and figure painter; Frank Dickins, a London
painter, is known only for landscape and genre pictures exhibited
1886–87. William Brassey Hole (1846–1917) was a Scottish etcher and
painter of landscapes. Adolphe Monticelli (1824–86) was an Italian
landscape artist; Narcisse Diaz de la Peña (1807–76) was a Spanish
genre painter who worked in France. William Ernest Henley (1849–
1903), Scottish editor, poet, and critic, wrote the catalogue copy.*

*The German-born Lady Maxse was the widow of Sir Henry Maxse
(1832–83), English colonial administrator and Crimean War hero.]*

Several of the winter exhibitions of pictures opened this week. Mr.
Thomas McLean, in the Haymarket, takes a strong lead with seventy
picked works, including two new ones by Sir John Millais; a masterly
portrait of a lioness painted by Rosa Bonheur in 1883, and now exhibited
for the first time; and pictures by Mr. Leader, Mr. Fildes, Mr. Boughton,
Mr. Seymour Lucas, and several brilliant foreign artists—Wilda,
Munthe, Kiesel, Gallegos, Gaisser, Zuber, Menzler, van Haanen, and
Laurenti. Mr. Fildes has contributed "An English Maiden," all summer
innocence, muslin, and straw hat, to a series of eight pictures entitled
"Daughters of Eve"; but the first place among these is taken easily by
John Phillip's "Highland Lassie." Of Sir John Millais' "Allegro" and
"Penseroso," the first is the better, the tender gaiety of the colouring
being irresistible. The "Penseroso" strikes one as somewhat of an out-
rage on Milton; and there is not much more drawing in the young lady's

eyes than in the rims of an average pair of spectacles. However, if Sir John has come to regard the taking of infinite pains as vanity, it certainly cannot be said that he has not tried it.

At Messrs. Tooth's, next door to Mr. McLean's, the most remarkable picture is M. Léon Lhermitte's "Toil and Thrift," on a theme frankly borrowed from Millet. Mr. Keeley Halswelle's coast scene is the happiest example of his manner we have had from him of late; and S. S. Barbudo's "Court Matinée" is satirically splendid. Miss Clara Montalba's "Old Hastings," though not extraordinarily meritorious, is at least not the trick with a few colours which has served her for so many turns lately. Raphael Sorbi's pictures are vivacious and cleverly drawn; but they are void of atmosphere. Mr. Logsdail has quitted Venice, and started work in Cairo, which is rapidly getting painted to death. As usual at Messrs. Tooth's, Mr. Blinks's hounds are in full cry on every wall; and Mr. de Blaas is at his bravest. Francisque Noailly's "Halt" is an attractive bit of the sandy East—the sand being for once in a cool shadow, and not glaring—is custom always of an afternoon in the school of Leopold Müller.

At the Hanover Gallery, the trail of the French romantic and impressionist schools can always be struck. Among the more noteworthy pictures to be seen there at present are Gilbert Munger's landscapes, especially "Harvesting" (No. 12), Gérôme's "Diogenes," Aimé Perret's "Woodcutters," Émile Breton's "Moonlight at Artois" (which is an interesting departure from the conventional silvery studio moonlight), Berne Bellecour's military pictures, a little corner of garden-landscape by J. F. Millet (fils, and apparently a chip of the old block), Gabriel Max's "Homewards," Wally Moes's characteristic "Plucking Wild Flowers," and Mademoiselle Brandeis' Venetian canal-sketches. Mr. R. Elmore still follows Turner in his shadowy way; and Mr. E. Sanguinetti, having apparently given up fine art as a bad job, had devoted himself to the production of a "Rotten Roy" of the usual kind. It is greatly to his credit that he has done it so badly.

The Nineteenth Century gallery, being practically a cooperative show-room, naturally contains a few exceedingly bad pictures. Still, there is some promising work withal, as well as much that will amuse the innocent bourgeois without over-stimulating him. Mr. J. Thomson Dunning's "Off Dartmoor" is not bad; and Mr. Frank Dickins's "Sunny Sussex" is a simple, honest portrait of the place it represents. Miss Alice Miller "Lady Maxse" is clever but unsatisfactory—there is more in a face than Miss Miller sees there. The trees in Mr. Yglesias's "Undine" suggest thistles in a fog. Mr. W. Padgett sticks to his favourite bit of pictorial poetry in "The Camp Fire." He does it very well: but it is such a very little bit! The water-colours are not up to the standard of

past exhibitions, Mr. Slocombe's graceful and ingenious specimens of mezzotinting being the most interesting feature in the smaller room.

A reminder of the French and Dutch pictures at the Edinburgh International Exhibition of 1886 is in the market in the shape of a memorial catalogue, published by David Douglas. It is a very handsome piece of printing, as becomes a catalogue which runs into guineas. Mr. William Hole, in attempting to imitate the work of the Marises, Monticelli, and Diaz with the needle (etching-needle, *bien entendu*, not crochet), has courted honourable defeat, more than compensated by his success with Corot and Bosboom. Mr. W. E. Henley is responsible for the biographies and descriptive notes.

The World, 2 November 1887 [C370]

[French Influences]

[E. Aubrey Hunt (1855–1922) was born in Boston but lived and worked in Hastings, Sussex, where he painted landscapes and country scenes. Joseph Pennell (1857–1926) was born in Philadelphia but lived most of his life in London, working as an etcher and book illustrator, and in the days before he could find much artistic work, as art critic and even as cycling columnist—a job which Shaw found for him.

Raffaele Giannetti (1832–1916) worked in pastel and watercolor. Webb's picture was of the Dutch river town near Rotterdam.

Lucien Davis (1860–1941) was an artist for The Graphic *and* The Illustrated London News, *and an historical and still-life painter. Edith Driskane Somerville of Skibereen, County Cork, had exhibited two pictures, a small "Dreaming" and a large "Ordered for Execution." Arthur George Bell (1849–1916) was a London genre painter and book illustrator.*

Caldecott's Tichborne reproduction depicted the trial of "Arthur Orton" of Wapping, actually Thomas Castro of Australia, who claimed to be the heir of a large English fortune, left by Roger Charles Tichborne (1829–54), who had been lost at sea. After a trial of 103 days in 1871–72, the case collapsed, and the "Tichborne Claimant" was sentenced to fourteen years for perjury.

(Sir) Frank Short (1857–1945) was a Sussex etcher and engraver, considered a master of both techniques.

W. H. Wheelwright was a decorator and painter of interior scenes; Walter Paris the younger (1842–1906) emigrated to the United States

*and painted American settings. Shaw may be confusing him with the
elder Paris, who traveled from London to paint European and Indian
settings.]*

The private views last week were very private indeed, and the pic-
tures hardly visible, owing to the abominable weather. At the Goupil
Gallery the gas had to be turned on, to the great disadvantage of Mr.
Aubrey Hunt's Seine and Marne landscapes. Still, the sun, space, air,
cloud, vivid colour, and delicate tone in them could be appreciated in
spite of the sticky edges and garish gleams raised by the yellow glare.
These American artists trained in France are cutting out arduous work
for our home-made painters. There is Mr. Whistler, Mr. Sargent, Mr.
Parsons, Mr. Hennessy, Mr. Aubrey Hunt, and—in black and white—
Mr. "Jo" Pennell. They may be depended upon to keep the British
school awake for some years to come.

❖

Mr. J. P. Mendoza's black and white exhibition at the St. James's
Gallery in King Street contains plenty of smart work by well-known
artists. A couple of large works by R. Giannetti, in pastel, though still in
black and white, are beautifully soft, and full of suggestions of colour.
A tinted picture of Dordrecht, by Mr. James Webb, looks like an uncom-
monly strong piece of work; but Mr. Mendoza must find a better light
for it before any confident judgment can pass upon it.

❖

The Winter Exhibition of the Dudley Gallery Imperial Art Society,
though not so imperial as it might be, is up to the Dudley standard. The
growing influence of the modern French school is very notable: Mr.
Lucien Davis, Mr. Arthur Bell, and Miss Somerville especially defying
all British tradition. Miss Somerville's very distinct and welcome gain
in knowledge and power has, however, so far resulted chiefly in inter-
esting but ugly and consequently unpopular pictures. This is true of
most of her competitors from the French schools. The Dudley exhibi-
tion may be roughly divided into those who know what to paint better
than how to paint it, and those who know—how better than what, in
short.

❖

At the Rembrandt Head in Vigo Street, Mr. Dunthorne has some
essays in plaster and in terra-cotta by Randolph Caldecott. They were
found among his belongings at the Pantechnicon after his death; and
they show that his "knack of laying a few pretty lines" was based on

real knowledge of form. Some of the horses and calves in low relief are excellent; and the terra-cotta group of the Tichborne trial, in which gowned and wigged owls and tortoises fantastically suggest the eminent legal personages concerned, is a remarkable example of comic draughtsmanship "in the round." Mezzotint fanciers should examine Mr. Frank Short's plate after Mr. Alfred Parsons' clever but intolerably green "Cider Country." Also a masterly mezzotint of Mr. Watts's portrait by himself, one of Campbell's last works.

❖

The exhibition of sporting pictures at the Burlington Gallery contains a good many of those fresh, strong, open-air pictures of life on the frontiers of civilisation, which enlivened the Colonial Exhibition at this gallery two years ago. The customary sporting pictures by artists who are no sportsmen, or sportsmen who are no artists, are but slenderly represented. Mr. W. H. Wheelwright's painted screens are the very thing for a country house at this time of year. Across the street, at the Chesham Gallery, Mr. Walter Paris, the professor of landscape-painting at Woolwich, exhibits a series of water-colour drawings of North American scenery—Florida, California, the coast of Massachusetts, and so on—interesting in a quiet way, and, of course, competently executed.

The World, 23 November 1887 [C376]

In the Picture-Galleries
The Royal Institute and the British Artists

["Buffalo Bill"—William Franklin Cody (1846–1917)—had brought his Wild West show to England for the Jubilee year. Even the queen went to see it. Whistler did several minimalist etchings of the performances. Joe Gargery is young Pip's laconic but unintimidated brother-in-law in Dickens's Great Expectations *who negotiates Pip's London education with the supersecretive Jaggers, an overbearing lawyer accustomed to getting his own way.*

G. Demaine of Skipton, Yorkshire, is only on record as having exhibited the one landscape which Shaw viewed. William Gunning King (1859–1940) of Petersfield, Hampshire, painted figurative subjects. Mrs. Menpes was the wife of artist Mortimer Menpes. Mrs. Thornton was the wife of Edward Thornton, Hon. Secretary of the Bishop of London's Fund 1863–91. (Sir) Henry Rider Haggard (1856–1925) was

a novelist of increasing reputation; James Stanley Little (1856–1940), paired with him, was the executive secretary of the newly formed Society of Authors (the painter was his brother). Edward Smith Willard (1853–1915) played villains in a succession of melodramas.

Walter Richard Sickert (1860–1942) came to London from Munich as a child. His master—as with Anthony Ludovici—was Whistler. His theater and music hall interiors and London genre scenes made his reputation. Leonard Raven Hill exhibited figurative subjects in London galleries 1885–98. Shaw considered Claude Monet (1840–1926) the best contemporary Impressionist painter. George Leon Little (1862–1902?) was a portraitist and landscapist. Harry Quilter (1851–1907), art critic for The Times *and implacable enemy of Whistler, fancied himself a landscape painter. George Sherwood Hunter, Aberdeen landscape and genre painter, would join the Newlyn colony in Cornwall in 1898.*

St. George Hare (1857–1933), born in Limerick, settled in London and painted genre, portraits of children and of fluffy professional beauties, and historical pictures exploiting the nude. William Luker, Jr., son of a painter, exhibited 1870–93; he painted domestic subjects from his home in Berkshire. A. H. Bucknall is known only from this exhibition; Edward Clegg Wilkinson exhibited genre, landscapes, and portraits 1882–1904. William Henry James Boot (1848–1918) was a London painter of landscapes and domestic settings. Edwin Ellis (1841–95) painted Welsh, Cornish, and Yorkshire landscapes and coastal scenes; Frank Huddlestone Potter (1845–87) was a London genre painter.]

Just at present Mr. Whistler must be at least as well satisfied as any propagandist in London. The defeat of his opponents at the winter exhibitions is decisive. It is not so much that the new school (or the young school, the French school, the Parisian-American school, the naturalistic school, the impressionist school, the atmospheric school, the "New English Art" school, the Whistleristic school, or whatever you are in the habit of calling it) displays the best pictures, as that it puts the old school so hopelessly out of countenance. The empty artificiality of the venerable assortment of colours as recommended by the Society of Arts, laid on in the good north light that never was on sea or land outside a St. John's Wood studio, is shown up as strongly by the extravagant and bad pictures of the innovators as by their genuine triumphs. And just as, when a cherished acquaintance turns out to be a swindler, we cannot resist the illusion that somehow we saw through him all along, so looking at the more elderly British wall-ornaments at the Institute, it is hard to admit that such airless, lightless, sunless

crudities, coloured in the taste of a third-rate toymaker, and full of absurd shadows put in *a priori* as a matter of applied physics, could ever have seemed satisfactory pictures. You turn with relief even to the uncouth works of Mr. Charles Shannon, who, potentially able, but as yet only half emerged from chaos, paints strange little daubs of primeval man flying before the mammoth, and has them hung as if they were pictorial gems. In speaking thus contemptuously about the elderly school, I am doubtless sinking the critic in the reactionist; but this is not a time to be just to it. Its principle of giving a precise pictorial account of what it knew to be before it, led it to paint a great deal that it did not see, and to omit a great deal that it did see. It is now getting a tremendous lesson from the men who are trying to paint no more and no less than they see; and I am more disposed to help to rub that lesson in than to make untimely excuses for people who for many years outraged my taste for nature until I positively hated the sight of an ordinary picture.

At the same time, your naturalist gentlemen and ladies are not always easy to get on with. My delight in seeing a picture with something to breathe in it does not in the least reconcile me to the occasional prevalence of a ghastly lilac-coloured fog, worse, almost, than the good north light of the studio. Nor, though Mr. Whistler's "Red Note" on the fête on the Ostend sands seems to me the most exquisitely truthful achievement in Suffolk Street, and his No. 1 etching of Buffalo Bill's show inimitably happy and sufficient, can I be induced to tolerate his lithograph entitled "Reading." In much the same spirit as that in which Joseph Gargery met the supersubtleties of Mr. Jaggers, I ask Mr. Whistler if so be as he can draw a girl reading, to up and draw her: if not, to let her alone and give us some more red notes at Ostend. I would further say to Mr. G. Demaine, Mr. Gunning King, and others whom it may concern, that in these latitudes the sun, even on the summeriest days, never raises young ladies, muslin dresses, and flowers to a pitch of incandescence at which they seem on the point of fading into a white hot glow. Then, there are tricks—that of Mr. Theodore Roussel's portrait of Mrs. Menpes, for instance—which grow hackneyed: Mr. J. J. Shannon, in his dainty portrait of Mrs. Thornton at the Institute, is far more original and masterly than Mr. Roussel. I hardly like to call Mr. William-Stott's Venus hateful; but I must maintain that a painter who sees nothing in a woman but an idiotic doll, sees too little, whatever his school may be. And Mr. Walter Sickert, though his "Raven" proves him to be one of the gifted disciples of the new faith, exhibits some other little pictures which seem to me, to say the least, to be rather cheap.

Next to Mr. Whistler in subtle sense of tone, and superior to him in

completeness of representation, comes Mr. A. Ludovici junior, whose "Kept In" is really a masterpiece of its kind, and whose smaller works are of proportionate excellence. Mr. L. Raven Hill has a depressing composition with a student-like touch of the life school about it (though a genuine picture for all that), representing ancient Britons shooting one another at sight with arrows. The weather in it is intensely British, and very well painted; but I have always understood— and I hope I have not been deceived—that the ancient Britons stained themselves blue. In sharp contrast to this is an amusing little picture by the same artist called "On Guard," in which a dog sits on the sands watching a pink unbrella and other particulars in the equipment of a bevy of ladies who are presumably bathing. M. Claude Monet, rebelling against the sacrifice of vivid colour to truth of tone, impressionises in violent aniline hues, which justify themselves to the eye at a certain distance. Mr. Leon Little's double portrait of Messrs. Rider Haggard and Stanley Little is a praiseworthy attempt to get loose from the studio portrait of commerce; but though the features suggest the two sitters, the texture of the faces certainly does not suggest flesh, or anything like flesh. Mr. Sidney Starr's portrait of Mr. Willard in a stern jam-pot collar is much more like Mr. Willard than he himself is off the stage.

At the Institute it is satisfactory to note that Mr. Harry Quilter is progressing in his studies as a landscape painter. Mr. Tom Lloyd clings obstinately to his yellow gorse blossoms shining in strong lamplight in spite of the May morning, but Mr. Yeend King has seen the evil of his metallic green, and has modified it, with happy results, almost to what may now be called Parson's green. Though Mr. J. T. Nettleship, satiated with lions and tigers, has taken to painting cows, his imaginative manner is not subdued to the subject: there is in it something vaguely monstrous which turns the innocent milky mother into Behemoth. Mr. Philip Burne Jones's "Harvest Moon" is effective; but it is invented, not observed. Miss Pickering's "Hope in the Prison of Despair" is much better than her contribution to the last exhibition. The prison differs from ordinary prisons in having a doorway of magenta-coloured brick, and an arrangement of window-bars over which a captive of moderate activity could escape with ease. A new fashion in Dutch pictures has been hit upon by Mr. G. Sherwood Hunter, whose praying peasant in "Ave Maria" has a forcible realism, to which gleaming satin-white tiles and dark violet draperies give a certain singularity. There is a dash of Celtic romance in Mr. John Scott, which enables him to succeed with a degree of manual skill which would not carry most men very far. Mr. George Hare's "Cure for a Cold" is "still life" *in excelsis*; and his "Salvation Sisters" and "Fortune Teller" contain a couple of faces treated with a fine sensibility which is repulsively wanting in Mr. John Collier's

brilliantly handled figure of a girl posing, without a touch of dignity or reticence, as "A Priestess of Bacchus." Mr. W. Luker's "Which can I spare?" is a decidedly smart sample of the new style as applied to tailor-made dresses. Mr. A. H. Bucknall's "Old Coat" is of that variety of impressionism which sacrifices luminosity rather than form and colour in order to get a true effect of atmosphere. Mr. Clegg Wilkinson, again, has gone to extremes in order to give the people in his "Piccadilly" air; but it is not the air of Hyde Park Corner. Mr. J. Shannon and Mr. T. B. Kennington, whose work shows conspicuous talent, have occasionally fallen just short of their mark, as in the somewhat ghastly "Lady Maude Hooper," and in "Pleasure and Pain," where, but for the lamp on the table, the light would be taken for that of the sun subdued by yellow Venetian blinds. Mr. Reid has at least one notable picture; but his palette seems to get more and more muddled with brick-dust.

Returning for a moment to the British Artists to say a word for Mr. W. H. J. Boot's house-boat with Chinese lanterns on the river in "A Midsummer Night"; to congratulate Mr. Edwin Ellis on such a striking subject as "The King and Queen, Flamborough" without inquiring too curiously into the structure of these iceberg-like headlands; and to express my humiliation at finding out from the collection of works by the late F. H. Potter that I was utterly ignorant of the existence of a very interesting artist, I must conclude with a warning to my readers that I have left a quantity of good work by Mr. Stanhope Forbes, Mr. Jacomb Hood, Mr. Ayerst Ingram, Mr. Aubrey Hunt, Mr. Alfred Stevens, and many others (not, by the bye, including Mr. Sargent or Mr. Clausen, who do not exhibit) unnoticed for lack of space.

The World, 30 November 1887 [C378]

[The Royal Water-Colour Society]

[Wilfred Williams Ball (1853–1917) was a London-based landscape and marine painter.]

The winter exhibition at the Royal Water-Colour Society is as good as ever; but as there are no new exhibitors, and no new departures by the old ones, it is impossible to say anything to the point that has not been said too often already. The old society's art is a happy one that has no history. Mr. Wilfred Ball has sent some Venetian sketches to Mr. Dunthorne's little gallery at Vigo Street. Paladiense's Gallery, one of

the oddest establishments of the kind in New Bond Street, will not survive the year. Its manager, Miss Campotosto, who was so original that she was often unjustly suspected of having painted the whole collection herself, has resolved to abandon it, and devote herself wholly to her brother's art academy in Kensington Gardens Square.

The World, 7 December 1887 [C382]

[The Goupil and Fine Art Society Galleries]

[Shaw writes here almost as if he were an old Etonian; his Dublin schooling was both far different, and abbreviated. (Sir) Ernest George (1839–1922), by profession an architect, was also a recognized water-colorist and etcher. Lillie Langtry (1853–1929) was a professional beauty seen in dozens of "keepsake" portraits in the shops; she made a number of stage appearances to take box-office advantage of her notoriety. The Langtryesque figure "in the costume of Keats's Ceylon diver"—a reference to "Isabella"— in the poet's words "went all naked."]

 Mr. Russell Dowson's pictures of Eton at the Fine Art Society's Gallery are all the better for being painted in the colours which the school-boy remembers—the sunny green foliage and red bricks, or the melancholy winter skies and wet fields. The Etonian does not see with the eye of Suffolk Street. Those who find themselves overcharged with reminiscences and vain regrets can get prompt relief in the next room from Mr. Ernest George, whose copious sketches of bits of street in Venice, Rouen, and London are as little sentimental as even an architect's pictures can be.

❖

 Gérôme's picture called "Awakening," remarkable—in England at least—for the resemblance to Mrs. Langtry of the lady who is braving the morning air in the costume of Keats's Ceylon diver, is among the foreign works now at the Goupil Gallery. The figure shows the first faint symptoms of the growing infirmity of the master's hand. Bastien Lepage's "Going to School" is a masterly piece of painting; nothing else in the collection is so good. At Messrs. Agnew's there is a proof of Mr. Macbeth's etching of Walker's "Bathers." The brown tone is certainly

not suggestive of the original; but the plate is extraordinarily clever—too clever, if anything. Even the printer of the impression must be a workman of exceptional skill.

The World, 21 December 1887 [C384]

[British and Other Old Masters]

[George Romney (1734–1802) painted portraits, and allegorical and historical subjects, largely from London. George Morland (1763–1804), his contemporary, was a rustic genre, animal, and landscape painter who, despite his successes, ended his life in a debtor's prison, a victim of his extravagances. F. G. Stephens edited and annotated the Grosvenor catalogues, according to a non-Shavian entry in The World *this date, "with the art of imparting information without making the reader grateful for it."*

Mrs. Carwardine (1752–1817), shown by Romney in 1775 as a young mother with a small boy nestling against her shoulder, was the wife of the Rev. Thomas Carwardine, who accompanied the artist on one of his painting expeditions to Italy.

The Flemish painter Sir Anthony Van Dyck—also Vandyck—(1599–1641) was one of his century's greatest portraitists, Court painter to Charles I of England. His "Le Roys" are a pair of portraits of Philippe le Roy, Siegneur de Ravels, and his wife, Marie de Roet, acquired for the collection of Sir Richard Wallace (1828–90), Manchester Square, where they remain. George Villiers (1592–1628), first Duke of Buckingham, was a Court favorite of James I of England. Sir Kenelm Digby (1603–65) was an English diplomat and writer.

Giorgio Barbarelli (1477–1510), known as Giorgione, produced, in oils and fresco, large religious and mythological canvases, often with colorful landscape backgrounds. Johann (John) Zoffany (1733–1810), a favorite painter of George III, was of German origin but painted largely in London, where he produced portraits and conversation pieces. He did a number of pictures of David Garrick (1717–79), the most versatile English actor of his time. Sir Henry Raeburn (1756–1823), ARA 1814, was the favorite Scots painter of George IV, and his portraiture marked by bold brushwork. Sir Joshua Reynolds (1723–92), perhaps the greatest English portraitist, was the first President of the Royal Academy (1768).]

If this "Century of British Art, from 1737 to 1837," gathered by Sir Coutts Lindsay, should be halved next year and brought up to Jubilee date, the Grosvenor Gallery will not lack interest next winter. It may be remarked, in support of an idea of "outsider" interest, broached in this column last week, that three outsiders—Hogarth, Romney, and Morland—are the backbone of the present show, comprising the works of forty-six artists outside the Royal Academy and twenty-eight within its gates. Mr. Stephens is quieting down in his editorial vagaries of the catalogue; to be sure, he has found a new pet adjective in "verdurous" in place of verdant, "empowdered" hair is mightily affected, and there is a muddle, at No. 79, about "Porta Molli" and "Ponte Malle" (which may be a gate or a bridge, but cannot be both), I fancy, though I am not much in the Italian. Nor does this sentence seem quite in the English way; at page 109 he writes, "The turbulent breeze lashes the dark olive-green and gray water, which, dashed with lustrous ripples, are seen between two grave-looking yet elegant groups of trees." But "revision" will amend what is a very readable guide as it now stands. The portrait of Mrs. Thomas Carwardine and child (148), by Romney, will probably be the favourite among the large collection of portraits; for all the men would like to kiss the mother, and all the women would like to pet the child.

❖

The old masters at the Academy are eked out in the water-colour room by a show of bronzes, medals, reliefs and della Robbia ware, the last including that "Virgin and Child" with the lilies which is one of Mr. Holman Hunt's choicest possessions, and which it is really difficult to resist stealing. The inevitable huge Vandyke at the end of the large room is an absurd apotheosis of the first Villiers Duke of Buckingham; but the portraits of the Le Roys which flank it are very fine. The "Virgin and Child," No. 141, whether by Giorgione or not, is full of that master's peculiar charm. As usual, the exhibition is strong in Dutch masters. De Hooghe's "Music Party" is remarkable for the effect of the light transmitted through the red curtains, which in the splendid apartment depicted take the place of his favourite red tiles. Zoffany's character-pictures of Garrick, here and in the Grosvenor, will interest stage historians who may be curious as to the great actor's manner of "mugging." Raeburn's masterly portrait of his wife, in the first gallery, is full of that suggestion of the personal qualities of Sir Joshua which gained Raeburn the title of "the Reynolds of the North." The immense Marlborough Reynolds contains a delightful group of children; and Vandyke's "Sir Kenelm Digby" anticipating modern aestheticism with a sun-

flower, is full of power. There are Romneys all over the place; but the merits of these make too old a story to be pursued here.

The World, 4 January 1888 [C386]

[Monticelli and Mosaics]

[Adolphe Monticelli (1824–86), a Marseilles painter in the Barbizon and, later, in the Impressionist manner, was receiving his first posthumous show in England. Clement Heaton the elder (1824–82) was also recently dead, and Shaw's present tense suggests the younger (1861– ?), both London artists. Frederic Shields (1833–1911) was a Manchester watercolorist and illustrator in the Pre-Raphaelite manner, producing both religious and realistic work. Ernest Dade (1868–1929) was a Scarborough marine painter who lived and worked in the 1880s in Chelsea.

W. H. Wheeler (?–1887), who had painted from Richmond, was represented by items 131–74 in the show, landscapes and harborscapes from Kent to Cornwall.]

Messrs. Dowdeswell have succeeded in getting together seventy-five of Monticelli's pictures at their gallery in Bond Street. Monticelli is not a young man, startling the academies from their propriety by his daring modernity, but merely the name of a painter who was born so long ago as 1824, and died (of absinthe) in 1886. He began by painting in the manner of Diaz, but soon succeeded in getting rid of the ghastly cold grays and ivory-blue shadows that marred that master's gorgeous colour, and achieving an exquisite richness of bloom, warmth of atmosphere, and tenderness of tone. Finally, however, he forgot the tenderness of tone; became colour-mad; and lost so much more in beauty of form and grace of composition than he gained in heat and glamour, that some of his latest pictures are almost absurd. But there will be no conflict of opinion as to the beauty of such works of his second period as numbers 5, 9, 10, 13, 18, 30, 36, and 46. The titles—"L'Avenue," "Le Soir," "Sur la Terrasse," "Promenade au Jardin," &c.—are not worth giving: they are merely conventional, and express less, if possible, than the numbers.

❖

Mr. Clement Heaton also exhibits at Messrs. Dowdeswell's some specimens of what he calls "cloisonné mosaic." The *cloisons*, standing on metal panels, enclose spaces filled with marble cement, the colouring and manipulation of which give opportunity for considerable freedom of artistic treatment. So far, the purely decorative panels have been the most successful; but the process seems superior to mosaic in point of adaptability to figure subjects: and Mr. Heaton only needs bolder designs than those of Mr. Frederic Shields to make this evident. In the smaller gallery is a clever and promising set of sketches in water-colour by Mr. Ernest Dade, a young artist whose favourite subjects resemble those of Mr. Ayerst Ingram and Messrs. Wyllie. Also a collection of finished works left by the late W. H. Wheeler, whose unlucky sketching exploits amid the sewerage of Falmouth Harbour cost him his life.

<div align="right">The World, 11 January 1888 [C388]</div>

[Clara Montalba and David Law]

[A general with service in the Sudan who had published books was the future Viscount Wolseley, Garnet Joseph Wolseley (1833–1912); he would later write lives of Marlborough and Napoleon. Rhoda Broughton (1840–1920) wrote light, witty novels of country and town life. Her audacious young heroines in Shaw's later words had "obsolete schooling and no training whatever."

Jean-Joseph Pelissier was a Parisian artist in watercolors who exhibited in the 1880s and 1890s. Charles MacIver Grierson (1864–1939), an Irishman who had settled in London, painted genre and figurative subjects. Nelson Dawson (1859–1941) was a Yorkshire painter and designer whose works then in the exhibition were "The Soap Works, Putney," "An Appledore Beach," and "Permizzen Cliffs."]

The exhibition of water-colour drawings by Miss Clara Montalba at Mr. M'Lean's in the Haymarket comes in good time to rehabilitate the artist's reputation for versatility. Her pictures are so remarkably unlike other peoples' that, when met with by ones and twos in general exhibitions, they seem more like each other than they really are, so that one is tempted to dismiss them as mere repetitions of a set of tricks with chocolate-browns, greens, and oranges in a haze of gold or a delicate mist of transparent pink or green. Their variety is apparent enough at

Mr. M'Lean's. The subjects range from Dalmatian fishing-boats, the most artistic industrial implements civilisation has left us, the Cannon Street railway-bridges, which are stupendously ugly; from gaudy regattas in Venice to charming old English gardens in the Thames valley. Sometimes the representation is too good to be true: there is a doubtful sky here and there; and the water under the counter of H.M.S. Worcester in No. 20 will convince nobody familiar with such sights in Nature. It is not carelessness, but enjoyment of colour, which has got the better of Miss Montalba's conscience in these instances; and the result is certainly delightful.

❖

The private view of Miss Clara Montalba's pictures on Saturday afternoon brought together the usual crowd, with perhaps more than the usual excuse. The struggling mass of miscellaneous spectators prevented the true connoisseurs from getting anywhere near the drawings, and produced an almost insufferable condition of atmosphere, more Soudanese than Venetian, as must have occurred to a gallant General, equally distinguished in arms and in literature, who was in the thick of the throng.

❖

At the Goupil Gallery some "past and present students of the Royal Institute of Water-Colour Painters" have a little exhibition. The clever glimpses of nursery and schoolroom life, by Mr. W. Luker junior, recall Miss Rhoda Broughton's sketches of ill-regulated households. There is some good work by Mr. Pelissier, Mr. Grierson, Mr. Nelson Dawson, and others.

❖

Messrs. Dowdeswells have brought out, and, indeed, already sold out, Mr. David Law's etching of "Warwick Castle." Is there not a ghost in one of Shakespeare's histories who says somewhere, "Let him shun castles: safer shall he be upon the sandy plain than where castles mounted stand"? In the face of two plates so admirable in many respects as "Windsor Castle" and "Warwick Castle," it would be ungrateful to recommend Mr. Law to consider the ghost's advice; but it cannot be denied that his aerial touch, which serves him so exquisitely in skies, produces unsubstantial castles. This rather weakens the "Warwick Castle," which will be valued chiefly for the delicacy of the clouds and foliage, and the gentle summer atmosphere in which the landscape is bathed.

The World, 8 February 1888 [C401]

[The Nineteenth-Century Art Gallery]

[The "young gentleman" artist was Philip Burne Jones, who was labor-ing in his father's shadow. His Aesthetic sister was Margaret Burne Jones, then twenty-one. Julius Olsson (1864–1942) was an Anglo-Swedish landscape and marine painter influenced by Impressionism. Charles Gordon-Frazer, a landscape and figure painter, had hung two pictures, "Pontine Marshes" and "By Death's Hand Wedded," to which was attached a melodramatic quatrain about a dying lover. Friedrich Retzsch (1779–1857), a German painter and etcher, illustrated many classics, including Schiller, Goethe, and Shakespeare.]

The Nineteenth Century Art Gallery never disappoints modest expec-tations, and is, on the whole, improving. The young gentleman who laboriously paints his sister in her most aesthetic gown, and describes her in the catalogue as "A Daughter of Eve," is of course fully repre-sented; and nobody will grudge him an encouraging word. There is nothing else to note specially this season, except Mr. William Padgett's "Water Mill," with trees after Corot; Mr. Julius Olsson's too bold "im-pression" of quivering lights on the seashore; and a carefully finished water-colour by Mr. Charles Gordon-Frazer, which in conception and some qualities of execution reminds one of Retzsch, etcher of the famous but indifferent illustrations to *Faust*, and of the less known but much better outlines to *Burger's Ballads*.

The World, 22 February 1888 [C406]

[Bruce Joy and Anthony Ludovici]

[The commission for a Matthew Wilson statue had come from Skipton, whose M.P. he was. Wilson (1802–91) would be at the unveiling in the High Street, Skipton, on 7 June 1888. Alexander Balfour (1769–1829) was the author of Highland Mary *(1827) and other Scottish novels. The first Baron Farnborough was Thomas Erskine May (1815–86), jurist and author of the* Treatise on the Law, Privileges, Proceedings and Usage of Parliament, *still a standard work. George Berkeley, Bishop of Cloyne (1685–1753), born in Kilkenny, was an Anglican bishop and influential philosopher.*

Edwin Hayes (1820–1904), marine painter in oils and in watercol-ors, exhibited at the RA from 1855 until his death. William Clarkson

Stanfield (1793–1867) painted much of the scenery for the private theatricals staged by his friend Charles Dickens at Tavistock House. He was primarily a marine painter, in oils and watercolors, exhibiting coastal views and shipping at the RA from 1827.]

Mr. Bruce Joy has just sent a brace of colossal statues to the foundry. The production of these articles of bigotry and virtue involves a struggle with modern costume which tries a sculptor severely; and Mr. Bruce Joy generally compromises it by the judicious use of the Inverness cape. One of them is a statue of Alexander Balfour of Ashton Hall, to be erected at Skipton, though the commission came from the town of Bradford. The statue of Sir Matthew Wilson is more striking, the subject having had a monumental head, affording scope for a certain delicacy, energy, and accurate knowledge which give a remarkable force to Mr. Bruce Joy's heads, no matter on what scale they are designed. His bust of the late Lord Farnborough is so far advanced that, if sent to the House of Commons without further elaboration, it would probably be accepted by our innocent legislators as finished. A very beautiful piece of work in alabaster is the tomb of Bishop Berkeley of Cloyne, in modelling which Mr. Joy escaped for once from the colossal trousers and waistcoats which have been his doom since Fate began to pursue him with commissions for public statues of heroes in broadcloth.

❖

The last exhibition in Suffolk Street by the British Artists brought Mr. A. Ludovici to the front as the only pupil of Mr. Whistler subtle enough to do the master's best, and sensible enough not to do his worst. Accordingly, Messrs. Dowdeswell, as connoisseurs in Whistlerism, have given him a gallery all to himself; and his work stands the ordeal well. The petty vulgarities of the school are not spared: too few of the subjects are beyond the scope of any perfectly illiterate Cockney acquainted with Leicester Square, Liberty's shop, and nothing else; and the title of the collection—"Dots, Notes, and Spots,"—is in a vein which no one is bound to fall in with, and which those who take Mr. Ludovici's art seriously will be strongly disposed to fall out with. But there is no deliberate inaccuracy or ostentatious trifling in the less interesting parts of the pictures; and the good points—the delicate sense of colour, tone, light, and atmosphere—are all there. Mr. Edwin Hayes's pictures in the next room are so crowded on the walls, in consequence of their small size and great number, that many of them are spoiled by their neighbours. They are for the most part sea-pieces of the Stanfield type, lacking Stanfield's scene-painterly breadth, but showing a versatility and energy, a freshness and enterprise in trying

various styles and subjects, that he conspicuously lacked. There are several fine and happy bits of work in this collection, which Mr. Hayes has been accumulating for many years, and which he has hitherto kept apart from his contributions to the exhibitions.

The World, 29 February 1888 [C408]

The New Galleries at the British Museum

[White's wing now houses the Print Collection. William White had died at twenty-three in 1823, but it took a long time for his estate to revert to the British Museum. He had left considerable property in Hampshire and on the Isle of Wight, which by 1879, on the death of his widow, brought the Museum only £65,411 after duties. Edward A. Bond, who wrote the memorial leaflet from which Shaw derived his facts, was the Librarian of the Museum.

Sir John Lubbock (1834–1913), later Lord Avebury, was M.P. for the University of London, 1886–1900, and its former Vice-Chancellor. George Augustus Frederick Cavendish-Bentinck (1821–91), M.P. and a Privy Councillor, was a trustee of the Museum. His Grafton Street mansion was full of Venetian art and contemporary British art, and according to The World, *18 December 1889, he knew "more about Italian art and French furniture than any living Englishman." William Lecky (1838–1903), Irish-born historian and philosopher, was author of* A History of England in the Eighteenth Century *(1878–90), and would be M.P. for Dublin University. Richard Assheton Cross (1823–1914), M.P., held a number of cabinet posts and was then Secretary for India. Hugh Reginald Haweis (1838–1901), curate of St. James's, wrote on musical subjects and was an authority on violins. Dr. George Granville Bradley (1821–1903), Dean of Westminster since 1881, had been Headmaster of Marlborough and Master of University College, London. Edward Montagu Granville Montagu Wortley Mackenzie, first Earl of Wharncliffe (1827–1899), was a Museum trustee. Sir Edward Fry (1827–1918), Lord Justice, was an eminent jurist and as an authority on international law was involved in mediating international disputes.*

Aloys Károlyi (1825–89) was a Hungarian-born career Austrian diplomat. James Bryce (1838–1922), later first Viscount Bryce, was then Regius Professor of Civil Law at Oxford. Francis Charles Hastings Russell (1819–91) was the ninth Duke of Bedford; Sir Lewis

Pelly (1825–92) was an official in the India Office. (Sir) Sidney Colvin (1845–1927) had been Slade Professor of Fine Art at Cambridge and director of the Fitzwilliam Museum. He had become Keeper of Prints and Drawings at the British Museum in 1884, a post he would hold until 1912. Sir George Grove (1820–1900), critic and editor, prepared the analytic programs for the Crystal Palace concerts for more than forty years; he is now remembered for his Dictionary of Music *(1879– 89), now an institution. (Sir) Benjamin Ward Richardson, M.D. (1828–96), was a leader in public health reform movements and in medical education; he was also a published author of poetry, fiction, and biography. Lord Ronald Gower (1845–1916), a litterateur and art collector, had assembled a prodigious collection of prints and drawings relating to the French Revolution.*

Kyōsai (1831–89), also Englished as Gyōsai, a major Japanese print- maker, produced a Hades *series which included scenes of victims brought before Hellish devils.]*

"Private views" are not much known at the British Museum, but art, science, literature, dilletantism, and fashion made a pilgrimage to Bloomsbury on Saturday afternoon, at the invitation of Mr. [Edward Augustus] Bond, to enjoy a first peep at the wonderful Chinese and Japanese drawings and the glass and ceramic collections in the new portion of the building just opened, which has been christened the White Wing. This much-needed addition to the museum has been built from funds bequeathed by the late William White, who, by his will dated 10 December 1822, directed that on the death of his wife and child his considerable landed property and the bulk of his personal estate should revert to the trustees of the British Museum. Mr. White died in 1823, but his widow outlived him for a period of 56 years, so that it was not until 1879 that the trustees of the Museum took the benefit of the bequest.

Better late than never, however; and it so chanced that the funds came to hand at an exceedingly opportune moment. For, in 1879, the Government, in a burst of quite uncommon generosity, was spending handsome sums of the new natural-history buildings in South Kensing- ton. These were wanted badly enough, but extra accommodation was quite as sorely needed in Bloomsbury. The Government declined to pay the piper in Bloomsbury and South Kensington at the same time; so the moment the White funds became available there was abundant use for them. Space was required for the proper arrangement of the Greek and Roman sculptures; urgent relief was needed for the over- crowded state of the reading-room; a suitable room was lacking to the manuscripts department; and the department of prints and drawings

had been waiting many years for space adapted to the growth of the collections and for their exhibition. All these wants were enabled to be met in a more or less satisfactory manner by the help of Mr. White's bequest. A gallery was built in connection with the department of Greek and Roman antiquities, and an extensive building was erected on the south-eastern side of the museum, within which a reading-room for newspapers has been opened. Working-rooms have been provided for the manuscripts department; the ceramic and glass collections have gained a well-lighted gallery; and the entire department of prints and drawings has obtained convenient accommodation with a large gallery for the display of its treasures.

It was in the gallery devoted to the Chinese and Japanese drawings that Mr. Bond, the principal librarian, who played his part of host kindly, but somewhat shyly, received his guests. They were numerous and distinguished. Sir Frederick Leighton, P.R.A., one of the trustees of the Museum, strutted jauntily about in a blue coat of original cut and a blue tie, which was extravagant in size even for Sir Frederick. Sir John Lubbock and Mr. Cavendish Bentinck were the only other trustees whom we noticed. Mr. [Robert] Browning, looking as hearty and fresh as ever, had, as usual, so much handshaking to do that he could bestow but little attention on the collections. The tall, stooping figure of Mr. [William] Lecky, the historian, was visible everywhere, and the pale, intellectual features were very frequently lighted by Mr. Lecky's peculiarly seraphic smile. The Duke of Bedford, fresh from visiting the Queen at Windsor, kept 'isself to 'isself, as a duke should always do. That lively little clergyman and *littérateur,* Mr. [Hugh Reginald] Haweis, hid his clerical garb (as he is fond of doing) under a topcoat which reached his heels, and was surmounted by an Astrachan collar. Lord Cross, not much observed, looked as though he would like to ask somebody what Japanese art was all about, if he could but bring himself to ask anybody anything. The Dean of Westminster [Dr. George Granville Bradley] glanced sideways at Kiò-Sai's extraordinary studies of the King of Hell, and chuckled to himself when he thought nobody was looking. Lord Wharncliffe, Lord Justice [Sir Edward] Fry, Sir J. Linton, the Austrian ambassador [Count Aloys Károlyi], Sir Lewis Pelly, Mr. Andrew Lang, Mr. Ernest Hart, Sir George Grove, Professor [James] Bryce, Sir R. Pollock, Mr. [Thomas] Woolner, R.A., Dr. [Benjamin] Richardson, Lord Ronald Gower, and several gentlemen from the Chinese Embassy, in full Chinese rig, were a few other of the notabilities whom we passed in one or other of the rooms. As for the really splendid collection of Chinese and Japanese drawings, both ancient and modern, we could talk very learnedly about them if we chose; only we should have to do so by the guidebook of Mr. Sidney Colvin; for

our own unfamiliarity with the subject is as prodigious in its way as the muttonchop whiskers which Kiò-Sai has given to the King of Hell.

The Star, 6 March 1888 [C410]

[Millais and Birket Foster]

[J. Haynes Williams (1836–1908) was best known for his genre pictures, although here he has turned to interiors.

Francis I (1494–1547) was King of France 1515–47; Diana of Poitiers (1499–1566) was the mistress of Henry II of France, who, during her sway over him, ousted the Queen, Catherine de Medici, from Court.

Christopher Casby in Dickens's Little Dorrit *is a grasping and extortionate property owner (of Bleeding Heart Yard) who pretends benevolence but is exposed. Astarte in Phoenician myth is the goddess of love and fertility.*

George Oeder (1846–1931) was a German landscape and genre painter; Anton Laupheimer (1848–1927) was a German genre painter. Ferenc Eisenhut (1857–1903) was a Hungarian genre painter who specialized in Middle Eastern settings. Carl Wünnenberg, a German artist who worked in Rome, exhibited in the 1870s and 1880s; Louis Neubert (1846–92) was a German landscape and genre painter. Edwin Ellis (1841–95) was a London landscape and marine painter whose views were largely of Yorkshire, Wales, and Cornwall. Frederick George Cotman (1850–1920) was an East Anglian landscape and historical painter, mostly in watercolors.]

The chief excitement this spring at the picture-galleries is Sir John Millais' "Christmas Eve," at Mr. T. McLean's Gallery. At the Goupil Gallery, Mr. J. Haynes Williams shows the interior of the palace of Fontainebleau room by room, with a running commentary in the catalogue concerning Francis I, Diana of Poitiers, and the other disreputables. The French Gallery harbours the inevitable Heffners, with plush moss and satin water; a couple of capital Seilers, with Voltaire in a rage in one, and Benjamin Franklin, strongly suggestive of Mr. Casby, in the other; some cool and quietly but expensively got-up ecclesiastics by Professor Holmberg; and an arresting Astarte, with a surpassingly disagreeable lilac-ish background by Gabriel Max. Joanowits's large "Montenegrins bringing in Prisoners" is weak; the sky in Oeder's "Stormy Day" is vigorous and refreshing; and A. Laupheimer's "Hope

of the Family" has truth and humour. Messrs. Tooth in the Haymarket give the places of honour in their exhibition to Eisenhut's "Snake-Charmer," one of those glaring ophthalmic pictures which came into fashion with Cairo; and a shepherd-girl by Bouguereau, made positively ugly by the false lighting of the figure. Conrad Kiesel's "At the Bal Masqué" is a rich and striking treatment of a lady in costume: but for the superficiality of the head, it might, by its clever arrangement, pass at a distance for a Millais. C. Wünnenberg's delicate and fanciful work is curious, but will possibly come to be tedious after a year or so. Meissonier's "Standard-Bearer" and J. Maris's "Dordt" are the finest things in the smaller room.

❖

The Millais aforesaid at Mr. McLean's—a masterpiece of sentimental landscape—shows a corner of the park of Murthly Castle, Perthshire. The snow on the ground is "million-coloured," as Shelley has it; and the circles of fallen leaves under the trees are like rainbows. At close quarters the castle and the tree-trunks seem woolly and inform, but at the proper distance the illusion is astonishing. The sky, the park-wall, and the glint in the windows of the castle are quite undeniable. Such wonderful work puts to shame the clever tricks of L. Neubert, and the deliberately forced effect of cliff and sea in Mr. Edwin Ellis's "Fishing Bay on the Cornish Coast." The pleasantest glimpse of the sea in the gallery is M. J. MacWhiter's "Corrie, Isle of Arran." C. Wilda's pictures are remarkable, especially that shady corner in Cairo, with the white donkey and the man in the blue wrap.

❖

The pictures at the Hugh Willoughby Sweny Memorial Exhibition in Suffolk Street must pass exempt from criticism by the rule which forbids inspection of a gift horse's mouth. Mr. Whistler has sent an etching, Sir F. Leighton one of his studies in black and gray for "Cymon and Iphigenia," and Sir J. D. Linton a drawing of a mounted man in armour. The contributions are extraordinarily numerous. It may be doubted whether any equally unlucky man was so popular as poor "Mahlstick." He was quite indescribable and inimitable in his way; and though one could not help expecting that he would join the majority, as he did everything else, in some unaccountable fashion, his mysterious death by violence in the Fulham Road seemed a needlessly harsh stroke of Fate. It was a ill-natured turn done to a very good-natured man.

❖

The fifty water-colours by Mr. Birket Foster exhibited by Messrs. Vokins, in Great Portland Street, are pretty; but they smell a little of the lamp, suffering unduly, perhaps, from comparison with Mr. Thorne Waite's dozen or so of drawings made at Dover and thereabouts. Nothing can be fresher or pleasanter than these, except the downs and cliffs themselves in perfect Bank Holiday condition. In this respect they resemble the sketches of the country about London, by Mr. F. G. Cotman, just added to the Ludovici and Ellis exhibition, at Messrs. Dowdeswell's in Bond Street. The display at Great Portland Street is not confined to the work of Mr. Birket Foster and Mr. Thorne Waite. Messrs. Vokins are never at a loss for a Copley Fielding or the like to give interest to a spare corner of their gallery.

The World, 21 March 1888 [C414]

Occident and Orient

[Theodore Jacques Ralli (1852–1909) painted in Paris and Lausanne; Franz Skarbina (1849–1910) was a German artist and art teacher. Émile Zola (1840–1902) was the eminent French Naturalist novelist. Joseph Eugéne Gilbault was a Swiss flower and still-life painter who exhibited in the 1870s and 1880s. Thomas Joseph Larkin imported Japanese art, including that of Sosen (1741–1821), who was famed for his realistic paintings of animals.]

The March summer exhibitions are taking time by the forelock like the September Christmas annuals. The Continental Gallery in Bond-street opened yesterday with a display which certainly does not lack variety. A. Normann's Norwegian scenes are so like one another that one hardly notices that the pictures are not the same as those of last season. Mr. Ralli exhibits a monk confronted by a vision of female loveliness, a subject that never seems to pall on French painters, although it is by this time quite threadbare, and indeed was not a very exquisite joke when it was new—if it ever was new. It is probably useless to try to persuade the painters who choose such subjects that pornographic art is undignified; but perhaps they may prove sensitive to the remark that it is extremely tedious. A picture by Jan van Beers entitled The Rendezvous, though it doth something smack, something grow to, is nevertheless raised to the impressiveness of a sermon by the truth with which a single figure is made to convey a character and a

story. Professor F. Skarbina emulates Zola in the fidelity with which he depicts a base, dowdy, impudent, and graceless person in a studio. E. Gilbault's clusters of grapes are fine examples of those fruit pieces without which no gentleman's gallery is complete. . . .

Mr. T. J. Larkin has opened a small Japanese gallery at 28 New Bond-street. Of the sixty odd "kakemono" exhibited, only a few—notably some monkeys by Sosen, and a squirrel by [the same artist]—will bear comparison with the contents of the White Wing at the British Museum; but even the inferior specimens have their interest as examples of what Japan can do in the way of bad pictures and doubtful "old masters." It may be well, in this connection, to drop a reminder of the fact that the collection of Japanese engravings and block prints at the Burlington Fine Arts Club will soon be closed. No amateur who does not already know how cunningly engraving can imitate the touch and stroke of the brush should omit a trip to Savile Row. Those who do not care for such niceties will find something to amuse them in the sketches and caricatures of western civilization in Japanese books.

The Star, 27 March 1888 [C416]

The French Gallery and Fontainebleau

[Henri Rousseau (1844–1910) was the French primitive painter. A minor customs official, he had retired in 1885 to devote himself to art. Walther von Firle (1859–1929), a Bremen genre painter, usually exhibited in Munich and in the Netherlands.]

At the French Gallery Mr. Wallis has provided an excellent selection of foreign works. The school of minute detail, headed by Herr Seiler, is in strong force. The latter's Arrest of Voltaire at Antwerp is full of character as well as of extraordinary finish, but it lacks the breadth that would make it a really fine work. Professor Holmberg's works, which receive the honors of position and drapery, are certainly more worthy of them; but the vigor and spontaneity of Joanowits's Montenegrin pictures are to some extent discounted by a certain crudity of treatment and poverty of composition; and the large landscapes of Herr Heffner and others serve to shew how much stronger is the English school of landscape. The latter artist, however, has an excellent work in the little View of Padua, and of the Barbizon school there are fine specimens of Rousseau and Corot. Diaz, too, is admirably represented. Humorous "char-

acter" seems now to be the fault of the foreign cabinet-picture painters; indeed, only two artists rise above the "anecdotic"—Jozef Israëls, and his sad, almost painful Old and Worn-out, and W. Firle, in the study of age and youth in Spring and Winter.

In the exhibition called Fair and Famous Fontainebleau, at Messrs Boussod, Valadon and Company's Gallery, Mr. Haynes Williams has gathered together the result of two years' work in the Palace of Fontainebleau—within the palace, be it understood, for the pictures are all views of interiors, but they are painted with so much artistic feeling that even when no figures are introduced to make "subjects" of them they are eminently pictorial, and from that point of view almost invariably satisfactory. The castle itself teems with historical interest— association from François the first onward—and dates practically from the French Renaissance. Mr. Haynes Williams has made admirable selections on the whole, and has in a remarkable manner united suggestion of minute detail with great breadth of treatment. Especially noticeable is this in Salle Louis XIII, in The Music Gallery, and in the Salle des Gardes. But the whole thirty-odd pictures convey so well the style and color, the magnificence and splendor of the old chateau in the days when Royalty was rampant, when intriguers conspired, and even when a Pope was held in imprisonment here, that to those who are concerned in the subject a visit to the gallery will be of greater interest and use than any amount of description.

Pall Mall Gazette, 28 March 1888 [C418]

[Watercolors]

[Ethel Brown is probably Shaw's error for Henrietta Brown of Phillimore Gardens, who was the only Brown in the Lady Artists' catalogue; similarly, only Mary Stuart Robinson of Cambridge appears in the catalogue.

Messrs. Agnew was the firm of Thomas Agnew & Sons. John Varley (1778–1842), landscape and architectural watercolorist, exhibited widely, published treatises on drawing and perspective, and taught such artists as Holman Hunt, Copley Fielding, and William Mulready. Samuel Prout (1783–1852), topographical and architectural watercolorist, much admired by Ruskin, also published a treatise on landscape painting. David Cox (1783–1859) painted English and Welsh landscapes and coastal scenes in both oils and watercolors, and also published two works on painting landscapes in watercolors.]

At the Continental Gallery there is an extremely clever picture by Jan van Beers called "The Rendezvous." A lady in the Bois de Boulogne has dismounted and thrown herself on a bank to wait for her lover. The significance and expression of her eyelids, her lips, and the disposition of her limbs could not be surpassed by Rembrandt or Holbein. Comparing the power displayed with the choice of subject, one can only gasp, and hurry away to the fresher atmosphere of the Lady Artists' exhibition at the Egyptian Hall, which contains a mass of work of great merit, especially in water-colours. There is so little disparity among the best hundred, that any attempt to single out works for special mention would be invidious. Besides, as the catalogue gives no hint as to the status of the exhibitors, it would be dangerous as well. Everybody knows that "Kate Perugini" is Mrs. Perugini, and that "Hilda Montalba" is Miss Montalba; but what about Ethel Brown and Hypatia Robinson? It seems hardly polite to drop all prefix, and we have not yet come to citizeness! Will the exhibitors take the hint for next year's catalogue?

❖

The water-colour exhibition at Messrs. Agnew's contains examples of nearly every famous master in that medium from [Thomas] Girtin to Mr. C. Gregory. There are Turners, Varleys, Prouts, William Hunts, Copley Fieldings, De Wints, David Coxes, Constables, and Linnells for the Ruskinian generation; and for younger amateurs a good selection from the artists who still exhibit twice a year at the Old Water-Colour Society. A couple of prosaic bits of road and river are signed with the terrible name of John Martin. The specimens of Mr. Albert Goodwin's work belong to an earlier and daintier phase of his development than that through which he is now passing. The most remarkable Turner is the original of the "Cowes" in "England and Wales." Prout's "Tomb of the Scaligers, Verona," is, to the true Prout taste, irresistible. The two Fred Walkers are not of his best and tenderest: Mr. Herkomer's "Weary" is better than either of them. The minor modern work, as might have been expected, is heavily discounted by comparison.

The World, 4 April 1888 [C421]

New English Art

[John Partridge (1790–1872), a highly successful society portrait painter, exhibited portraits of Queen Victoria and Prince Albert in

1842. Walter Richard Sickert's theatrical pictures included Katie Law-
rence, music-hall singer remembered now for popularizing the waltz
tune by Karl Kaps, "Daisy Bell" ("A Bicycle Built for Two").

H. Francis Bate (1853–1950), an English genre painter who studied
in Antwerp, published a treatise, The Naturalistic School of Painting
(1887). Jacques-Émile Blanche (1861–1942), French portrait and
genre painter, lived and worked much of his professional life in Lon-
don, and was a friend of Aubrey Beardsley and James McNeill Whis-
tler. Philip Wilson Steer (1860–1942), portrait and landscape painter
in the manner of Whistler and the French, became one of the major
English Impressionists. Frank W. Bourdillon, who exhibited in the
1880s and 1890s, painted landscapes and genre, often from Cornwall;
in later life he abandoned art for missionary work.]

The Dudley Gallery is just now a Castle of Astonishment to those
who are not yet accustomed to the New English Art Club. If the ghost
of [John] Partridge were to visit the Egyptian Hall it would probably
prefer the works of the old school, on the ground that anybody could
see that they were pictures, which is more than could be confidently
said at the first glance by a novice confronted with the more character-
istic examples of "New English Art." But the exhibition is, on the
whole, successful enough to help the club greatly in its work of educat-
ing the public. Even the scoffers will soon be unable to endure pictures
in which there is no attempt to represent any effects of light, air, heat,
cold, or weather except such as prevail in a St. John's Wood studio.
The first painter whom one misses in the catalog is Mr. Sargent, and
the first one notices by his handiwork on the wall is Mr. Walter Sickert,
whose Gatti's Hungerford Palace of Varieties: second turn of Miss
Katie Lawrence, contains an excellently-painted tall hat in the right-
hand corner, and is in every other respect as complete a failure as the
most devoted martyr of the new art could desire to achieve.

Mr. Francis Bate's Gaslight and Matchlight, a full-length portrait of
Mr. Léon Little lighting a cigarette as he passes a street lamp, is a
clever attempt at the impossible. Mr. Whistler's etching of the Grand
Place, Brussels, hangs hard by; and a little past it is Mr. Charles Shan-
non's Return of the Prodigal, a finely-drawn figure subject, which
marks another step in the steady emergence of this promising painter
from the confusion in which he once delighted to welter. Mr. Fred.
Brown's When the Sun is Setting Low only needs a little toning down
of the orange flesh-tints to be an excellent picture. Jacques Blanche's
Printemps Maladies represents a lady reclining in a chair in a garden.
Her face is in shadow, and the painter has attacked it with a mixture of
lilac and black-lead. It is a bold attempt, and very nearly successful,

but not quite; the black-lead has been too much for the lilac. The lady is drawn with remarkable elegance, but an inexcusably careless piece of figured drapery almost spoils the dress. Mr. Wilson Steer's Summer's Evening is a beach glowing aridly in mauve and garnet, with three nymphs enjoying the heat in the coolest possible circumstances. Startling as it all looks, the scenic effect aimed at is produced truthfully enough. The girls' flesh, however, is of the color and texture of yellow brick. Mr. Anderson Hague has somehow missed the true shade of the background in his otherwise admirable Unwilling Model. Messrs. Bourdillon and Chevallier Tayler evidently paint with one eye on New English Art and the other on the British public. Mr. Sidney Starr, like Mr. Walter Sickert, occasionally loses the sanity of vision which that public rightly insists upon.

<div style="text-align: right">The Star, 9 April 1888 [C422]</div>

[The] New English Art [Club]

The New English Art Club is newer than ever at the Egyptian Hall this year. The resolution, sincerity, and disdain of buyers' prejudices, with which the members successfully paint the unpaintable, are as remarkable as the blindness, perversity, or incapacity with which they leave the paintable unpainted. Those who have avoided this are rather the Mr. Facing-both-ways of the club than the complete painters. But what has been gained in the representation of light and atmosphere is a gain to art: what has been lost is only a temporary loss to the individual painters, who will recover it fast enough when competition forces them to add the old qualities to the new charms. There is but one picture in the gallery, which is at once very characteristic of the club, and very bad. Of few other exhibitions can as much be said. The names of these doughty painters are recorded in their proper place—the catalogue.

<div style="text-align: right">The World, 11 April 1888 [C423]</div>

[Old-Fashioned New Art]

[James Webb (1825–95) was a British marine and landscape painter; (Sir) John Tenniel (1820–1914) was a painter, illustrator, and cartoon-

ist for Punch, *famed earlier for his illustrations to* Alice in Wonderland *and* Through the Looking Glass. *Edith Mendham was a Somersetshire painter unknown beyond this exhibition; Edward John Gregory (1850– 1909) was a British portrait and genre painter. Alfred O. Townsend exhibited landscapes 1888–1902; Mary Joyce, South London flower and genre painter, exhibited 1880–93. Bernard Evans (1848–1922), a Birmingham landscapist of Midlands and Welsh scenes, worked in both oils and watercolors.*

William Barnes Wollen's military picture was of Pierre François Augereau (1757–1816), created by Napoleon a Marshal of the Empire in 1804, and in 1808 Duc de Castiglione.

William Hatherell (1855–1928) of London painted figurative, historical, and literary subjects; John Austen Fitzgerald (1832–1906) painted fairy and other imaginative and dream scenes. Gertrude Hammond (1862–1953) painted portraits and genre, exhibiting 1886– 1903.

Arthur Melville (1855–1904), Glasgow painter, produced Scottish genre pictures and large Middle Eastern subjects. Alfred Edward Emslie (1848–1900?) was a London genre and portrait painter; William W. Callow (1812–1908), landscape, marine, and architectural painter, was briefly the drawing master to the family of King Louis-Philippe.]

The Water-Colours at the Institute this spring—nine hundred and thirty-five, all told—are pretty, pastoral, unimpeachably proper, and about as novel as the Thames Embankment. The old hands only live up to themselves comfortably, except perhaps Mr. Orrock, who surpasses himself; Messrs. Alfred East and James Webb, who are in their finest vein; and Mr. Keeley Halswelle, who has ventured on a couple of comparatively genial experiments in composition and colour. Mr. Fulley-love's "Magdalen Tower and Bridge," too, is a noteworthy achievement. John Tenniel sends a scene from Scott, which, slight as it is, contains some quietly beautiful work. If he could borrow Sir James Linton's skill in painting, or lend him a little of his inventiveness and power of characterisation, some treasures in the shape of cabinet pictures would come of the transaction. Miss Edith Mendham has painted "Thalaba and the Simorg." Mr. E. J. Gregory was hardly well advised when he decided to exhibit his "Marooned" a second time. It is catching; but it is also vulgar. Among the painters of less note who have done well may be mentioned Mr. A. O. Townsend, Miss Mary Joyce (who has caught a delicate shade of expression in a girl's face very happily and prettily), and Mr. Bernard Evans. Mr. Wollen has a picture of General Augereau performing, not in the waltz in *Madame Angot*, but in an extraordinarily disastrous battle.

There is some expressive figure-drawing in Mr. W. Hatherell's "P. and
O. Steamer"; and Mr. J. A. Fitzgerald has raised an enchanting aspect of
the sea in his little Ariel picture. Miss Gertrude Hammond's drawing-
room interiors are inharmoniously and coldly lighted; but they show
promising powers of work.

❖

The Old Water-Colour Society maintains its eminence easily against
Prince's Hall, except in the matter of the catalogue, the "reproduc-
tions" at the end of which are detestable. In all the highest qualities of
the art Mr. Alfred Hunt and Mr. Albert Goodwin are foremost, Mr.
Goodwin's "Lincoln" only needing a softening touch in the blue corner
of the sky to place it beyond reproach. Mr. Poynter has certainly suc-
ceeded with the lamplight, the tulips, and the figure in high relief in
"Evenings at Home"; but he will have to draw in the lady's hand
deliberately: he has not the touch that indicates form with a stroke of
the brush. Mr. Arthur Melville has applied the impressionist method
like a master in "Kirkwall Fair," which is greatly to be preferred to his
more pretentious pictures on the opposite wall. Mr. A. E. Emslie, who
is coming to the front with a rush, is at his best in "Shakespeare or
Bacon?" though a few white touches on the standing figure need to be
lowered half a tone. His other picture, daintily executed, is rather
charming in sentiment. Mr. W. Callow's "Market House, Marburg," is
a poor example of the Prout school. Mr. David Murray conveys an
impression of being rather too clever at everything except drawing by
his contributions this year. In "the Miller's Firstborn" Mr. Robert
Barnes has forgotten that flour leaves its mark on millers. Mr. Walter
Crane exhibits several strong sketches and a figure-subject; but a
picture-gallery is the last place in the world in which to appreciate Mr.
Crane's remarkable and varied artistic gifts.

The World, 25 April 1888 [C429]

[John Haynes Williams]

*[The paragraph on John Haynes Williams's Fontainebleau pictures
echoes so closely Shaw's sentiments of 28 March (C418) as to suggest
that his enthusiasm carried over into a second exhortation to the
public to see the exhibition. (It was also for a different paper.) Since*

*Haynes Williams's work is now in the Tate Gallery and in the Victoria
and Albert Museum, the interest may not have been misplaced.]*

With so many competing shows there is some risk that the interest-
ing and laborious work of Mr. Haynes Williams, now exhibited at
Goupil's, may escape due notice. Mr. Haynes Williams, under the title
of "Fair and Famous Fontainebleau," shows a collection of paintings
which has occupied nearly all his time for fully two years. They have all
been executed within the walls of the palace itself, and are faithful
transcripts of the original, so to say; but they are more than this. They
are filled with the sentiment of the place. Only rarely are figures intro-
duced into the apartments; but "we see the smouldering fires, a forgot-
ten glove, a whip, or a bouquet," which are full of the suggestion of
recent occupation. Every room seems to have its story. The execution
of the whole series will certainly considerably raise Mr. Haynes Wil-
liams's well-established reputation as a painter of interiors; and there
are very few of the rival shows in Bond Street where an hour may be
more agreeably employed.

<div align="right">*The World,* 25 April 1888 [NIL]</div>

[The Royal Academy Spring Exhibition]

*[Shaw's unsigned piece in a place where he seldom wrote about art was
less about pictures than about the Academy's obsolete system of dis-
playing its wares.]*

The assault made last year on the Royal Academy by Mr. Harry
Furniss is being followed up by some of the critics. At the great annual
picture show there are usually upwards of 1500 works, about ten or
twelve score of which many papers persist in publishing a string of
remarks more or less critical. Most of these oracles could be spared
without provoking any very violent demonstration of popular regret;
but whilst the custom of inflicting them holds, it is not surprising that
the critics find the one day set apart for them before the private view
(which is a separate affair) insufficient for an exhaustive examination.
They complain also that the heating apparatus is not at work on that
day; that the refreshment room is closed; and that they are not encour-
aged to smoke. They further object that the Academy is the only exhibi-
tion for which the Pressman's card is not a season's ticket.

Already one critic has suggested the boycott as a means of bringing the council to its senses. But the council know it would be as easy for the Reporter's gallery [in Commons] to boycott the Government as for the art writer to ignore the Academicians. The fact is, the Academy is that undemocratic institution, a body with privileges but without representation. The public makes it a present of the rack-rent of the immensely valuable space it occupies in Burlington House and in return it treats the representatives of the press more stingily than any unsubsidised exhibition in London.

It is time to suggest to the self-elected Party that a too-exclusive attention to shilling-grubbing may raise questions quite outside the art critic's province, but not on that account less awkward for a "Royal" Academy to face.

The Star, 1 May 1888 [C433]

[Sculpture and Etchings]

[T. Nelson Maclean of Church Street, Chelsea, had exhibited statuettes and busts in London since 1876; William Couper (1853–1942), who also exhibited in Florence, Munich, and New York, sometimes signed his work in the French style "Guillaume Couper."

Victor Gustave Lhuillier, despite the French name, was a London etcher and illustrator who exhibited in the 1870s and 1880s.]

Messrs. Bellman and Ivey have opened a gallery for sculpture at 37 Piccadilly, made interesting chiefly by Mr. T. Nelson Maclean's "Ione," and Mr. William Couper's work. Mr. Harry Dickins, of 79 Regent Street, publishes an etching by Victor Lhuillier, after Mr. Phil Morris's "Sweethearts and Wives," exhibited at the Academy four or five years ago. The special qualities of Mr. Morris's handling are admirably suggested by the etcher. Mr. Dunthorne of the Rembrandt Head, Vigo Street, has just got out Mr. W. L. Wyllie's etching of "Bruinisse." As an additional proof of the artist's versatility, it should be studied with the illustrations to the log kept by Mrs. Wyllie on their Dutch sketching trip, and published as a preface to the catalogue of the exhibition at Mr. Dunthorne's.

The World, 2 May 1888 [C434]

In the Picture-Galleries
The Grosvenor—Meissonier—Press Day at the Academy

["The Golden Stairs," a large picture by Burne-Jones of a group of young women of Pre-Raphaelite beauty ascending a circular staircase, was briefly famous. It is in the Tate Gallery but now seldom exhibited.

Herbert Gilchrist, who exhibited 1876–96, was the son of an early English admirer of Walt Whitman, and brother of a young woman, Grace Gilchrist, who had taken a largely unreciprocated fancy to Shaw. His kind words were in the nature of amends, as Herbert Gilchrist had accused Shaw of leading his sister on.

The Rev. Philip Wicksteed (1844–1927), a Unitarian clergyman who became a disciple of Henry George's brand of Socialism, was later labeled by Shaw "my master in economics."

Frank Markham Skipworth (1854–1929) was a Chelsea genre and portrait painter; Adolf von Menzell (1815–1905) was a Berlin illustrator and etcher. Charles Fairfax Murray (1849–1919), a disciple first of Dante Gabriel Rossetti and then of William Morris, painted in the Pre-Raphaelite manner before turning (he had independent means) to collecting art. Bonifazio Veronese (1487–1553), who was Bonifazio di Pitati, painted sensuous nudes. Alfred Hartley (1855–1933), a versatile painter who worked in many media, was most successful as a portraitist and limned many notable persons of his time. (Sir) Samuel Henry William Llewellyn (1858–1941), ARA 1912, began as a landscapist but turned advantageously to portraiture, with his triumph the state portrait of Queen Mary in 1910. Walter Paget, the least successful of three painter brothers, exhibited in the 1870s and 1880s; Thomas Mitchell, a Yorkshireman, is only on record with this exhibition.

John Smart (1838–99) painted landscapes of the Scottish Highlands; John Clayton Adams (1840–1906) was a Surrey landscape painter who used color sensitively.

Edward John Gregory's "remarkable" portrait of a girl in a crimson dress, in a drawing room setting, was of one of the nine daughters of the eighth Earl of Galloway.]

To form an exhibition in a gallery with the traditions of the Grosvenor, without any contributions from Mr. Burne Jones, Mr. Strudwick, Mr.

Orchardson, or Mr. Watts, was an undertaking which Sir Coutts Lindsay's best friends could only wish him well out of. On the whole he has not come off so badly. There is no disguising the fact that the Grosvenor has lost its old distinction—the only alternative to that was an amalgamation with the New English Art Club; but in becoming like any other exhibition it will be considered by many to have gained instead of lost. When they enter the East Gallery and see a "Portrait of the Master of the Epping Forest Harriers" in the place of honour at the head of the room, they will feel more at home than they did at the foot of "The Golden Stairs."

The best picture in the collection is Mr. G. Clausen's "Plough Boy." Bastien Lepage could not have improved him. Not far from it is Mr. John Reid's "Smugglers," a serio-comic picture, with some admirable detail of shop-window, sugar-stick, doll, lobster, and leeds, as well as a few figures which are excellent in point of expression and character, but still not a picture to which, as a whole, any sane person can agree. The impossibily hoary smuggler embracing the girl with his handcuffs, the gigantic young naval officer considering how to carve him with his gleaming cutlass, the ashen faces in the torch-light and the Wardour Street table and blue jar tastefully placed in the middle of the village street, are striking things, but they banish seriousness from the critical mind. Mr. Hope McLachlan, who for some years has stopped the gap left in the original Grosvenor phalanx by the death of Cecil Lawson, has only one work, and that badly hung, this year, his place as the exponent of poetic landscape being taken with undeniable authority and power by Mr. Alfred East. Mr. Yeend King, in the prosaic landscape department, has one work, "Sentiment and Interest," in which the false metallic lustre which formerly disfigured his pictures reappears in an aggravated degree, whereas in another, called "Where the Morning Dew lies longest," the green is varied from wet to dry, fresh to dusty, sunlit to shaded, with a remarkable mastery of the colour that used so often to master him. Mr. Anderson Hague has changed his palette, and is trying his hand at rich brown foregrounds and skies of Titian's blue. It is not necessary to describe the portraits signed Richmond, Holl, Collier, and Herman Herkomer. Mr. Gilchrist's "Walt Whitman," in spite of the interest of the subject and the novelty and technical merit of the handling, is hung so high that it would have been fairer to the painter not to hang it at all. On the other hand, the hanging of Mr. Emslie's portrait of the Rev. Philip Wicksteed is better than it can quite bear. Though a clever likeness, it is a superficial study of a by no means superficial sitter. At opposite ends of the west gallery Mr. Arthur Hacker's "By the Waters of Babylon" and Mr.

W. E. F. Britten's "Noble Family of Shipwrecked Huguenot Refugees" keep one another in countenance. I hasten past in silence to admire Mr. Markham Skipworth's charming little sketch of a girl entitled "Waiting." Mr. Albert Moore's figures become more and more real as he grows a sadder, and, in my opinion, a wiser painter. His "Waiting to Cross" is a step in this process.

Professor Menzell's "Piazza d'Erbe, Verona," will hardly remind any one who has not been there of Mr. Birket Foster's view of it at the Old Water-Colour Society. He deals with it exactly as Mr. Frith dealt with the Derby. Mr. Fairfax Murray's "Violin Player" reminds me of Bonifazio; but I cannot think of any work of Bonifazio's that reminds me of Mr. Fairfax Murray. He, like Miss Pickering and Mr. Spencer Stanhope, remains faithful to the school of Mr. Burne Jones without deserting Sir Coutts Lindsay and the Grosvenor. In Mr. Gilchrist's "Rape of the Lock," the peer's left eye catches a ray from the window in such a way as to distort his features awkwardly; but otherwise the lighting of the group is skilfully managed, and the rich colours are well harmonised by the golden glow of the afternoon. Mr. Jacomb Hood's large "Triumph of Spring" is gracefully composed and pleasantly vernal in its brightness; but the flesh seems a degree to dull and opaque, as if the shadow in which the procession moves were that of a roof and four walls instead of a tree or hill. In Mr. Roussel's ingenious portrait in the corner, Mrs. Walter Sickert is unfairly subordinated to a pair of stays covered with white satin, which is the centre of attraction in the picture. Mr. Phil Morris's "Storm on Albion's Coast" contains a raging ocean made of what I think is called "tulle." The threat of rain in Mr. Edgar Barclay's "Saving the Hay" is happily suggested. Attractive bits of landscape are to be found in works by Messrs. A. Hartley, S. H. W. Llewellyn, W. Paget, Tom Mitchell, W. J. Hennessy, John Smart, Biscombe Gardner, and Clayton Adams. Mr. Boughton's "Welcome" is a curious confection; and Mr. Kennedy has spent much careful work to doubtful advantage on something resembling an East End starveling stuffed into the tail of a stale salmon, and called a mermaid. Miss Dorothy Tennant is reviving the traditional "brown tree" with a vengeance, as a background to her dainty little nude figures. The humorous picture of the year is Mr. C. Shannon's "Will he come in?" a group of primeval men in a pond, where they have taken refuge from a red-haired mammoth. The portrait of Miss Mabel Galloway by Mr. E. J. Gregory is no doubt a remarkable piece of work; and those who are not by temperament averse to crimson plush frocks set off by white lace collars and linerusta walls will be able to do it justice.

The great Meissonier—a water-colour measuring 8 feet 4 inches by 4 feet 10 inches—at Messrs. Tooth's in the Haymarket, makes one wonder at the painter's technical knowledge and skill. Every horse in it has its individuality as much as every man. The drawing of the uneven ground, and of the long grass through which the cuirassiers are riding, is as consummate as the minute elaboration of the sword-hilts. The disposition of the groups and masses of men is a triumph of pictorial generalship. Everything is quietly right, with an effect which is digni-fied and impressive, without being in the least heavy or unhandsome. But the particular view of history that makes heavy cavalry a spectacle for the nations is growing old-fashioned. Napoleon with the face of an ecclesiastic is a novelty; and the white horse Marengo is a beauty; but as to the shouting troop of cuirassiers, it is easier to admire the way they are painted than to feel quite convinced that they are worth the trouble they must have cost.

Since to-morrow is press-day at the Academy, and Mr. Harry Furniss has succeeded in stirring up some protest against the stinginess of allowing the professional critics only one day for the examination of upwards of fifteen hundred pictures, I may as well say that if the Acade-micians contend that one day of their exhibition is enough for any man of really sound judgment, I shall not pretend to disagree with them. A critic who is content to deal with the three dozen most noteworthy pictures, and who can see at once whether a picture has any chance of a place among them, can finish with the Academy in a day by not giving a second glance or thought to ninety-seven per cent of the works hung. But whilst the more exhaustive method unhappily prevails, the one day is absurdly insufficient. Under the present system, however, the forty Barmecides can deny privileges to pressmen much more easily than the pressmen can deny to the forty the same prominence in print as on the line inside Burlington House. So I do not see what the pressmen can do at the odds, except buy season-tickets and grumble. For my own part, I am in favour, not only of additional free admissions for the press, but the institution of free days for everybody, the functions of a Royal Academy, as I conceive them, including much that is not covered by school-keeping and the extortion of shillings.

G.B.S.

P.S.—Sir John Millais sent an unfinished portrait of Sir Arthur Sulli-van to the Grosvenor Gallery in time for the private view. I should also have mentioned the splendidly able and workmanlike water colour sketches by Mr. Hubert Herkomer, just added to the exhibition at the Fine Art Society's Gallery.

The World, 2 May 1888 [C435]

In the Picture-Galleries
The Academy—The British Artists

[Jan Hoynck van Papendrecht (1858–1933), painter and illustrator, worked in Rotterdam, Antwerp, and Munich. Herbert Arnould Olivier (1861–1952) painted figurative subjects and portraits from a London studio. Thomas Faed (1826–1900), ARA 1859, was a Scottish painter of sentimental domestic scenes whose work became widely known through engravings. "The President" was still Sir Frederic Leighton.

(Sir) Frank Brangwyn (1867–1956), painter, etcher, and lithographer, was then a genre and marine painter. Ellen Montalba, who exhibited 1868–1902, was the younger sister of Clara Montalba. Frederick Hall (1860–1948) was then a member of the Newlyn school in Cornwall, painting landscapes and rustic genre. Adrian Scott Stokes (1854–1935), ARA 1910, was a landscape and genre painter who in 1925 published a book on landscape painting. Bostonian William Mark Fisher (1841–1923), ARA 1911, came to England in 1872, exhibiting landscapes at the RA beginning in that year. Van Marcke referred to Émile van Marcke de Lummen (1827–90), Flemish landscape and rustic genre painter.

Anna Bilinska (1857–93) was a Polish painter; Ethel Webling is unknown but for this exhibition. John Charlton (1849–1917), a Northumberland painter of portraits and sporting subjects, turned increasingly to battle scenes, including "God Save the Queen" commissioned by Queen Victoria. Caton Woodville, another limner of battle scenes, however, is here castigated for his apparently less-than-mediocre picture of a royal wedding. The Queen's youngest daughter, Princess Beatrice, had been married to Prince Henry of Battenberg in July 1885.

Frank Holl's portrait was of John Poyntz Spencer, fifth Earl Spencer (1835–1910), former Lord Lieutenant of Ireland, and future First Lord of the Admiralty. J. S. Sargent's portrait was of Mrs. Edward Darley Boit, a prominent Bostonian in the expatriate communities of Paris and Rome; earlier, Sargent had painted the Boit children. John Pettie's subject, (Sir) Charles Wyndham (1837–1910), was actor-manager at the Criterion Theatre; in 1899 he would open his own theater, Wyndham's. Carolus-Duran's Comtesse di Rigo portrayed a former American heiress known in English circles as well as French salons for her emancipated ways.

After Whistler had repainted the signboard at the Royal Society of British Artists, reflecting the new "Royal" designation granted at Golden Jubilee time, and added his personal butterfly signature, he was

effectively unseated as President. A crisis meeting on 4 May, over his idiosyncratic regime, with motions for his censure or expulsion, made the end inevitable. At the annual meeting on 4 June, (Sir) Wyke Bayliss (1835–1906), a painter and architect, would be elected RSBA President. Whistler and his minority would then resign, the ex-President announcing, "I am taking with me the Artists, and I leave the British."

From their base in Wallingford, James Hayllar (1829–1920) and his wife, Mary, exhibited genre paintings at the RA for over forty years; of their nine children, four daughters also became artists exhibiting alongside their parents. Peter Macnab (?–1900) of Shepherd's Bush was a genre and landscape painter whose last RSBA exhibition was in 1888. James Hay Davies (1844–?) was a Manchester landscape artist who painted scenes of the Home Counties and Wales, and exhibited 1875–91.

The "lamenting Flora Macdonald" refers to the Scot gentlewoman (see 2 January 1889, C523), Flora Macdonald, who in 1746 helped "Bonnie Prince Charlie," the Young Pretender, to escape capture disguised in petticoats as "an Irish spinning maid, Betty Burke." Whether traitress or heroine, Miss Macdonald was arrested and went to the Tower of London, to be released after an amnesty in 1747.]

The Royal Academy, with the Grosvenor, the New Gallery, the Institute, the British Artists, and the New English Art club competing with all their might with it for supremacy, has risen to the occasion in its own fashion by showing how little it cares for such competition. It has spurned the canvasses which its rivals have been glad to hang: and it has selected and conspicuously exhibited the very largest and worst attainable specimens of the picture-shop refuse of 1889, carefully placing these wherever the frames would fit, and wherever the colours would not. It has, indeed, done indescribable things—things that overstrain and paralyse the objurgatory centres, leaving the spectator limply querulous, and the unmoved Council masters of the situation.

Proceed we, then, in ordered hopelessness to review the rooms. Room I.: A shipshape study of daylight between decks by J. H. van Papendrecht. Something good, but not novel, by Mr. Henry Moore. A relentlessly real portrait by Mr. Herbert Olivier, most joyless in its darkling blue. Startling example of academic rights to spaces on the line by Mr. Phil Morris. Room II: Examples continued by Messrs. Poynter and Armitage. An experiment in English landscape by Mr. Boughton, too good to be much affected by the painter's favourite touches of pink paste in the clouds. A work by Mr. [Thomas] Faed entitled "The Burden of Years," the symbolism of which overcomes one's command of countenance. An effective portrait of the master of Trinity, with blue hair, by Mr. Hubert Herkomer. A charming land-

scape by Mr. David Murray, close to a finely decorative picture of three women at the pebbly margin of a river, by Mr. Albert Moore. Portrait of Pasteur by M. Carolus-Duran, of whom more anon. The Large Room: "Dawn," by Mr. Watts, keeping herself apart from a surpassing collection of ugly portraits grouped on the western wall around a flat patch of low-toned purple, which turns out to be a conscientous, but, under the circumstances, unattractive study of a Yarmouth Shoal by Mr. T. F. Goodall. A small but consummate "Barde Noir," by J. L. Gérôme. Some good portraits by Mr. Ouless and Mr. Holl, notably one by Mr. Holl of Lord Spencer. A large work by the President—ostensibly Andromache in captivity, but really a carnival of graceful and voluptuous, but not undignified, feminine modelling. Picture by Mr. Gow—alone, as usual, in his dramatic inventiveness—of James II. embarking for flight after the Battle of the Boyne. The Kings packs his way down the steps, realising nothing of his situation except the immediate peril of slipping into the water, and insensible to the feelings of the respectfully grieved gentlemen and respectfully contemptuous soldier-servants bidding him farewell from the quay. Mr. Orchardson's usual bilious, and by this time somewhat tedious, drawing-room comedy, apparently representing the curtain tableau from *Uncle's Will*. A Scotch bog by Sir John Millais—inform and woolly at close quarters, but right as right can be from the middle of the room. Mr. Alma Tadema's rose-leaf feast, the shower of petals certainly not so uncongenial as a shower of oyster-shells, but still far from realising the luxurious fancy of Heliogabalus. A dusty picture of woodcutters by Mr. Frank Brangwyn, rather put out of countenance by its flowering neighbours, but not to be passed too hastily. Room IV.: Mr. Goo— Better go on to Room V. where, however, there is little to do but congratulate Miss Ellen Montalba on her "Dutch Girl." Pattern works by Mr. Leader and Mr. Edwin Long. Flattering portraits by Mr. Richmond. Room VI.: Aha! A magnificent portrait, by M. Carolus-Duran, of a lady (Comtesse de Rigo) in a low-necked crimson velvet dress. All flesh is as snow beside such velvet: yet the Comtesse is not sacrificed, although the crimson is of intoxicating splendour. And what is that in the opposite corner? A portrait by Mr. [Solomon J.] Solomon of a lady in a low-necked crimson velvet dress. Luckless Mr. Solomon! Mr. Sargent smartly outfaces a like comparison with his distinguished master by his brilliant portrait of Mrs. Boit. Mr. Gladstone, by Mr. Holl, reminds me that I passed The Speaker, by Mr. Hubert Herkomer in the other room. Mr. Waterhouse's "Lady of Shalott" is ill-favoured and unladylike with a complexion out of all relation to the landscape, which is excellent. Mr. Clayton Adams's "Rough Road" deserves the good place it occupies. Room VII.: A pair of pictures by Mr. Fred Hall about the old woman, the goose, and the

golden eggs, clever, but not quite up to the standard of honesty demanded by New English Art. "Les Miserables," woebegone cab-horses by Mr. Dollman. A delicate interior by Mr. Albert Ludovici; and "Naaman's Wife," with a very good Israelite made by Mr. Frank Topham. — Room VIII: A large work by Mr. Herbert, by no means bad as the accepted pictures go this year. A fine pair of open-air views by Mr. Yeend King. "Niobe," all tears and all stone by Mr. Solomon, still unable to get deep enough into life to pick up a real subject. Room IX.: Mr. Gow's "Captured Covenanter," an old woman letting three godless dragoons know that they are not going to chivy her out of her faith. An essay by Mr. Brett in the style of Mr. [Albert] Moore. Room X: "Upland and Sky," by Mr. Adrian Stokes, who has not spared good work, but might have contented himself with a little less sky, considering the value of space on the line. "Marlow Meadows" in the van Marcke manner, by Mr. Mark Fisher. A Royal wedding, by Mr. Caton Woodville, adequate criticism of which might entail prosecution for treason. Room XI : brilliant portrait of Mr. Charles Wyndham as David Garrick, in mauve silk, by Mr. Pettie, who is recovering handsomely from chalkiness of the past few years. Village musicians practising in a large low room, the daylight in which is eked out by a few lamps: a difficult subject handled with great ability by Mr. Stanhope Forbes. It only remains, as far as the oil-colours are concerned, to return for a moment to Room IV for a second look at Mr. Vicat Cole's "Pool of London," into which he has put his best skill without stint of labour. In the Water-Colour Room is one of the gems of the exhibition—a beautiful drawing of a girl's head in pastel by Mr. Watts; also a dexterous portrait, in the same medium, by Miss Anna Bilinska, of herself. The Black and White Room contains some clever portrait-sketches by Miss Ethel Webling, and one or two fine examples of wood-engraving by Mr. Biscombe Gardner. The image department is as depressing as usual. Indeed, the only departments which flourish exceedingly are the puerility, triviality, and pot-boiling departments. The absurd canvases covered with huge lions, and the courtierly portraits of ladies in the taste and style of Euston Road photography, exceed even the Burlington House license in such things. Mr. Burne Jones has abandoned the Academy to those whom it delights to honour, and contributes nothing.

At the British Artists, Mr. Whistler has repainted the signboard, and put his butterfly, considerably magnified, in the corner; but other work from his hand there is none. Few secrets, even in London, are better known than that the new President no longer presides in Suffolk Street. The public do not gain by the derangement, for this exhibition shows a deplorable falling-off from the standard of the two last. The places of honour are almost as poorly furnished as at the Grosvenor.

But for Mr. Anderson Hague, whose "Early Primroses" would be the best picture in the gallery if it were not eclipsed by "Early Spring," his masterpiece this year, one would be tempted to dismiss the whole collection very curtly indeed. Mr. William Stott's Diana of the tight rope, and Mr. Charlton's portrait of a chestnut horse shining like a new penny, are very trying. But the pastoral by Mr. William Stott in one of the small rooms gives a simple but glorious effect of sky, land and space with extraordinary truth. Among the less pretentious works will be found an admirably faithful cottage interior in full light, by Mr. James Hayllar; a shabby little field with a few roses artistically stuck on by Miss Hilda Montalba; a lamenting Flora Macdonald ingeniously worked into a mother-of-pearl colour scheme, by Mr. Peter Macnab; and some landscape work by Mr. James Peel and Mr. J. Hay Davies.

The New Gallery remains to be seen. I look forward to it eagerly: for I cannot believe, after examining its rivals, especially the Academy, that there were any bad pictures left for it.

<div align="right">G.B.S.</div>

<div align="right">*The World,* 9 May 1888 [C437]</div>

[Thomas Bush Hardy]

The best places in the water-colour room at the Academy have been given to Mr. T. B. Hardy for his two big marine pictures. The one represents some Dutch fishing-boats swinging along in a rather heavy sea. In the other, an angry sky, with a threatening rack coming at us over a dark line of surf, is seen from the beach near Katwijk. Mr. Hardy is not one of the many who are bewailing their treatment by the Academy. They have given him thirty-six square feet of the most valuable space at their disposal.

<div align="right">*The World,* 16 May 1888 [C440]</div>

In the Picture-Galleries
The New Gallery—The Kakemonos in Bond Street

[William Blake Richmond had already painted Miss Gladstone's father, the four-times prime minister, and Shaw's comments are

tongue-in-cheek. The portrait was a commission for Newnham College, Cambridge.

Acrasia typified Intemperance in the Faerie Queene *(spelled differently by Shaw). She is captured and bound, and her Bower of Bliss destroyed. Nicholas Rowe (1674–1718), whom Shaw quotes, was a fashionable playwright and early editor of Shakespeare.*

Alphonse Legros (1837–1911), born in Dijon, was then Slade Professor of Fine Art at University College, London (until 1892), and an influential teacher and versatile painter, etcher, and designer. His "miserable subject of the Graiae" portrays an episode from William Morris's The Earthly Paradise, *about one-eyed, white-haired "crones" with faces "carved all about with wrinkles of despair" who croon a lament "that their lives should last so long."*

Other portrait subjects are the socialite Miss Wardour; the playwright and editor of Punch *Sir Francis Cowley Burnand (1836– 1917); editor-politician John Morley (1838–1923), the future first Viscount Morley and biographer of Gladstone; and editor-proprietor (of* Truth *) and Liberal M.P. Henry Labouchere (1831–1912).*

Matthew Ridley Corbet (1850–1902), ARA 1902, produced poetic English and Italian landscapes; William D'Urban, a Hertfordshire landscapist, exhibited briefly in the later 1880s. Lisa R. Stillman, a London painter, exhibited 1888–94.

The Ahrens collection of Japanese art was built by Henry Ahrens (?– 1887), an English merchant resident in Japan, according to the catalogue, "from the opening of the country to foreign intercourse"; it included 1,200 items.]

The New Gallery contains at present the cream of the year's pictures. There is no denying now that Mr. Burne Jones has the power to change the character of an entire exhibition by contributing or withholding his work. The Grosvenor, in losing him, has lost everything: the New Gallery, in gaining him, has gained everything. Yet his natural gifts are not so extravagant as this seems to imply. It would be easy to name painters wider in their range and quite as skilful with their hands. But they are venal, ambitious, time-serving, and consequently tiresome and vulgar. As to the "New English Art" reformers they are, for the most part, honest as well as adroit: but so far they have only advanced technically: they lack the constructive imagination to make pictures out of their studies. And so Mr. Burne Jones maintains his lead, and does not seem likely to lose it. Of his three chief works at the New Gallery, the "Tower of Brass" is made the best by the figure of Dame. The drapery, the hands, the pose of the beautiful head, are, no less than the face, charged with expression, that greatest quality in

figure draughtsmanship. The Perseus pictures, fine as they are, are less real. The mere pleasure of drawing coils is no adequate excuse for representing the monster as a boa-constrictor in a blue mackintosh; and the picture in which he does not appear conveys irresistible suggestions of a village pump, with a lad manoeuvring round it for a glimpse of a young lady who for obvious reasons desires to remain unseen. It is disappointing to find that the least sincere pictures in the gallery are by Mr. Philip Burne Jones, who seems to have abandoned any designs he may have entertained of doing serious work as a painter. Mr. [William Blake] Richmond's portrait of Miss Gladstone, an ingenious "composite" of the lady's face and her father's, is a masterpiece of audacious flattery, of which lucrative art Mr. Richmond has sent many other examples. His improvements in the shape of the female eye are surprisingly effective, and can be adapted to all sitters. Mr. Strudwick, working by what Nicholas Rowe (apologising for Shakespere) called "a mere light of nature," makes his mark, as usual, as the faultless painter—an aggravating character in some respects. It does not seem to be generally known that "Acrasia," his subject, is a loose person in Spenser's *Faëry Queene*. There is an air of Acrasia about Sir John Millais's "Forlorn," who ought surely to have been called "Abandoned." She is an arrant pot-boiler as ever was painted: her upper lip dripping vermilion, and her ill-made flaunting theatrical red sleeves, are intolerable to contemplate. Mr. Alma Tadema exhibits the first sketch of the "Feast of Roses." The arrangement is more stagey and commonplace than in the finished picture. The flesh in his portraits is vitreous. Mrs. Stillman's gift of convincing story-telling—"Dante at Verona," for example—grows more apparent as the flight of time proves that, in spite of her manipulative deficiencies, her pictures have the rare quality of being memorable. Mr. Watts's "Angel of Death" is perhaps meant to be tender and consoling. It is, in fact, ghastly and terrifying, like a child's nightmare. People of the Gothic temperament, to whom death is a disagreeable subject, should not allude to it. As to Mr. Legros, he not only adds pain to death in his autopsical No. 64, but subtracts joy from life in his other pictures, and shows us, with a pessimistic care for which we owe him no thanks, the world as it appears to us in our worst fits of depression. Mr. Spencer Stanhope, on the other hand, has taken the miserable subject of the Graiae, and made of it the best picture he has painted for a long time. The action of the blind old creatures reaching out to one another for the companionship of a touch is well conceived, and the lines of the groping arms are finely disposed. Miss Pickering has also done her best for the New Gallery; and Mr. T. M. Rooke in his "Savoyard Hospitality" rivals the laboriousness of Mr. Holman Hunt, who, by the bye, exhibits a portrait which is not gener-

ally admired. Mrs. Swynnerton's rustics are so much ruddier than the cherry that Nature cries out for a more delicate palette in a lady's hand. Many dressmakers' dummies look as lifelike in their clothes as Miss Wardour does in Sir J. D. Linton's portrait, elaborate as it is. Mr. E. A. Ward is far more human in his skilful little portraits of Mr. Burnand, Mr. John Morley, and especially of Mr. Henry Labouchere, to whose characteristic air of melancholy he has done uncompromising justice. Mr. Clausen's old woman, in the shade and in the corner, is less happy than his Grosvenor ploughboy in the sun and in the open. Mr. Hallé has a "Paolo and Francesca"; and let it be said that he has often exhibited worse pictures. Mr. Costa's curious habit of sitting down to paint in places where any one else would pass on prevents him from ever reaching the climax at which most painters find themselves inspired; but no one would desire to see him assimilated to Messrs. Leader, Keeley Halswelle, Vicat Cole, and other popular exploiters of Cockney rurolatry. His follower Mr. Corbet, sends a picture of "the orange light of widening morn," which compares very advantageously with the forced and showy effects which some older hands have condescended to of late. Much coarser work than this is Mr. William D'Urban's "Ruined Choirs"; but there is a note of poetic promise in it. I must pass over the balcony, which contains some black and white of the highest order, as well as some clever painting by Miss Lisa Stillman and others. Mr. Walter Crane's sketches and Miss Dorothy Tennant's funny "Dead Merbaby" are also in this region.

The Kakemonos at Messrs. Dowdeswell's, though hung three deep (for kakemonos, being pictures on oblong strips of silk mounted mapwise on rollers, can be hung in this fashion), do not comprise more than half the Ahrens collection. Any one who prefers the picture-buying method of investing money, and who can recognise a great artist's hand by the lines and touches of his brush, without reference to his name and reputation, may here lay up stores of unearned increment for himself by cheaply purchasing exquisite drawings of monkeys, carp, and what not by Sosen, Ōkyo, and other first-rate masters, whilst the public are busy buying emphatic eagles and dolphins, very clever and aggressively Japanese, which can be turned out in Japan to-day in any quantity that the demand may make worth while. The best kakemonos in this collection are better than any that are likely to come into the market before their prices rise to something like their value; but the worst—which are by no means bad—are worth no more than is asked for them. The opportunity, in short, is only for those who know not only good from bad, but good from better and better from best.

G.B.S.

The World, 16 May 1888 [C441]

[Bucknall's Surrey Landscapes]

[Ernest Pile Bucknall (1861–1919?), born in Liverpool, exhibited land-scapes in London from 1887.]

Mr. E. P. Bucknall has been among the Surrey hills, and has painted them with straightforward skill in their freshest and sunniest British Bank Holiday aspect. The drawings, which are in water-colour, have just been added to the collection at the Burlington Gallery, in Old Bond Street.

The World, 23 May 1888 [C443]

[Falero's "Nightmare"]

[It had become modish among some artists, the Spanish painter Louis Faléro among them, to follow Gustave Moreau (1826–98) and Felicien Rops (1833–98) in depicting women—usually nude—in witches' sab-baths, in the company of nightmarish animals, as the personification of degenerative and perverse sexual evil. Whether the artists' market consisted of men seeking relief from temptation, or those seeking ex-otic temptation, the works, many of them showing sphinxlike women, or others partly bestial, were widely exhibited.]

At the Gainsborough Gallery there is a huge picture by Faléro entitled "Nightmare," which was exhibited in Paris some years ago. A monstrous creature, something between a bat, an owl, and an octo-pus, is bearing away a beautiful unclothed person with golden hair, to whom two others, also unclothed, but marvellously ill-favoured, cling desperately, whether to help the monster to drag her down or to prevent him from dragging her up is not clear. It does not matter, however; for the picture is only another example of cleverness thrown away. Nobody ever dreamt anything so flashily imaginative; and cer-tainly no painter ever dreamt of figures so unfeelingly drawn, or flesh so like indiarubber.

The World, 30 May 1888 [C445]

[Old Masters]

[Shaw probably had in mind, of many painters named Phillip, the Scottish John Phillip (1817–67), often called "Spanish Phillip" because of his great successes with Spanish themes and settings. Bronzino, whose actual name was Agnolo di Cosimo di Mariano (1502–72), was a Florentine portrait and religious painter who enjoyed Medici patronage.

Howard Helmick (1845–1907) was an American expatriate artist who worked in England and Ireland. Mary L. Gow (1851–1929), who became Mrs. Sydney Prior Hall, painted portraits and genre subjects in oils and watercolors. Her subject Lady Jane Grey (1537–54) was the pretender to the throne on the death of her young cousin Edward VI, losing her head on the accession on Queen Mary.]

Mr. Borgen's old masters at 14 Old Bond Street are worth a visit from the faithful who still prefer such wares to modern ten-thousand-pounder [Rosa] Bonheurs, [John] Phillipses and [Jean-Louis] Meissoniers. There are two portraits by Bronzino, which may be recommended to those who, all things considered, like Bronzino. A picture of an old man, ascribed to Titian, but probably by Tintoretto, will impress every one who is not repelled by its sombre tone, which is not exactly of the shade to attract a novice. The Rubens, with Vandyke in the character of King Ahasuerus, though a bad picture, is a splendid painting as far as the work of Ruben's own hand in it goes. The Jan Steen, and the fruitseller in one of the Tintorettos, are also fine; and there are several other works of considerable interest.

❖

The Cassell black and white exhibition at the Memorial Hall costs nothing to see except half-an-hour's time; and on the whole it is cheap at the price. The drawings seem decidedly more thorough than those exhibited in former years. Mr. Helmick's Irish illustrations, for example, are complete pictures in monochrome. Miss Gow, though she depends too much on her power of drawing things "out of her own head," has added some nobly beautiful figures—especially one of Lady Jane Grey—to the History of England series, in which Mr. Blair Leighton also distinguishes himself. A happily touched sketch by Mr. [Sidney] Paget of a scene at the pianoforte, and some clever pen-and-ink work done in Australia by Mr. [William] Hatherell, are also worth looking at.

The World, 13 June 1888 [C450]

[Maris, Abbey, and Others]

*[Settimio Giampietri was an Italian painter who worked in Rome;
Lucien Doucet (1856–95) painted in Paris. Edward Penstone (?–
1896) was a London genre and landscape painter. Jacobus ("James" to
Shaw) Maris (1837–99) was the contemporary Dutch master. Ameri-
can expatriate Edwin Abbey often illustrated editions of English liter-
ary masterpieces; Shaw had reviewed earlier examples.]*

The private views of Saturday were as numerous as in the first
weeks of May. The interest excited by the water-colours at the Dudley
stopped short of enthusiasm; for public curiosity hardly keeps up with
the willingness of Mr. Walter Severn and Mr. Rupert Stevens to show
their too conscious strength. Signor Giampetri's tricks of perspective
are attractive, but too artless: M. Doucet's work, on the contrary, is full
of art, but not attractive. Then there are Mr. Herne, and Mr. Donne,
and Mr. Burgess, and the rest. Mr. Edward Penstone, whose range is
not yet very wide, has nevertheless succeeded in adding a touch of
poetry to the prevailing barren display of technical skill; and the sug-
gestion of human interest and feeling in some work signed Mildred A.
Butler has the importance of a drop of water in a thirsty land.

❖

At Clifford's Gallery in Piccadilly, Mr. Heath Wilson exhibits Vene-
tian sketches in oil, and illustrates the catalogue by a surpassingly bad
etching. The merit of the sketches, however, is the more conspicuous.
Though they are full of colour and light, they have none of the flimsi-
ness and glitter which make pictorial Venice the most tiresome of
subjects. It is Venice clean and sober for once in a way, and greatly
improved thereby.

❖

Messrs. Boussod & Valadon, at the Goupil Gallery, have hung some
five dozen works by that great Dutch master, James Maris. His "Lock
near the Windmill" is a veritable treasure—one of those simple, right,
and grand pieces of landscape which find their way surely in the long-
run into national galleries. Further down Bond Street, at the Fine Arts
Society, Mr. E. A. Abbey's pen drawings to *She Stoops to Conquer* are
to be seen. In grace and expression, the essentials of figure draughts-
manship, Mr. Abbey excels; and on this he is the more to be congratu-
lated, since in most other points he is laborious at best: affected and
inefficient at worst. The decorative work and bits of script contributed

by Mr. Alfred Parsons are more workmanlike, though they are not strikingly original.

❖

Messrs. Dickinson & Foster, at 114 New Bond Street, have added Winchester and Westminster to the Rugby, Eton, and Harrow of their public school series. The art of these pictures is nothing to the spectator, although the fact that it does not obtrude itself proves it to be faithful and adequate. It is the sensation of being in school again that makes the true speciality of the gallery. Few old boys can withstand the temptation to go thither and reminisce.

The World, 20 June 1888 [C452]

[Gardner and Tuxen]

[Laurits Tuxen (1853–1927) was a Danish artist whose entrée to the Royal Family was Alexandra, the Danish Princess of Wales.]

Mr. Biscombe Gardner, whose exhibition at Westminster of drawings in black-and-white, made in the Surrey country down by Dorking, Leith Hill, and Abinger, will remain open for this week only, is a consummately skilful wood engraver in the department of translating coloured pictures into black-and-white, a department formerly sacred to the line engraver on steel. His methods are as interesting and exceptional as might have been expected. Although he invariably produces his tint with a wash, and never, engraver-like, with a series of parallel lines, he introduces the peculiar devices of his handicraft on occasion with novel effect in the markings of farm-buildings, roofs, and bark on tree-trunks. The wood behind Netley Farm in No. 4, and the sky and roofs in No. 14 (Park Farm), could hardly be more truthfully and forcibly given in black-and-white. There is only one prevailing fault in the drawings, and that is the suggestion of a dazzling steely white light which is not like the soft orange glow associated with the Surrey hills.

❖

An invitation to inspect a picture of a drawing-room crowded by fifty-seven members of the Royal Family is not usually a thing to be thankful for. But Mr. Laurits Tuxen, a Danish artist, has contrived to make out of the subject a Jubilee memorial which is by no means the dread-

ful "conversation piece" which might have been expected. It is clever, effective, sunny, natural—everything, in short that such pictures usually are not. Mr. Mendoza has it in his gallery in King Street.

The World, 27 June 1888 [C457]

[Lowes Cato Dickinson, Portraitist]

[Lowes Cato Dickinson (1819–1908) was a portrait painter to whom many of the Victorian establishment sat—nobility, judiciary, political, military. His subject Lord Napier was Field Marshal Robert Napier (1810–90), an officer in campaigns in India, China, and Africa, later governor of Gibraltar.]

Mr. Lowes Dickinson has at last finished the portrait of Lord Napier of Magdala, which was interrupted thirteen years ago by the appointment of the sitter to the Governorship of Gibraltar. During that interval, Lord Napier has crossed to the wrong side of threescore years and ten; but Mr. Dickinson has not brought the portrait up to date; and it remains an unusually easy and convincing presentment of the hero-elect of the great Anglo-Russian War that never came off. The last of the three or four other dangerous duties that did come off, and incidentally made the reputation of the Engineer Captain, dates from eight years before the portrait, which will presumably be taken off Mr. Dickinson's hands by some public body.

The World, 11 July 1888 [C465]

[Wreckage from the Salon]

[Konstantin Gorsky (1859–?), Russian painter, depicted the gruesome tale of Coudeyar, half-brother of Ivan the Terrible (a fact unknown to both), who returns from exile at great risk to petition to be permitted to see his wife again. He vows his fidelity to the Czar, but Ivan IV insists on what he describes as three proofs. First, Coudeyar must assist at the torture of noblemen he knew who had been charged with treason. Then he must watch, without partaking himself, the Czar banquet at his table. Last, he must sup at his wife's table as commanded.]

Coudeyar is taken to the Imperial Courtyard, where he finds a tin bowl of soup and a crust of bread. Hanging by the table, dead, is his wife, Nastia. "Sit down to dine," one of Ivan's henchmen demands.

Enraged, Coudeyar attempts afterward to murder the Czar, but the floor gives way before Ivan, who laughs, "God protects his anointed."

Augustin Zwiller (1850–?) was a French genre painter; Louis Le Poitteven (1847–1909) was a French landscape and rural genre painter. François Richard de Montholon (1856–?) was a French landscape and genre painter; Alphonse-Jacques Lévy (1843–1918) was a painter, engraver, and illustrator who had studied with Gérôme. The Westall/Mrs. Siddons suggestion refers to William Westall (1781–1850), the most noted of a family of painters, and the great tragic actress Sarah Siddons (1755–1831), best known in a portrait by Joshua Reynolds.

Émile Friant (1863–1932) was a French genre and figurative painter; Johann Till (1827–94) was a Viennese landscape and genre painter. Alexandre Nozal (1852–1929), Charles Giron (1850–1914), Paul Émile Berton (?–1909), and Charles Alexander Coessin de la Fosse (1829–?) were French painters. Akseli Valdemar Gallen-Kallela (1865–1931) was a Swedish painter and Luigi Bazzani (1836–1927) an Italian artist. Frederick Bridgman had been noticed by Shaw earlier (C303).

Joszi Arpád Koppay, Baron von Drétoma (1859–?), was a Hungarian portrait, figurative, and genre painter. His subject, the boy king of Spain (1886–1941), was the posthumous son of Alfonso XII. Until 1902 the child's mother, Maria Christina of Austria, ruled as regent. Alfonso XIII was deposed by the Second Republic in 1931 and died in exile.]

The first sign of returning life in Bond Street is the opening of the Continental Gallery with some wreckage from the Salon. Gorsky's picture of Coudeyar dining in the presence of his wife's corpse is as horrible as heart could wish. The incident of the one slipper dropped from the dead foot is quite in the Madame Tussaud manner. Auguste Zwiller's "Drunkard Remorse" is really tragic and powerful. Its naturalism would be quite convincing but for the incident of the little boy turning his face to the wall to weep, the delicacy of the action being almost ludicrously beyond his years. The most remarkable landscape is M. Louis Le Poitteven's "Moonrise": there is a plain truth about it that is unanswerable. The handling of the sky and distance in Montholon's "Watchman's House" is curiously like that of Sir John Millais. M. Levy's "Birth of Benjamin," if it were engraved in line on steel, and the head of the mother made a trifle like Mrs. Siddons, might pass, by its

composition, for a Garrick Street print after Westall. Friant's "Scullers of the Meurthe," like M. Poitteven's landscape, has the superior force and truth of the new ways in painting; and M. Till's "Campagna" shows how completely those new ways have made it impossible for the older hands to persist in painting outdoor figures from indoor studies. Other noteworthy works are by Nozal, C. Giron, A. Gallen, C. A. Coessin, P. E. Berton, Professor Bazzani, and Mr. Bridgman.

❖

Professor Koppay's portrait of the King of Spain has been added to the collection at the French Gallery. Alfonso XIII, as he sits upon his stuffed pony, looks every inch a king (though that is not saying much, the inches being still very scarce); yet he is as short-frocked and bald-headed as heart could wish. The arrangement of the small figure on its big rocking-horse against a drapery, not of the hackneyed Imperial purple, but of pale blue silk embroidered with golden cranes, brings out the pictorial value of the little King's Spanish complexion very happily. Professor Koppay, who is a young Hungarian painter, is a born painter of children. He has seized and fixed that appealing interest, the special charm of early childhood, which has eluded so many able masters of portraiture. The nursery is a department to which many painters are called, but few chosen; but Professor Koppay seems to be one of the few.

The World, 19 September 1888 [C482]

In the Picture-Galleries
Arts and Crafts

[This is the first major exhibition of the Arts and Crafts movement, important in the genesis of the international style of the twentieth century. Shaw recognized the implications.

Philip Webb (1831–1915) was the architect of William Morris's "Red House" at Upton and influential in Victorian design. Benjamin Creswick, Birmingham sculptor, exhibited in London 1888–1909. Mary (May) Morris (1863–1938), younger daughter of William Morris, was his disciple in arts and crafts and particularly proficient in embroidery. Her infatuation with Shaw at the time was considerable; however, with no prospect of becoming Mrs. Shaw in sight, she married fellow-Fabian Henry Halliday Sparling in 1890.

Herbert Horne (1865–1916) was an art historian and painter who edited the influential Century Guild Hobby-Horse. *Selwyn Image (1849–1930), a Ruskin disciple, was a designer of stained glass and decorative pages; in 1910 he would become Slade Professor of Fine Art at Oxford. Arthur H. Mackmurdo (1851–1942), Glasgow architect and designer, founded the Century Guild in 1882. Lewis Foreman Day (1845–?) was a London illustrator; William Harcourt Hooper (1834– 1912) was a masterly wood engraver for Morris's Kelmscott Press and also engraved drawings for* Punch *and the* Illustrated London News. *Thomas Wardle, an expert on textile dyes, who exhibited in London and Paris, was president of the Silk Association of Great Britain and had been chairman of the Silk Culture gallery at the Colonial and Indian Exhibition in London in 1886. His brother George William de Morgan (1839–1917), a designer of stained glass, pottery, tiles, and ceramics, largely for Morris and Co., would begin a successful career as a novelist after his own works closed in 1905. (Sir) James Guthrie (1859–1930), leading member of a Glasgow artistic family, was a landscape and portrait painter.]*

It has been for a long time past evident that the first step towards making our picture-galleries endurable is to get rid of the pictures— the detestable pictures—the silly British pictures, the vicious foreign pictures, the venal popular pictures, the pigheaded academic pictures, signboards all of them of the wasted talent and perverted ambition of men who might have been passably useful as architects, engineers, potters, cabinet-makers, smiths, or bookbinders. But there comes an end to all things; and perhaps the beginning of the end of the easel-picture despotism is the appearance in the New Gallery of the handi-craftsman with his pots and pans, textiles and fictiles, and things in general that have some other use than to hang on a nail and collect bacteria. Here, for instance, is Mr. Cobden Sanderson, a gentleman of artistic instincts. Does Mr. Cobden Sanderson paint wooden portraits of his female relatives, and label them Juliet or Ophelia, according to the colour of their hair? No: he binds books, and makes them pleasant to look at, pleasant to handle, pleasant to open and shut, pleasant to possess, and as much of a delight as the outside of a book can be. Among the books he has bound are illuminated manuscripts written by William Morris. The largest is a history of one Flatneb, no doubt trans-lated from the Icelandish; but it is by no means a superlative example of Mr. Morris's skill in handwriting. The letters are more open and straggling than in his caligraphic masterpieces; and the decorative diagonal strokes suggest the conventional representation of a shower, as affected by artists who design advertisements of mackintoshes. The

smaller unbound pages in the same case show better what Mr. Morris can do with his valuable time in his serious moments, when he is not diverting himself with wall decoration, epic story-telling, revolutionary journalism and oratory, fishing and other frivolities of genius. From his factory he sends specimens of the familiar wall-papers and carpets; but the highest point in decorative manufacture is reached in his "arras" tapestries, and in a magical piece of stained-glass after a design by Mr. Burne Jones. Mr. Burne Jones, indeed, is even more prominent here than in the ordinary annual picture-show. In his designs for the mosaics of the American Church in Rome, which look oddly out of drawing as they hang, flat and unforeshortened, on the wall of the north gallery, the identification of the art of the pictorial draughtsman with that of the architect is so perfect that Mr. Burne Jones must be classed, not as a mere painter of a picture in the church, but as one of the veritable makers of the church itself. He also shows his skill as a domestic craftsman by a golden "cassone" or ark, with a picture in gesso of the Garden of the Hesperides. This ark is the most beautiful simple object in the exhibition. Not far from it is a superb set of plaster casts (No. 246) for frieze decoration, unique in quality of execution, by Mr. Philip Webb, the architect. Hard by it is a sketch in plaster for the frieze of the Cutlers' Hall, by Mr. B. Creswick, a born sculptor. Mr. Walter Crane, as a cunning man of his hands, skilled in the manipulation of plastic materials, and a great designer and decorator, usually appears in a picture-gallery like a fish out of water; but among the arts and crafts he is in his element; and many persons will learn there for the first time what an able workman and genuinely constructive artist he is. His frieze illustrating Longfellow's "Skeleton in Armour," his wall-decoration—one of the best in the exhibition—called "The Wood-notes," and the cover designed by him for the *Scottish Art Review,* mark his wide range of production with brush and pencil; but if they were withdrawn from the galleries there would be enough work in plaster and metal left to justify his reputation. Among the needle-workers, Miss May Morris is the only one who quite overcomes that consciousness of the horrible tediousness of the process which is the main drawback to a rational enjoyment of embroidery. She exhibits only her quieter achievements, all her great curtains covered with glowing fruit-forests having presumably been ravished across the ocean by the millionaire fanciers of the States. The Century Guild are naturally prominent at an exhibition which they have done much to render possible. *The Hobby Horse* is enshrined in one of the glass cases, showing the other magazines how attractive a printed page can be made by simply setting up old-faced type "solid"; and Messrs. Herbert Horne, Selwyn Image, and Arthur Mackmurdo (for these are the

Guild) have handiwork of their own elsewhere in the exhibition. Mr. Lewis F. Day exhibits extensively; and his best work is, to say the least, very plausible. His design for *The Woman's World,* admirably engraved by Mr. William Hooper, is a capital specimen of its kind. In the west gallery, beside the exhibits already mentioned, Mr. Tom Wardle's handsome silk fabrics and Messrs. de Morgan's clear, rich, and pleasantly splendacious tile-work are conspicuous. The stained-glass department is poor: but for the window by Messrs. Morris, and a well-put-together picture by Messrs. Guthrie, it would not be worth going up-stairs to see. No exhaustive description of the rest of the exhibition is either desirable or possible. Nearly everything there is interesting in its way. The whole gives some faint notion of what a magnificent show of the arts and crafts the shop-windows of London will be when the soil from which the arts and crafts spring is a little improved.

The World, 3 October 1888 [C487]

[Victorian Sculpture, Continental Pictures]

[Mario Raggi (1821–1907), Italian-born monumental sculptor, had a studio in a street where Shaw had lived 1882–87.

Théophile Marie François Lybaert (1848–1927) was a Belgian painter; Jean Charles Cazin (1841–1901) was a French landscape painter. Millet fils was Jean-Baptiste Millet (1831–1906), French landscape and genre painter.]

The loyalty of Hong-Kong has found expression in a colossal statue of the Queen, which is at present overshadowing Signor Raggi's studio in Osnaburgh Street. Its destination, after the foundry, is China, where it will be placed under a shrine in the manner of the Albert Memorial. The majesty of the figure will certainly not disappoint the excited imagination of the colonists, or fail to impress the Chinese amateur. The statue is a little taller and a little more massive in its columnar neck than a statue of any less important person might be, but otherwise these is no deception—the likeness is faithful and characteristic. The arrangement and execution of the drapery are especially remarkable.

❖

At the Hanover Gallery, Millet's "Denicheurs" is the chief attraction. Lybaert's "Caligula" compels your attention by its even and thorough

execution, and by the truth and force with which the face tells the character and mood of the vain and vicious brute, eagerly pretending to himself that he is a god. There is a curious Corot with a Canaletto subject; and a fine landscape and flock of sheep by Rosa Bonheur. Madrazo's work is coarse and slovenly, compared to what it once was; and Gilbert Munger's knack of landscape-painting is little better than a trade secret. When Mr. James Webb's selection of a subject does not lead to his simply doing something worse than Turner did it, his pictures are always valuable. In M. Cazin's pastels the British picture-fancier will miss the sticky richness of the customary oil paint; but if he has an eye for Nature, he will think none the worse of M. Cazin. There is the usual sprinkling of works by Diaz, Daubigny, Ziem, Roybet, Millet *fils*, &c.

The World, 10 October 1888 [C489]

In the Picture-Galleries
Pastels at the Grosvenor, etc.

[James Aumonier (1832–1911) painted animals and quiet pastoral landscapes; Thomas Alexander Ferguson Graham (1840–1906) painted Scottish fishing and country life. Hubert Vos (1855–?), a Dutch painter of landscape and genre, lived in England 1885–92; he then moved to New York and became an American citizen. Roger Leigh, a Kentish painter of landscapes, did views of France and Holland, exhibiting in London 1878–88. Otto Scholderer (1834–1902), a Frankfurt genre and still-life painter, lived in England 1871–99. Madeleine Jeanne Lemaire (1845–1928) was a Paris flower and figure painter as well as a book illustrator. Jules Louis Marchard (1839–1900) and Paul Albert Besnard (1849–1934) were Parisian painters.

Elizabeth Armstrong (1859–1912), genre and flower painter, became Mrs. Stanhope Forbes in 1899, founding with him the Newlyn Art School. Born in Geneva, Charles Ricketts (1866–1931) worked in London as figurative painter, sculptor, engraver, theatrical designer, and writer on art. Florence Pash Humphrey painted genre subjects, exhibiting in London until 1905; Chrissie Ash painted figurative subjects, exhibiting until 1899. Kathleen Trousdell Shaw (1870–1958), a portraitist and genre painter, later turned to sculpting.

Solomon J. Solomon's subject, Ethel Wright Barclay, London painter of flowers, genre, miniatures, and portraits, exhibited 1887–1915; Maude Walker, figurative and genre painter, exhibited in London 1887–92.]

The exhibition of pastels at the Grosvenor Gallery is one of those venerable novelties which from time to time make an astonished British public aware of something that everybody else has been familiar with for years. Pastel, it may be observed, is not chalk or crayon, as Mr. Holman Hunt seems to think: it is dry colour rubbed into coarse paper. Whilst it remains there it is supposed not to change: the only difficulty is that it sometimes does not remain there. An earthquake, for instance, may shake a portrait's head off. Its advantages, in comparison with oil-painting, are purity of colour, the absence of the sticky and more or less brown vehicle, and ease of manipulation. Oil-painters, after a little practice, surpass themselves at it. All sorts of effects, from the rich umber tone of the Dutch landscape-painters to the brilliant pinks and lilacs which are immediately recognised as pastel work, are equally feasible with the dry colour. At the Grosvenor, its range can be judged from the warmth and solidity of Miss Anna Bilinska's flesh painting in her "Highlander of the Carpathians"; Mr. Aumonier's "Sussex Downs," with its reproduction of the water-colour effects beloved by Mr. Hine and Mr. Thorne Waite; Mr. Tom Graham's "Cowherd"; Hubert Vos's "Porlock in Somersetshire"; Mr. Roger Leigh's "Amsterdam"; Mr. Otto Scholderer's "Master Victor"; Mr. A. D. Peppercorn's "Bend in the River"; and Mr. Fred. Brown's "At the Table." No greater variety of tone and treatment than these works present can be found in any gallery of cabinet pictures. The members of the Society of French Pastelists help out the exhibition bravely. Madeleine Lemaire's "Fancy Portrait," though an unmistakable potboiling plausibility robs it of the complete grace and dignity of her water-colour work, contains some enchanting bits of colour. Dubufe is skilful, pretty, and insincere, as usual. J. E. Blanche, whose works are very prominently placed, has a certain distinction of style; but his constrained draughtsmanship tells against him. J. L. Machard is pretentiously middling; but P. A. Besnard's portrait of an etcher working at a copper-plate, from which the lamplight is reflected on his face, is a very clever piece of work. On our own side, the pictures are by no means inferior. Mr. Whistler's achievements in pastel are already familiar. Mr. Solomon's portrait of Miss Ethel Wright is remarkable rather for its drawing and modelling than for its colour, which is not clean. Mrs. Jopling's portraits are much better than anything she has lately done in oils. Miss Elizabeth

Armstrong's work is almost too strong. There are some interesting contributions by Messrs. Ricketts, Clausen, Britten, and Jacomb Hood, besides a drawing in black and red chalk by Mr. Holman Hunt, which has no business in an exhibition of pastels.

Mr. Arthur Hopkins and Mr. C. Robertson share the walls of the Dowdeswell Gallery. Their "manners" contrast rather happily. Mr. Robertson is a little old-fashioned, mostly painting vignettes on a white ground, whilst Mr. Hopkins, with a deeper feeling for nature, plunges into a true country atmosphere of wet green. It is amusing to note how badly Mr. Hopkins comes off when he tries Mr. Robertson's system of projection on white, and how dull Mr. Robertson is when he abandons it for experiments in Mr. Hopkins's direction. The public will be especially delighted with Mr. Hopkins's graceful figure-painting.

Mr. A. Ludovici, one of the cleverest of the "British Artists" during Mr. Whistler's brief and beneficent reign in Suffolk Street, has since 1880 presided over an *atelier* in Charlotte Street, Fitzroy Square (just where Thackeray would have looked for it). This has had some considerable success, owing, apparently, to Mr. Ludovici's practice—unusual in art-academies—of doing nothing to prevent his pupils from learning to paint. Messrs. Dowdeswell are at present exhibiting the results of a competition adjudicated upon by Messrs. Boughton, Menpes, and Albert Moore, consisting of works done by certain young ladies in their holidays, far away from the Ludovician eye. The four pictures honoured by the judges are curiously good for students' work. Miss Florence Pash has taken the gold medal for a picture of a group of dressmakers in a lamp-lit workroom, with daylight streaming in as a girl draws the blind. It would pass for a good specimen of Mr. Ludovici's own work; and if he is ever driven to employ a "ghost," Miss Pash will be able to maintain his reputation. The sky in Miss Chrissie Ash's silver-medal picture is admirable in tone; and Miss Kathleen Shaw's "Gipsy Encampment" would have deserved equal praise but for the perfunctory execution of the foreground. Miss Maude Walker's "Waif" shows some power of dramatic expression; and the touch of exaggeration in the breadth and colour of the head of the drowned girl, though it probably cost Miss Walker the medal, is not unpardonable. The other paintings, it must be confessed, are not so good; but the excellence of these four is remarkable.

All the other aquarellists whose works are the glory of the Institute and the Royal Water-Colour Society have contributed to an exhibition at the Fine Arts Gallery.

The World, 24 October 1888 [C492]

[Minor Exhibitions]

[Louis Bosworth Hurt (1856–1929) was a Derbyshire landscape painter. Émile van Marcke de Lummen (1827–90) was a Flemish landscape and rustic genre painter. Christofell Bisschop (1828–1904) was a Dutch landscapist. Pascal Adolphe Jean Dagnan-Bouveret (1852–1931) was a French painter of genre subjects. The younger Meissonier (1848–1917) was also Jean-Louis-Ernest (C199); Coquelin fils was Jean Coquelin (1865–1944), son of the famed interpreter of Molière's plays, Benôit Constant Coquelin (1841–1909).

Isabel de Steiger, a London painter of genre and historical subjects, exhibited 1879–88. Margaret Murray Cookesley (?–1927), like her husband, painted Middle Eastern subjects, mostly Egyptian scenes. Clifford Montague, a Birmingham landscape and coastal painter, exhibited 1883–1900.]

This week witnesses the opening of most of the minor picture exhibitions—McLean's, Messrs. Tooth's, the Nineteenth Century Gallery in Conduit Street, and so on. At Mr. McLean's, pasture pictures are the chief attraction, Mr. L. B. Hurt's imitations of Mr. Peter Graham being put out of countenance by a strong picture of Van Marcke's, which is itself surpassed in beauty of landscape, and indeed in all pleasant qualities except mere force and breadth of cow-portraiture, by Rosa Bonheur's "Pasturage in the Pyrenees." The title of Barbudo's glittering "First Communion" suggests Mr. Phil Morris; but a glance at the picture dispels the association, as Barbudo sees the ceremony with an eye partly Voltairian, partly merely boulevardian, but at all events wholly un-Britannic.

❖

Messrs. Tooth, whose galleries afford rather more space than they can always find good pictures for, are well provided this time. Bisschop's "Sunny Moment" is a masterpiece of rich harmonious light and colour. "Home to the Fold," with the plantation on top of the hill, and the inevitable flock of sheep put back to the middle distance, is an example of Mauve at his best. Modern French pre-Raphaelitism is responsible for Dagnan-Bouveret's uncompromising representation of a religious procession in Brittany. In the late Frank Holl's "Besieged" the woman's figure is full of expression: the picture is worth half-a-dozen of his portraits. Meissonier's "Piquet" is worthy of its date (1872), which is saying a good deal. "The Improvisatore" is signed Meissonier *fils*, who paints by no means badly, just as Coquelin *fils* acts by no means badly.

"La Jeune Favorite" is none the worse for being less minutely finished than Deutsch's work used to be.

❖

The Nineteenth Century Gallery, devoted chiefly to learners in various stages of proficiency, shows a praiseworthy improvement in the oil-colour department. "Paintiness," of which Mr. Charles Stuart displays a remarkable command in his landscapes, is the prevailing defect. Madame de Steiger, less ambitious than last year, is much more successful. Mrs. Murray Cookesley is advancing by leaps and bounds. Mr. Clifford Montague's Dolgelly picture, in spite of one or two interpolated "bits of colour," is, perhaps, the best of the smaller landscapes in oil. The water-colours, with one or two conspicuous exceptions, are not up to the usual standard.

The World, 31 October 1888 [C494]

[629 Pictures]

[Sir James Linton, Institute President, painted Maud and May, the daughters of E. Meredith Crosse, a prominent lawyer. John Hardwick Lewis (1840–1927) was an American then living in Kentish Town; his only picture in the show was "The Last Gleam on Rose Peak, Arroyo Secco [sic], California." Downward Birch (1827–97) was an English landscape painter. Beatrice Meyer painted historical scenes and figures, exhibiting 1873–93; Catherine Wood, who exhibited for forty years, into 1922, married artist Richard Henry Wright in 1892.]

The pictures at the Institute are rather depressing. There are six hundred and twenty-nine all told, none of them either good enough or bad enough to be worth much critical powder and shot. The painters, more or less skilful, are not inventive, and not original; not only are their "plots" of the feeblest, but they cannot even see colour and form with their own eyes. Among the exceptions are Mr. J. R. Reid, to whom Nature always appears extraordinarily red in the face; Mr. Edwin Ward, who certainly has his own way of looking at a sitter; and Mr. David Murray, who gives us a pleasant and charmingly natural glimpse of a tall cottage chimney peeping through the dusk, above a curtained window dimly glowing on a hillside in the evening. Mr. Blair Leighton's work shows increasing power and resource; and Miss Maude Goodman and

Mr. Kilburne, having duly persevered, have duly improved. Mr. F. D. Millet's "Tender Chord" (titled "Thunder Cloud" in the catalogue) is beautifully delicate in colour, contrasting strongly with the heavy richness of the President's portraits of Miss Meredith Crosse and her sister. Of Mr. Alfred East's two chief pictures, the most original is comparatively hard and shallow; the other, good as it is, owes almost as much to the memory of Cecil Lawson as to Mr. East. Mr. J. J. Shannon's "Rose Pink" is a remarkably foreshortened lady, whose knee, as she sits facing you, seems to project beyond the frame, whilst her head is faintly discernible in the remote background, her waist gracefully occupying the middle distance. Mr. Sherwood Hunter, Mr. Herbert Olivier, Mr. Hardwick Lewis, Mr. Downward Birch, Mr. Charles Collins, Miss Beatrice Meyer, and Miss Catherine Wood are among those who have contrived to escape in some degree the prevailing mediocrity.

The World, 7 November 1888 [C497]

[Four Galleries]

[Charles Thomas Burt (1823–1902) was a Midlands landscape painter who specialized in moorland and Highland scenes. Richard Wane (1852–1904) was a Cheshire landscape and coastal painter, usually of Welsh and Liverpool-area settings. Audley Mackworth painted genre, historical, and biblical subjects, exhibiting in London 1885–90. Charles Augustus Henry Lutyens (1829–1915) was a London painter of portraits, rustic genre, and hunting scenes, exhibiting 1861–1903.

Many of the works in the Vokins exhibition were from the Gilbey collection of English drawings; sale of the catalogue benefited the Artists' General Benevolent Fund. (Sir) Walter Gilbey (1831–1914) was a wine merchant who wrote on sporting subjects and collected related art. Thomas Watson (1743–81) was a mezzotint engraver who published prints with another engraver William Dickinson (1746–1823). Mrs. Charles Pelham (Sophia Aufrère) had been painted by Joshua Reynolds about 1774; the engraving was made by Dickinson in 1775. Mrs. John Beresford (Barbara Montgomery) was one of three Montgomery sisters painted by Reynolds (with Lady Townshend and Elizabeth Montgomery Gardiner) as "The Three Graces decorating a terminal figure of Hymen." Watson made a famous engraving from the picture. James Ward (1769–1859) was a famous animal painter, notably of

horses; Samuel Cousins (1801–87) was an engraver and painter of sporting scenes.

Reginald T. Jones (1857–1904) painted landscapes and coastal scenes, primarily in watercolors; Augustus Wolford Weedon (1838–1908) was a landscape painter in watercolors who had exhibited since 1859. John Henry Dearle (1860–1932), son of an artist, was a painter and designer who worked in many media, including products for Morris and Co. Hector Gaffieri (1847–1932), a London painter and water-colorist, worked in London and Boulogne on fishing scenes, sporting subjects, landscapes, and flowers.

Frederick III (1831–88), Emperor of Germany for only ninety-nine days, had died of cancer of the larynx on 15 June 1888, widowing Victoria, eldest daughter of Queen Victoria. Deathbed and lying-in-state scenes were commonly painted as memorials, often including participants who were not actually present but whose appearance in the picture was a courtesy to the subject and an honor to the deceased. To speed the task, four minor painters shared the commission of the Frederick III canvas. Included in the scene were the Empress Frederick (1840–1901), Princess Royal of England; Helmuth, Count von Moltke (1800–91), the venerable Prussian field-marshal; Prince Otto von Bismarck (1815–98), the "Iron Chancellor" who would be dismissed by Frederick's son and successor, Wilhelm II (1859–1941); Adolph von Stoecker (1835–1909), former Court chaplain and notorious anti-Semite, the leader of the ultra-conservative Kreuzzeiting Party, who Frederick despised but who was a powerful influence upon the new emperor; Leonard, Count von Blumenthal (1810–1900), a field-marshal; and Major General Alexander von Pape (1813–95).]

The Dudley Gallery Art Society cannot with any conscience be congratulated on its management. It generally secures quite enough good pictures to keep up its position, if it did not habitually discount them by filling the rest of the space with productions which a third-rate dealer would hesitate to put in his shop-window. Furthermore, no gallery is so disagreeable to the critics as the Dudley. They are presented with misprinted catalogues, brought face to face with artists finishing their works on the walls, and generally put out of temper by having their duty made as embarrassing as, without actual malevolence, it could well be. Those who are fortunate enough to visit the gallery in a private capacity can note at their ease that Mr. Rupert Stevens takes a strong lead in landscape; that Mr. Stuart-Wortley and Mr. C. T. Burt can paint views of shooting-country in which the heather is better than the

birds; that Mr. Richard Wane is at his best when he avoids the later showy manner of Mr. Ellis; that Mr. Audley Mackworth's capital subject of "Steel Forging," in which all local colour disappears in a fiery glow, only wants a little more heat to be quite convincing; that Mr. Charles Lutyens's able work, "hot," ought to be called "Cold"; and that all these pictures deserve better company than the hanging committee, if such a body exists, has selected for them.

❖

The winter exhibition at Messrs. Vokins' in Great Portland Street consists this year entirely of mezzotints, which are growing in favour now that people are heartily tired of etchings. A glance at the finest of the prints lent by Mr. Henry Blyth will show how much the most artistic of all metal-engraving processes mezzotint is. Mr. Walter Gilbey also contributes extensively. There are proofs in excellent states from Raphael Smith's, Watson's, and Dickinson's plates after Reynolds. Dickinson's Mrs. Pelham, and the "Mrs. Beresford, Lady Townshend, and Mrs. Gardiner," are especially fine. The horses by Ward, and the pretty plates by Samuel Cousins, bring the collection nearer to our time. According to the custom at Messrs. Vokins', there is no charge for admission.

❖

An exhibition of drawings has been opened at the Burlington Gallery. Mr. Reginald Jones's Sussex pictures are very effective, but they are not so fresh and quiet as they might be. No landscape in nature ever looks as if it were worked in plush, as some of Mr. Jones's do. Mr. A. F. Grace, Mr. A. W. Weedon, Mr. Dearle, Mr. C. E. Hern, Mr. Brewtnall, and Mr. Caffieri are among the contributors.

❖

The picture at the Gainsborough Gallery of the lying-in-state of the late Emperor at Friedrichskron is a successful attempt by four painters to place a painful ceremony exactly before us. The portraits include the Emperor, the Empress Frederick, Moltke, Bismarck, Stoecker, Blumenthal, Pape, and others. The artists—Hirsch, Aglita, Vieweg, and Schmidt—have been unsparing in their representation of death, and the effect is oppressive rather than impressive.

The World, 14 November 1888 [C502]

[Arts and Crafts; Black-and-White]

[(Sir) Emery Walker (1851–1933), a Hammersmith Terrace neighbor and friend of William Morris, was a photographer and printer associated with Morris in the Kelmscott Press. Later he was involved in other fine-printing ventures, including, with T. J. Cobden-Sanderson, the Doves Press.

Oscar Wilde (1854–1900), not yet a recognized dramatist, was then a poet and critic. William James Linton (1812–98), wood engraver, poet, and political reformer, known for his designs of the covers of The Cornhill *and* The Illustrated London News, *had settled in the United States but returned for professional reasons.*

Frederick James Aldridge (1850–1933) was a Sussex landscape and seascape painter. Rosa Fryer Hensman, a London genre painter, exhibited 1886–94; Clough W. Bromley, London landscape and flower painter and engraver for Vicat Cole, exhibited 1870–1904. Florence Claxton and her sister, Adelaide Claxton, illustrated for London magazines (usually humorous subjects) and exhibited watercolors and drawings 1859–89. Alice Majory Gow-Stewart exhibited 1888–1906 in London, afterwards in Paris. Raffaele Giannetti (1832–1916) was an Italian genre artist; L. Bruck Lajos exhibited realistic scenes of London street life into the 1890s.

William Chappell (1809–88) had been head of the great London music publishing house.]

At the Arts and Crafts Exhibition, on Thursday evening last, Mr. Emery Walker's lecture on printing was the occasion of an amusing scene. Mr. Walker had expressed himself mildly as to the mechanical ugliness of "new face" type, and the folly, from the artistic printer's point of view, of illustrating books with pictures designed without reference to their destination as part of a printed page. By this, Mr. Walker meant—thought he did not say so—that a monthly part of *Harper's* or the *Century* is, looked at as a decorative object, the abomination of desolation. An American gentleman present ventured to remonstrate. Thereupon Mr. William Morris clothed Mr. Walker's unspoken thought in unmeasured words, denouncing American artists, engravers, and printers alike, regardless of the fact that the American gentleman happened to be Mr. Joseph Pennell, whose works in black-and-white are the pride of the *Century*. The Arts and Crafts speedily made a ring and looked on with much relish. Mr. Crane was there, with Mr. Cobden-Sanderson, Mr. Oscar Wilde, the veteran W. J. Linton, and other more

or less well-known spectators. Poor Mr. Pennell, too polite to retort the ill-usage of his older and more famous adversary, could only appeal mutely from the injustice and explosiveness of poetic and socialistic Man to his own work and experience. The "Pennell incident" will probably be the staple topic next Thursday, when Mr. Cobden-Sanderson lectures on bookbinding.

❖

The Black-and-White Exhibition at Mr. Mendoza's gallery in King Street is the best and richest in original work that he has yet succeeded in getting together. Mr. F. Aldridge's "Fresh Breeze" is a delicate and truthful piece of work; and Miss Pash's and Miss Hensman's drawings show artistic fancy and remarkable command of tone. There is a successful etching by Mr. Clough Bromley, a humorous and spirited satirical allegory by Miss F. Claxton; some pretty heads by Mr. Henry Ryland; some little drawings with an invaluable dash of imagination in them by Miss Gow-Stewart; and plenty of work by Signor Giannetti, Messrs. Dadd and Dollman, and others whom one expects to find represented at this exhibition.

❖

Mr. Lefevre of King Street exhibits Bruck Lajos's picture of the Monday Popular quartet, with Joachim as first violin and Mr. Straus at the tenor. St. James's Hall devotees will be delighted with the portraits of the players, who are represented, not on the platform, but in a commodious drawing-room, with no audience except the portrait of Mr. Chappell on the wall.

The World, 21 November 1888 [C504]

[The RSBA Without Whistler; Cobden-Sanderson on Bookbinding]

[Frederick Yeates Hurlstone (1801–69), a portrait and historical painter, had been president of the pre-Royal Society of British Artists 1835–69, thus a predecessor of the departed Whistler. Henry Mark Anthony (1817–86), a London painter and close friend of Ford Madox Brown, was never SBA president, but was a leading member, and a tall, imposing man of presidential mien. According to William Michael Rossetti (Brown's son-in-law), Anthony's "domestic life was not so

correct as it should have been; a case came into court, and it was held that this furnished the Royal Academicians [who had exhibited his work: he was not an RA] with a handle for refusing him. . . ." Anthony then vanished from the SBA as well, painting sourly in his studio in Hampstead. It was John Burr (1831–93) whom Whistler succeeded as President of the SBA in 1886, and Wyke Bayliss who replaced Whistler in mid-1888.

The President of the Royal Academy remained Frederick Leighton. A one-time art-student crony of Whistler in Paris, he was now an implacable opponent, and in helping out Wyke Bayliss he was demonstrating that enmity.]

The Society of British Artists—it should be written the Royal Society, but the honour is new and one is forgetful—is a kind of "Sick Man" in the world of English art: it seems constantly a probability that it is at its last gasp, but it as often recovers and comes up to time smiling. In my time, as Mr. Hurlstone and Mr. Anthony ceased to be its President, "the crisis," and the painters, "had come." But Mr. Whistler took the vacant chair: he beautified the rooms, made the place talked of once again, and having come, seen, and conquered, he vanished airily, as Mr. Anthony had vanished in his stately fashion years before. Now, no sign remains of Mr. Whistler but his butterfly without and his *velarium* within the building. Mr. Wyke Bayliss rules over the pretty rooms, the pictures are once more hung close together, and still the Royal Society appears outwardly what it was thirty years back, only less dingy. Impressionism has vanished like Harlequin, and the President of the Royal Academy, with one or two of the members, has lent a few studies to help the winter venture, if such aid is really a help. But as the visitor walks through the rooms of these minor societies, he seems to be looking at the Royal Academy through reversed opera-glasses, and longs for something quite differently arranged.

❖

Mr. Cobden-Sanderson's lecture in bookbinding at the Arts and Crafts on Thursday was an uncommonly clever and well-acted impersonation of the ideal craftsman invented by the guild. The business of taking off his coat and tying on his apron—"the banner of the future," he called it—brought down the house. When he said that "the sensitive nature of the book" revolted against the hammering required for round backs, approval beamed from every eye except that of a poor professional student near the door, who growled that Mr. Sanderson was "no genuine tradesman." "Let him try an' get his livin' by it," he said

enviously. But he was taken aback by the excellence of Mr. Sanderson's handiwork. Next Thursday Mr. Walter Crane lectures on design.

The World, 28 November 1888 [C507]

Last Lecture at the Craneries
Walter Crane as a "Lightning Sketcher"—
The Exhibition Has Paid Its Way

[Caroline ("Dollie") Radford (?–1920), wife of barrister Ernest Radford (1857–1919), was an amateur poet and friend of Shaw since 1884. Geraldine Spooner was a young artist who became a Fabian Society member in part to be closer to Shaw, but when his continuing attentions and admiration did not lead to matrimony, she married fellow-Fabian Herbert Wildon Carr in 1890. Lord Randolph Churchill (1849–95) was the M.P. and former Cabinet minister.]

The last of the lectures at the Arts and Crafts was a great success. Their fame has evidently been spreading; for whereas Mr. William Morris's lecture was well attended, Mr. Emery Walker's full, and Mr. Cobden-Sanderson's crowded, Mr. Walter Crane's audience overflowed in all directions. It had blocked up the pavement in Regent Street before eight o'clock. By half past the north gallery was packed. The people whose heads appeared over the screen between the doors must have been standing on the Burne-Jones[-decorated] piano; and at the opposite end the Burne-Jones *cassone* remained covered with tall hats until Mr. de Morgan appealed to the owners to consider that the great artist might at any moment enter the room and be stricken by the profanation of his golden ark. Those who were unable to effect an entrance wandered about the other rooms with a noise of many footsteps; and their shuffling, creaking, and heel clinking, with the occasional skidding of a chair along the slippery flags, made it some[what] the easier to hear the lecture from the neighborhood of the doorways. Mr. Crane is not easy to follow under the most favorable circumstances. He writes a capital paper, and has one of those light tenor voices that are heard without effort; but his modesty recoils from the slow pointed elocution, and

GRAND PANJANDRUM EMPHASIS

which save so much straining of ear and attention. Fortunately, those who could not hear could at least see the lecture when he went to the

blackboard, chalk in hand, and there and then turned out some really artistic work as easily and rapidly as a lightning sketcher turns out portraits of Bismarck and Lord Randolph Churchill. First he drew an oak tree in its native majesty. Then, without in the least spoiling its beauty, he drew it again so that its outline exactly fitted into, and decorated, a hard and fast rectangle. These feats being rapturously applauded, he exhibited several other drawings, and finished up with a figure, drawn swiftly and freely in flowing curves, of a female who may possibly replace Britannia on our pennies when we get as far as a Socialist coinage. Mr. Cobden-Sanderson, who appeared this time without his apron, acted as amateur light porter in displaying the designs, performing

HERCULEAN FEATS WITH THE BLACKBOARD.

When the lecture was over, Mr. Crane stated that the exhibition had paid its way and something over, and that it had been decided to hold another exhibition, and to continue the lectures next winter. Mr. Sanderson then pronounced a brief benediction; and the chairs went clattering and sliding as the audience rose not to disperse, but to improvise an informal conversazione, the outsiders lingering near the platform to compare Mrs. Stillman's style of beauty with Mrs. Radford's, to try to believe that Miss Geraldine Spooner was really fresh from an energetic School Board canvass in the Tower Hamlets, to inquire which was Mrs. Crane and which Mrs. Oscar Wilde, and to stare mistrustfully at the figures whose baleful oddity bewrayed the Socialist in the haunts of the artist. The gallery was not finally cleared until sleep had all but overpowered the attendants.

The Star, 30 November 1888 [C508]

[Watercolors]

At the Royal Water-Colour Society there is, as usual, an excellent exhibition, about which there is little to be said. Mr. Alfred Hunt and Mr. Albert Goodwin are still preeminent; Mr. Robert W. Allan is coming forward with quickening strides, Mr. Charles Gregory has made a determined attempt, with the best results, to break off his habit of using colours like a flower-girl, Mr. Arthur H. Marsh insists on some attention; Mr. Walter Crane has a beautiful study of "Mediterranean Blue," full of decorative wave-lines; Mr. David Murray exhibits a little picture called "Adversity," which would be a desirable possession if the roadway in it

were more plausible, and Miss Clara Montalba has sent some valuable results—most unkindly hung—of a tour in Sweden. Instead of the customary tolerated example of black-and-white from Mr. Du Maurier, there are several drawings by Mr. Burne-Jones, beautiful, but out of place. To make amends, a large and solidly-painted picture from the same hand, entitled "Caritas," is a fine specimen of the master. The catalogue has been happily reduced to a convenient size by the omission of the bundle of valueless sketches at the end. These have long ago lost their novelty—the only merit they ever possessed.

❖

The lectures at the Arts and Crafts are over. Mr. Walter Crane delivered the last of them on Thursday to a packed audience, which was much entertained by his feats of drawing on the blackboard. He announced that the exhibition has been financially successful, and will be repeated next winter.

The World, 5 December 1888 [C513]

[Conrad Beckmann; Sutton Palmer]

[Conrad Beckmann (1846–1902) was a German portrait and historical painter. Composer Richard Wagner (1813–83) was the son-in-law of composer Franz Liszt (1811–86), whose daughter Cosima (1837–1930) made Wagner her second husband. Hans Paul von Wolzogen (1848–1938) was the editor of Wagner's Bayreuther Blätter *and author of books on the composer and his work. Rudolph Ibach, a German-born manufacturer and merchant of pianos, had been a friend of Wagner; the London premises of Rudolph Ibach and Co. were at 113 Oxford Street.]*

The interest of Professor Beckmann's "conversation piece" of Wagner, Liszt, Von Wolzogen, and Cosima Wagner discussing the score of "Parsifal" in the study at "Wahnfried," has been partly discounted by the photogravure which has been published. However, the original is worth seeing, as it at least gives a more luxurious impression of the extent to which Wagner was finally enabled to make himself comfortable, in spite of having had in his prime to beg piteously for "half a decent mechanic's wages," to enable him to compose *Siegfried*. The picture is on its way to America; but Mr. Rudolph Ibach has hung it in

his pianoforte-room at 113 Oxford Street, for the benefit of any one who cares to inspect it before the end of the year.

❖

No artist has had so much first-rate work to show for the past two years as Mr. Sutton Palmer, who has within that period finished the seven dozen pictures of Highland scenery now at the Dowdeswell Gallery. The drawing is so faithful that no trick or turn of the painter's hand can be discerned in it, any more than in a photograph. Even the composition and the harmonious tone and delicate colour are so admirably natural that the artist is forgotten in his work—a delightful thing to have to record nowadays, when a painter's intrusiveness is generally in direct proportion to his cleverness. Mr. Sutton Palmer's studies of everything that will stand still to be studied are so exhaustive that he is comparatively at a disadvantage as a painter of foaming torrents and waterfalls; but there is no way of avoiding this, short of painting the perfect parts of the picture down to the level of the inevitable imperfections. The glow of the field in "Sunset, Brig of Turk," the changing light on the mountain-side in "Glencoe," the group of trees to the right in "Tollie Crage," and the wonderful bower of clouds mirrored in "Loch Achray," are not better than other things in the exhibition, but they may be mentioned as samples of what is most enchanting in them. The few experiments in stronger and wilder masses of colour are justified by their success. Future exhibitions will probably show a development of Mr. Sutton Palmer's style in this direction.

The World, 12 December 1888 [C517]

[Stuarts]

[James IV (1473–1513), a Stuart, was King of Scotland from 1488; Henry VII (1457–1509), first of the Tudors, was King of England from 1485. Marmion, a Tale of Flodden Field *was a Walter Scott historical romance. James VI (1566–1625), King of Scotland from 1567, succeeded Elizabeth I as James I, the first Stuart King of England, in 1603. His parents were Mary Queen of Scots (1542–87), forced to abdicate in 1567 in favor of her son, and Henry Stuart, Lord Darnley (1545–67). ("Maries" refers to Mary of Scotland.) Charles I (1600–1649), son of James I, lost his head as well as his throne. Flora Macdonald (1722–90), Jacobite heroine, helped the Young Pretender, "Bonnie Prince Charlie"*

(1720–88), styled James III by his followers, to escape to Skye after the military disaster at Culloden. Mary of Modena (1658–1718) was consort of James II, grandmother of the "Bonnie Prince." Queen Henrietta Maria (1609–69) was the consort of Charles I of England. James Scott (Fitzroy), Duke of Monmouth and Buccleuch (1649–85), was the illegitimate son of Charles II (1630–85), King of Scotland from 1651, of England (following the Commonwealth in 1660. John Graham Claverhouse (1648–89) was the first Viscount Dundee.

Alfred Maltby (?–1901) was an actor, scene designer, and theater manager.]

The Stuart Exhibition at the New Gallery, if not exactly delightful, is curious. One would observe, guardedly, that there were a good many Stuarts, and that they were not all interesting. Of the four who have been exceptionally well written up, James IV turns out to have been more like Erasmus or Henry VII than might be imagined from reading *Marmion*. Mary, of whom innumerable bogus likenesses have been made by painting new faces into portraits of the period, was no voluptuous beauty, but merely a refined ladylike person, with a high forehead and the family nose. Charles I need not be described, as his is probably the best known face in London; nor does the Exhibition offer any novel view of bonnie Prince Charlie. There are plenty of relics from Flodden and Culloden, Fotheringay and Whitehall, with locks of hair, stray pieces of furniture and articles of underclothing, roses and cockades from 1745, Flora Macdonaldiana, and a ruck of letters, rings, miniatures, gloves, spurs, stirrups, and a saddle or two. The ante-Vandyke portraits are a very miscellaneous lot indeed, presenting two utterly incompatible James the Sixths, half a dozen irreconcilable Maries, and a fairly consistent Darnley, whose most characteristic features have descended upon Mr. Maltby of the Criterion Theatre. For personal beauty the palm must be given to Mary of Modena, Monmouth (as a boy), and Claverhouse. The only really tragic portrait is one of Henrietta Maria in her latter days, when misfortune and ill-health had worn her out, and she had death in her face.

The World, 2 January 1889 [C523]

[English, Dutch, and French Masters]

[Augustus Leopold Egg (1816–63) was a London literary, historical, and genre painter, ARA 1849. William Etty (1787–1849), ARA 1824,

*used classical and mythological titles to paint luscious nudes which
often scandalized the Victorian public but found a ready market. Jean
Antoine Watteau (1684–1721), French figure and landscape painter,
painted quasi-pastoral and neoclassical scenes; he would be a major
influence upon Fragonard, Boucher, and the Impressionists. Nicolas
Lancret (1690–1743) painted quasi-pastoral and fête galante scenes
in the manner of Watteau. Thomas Gainsborough (1727–88), a
founder-member of the RA, was one of the greatest English landscape
and portrait painters.*

*Among portrait subjects are Thomas Howard, second Earl of Arun-
del and Surrey (1586–1646), English statesman and art connoisseur;
and Sir George Otto Trevelyan (1838–1928), Liberal M.P., who held
several Cabinet portfolios 1868–95).]*

The Old Masters at the Academy this season are Dutch or French to
a man. There is not a single Italian picture in the exhibition. The fifty-
one Rhine sketches made by Turner in 1819, miracles of sure, rapid,
beautiful work with brush and penknife, are the treasures of the collec-
tion; but their inspection involves an Arctic expedition into the water-
colour room, which is not heated, or, at any rate, was not on "press-
day." There was even some question among the shivering critics as to
whether it had not been specially refrigerated for them. The first room,
in which the British school chiefly rages, revives the memory of Augus-
tus Egg, and heavily damages the reputation of Leslie and also of
Maclise, who ought to be represented by something better than his
"Vicar of Wakefield" scene, or else left in peace. Etty and John Freder-
ick Lewis fare much better; and there is a fine landscape, "Purchased
Flock," by John Linnell. Watteau and Lancret are in force in the sec-
ond room: Greuze is also there, with the usual padding of Wouverman,
Teniers, and the Dutch school generally. The large gallery has a splen-
did wallful of Rembrandts, each of which has been duly condemned as
spurious by some competent authority, and hailed by another, not less
competent, as the only unquestionably genuine Rembrandt in the
place. Rubens' masterly portrait of the Earl of Arundel is hung by the
side of his disreputable and ridiculous "Marriage of Mars and Venus."
A couple of landscapes by Gainsborough, full of his indescribable
charm, stand out from among the Reynoldses and Romneys which
stop the remaining gaps. Two other rooms are open, both devoted to
the works of Frank Holl. After Rembrandt, the pastiness and opacity of
Holl's flesh-painting, and the black-and-white style to which he was
led by his lack of the artistic colour-sense, are very apparent. The
prosaic verisimilitude of Lord Spencer's red beard and blue ribbon is
quite curious as an example of this. The only portrait which pretends

to be a picture is that of Mr. John Bright, who seems to be awaiting execution in a vaulted cell. The portrait of Sir George Trevelyan is a capital likeness. The earlier works arrest attention by their painful subjects; but they are not pathetic. Holl, in short, had remarkable graphic ability and a style of his own; but if we preserve any of his works it will be among our national portraits, not among our national pictures.

The World, 9 January 1889 [C525]

[Wyllie's "Queen's Navy" Sketches]

Mr. W. L. Wyllie's "Queen's Navy" sketches at the Fine Art Society's gallery are chiefly interesting from the hearts of oak point of view; but here and there in "The Spider with a Telegram for the Admiral," for instance—a dash of saltwater or a wreath of mist brings the painter's feeling for Nature up through "our special artist's" feeling for a naval review. It may sound all but blasphemous to say that the new ironclads are much prettier than the old three deckers; but the truth is the truth: the wooden walls are, in comparison, lumpish in the hull, and rigged like an old fashioned builder's scaffolding, all right angles. The photographs in the other room are worth examining; but it was not wise to restrict the examples to prize winners at former exhibitions. Until quite lately the distinctions were so commonly awarded to the most ingenious specimens of photographic cookery, that it would have been more to the point had medals and honorary mentions been regarded as a disqualification, or, at least, as a valid ground for suspicion. However, the committee has been tolerably wide awake, and nothing very flagrant spoils the interest of the show.

The World, 16 January 1889 [C526]

[British Art, 1737–1837]

[John Berney Crome (1794–1842), a Norwich landscape and coastal scene painter, was known for his moonlit scenes, anticipating John Atkinson Grimshaw (1836–93). Robert Thomas Stothard, who exhib-

*ited 1821–65, painted portraits, group portraits, and figurative sub-
jects. John Russell (1745–1806), RA 1768, was a Guildford portrait
painter.*

*Subjects of portraits include William Musters Chaworth, an Annes-
ley squire who had married Mary Chaworth of Newstead, an heiress
much admired by Lord Byron in his youth, and taken her name in the
fashion of the time; Robert Steward, Viscount Castlereagh (1769–
1822), Ulster-born English Foreign Minister during the close of the
Napoleonic wars, who became Marquis of Londonderry in 1816; and
Dorothea Bland Jordan (1762–1816), Irish actress who for twenty-
one years was mistress of the Duke of Clarence (later William IV),
bearing him a brood of FitzClarences. Laurence Sterne (1713–68) was
the novelist whose masterpiece was* Tristram Shandy. *"Farinelli" was
Carlo Broschi (1705–82), a spectacular soprano castrati singer from
Bologna who first sang in London at the Haymarket in 1734.]*

Sir Coutts Lindsay, with his Century of British Art (1737–1837) at
the Grosvenor, has thrown back the New Gallery on its relic hunters,
and left the Academy nowhere. Such handsome Gainsboroughs, nip-
ping northeasterly Constables, rich brown-and-yellow Reynoldses,
masterly genuine Cromes from Norwich and clever sham ones from
France, are not to be seen together elsewhere in London. In compari-
son, the British side of the National Gallery is a den of confusion.
Stothard's "Speech Day at Christ's Hospital," a scene in an old-
fashioned panelled room, prosaic enough, is glorified by a flood of
warm, diffused sunlight—Stothard might have left us a bottle to dip
our brushes in. One of the two pictures attributed to Cotman is a
capital example of how far he could go in Turner's direction; but the
other, a perfect Flying Dutchman of a ship, has a completeness and
success that make one doubt whether Cotman really painted it. The
finest Turner is "Pope's Villa." Time has somewhat jaundiced and
dried up the sun in it, but the mellow radiance on the river is still
nearly as enchanting as ever. Russell's eighteenth-century pastels
prove that dry colours get shabby with age just as oil-colours do; and do
not, as oil-colours sometimes do, change into something rich and
strange. The eighty-six sketches and studies by Constable, now exhib-
ited for the first time, are of great interest. Some of them, as might
have been expected, are exquisite little pictures. People who do not
take their art artistically will be entertained by the portraits of William
Chaworth, the victim of the Byron-Chaworth duel; of William Gillford
of the *Quarterly* [*Review*]; of Farinelli the singer; of Castlereagh; of
Mrs. Jordan by Romney, and of Sterne by Reynolds. Also "relics" of
Constable, in the shape of a battered paint-box and some old colours,

the whole tastefully arranged in a glass case, offering an immensely gratifying spectacle to the thoughtful visitor.

❖

Mr. James Webb has a hundred sketches or so in all at Mr. Thomas McLeans's gallery in the Haymarket. They are of very modest dimensions, but they prove, as well as his more ambitious works, what a master Mr. Webb is of all the moods of the sky—except perhaps the Whit-Monday mood, for the omission of which may we all be truly thankful.

The World, 23 January 1889 [C530]

[Mortimer Menpes]

[Thomas Humphry Ward (1845–1926) was an editor on the staff of The Times, *and literary critic. For Wimbledon, see C576.]*

Mr. Mortimer Menpes has, perhaps, taken to dry-point etching to show that the sure eye and steady wrist which made him famous as a rifleman still survive, though Wimbledon is no more. He has certainly achieved a remarkable success with the needle (said to be a French darning needle, cunningly ground by the etcher himself, and fixed in a handle, with only the sixteenth of an inch or so projecting) in his large plate after Frans Hals' "Banquet of the Archers." No result at all worthy of comparison with this etching has been attained by the ordinary scratching and biting process hitherto supposed to be the only one possible with plates measuring three feet by two. According to Mr. Humphry Ward, Mr. Menpes aimed at suggesting the colour of the original picture. If so, he has been about as successful as Liszt was in suggesting in his pianoforte transcriptions the orchestral colour of Beethoven's symphonies—that is to say, not successful at all. But what can be done in brown and white by extraordinary strength, precision, and delicacy of touch, he has done. The sheets, be it noted, have an unusually pleasant appearance. If this criticism puzzles any collector, let him study the contents of his portfolio for a moment apart from the artistic merit of the impressions they bear, as a printer studies the prettiness of a printed page apart from its literary merit. From this point of view he will find Mr. Macbeth's "Bacchus" clumsy and M. Waltner's "Night

Watch" positively hideous. Mr. Menpes, being his own printer, has made no such oversight. He was infected with the Hals enthusiasm by Mr. Charles Dowdeswell, who caught it in the usual way during a trip to Holland; and a few proofs from the nearly finished plate are now to be seen at the Dowdeswell Gallery in New Bond Street.

The World, 30 January 1889 [C532]

[Landscapes]

The Nineteenth Century Art Society, in its anxiety not to discourage beginners, has hung some pictures which would be indignantly stamped out by any policeman of taste if perpetrated by one of the artists of the pavement. Some laborious attempts to copy landscape faithfully from Nature are respectable, and even interesting. As usual, the works are for the most part by professional painters who are not very good, and amateurs who are not very bad. There is improvement still, but its rate has been checked since last exhibition.

❖

Mr. Paul Naftel's Channel Island sketches have been launched at the Fine Art Society's gallery, with a clever catalogue-preface by Lady Colin Campbell. Sark was just the place for Mr. Naftel, who likes his colour natural, if possible, but bright, in any case. The greater scope and power of these sketches will surprise those who only know him by his variations on mustard-sprinkled trees at the Old Water-Colour Society. Another luxurious colourist who has braced himself up is Mr. E. P. Bucknall, whose new Welsh sketches at the Burlington Gallery show an advance in breadth of handling and freedom from the monotonously pretty tourists' weather prevalent in water-colour exhibitions. The Burlington Gallery is also much occupied by screens covered, without the slightest regard to decorative propriety, with sporting pictures,—grievous things to the eye of Mr. Walter Crane, but not ill calculated to gratify country gentlemen in search of interesting drawing-room furniture.

❖

Messrs. Vokins of Great Portland Street are getting together for exhibition next month a loan collection of works by George Cattermole. If

there are any unknown Cattermoles hidden in private collections, now is the time for the owners to let us have a peep at them. Messrs. Vokins' exhibitions are free, and their exhibits fully insured; so there is no reason for withholding good things from their gallery.

The World, 13 February 1889 [C535]

[Bond Street]

[Alexander Young was a Scottish-born painter who lived in London but painted the landscapes of his origins, exhibiting in the 1880s and 1890s. Charles West Cope (1811–90), ARA 1843, was a versatile painter, producing large works as well as cabinet pictures, and working as painter, illustrator, and engraver. John Varley (1778–1842) was a landscape and architectural watercolorist whose pupils numbered many major mid-Victorian artists, including Linnell, Hunt, Mulready, and Fielding. Luigi Chialiva (1842–1914), an Italian painter, exhibited in Zurich, Paris, London, and Rome. B. J. M. Donne, a Campden Grove landscapist, exhibited Continental scenes in the 1880s and 1890s. William Sidney Cooper, a Canterbury landscape painter, exhibited 1871–1908. Henri Gervex (1852–1929) was a French genre painter.]

Bond Street was full of private viewers on Saturday. The Corots at the Goupil Gallery are not very numerous—only twenty-one all told; but they are fairly representative. Mr. Alexander Young's "Bent Tree" is a regulation leafy Corot; Mr. A. S. Forbes's "Lac de Garde" is a regulation silvery Corot. "The Nymphs' Dance" has a grace that recalls the exquisite Gainsborough at the Academy (Hyde Park, or The Mall, or some such title). One or two figure subjects remind us, in Corot's fashion, that flesh is but clay, and might as well be made to look like it. Mr. Mesdag's "The Cliffs" is out of the painter's favourite line, and is as bad as might be expected under the circumstances. "La Vanne" (lent by M. Vever) is full of an indescribable feathery radiance that is quite enchanting. A wonderful man, Corot!

❖

Mr. Agnew could not have described his exhibition better than he has done by his phrase, "Selected high-class drawings." That is exactly

what they are. De Wints, Copley Fieldings, Prouts, Hunts, Catter-moles, Copes, Barrets, Turners, Stanfields, Varleys, Hollands—need one continue? Two drawings by Mr. Du Maurier are in colour; Signor Chialiva, whose work is not to be found elsewhere than at Mr. Agnew's, has a few pictures—chiefly phases of Mary with her little lamb. Mr. W. Langley's "Orphan," is very well, but the orphan's grand-mother's nose and chin are becoming tedious; he should study a new face for us. Sir John Gilbert, Mr. Sidney Cooper, and Mr. Vicat Cole also contribute to the show, which is varied and valuable, but not, on the whole, remarkable for novelty.

❖

Messrs. Dowdeswell have no less than three exhibitions at their galleries this week. One, which will assuredly be counted to them for righteousness, is "London Churches," by Mr. C. E. Hern, drawing-master at Marlborough House. Instinctively the public takes off its hat, looks for its own particular church, and turns, after a pause of reverent contemplation, to Mr. B. J. M. Donne's sketches in the Austrian and Italian Tyrol, which are exactly like all Mr. Donne's previous sketches in mountain-land. A fresher joy is Mr. A. Ludovici's London Life series, grouped under such heads as "The Parks," "The Restaurants," "The River," "The Theatre," &c. Mr. Ludovici calls himself an impressionist, which may mean anything; and he evidently values himself on his delicate sense of tone, which is certainly extraordinary. "Kensington Gardens," "A Soiree at Messrs. Dowdeswell's," and several other sketches are curiously right in this respect. But an ounce of humanity is worth a ton of nebulous "values"; and the most important of Mr. Ludovici's gifts is that which enabled him to catch so swiftly and fix so happily the expression, carried right throughout the figures, of the lady and the cabman in No. 5, of the inimitable housemaid in No. 8, the children round the fire in the Drury Lane property-room in 23, the girl practising in 83, the lady in the riding habit opening the letter in 84, and the woman "writing for the press" in 90. It would take a combina-tion of Gervex or Van Beers with Mr. Whistler to beat Mr. Ludovici in work of this sort. The Henley sketches, though the water in some of them might look fresher and wetter, are not to be hastily misliked for their pyrotechnic complexion. In "The Pitti Sing" the glimpse of the snug inside of the houseboat, seen through and amidst the colder gloom outside, makes you half shiver. Mr. Ludovici is unquestionably one of the young lions of his school.

The World, 27 February 1889 [C543]

[Stuarts]

[The Duc de Fitz-James was the sixth duke in the line of pretenders to the throne of James II, all of whom lived in exile in France.

The paragraph, although Shaw's, appeared under the pen-name of the editor of The World, *Edmund Yates (1831–94), a common practice.]*

The Stuart Exhibition has been reinforced by a revised edition of the catalogue, and a model in wax of the head of James II, taken immediately after his death. "This object," as the managers call it, has been lent by the Duc de Fitzjames. According to their description, "the face, though deathlike, has a very placid appearance," which is not, after all, so very surprising.

<div align="right">

Atlas.

The World, 6 March 1889 [C547]

</div>

[Haden's Etchings; Cattermole's Histories]

[Sir Francis Seymour Haden (1818–1910), London surgeon, turned to etching and promoted its revival in England as an art, founding the Society of Painter-Etchers in 1880. He married Whistler's half-sister, Deborah.

Shaw's reference to Mr. Merdle is to the swindler and his lawyer in Dickens's Little Dorrit. *Hablôt Knight Browne (1815–92), etcher and illustrator of many of Dickens's books, often used the pseudonym "Phiz."*

William Strang (1859–1929), a Scottish painter and etcher, specialized in portraits and figurative subjects.]

The Royal Society of Painter-Etchers preface the catalogue to their exhibition at the Old Water Colour Society's gallery in Pall Mall with the following resolution, passed on the 20th February last: "That in partial acknowledgment of the invaluable services of the President (Mr. Seymour Haden) in promoting the art of the original engraver, and in prosecuting for this society its claim to Royal recognition, a strong representation of his etched work will be made a prominent feature of the forthcoming exhibition." As Mr. Merdle's representative of the Bar would have said, this is "cheering to know, cheering to

know." Mr. Seymour Haden's success in procuring for the Painter-Etchers a trifling compliment, which has not even been thought worth denying to the Society of British Artists, is formally declared of equal worth with his long and earnest campaign as artist, critic, and propagandist of etching. The only possible comment is a protest against the term painter-etcher as needlessly polysyllable. As to the exhibition, there is no reason why it should be a bad one, as, with all due deference to its apostles, etching is evidently among the easiest of the fine arts. The plates by Mr. Seymour Haden are all interesting, failures and successes alike. For the rest, Mr. Strang has an idea or two; and the others have fairly dexterous hands and good eyes—except Mr. Walter Sickert, who ought to turn musician, if he does not soon find himself able to see more than he sets down at present. Mr. Axel Haig's gloomy interiors remind one here and there of the effects obtained years ago by Hablôt Browne in his illustrations to *Little Dorrit*. Mezzo-tinting and block-printing (to give its right name) have been freely used by the P.-E.s.

❖

Messrs. Vokins have been completely successful in their Cattermole Exhibition. The whole man is there—cloaks, daggers, armour, trap-doors, State barges, falcons, gauntlets, moats, keeps, serenades, anachronisms, and all. To Cattermole there was only one historic period—the past, with one appropriate costume. Fortunately it was a romantic, stately, chivalrous past, and the costume was handsome and becoming. He had imagination; and though, like Don Quixote's, it ran mostly on things that never existed, he could draw and paint them with the pleasantest ease, grace, and skill. The generation that knows not Cattermole should hurry to Great Portland Street to repair its ignorance.

The World, 13 March 1889 [C549]

In the Picture Galleries
The Royal Institute—French Gallery—Tooth's—M'Lean's—Gainsborough Gallery

[Francis, sixth Duc de la Rochefoucauld (1613–80), a courtier during the reign of Louis XIV, was author of Reflexions, ou sentences et maximes morales *(1665), a work that influenced Shaw's "Maxims for*

Revolutionists" appended to Man and Superman (1903). Charles Green's "Dick Swiveller" illustrated the cheerful and endearing, but disreputable, character in Dickens's Old Curiosity Shop. "Mr. Mantalini" illustrated the character from Nicholas Nickleby; Kate Nickleby was Nicholas's sister. Mark Tapley is a servant at the Dragon Inn in Martin Chuzzlewit, who leaves to find a position in which his good humor can operate.

Henrik Ibsen's play in which a character (Gregers Werle) upholds the ideal to everyone's cost is The Wild Duck. Robert Buchanan (1841–1901), conservative journalist and minor novelist and poet, was often at odds with Shaw.

Walter Langley (1852–1922), a Newlyn (Cornwall) painter, produced genre pictures largely of fisherfolk life. Alexander M. Rossi, a London domestic genre and portrait painter, exhibited 1870–1903. The President of the Royal Academy of Canada was Lucius Richard O'Brien (1832–89), who painted Canadian landscape and genre scenes, largely in watercolors. Richard Phené Spiers (1838–1916) was a London architectural painter, usually in watercolors, whose views included Pisa, Nuremberg, Rouen, Athens, and Paris. Arthur Henry Enock, a Birmingham watercolorist who in 1890 would move to Devon, experimented with the effects of mist and sunlight; he exhibited 1869–1910. Johann Viktor Krämer (1861–1949), a German painter, produced genre and religious scenes.

Jane Eleanor Benham Hay illustrated literary works, and was best known for her settings of Longfellow's poems; her son Bernardo Hay was also a painter. Rudolf Otto von Ottenfeld (1856–1913) painted in Italy; Mariano Fortuny y Carbo (1839–74) painted in Spain and North Africa. Richard Winternitz (1861–1929) was a German genre painter; David Farquharson (1840–1907), ARA 1905, was a Scottish landscape and coastal painter who liked to depict his settings in less than perfect weather. John William Godward (1861–1922) was a London neoclassical painter in the Alma-Tadema manner, his subjects usually flimsily robed females reclining in marble interiors.

The ornithologist John Gould (1804–81) produced oversized books with sharply detailed drawings which had been transferred to stone by his wife. He was assisted for a time by Edward Lear. His works included Birds of Europe, Birds of Australia, and Birds of Great Britain.]

At the Royal Institute, the first thing you do after paying a shilling for admission is to pay another for a catalogue. This volume consists of fifty-two necessary pages, with the names and numbers of the pictures, painters' directory, &c. As if this were not enough to carry about, there are no less than sixty-two pages on heavy paper of "processed"

sketches of the pictures—sketches which might possibly amuse a child, but which have no interest to any moderately sane adult. They have certainly no merit. Add to this eighteen pages of advertisements, and you have your shillingsworth complete. Doubtless by the time the Institute succeeds in procuring a hundred pages of advertisements it will raise the price of the catalogue to half-a-crown. The wonder is that the public submits to the extortion. All the artists sign their pictures in bold vermilion (Mr. Corbould actually adds his address), so that there is nothing to be learnt from the catalogue except the titles; and half of these are as obvious—"Making Hay," for instance—as the other half, of which "I know a maiden fair to see" may serve as a specimen, are imbecile.

As to criticising the pictures at the Institute, that is out of the question. One might as well compile an analytical programme of the dance-music for the use of the guests at a ball. Still, as there is always a certain piquancy in disparagement (this point was rather too plainly put by La Rochefoucauld), it may please Mr. Charles Green's friends to hear that his inveterate rusticity makes him impossible as an illustrator of Dickens. The young man from the country, whom he labelled Dick Swiveller, was bad enough; but what is to be said of the bucolic Mantalini and the flagrant parish clerk ineffectually masquerading as a broker's man in "What's the demd total?" It is a pity that the only capable artist-devotee of Dickens, who is neither mannered nor vulgar, should be placed at such a diminutive discount by the ineradicable villager in him. Be it also observed that Kate Nickleby was the last person in the world to put her elbow on the mantelpiece of the show-room and strike an attitude. Mr. Henry Stocks, with his "Immortality's Sunrise," rather reminds one of the man in Ibsen's play, who, like Mr. Robert Buchanan, persistently held aloft the banner of the ideal with results favourable to the popularity of realism. "Disaster" is the title given by Mr. Walter Langley to his scene in a Cornish fishing-village; and, on the whole, I agree. The man who can believe in that storm could believe in anything. Mr. A. M. Rossi seems to have produced "The Little Gleaner" by placing a little girl before the kitchen fire and then surrounding her glowing countenance with autumnal landscape. The effect is pretty, but unconvincing. Mr. Alfred East has, among other more candid achievements, grossly flattered old Battersea Bridge. The President of the Royal Canadian Academy paints in the style of Mr. Donne; but his remark is purely descriptive: it is not suggested that the resemblance is intentional. The tiger in "Alert" is sitting for its portrait with immense self-satisfaction, and is quite an example to the primeval beasts who used to prowl about Mr. Nettleship's canvases. Nothing in the Institute is better in its way than Mr. Phené Spiers' bow-window

from Eton. Mr. Enock is to be congratulated for getting a large and frankly bad picture hung by calling it " 'That Beautiful Dartmouth,' (Queen's Diary)." But then Mr. Enock comes of a family that has always been on familiar terms with distinguished persons. Miss Louise Rayner's "Derby House, Chester," is a bright, clean, conscientious piece of work; and Mr. Bernard Evans's "Knaresbro' " is also conscientious, and courageous too, considering the great men that have handled the subject before him—men that coordinated the very complex landscape much more successfully than he.

At the French Gallery there is a prodigious "Descent from the Cross," by J. V. Krämer, the most striking characteristic of which is its extreme cheerfulness. The subject is treated much as Mark Tapley might have made a point of honour of treating it, if he had had occasion to come out strong in an altarpiece. To Mrs. Jane Eleanor Benham Hay, whose "Florentine Procession" (Savonarola, of course) is nearly as long as a policeman's beat, must be accorded the meed of a sincere and laborious effort to improve the public mind. Karl Heffner's thirty-four studies are worthy of their frames of green plush and gold. R. von Ottenfeld's Meissonierettes, trivial as they are, are the best Mr. Wallis has yet secured: they are pleasanter in tone and less painfully laborious than Seiler's.

At Tooth's gallery the special attraction is "Le Jardin du Poëte," by Fortuny, clever and glittering in the highest degree, unnatural and indecorous in the lowest. There are three recent Meissoniers, in which, unexpectedly, the earliest (1888) is the only one that shows, in the epaulet and bricky cheek of the soldier "on guard," the effect of age on the painter's hand. R. Winternitz's "Gunsmith," scrutinising a pistol in daylit up-stairs workshop, is good. Mr. David Farquharson secures more than his usual share of attention with his "Aberdeen Harbour." Bouguereau's "Sylvan Simplicity" is spoiled by its meaningless background of cold black void.

Mr. M'Lean has got a Munkacsy and a Millais, both new, at his exhibition. The Millais is a pretty little girl in green, pink, and yellow, ogling with artless eyes the eager oof-bird. The Munkacsy is a consummate piece of work. The quiet light, the management of the colour with its long scale of reds, the expression of the figures (a man lolling in a chair listening to a girl who leans against the wall between two windows, singing), the sort of down of white fire made by the sun as it strikes on the fair skin of the woman's cheek—everything is masterly. Madrazo's "Summer Time" shows how the hand that used to be so dexterous with the rouge-pot is failing. There is a picture called "Callirhoë" by a Mr. J. W. Godward. The left arm and the face are beginner's work; but the picture is plausible, and shows power of the

kind that makes its way in England. Rosa Bonheur's "Landais Peas-
ants carting Timber" is less remarkable than the last two she sent to
this gallery.

I have said nothing about the works of Benlliure, Gallegos, Andreotti,
Conrad Kiesel, Professor Holmberg, and their school. The smartness of
these gentlemen is beyond my humble powers of description.

Messrs. H. Sotheran & Co., the booksellers opposite St. James's
Church, have shown me a complete series of the works of the late John
Gould, the ornithologist. There are forty-three imperial folio volumes in
all; and the price, bookcase included, is only a thousand pounds. No
doubt those brother critics of mine who have lavished praise on this
mighty work have seen all the birds depicted in it, and can answer for
the verisimilitude of the plates. For my poor part, I can only marvel and
testify to four things: 1. The work appears admirably done. 2. It is
inexhaustibly interesting. 3. The British birds, though not the gaudi-
est, are the most richly and softly coloured. 4. A bird coloured by hand
is worth any two of the same species I have ever seen in the bush.

The World, 20 March 1889 [C552]

In the Picture-Galleries
Romanticists at Dowdeswell's—British Artists—
Lady Artists—Hanover Gallery—and Others

[Alfred Sensier (1815–77), Paris museum administrator, published
Jean-François Millet, Peasant and Painter—*in French* La Vie et
L'ouevre de J. F. Millet—*in 1881. Matthew Maris (1839–1917), Dutch
landscape and genre painter, was one of three artist brothers. Jean-
Auguste-Dominique Ingres (1780–1867) painted neoclassical nudes
and historical subjects with an emphasis upon draughtsmanship
rather than color. A dominant artistic figure, he was considered an
ornament of the state during the era of Napoleon III and even made a
senator. Jules Adolphe Breton (1827–1906) was a portrayer of peas-
ant life along the lines of Millet; Adolphe Hervier (1818–79) was a
French genre painter. Charles Jacque (1813–94) was a Barbizon
school painter and etcher who depicted rural scenes; Georges Michel
(1763–1848), a Parisian painter with four landscapes in this exhibi-
tion, was almost unrecognized until posthumous showings of his
work. Willem Roelofs (1822–97), Amsterdam-born Belgian landscap-*

ist in watercolors, enjoyed a parallel career as an entomologist, winning wide recognition in both areas. Antoine Vollon (1833–1900) was a Lyons engraver who turned in mid-career to painting; Léon Chevalier was a French landscape painter.

Alice Corkran (1845?–1916) was a journalist and artist who lived with writer Richard Whiteing in Bloomsbury.

Edgard Farasyn (1858–1938) was a Belgian genre painter; Jean-Baptiste-Paul Lazerges (1845–1902) was a French figurative and genre painter. F. G. Coleridge was a Berkshire landscape painter in watercolors who exhibited 1866–91. Isaac Cullen (sometimes Cullin), painter of domestic and sporting subjects, exhibited in the 1880s.]

The Romanticist exhibition at Dowdeswell's comes just at the right time. Stray pictures and catalogue notes at the minor galleries, magazine articles and illustrations, and such books as Sensier's Life of Millet have all been leading up to the point at which people begin to crave for a comprehensive look at the works of the Barbizon community. Messrs. Buck & Reid and the Dowdeswells have borrowed all the finest specimens they could find room for; and the result is an exhibition which no well-posted amateur can afford to leave unseen. In the catalogue, printed by Constable, Mr. W. E. Henley has his say about the painters trenchantly and finely, making it a book for the shelf instead of the waste-paper basket. Corot may be judged from twenty-two happily selected and inexhaustibly beautiful works, besides a bad figure-painting and an odd early production, a hard, prosaic, painstaking, unrecognisable picture, with a carefully-drawn tree in it. In spite of "The Shepherdess," from which it is necessary to stand further off than one naturally does in Dowdeswell's gallery, Millet can hardly be said to be adequately represented. "The Good Samaritan" and "The Barque of Don Juan" are not much of Delacroix; but they exemplify what there was of him, after all. The naked figure in the "Samaritan" is a complete example of his monstrous sort of power. Courbet is not to be fully estimated by the three works exhibited, though "L'Immensité" is a remarkable picture in its way. The inferiority of Diaz's figures and flowers to his landscapes comes out startlingly; but his "Dogs and Hawk," which is a figure-subject, is an extraordinary feat in colour. Philistines will hardly believe that Matthew Maris is, in the rarest artistic qualities, the finest painter represented, except Corot. He is so, nevertheless. The entire list comprises Diaz, Corot, Daubigny, Troyon, Rousseau, Millet, Delacroix, Dupré, Ingres, van Marcke, Meissonier, Gérôme, Monticelli, Courbet, Israels, the three Marises, Mauve, Mesdag, Bosboom, Jules Breton, Hervier, Jacque, Michel, Roelofs, Roybet, and Vollon.

The British Artists, sorely chastened by adverse criticism, have made an effort, and the Suffolk Street exhibition is once more fairly present-able. Mr. Hubert Vos, instead of relying solely upon clever portraits, has sent in several pictures severe enough to satisfy even M. Legros. "Pauvres Gens" shows a miserable room, with a corpse stretched on a bed. There are the usual grieving adults and careless children; but the characteristic painter's imagination comes out most strongly in the glimmering green window, the gloom of the long room, and the heavy beam that supports the blackened ceiling. "A Gleam of Sunshine" and "The Old Fountain, St. Cloud," are curiously successful in tone; but in the figure-subjects this sort of truth has been attained at the expense of a blur which there is no good reason to tolerate. Mr. Sherwood Hunter, the new member, still sees Nature, indoor and out, through neutral-tinted spectacles. The greatest colourist in the society is unquestion-ably Mr. Anderson Hague, whose "Watercress Gatherers" is the only genuine piece of work painted at full concert-pitch. The President, Mr. Wyke Bayliss, also specially distinguishes himself this season.

The Society of Lady Artists has done very well indeed this year. Space is limited at the Egyptian Hall; but the difficulty has been minimised by the hanging, which is a model of judicious contrivance. The prices are modest and the works excellent; in fact, the show is relatively better than that at the Institute. Among the successful efforts in special directions may be mentioned Miss Mendham's goblins, Miss Alice Corkran's clever pastel study in a looking-glass, and a capital miniature by Mrs. Perugini.

At the Hanover Gallery there are two remarkable pictures: Meis-sonier "1814" and Courbet's "Storm." Farasyn's "Emigrants," though it has much quiet truth in it, is not particularly strong. The works of L. Chevalier, mostly river-studies in a bright green, once much affected by Mr. Alfred Parsons, are novelties. M. Chevalier exploits verdure almost as well as it need be done; but there is certainly not the slightest sign of his eclipsing Corot or even Daubigny, as some of his admirers seem to expect. There are the usual contributions by Lazerges, Munger, Wally Moes, Mr. Alfred Stevens, Mr. Elmore, Mr. James Webb, and others.

Messrs. Dickinson & Forster, of 115 New Bond Street, have filled their gallery with the cream of a loan collection of drawings by Alken— old Henry Alken—Alken the great. Some of them ought to go to South Kensington as examples of how a man may have every accomplish-ment and virtue of an artist without being one. Alken's drawing is beautiful; his composition is masterly; his exactitude in detail scrupu-lously truthful; his knowledge of horses and huntsmen never at fault; and his power of indicating the southerly-wind and cloudy-sky tone

worthy of any impressionist. Yet he never was an artist. He drew
ludicrous mishaps so literally that they were not comic; and his hunts
are so faithful that the only taste they gratify is the taste for hunting.
This exhibition of Mr. Dickinson's is, from the artistic point of view,
quite the most curious in London.

At Messrs. Vicars' in Eagle Place, Piccadilly, there is a new picture
by Blaise Bukovacs, whose fascinating nudities have at least evolved
into draped figures from the New Testament, by a transition through
Potiphar's wife and Adam and Eve. "Forbid Them Not" is a large com-
position, skilfully exhibited, so as to make the most of the luminous
beauty and softness of the painter's colours, which are shown as in full
sunlight. Neither the sunlight nor the fair and tender skins of the
children are in the least Syrian; there is no attempt at local truth, or
symbolically significant treatment of the subject in the manner of Mr.
Holman Hunt. But it is all the more certain to be popular. The baby
seated on the arm of the principal figure would secure that result by
itself, even if all the rest were painted out.

The Fine Art Society have added to their exhibition of Mr. Naftel's
sketches of Sark and the Dutch water-colours, a series of pleasant
holiday drawings of the Thames, by Mr. F. G. Coleridge.

The late William F. Donkin's photographs of Alpine peaks are now at
the Gainsborough Gallery. To go through them is, to a truly adventur-
ous and imaginative soul, better than climbing the Matterhorn. It is
also cheaper.

Mr. Isaac Cullin's picture, "A Sale of Yearlings at Newmarket" is
now at Mr. Mendoza's gallery in King Street.

The World, 3 April 1889 [C557]

In the Picture-Galleries
The New English Art Club—Monet at the Goupil Gallery

*[(Sir) Francis Galton (1822–1911), anthropologist and eugenicist, pub-
lished papers on mental imagery, color blindness, heredity, meteorology
and other interests. Francis Edward James (1849–1920) painted Sus-
sex and Devon landscapes and coastal views in watercolors. James
Peterson (1854–1932) was a Glasgow landscape watercolorist whose
work shows the romantic influence of the Barbizon painters. Norman*

Garstin (1855–1926), an Irish painter transplanted to Penzance, painted genre subjects in both oils and watercolors. Theodore Roussel (1847–1926), a Brittany artist who now lived in London, painted and etched genre scenes and landscapes. Lily Delissa Joseph (1846–1940), a sister of Solomon J. Solomon, painted portraits, landscapes, and domestic subjects. Annie Ayrton lived and worked in both London and Paris, painting still-life and figurative subjects, and had exhibited since 1878. Edward Arthur Walton (1860–1922) was a Scottish painter of landscapes and portraits who would work in London 1894–1904.

Sidney Starr's portrait subject was André Raffalovich (1864–1934), Russian-born and French-educated poet and critic, and long-time companion of poet John Gray (1866–1934). Solomon J. Solomon's subject, Miss Berens, was a minor painter.]

The New English Art Club is a body not to be disparaged by any critic with a conscience. To give fair words safely and acceptably to the plausible venalities of the ordinary shows, and then to proclaim nothing but the faults of men who are deliberately damning themselves from the dealer's point of view in order to paint sincerely, is to sin against the light. These impressionables render us the inestimable service of doing those things which the buyers do not want to be done, and leaving undone those things which the buyers want to be done: consequently there are no commissions in them. Even when they create—as they will—a demand for truth of tone, outdoor light, and atmosphere in pictures, the profits are likely to go to clever worshippers of the jumping cat, who will steal their method ready made as soon as it is perfected and popular.

A highly characteristic picture at the Club's exhibition in the Egyptian Hall is Mr. Walter Sickert's "Collins's Music-Hall," a success which is the reward of many failures. The chairman's face and cigar will be recognised by every one as happy examples of impressionism, although there must be many people who can see a pin where Mr. Walter Sickert cannot see a tenpenny nail. It would save some misunderstanding if the members of the N.E.A.C. would visit Mr. Galton's anthropometric laboratory at South Kensington, and ascertain, for publication in the catalogue, the number of inches at which they can read diamond print. The critics could do the same, and allow for the difference in visual power in judging the impressions. Account should also be taken of how far off the artist saw his subject. At the right distance, which is about the width of the Thames at Cookham, Mr. Fred. Brown's "Water Frolic" is truth itself. There is nothing revolutionary about Mr. S. J. Solomon's portrait of Miss Berens: it might be the work of a member of the Society of British Artists. Mr. Sargent's cleverness

this year is overpowering. In "St. Martin's Summer," and especially in "A Morning Walk," which out-Monets Monet in his best qualities as a figure-painter, Mr. Sargent shows how to do it as conclusively as Mr. Wilson Steer, in his "Head of a Young Girl," shows how not to do it. Mr. Stanhope Forbes's "Bridge" suffers from a want of freshness, with a suspicion of Mr. Yeend King's metallic mechanical manner, which is new in his work. The flower-pieces are a welcome relief to the usual florists' samples, Mr. F. E. James's touch in water-colour giving the blush and crumple of a roseleaf to perfection, whilst Mr. J. Paterson's "Azalea" is a good example of distinctively "New English" flower-painting. Mr. Norman Garstin found in a railway waiting room at night a combination of lights—light, firelight, and starlight—which he has managed to get on his canvas without any of the blur which mars the completeness of Mr. Bernhard Sickert's forge and Mr. James Guthrie's ropewalk. The conventional unconventional pictures—and this is the most exasperating sort of conventionality—include Mr. Roussel's "Evening in June," which is like spiritualistic drawing; a portrait by Mr. Greiffenhagen; Mr. Edward Stott's "Village Street"; Mrs. Lily Delissa Joseph's "Verve"; Mr. Sidney Starr's portrait of Mr. Raffalovich; and even Mr. E. A. Walton's landscape, laboriously studied from Nature at first hand as it evidently was. There is nothing new to be said of the work of Mr. Anderson Hague, Mr. Clausen, Mr. Whistler, and Mr. Hubert Vos. Mrs. Ayrton's two pictures show considerable skill; and Mr. Scott Tuke has made an attempt, very nearly but not quite successful, to vanquish the old difficulty of painting flesh amid the greenery of a sunlit orchard.

In acknowledging the hospitality of the New English Art Club on press-day, may a critic be permitted to suggest that on such occasions highest duty of the host is to stay away? A secretary to examine credentials, and a policeman to see that the critics do not steal the pictures, or assault one another, may justifiably be on the premises; but the presence of artists is indefensible. At the Egyptian Hall on Thursday they were in such numbers as to be in the way physically as well as morally. The free discussions by which critical acquaintances occasionally help each other in their work under less embarrassing circumstances were, of course out of the question.

Allusion has been made above to Claude Monet. Those who admire him should go to the Goupil Gallery, where twenty pictures of his have room all to themselves. It is possible that some who visit that room will consider themselves the victims of a practical joke; for Monet's pictures are not what the British gallery-goer is accustomed to. But nobody with more than half an eye will need more than a glance at the super "Mediterranean: Vent de Mistral" to convince him that Monet,

his apparently extravagant violets and poppy reds notwithstanding, is one of the most vividly faithful landscapists living. In the "Thaw: Argenteuil," cold and sloppy, and the "Moulin d'Orgemont," bathed in hot sleepy sunlight given quite newly and truly in a *gray* tone, his independence of the more startling resources of his palette is proved. In the two pictures described as "Prairie and Figures" his inferiority to Mr. Sargent in dealing with figures is very marked.

Messrs. Dickinson & Foster, of 114 New Bond Street, take friendly exception to my remark, *a propos* of their Alken Exhibition, that Henry Alken was no artist. If not, what was he? they ask. If so, I retort, what was Leech? The only parallel case to Alken's that I can recall just now is Verestschagin's. I may be asked, If Verestschagin is not an artist, what is he? And I retort again, If Verestschagin *is* an artist, what is Mr. Burne Jones? There is a difference in kind between Alken's work and Leech's, Verestschagin's and Burne Jones's. It does not make Alken's work or Verestschagin's less worth seeing: in fact, I am half inclined to maintain the contrary; but the difference is there, nevertheless, and in my capacity of critic I only exist to point out such things.

The World, 24 April 1889 [C562]

[The Royal Water-Colour Society]

[Richard Beavis (1824–96) was versatile and prolific, working in oils and watercolors, painting landscapes, rustic genre, military subjects, European and Middle Eastern scenes, even the ceiling of St. Bride's, Fleet Street. James Shaw Crompton (1853–1916) painted figure and domestic subjects, historical scenes, and Middle Eastern settings, usually in watercolors. Paulus (Paul) Potter (1625–54), Amsterdam painter and etcher of landscape and rustic genre, was celebrated primarily as an animal painter of sympathetic sensitivity.

George Lawrence Bulleid (1858–1933) painted, from his home in Bath, figure and mythological subjects, exhibiting from 1884, Edward Radford (1831–1920) was a genre painter in watercolors. Helen Paterson Allingham (1848–1926), wife of Irish poet William Allingham, painted rural scenes, gardens, and children.]

The Royal Water-Colour Society opened its summer exhibition on Monday. The show, like Mr. Alfred Hunt's one contribution to it, is good without being specially dainty or distinguished. Mr. R. W. Allan

and Mr. Henry Moore are strong in the fresh breezy aspect of things; but both of them have carried freedom of handling a little too far, Mr. Moore's sea-piece (128) being almost a scribble, and Mr. Allan's "Glen Catacol" being blotted in at a rate at which the hand lost its delicacy. He makes amends, however, in "St. Martin's Cross, Iona," which is a triumph of his manner. Mr. Walter Crane's vigorous and decorative "Pegasus" has gorgeous wings, but their blaze of colour is chilled by the cold strong blue of his favourite background. Mr. William Callow still caters for the globe-trotter with unvarying skill in market squares, cathedrals, and Baedekeresque places generally. Mr. Albert Goodwin's "Harbour Bar" seems to have been produced chiefly because people have got into the way of expecting a tragic sunset from him; and as to the "Bridgenorth," does Mr. Goodwin maintain that a distant church on a high hill has thick dark outlines and vivid cinnamon-toned walls? If these washed-in pencil sketches are presented as complete pictures, then, pretty as they are, it is time to insist that they are considerable liberties with Nature. Mr. Du Maurier's heads in colour are hatched less inkily than usual; but "Joconda" (230) seems to have been unmercifully beaten, for her breast is black and blue, and her neck yellow. Mr. A. E. Emslie's strength becomes yearly more evident; but he is recklessly sacrificing all local colour to the consistency of his favourite steely tone—witness Shaw Crompton's fiddle, the colour of which is really nonsensical. Mr. Richard Beavis's "Gossip in a Spanish Court-yard" makes a good picture, in spite of some slovenly drawing: the pair of oxen stick their noses out at you, like Paul Potter's. Mr. Lawrence Bulleid supplies Mr. Radford with a competitor in cabinet figure subjects; and Mr. Naftel and Mr. Poynter exhibit exceptionally good examples of their very different styles in water-colour. The rest of the work goes without saying.

❖

At the Fine Art Society's Gallery, Mrs. Allingham is in possession, with Surrey, sunshine, primroses, laburnum, gorse, wallflowers, tulips, violets, bluebells, lavender, print gowns, straw hats, ruddy cheeks, tiled roofs, green hedges, Hindhead, Hazelmere, and so on, all engagingly and, within holiday limits, truthfully done. An inexperienced person might infer from the collection that it never rains in Surrey, or blows coldly from the North Sea, or is vilely sloppy with a peculiarly odious gamboge mud; but, after all, one does not want drawings of these aspects of the county. Mrs. Allingham reminds you of what you wish to remember; and what more would you have?

The World, 1 May 1889 [C567]

In the Picture-Galleries

[*Subjects of portraits and busts include (Dame) Ellen Terry (1847–1928), leading actress of her time in Shakespearean roles; and General Sir Frederick Roberts (1832–1914), then commander-in-chief in India and later commander in South Africa during the Boer War and first Earl Roberts (1901).* The Profligate, *by Arthur Wing Pinero (1855–1934), opened at the Garrick Theatre, London, April 24, 1889, and argued—more, seemingly, to titillate than to preach—against the sexual double-standard for husband and wife. Oliver Wendell Holmes, Sr. (1809–94), American physician and writer, was best known for his witty* The Autocrat of the Breakfast Table. *Spanish captain Don Pedro de Valdez lost his ship,* The Rosario, *to Admiral Sir Francis Drake and three years later had himself ransomed for £3,000. Colonel Thomas Newcome in Thackeray's* The Newcomes *(1855) is a simple-minded gentleman guided through life by sentiments of duty and honor. Losing his fortune and his household, he ends his days in a "Greyfriars" (Charterhouse) almshouse.*

Cecil M. Round was a London-based painter, largely of landscapes, who exhibited 1884–98. John Henry Lorimer (1856–1936) exhibited portraits and flower studies from 1873, then turned to scenes of Scottish domestic life. John Macallan Swan (1847–1910), ARA 1894, animal painter and sculptor, was recognized for his depictions of lions, leopards, and tigers. Marcus Stone (1840–1921) was a historical genre painter and book illustrator (Dickens's Our Mutual Friend *) most at ease with eighteenth-century or Empire settings and with sentimental or humorous attitudes.*

Edward Simmons, who painted from St. Ives, Cornwall and exhibited landscapes and figurative subjects 1881–91, owed his carpenter's shop allusion to the boyhood of Jesus and, although Shaw does not allude to it, to Millais and early Pre-Raphaelitism and, perhaps even earlier, to John Rogers Herbert (1810–90). In 1847 Herbert had exhibited Our Savior, subject to His Parents at Nazareth; *Millais's 1850* Christ in the House of His Parents (The Carpenter's Shop) *provoked, in its literalism, a storm of abuse and made the painter famous.*

Wolfram Onslow Ford exhibited in London through 1904, showing a range of subjects from landscapes and still-lifes to a portrait of Joan of Arc. Henrietta Montalba (1856–93), portrait sculptor, had three sisters who were painters.]

Large allowances must be made this year for the effect on the critics of spending three consecutive days at the Grosvenor, the New Gallery,

and the Academy. Those who went through with it bore marks of heavy punishment. On Monday evening they were jaded, on Tuesday vindictive, on Wednesday callous. Genial men waxed into expostulatoriness, and waned into spasmodic flippancy. Serious men became querulous, then savage, then broodingly pessimistic. The inveterately amiable discovered pretty bits, and dwelt pleadingly on them. The inveterately cynical were soon worn down by the prevalence of empty-headed pictures, and the consequent slipping of the paradoxical grip. The happiest were those who had new hats, in the pride of which they could bear themselves with *aplomb* at the overlapping private views, whither we all resorted for half-an-hour or so.

The power of the New Gallery to take the best, even among the pictures which have a right to a place on the line at the Academy, seems pretty well established. In all the higher qualities of great painting, Mr. Watts this year distances every competitor. His "Pluto's Wife" and "Fata Morgana" are masterpieces, but he has considerably refrained from putting the Academy out of countenance with them: both are in Regent Street. Mr. Burne Jones has only sent a set of drawings, yet he is hardly missed; although last year his pictures made all the difference between the New Gallery and the Grosvenor. Mr. Sargent, who has put the Academy off with a couple of amusing slapdash caricatures of Mr. Henschel and Mr. Henry Irving, has given the New Gallery his "Lady Macbeth," a superb portrait of Miss Ellen Terry, more like her than she, except in rare inspired moments, is like herself. The depth of the background, being purely a depth of colour, gives the picture a certain character of flat surface decoration which would make a Rembrandt dangerous company for it. Another portrait which was much discussed, and with reference to which my own position was generally conceived as one of some delicacy, represents Mr. Edmund Yates, apparently taken aback by some keen sting of conscience, in the act of composing a song. Like Frederick the Great in Gérôme's picture, he is presided over by a bust of Voltaire. I cannot say that I regard the taken-aback expression as characteristic; and the key in which the colour scheme is pitched is almost as trying to my taste as it is to my chief's complexion. However, the portrait shows considerable ability on the part of Mr. Cecil Round, the subject being a somewhat difficult one to manage. Other younger painters who are coming on fast are Mr. J. H. Lorimer, whose brown room at the New Gallery, with the glimpse of landscape and outdoor light through the window, is more homogeneous, though not more cleverly handled, than his "Pot Pourri" at the Academy; Mr. Adrian Stokes, whose "Wet West Wind" (also at the New Gallery) is full of wind and salt spray; and Mr. John M. Swan, whose two swimming Polar bears are quaintly conceived and

finely drawn. His Grosvenor lion is not interesting; but there is some beautiful work in "The Prodigal Son" at the Academy, though the prodigal is rather sacrificed to the pigs, and the landscape to both. Mr. Nettleship is to the fore again as of old, drawing huge animals with the dreadful delight of a cave-man drawing mammoths. His "Destroyer" at Burlington House is, of course, a tiger, and there is destruction in his prowl and doom in the sky above him. Mr. Nettleship's execution is not what one would call smart: but his pictures are among the very few that are not forgotten before the turn of the next page of the catalogue. Some of the younger painters who were hurrying fast to the front last year have since then been marking time only, although they have been marking it with plenty of paint. Mr. Alfred East, Mr. David Murray, Mr. Albert Goodwin, Mr. F. D. Millet, Mr. Jacomb Hood, Mr. F. M. Skipworth, Mr. J. W. North, and Mr. Starr have not advanced, and have therefore lost ground relatively. As for the R.A.s, they are practically extinct, except Mr. Watts, as aforesaid, Mr. Alma Tadema, and Sir John Millais. Not that I would imply that Mr. Alma Tadema has seen or thought anything new since last year, or that I am blind to the process by which, as his artistic ideas lose interest by repetition, his trick of making his faces reflect light as stone reflects it and as flesh never does, becomes more and more annoying. Nor is it necessary to go into ecstasy over the mineral-green peasepods and unfinished hands in Sir John's present to Sir Frederick [Leighton] at the Grosvenor, even granting that nobody but Millais could have painted it. As to his garden-roller landscapes at the Academy, the widest difference of opinion is possible about them, accordingly as they are judged by their puerile fancy or their incomparable truth to nature at certain points. Mr. Orchardson has made an attempt to force forward, as one of the pictures of the year, a large canvas containing an exquisite study of tablecloth and dessert-service in the lower half, and a row of ludicrous figures, all exactly like one another, in the upper; but I really cannot be expected to abet Mr. Orchardson by taking this seriously: one might as well waste the world's space on such work as Mr. Marcus Stone turns out now—work to the complexion of which, I am sorry to say, Mr. Luke Fildes's is rapidly coming. If these Academicians can look outsiders like Mr. Frank Bramley and Mr. Stanhope Forbes—not to mention half-a-dozen others—in the face without blushing, they must be hardened beyond redemption at the hands of an indignant press. Yet it must be admitted that the Academy shows a disposition to allow other people to move with the times. Mr. Edward E. Simmons has painted in the most direct and literal way a boy in a carpenter's shop, with a carpenter and his wife at work in the background, just as he may have seen them this year in England. The entry in the catalogue is "The

Carpenter's Son—St. Luke ii. 40." This picture will be one of the successes of the year through the verdict of those who feel that the conventional Academy Christ would long ago have been prosecuted for blasphemy if it had been possible to associate anything so energetic with anybody so vapid. Again, in the sculpture-room, there is a colossal statue by Mr. Richmond, entitled "The Arcadian Shepherd." He is naked, and not ashamed; and Mr. Richmond is not ashamed; and the Academy (for once) is not ashamed; and it may confidently be predicted that the public will not be ashamed. Indeed, there is a perceptible movement among the sculptors as if their stocks and stones were coming to life at last. Mr. Hamo Thornycroft is setting up a small business in impulses and ideals of his own, though the heroic borrowed articles are, no doubt, still in stock for expensive commissions. Mr. Onslow Ford's "Singer" is a young Egyptian woman suffering from a bad singing-master, who has evidently told her to keep her shoulders well back and shout. Her arms hang awkwardly; her mouth opens as if to bite as well as to sing; and her neck is of monumental thickness and solidity. But the delicacy and truth with which the surface of her body is modelled makes amends, and she is sure to be much admired. Mr. Bruce Joy's "Sir Frederick Roberts" is by far the best of the portrait-busts. Miss Henrietta Montalba, by the way, has turned out some clever heads in terra-cotta, notably one at the Grosvenor Gallery of Mrs. Henderson Smith. Sarah Bernhardt used to do this sort of thing very smartly, and Miss Montalba seems to have the same knack, plus the artistic feeling which runs in her family.

Except Mr. Pinero's "Profligate," the year's art can boast nothing more edifying than Mr. Solomon's "Sacred and Profane Love." Somebody (Oliver Wendell Holmes?) has said that no decent woman ever parades an air of offended virtue. It was a wise saying: let Mr. Solomon's angel look to it! From such profound didacticism I fly back to the New Gallery, and refresh myself by a look at Mr. Strudwick's "Rampart of God's House," which looks like a picture on vellum. Comparing such fastidiously reticent colouring as Mr. Strudwick's with the bold red, white, and blue of Mr. MacWhirter, for instance, one feels inexpressibly sorry—for Mr. MacWhirter. The comparison, however, is really an outrage upon Mr. Strudwick, whose work is out of reach of all criticism, except that which objects to any given thing whatsoever on the ground that it is not something else. Quite another order of first-rate hand is Heer Mesdag's. His "Early Morning: Scheveningen" is one of the treasures of the exhibition. In the daffodil field in Mr. Alfred Parsons' "On Mendip" there is an effect as of a shadow of a cloud that does not appear in the sky. This effect occurs in nature, though it has obviously no business to. Mr. Parsons' painting of it, of the road and house in the middle distance to

the right, of the far-away hills to the left, and, in short, of the whole picture, is consummate naturalism. For fine and thorough drawing, Mr. Biscombe Gardner's "Rocky Shore" is not surpassed by any landscapist this year. Mr. Philip Burne Jones, repenting of his follies, has made himself useful by painting a number of excellent small portraits, which are at the same time pictures of considerable merit. The landscape studies of Professor Legros are not cheerful: the pitch is low and the mode minor—E flat minor, in fact; but the harmony is perfect in that mode, and the poetic feeling for nature unfailing.

Before closing this first article I may as well return for a moment to the Academy to get the Associates off my mind. Of Mr. Richmond I have already spoken; of Mr. Phil Morris and his "Home: a Family Group" I cannot speak, for I am really getting too old to be sarcastic enough to do justice to the occasion. Mr. Waterhouse's "Ophelia" is unShakespearean and much in the vein of "The Lady of Shalott"; but it succeeds where that picture failed: namely, in the relation between the landscape and the face, which latter should be studied, as it is more pathetic than it appears at the first upside-down glance. Mr. Seymour Lucas's "Surrender" (of Don Pedro de Valdez to Drake) is made a picture of by the humour of Drake's desperate attempt to put on company manners with the Spaniard. There is not one but a half-dozen points of humour in Mr. Andrew Gow's "Visit of Charles I to Kingston-on-Hull." The face of the boy prince contemplating the wicked mayor, who refuses to open the gates to his father, is irresistibly funny. The picture, except as to scale and size, is much in the manner of Meissonier. Mr. Hubert Herkomer is all over the place with portraits, most of them uninteresting affairs with kamptulicon [a cheap carpet] backgrounds. I will not pretend to judge his "Charterhouse." As an assemblage of Colonel Newcomes, it rouses all my most rooted literary prejudices. I never could endure Colonel Newcome except as an illustration of the fact that a fool is sometimes more dangerous than a rogue. Mr. W. L. Wyllie has signalised his promotion by painting a phantom ship which would not frighten anybody, and consequently fails in the sole object of a phantom ship. The rest, as far as the Associates are concerned, is silence.

The World, 8 May 1889 [C570]

[Minor Exhibitions]

[George John Whyte-Melville (1821–78) was a British authority on field sports and wrote novels on racing, fox-hunting, and steeple-

chasing. Sir Robert Ponsonby Staples (1853–1943) was an Irish baronet well known for his portraits and genre studies.

The Olympia was a huge, electrified new exhibition hall in West London for extravaganzas of all sorts, such as a miniature Venice, complete to canals and gondolas. Even Queen Victoria was magnetized by events staged there.]

During these busy weeks, minor exhibitions have been opening in all directions. At Mr. Lefevre's in King Street there is Mr. Alma Tadema's newest *magnum opus*, "A Dedication to Bacchus." It rouses not only admiration—all his pictures do that—but interest, which is more than can be said for the "Women of Amphissa," the "Roses of Elagabalus," the "Shrine of Venus," or any work of his since "Sappho," which contained much less matter than this Bacchus picture. It is full of skilful contrivances, executed with consummate dexterity, to attain the utmost variety and beauty of effect. In hardness, polish, and insistence on local colour, it is almost excessively characteristic of the artist. Its appearance at a private dealer's instead of at the Academy or New Gallery may be so much the better for Mr. Alma Tadema individually; it is certainly so much the worse for the public. Besides the Tadema, there is a new picture, "Scotch Cattle at Rest," by Rosa Bonheur, whose hand has lost none of its cunning.

❖

Mr. Lefevre's neighbour, Mr. Mendoza, has also snatched a pair of pictures by Mr. Heywood Hardy from the Grosvenor Gallery. The usual bit of romance and bit of horseflesh, which make Mr. Heywood Hardy the Whyte-Melville of the studio, are in both works. At Mr. McLean's, in the Haymarket, Mr. Ponsonby Staples exhibits "The Last Shot for the Queen's Prize—Wimbledon, 1887," which is by no means deficient in artistic feeling and unity, the figures being clever life studies, and not copies from photographs arranged in the manner of a tailor's fashion-plate. Mr. F. S. Walker has turned his hand to etching with happy results. Messrs. Colnaghi of 14 Pall Mall East have a large plate by him of "St. Paul's by Moonlight." How much of it is technically pure etching I leave to be decided by those who know at sight how everything of the kind is done (they are invariably contradicted by the artist); but upon its value as a poetic picture in black and white, rich in work and thought, there is not likely to be much difference of opinion. Mr. C. Fairfax Murray's "Music Party," a decorative picture, weak in the hands, stronger in the heads, and strongest in the Venetian warmth of its colouring, is at Mr. S. T. Gooden's, 57 Pall Mall. The Nineteenth Century Art Gallery opened on Monday week; but the

exhibition is not specially interesting: perhaps the seductions of Olympia have proved too much for its more aspiring supporters.

The World, 22 May 1889 [C576]

[Flowers and Horses]

[Ada Bell (c.1853–1907) exhibited landscapes and flower pictures in London from 1878. The first Marquess of Zetland, Lawrence Dundas (1844–1929), was Viceroy of Ireland 1889–92.]

Miss Ada Bell's cut-flower pictures at Tooth's in the Haymarket held their own against the real flowers at the private view even before the heat of the day began to operate, when the advantage of painting the lily became obvious. Up at the Goupil Gallery they have cleared out the Monets and replaced them by Peppercorns. In painting, the more you omit the better you must paint what you do not omit. Mr. Peppercorn omits a good deal; but he makes amends by the tone of his foregrounds and some of his skies—notably one caught and fixed at early morning. There is much in his work which does not show itself at a glance, and so gets passed over in miscellaneous collections. 58 Pall Mall is now called the "Land and Water" Gallery. The chief thing to see there is Mr. Heywood Hardy's picture of Lord Zetland's pack. The horses are capital, and the bit of landscape and sky not bad.

The World, 5 June 1889 [C583]

In the Picture-Galleries
Humourists at the Institute—Dowdeswell's, Etc.

[James Gillray (1757–1815), English caricaturist and engraver, satirized the leading politicians and social follies of his day, sparing neither George III nor Napoleon.
Ally Sloper was a comic character created by Charles Henry Ross in 1867 for his humor weekly, Judy. *W. G. Baxter then created, for the character,* Ally Sloper's Half-Holiday, *a weekly family paper for which Ally Sloper appeared, in a topical cartoon, on the front page. The paper*

became the poor man's Punch. *The masses, who never quite took to Britannia or to John Bull, understood Ally Sloper, an absurd figure with bulbous red nose, Micawber hat, baggy trousers, and propensity for slapstick incident. As recently as autumn 1987 the Bristol Old Vic was featuring an Ally Sloper dramatization, suggesting the character's continuing appeal. The character type, Shaw notes, had been appropriated from Marie Duval (Isabelle Emilie de Tessier), a cartoonist, illustrator, and actress whose decade of popularity was the 1870s.*

John Leech (1817–64) was illustrator and Punch *caricaturist from its founding years; (Sir) William Schwenck Gilbert (1836–1911) in pre-operetta days as playwright-librettist half of the Gilbert-and-Sullivan team, wrote and illustrated comic verses for* Fun *as "Bab." The first collection, it 1869, became known as the "Bab Ballads," a name that stuck. Thomas Rowlandson (1756–1827), illustrator and watercolorist, was one of the great caricaturists of his time.*

William Brunton (?–1878) was a humorous illustrator and engraver who contributed to Tinsley's, The Broadway, *and* Punch. *Robert George Seymour (1836–85) was a Dublin solicitor who after his retirement moved to London, where he produced clever drawings and watercolors. "Phiz" was Hablot Knight Browne.*

Conrad Dressler (1856–1940) was a sculptor and pottery designer whose forte was the depiction of contemporaries, often notable only for their ability to pay his commission. Yet he did do actor George Grossmith (1847–1912), historian James Anthony Froude (1818–94), poet Algernon Swinburne (1837–1909), and dozens of generals, politicians, poets, and aristocrats still remembered. Walter William May (1831–96) was an English marine painter and watercolorist; Chauncey B. Ives (1810–96) was an American sculptor influenced by the once-fashionable Venetian Antonio Canova (1757–1822).

Candace Thurber Wheeler (1827–1923) was an American artist and interior designer; John La Farge (1835–1910) was a New York landscape painter and stained-glass artist. John Williams produced wrought iron architectural decorations in New York; Maria Longworth Storer fashioned her pottery in Cincinnati.]

It is fortunate that some of the greatest English humourists in art are dead. There is no saying what would happen if Gillray and George Cruikshank could visit the Institute, and see their smallest and daintiest plates, full of microscopic detail, skied in dozens; whilst much space on the line is covered with monstrous Ally Sloper drawings, freshly stale from the shop-windows, and wrought by Mr. Baxter, who simply annexed the original as invented by Marie Duval, who is ignored in the exhibition. The catalogue is marked "under revision"; but

no revision can do away with the inconvenience of first numbering the plates and then hanging them promiscuously, just as they happened to fit. Out of the sixty-two gentlemen who had the matter in hand, those who were themselves exhibitors have certainly displayed great energy in taking care of No. 1 (I wish they had thought of putting it next to No. 2); but as for the rest—my compliments, and they could not have possibly done worse.

Besides irregularity of arrangement, the collection has the cardinal fault of being in no sense what it professes to be. There are practically no Hogarths; the Gillrays are ill-hung, and not very numerous; the Cruikshanks, with the exception of some of the water-colour drawings made by him from his own book-illustrations, include hardly any examples of his most artistic and individual work; Henry Alken is quite out of it; Leech is represented mainly by his coarsest shop-window funniments; neither Brunton nor Mr. Gilbert is in the catalogue; Seymour and Thackeray fare little better; and Maclise has been wholly forgotten. On the other hand, the display of works by Thomas Rowlandson is magnificent; in fact, the exhibition is a Rowlandson exhibition, and had better have been called so. This, however, is saying a good deal in its favour, for Rowlandson was a great artist. He could draw streets as well as Prout, without Prout's mannerism; his landscape drawing with the pencil will bear comparison with Turner's; his tinting is exquisite; his knowledge of life and character is as wide as it is genial. Even in his ridicule of distortion and ugliness there is no savage scorn: his raillery is full of grace, and his sense of beauty always insists on satisfaction somewhere in the picture. There are no less than two hundred and sixty-five works by him at the Institute, as against thirty-three by Gillray.

The change from the old order in caricature to the new is really a change in the social status of the artists. It is all for the better as far as they are concerned, but it has not improved their art. The process usually described as knocking the conceit out of a young man is terribly thorough with subjects whose income is precarious and whose social position is doubtful. They come out without much mercy for their own follies and illusions, and with none at all for those of others. In learning their own place they have learned the place of the people they see around them; and they have generally discovered, too, that society in the special sense consists mostly of persons who do not know their places. This was the position of caricaturists like Hogarth and Gillray. But it is not that of Mr. Du Maurier and Mr. Furniss. These gentlemen have always been respectable; the life of their class has not seemed to them ridiculous, but only inevitably dull. They do not see the irony of respectability, just as they do not know the taste of water

because their palates have always been moistened with it. Interest, romance, adventure does not enter into middle-class life: it is enjoyed there fictitiously through art; and to art, accordingly, all the geniuses of the middle class turn for a career. Their caricaturists caricature art instead of life, which is to them too prosaic for art-material. Hence we have from Mr. Tenniel satirical criticism of middle-class politics; from Mr. Du Maurier satirical criticism of drawing-room "culture" and Bond Street art; and from Mr. Furniss satirical criticism of St. Stephen's manners and of the Academy. Rowlandson would have caricatured these three themselves, and that not with any concentration, but as figures in his crowds, where there are all sorts of figures. Mr. Tenniel and Mr. Du Maurier, unhampered by their limits, have elaborated their work to perfection within them. Mr. Furniss, on the contrary, tries in all directions for new subject-matter; worries and overdoes the old in his attempts to get something funny out of it; and yet cannot, with all his efforts, get a true Homeric laugh anywhere. But the more he struggles, the more likely he is to break his bonds asunder some day.

A pencil-note on one of Browne's illustrations epitomises all that Dickens suffered at the hands of his artists. "I don't think Smike is frightened enough—earnest enough—for my purpose." When were any of them ever earnest enough through their fun for Dickens? The best political caricatures are still Gillray's George III as King of Brobdingnag, with Napoleon as Gulliver in his hand; and Mr. Tenniel's Disraeli and the Sphinx winking at one another over the Suez Canal shares. Mr. Watts's "First Oyster" is happy; so it Phiz's "Introduction," the two parties meeting for the first time on the gallows, where they are about to be hanged from the same beam. The hangman introduces them, and they bow with unctuous politeness. There is an irresistible absurdity in the literalness of Cruikshank's "Raining Cats, Dogs, and Pitchforks."

Those who go to the Dowdeswell Gallery to see Mr. Conrad Dressler's busts of "leading men" must not expect too much in the way of leadership. Mr. Walter Gilbey, Mr. Romer Williams, Mr. Henry J.P. Dumas, and Mr. George Henry Pinckard may one day be historic figures; but, so far, they are not quite so well known as the late Lord Henry Lennox, although even his fame hardly comes up to that of Mr. [George] Grossmith, who will be gratified to find his bust sweltering in blanketed niches with those of Mr. William Morris, Mr. John Ruskin, Mr. Swinburne, Mr. [James] Froude, Mr. [Henry Morton] Stanley, and General Roberts. To get your bust done by Mr. Dressler is evidently in itself a passport to fame. The blankets and the velarium are rather oppressive; and it is cooler work, on the whole, to examine Mr. Walter May's Lough Swilly sketches in the next room.

Sculpture is rampant also at the Burlington Gallery, where Mr. Chauncey B. Ives, an American sculptor who survives from a period when Canova was still talked about, exhibits ten works in marble. I cannot say that his statues have to me the remotest association with life; but they have the graces of their school. His "Undine" has even a little more than that.

Messrs. Johnstone & Norman's exhibition of American decorative art (67 New Bond Street) is full of examples of ingenious and dexterous workmanship, and beautiful natural materials in the way of woods and clays. In point of execution we cannot beat the needle-woven tapestries from Mrs. Candace Wheeler's association of women artists, the stained glass by John La Farge, Mr. John Williams's wrought-iron work, and Mrs. Maria Longworth Storer's Rookwood pottery. The impulse to be artistic is strong in all this work; and if that were only the same thing as artistic impulse, there would be an American school of decoration. As it is, America is much as Bond Street is: able to beat ordinary upholstery, but not to defend itself against the reproaches of the Arts and Crafts people. A display of needlework by Miss Tuckett, a Bristol artist, is also at Messrs. Johnstone & Norman's. It shows what can be done by a rapid and tasteful worker who is not disposed to pursue the art to the point at which it costs eyesight as well as endless labour.

The World, 12 June 1889 [C590]

[Four Exhibitions]

[Édouard-Bernard Debat-Ponsan (1847–1913) exhibited regularly at the Salon from 1870, after 1879 under the name Ponsan-Debat. His equestrian subject was General Georges Boulanger (1837–91), anti-Republican royalist demagogue charged with treason in April 1889. A supporter of Zola during the Dreyfus affair, Ponsan would exhibit an Allegory of Truth *at the Salon in 1898.*

John Cassell (1817–65) founded a publishing house for illustrated popular books and magazines which gave employment to dozens of draughtsmen. H. William Rainey (1852–1936) was a genre and landscape artist; Eduard Grützner (1846–1925) was a Belgian book illustrator.

Edward Roper (1857–1901) was a Canadian landscape painter; Hermann Schmiechen (1855–?) was a German portrait painter. His

subject Mohini Mohun Chatterji was an Indian writer and translator then known for his version of the Bhagavad Gita *(1887).]*

The exhibition at the Hanover Gallery has been reinforced by M. Debat-Ponsan's portrait of *le brav' Général* on his black charger, saluting the French Army. A group of subsidiary field-marshals contemplate him reverently at a respectful distance. As the Army is on a small scale and the General on a large one, the effect is appropriately glorious.

❖

The Cassell black-and-white exhibition at the Memorial Hall closes on the 21st. Its most encouraging features are the increase of works in genuine monochrome, and the corresponding decrease of those executed in washes of blue-black with white body-colour, the effects so obtained being generally false and always wearisome beyond description. Mr. W. Hatherell makes the most distinct mark of any this year; but Mr. W. Paget, Mr. Rainey, Mr. William Hole, Miss M. L. Gow, and Miss Dorothy Tennant have also done distinguished work. Mr. W. J. Hennessy's "In Picardy" is the only picture which stands quite apart from the routine of book-illustration; it is quite the most desirable single drawing in the gallery. The International Shakespeare pictures mostly deal with Falstaff, who has escaped Germanisation at the hands of Professor Grutzner. There is, however, a touch of the elderly Belgian in him.

❖

Mr. Edward Roper's pictures at the Egyptian Hall are of no great artistic pretension—which is rather a relief than otherwise—but they are full of interest for people who are curious about Indians, black fellows, bears, kangaroos, gold-diggings, corrobories, totems, and the scenery of British Columbia and New Zealand. In fact, the exhibition is a sort of panorama, except that you travel in front of the pictures instead of the pictures travelling in front of you. The lecture is printed in the catalogue.

❖

Mr. Martin Colnaghi has made room at the Marlborough Gallery for a collection of portraits by Mr. Hermann Schmiechen. The few which represent male subjects are weak and unsympathetic, except, perhaps, that of Mr. Mohini Chatterji; but the portraits of women are sensitively drawn and brilliantly painted. In one or two instances, when the sitter

was less splendidly prosaic than the ordinary woman of fashion is apt to be, Mr. Schmiechen has produced a true picture, his treatment of certain beautiful brown tones showing a keen if somewhat luxurious feeling for colour.

The World, 19 June 1889 [C596]

[Rejected Art]

The exhibition at Olympia may or may not be fairly representative of "the rejected and crowded out"; but if it is, no further attention need be wasted on complaints of the favouritism of the Academy. There are, perhaps, two rejected pictures at Olympia which, if they could be fitted into the space, might replace two of the worst non-privileged pictures on or about the line at Burlington House, without detriment to the show there; but this is the most that can be said. Nor that the accepted are more deserving than the rejected: on the contrary, it is quite pathetic to see how the inept faithful, doing the very best they could, have been ousted by the deft fashionable, doing the very worst they dared. Unluckily, their worst is better technically than the others' best. The gallery has been partitioned into three-walled compartments in such a manner that though the pictures are excellently lighted and hung, yet it is quite easy for promenaders to avoid seeing them unless they are bent on doing so. The arena is void and desolate. Whether the exhibition will prove attractive as an afternoon tea promenade remains to be seen. It is cool and pleasant enough, if there were only something more decorative about it than the rejected.

❖

The Rejected R.A., or R.A. Rejected, certainly appears to be the fiasco predicted by a correspondent in this column a few weeks since. Now that it is opened, I may inform the conveniently short-memoried friends on the press of Olympia that the "brilliant idea" of such a display is by no means a novelty. A scratch lot of pictures offered to the Royal Academy has been got together at various times at the Albert Hall, at Mr. Benson's in Old Bond Street, and even so long ago as at the Adelaide Gallery in the Lowther Arcade; and always with the same result—namely, to apparently justify the Royal Academy. Whether, if the artists rejected would take the business into their own hands,

without the help (pecuniary or otherwise) of any middleman, a different result might not happen, is quite another question.

The World, 26 June 1889 [C598]

[Wores and Roussoff]

[Like Mortimer Menpes, Theodore Wores (1858–1939) lived and painted in Japan. San Francisco born, he traveled much in the Pacific and American Southwest, painting as "artist-ethnographer." Mrs. Campbell Praed (1851–1935) was a very minor novelist of Australian origin, author of The Mystery Woman, The Soul of Nyria, *and other fiction. Justin McCarthy (1830–1912) was an Irish M.P., novelist, and journalist.*

Alexandre N. Roussoff (1844–1928) was a Russian landscape and genre painter who lived in London but painted Eastern Mediterranean settings.]

Mr. Theodore Wores, an American artist, has taken Japan very literally indeed in the series now at the Dowdeswell Gallery. The result, naturally, is in strong contrast to the "impressions" of Mr. Mortimer Menpes. The skies and faces are rather "painty," but the pictures have a certain pre-Raphaelite sincerity and strength of colour which are worth a good deal. Mr. Menpes is in evidence with his "Impressions of London," twelve vigorously dainty etchings of waterside wharf and spire scenery, two hundred impressions of which are to be published, with letterpress by Mrs. Campbell Praed and Mr. Justin McCarthy.

❖

At the Fine Art Society's rooms Mr. Alexander Scott's Indian sketches have been replaced by Mr. A. N. Roussoff's popular and attractive Cairene drawings, full of the brightness and cleverness, without the defects, of his Venetian series, which, smart as they were, lacked breadth, and were gaudy and shallow. There is still, perhaps, a trifle too much repetition of the same effects and even of the same bits of street: but, on the whole, the improvement in Mr. Roussoff's style is very marked.

The World, 3 July 1889 [C601]

[Herbert Ward's Africa]

[Herbert Ward was a British adventurer, artist, and writer who, while spending 1884–89 in central Africa, joined Henry Morton Stanley's Emin Pasha Relief Expedition. Emin Pasha, originally Eduard Schnitzer (1840–92), was a German doctor and explorer of Jewish parentage but a convert to Islam who as one of General Charles Gordon's lieutenants had been cut off in equatorial Africa after the fall of Khartoum and Gordon's death. The successful but costly relief expedition led by Stanley lost all but 233 of its 655 men in 1887–89. "Emin"—a linguist, anthropologist, and natural scientist dedicated to African research—accompanied Stanley to Zanzibar only briefly and returned to the Lake Victoria area, to be murdered by Arabs three years later.

Edmund Musgrave Barttelot (1859–88), a captain in the relief party, and an officer in the Royal Fusiliers, commanded the rear column. He was shot and killed by one of the followers of "Tippoo Tip" (or Tib), "the one who blinks"—an appellation from his nervous twitching of the eyes. "Tippoo" was Hamed bin Muhammed bin Rajad el Murjebi (1830?–1905), one of the last great slavers of the nineteenth century, an Arab of mixed African blood who ruled much of central Africa whatever the artificial political borders, and who was much deferred to by Belgian, German, and British colonialists.]

Central Africa is not so far behind the rest of the world as a Cockney might suppose. Mr. Herbert Ward, one of the volunteers of the Emin relief expedition, is in London, and he has filled a room at the Vander Weyde studio in Regent Street with products collected by him in the cannibal districts of the Upper Congo. Though they carry meat-eating to its logical extreme, the people there are evidently no mere savages. Not only do they turn out paddles and spears of the greatest variety and beauty of form, but they are accomplished and artistic workers in native iron and steel. Their swords are curiously designed and highly finished; they have a currency consisting of spearhead-shaped blades of iron of various lengths, some of them running to six feet; and their musical instruments include sets of vibrating prongs of the Jew's harp type, among the intervals of which minor and major thirds can be distinguished. Our dinner forks are rude and primitive in comparison to theirs—perhaps because we have not to cope with long pig. The most surprising feature of the metal work is the civilised character of the decoration: it is not childish or freakish, but deliberately and appropriately ornamental. Among the photographs is one of Tippoo Tib, an

old gentleman who strikes one as shrewd and not straitlaced, but affable and easygoing withal. Mr. Ward also made many drawings, which form part of the exhibition. He was one of those who were left at Yamburra camp; but on the subject of Barttelot's death and other personal matters he is significantly uncommunicative.

The World, 24 July 1889 [C609]

In the Picture-Galleries
The Arts and Crafts—The Old Water-Colour Society

[J. W. Comyns Carr (1849–1916) was a many-sided arts entrepreneur; a playwright and critic, he also operated the New Gallery. Thackeray Turner, designer, was also secretary of the William Morris-inspired Society for the Protection of Ancient Buildings, known familiarly as "Anti-Scrape." Ulysse Cantagalli (?–1902), a Florentine designer and potter, beginning in 1878, manufactured reproductions and modernizations of early Italian originals. Cantagalli ware used as potter's mark a crowing cock—a rebus for the maker's name. W. A. S. Benson, architect and designer, produced ironwork and copperwork in art nouveau shapes, influenced by the decorative work of William Morris.]

The Arts and Crafts committee-men have hung up their sign at the New Gallery; but, by way of precaution, it has been hung inside the building, because last year Mr. Comyns Carr used to take it in as often as Master Decorator Walter Crane hung it out; and mediaeval feuds between the Misters and Masters ensued. The exhibition is not so attractive as last year's: all statements to the contrary are due either to the ubiquitous enthusiast who always thinks "this" the best show ever held, or to forgetfulness of the titbits which were sent once for all to the first exhibition: as, for example, the Burne Jones golden ark, the Morris illuminated MSS., the decorations for the American church at Rome, and the wonderful piece of stained-glass with the story of the finding of the Holy Grail. This year there is hardly any stained-glass. The fact is, there were no adequate arrangements for its display last year; and, as they say down at the Docks, "That's wot give 'em the 'ump"; for though an elaborate dark room was fitted up expressly this year, the offended glaziers would have none of it. And I must say also

that though all sorts of considerations, personal, artistic, and political, prejudice me strongly in Mr. Walter Crane's favour, yet never, even in the days when Mr. Herbert used to hang eight pictures on the line at the Academy every year, have I seen such an unblushing preemption of wall acreage by a "boss" member of the governing body of an exhibiting institution as Reformer Crane has apparently been guilty of at the New Gallery. I say apparently; for I suppose the truth is that, as usual, he has had to ransack his studio and workshop to fill up odd corners and vacant spaces. One of the exhibits, the golden wedding address presented to Mr. Gladstone by the members of the National Liberal Club, will be criticised without the faintest reference to its artistic merit from the Unionist and Home Rule point of view. I would, therefore, direct the attention of the Home Rulers to the text of the address, as the lettering is very good; and that of Unionists to the decorations and pictures, which for unmitigated ugliness and inappropriateness seem to me to overstep the license even of a British golden wedding. Mr. MacWhirter's view of Edinburgh is a studied outrage upon all the principles of book decoration preached so vehemently last year at the lectures of the society; and the President's design, in which Mr. Gladstone, axe in hand, cuts down a serpent a thousand feet high, in allegory reduced to the desperation of mixed metaphor. Hard by the case devoted to the promulgation of this manifesto is Master Cobden-Sanderson's array of bound books, sewn by Mrs. Cobden-Sanderson and lettered from alphabets designed by Mistress May Morris. This, as far as I know, is incomparably the best contemporary bookbinding to be seen anywhere in England at present. It ranks with President Crane's line decorations on flat surfaces and Master William Morris's textiles and tapestries, among the few examples in the gallery of art and crafts strongly and permanently mastered and appropriated by individual artists. Master Thackeray Turner's cups and saucers are more to my taste than the Cantagalli plates, which, handsome as they are, expressly challenge comparison with old work to which they are inferior in colour. Master Coppersmith Benson is subject to aberrations of fancy, in which he fashions smoke guards into screw-propellers, and lamp-stems into toy umbrella-stands and at such times I am moved to deal grievously with him in criticism but this year his kettles and breakfast-dishes are smart and workmanlike showing off the artistic qualities of the metal by their sharp sure curve. The cinerary urns are interesting, but the catalogue does not say how many they are intended to hold. The terra-cotta ones seem the cheapest as well as the best adapted to the requirements of a large family. Guess work is looking up; the combination of oil-painting with it is not, however, a success: it would evidently be as easy to learn to do the whole picture

in *gesso* as to paint flat portions up to it. I shall spare the rest of the catalogue, merely remarking that, though all the exhibitors have unquestionably a sincere taste for preëxistent decorations, very few of them are persons of original decorative impulse, which is, after all, what makes your craftsman a genuine artist.

On Saturday I looked in at the photographic exhibition at the Old Water-Colour Society's rooms in Pall Mall East, and rejoiced over a great improvement in matters there. A few years ago this annual show meant a display of all the horrors of shop-window photography, with "gold medal" stuck on the most fraudulent example of retouching or picture-faking. *The World* had to come to the rescue of the public, since nobody else would, by making a fell onslaught on these abuses, with the usual result that those who should have taken the initiative chuckled, but lay low to escape unpleasantness. As for me, my public spirit cost me eighteenpence a year, representing a capital sum of no less than thirty shillings, through the cutting off of my invitations to the press views. I now perforce pay at the turnstile, and buy my catalogue like any ordinary unit of the mob; but when I look around and see the reformation I have wrought, I bear my chastening stoically, and even laugh a little in my sleeve. But I have been taught my place, and therefore I dare not ask the committee whether they really admire that conspicuously hung lady who has been adorned with eyebrows by the retoucher in the straightforward but somewhat obviously conventionalised style affected by schoolboys when they touch up Julius Caesar with a pair of moustaches.

<div align="right">

The World, 9 October 1889 [C634]

</div>

In the Picture-Galleries
Pastels at the Grosvenor

[In Dickens's Bleak House, Jobling, a pal of Mr. Guppy, has decorated the walls of his room with engravings of current Fashionable Ladies, presumably torn from old numbers of magazines or bought from shop windows.

Emile Wauters (1846–1933) was a Belgian historical and portrait painter; Frank Hind, English painter who exhibited from 1885, produced landscapes and townscapes of Holland, Italy, Spain, and Britain. The late François de Marneff (1793–1877) had been a Belgian painter; Arthur James Stark (1831–1902) was a Surrey painter of

rustic scenes. Rosalie Emslie, a miniaturist, was the wife of artist
Alfred Emslie; Ellen Gertrude Cohen, a London painter of domestic
scenes and children, exhibited 1881–1904. Anna Nordgren (1847–
1916) was a Swedish painter; Marianne Preindlsberger Stokes (1855–
1927), an Austrian and wife of artist Adrian Stokes, painted biblical
and mythological scenes in a decorative style, often in gesso and tem-
pera, to give the appearance of fresco. Frederick Hamilton Jackson
(1848–1923) taught at the Slade School (London) and worked in paint-
ing, illustration, and design and ecclesiastical decoration.

Leon Frederic (1856–1940) was a Belgian genre painter; Eugene
van Gelder (1856–?), also Belgian, began exhibiting, in 1886, in Ber-
lin. His pictures in this exhibition were "The Blind Man" and "Portrait
of an Old Man." Also Belgian was Adrien de Braekelear (1818–1904).
Louis Welden Hawkins (?–1910) was a German-born painter of En-
glish parentage who lived and worked in Paris.

Shaw's reference to the magnetic attraction of violin virtuoso Pablo
de Sarasate (1844–1908) evidenced not only his parallel journalistic
assignments as music critic, but the growing hold of music over his
time and interests. There were concerts daily and nightly, and art
openings were losing out to them in his priorities. Shaw's "wedding
guest" paraphrase echoes the familiar lines from Coleridge's "Rime of
the Ancient Mariner."]

The Grosvenor at present is like nothing so much as Mr. Jobling's
Galaxy Gallery of British Beauty. I can forgive Sir Coutts Lindsay for
his clandestine private view (imagine a private view without the press
there to make it public!); and it would hardly be dignified in me to
abuse the exhibition merely because the invitation, which used to run
for the entire season, has this time been cut down to a single day. I
have always understood that my privileges as a critic were meant to
corrupt me; and I trust I am not so ill-conditioned a man as to be
incapable of expanding in a genial atmosphere of blarney and free
admissions. But I have long foreseen that with the multiplication of
papers and newspaper men (and women) the dealers and *entrepre-*
neurs must, in mere self-defence, curtail the old civilities; and though
the curtailment has only just touched me, as recorded above, I already
feel distinctly more conscientious. Every man has his price: that much
is now statistically proved by the overwhelming fact that every addi-
tional penny in the income-tax brings in a smaller revenue that the
preceding one; and as my particular price has not been paid this time, I
must say disinterestedly that the display of young females in chalky
millinery at the Grosvenor is excessive. An art-gallery should be a
beauty show, but not too exclusively a feminine beauty show.

Pastel, as one might expect, seems to come easily to the younger artists who have had some sort of real training in colour and handling in French *ateliers*. The fine old English artist who can neither draw nor paint does not take to it kindly; but Mr. Wauters, Mr. Stott, Mr. [Frank] Hind, Mr. St. George Hale, Mr. Ludovici, Mr. Dampier May, Mr. W. J. Hennessy, Mr. Peppercorn, Mr. Otto Scholderer, Mr. Hubert Vos, Mr. de Marneff, Mr. Stark, and Mr. Llewellyn have passed from oil-colour to it without apparent effort. Ladies seem to take to it kindly. Mrs. Jopling's pastelling is better than her painting; and Mrs. Emslie, Miss Cohen, Miss Chomely, and Miss Nordgren exhibit work of varying merit, but of considerable freshness and promise. Freshness, by the way, is exactly what Mrs. Marianne Stokes's gaudy little cupid wants. Mr. Charles Shannon's "The Sheep hear his Voice" is imaginative and decorative, for which be all his sins forgiven him! For a feebler touch of poetic quality, Mr. Hamilton Jackson's "Cupid leaves Psyche," I prefer to much in the gallery that is cleverer. The barrenness of the clever people grows oppressive occasionally. Since Mr. Solomon's "Amazon" is not fair to me, what care I how fair she be? Her flesh-tones are ghastly; besides, she is not a picture, but a life-school study. As to Mr. J. E. Blanche, his talent and distinction are real; but so is not his "Simone," who is a deal woodener than her doll.

Mr. [Henry Stacy] Marks's flamingoes, pelicans, and other feathered inhabitants of Regent's Park are the best things he has done for a long time. They are faithful enough to be added to Gould's ornithology, and withal delicately painted and artistically treated, especially those in water-colour. The expressions of the birds, quaintly human as some of them are, are natural. None of your AEsop's Fables illustrations, with legal storks and clerical crows, such as Mr. Marks thinks good enough for innocent Academy-goers. These birds, observe, are not at the Grosvenor, but at the Fine Art Society's Gallery.

I cannot guarantee my very favourable impression of the Hanover Gallery, as I only saw it by gaslight. This was the fault of Sarasate, who played the Ancient Mariner with me. He fixed me with his violin on my way to Bond Street, and though, like the wedding guest, I tried my best, I could not choose but hear. Messrs. Hollender and Cremetti have secured a few good Courbets and Jacques—fawns and sheep, of course, Courbet's especially noteworthy; some life-size realistic pictures, by Léon Frédéric, of labour on the tramp, joyless, but painted with much power and earnestness; certain clever and faithful cabinet pictures of proletarian types by Eugene van Gelder; a couple of strong Roybets; a Troyon with a cow on tiptoe—the more I see of Troyon the more I am convinced of the hopelessness of claiming a permanent first class for him; a good Dutch interior by de Braekelear; an excellent orchard scene

by Welden-Hawkins; and a new and impressively admirable picture, "The Woodcutters," by Professor Legros, as deeply felt as anything that ever came from Barbizon, and alone worth a visit to the gallery.

The World, 23 October 1889 [C639]

[The Old English School]

["Old Crome" was John Berney Crome (1794–1842), a Norwich land-scape painter known for his moonlit scenes; his two sons were also painters in his style. James Baker Pyne (1800–1870) was a Bristol landscape painter and watercolorist. Henry Dawson (1811–78), a Hull painter of landscapes and coastal scenes, moved later to Nottingham and then Liverpool.]

Those who care to study the old English school within prescribed limits should look in at Shepherds' Galleries in King Street, St. James's. They will find an excellent little Constable—a study on the Suffolk coast—and a picture on the River Brett, by the same master; Old Crome and Cotman are also there in their pleasantest moods. There is a poetic [Richard] Wilson, a quiet Gainsborough, picturesque J. B. Pynes, and some interesting pictures by Henry Dawson and other artists of the Norwich school. The little gallery is worth looking into, if only to see how some of the old painters spent their spare moments.

The World, 30 October 1889 [C641]

[Resignation]

In the Star's *"Mainly About People" column, 17 December 1889, appeared an unsigned note confirming that Shaw had left regular art reviewing:*

Readers of the *World* will note with regret the disappearance of the letters "G.B.S." underneath the art criticisms. This means the severance of Mr. Bernard Shaw's connection with Mr. [Edmund] Yates's newspaper, the act being that of the critic and not of the editor. His

place is being taken by Lady Colin Campbell, who, under the signature "Q.E.D.," transfers her services from the jewellery and fancy establishments of Bond Street to its picture galleries. Mr. Shaw never, of course, had a free hand on the *World,* but he did a good deal of delicate, discriminating work, all the more valuable because it was so free from affectation. The picture galleries are now, on account of Mr. Shaw's voluntary banishment, in danger of losing one of their brightest ornaments. Even Lady Colin's dark eyes and witching dresses will not atone for the absence of the famous harmony in snuff-color with which Mr. Shaw used to enliven Academy picture-shows. Probably, however, now that the editors know that he is free, there will be an indecent scramble for his services.

❖

Shaw responded in a letter to the editor in the *Star,* published 18 December 1889 (C666), and denying that he had suffered any restrictions.

❖

. . . I never had a freer hand with any editor than with Mr. Yates, and . . . I prefer Conservative editors to Radical ones. They can steal a horse when a Radical dare not look over a hedge; and I, as a habitual horse-thief even in art-criticism, have found that the more advanced a paper believes itself to be, the more it is afraid of a contributor who is an eighth of an inch more advanced than itself.

. . . On reflection you will see that every other critic on the staff of the *World* has his differences of opinion with Mr. Yates as I had, and lets them be seen as unrestrainedly as I did. The result is that each man brings out his bias so sharply and individually that it is never confused with the editor's; and nobody supposes that Mr. Yates is an Ibsenite, a bi-metallist, an anti-Wagnerite, a Socialist, or a cynic, because gentlemen of these persuasions have written for him on the drama, the money market, music, pictures, and Paris. I never trimmed a line. . . .

In the Picture-Galleries
Old Masters at the Academy

[Although Shaw had officially left regular art criticism he continued to substitute for his successor and to write occasional pieces elsewhere.

When he discovered how much his journalistic income had dropped off, he even attempted to find a new art column assignment.

Star founder and editor Thomas Power ("Tay Pay") O'Connor (1848–1929), whom Shaw claimed facetiously to see in a Turner picture, was an M.P. and Irish Nationalist.

Joseph Wright (1734–97), portrait and genre painter, was known as "Wright of Derby." Sir Martin Archer-Shee (1769–1850), a Dublin-born portraitist of the high-born, including Queen Victoria, became President of the Royal Academy in 1830. Diego de Silva y Velázquez (1599–1660), one of the great Spanish portrait masters, was distinguished for his uncompromising realism. His pathetic Mariana of Austria captured the new young queen of Spain, married to Philip IV (1605–65) as his second wife in 1649, when she was fourteen. Admiral Adrian Pulido Pareja (1606–60) was commander of the fleet of New Spain. Prince Balthazar Carlos (1629–46) was the eldest son of Philip IV and Isabella of Bourbon (1629–46).

Bartolomé Esteban Murillo (1618–82) was a Seville painter of scenes from low life and religious pictures. Luigi Arditi (1822–1903), whose eyes Shaw claimed to see in a Rembrandt self-portrait, was the Italian violinist, conductor, and composer; Shaw heard him as long-time musical director at Her Majesty's Theatre.

Among collectors who had lent grand pictures were Charles Alfred Worsley (1859–1936), fourth Earl of Yarborough, the late William Bingham Baring (1799–1864), second Baron Ashburton. Clearly the picture had been sent by his widow—from Bath House, Piccadilly, Lady Ashburton was one of the great London hostesses of the day. Her Vandyck portrait of Count John of Nassau was painted in 1634–35. The Vandyck portrait of Thomas Howard (1586–1646), second Earl of Arundel and Surrey, was one of seven of the Earl done for his patron.

Sir Joshua Reynolds's portrait in the exhibition, clearly in desperate need of restoration, was of Margaret Leveson-Gower (1753–1824), married to Frederick Howard (1748–1825), fifth Earl of Carlisle. Joseph Kenny Meadows (1790–1874) was a Scottish portraitist, illustrator, and caricaturist whose work Shaw did not admire. Nor, obviously, did he approve of Romney, whose influence he saw in Francis Danby (1793–1861), an Irish-born painter of wildly romantic pictures. Danby's life was its melodramatic equal, and included matrimonial scandals, self-exile, and triumphant return, with paintings reflecting the sunset tranquility of his later years.

Sir Augustus Wall Callcott (1779–1884) was a romantic landscapist known as "the English Claude"; Sir William Beechey (1753–1839), RA 1798, was a portrait painter in the Reynolds tradition; Thomas Webster (1800–1886), ARA 1840, was highly successful with

genre scenes of everyday life in the Dutch manner. Sir Edwin Henry Landseer (1802–73), ARA 1826, won royal favor with his sporting, animal, and Highland paintings, and his animal sculpture; Victoria gave him commissions for pictures and statuary, and he modelled the bronze lions in Trafalgar Square. Thomas Creswick (1811–69), ARA 1842, was a landscape painter of Welsh and north-of-England settings, and a book illustrator. Richard Wilson (1714–82) was one of the leading landscape painters of his time; in 1776 he became librarian to the Royal Academy.

John Singleton Copley (1737–1815), RA 1779, Boston-born historical and portrait painter, left for England in 1774 to seek subjects and commissions, finding them in profusion. Philadelphian Charles Robert Leslie (1794–1859), ARA 1825, like Copley, eager to make his artistic fortune where there were indeed fortunes, was portrait painter, historical painter, and illustrator; in 1838 he painted the Coronation picture "Queen Victoria Receiving the Sacrament."

Christian Wilhelm Ernst Dietrich (1712–74) was a German religious and genre painter. Cuyp is Albert Cuyp rather than his father, Jacob ("Old Cuyp"). Sir Peter Lely (1618–80), Flemish portraitist who was Court painter to Charles II, painted Diana Kirke de Vere, second wife of the twentieth Earl of Oxford; Sir William Lovelace "of Woolwich" (1584–1628) was killed at the siege of Grolle in Holland.

The Duke of Wellington monument designed for St. Paul's by Alfred Stevens was first, in its incomplete form, placed in the Chapel of St. Michael and St. George. When it was transferred to its intended location the equestrian statue at the top was omitted, because the Dean of St. Paul's, Henry Hart Milman (1791–1868), objected to a horse in a church. When it was completed by sculptor John Tweed (1869–1933), the horseback statue was added in 1903, and the entire monument finally finished in 1913.]

Is there anything more exasperating than to be solemnly invited to a palatial mansion, there to be received by a gorgeous retainer and ushered into a splendid banqueting hall, only to sit shivering and hungry because your host is too stingy to light the fire or spread the board? What a farcically disgraceful scene that was in the Academy last Friday! The thermometer miles below zero; the iron pipes under the gratings cold as death; the critics, huddled together in little groups for warmth, vainly trying to out-chatter their own teeth; Cuyp's sunbathed horsemen grinning in mockery from the walls; and the two beadles in attendance, splendid as cardinals, and solemn as presidents of the Royal College of Physicians, receiving each addition to the Inferno with a deferential slice of cold catalogue. I look down the list of

the forty gentlemen, from Lawrence Alma-Tadema, Esq., to William Frederick Yeames, Esq., who are accountable for this incredible parsimony, this inhuman churlishness; and I ask, with a gasp, where are their imagination, their sympathy, their manners? By whom were they brought up? Do they individually in their own houses treat their visitors as they collectively treat them in Burlington House? Do they suppose that critics carry their own hot water about with them; or is the winter show of Deceased Masters of the British School only the bait in an influenza trap designed to produce a spring exhibition of Deceased Critics of the same august institution? Well, no matter! later on—in May—we shall see what we shall see.

In the course of my north-west passage through the five rooms, I could not help coming to the conclusion that George Romney had very little in him, and consequently could see very little in other people. It is true that this did not surprise me quite so much as an unmistakable portrait of Mr. T. P. O'Connor, thinly disguised as an elderly skipper, by no less a painter than Turner; for I have long had my suspicions about Romney, even when his Lady Hamiltons had nothing more formidable to contend with than authentic Wrights, Grants, Shees, and similar art-treasures. But imagine Romney in the same room, not only with Vandyke, but with Vandyke having to do his very best to keep in countenance beside Velasquez and Rembrandt! In such company Romney is nowhere: and yet, at the Academy, the more he is nowhere the more obtrusively is he everywhere. All these Romneys ought to be cleared out save No. 121, the two children of the second Earl of Warwick. In this picture you have the whole Romney gamut. The girl has his laughing, sunny, conscious grace: the boy has his scooped, empty, feelingless drawing, disguised by that likeness to the sitter which he had the knack of catching. The Gainsborough portraits might be cleared out, too, as unfortunate examples of a great master, painted in that horrible manner of his which suggests that he occasionally tried black-lead as a vehicle for his colours. His pretty housemaid, in the first room, unfinished as it is, is worth a dozen such.

I do not know whether Velasquez's sitters ever objected to his portraying them as incarnations of their ruling passions and darling sins. Probably he said nothing, and they pretended not to notice. Anyhow, it is hard to believe that Mariana of Austria was sufficiently proud of her pride to relish the ruthless picture of it rather than of her which Velasquez made of her portrait; or that Captain-General Adrian Pulido Pareja rejoiced in the intensity of his scowling truculence on immortal canvas. Such pictures must have cleft their hearts in twain, if they had any hearts to cleave. Depend upon it, Velasquez liked neither of these patrons of his as he must have liked little Don Balthazar Carlos, Philip

IV's son, of whom there are four portraits here, each as engaging as it is masterly. Before coming to the pictures—eight, all told—by Velasquez, you pass a Murillo, with a heavenly-faced infant shepherd Christ. After passing them you come to a second Murillo, a Madonna, from the discordant mock Roman colouring of which your very soul recoils, so villainously does it jar after the majestic harmonies of Velasquez. Indeed, Rembrandt alone holds his own in that perilous juxtaposition, more by a more consummate portrait of himself, in which the eyes recall Signor Arditi in the oddest way, than by the ignobly stupid old woman whose possession nobody but a dealer will ever envy the Earl of Yarborough. Even the plausible and distinguished Vandyck can hardly be admired at this enchanted corner of the big room without hurrying past his portrait of an artist, and getting at once to that of Thomas Howard, whose face is a wonderful feat of portraiture. Lord Ashburton's "John of Nassau Dillenbourg" is another very skilful piece of work, but it is joyless. No: call Vandyck's work powerful, refined, interesting, handsome, magnificently dexterous; all that does not seem to bring him an inch nearer to his two rivals. You can read the intellect and the manners of his sitters on his canvas; and you cannot deny that the colour of their clothes is arranged with the most dignified taste—that it is stupendously finer than the work of poor Frank Holl, for instance; but a glance at Rembrandt and Velasquez devastates it. These men get behind the intellect and manner to the very will of their men and women; and their colour strikes like music right through and through the eye, far into the recesses of the poetic sense.

Reynolds, to people whose imagination can reconstruct a picture from its ruins, is best represented this year by his portrait of the Countess of Carlisle. When that French gray robe was new, and that rose unwithered, what an exquisite picture it must have been! The famous "Puck" is an ill-imagined thing, more worthy of Kenny Meadows than of Sir Joshua. The British school abounds chiefly in the first gallery, which is much pervaded by the wretched Romney, by Danby the Dreadful, by Callcott and Sir William Beechey, by Thomas Webster and Landseer, by Creswick, Copley, James Ward, Leslie, [Richard] Wilson, and Zoffany, with brief lucid intervals of Morland, [William] Mulready, Turner, Gainsborough, John Linnell, and Constable. There are many coast and sea pieces; and as I came up from Broadstairs by an early train for the press view, I was specially critical of these. Not one of them is in the least like the real thing except Constable's half-finished "Chain Pier at Brighton." When I looked at that, I smelt the ozone again.

From the Dutch painters in Gallery II, Peter the Great (otherwise de

Hooghe) is absent; and the unspeakably ruffianly cows in the west corner are hardly what might have been expected from Paul Potter. Jan Steen is there in Rabelaisian grandeur; and the Earl of Yarborough's "Scene on the Ice," by Cuyp, is, in one word, beautiful. Christian Dietrich's merry "Adoration of the Shepherds" reminded me of the line, "Joseph whistled and Mary sang," from a carol immensely in vogue a fortnight ago at Broadstairs. As to the couple of dozen full-length portraits, *en suite,* in the fourth room, they are a magnificent series of seventeenth-century fashion-plates. I recommend all modistes to study No. 168, the beautiful Lady Oxford; and all costumiers to reflect upon Sir William Lovelace (No. 181).

The water-colour room is obviously a challenge to us all to admit that Alfred Stevens was a great artist. Well, I do not mind acknowledging heartily that he was a very able man, and that his works are always full of matter, and often contain striking and original parts. I also quite agree that Dean Milman should either have rejected the Wellington monument altogether, or else swallowed the horse as well as the pedestal. Nine-tenths of the Christian churches of the world contain representations of a donkey, of flocks of sheep, Tobit's fish, Jonah's whale, and a centurion or two on horseback. But our great centurion must leave his horse behind him at the gate of St. Paul's. However, my business is to criticise painters, not deans—a fact upon which the dean in question is, I flatter myself, to be congratulated this Christmas.

The World, 9 January 1890 [C672]

Greater Than Da Vinci?

[Shaw's columns for Truth *did not lead, as he had hoped, to a new career as art critic. Shaw would not accept dictation. The proprietor, Henry Labouchere, had his own agenda, which was bad enough, but his wife also interfered. Shaw wrote to William Archer on 10 November 1891 (CL), "You know that I lost about £100 a year for refusing to criticise in the private interests of Mrs. Labouchere."*

Leonardo da Vinci (1452–1519) was one of the great painters, but Shaw was serious in thinking that his "Last Supper" was more a picture than a portrayal of an event. Whether it was the political radical in Shaw or the social realism of Fritz Carl Hermann von Uhde (1848–1911), the modern version of the story impressed him.

Mr. Lillyvick—Shaw was forever snatching metaphors from Dickens—was a collector of water rates in Nicholas Nickleby.

Max Liebermann (1847–1935), German painter and etcher influenced by Impressionism, also impressed Shaw for both artistic and political reasons. Carl Christian Ernst Hartmann (1837–1901) was a Copenhagen painter and sculptor; Robert Noble (1857–1917) was a Scottish landscape and genre painter. Ebenezer Wake Cook (1843–1926) was a watercolorist of landscapes and river views, especially of the Thames, Venice, and Florence.

The Vendome column, which Gustave Courbet "helped to pull down," stands in the Place Vendôme, near the Paris Opera. For more than sixty years the obelisk, a pseudo-Roman column topped by a bronze Napoleon, had been an abomination to Parisian republicans. After the fall of Napoleon III, the despised emperor's nephew, in 1870, Courbet, as President of the New Arts Commission, petitioned the interim Government of National Defence to authorize him to "unbolt" (déboulonner) the column, which wounded the "natural susceptibilities of European democracy," and to send parts worth preserving to appropriate museums. Instead, the Commune had the pillar demolished by attaching cables to it and pulling it down with a winch while several military bands played the Marsellaise. *When the revolutionary regime was suppressed in May 1871, Courbet was jailed. In a trial in absentia after his release and escape to Switzerland, the conservative new republic ordered Courbet to personally pay 320,000 francs for costs of restoring a facsimile of the original. In an appeal his lawyer managed to have the sum made payable in annual installments of 10,000 francs, which would have taken the old rebel into his nineties; however his health, undermined by imprisonment, flight, confiscation of his property, and the need to produce works at factorylike rapidity to survive, had given way, and he died in 1877, at fifty-eight.]*

Does any one wish to see a greater "Last Supper" than Leonardo da Vinci's? If so, there is one in the French Gallery in Pall Mall. Not that this is saying so much after all to those who have looked at the famous *cenacolo* with some kindred experience of what the ordeal of fighting society for its own good in the early Christian style must have been. Leonardo, as they well know, was no judge of the look of the sort of man who becomes a disciple and sticks to it. He took monks for his models—men who had run away from the battle of life into the monastery. Fritz von Uhde, the painter of the Supper at the French Gallery, has done better than that. He has taken the workman of his own day—not the average tradesman's hand who backs a horse whenever he has the wherewithal, and is not so far above a dog-fight as the pious could

desire; but the laborer who gives his life to realize a dream, which, because it is a poor man's dream (one's income makes all the difference in the world, even in dreams) is sure to be some vision of universal brotherhood and equality. Such views are apt to get a man into trouble with his employers, not to mention the police, to an extent that throws him back on his faith continually for some sort of stay in his chronic and heavy adversity, and finally leaves a mark that there is no mistaking on his face. The early Christian, clearly a man of this stamp, was as little like a member of a crack monastery in Leonardo's time (one able to give commissions to a fashionable painter) as their common humanity admitted. Von Uhde's models are poor Communist dreamers of today; and with them he has if one may be suffered to use such an expression in this connection, put Leonardo's nose out of joint as the prince of *cenacolo* painters. There is not a single figure at Leonardo's table that ever knew what it was to go supperless, or, for that matter, dinnerless, to bed; not even one who looks as if he had ever troubled himself much about the hardships of less lucky people in that respect. You have only to look at von Uhde's disciples to see that Leonardo's are rank impostors. But we must pass on to the next picture.

This is also by the uncompromising von Uhde, and this time his subject is "Suffer Little Children." Dante Rossetti once painted, or proposed to paint, St Matthew in the guise of a modern tax-collector—something like Mr Lillyvick in "Nicholas Nickleby"—with a comforter, chimney-pot hat, and even a clay pipe. But it was felt that the essence of decorum in pious art was the concealment of the unfortunate fact that apostles and saints—to go no further—were not in society. Hence it was felt that the projected translation of the evangelist who sat at the receipt of custom into his modern equivalent would be indelicate and subversive; and so the proposition fell through. But once these notions get born, they do not wait for ever to be executed; nor does any mortal power seem able to prevail against them. Here, in von Uhde's picture, is Christ sitting in a modern room, in the shabby robe of a Messiah who cannot afford to buy a new one very often, talking to the children in the presence of men in the ordinary tailorings of the middle-class German of today. What is more, the effect is so far from incongruous that it makes you feel at once, in the most vivid way, that the incongruity is altogether on the other side—that it is the conventional arrangement that is incongruous. By way of test, just go straight from the French Gallery to Messrs Vicars's and see whether you can stand Bukovac's eminently pretty and proper treatment of the same subject. If you can, it is safe to say that religious art is not your forte. This von Uhde is not only a thinker able to conceive a subject with great sense and insight; he is a painter and draughtsman of notable technical skill and original-

ity. Though the remarkable aerial perspective boasted in the catalog is due largely to the mechanical effect of giving a bird's eye view of the scene—this is particularly obvious in "My Children's Nursery"—yet the delicacy and knowledge with which the light is treated, and the painter's faithful resolution to adhere to a perfectly dry and literal method without recourse to the conventional Venetian or Rembrandt-esque glow and suffusion of some leading harmony of orange, at once justify his reputation for extraordinary powers of execution, and explain why he had so long to make his living as a soldier and riding-master (of all things) before he could manage his method sufficiently to turn out presentable work.

Max Liebermann, also in force at Mr. Wallis's gallery, is like Uhde only in this, that he will not tell lies with his brush, come what may of it. Needless to add, he is not a portrait painter. He shows you a party of women at work in a factory, and another on the sands making nets; and you may draw what moral you please; there are the women to the grim life, with all the unlovely wear and tear of their hard life on them. They may make you uncomfortable, but you cannot deny the power, the verisimilitude, the seriousness of the pictures. After these two strong men, one leaves the gallery oblivious of Firle, Adrien Demont, and all the other clever ones, Munkacsy himself not excepted, whose work hangs about.

At Tooth's Gallery, however, Munkacsy is first, and the rest no-where. It is all very well to hang a puerility by Joanowits in a place of honor; but since it appears that Joanowits does not intend to improve on the boyish pictures of pirates and brigands which won him some kindly encouragement at first, I am certainly not going to help my good friends the dealers to keep up the pretense that he has won a position of the smallest importance. Eugène de Blaas is also for the moment on the downgrade—a serious matter for a gentleman who never attained any very alpine altitude. On the whole, I cannot say that Tooth's is particularly good this time, though Munkacsy's repetition of the motive of the charming piece he exhibited at McLean's last year, taken with a similar repetition by Bisschop, and a treasure by the great Fortuny— for which treasure I must add that I would not myself give twopence, Fortuny being a taste which I have not yet acquired—saves the exhibition from the reproach of lacking any distinguished work.

Next door, at McLean's, there are some uncommonly clever sketches of boys up to various larks, by C. Hartmann; also an Eastern scene by the respectable Bauerfeind, whose pictures have all the interest of books of travel, and absolutely no artistic interest that [I] can discover. Mr. Or-chardson sends an exquisite ideal drawingroom, with some dainty

china, and a couple of human figures thrown in to shew the scale of the real subjects of the picture.

I always make a point of looking up Messrs. Vokins whenever there is an exhibition at their place in Great Portland-street. There is a sort of grand tradition about the Vokinses: they have never condescended to go down into Bond-street; and they scorn turnstiles and shillings. If you are a connoisseur, you go into their gallery of natural right. If you choose to do so now, you will find a room full of water-colors by Mr. E. Wake Cook, the result of two years' work in what he, dropping into poetry, calls "the sunny south." There are collectors who affect Mr. Cook's delicate and cheerful work; and I have nothing to say against it, except that I like him least when he attempts rocks and ripples, with the forms of which his touch with the brush refuses to shew the least sympathy.

At the Fine Art Society's Galleries, Mr. Herbert Marshall has a new series of sketches of London. He is at his best in aerial effects, and in painting comparatively open spaces: the spire of St. Mary-le-Strand, for instance, and the two views of Whitehall, could not reasonably be better; but I do not think Mr. Marshall has yet succeeded in catching the peculiar intramural gloom of a narrow London street like Cheapside. Mr. East's Japanese sketches are still in the next room; and very interesting some of them are for people who are familiar with the White wing of the British Museum, since Mr. East has found in nature some of the very effects of color which we took on trust as combinations of the subtlest art.

The exhibition which, after the French Gallery, ranks next, is that at Dowdeswell's. Whenever Mr. Dowdeswell gives his Monticellis and his Segantinis an airing, then is the time to haste to 160 New Bond-street, and enjoy yourself—unless, indeed, you prefer the school of Mr. Marcus Stone or Mr. [Samuel Edmund] Waller, in which case you may not improbably consider that Mr. Dowdeswell is stark mad. But do not express these opinions if you wish to pass as a picture fancier, for Mr. Dowdeswell never knew what he was about better than when he pounced on Segantini at the Italian Exhibition, or when he bought for the rise in Monticellis which may be expected by the time custom begins to stale Mr. Stone's less than infinite variety. The twenty-eight pictures by Hervier make me feel sorry that so estimable a painter should not have received more encouragement in his lifetime; but I am not very sanguine as to the likelihood of his work compelling posterity to make amends. Courbet was a strong man if you please, though his range of color was limited. Besides, he helped to pull down the Vendôme Column, and if people were foolish enough to put it up again,

that was not his fault. The one of the three Troyons which is not in the style of Diaz is a better specimen of his work than many of his bigger and more famous cow-pieces. There is a good display of [Georges] Michels, and some excellent work by Mr. Robert Noble.

I thought I had finished; but I find that I have quite forgotten the Institute. Well, there are 791 pictures in the Institute; so perhaps my omission is not wholly to be deplored. What is there left to say at this time of day about the landscapes of Mr. Arthur Severn, Mr. Keeley Halswelle, and Mr. Joseph Knight? or about the un-Dickensian Pickwick scenes of Mr. Charles Green, and the neatly stuffed heroines of Sir James Linton? Clearly nothing at all. Suffice it, then, to add that the 791 pictures are mostly very pretty, and that the catalog, with its useless bundle of processed pictures, is unnecessarily heavy to carry, and by no means worth a shilling.

Truth, 20 March 1890 [C698]

The New English Art Club

[William Brown Macdougall (?–1936), Glasgow-born painter of landscapes and figurative subjects, learned his art in France but lived in Essex. Bertha Newcombe (c.1860–c.1947) was an artist then known for her work in the English Illustrated Magazine. *Shaw would meet her for the first time in February 1892, after she asked him to sit for a three-quarter-length portrait to be exhibited at the New English Art Club. The finished work would become known as "The Platform Spellbinder," and was the best early portrait of Shaw. However, Miss Newcombe had fallen, vainly, in love with her subject, and was doomed to disappointment. Shaw then had other female interests.*

W. R. Sickert's portrait was of the radical M.P. for Northampton, Charles Bradlaugh (1833–91), who had been denied his seat twice by the Commons for refusing to take a religious oath, was reelected once more, and finally seated in 1886, having forced a liberalization of the rules for oaths. Starr's portrait was of the wife of writer W. Brandon Thomas (1849–1914), soon to be author of the farce Charley's Aunt *(1892).*

Bernhard Sickert (1862–1932), a younger Sickert brother, painted landscapes and cityscapes, interiors, and still-lifes. William Kennedy (1860–1918) painted Stirling and Glasgow settings, and the South of England.]

The one objection to the Knightsbridge quarters of the New English Art Club is that the largest room is rather dark. The members do not dispute the fact: they glory in it. "You see," they argue, "pictures are hung in rooms; not in glass-roofed galleries. The man who buys a picture here sees what it will look like when he brings it home and hangs it up over the sideboard." This sounded so plausible that I assented to it at once with the utmost cordiality and enthusiasm, but on reflection I perceive that if Humphreys' Buildings had happened to be exceptionally well lighted in the orthodox Bond-street manner, the members would hardly have forborne to congratulate themselves upon that circumstance. So I shall confine myself to the remark that there is much to be said on both sides, and that the balance depends on the particular part of the room you happen to be in when you draw your conclusion. To be exact, there are some half-dozen pictures hopelessly in the dark, some half-dozen more that might be better lighted, and 170 that undeniably are more fairly shewn than they would be in any other exhibition. What is more, they are better worth seeing, and I desire to insist on this rather particularly, because if there is one place more than another where the average Philistine is likely to make an ass of himself, it is in this New English Art Club. The Philistine always falls back on his knowledge to make up for the ineptitude of his eyes. He therefore loves the knowledgeable school—the George Sampson school, as I may call it; though I should perhaps explain that George Sampson was not a famous painter, but only the gentleman in [Dickens's] Our Mutual Friend who scandalized Mrs. Wilfer by alluding to her petticoat, and then tried to relieve her embarrassment by pleading, "After all, ma'am, we know it's there." In the same spirit your great academic figure-painter cuts up corpses in order that he may know what's there, and then proceeds to paint it (subject to certain delicate reservations), muscle by muscle, without the slightest regard as to whether he sees them all or not. Now, far be it from me to deprecate knowledge; for nothing conduces more to individual happiness than the power of shutting up other people on points of fact; but I do now strenuously deny that a correct anatomical diagram of a human figure is a picture of a man. It is not what I see when I look at a man; it is not even what I know to be there unless I happen to be an anatomic expert, whereas I need hardly say that I know no more about anatomy than George Sampson did. The truth is that your learned people keep up their reputation by pretending that what they dont know (how to use their eyes, for instance; and how to paint) isn't knowledge. Still, this must not be applied all on one side. Raphael's figures are none the worse because he used to draw them naked before he draped them, though Mrs. Wilfer would probably rather have died than have met the

penetrating eye of Raphael when he was prospecting for a likely model. And when I looked at Mr. [James] Guthrie's Lily, one of the cleverest pictures in Humphrey's Buildings, the George Sampson in me revolted against the young lady's hand on the doorknob. It struck me that the hand would have been done better by Mr.——but no, I only thought of him because he would have done the picture so much worse in every other respect; so let us say that Raphael would have done it better. The truth is, you can see more of and about a human hand than Mr. Guthrie shows of Lily's, if your eyes are worth anything.

But pray do not suppose that I recommend any attempt to combine the two schools; for the very worst pictures in the exhibition are those in which the artists have tried to eke out impressionism with the dodges of the academic plan. There are one or two portraits here that— no more impressionist than the portraits of Mr. Sant or the cartoons of Mr. Armitage—are yet "faked up" with the prevailing low tones and lilac shades of the impressionist school so as to take in greenhorns. Humphreys' Buildings, like Burlington House, has its humbugs and its modists, though it does not encourage them so flagrantly. Between these humbugs and the uncompromisingly honest impressionists—the Sickerts, Guthries, Steers, Macdougalls, and the rest—there comes a class of workers whose technique, though up to the highest modern standard of skill and effectiveness, is yet an artificial technique, learned in an atelier, albeit a French one. For example, Miss Bertha New- combe's technical superiority to the average R.A. is at least as great as Munkacsy's superiority to herself, but she is not a pure impressionist— not, strictly speaking, an impressionist at all. How, then, does she stand relatively to Mr. Walter Sickert, who is a genuine impressionist? Well, very enviably on many accounts. She is guaranteed against failure: all her pictures will be presentable and saleable: her skill and surety may increase until she paints like another Carolus Duran: when her turn comes, her income will be worth the trouble the technique cost her. As to Mr. Sickert, his prospects are comparatively dubious. The day before yesterday his works were all failures; yesterday they were only half successes; today they are successes as far as they go; but then they don't go the whole way: he can paint hardly as much light as will come into a room with all the blinds down; and as for color, I, who dearly love crimson and green, orange and purple, at their richest effulgence, would not give a straw for his whole palette. Only, there is no terminus, of Carolus Duran or anyone else, to the line he is pursuing. I can prophesy with the utmost confidence how much can be done with Miss Newcombe's ready-made French technique; but Mr. Sickert need not stop short of working out all that is in him, which, at his age, is, of course, an unknown quantity. Between assured success within limits

and problematical success without any bounds except those of human life and strength, artists must choose for themselves. If a man were to ask me whether he had better start in a four-in-hand for Brighton or on a voyage of discovery to the heart of the Dark Continent, I should decline the responsibility of advising him.

One of Mr. Sickert's most interesting achievements is his portrait of Mr. [Charles] Bradlaugh, who has hitherto baffled not only the carica-turists, but even the photographers. Mr. Harry Furniss has never come within a mile of him, nor is there one of the shop-window *cartes* that conveys anything like the impression made by the original at close quarters. Mr. Sickert has been the first to solve the problem. Instead of the prognathous stage Irishman, all jaw and no head, of Punch, you have the working-class leader, the thinker and orator of the House of Commons. It may be objected that the colors are represented only by values of brown and yellow, and that the expression of the oath-abolitionist is a trifle too devotional, as if he were studying the Bible instead of the Market Tolls Bill; but the excellence of the portrait, and its uniqueness, are above all cavil. Mr. Sidney Starr's portrait of Mrs. Brandon Thomas (as seen apparently by a painter seated on the cor-nice, by the bye, but let that pass: perhaps Mr. Starr is an abnormally tall man) I place after Mr. Sickert's work because, though it is equally strong and honest, and no worse off for light and color, yet its truths are imperfectly related to one another. The picture makes you lust after the perfect concord of Peter de Hooghe's interiors. The defect is a typical one: nearly all the young impressionists are struggling with it. The intensity of their interest in their work saves them from the horri-ble triviality that reigns at the Academy and the Institute; but, in spite of the vividness of the impression produced by their earnestness and the skill it has enabled them to attain, the final art of composition in color yet remains for them to master, and the lack of it will become very apparent when the impressionist technique becomes a matter of course, instead of a curiosity as it is today, or a scandal as it was not long ago.

I have no intention of cataloging the remainder of the show. Mr. Wilson Steer is right to fight desperately for more color; and I have no doubt that he will end by getting it. Mr. Bernhard Sickert, bent on truth of tone, leaves his lines too thick and stiff. I do not expect a painter to draw the edge of a pier or of a railway platform as Holbein drew the profile of a nose or a brow; yet even sticks and stones have some feeling in their outlines. I find the same fault with Park-lane, by Mr. Ludovici, who could have drawn the curve of the pavement on the right-hand side finely enough if he had chosen to take the needful trouble. Let me congratulate Mr. William Kennedy on his Stirling

Station. I like railway stations (overground and non-terminal) almost as much as I loathe wayside inns, and whenever I find a modern artist or writer affecting to treat either of them in the spirit of Dickens or Ruskin, I dismiss him from my consideration as a second-hand person. I would swap the best George Morland in England for a good railway-station by Mr. Kennedy, even if he went no further afield for it than Clapham Junction.

Truth 3 April 1890 [C702]

New Wine from An Old Bottle

[Thomas Edward Roberts (1820–1901), London landscape and marine painter, was secretary, for many years, of the (Royal) Society of British Artists. Walter Goodman (1838–?), a London portrait painter, had exhibited since 1859. Robert R. W. Rouse (?–1929), London landscape painter, was a member of the Royal Society of British Artists. Francis William Synge Le Maistre (1859–?), a Channel Islands painter of landscapes and seascapes, exhibited into 1921. Jane Inglis (?–1916) exhibited still-lifes and landscapes from 1859, including a Salon painting in 1891. Robert Catterson Smith, an English painter of landscapes and genre, exhibited 1880–90; Carl Wilhelm Böckmann Barth (1847–?) was a Norwegian seascape painter. Alois Hans Schram (1864–1919) was a German figurative and portrait painter; Tilhamer von Margitay (1859–1922) was a Hungarian genre painter. Nils Gustav Wentzel (1859–1927) was a Norwegian landscape and seascape painter; Gustav Wertheimer (1847–1902) was a German painter and illustrator.]

I am aware that there is an impression abroad that the art critic is independent of inspiration, and can always draw upon his own venom for subject matter. But there are galleries which empty my mind so completely that criticism becomes impossible. Some of the pictures disarm me; other paralyze me; the rest do not interest me sufficiently to produce any appreciable cerebration. The British Artists have had this effect on me very often. Whilst Mr. Whistler reigned in Suffolk-street, things were more exciting, but the new wine soon blew the cork from the old bottle, and everything fizzed out except the flat liquor of the old British tipple; so that now my pen flags as of old

whenever I go to Suffolk-street. And I would ask any reasonable person who may be at this moment contemplating Mr. T. Roberts's "Land, ho!" or even the whole page of the catalog which is devoted to a copy of it in black and white, whether a critic can do more than reel away from this department of British art with mind unhinged and spirits depressed to influenza pitch? These pleasing, popular, saleable articles of commerce are not my natural prey: I pass on, baffled, to take languid note of President Bayliss's gorgeous phantoms of cathedrals; of Mr. Sherwood Hunter's ungainly bowlers disputing in a strange atmosphere of Worcester blue; of the rainbow radiance of Mr. Horace Cauty's palette; and of Mr. Walter Goodman's colorless portrait of Wilkie Collins at the age of fiftysix. Here and there I note a clever piece of landscape painting by Mr. Rouse; an Irish landscape by Mr. Le Maistre, evidently faithfully studied on the spot—not studied through English bank-holiday-in-Surrey spectacles, but realizing the faithful work of Miss Jane Inglis at the new English Art Club— and a little picture by Mr. Catterson Smith, entitled Curiosity, and offered at one-fifth the price of Mr. Roberts's masterpiece, whilst displaying at least five times as much artistic abílity. I also observe that Mr. V. P. Yglesias is making notable strides as a landscape painter now that he has given up his murky moons and night clouds, and come into the open day.

It is a little late in the day to notice the collection of water-colors by Mr. F. G. Cotman, at Dunthorne's; still I am glad I did not miss them. People who only care for the mountain and the flood will perhaps not relish them, but those who are sensitive to the peaceful charm of the home counties on the evening of a fine summer day will find Mr. Cotman very delicately in sympathy with them.

At the Continental Gallery the chief novelty is a group of sea-pieces by Mr. C. W. Barth, a young Norwegian marine painter, whose work gives that refreshing sense of contact with nature and of imaginative vigor and simplicity that has been bringing Norwegian art so steadily forward of recent years. Of A. H. Schram's handsome, shallow, facile work the best sample is the mother and child called Madonna della Vigna. Before the Altar, by Tilhamer Margitay, is an advance on the Adelphi theatrical posters, but not a very important one, the posters being quite good enough for their purpose. In Wentzel's Morning the sunlight is undeniably forced, but the effect almost justifies the license. The peepshow picture of the exhibition (the Continental Gallery always insists on a specialty of this description) is a well-imagined Flying Dutchman by Wertheimer.

Truth, 10 April 1890 [C704]

In the Picture Galleries

[John Kay, the inventor of the fly shuttle, was the subject of one of the twelve wall paintings done by Ford Madox Brown for the Great Hall of the Manchester Town Hall; a hanging duplicate was painted for Henry Boddington in 1890 as part of a multipicture commission. "John Dalton Collecting Marsh Gas" was painted in 1887, and showed Dalton (1766–1844), the chemist, atomic theorist, and meteorologist impassively pumping for marsh gas before an audience of children. The "jack o' lantern," or ignis fatuus (also "will o' the wisp"), is a phosphorescent light that hovers or flits over swampy ground at night, probably caused by a spontaneous combustion of organic gases emitted by rotting organic matter. The little girl Shaw describes is telling another child, so Madox Brown described it, that "Mr. Dalton is catching Jack o' Lanterns."

William Charles Estall (1857–97) was a Manchester landscape painter who specialized in evening mists and moonlight.

Shaw's reference to Fred Bayham may be less to the Thackeray novel than to the fact that "Fred Bayham" was William Archer's pseudonym as art critic of The World *before he turned the job over to Shaw early in 1886. Much, then, had changed in five years of art.]*

Mr. Ford Madox Brown is a delightful subject for criticism. He is among the foremost painters in England. His wall paintings in the Manchester Town Hall are immeasurably more famous than Sir Frederick Leighton's in the South Kensington Museum: their destruction would be lamented by a generation which has witnessed the fading out of Maclise's Waterloo and Trafalgar frescos without the slightest concern. Yet, whilst Maclise was a great draughtsman, and our P.R.A. is no whit behind him in that respect, Mr. Ford Madox Brown handles a pencil like a boy of six without any talent for drawing. If you think this too strong, go to Messrs. Dowdeswell's and look at Mrs. John Kay's ankles, or at the arm of the little girl who is watching Dalton "catching Jack o' lanterns." His brush-work is about as clever as the stirring of a basin of gruel: witness again the cheek and forehead of his portrait by his own hand at the same gallery. Yet his badly-drawn and badly-painted masterpieces of design and color are not to be denied their high place among the art works of the century. If a man has a fine sense of color and knows *where* to put it on, it is idle to object that he does not know how to put it on: there it is, right as a trivet; and there is nothing more to be said. If, in addition to this, he can imagine a scene that tells a story pictorially, he is critic-proof:

his works will be remembered when the merely dexterous lie howl-
ing, as Laertes said.

In the days of my early novitiate as a critic of painters, I got a
wholesome lesson from the works of Mrs. [Marie Spartali] Stillman. In
a superior manner I pointed out certain obvious technical infirmities in
her works, and paid no more attention to them until I began to find, as
the years passed on, that I always remembered Mrs. Stillman's pic-
tures, whereas the impression made by her adroit, brilliant, swift-
handed competitors had faded as completely as last year's snow. My
mind misgave me that I had not been quite so smart as might have
been expected from my uncommon ability; and since then I have let
Mrs. Stillman alone, or else given her fair words. If any one wishes to
have the same experience at the expense of Mr. Ford Madox Brown,
let him by all means go to Dowdeswell's and enjoy himself; but let him
remember that I have said nothing against the pictures. I have been in
Kay's sunshiny workshop; I have seen Dalton troubling the pool; and I
believe in them.

There is nothing very wonderful, either for good or bad, among the
Dudley Gallery water-colors this time. Mr. Rupert Stevens and Mr.
William Estall have simultaneously recognized that winter sometimes
wears a bright dress of red which utterly belies the thermometer; and
as they are among the best of the Dudley landscapists, they have
exploited their discovery with much delicacy and truth. Miss Macau-
lay, Miss Rose Barton, Mr. Burgess, and Mr. Medlycott do themselves
more than justice. Perhaps Mr. Estall has the best of it, as far as
making an individual mark is concerned. There is a certain naivete
about the Dudley Gallery Society—a lingering flavor of the bygone
world of Fred. Bayham [in Thackeray's *The Newcomes*]—that makes it
pleasant to find something to admire at the Egyptian hall. The Dudley
members have an innocent way of turning up on press-day, and put-
ting in a good word for one another, which is quite irresistible. To have
a really able artist go round with you, and ask you, with unblushing
good nature, whether you don't think that such and such a little bit is
very pretty or very clever, with his own work before your eyes to prove
that he knows better than to believe anything of the sort, is amusing
when the work in hand is not too exacting in its demands on your
attention. I suppose there is no rule of etiquette in the world more
obvious and salutary than that which forbids the appearance of an
artist in a gallery on press-day; but at the Dudley the breach of it is as
much a matter of course as the supply of whisky and cigars which puts
Mr. Bayham into good humor with the show. Yet I think it wise to
remind all and sundry of the continued existence and validity of the
rule. At a young exhibition, where half-a-dozen of the members must

turn up to help in getting the place ready, the license is cheerfully tolerated by socially-disposed critics; but if our victims think that we like it for its own sake, or that we do not strongly resent it wherever it is clearly avoidable, they are hugely misled. It is about as pleasant to critize a picture with the painter looking at you as it would be to paint it with the critic looking at you. I am often very glad to consult a colleague whose judgment I respect, as to some picture about which I cannot make up my mind; and I naturally wish to approach him with some such remark as "Dont you think that this is rather rot, eh?" But how are such consultations possible when, for all I know, the furtive gentleman at our elbow may be the artist himself, anxiously hanging on our verdict?

I was rather surprised to find myself in the Doré Gallery the other day for the first time these ten or twelve years. The occasion was the addition to the collection of a picture by Mr. Edwin Long. The policy of this new departure is obvious. Although the country cousin goes straight to the Doré Gallery on his first day in London, and is fully persuaded that the national collection is comparatively small potatoes, yet it seems to me that every provincial in the three kingdoms must by this time have exhausted the delights of "The Praetorium" and "The Christian Martyrs." There is the rising generation, of course; but it consists largely of young persons only too well aware that it is not now the smart thing to admire Doré. Hence I presume, the inauguration of a policy of new pictures. Mr. Long's "Market place in Nazareth" is the best piece of work he has turned out for some time past, and there can be no doubt that it will be popular with a considerable section of the public. The young lady selling honey is so well brought up, so clean, so exactly like what a dean's daughter would be under the same circumstances, that we feel at once that here, indeed, is the true Nazareth of Scripture.

Before leaving the gallery I took a cast round to see how much there was left of Doré; and I am glad to be able to say that there was more of him than I expected. Among artists who have any executive power worth considering, imagination is so rare that a man who combines the two gifts in an extraordinary degree can outface all his shortcomings whilst his pictures stand the attacks of time and London soot. But imagination sometimes plays curious pranks. Balzac's imagination was strong enough to convince him that he was a profound psychologist, physiologist, sociologist, and what not. In the same way Doré persuaded himself that he was a great religious painter and an inspired interpreter of Dante, though there is not the smallest reason to suppose that he had any notion of what Dante was driving at, or had ever suffered from a single attack of the religious spirit. Consequently, the

gallery is still a gallery of delusion as far as it pretends to be a temple of religious art. But it remains one of the most interesting of picture exhibitions, not only for imaginative incident, but for glimpses of rock, sky, and forest, that shew a true feeling for nature and an extraordinary power of representing its aspects. The color is standing tolerably well: for instance, the "Entry into Jerusalem" is very little duller than it was when I last saw it. On that occasion Doré himself was contemplating it with reverent awe in the most extravagantly bad hat I have ever seen a man wear in Bond-street.

Truth, 17 April 1890 [C707]

England's Prestige in Art

[John Parker (1839–1915), a Birmingham-born St. John's Wood painter of landscapes and genre, was RA from 1871. Gustavus Gräef (1821–95) was a German painter of portraits and historical subjects; Wilhelm von Kaulbach (1805–74) had been his model. Albert Aublet (1851–1938) was a French painter and sculptor.]

England's prestige in art is safe for the year. This does not mean that I have seen the masterpieces that are to adorn the Academy. The majority of contributors to that exhibition will be, as usual, gentlemen who do not know how to paint as painting goes nowadays—painters who have been so long busy painting what they never saw that they have lost the power of seeing what they never paint, and what, unluckily for them, the man in the street is beginning to expect in his shillingsworth. From these gratuitous insults to the British School I exempt no man merely because he is one of the forty whom the votes of the other thirty-nine have placed *hors concours*. A beginner who cannot paint better today than the average R.A. cuts a poor figure, even among beginners. Some years ago this was a family secret. Then Mr. Whistler blabbed. Then people called Mr. Whistler injurious names. Then they accepted him as a *farceur* of some piquancy, and called him Jimmy. But when French Romanticists, Dutch Naturalists, and Impressionists from all lands became familiar in Bond-street, the gaff was blown; and now it is plain to those who know the back of a picture from the front that, unless "New English Art" succeeds the Dutch school as the Dutch succeeded the school of Barbizon, we shall have nothing to shew for all our South Kensington propaganda except the *tours de*

force of each accidental genius as must have turned up under any circumstances on the average of chances.

Even so, our credit will be saved by the members of the old Water-Colour Society. In the rooms at Pall Mall East the scoffer at Burlington House is grave, decorous, interested, often delighted. And my preliminary remark that England's prestige is safe for the year simply means that the old Society is better than ever this time. You could not realize there that the Academy is within eight minute's walk were it not for Mr. Glindoni's vulgar "Artful Cards," which is painfully out of place among so much earnest and delicate work. The unusual strength of the exhibition is due chiefly to Mr. Eyre Walker, Mr. Paul Naftel, and Mr. Albert Goodwin. Mr. Walker has produced plenty of pictures like "A Thunder Cloud"; but he has never shewn work so indisputably up to the highest standard of the old Society as his two Wharfedale pictures. It is impossible to choose between the exquisite natural grace of "Under the Trees: January," and the delicate composition of "A Gleam of Winter Sunshine." As to Mr. Naftel, it would have been hard to persuade me a few years ago, when he was turning out very pretty and popular little pictures, gaily decked out in touches of body color with morsels of gorse-blossom yellow stuck on top of them, that he would today be painting with genuine power and simplicity, his refinement still unimpaired and his trickery quite gone. He appears to have found salvation in the Channel Islands: the change dates from the spell of work he did there. It seems late in the day to announce anything new in Mr. Goodwin's work, but I think that a glance at his view of Zermatt will shew that he has this year mastered a style of work which he has been experimenting in for some time past without getting beyond very exquisitely tinted pencil drawings. But the experiments have succeeded at last: the Zermatt is no mere tinted drawing, but a complete picture in water-color. Another painter who has made a signal advance is Mr. C. B. Phillip, who has now got his powers fairly coordinated, and has produced several admirable landscapes, full of matter and masterfully composed, instead of the clever studies which formerly constituted his output. Mr. Walter Crane ought to be quite out of countenance among competitors who devote themselves exclusively to landscape painting, which to him must be a recreation snatched in holiday time; but there is no gainsaying the truth of the glimpse under the trees in his orchard sketch. Mr. [Robert Weir] Allan is in great force this year, and yet I cannot enthuse over his work. The fact is that whilst I appreciate the merits of his technique, I wish he would not throw it quite so emphatically in my face. Technique fanciers have been known to declare that there is no art in English water-color, because the school sticks to the old canon that technical methods are to be concealed instead of flour-

ished in the teeth of the public. For my part I do not find that the force and freshness of Mr. Allan's style put the old school in the least out of countenance; and as he varies neither his theme nor his key, being, it seems to me, quite as much the slave of his technique as its master, I perceive that after a few dozen more exhibitions I shall begin to get a little tired of his breeziness and spirit.

Mr. [Arthur] Melville's ostentatious dexterity also appears comparatively obtrusive in the quiet of the old Society's rooms. Mr. David Murray, another of the clever ones, does not reconcile me to his stiff, insensible drawing by his color and tone, rich as the one is often, and true as the other is always. Surely Mr. Murray can draw a field better than Romney could draw a face—draw it and not scoop it. I do not care for the waggon picture to which Mr. Thorne Waite has given such prominence, but the rest of his work is excellent in the superlative degree. Nothing could be daintier than Mr. [John William] North's "Late Autumn," which is, besides, of unimpeachable sincerity, which is more than one always feels certain of in his most attractive pictures. Mr. Clausen's boy trimming a hedge has got a true grey weather light on his face, whereat let us rejoice; for it seemed as if Mr. Clausen's subjects would never wash off the violent sunlight which was his specialty a few years ago. Mrs. Allingham's cottages are as good as ever; and Mr. Tom Lloyd's river scenes with glowing young peasant women are nearly as convincing as the sunsets of Jules Bréton—a criticism which you may interpret according to your opinion of Jules. A word of recognition is due to the share borne by Mr. [John] Parker in sustaining the high average of the exhibition; and with this, and an acknowledgment of the fine examples of decorative figure-drawing in the classical style contributed by Mr. Bulleid, I must hurry on to other matters.

Of all the pictures made in the hand-loom by Mr. William Morris and Mr. [Edward] Burne Jones, none that I have seen are equal to the extraordinarily beautiful Arras tapestry just completed for Exeter College, Oxford. No critic dare pronounce which has shewn himself the greater artist—the painter or the craftsman. The tapestry will be at 449, Oxford-street until the end of this week only; and as it is a veritable treasure of English art, people who care about such things will eventually find themselves going to Oxford after it if they neglect the chance of seeing it now.

The exhibition of Mauve's pictures at the Goupil Gallery will do almost as much as his death to establish his reputation. In former exhibitions, to which the greatest men of the modern Dutch school contributed, he was overshadowed by James [Jacob] Maris, one of the first among living painters; and indeed his own pictures are divisible

into first class and second class, the second class being markedly inferior to the first. For instance, if the donkey waggon numbered 34 in the Goupil catalog were taken as a sample of his best work, the verdict, though favorable, would be much less so than if based on No. 5, with the fine sky over the ploughman; No. 6, with its subtly-caught window light; "La Petite Tricoteuse," with its dusky gloaming; "Cavaliers on the Shore," with its perfectly toned sunless daylight; or the two men riding down the avenue under the trees in "Sous Bois," which could hardly have been better done. Mauve's pictures are poorly filled in comparison with those of the greatest of his countrymen, but what there is in them is finely done. At his best he was a master of tone.

At the Hanover Gallery there are some pictures by Gustavus Graef, who followed Delaroche and Kaulbach, his masters, in their ideas of art, and painted portraits and romantic allegories, of which the most famous, "The Persecution of Fantasy," is now in Bond-street. There is evidently some history connected with him which I ought to know all about—a trial and imprisonment or something of that sort; but I blush to say that I remember nothing about it, and have not had time to look up the subject. The most remarkable picture in the collection is a group of ladies equipped for lawn tennis, painted literally in the style of Giotto, and with such success that the Arundel Society might do worse than reproduce it. [Albert] Aublet and Mr. [W. J.] Laidlay are specially in evidence: the rest is the usual Hanover fare.

Truth, 24 April 1890 [C711]

Among the Pictures

[Camill Stuchlik (1863–?) was a Prague painter and illustrator. Hugh Norris exhibited landscapes and country subjects in London 1882–1904 and was identified with the Newlyn school of painting. While Sargent's Lady Agnew was the wife of Sir Andrew Agnew, Fildes painted Mrs. Lockett Agnew, wife of the Bond Street picture dealer. Sargent's portrait in this show was of the mother of Maria Louisa Kissam (Mrs. William Henry) Vanderbilt, wife of a prominent New York clergyman. Mrs. Comyns Carr was the wife of the writer and gallery proprietor.

William Turner Dannat (1853–?), American painter of genre and portraits, was apparently thought by Shaw, because of surname and training under Carolus Duran, to be French; he did indeed debut at

the Salon in 1883. John McClure Hamilton (1853–1956) was an American genre and portrait painter who studied under Gérôme and debuted at the RA in 1878.

Ernest Crofts (1847–1911) painted historical scenes, often episodes in the English Civil War, in the style of Meissonier. In the picture Shaw derided, William Juxon (1582–1663), Bishop of London, ministered to Charles I on the scaffold; after the Restoration Juxon became Archbishop of Canterbury. Dudley Hardy (1866–1922), watercolorist and illustrator, worked for The Sketch, The Lady's Pictorial, Black and White, *and other popular magazines.*

The expatriate American sculptor John Donoghue (1853–1903) exhibited in London and Paris; British sculptor Arthur Atkinson exhibited at the RA 1879–91. Onslow Ford's camel rider was the late General "Chinese" Gordon, victim of the military disaster of his own making at Khartoum in 1885; the Dickens reference is to Hamilton Veneering of Our Mutual Friend, *a self-made rich man given to Society pretensions, and purchaser of a rotten borough seat in Parliament.*

Henriette Knip Ronner (1821–1909) was a Dutch genre and animal painter whose specialty was cats. William Ewart Lockhart (1846–1900), Scottish painter of landscapes, portraits, and historical subjects, had been commissioned by Queen Victoria in 1887 to record "The Jubilee Ceremony at Westminster Abbey." The task kept him busy long after the event while he meticulously painted authentic heads and costumes, in the process permitting life to escape.]

There are just three pictures in the Academy which rise above the mere journalism, more or less clever, of painting. One of them is actually by an Academician—Sir John Millais. His landscape in the first room, entitled The Moon is Up; and Yet it is Not Night, will not, perhaps, be overmuch praised: Sir John has so often shewn himself incapable of employing his genius to the greatest advantage that it has become quite safe to laugh at him; and even I, though his follies and his potboilers have often lashed me into accusing him of an incurably weak will and muddled head, so that I have wished that he could be directed and exploited, like a stupid skilled workman, by some capable *entrepreneur*, have still been strongly affected by the struggle for realization of his true and deep painter's instinct in all those works of his which are not frankly venal. The woolly texture of his landscape may seem uninteresting after the sharp touch and bold impressionism of some of his younger competitors; and even the shilling Philistine may—or rather certainly will—think Mr. [Benjamin Williams] Leader a far more cheerful sort of country fancier; but the fact remains that there is no landscape in the whole year's crop that is fit to hang beside

his, though it will not rank among the greatest Millais pictures of nature by a long way. The second of the three, and on the whole the best picture in the Academy, is Mr. Stanhope Forbes's By Order of the Court, in which the wedding of last year is replaced by an auction. Here at last the mastery of indoor light, at which the painter has aimed so diligently, is consummate. If Mr. Forbes had failed by a hair's breadth in characterization, in drama, in human interest, the impossibility of combining truth with esthetic beauty in representing a grove of commonplace heads round an auctioneer would have spoiled the picture. But he has not failed: the human interest steps in to the rescue where the beauty ceases; and it is surrounded with such perfection of appropriate harmony of tone and color that the dramatic and esthetic sides of the picture are made perfectly homogeneous. It is painful to have to add that the Academicians suffer by their unselfishness in not rejecting this picture, for it brings out in a startling way that most of them are—the word is hard but inevitable—duffers. The third picture is Camill Stuchlik's Girl Reading. It is in the manner of Walther Firle, and has all his truthful lighting, his freshness, and something more than his charm; but it ought not to be possible in London's leading exhibition to give a work of no greater calibre third place, or thirtieth, among two thousand. Some people will think that Mr. Brangwyn has done better in his sea-pieces. I do not deny the merit of these; but they are pictures in tone, not in color. Mr. Tuke, aware of this deficiency, has boldly dressed one of his own seamen in a jacket of blushing pink; but the eye refuses that mariner wholly. Mr. Hugh L. Norris's Washing Day: Newlyn is thoroughly good in its way, and would hold its own beside Stuchlik's work if sweetness and light were of no account. Newlyn seems to me to be a gloomy, low-spirited place, where men work earnestly at their painting to keep themselves from going melancholy mad.

The most perfectly successful picture in the exhibition is Mr. Fildes' portrait of Mrs. Agnew. Never did a painter fulfil with such gorgeous utterness that to which he set his hand. M. Dannat has attacked the stock problem of the woman in splendid red, with bare neck and arms. Ever since Carolus Duran solved it so triumphantly, Mr. Solomon and others have lusted after it, undeterred by the knowledge that it offers no possible escape between superb success and odious failure—that it is literally neck or nothing. In my opinion M. Dannat has failed. Now that I come think of it, it is absurd to place that trivial picture of Camill Stuchlik's before Mr. McLure Hamilton's strong and true group of naked children rolling among the gorse on a British common. If it were only a little less of a study and more of a picture I should never have thought of doing so. The sentiment of Mr. Chevallier Tayler's deathbed

scene is shallow—indeed it is hard to imagine any deep flood of feeling in an artist who would choose such a subject in a general way; but the execution is original and genuine if the conception is conventional and popular: the impressionism which used to be only a veneer with Mr. Tayler now seems to go right through his work. Mr. Peppercorn's Evening in the large room asserts its excellence without the least regard for the amateurish sketching from nature of most of the landscapists of the forty elect. They, by the bye, should lose no time in adding to their ranks Mr. [Samuel Edmund] Waller and Mr. Logsdail. Mr. Waller's Dawn is one of a long series of pictures in which the aim and spirit of the Royal Academy shine through every hue and every line. As for Mr. Logsdail, his 9th November is absolutely conclusive. Make him an R.A. at once, by all means.

Mr. Sargent has been having extraordinary games with his sitters this year. The primest, perhaps, was making a lady-sitter hold up her dress to shew her ankles, and then cutting her off at the knees with a three-quarter length. I am prepared to back up any protest against the uppishness and beautification which are palmed off on us as dignity and grace in the ordinary commercial portrait; but these practical jokes of Mr. Sargent's, clever as they are, can only discourage the patrons of the naturalist school and drive them back into the studios of the adversary. If I were a lady ordering a portrait, I should object to being perpetuated with an air of making a fool of myself, or of having been fished up out of the Seine after several day's immersion. I do not say that Mrs. K. need complain of Mr. Sargent's treatment of her; but the lady in No. 421, and Mrs. Comyns Carr (at the New Gallery), would, in my judgment, be justified in demanding their money back. Another clever American, Mr. [Edwin] Abbey, sends one of his pictures of a man and a maid (Puritan), ill-drawn, ill-colored, treated throughout on black-and-white principles, and yet pleasing, fanciful, suggestive, and even natural—there is no accounting for these things.

Mr. [Andrew] Gow has failed this year: his dramatic instinct for breathless historic moments must be getting terribly jaded if he can think of nothing better than that flat, colorless, ignoble presentation of Napoleon, in his forgotten character of "Boney," running away—actually skedaddling—from Waterloo. Mr. Crofts's picture of Charles I having a lively squabble on the scaffold with [Bishop] Juxon, who has apparently demanded an extortionate gratuity for undertaking to take care of his George [insignia of the Garter] during the ceremony of decapitation, is too funny for any caricaturist to improve on. As to Mr. Phil. Morris's La Belle Americaine, I am simply not equal to it: even Mr. Logsdail must acknowledge his master here. Miss Jessica Hayllar, by sheer devotion, has produced an appallingly true picture of the

intensely proper, joyless, beautyless middle-class British wedding—a spectacle almost enough to drive the world into reckless promiscuity. Mr. Dudley Hardy's clever dock strike picture is interesting from the Daily Graphic point of view, but the heavenward gesture of the orator is not a typical one; and I suspect Mr. Hardy of having invented instead of observing it. Mr. Noble's landscapes are strong, in spite of the excess of varnish and the mannered horizontal brushwork. The President [Sir Frederick Leighton] is as presidential as ever: his Bath of Psyche, though it neither is nor pretends to be like anything ever seen by mortal man, is exquisite enough to justify its purchase under the terms of the Chantrey bequest. The same honor has been conferred on Mr. [Robert Walker] Macbeth's Cast Shoe, a proceeding which seems to me to demand nothing less than the instant abolition of the entire institution. And yet I admit a certain fascination about the huge draught-horse made of soapsuds—a veritable Pegasus too ethereal to need wings.

There is no space for more than the most cursory reference to the sculpture. Mr. Donoghue's Young Sophocles is promising, though the ideal head and arms do not belong to the carefully-studied trunk and legs. Mr. Atkinson's field laborer is so obviously the best statue that everybody will pretend not to think so. Mr. Onslow Ford, in building his immense camel, with Gordon on top, has dispatched a difficult job in a workmanlike manner; but the monument, as a whole, fails to remind me of anything nobler than Mr. Veneering's candlesticks [in Dickens's *Our Mutual Friend*].

In the rush of the week it has been impossible to reserve adequate room for Madame Ronner's cats at the Fine Art Society's rooms. But all the world knows, or should know, that not to have seen Madame Ronner's work is to know nothing of the cat on canvas. After the sham cats of the Christmas cards and the illustrated papers—cats which are always caricatures of human instead of feline expression—Madame Ronner's should strike with wonder and awe the simpleton who has been taken in by these things. One understands the possibility of cat worship better when looking at them.

Mr. William Strang's etched and mezzotinted work at Dunthorne's is interesting both in its imaginative and in its technical qualities; but I, for one, shall not consider that Mr. Strang has finished his apprenticeship until he definitely makes up his mind that he is not Rembrandt. Where on earth is Mr. Strang's own style, and what does he mean by making Dutchmen of his Scriptural figures? I respectfully suggest that forgery, however clever and openly practised, is beside the purpose of art. Some of Mr. Strang's original work is full of artistic

inventiveness and storytelling power—to the making of which latter many rare qualities go.

Mr. Lockhart's Jubilee picture at Waterloo House is described and criticized so eloquently in a document which is handed to each visitor that I feel that any additional remarks from me would be superfluous, if not impertinent. It may be that "with perfect harmony of line and supremely effective harmony of color, the artist has so treated the subject that the glittering sheen of ceremonial apparel is subdued, and its infinite variety blended into an artistic whole." I can only say that the Abbey in the picture looks to me as if it were built of wood. As to "The Queen-Empress bending in humble reverence and deep gratitude before the King of Kings," I was unable to discern the smallest suggestion of any such forgetfulness of an exalted position on the part of the principal figure. In short, the picture will chiefly interest people who like the fun of picking out portraits with the aid of a key-cartoon; and I recommend visitors to the gallery—which is a commodious and cool one, by the bye—to give the greater share of their attention to the other works of Mr. Lockhart which are on view.

Truth, 8 May 1890 [C717]

Young Art at the Grosvenor

["Todgers and Prodgers, Codgers and Stodgers"—Shaw's reference to characters in Dickens's Martin Chuzzlewit—*is less literal than a slam at the stodginess and exhaustion he perceived.*

Bernard Cecil Gotch (1876–?) was a British landscape painter; Sir Arthur Temple Felix Clay (1842–1928) was a British painter of historical subjects and portraits. Charles Wellington Furse (1868–1904), ARA 1904, painted portraits and figurative subjects. Thomas Millie Dow (1848–1919) was a Fifeshire landscape painter who had studied under Carolus Duran.

John Evan Hodgson (1831–95), ARA 1872, a St. John's Wood artist, painted genre, historical, and landscape subjects, largely North African. Radclyffe Radclyffe-Hall lived on inherited wealth from his father, an eminent Torquay physician, and painted for his own pleasure. His daughter was the novelist of The Well of Loneliness *(1928).*

The baby's head "glowing like a Bengal light" refers to the firework which produced a steady, vivid, blue light used for signals.]

It is quite like old times to go to the exhibitions and find the Grosvenor Gallery once more first, and the rest nowhere. For a couple of summers past it has seemed as if the glory of Bond-street had taken its hat for the New Gallery, and that the Grosvenor was left behind by both its rivals to struggle feebly for third place with the British Artists. Burne-Jones and Strudwick, Whistler and Cecil Lawson had given place to Todgers and Prodgers, Codgers and Stodgers—especially Stodgers. The departed and dead were succeeded by the deplorable and the damned. But these too have gone their ways, and Sir Coutts Lindsay has regained his old prestige at a stroke by again making his gallery the field for the young art that is all a-blowing and a-growing.

The most pretentious picture in point of size is Mr. John M. Swan's Maternity, typified by a huge lioness suckling a litter of greedy cubs. This tigress will be popular because there is nothing tigerish about her. Her French-polished paw would not hurt a lap-dog; and as she rolls over in an ecstasy of lactation with all those hungry mouths at her teats, she, with admirable propriety, subdues all trace of the terrible voluptuousness with which she would abandon herself to them any-where but in Bond-street. If Mr. Nettleship had painted that picture I might have felt creepy enough to keep my distance. But I went close to Mr. Swan's handiwork, and admired myself in the varnish as in the door of a brougham. Another big picture is Mr. Melville's Audrey, which the Royal Academy rejected, it is said, and which I should therefore proclaim the head of the corner if I could do so with the faintest plausibility. But I must grudgingly admit that the Academy has the laugh on its side this time. If Audrey were a success, it would be a great success, but it has just missed; and the case is one in which a miss is as good as a mile. Mr. Muhrman is another painter who has failed in a promising way that is not at all inglorious. His Harvesters are not without their merits, but that horrible dry darkness out of which they loom is not to be endured. Impressionism begins in the dusk, and emerges into light and color as it gains skill. The impression-ists must recognize this if they wish to keep pace with their competi-tors. Two years ago I was prepared to give hearty commendation to works that I should now unhesitatingly condemn as deficient in the light and color which the most diligent of the young naturalists have by this time added to their original qualities of tone and atmosphere. Mr. B. C. Gotch, Mr. James Paterson, and Mr. Muhrman are behind the times: they must hurry up if they wish to keep their old places.

Mr. William Stott of Oldham simplifies his subjects so much by abstracting from them everything except the particular effect he wishes to paint, that it is not unreasonable to expect the effect to be uncommonly well painted. Reasonable or not, the expectation is ruth-

lessly disappointed both in his Soft Winds and in his mesmerically-stiffened Diana, whom I decline to admire on any terms. Nor am I to be appeased with Mr. Millie Dow's After-glow, which was surely studied in a bonnet-shop, so frankly millineresque is the color. Mr. Peppercorn, in The Edge of the Wood, has suddenly thrown off all the mystery and poetry of his customary mood, and given us a landscape in hard mineral green foliage and prosaic blue and white sky, just to see whether anybody would notice the difference. I do, and I beg Mr. Peppercorn not to trespass again in a field which he may safely leave to Mr. Yeend King and others. Mr. James Guthrie's Orchard is meritorious but dry. Who could admire a dusty, lackluster orchard that has not had a shower on it for months—and on a dull day, too?

The good pictures begin with No. 1, a badly skied seascape by Mr. C. W. Barth, which has a temptingly fresh horizon, although the pie-crusty reef in the foreground has an unconquerable natural prosaicity (a new word, useful as a rhyme to Mosaicity) which probably earned the picture its unfavorable place. Mr. Stanhope Forbes shews, in his Road from a Market Town, that though he can conquer daylight when it is subdued by four walls and a roof, it baffles him out of doors. The picture is too dark: there never yet was a heaven without more light in it than that. Mr. Olsson's Grey October Morning is his first unquestionable success, and his transfer thereupon from the Nineteenth Century Gallery to the Grosvenor does credit to Sir Coutts [Lindsay]'s critical acuteness. The girl at the gate next to it is recognizable at any distance practicable in the gallery as Mr. Clausen's. It is perhaps the best piece of work in the exhibition, but I cannot promise Mr. Clausen that my interest in that particular type of face will survive many dozen more such pictures. Mr. Hubert Vos, whose Belgian Almshouse runs Mr. Clausen's work hard, is decidedly more entertaining. Further up on the west gallery is a third-rate portrait of a boy, which is by Millais, but which does not recall the old days, when his portraits of Mrs. Jopling and Mrs. Perugini hung thereabouts. Mrs. Jopling, by the bye, has a particularly clever Flora in the East Gallery. I confess I do not understand Mrs. Marianne Stokes's Light of Light. A baby with its head glowing like a Bengal light makes me laugh, and I suspect that Mrs. Stokes rather aimed at exciting the more pious emotions in me. Mr. Orchardson has, in true artist fashion, succeeded in making himself incredibly uninteresting in his portrait by his own hand. Sir Arthur Clay's Court of Criminal Appeal is hardly to be contemplated from the art point of view without cries of pain, being really an unmercifully uglified piece of canvas. For relief one turns to the fresh landscape work of Mr. Estall and Mr. C. W. Furse, or even to the portrait of a boy by Mr. Olivier, who is by no means a consolatory painter, though, so far

as his coldness comes of a disdain for painting a picture destined for a private room up to full exhibition pitch, I have only praise for it.

It is curious to stroll down from the Grosvenor, where the public first learned that Mr. Burne-Jones was by far the greatest classical painter in England, to Messrs Agnew's, there to reflect that the painter of The Briar Rose [Burne-Jones] is, in spite of his recent Associateship, an outsider at the Academy, whilst Mr. Hodgson is an R.A. The Academy cannot long survive that preposterous fact. Nobody expects imagination, generosity, or good manners from the forty chartered duffers of Burlington House, but their failure to sedulously court the one man who is preeminent for his mastery of the Academic qualities of ideal beauty of design and color is more than prosaic, more than envious, more than boorish: it is asinine. It is suicidal, too. This year the man who has not been to the Academy will be complimented on his good sense, but who will dare to say that he has missed these four wonderful pictures at Messrs Agnew's? It would be absurd to describe them: they must be seen, though I must not declare that they are beyond criticism, since one old lady, surveying their leading harmonies of blue and green in my presence, said to her daughter, "The coloring is crude: blue and green should never be contrasted." The remark was almost worthy of a professional critic.

At Messrs. Tooth's there is a new picture by Rosa Bonheur, called Highland Sires. Though a water-color, it is by no means inferior in size or importance to any of the artist's recent works in oil.

The Nineteenth Century Gallery contains at least one picture which ought to have found a place—a good place—at one of the three principal exhibitions. It is called In the Lap of Winter and is one of the best pictures of the year: indeed it is the best snow-scene of many years. The painter is Mr. G. Leon Little. Mr. Radclyffe Hall's Weedy Pool Beneath the Trees shows unmistakeable feeling for nature and notable executive skill. Altogether, the Conduit-street refuge for unappreciated painters is beginning to assert itself.

Truth, 15 May 1890 [C720]

The New Gallery and Some Minor Shows

[Jean-Baptiste-Joseph Duchesne (1770–1856) was a French painter of miniatures and portraits.

John Collier's portrait subject John Burns (1858–1943) was a La-

bour Party politician and trade-union leader who became M.P. for Battersea in 1892. Portraitist (Sir) Leslie Ward (1851–1922) drew caricatures for Vanity Fair *as "Spy" for many years. Tommaso Aniello (1623–47) was a Neapolitan orator and patriot. Francisco José de Goya y Lucientes (1746–1828) was the great Spanish painter; Antoine Louis Barye (1796–1875) was a French sculptor notable for his animal bronzes. George Hitchcock (1850–1913) was an American painter and illustrator.*

(Sir) Walter Armstrong (1850–1918) was a Scottish writer on art and artists who became director of the National Gallery of Ireland 1892–1914. Colonel H. B. Hanna and French politician Victor Henri Rochefort (1832–1913) were art collectors, as was Major Reginald Whitworth Porter (?–1902).]

The New Gallery has lost its lead this year. The absence of any canvas by Mr. Burne-Jones and the presence of a number of irritating little portraits by his son have something to do with this; and Mr. Watts has not come to the rescue with any work from which a novice could gather that he is one of the greatest of living painters. Then there is a sort of [Hubert] Herkomer horror on the place—a plague of portraits which one puts up with because they presumably help to keep the pot boiling at that useful institution the art school at Bushey, but which are nonetheless deadly in their effect on the exhibition. Nobody has done anything in particular, except Mr. Strudwick, and the thoroughness and beauty of his work are so much a matter of course that a craving to tempt him to paint something detestably vulgar and sensational comes unbidden into the critic's mind, like one of those impulses to make a very pious and well-conducted man drunk which we have all experienced in our licentious moments. One would like to know who is collecting the Strudwicks. Other painters paint half-a-dozen pictures a year: he paints one; and it always vanishes, sold, no one knows whither. When the inevitable resurrection-day comes at Christie's, it will be curious to find out from the bidding how it pays to put into a square inch of canvas the labor usually spread over an acre.

Mr. Nettleship might perhaps dispute my remark about the absence of anything particular in the exhibition. He is always doing something particular: hence his work is always intrusive, its imaginative inspiration coming with the worst taste into a place where imagination is a painful subject, owing to the prevailing deficiency of it. A hospital for paralytics is not the fittest arena for glorying in athletic feats, and in a London picture gallery the feeling that a painter who calls himself a gentleman should in delicacy keep his imagination to himself often

finds critical expression in cold displeasure with Mr. Nettleship. For my part I am not enamored of his lioness checked on the warpath by a dreadful python. It is not so hotheaded as the antelope in the Academy, plunging into the abyss with its destroyer, but it is distinctly in that combative vein. They are tremendously game, these fighting champions of Nature, red in tooth and claw; but they do not affect me as other creations of his have done. His most terrible tiger was not killing anything: only a red danger signal in the sky above him made him an emblem of wrath and destruction. The most remarkable Nettleship lions have been either blind or else stealing awestruck through a desolate land, looking out for ghosts rather than for sheep.

Then there is Mr. La Thangue, against whose pictures, distinguished as they are, I revolt. That perpendicular smudging of the paint makes his handiwork unmistakeable, but it destroys all rational pleasure in it. Of all the mannerisms I know, this seems to me the most wanton; for instead of serving a mannerism's turn by concealing weak painting it spoils strong painting, being the only blot on pictures that are otherwise irreproachable. That it is possible to get over mannerisms is proved by the case of Mr. [George] Boughton, who has got over several since the days of The Waning of the Honeymoon when his figures were as remarkable for their charm as for the immense noses he always fitted them with. The break-up of that phase of his art had for its symptoms the execution of some excellent picture studies in tone, the best of which were comparable to the works of the modern Dutch school, and were indeed made in Holland, if I remember rightly. At the same time there appeared in his skies and in his faces a sort of pink paste, too sweet to be altogether credible, and yet occasionally too happy in its effect to be condemned, especially in rosy cloud effects. The difficulty was to paint up to it; for the old Boughtonian harmonies were decidedly too robust to keep it in countenance. This year the reconciliation is almost effected—would appear complete, perhaps, had not the artificiality of the excessively pretty pet color been unluckily emphasized by elaborate and expensive frames which only destroy the illusion of the pictures.

Mr. [William Blake] Richmond, the arch-flatterer, has not been so busy as usual turning out those clever likenesses of his with the patent Richmond eye which beautifies the plainest face. He has painted a Shelley illustration for the love of art—an attempt to realize a word picture from Epipsychidion. An outline drawing of it in the manner of Duchesne or Retzch would create a high opinion of its merit, but one cannot face its light and color and pronounce it a success. The portrait of John Burns by John Collier does not do justice to either. The likeness is plausible enough, as it could hardly have failed to be in a face so

strongly and boldly marked in black and white. But the expression is forced by placing the eyes too close together and setting them at a slight but sinister angle, and in consequence we have neither the orator of the dock strike nor the County Councillor, but rather a Cockney Masaniello born of Honorable John's novel-fed and essentially middle-class imagination. Mr. Leslie Ward's portraits are on a large scale this year. He has given up the small character sketch with the blue background, and attacked his subjects with a determination to paint what he saw in them anyhow he could get it, thus gaining for himself a notable advance in technical skill, besides investing with considerable artistic interest a couple of sitters whose points did not, to say the least, invite artistic treatment. The great canvas which Mr. Sargent has covered with a wilderness of lawn and hedge and an oasis or two of cleverly hit-off bits of tone, is a retrograde performance—one of those which make it hard for the ordinary man to go to picture galleries at all, since he cannot stand the conventional studio-wares of the R.A. after the works of the naturalists, and yet cannot stand the naturalists because they seem to think that he wants no more for his shilling than a note or two of accurately valued tone. Mr. Parsons is more conscientious, but he is dull, comparatively, this year. Mr. Alfred East has sent a study of trees and fallen leaves shot with a gorgeous stream of color, suggesting Millais in its artistic intention, but not, need I add, in its handling. There is much good work besides which I must skip for the present, lest the minor exhibitions overtake me hopelessly.

Chief among these is the collection of Indo-Persian pictures of the fifteenth, sixteenth, and seventeenth centuries, made by Colonel H. B. Hanna, and now at Dowdeswell's in New Bond-street. The mere minuteness of their execution will suffice to interest most people, though I must confess that it annoys me as the result of an unprofitable waste of time. But the exquisite quality of the drawing, the instinctive perfection of the Persian ornament, the vivid and delicate color, and the freshness of the glimpses of landscape surpass anything that I have seen in monkish missal painting, which is the most nearly related product of occidental art. Apart from the picture-fancier's point of view, the historical and ethnological interest of the collection is considerable. The kings are all such perfect gentlemen that one feels that the atrocities ascribed to them in the catalog must have been of the most refined kind. M. Henri Rochefort has taken the opportunity to let the public see some of his Goyas, and, in particular, his collection of small bronzes by Barye. No animal painter who has not already studied these should let the chance slip. Look at the play of the limbs, the shoulders, the neck, the head, in any of the lions or eagles, and you will begin to understand why some people do not see anything more in Landseer's

Trafalgar-square lion than a handsome model of makers of Noah's Arks.

Mr. Poynter's Meeting of Solomon and the Queen of Sheba is more in the ambitious manner of Atalanta's Race than anything he has given us of late years. I notice that Mr. W. Armstrong, who has provided the usual "note" by way of catalog, says a great deal about Josephus, Solomon, Gounod, Mahomet, Strabo, Diodorus, and other pundits, but nothing at all about Mr. Poynter. Perhaps Mr. Armstrong is right. Suffice it to say that when Mr. Poynter used to remind me of Michael Angelo I preferred Michael Angelo. Now that he reminds me of Mr. [Edwin] Long, the suggested comparison is less trying to him. But I am not a fair judge of your academic painters: I cannot stand anything that smacks of the School of Design. The picture is at McLean's in the Haymarket.

I went to the exhibition of pictures of India at 104, New Bond-street, with the direst misgivings, inspired by the following passages from the prospectus:

> The exhibition will consist of subjects exclusively Indian, including scenery, life, occupation, &c, &c, painted by officers of her Majesty's Army, Civil Service, and others, strictly amateurs, and should prove one of the most interesting of the year. It is under most distinguished patronage, and the services of art critics of great experience are retained, to ensure that nothing shall be admitted to the exhibition that is not a refined work, and also to enable exhibitors to get an able and perfectly independent criticism on their works.

I went into that gallery like a lion and came out like a lamb. The unexpected truth is that not only is the exhibition a success from Major Porter's standpoint, as a representation of India, but the average of artistic excellence requires no apology whatever on the score of amateurishness. Apparently the "art critics of great experience" have been a success.

Mr. Ernest George's Algerian and Tunisian sketches at the Fine Art Society's Gallery are simple notes of color, carried into no great detail, and executed with no very conspicuous force. They are all very well as a pendant to Madame Ronner's wonderful cat pictures, but by themselves they would make a very poor shillingsworth. Mr. Hitchcock's Atmospheric Notes in Pastel at Dunthorne's are affectedly named, for there is only one of them—called Night Rack—that is not a deliberately composed and sufficiently worked up landscape picture. Mr. Hitchcock knows a good deal about nature, but he is not a naturalist painter: he lifts the flatness of the canalized Dutch field, and he makes that

most prosaic of pretty sights, a Dutch hyacinth farm, poetic by imperceptible little licenses that mark him as an unpretentious but inveterate idealist.

Truth, 22 May 1890 [C723]

[The Grosvenor and Rabelais Exhibitions]

[Shaw saw the Grosvenor show at the Press View on 16 October; his diary evidences that the unsigned piece for The World *published a week later was his.*

Eduardo Tofano (1838–1920) was an Italian portraitist; his subject, Ellen Caroline Searle Holdsworth, was the wife of Charles Joseph Holdsworth, a London and Beckenham solicitor. Alexander Joseph Finberg was a genre painter who lived in Clapton; little is known of his exhibition history other than a watercolor shown in 1888. Louise Jopling-Rowe (1843–1933), a painter in the Whistler manner who had an atelier and studio to which young women were especially welcomed, had exhibited earlier as Mrs. Frank Romer.

Guillaume van Strydonck (1861–1937) was a Brussels genre and portrait painter; his subject was Mrs. Bernard van Cutsem. Peter Severin Kroyer (1851–1909) was a Danish watercolorist, engraver, and sculptor; Adolph Knopff (1851–1917) was a German portrait painter. Adolphus Birkenruth (1861–1940) was a South African landscape and figure painter who had moved to London.

François Rabelais (1494–1553) was the French satirist; his ribald, sprawling books Gargantua *(1534) and* Pantagruel *(1532), about a prince of gigantic stature and appetite, and his kindly, curious son, mingled seriousness and burlesque. Illustrations for a new edition prepared by Jules Arsène Garnier (1847–89) would be seized by the police after the National Vigilance Society, alleging obscenity, successfully prosecuted the exhibitors.*

Gilbert and Sullivan's light opera Patience *(1881), among other things a spoof of "Aesthetic" art, is the source of "greenery-yallery, Grosvenor Gallery," lines given to Reginald Bunthorne, a parody of Oscar Wilde.]*

The Pastels at the Grosvenor make, it is said, the last exhibition to be held there; and if that is so the last state of the gallery is worse than the first, for the best of the old "greenery-yallery" pictures are

memorable still, whilst the facile cleverness of the pastels has not a year's life in it. Mr. Guthrie and Mr. Melville are tiresomely smart; Mr. Shannon makes one yawn over his variations of the ingenious methods devised by Besnard; J. E. Blanche bores you to distraction with his matchboard faces and poker-work millinery. It is terribly played out, all this. Mr. Tofano's portrait of Mrs. Holdsworth is more interesting: the gamut of sun-suffused reds produced by the dress and the window-blind against a vivid green background is as softly brilliant as pastel can be. Besides, the work is finished with unaffected care: and the complete success of the undertaking is consequently admitted without a grudge. Mr. Finberg's portrait of an ineffably perfect masher in a green park must be seen to be appreciated. It is enormously funny; and the laugh is not at the artist, but with him. Mrs. Jopling-Rowe has flattered herself, and yet not flattered herself, in a naively clever likeness, which she offers not as a portrait, but as a study. In effect she says, "This is not like me; but you will find that face in mine if you study it," which must be true, since the picture commands instant recognition. Mr. McLure Hamilton's sketches of Mr. Gladstone, apparently modelled in steam, suggest the ghost of that statesman. The action, especially in the writing figure, is happily hit off. Mr. Van Strydonck's portrait of Madame V. is worth examining; and Mr. William Stott exhibits three admirable studies of glacier and torrent, which are very different from the comparatively empty "effects" which he has shown at recent exhibitions. There is plenty of attractive work by Muhrman, Kroyer, Knopff, Birkenruth, and other gentlemen; but it does not call for special description.

❖

At the Rabelais Exhibition at Waterloo House rather too much has been made of the unpresentable features of the display. A sort of special claim on the score of indecency has been made for some dozen out of the hundred and sixty pictures by putting them into a separate room, admission to which can only be obtained by persons giving "names and addresses." The absurdity of such a qualification is of a piece with the bad taste shown in making an indelicate mystery about a few pictures which are no whit more Rabelaisian than those in the outer galleries. The exhibition consists of a pictorial history of Gargantua and Pantagruel by the late Jules Garnier, who must have worked at the rate of one picture per week during three years. For such rapid work the execution is remarkably good, showing much knowledge of atmospheric effect, a certain humorous sense of colour, and a fantastic realism which, if it is too trivially worked out to be Gothic, and too mean to be Gargantuan, is yet not quite beside the mark. Garnier

did not succeed in perfectly reconciling the artistic with the literary motive in this curious enterprise of his; but Rabelais-fanciers who are not picture fanciers will find the collection worth pottering through.

The World 22 October 1890 [NIL]

[Dunthorne's, Dowdswells', and McLean's]

[Joseph Denovan Adam (1842–96), a Glasgow landscape and animal painter, was known for his depictions of Highland cattle; he established at Craigmill a school of animal painting.]

Messrs. Dowdeswell, still a century or so ahead of their competitors, have brought a hundred pictures by Mr. Denovan Adam across the Border, to show us what the Scotch school can do. If they could lay hands on a good Troyon, and hang it alongside for purposes of comparison, the power and originality of Mr. Adam's work would come out even more strikingly than at present. If many more painters of that stamp are extant in Scotland, the sooner we have a comprehensive London exhibition of the works of the school the better. Mr. Adam among ordinary cattle-painters is what Constable was among ordinary landscape-painters.

❖

Mr. Muhrman's Hampstead pastels, also at Dowdeswells', set every second woman at the private view saying, "It might be anywhere!" This was due to the un-Hampstead-like gloom of the very low key into which he has transposed the colour harmonies of the happy suburb; but the sketches are relatively true and their charm is undeniable. By the bye, nobody should leave the gallery without looking at a picture of a girl lying in a field, executed in water-colour and pastels, by Segantini. It might easily be mistaken for a Millet, and a masterpiece at that. In softness of colour and expressiveness of design it far surpasses the work which revealed Segantini to us at the Italian Exhibition.

❖

The pastels by Mr. Nettleship which Mr. Dunthorne is exhibiting at Vigo Street are almost as obnoxious to orthodox criticism as the frescoes of Mr. Ford Madox Brown. When Mr. Nettleship is on the warpath it is hardly safe to set down the *naïveté* of his drawing as "crudity,"

or to lecture him for inaccuracy because he does not hesitate some-times to give the serpent-like head and terrible paw of his tigers in the proportions which they assume in the imagination rather than in their exact measurements. One might as well object to the tiger in Blake's poem, on the ground that the real animal does not literally burn, brightly or otherwise. There is a sort of obscene horror, an atmosphere of dread, a malign brutishness about some of these huge creatures which no other animal-painter than Mr. Nettleship quite catches, and without which no painted animal looks as if it would really bite. If these drawings were reproduced by lithography and made into a book for children they might lead to a nightmare or two, or even to fits (espe-cially the toadlike leopard in No. 41); but they would be artistically better and far more instructive than the ordinary inanities of the shops.

❖

At McLean's Gallery the centrepiece is not this time a new Millais or Bonheur, but a Diaz—good, but nothing to rave about. The Munkacsy is a pot-boiler: he has put nothing into it that has not been used pretty frequently in other pictures of his. Mr. G. C. Kilburne sends a little out-of-doors scene which is rather a relief from the genteel eighteenth-century drawing-rooms to which he generally confines himself. There is a certain captivating modesty about Mr. Ernest Crofts' designation of a series of sketches for his Academy contributions as "designs for cele-brated pictures." Young Mr. Godward must wake up: he will never make a fine artist of himself on his present vulgar lines. He should be off to Paris, and get Carolus Duran or somebody to show him what painting really means. Seiler's "Etcher" is a good example of his work; and Wilda and Bauernfeind occupy their customary places in the gallery.

The World, 5 November 1890 [C758]

J. M. Strudwick

[Strudwick was a Fabian as well as an artist whom Shaw admired. In a notice on 8 May 1889 Shaw had praised him as "out of reach of all criticism." In July 1889, Marcus B. Huish (1843–1921), editor of Art Journal, *had asked Shaw to write a piece for him, and Shaw's response (8 August 1889) was that he could not then think of a subject. When he did, it was Strudwick. "I am sorry the article is no better than it is," he apologized to C. Lewis Hind (1862–1927), the assistant editor, on*

*returning corrected proofs (16 February 1891). "Most of it was writ-
ten in the train on my way to lecture at Yarmouth. . . ."*

*Years later, having decided that his hand had lost its artistic cun-
ning, Strudwick wrote a play about the Rossetti school of artists,
which he showed to Shaw. It was, Shaw reported, honestly (13 June
1922, NIL), "flagrant Kiss Mammy sentiment," and that although
there was "no chiaroscuro" in Rossettian art, drama required its
equivalent.*

*Shaw's musical metaphors—he was then primarily a music critic—
include references to Maria Luigi Cherubini (1760–1842), Italian com-
poser of operas and sacred music; Karl Czerny (1791—1857), Aus-
trian pianist and composer of widely used piano exercises; Muzio
Clementi (1752—1832), pianist and composer for the piano at a time
when the piano was succeeding the harpsichord as primary concert
keyboard instrument.*

John T. Delane (1817–79) was a journalist and editor of The Times
*for thirty-six years; Tom Taylor (1817–80), a dramatist, editor, and
art critic, was editor of* Punch *1874–80. Sir Joseph Whitworth (1803–
87), English engineer and inventor, was responsible for the standard
screw-thread.*

*Elijah Walton (1833–80) was a Birmingham landscape painter and
book illustrator known for his depictions of the Alps and the Eastern
Mediterranean; Sir Richard Redgrave (1804–88), ARA 1840, a genre
and landscape painter, was the first keeper of paintings at the South
Kensington Museum. "Il Perugino," the master of Raphael, was Pietro
Vannucci (1446–1523).*

*William Imrie was a shipowner and a patron of the Pre-Raphaelite
painters; James Carnegie, ninth Earl of Southesk (1827–1905) was
then a major art collector.]*

It cannot be said that we are suffering at present from any dearth of
persons able to draw and paint. Even in the old Academic days, when
drawing and painting were as painful and unwholesome as tight-
lacing, and much more difficult, there were always plenty of men who
could master them. But now that "naturalism" has sanctioned the
comparatively easy, healthy, and congenial practice of representing
the things we see as we see them, and accepted that end as a justifica-
tion of the means in all cases, technical skill that once would have
seemed prodigious is becoming commonplace. It is the same in all the
arts. Violinists who have sat at the leader's desk in famous orchestras
for twenty years are eclipsed by girl students; lads in the crudest imita-
tive stage compose "symphonic poems" in which the orchestra is han-
dled with a resource of which Cherubini had no conception; pianists

from the Weimar school learn enough in two years to put out of countenance their elders who drudged for ten over Czerny and Clementi; in literature the advance is so enormous that the press is kept going by unskilled hands and casuals, who yet turn out more readable work than the experts of the Delane and Tom Taylor period; minor poets are expected to versify far better than Pope or Byron; the mere routine of architecture transmogrifies our shops and villas past recognition; and our Art students, after a couple of seasons in Paris return with a technique which gives them but too good ground for deriding many of our Royal Academicians as obsolete bunglers. When one thinks of how tempting the artistic professions appear to young people who hate business (small blame to them under existing conditions), and who have neither aptitude, diligence, nor means to qualify them as doctors or lawyers, it is appalling to see the ease with which a highly plausible degree of executive power can be developed in the hands of persons who may, nevertheless, have no more real vocation for pictorial art than a circus horse has for dancing. In that case, when they take up painting as a profession, they are only good handicraftsmen spoiled. Fill the next Academy with their works, and no doubt a considerable advance on the present standard of execution will be the result. It does not follow in the least that the proportion of true pictures to wasted canvases will be raised a single fraction. The spring forward from the workmanship of a quarter of a century ago that of to-day is certainly tremendous. But so is the fact vouched for by Sir Joseph Whitworth, that a good Nottingham lace machine will turn out as much work as was formerly done by 8,000 women. Both have about equal bearing on our prospects of laying up treasure in pictorial art. Exhibitions of triumphs of execution are no doubt more interesting than the exhibitions of failures of execution which are the usual alternative; but when the triumphs owe their force and brilliancy to their very independence of the purpose of all artistic execution, that is, the production of pictures, then the interest they engage is the same as that appealed to by exhibitions of improvements, not in machines, but in machinery. In the end, all this execution for execution's sake—abstract execution, so to speak—becomes insufferably wearisome; and its professors, finding abstract execution unsaleable, get driven into portrait painting of the cleverest mechanical kind.

Now true pictorial execution—that which is only called into action as a means to materialise a picture conceived by a true creative artist, never looks like abstract execution. It differs not only for better or worse, but in kind. The adept in the one may be incapable of the other. I cannot say that I have ever heard a man say, "I can draw; I can paint; I can hit off values to a demi-semi-tone; but I cannot make a picture";

for persons so accomplished are seldom, if ever, conscious that their displays are not pictures. But the first time I ever spoke to the subject of this article, a true maker of pictures if ever there was one, he, no doubt concluding that I was a fancier of abstract execution, and being unwilling to disappoint me, informed me in an apologetic way that he could not draw—never could. This was neither mock modesty or genuine modesty. It was not modesty at all: it was simply a piece of information which was, in a certain sense, quite true. I firmly believe that Strudwick could no more draw, except as a necessary incident in the production of his pictures, than he could eat without appetite. Doubtless the feat would be physically possible: he could do it if a pistol were held to his head; but the result would have none of that expression of enjoyment in the feat as a feat—none of that triumph in the power to perform it, which carries our clever executants over their subjectless canvases, and nerves the professional oyster-eater to empty his hundredth shell with unabated excitement and hope.

This sort of incapacity is a priceless gift to a painter when he has finished his novitiate; but to the student it is so disadvantageous and discouraging that its possessor cannot feel otherwise than ashamed and diffident until the pictures come to justify it. Even then the habit of mind persists; and the maker of the true picture will expect you to disparage him because he did not, and could not, turn out one of those barren *tours de force* of which you are deadly tired. And this expectation will be fulfilled so often in the case of the professional critic, that even when the painter's constantly growing sense of the pre-eminent worth of the order of genius which is attended by such incapacity has deepened to a full and serene conviction, he still remains conscious of the great improbability of any acquaintance or critic having attained to that wisdom. And so, though at last void of all misgiving, and perfect in his faith, he continues to gently warn expectant visitors not to cherish expectations which he would now be very sorry to gratify. This, I believe, was the secret of Strudwick's attitude of apparent self-depreciation. Rightly understood, it was one of pure pity for me. Had I misunderstood it, and said pretty things of his work just to encourage him (privately not thinking much of it), no doubt I should have benefited by the fine social qualities of the painter, and escaped without a word or look to make me conscious that I was making a donkey of myself. It was impossible to consider the likelihood of such escapes occurring often without furtively looking to see whether his face had yet acquired an habitually sardonic expression. But Strudwick, if he laughs at all—and he has too fine a sense of humour to keep his countenance entirely—knows how to laugh in his sleeve, as the following sketch of his life will show.

He was born at Clapham in 1849, and was educated under Canon Bolger at St. Saviour's Grammar School, which he left at sixteen and a half with honourable mention for proficiency in the primitive drawing then taught in the establishment, but otherwise undistinguished and undecorated. It was proposed, as usual, that he should enter an office and learn business; but he was so clear on the point of having no vocation for commerce, and indeed of vehemently detesting it, that his family, much perplexed at his unreasonable prejudice, had to seek some other solution. His own views dated from certain hours of his boyhood during which he had played at being a painter in the studio of the late Elijah Walton, with whom his people were acquainted. That sort of life, he thought would meet his case exactly. So, since he would do nothing else, and could at any rate urge that drawing was the only thing he had ever beaten his competitors at, he was sent to South Kensington. As long as he had only to draw freehand scrolls in the elementary room there, he got on well enough; but when he reached the point of qualifying himself for admission to the antique room by one of those highly finished crayon studies which have done so much to make the official English Art curriculum ridiculous, he was hopelessly unable to comply with such a demand for "abstract execution." What was more, he felt that his impotence in this respect was incorrigible, and that if the antique room was to be attained at all, some other means must be found. One day, accordingly, he and a fellow student, who was equally impatient of chalk and breadcrumb, adventurously walked as of right into the upper division, and succeeded in seeming so perfectly at home there that nobody demanded their credentials. The next step was promotion to the Academy Schools; and for this chalk studies were again required, and unlawful entering was quite impracticable. It now occurred to Strudwick that the difficulty of the crayon work depended a good deal on the scale of the drawing, and that if he only went to work on a sufficiently colossal scale, he might pass muster. He accordingly chalked out a prodigious fighting gladiator—a "whacker," as he himself describes it; but Mr. Redgrave refused to recommend the evasive designer to Trafalgar Square. Strudwick, seeing that he had nothing to hope from professional judgment, bethought him that, by the constitution of the Royal Academy, students might be recommended by any citizen of ascertained professional status. He accordingly appealed to a friendly clergyman, who answered his purpose quite as well as Mr. Redgrave. The usual Academy course followed; and the novice set himself resolutely to attain the academic distinction to which he had certainly not, so far, established any claim. He competed for the "Life" medal, for the "Historical" medal, and every other prize that came in his way; and he was invariably highly unsuc-

cessful. The only encouragement he received was from John Pettie, who discerned some colour sense in him, and occasionally asked him to his studio. Out of this arose the most desperate of all Strudwick's enterprises, no less than an attempt, long persevered in, to acquire the Pettie technique, with its brilliant colour and slashing brushwork. It is quite unnecessary to say what the upshot of this was.

Strudwick was now a convicted failure. He had no excuse left for believing, or asking others to believe, that he could acquire a technique, or win gold medals, or even get beyond an elementary classroom by legitimate means. Under these circumstances there was nothing left for him to attempt except the painting of a picture; and this feat, which has baulked many a gold medallist, he achieved without any hitch. The Academy rejected the work. He sent it again; and they rejected it again. He kept on sending it until they found a place for it. Meanwhile—for each of these trials cost a year—he had exhibited at the Dudley Gallery; sold a potboiler or two, which exemplified his efforts in the splashy style; and finally got into regular employment in the studio of Mr. Spencer Stanhope, and subsequently of Mr. Burne-Jones, where he did such work as a painter of established reputation may have done for him without suspicion of keeping a "ghost." Then Lord Southesk bought the Academy picture for sixty guineas, and wrote to the painter in terms which showed that he, at least, was convinced that he was dealing with a real painter. Strudwick promptly hired a studio for himself; and since that time his vocation as an artist has never been challenged. There is no such thing in existence as an unsold picture by Strudwick; and so the story of his early struggles may be said to end here. It sufficiently explains the man as he appears now, charitably offering you the South Kensington view of himself as hopelessly deficient in skill, resource, and judgment; and offering it with a sincerity partly due to his having been imposed on by it during his most impressionable years, and partly, of course, to its being so far true that he, no more than Michael Angelo or any one else, has as much skill, resource, or judgment as he would like to have. But you have only to take him at this valuation, as you may easily do if you happen to be a bad judge of a man, and a worse one of a picture, to find that you are dealing with one of the most obstinate characters in creation. He has wide, altogether extra-"professional" views; and he defends them with extraordinary tenacity, not on the dogmatic ground that they are right, but from a conviction that they are the only possible views for him. As to the true relation between his own opinion of current Art or contemporary social life and the conventional pedantries and follies on these subjects, or between his own work and the ordinary Bond Street ware, it does not take long to discover that he is not the least in the dark on either

ground. Anybody with a quick eye for facial expression will detect even in the portrait given here a certain humorous sense of his real conclusions in the now celebrated case formerly adjudicated upon at South Kensington and Burlington House.

The pictures reproduced are all in the collection of Mr. W. Imrie, of Liverpool, to whose courtesy we are indebted for their appearance in these pages. The execution of these easel pictures is smooth, and the method of representation simply drawing on the flat surface and colouring it: Holbein, Hogarth, Bellini were not more exact and straitforward than Strudwick. The pictures are finished up to the point at which further elaboration would add nothing to the artistic value of the picture; and there the work stops not a stroke being wasted. Thus a typical Strudwick is not "finished" as a typical Meissonier is; but it costs more pains to produce. No matter how minutely a painter copies a model in the costume of a certain period, with appropriate furniture and accessories, his labour is as nothing compared to that of the man who creates his figures and invents all the circumstances and accessories. This is what Strudwick does. For instance, the censer in 'The Ramparts of God's House' is not to be purchased in Wardour Street, nor the angels' dresses hired in Bow Street, nor the sculptured marble seat copied at the Musée Cluny, nor the heads found on the shoulders of any living model. And not only are these pictures entirely invented, they are also exhaustively thought out, an important part in their excellence; for a painter may be so hasty and superficial in snatching at the first image his imagination offers him as to make one regret that he did not stick to the usual plan of painting some likely young woman of his acquaintance, and labelling her as one of Shakespeare's heroines. The conception of the Strudwick picture is as exhaustive as the execution; and this is what makes it so thorough and impressive. You sometimes remember a Strudwick better than you remember even a Burne-Jones of the same year.

Two remarkable examples of Strudwick's power of finding subjects for his pictures are here reproduced. In 'Passing Days' a man sits watching the periods of his life pass in procession from the future into the past. He stretches out his hands to the bygone years of his youth at the prompting of Love; but Time interposes the blade of his scythe between them; and the passing hour covers her face and weeps bitterly. The burdened years of age are helped by the strength of those that go before; and then comes a year which foresees death and shrinks from it, though the last year, which death overtakes, has lost all thought of it. As a pictorial poem, this subject could hardly be surpassed; and it is not unlikely that it will be painted again and again

by different hands. Indeed, the painter himself has recurred to it, though with an entirely new treatment; in 'The Ramparts of God's House' a man stands on the threshold of Heaven, with his earthly shackles, newly broken, lying where they have just dropped, at his feet. The subject of the picture is not the incident of the man's arrival, but the emotion with which he finds himself in that place, and with which he is welcomed by the angels. The foremost of the two stepping out from the gate to meet him is indeed angelic in her ineffable tenderness and loveliness: the expression of this group, heightened by its relation to the man, is so vivid, so intense, so beautiful that one wonders how this sordid nineteenth century of ours could have such dreams, and realize them in its art. Transcendent expressiveness is the moving quality in all Strudwick's works; and persons who are fully sensitive to it will take almost as a matter of course the charm of the architecture, the bits of landscape, the elaborately beautiful foliage, the ornamental accessories of all sorts, which would distinguish them even in a gallery of early Italian painting. He has been accused of imitating the men of that period, especially one painter, whose works are only to be seen in Italy, whither he has never travelled. But there is nothing of the fourteenth century about his work except that depth of feeling and passion for beauty which are common property for all who are fortunate enough to inherit them.

In colour these pictures are rich, but quietly pitched and exceedingly harmonious. They are full of subdued but glowing light; and there are no murky shadows or masses of treacly brown and black anywhere. As to screwing up his palette to the ordinary exhibition key, and thereby unfitting his pictures to hang anywhere except in an exhibition with every other canvas there at concert pitch, he has always cheerfully allowed his pictures to take their chance of being glared out of countenance in the Grosvenor or the New Gallery sooner than play any varnishing-day tricks with them. As he progresses, and his scheme of colour becomes subtler and more comprehensive, it gets rather lower in tone than higher, although his design becomes broader, and shows signs of that evolution which is most familiarly exemplified by the growth of Perugino's style in the hands of Raphael. It is impossible to foresee what sort of work Strudwick will be turning out ten years and twenty-five years hence; and this article, therefore, may as well stop here as make any pretence of completeness. But it may at least be said that some of the fruits of Strudwick's first manner are so beautiful that any change must involve loss as well as gain.

The Art Journal, April 1891 [C787]

The Royal Academy
First Notice

[The "First Notice" was not followed by a continuation column, since Shaw abruptly resigned as the Observer's *critic after one submission (see Introduction) because the proprietor, Rachel Beer—actually the wife of the ailing and absent owner, Frederick Beer—rewrote his piece to insert praise of her friends. Rachel Sassoon Beer (1859–1927), of a wealthy and influential family, was used to being high-handed, and used the chronic illness of Frederick Beer (1858–1901) first to install herself as assistant editor and then to promote herself to editor. (In 1893 she also purchased the* Sunday Times *and ran that paper as well until 1897.) Keeping her hand in the* Observer *until her late husband's trustees sold it in 1905, she did achieve one major journalistic coup. In August 1898 she broke the story of the confession of Count Esterhazy that he had, as suspected, forged the document that had convicted Captain Alfred Dreyfus of high treason.*

(Sir) Francis Bernard Dicksee (1853–1928), ARA 1881, painted romantic genre pictures and elegant society portraits. Luke Fildes's "The Doctor" would be one of his best-known paintings. Beatrice Gibbs, figurative painter, exhibited six times at the RA between 1888 and 1896. (Sir) Alfred Gilbert (1854–1934), English sculptor and goldsmith, would design the "Eros" in Piccadilly Circus. (Sir) Thomas Brock (1847–1922) exhibited his sculpture at the RA for more than forty years. G. W. Wilson's greatest success in sculpture seems to have been Shaw's commendation—and that may be suspect, given Rachel Beer's hand in the published column.]

All seasoned visitors to Burlington House are familiar with the illusion that the last exhibition is always the very worst on record. Yet when the show closes in August, and their misdeeds are hidden from the light for another nine months, the ideal Academy which never was on sea or land, consisting of forty disinterested men of genius and fosterers of the highest in art, soon regains possession of the public mind: and the venalities and stupidities of next year's exhibition come with as great a shock as if the same things had not been an invariable feature of every season within the memory of the oldest inhabitant. It may, therefore, safely be assumed that the present exhibition is, on the whole, as good as any former one, in spite of all appearances to the contrary.

There is, as usual, a numerous contingent of pictures, each of which has been compounded, like a chemist's prescription, according to a

formula of proved popularity. To spend any space on the discussion of
such well-known articles of furniture as the winter's output from the
studios of Mr. Marcus Stone and Mr. [Samuel Edmund] Waller would
be to make criticism ridiculous. Even before the works of Mr. Frank
Dicksee, who is under an obligation to be sentimental as well as pretty,
and so gets driven to seek new subjects to provoke fresh tears, little can
be said except that he is not yet quite so devitalised as Mr. Stone.
Cheap sentiment, however, is deliberately encouraged by the Royal
Academy, even when entirely divorced from pictorial art.

Among the painters who are still resisting the temptation to get into
a safe groove and live happily ever after is Mr. J. W. Waterhouse, who
has painted a striking picture of Ulysses and the Sirens. But he has
counted without the influence of the naturalists, who, if they have not
made their own pictures widely popular, have at least destroyed our
toleration of the false effects produced by painting figures in studio
lights, and fitting them with open air backgrounds. If those Sirens'
faces were painted on panels as heads of Madonnas seated in carven
niches, and hung in the subdued light of some cathedral, they might
pass unchallenged. Sir Frederick Leighton is more successful with his
"Perseus and Andromeda," which, though certainly not naturalistic, is
congruously and artistically denaturalized all through. But, when all is
said, the beauty of form and grace of composition at which the Presi-
dent aimed must be admitted as attained.

Sir J. Millais sends a charming portrait of a child, a successful lady's
portrait, a powerful landscape, and a fancy picture of a girl in old-
fashioned costume. Mr. Orchardson is well represented, chiefly by
portraits. Mr. Boughton is strong in his winter scenes. Mr. Briton
Riviere's "Nimrod the Hunter," in three panels, is vigorously painted
and decorative. Peter Graham, R.A., sends two pictures; his finest by
far is the one in the third room. In Room 5 there is, by the late Keeley
Halswelle, a delightful river landscape, with reeds and willows waving
in the winds. Mr. [Hubert] Herkomer has had the happy thought of
relieving one of the prosaic effigies in which his trade has flourished
so appallingly of late years, by substituting an admirably fresh and
spacious naturalistic interior for the usual "background," the effect,
however, being to make the spectator long to expunge the figure. His
subject picture, "On Strike," will only please those who are fortunate
enough to know nothing about strikes. Now that industrial warfare is
become, in a sense, fashionable, its incidents will no doubt appear
pretty frequent in our picture galleries. It may be safely predicted that
they will be about as faithfully depicted as the incidents of military
warfare are in our battle pieces, which are made by arranging cor
rectly uniformed figures in tableaux, ferociously or sentimentally patri-

otic, as the case may be. Just so has Mr. Herkomer taken the dogged labourer with his weeping wife, correctly corduroyed, knee-gartered, shawled, and gowned, and arranged them into a conventional tableau, which would make an excellent boarding advertisement for, say, the Shipping Federation, but which will certainly not make Mr. Herkomer the Verestschagin of "the class war." Mr. Fildes also exploits the proletarian vein in a large picture of a doctor watching a sick boy with a steady scientific attention which is in powerful dramatic contrast with the anxiety and grief of the parents in the background. The picture is very effectively composed—or perhaps it would be better to say stage managed; for the strength of the work lies in its drama, and by no means either in its colour, which is in the main rather treacly, or in its grouping, which has been arranged without any preoccupation as to harmonious distribution of masses or beautiful play of line simply to lead the eye to the central incident. On this account many persons will prefer the gay potboilers with which Mr. Fildes fills up the intervals between his serious achievements; but there can be no question as to which of the two classes of work will do most to sustain his reputation. The "Dancing Girl," by Miss Beatrice Gibbs, is an effective portrait figure.

There seem to be some infringements of the rule which excludes "works which have already been publicly exhibited in London and copies of any kind" this year. Mr. George Hitchcock's "Maternité," one of the most important pictures in the large room, has been exhibited at the Goupil Gallery, and the cattle picture by Mr. Denovan Adam is suspiciously like one which figured in the recent collection of the painter's works at Dowdeswells' gallery. The ghostly portrait of Mr. Gladstone by Mr. McLure Hamilton is an exact copy in oils of a pastel which will be recollected by all who were in at the death of the Grosvenor. The exhibition as a whole is strong in landscape and portraiture, but there is, as usual, a dearth of imagination.

The most important works in sculpture have already been exhibited here in clay, and are now to be seen in their completest forms in bronze, marble, and silver. The President's "Athlete," Mr. Bate's "Hounds in Leash," and Mr. Alfred Gilbert's statuette of "Victory," are excellent in their various styles. It is remarkable that the works in sculpture and in painting of the President should respectively be distinctly characterised, the one by a manly vigour and force, and the latter by a refinement and delicacy which too nearly borders on effeminacy and weakness. Mr. Brock's "Genius of Poetry," and "Model for a Fountain," by Mr. G. W. Wilson, are to be commended.

Observer, 3 May 1891 [C793]

Punch's Jubilee

[As Shaw was making a rare appearance in The Star, *where his music-critic pseudonym had been* Corno di Bassetto, *he signed this piece in that fashion.*

"Artist Unknown" was the pseudonym of Joseph Pennell, then the Star's *art critic. Shaw had helped him get the job. The Emperor of Germany was Victoria's grandson William II.*

Charles Keene (1823–91), cartoonist and illustrator, worked on Punch, The Illustrated London News, *and* Once a Week; *he also illustrated Charles Reade's* The Cloister and the Hearth. *Charles William Shirley Brooks (1816–74) was a novelist and editor of* Punch; *Mark Lemon (1809–70) was at first joint founding editor of* Punch; *he became sole editor in 1843. F. Anstey was the pseudonym of Thomas Anstey Guthrie (1856–1934), whimsical humorist. Helen Taylor (1831–1907) was the stepdaughter of John Stuart Mill, whose* Autobiography *she edited, and a founder of the radical Democratic Federation (1881).*

"Pinakothek" (or Pinacothek), the ancient Greek word for picture collection, was what Ludwig I called the building he commissioned in 1826 for Munich to house his art inheritance. The museum became the Alte Pinakothek, or old picture gallery, when the Neue Pinakothek opened across the street in 1853. During World War II the Alte Pinakothek was extensively damaged by bombs but afterwards restored to nearly original condition. It now houses 800 paintings from the Bavarian State Collection of 20,000 works of art.]

"Artist Unknown" informs me that he will be unavoidably absent from England for the next three months, as he has been commissioned to paint sixteen large frescos representing scenes from the life of the present Emperor of Germany on the great staircase of the Pinacothek in Berlin. Now, when I was last in the Pinacothek it was in Munich, and the staircase was nothing to speak of. Furthermore, three months seems to me a remarkably short allowance for sixteen frescos, especially as I have no reason to suppose that "A.U." is much of a dab—if I may so express myself—at the technical processes of that method of painting. However, there is no doubt that he has really left London; and as he foresaw that some one must do his work for him, he thought that I might as well take a turn occasionally to help to sustain his credit.

I confess I was astonished when the first duty put upon me was the celebration of Punch's jubilee. I have never, from my earliest child-

hood, concealed the fact that I am not so young as I was, but that anyone should have supposed me to be in a position to speak from personal knowledge of an event that happened as far back as 1841 is a little too much. I have not celebrated my own jubilee yet, and it is not likely that I am going to celebrate Punch's. Still, I am by no means at a loss for something to say on the subject.

Punch costs threepence. I have in the course of my life bought it perhaps twice, but as I frequent restaurants where they take it in, and have always been a diligent student of the shop-windows, I am well-informed about the paper to an extent that would surprise the proprietor. The great difficulty in the way of a pictorial comic paper is the extreme unlikelihood of finding men who are both humorists and artistic draughtsmen. How scarce men are who combine the two in their highest degrees can be realized by searching the history of painting for names which can be classed with those of Jan Steen and Hogarth, to match whom you would have to roll two men into one— Fielding and Reynolds, for example. As drawing is to some extent a teachable art, whilst humor is a purely natural infirmity, humorists are a good deal scarcer than draughtsmen: consequently the failures in comic draughtsmanship are oftener cases of humorists who come to grief in their attempts to draw than of draughtsmen who make futile attempts to be humorous. Thackeray was a fearful example of this: nothing proves the vitality of his novels more than the fact that they were not damned by his horrible drawings. Probably he would never have perpetrated them if it had not been for the tolerance of the public for ugliness in funny pictures. Do not think, however, that any man has ever made a great success as a comic draughtsman without a share of true artistic grace and power. Gainsborough was not more captivating than Rowlandson could be when he was following his own bent; and Gillray, with less charm of hand and less mercy in his view of life, yet always drew with intense energy of expression, and often produced figures and groups of great beauty.

Cruikshank, too, has left us many beautiful and genuinely dramatic needle pictures. But the public is an animal (excuse the freedom) which has a much greater capacity for heehawing than for appreciating the artistic beauties of a drawing. Rowlandson's enchanting grace—for it is enchanting at its best—would have brought him in very little had he not used it in an exquisitely improper manner; and Gillray and Cruikshank were dependent solely on their power of making people laugh. It is impossible for the proverbial Scotchman (I have met him several times and can certify that he was born in England) to look without positive roars of laughter at Gillray's "politeness," in which a

number of officers, starting up from table to save their hostess the trouble of ringing the bell, trip themselves up and upset the dishes, or at Cruikshank's picture of the old gentleman at the wedding breakfast, who keeps his countenance with extraordinary grimness whilst all the rest are dissolved in tears. It was for such hearty laughs that a comic draughtsman got paid by our barbarous forefathers. His purely artistic achievements were a secret between himself and half-a-dozen connoisseurs; to the public at large his only business was to be funny. That was why Thackeray thought, when he found that he could scribble funny caricatures, that he could make a profession of comic draughtsmanship without a single artistic quality in that line. At last people began to get tired of ugly fun. They did not get, and have not yet got, to the point of wanting to have their comic drawings "done beautifully"; but they began to insist on having them done genteelly. Cruikshank went out of fashion, and in spite of his attempts, which were shared by Hablôt Browne, to conciliate the rage for gentility by making his work as beautiful as he could, he lived to see himself and his school quite superseded by that of [Frederick] Walker, Frank Dicksee, and Marcus Stone. Whether [Anthony] Trollope and George Eliot were as well illustrated by Millais and Leighton as [Harrison] Ainsworth and [Charles] Lever were by Cruikshank and Phiz, is a point which I shall not raise here: suffice it to remark, as a matter of fact upon which no dispute is possible, that Millais and Leighton depended altogether on the artistic qualities of their illustrations for their acceptance by the public, whereas Cruikshank and Phiz worked like men who knew that whilst no artistic qualities would avail them if they were not sufficiently facetious and dramatic, they were free to secure these qualities at any sacrifice of naturalness aad propriety.

But what, you will say, has all this to do with Punch? My good sir or madam, it is the artistic history of Punch. Punch himself began as the motley ruffian who threw his too noisy infant out of the window (if it is fair to call a man a ruffian for yielding to so natural an impulse); but before long he became, like Mr. Pickwick after his first two or three chapters, a respectable and well-dressed gentleman, with an independent income and a stock of moral sentiment of the finest regulation pattern.

Do you remember Leech, the Philistine, the bourgeois, the goodhearted but slightly vulgar middle-class Leech? His fun was broad in the harmless sense: there was a touch of Bank Holiday or even November the 5th [Guy Fawkes Day] about it; but never was there a hint of the blackguardism of Rowlandson. See how his work evolves into that of the cultured Du Maurier, with his quintessence of good

form, and his figures so well dressed and so unmistakeably of the West-End West-Enderley, that nobody ever notices that they are all ten feet high or so. Du Maurier is really no truer to nature than Gillray, but as his exaggerations are vertical, instead of horizontal, flattering instead of degrading, his pictures carry out our notion of good taste, which is nothing more than the art of misrepresenting things so as to give them an agreeable appearance—mostly out of sheer moral cowardice.

Leech would have done more for the artistic development of comic draughtsmanship but for the unlucky circumstance that half the beauty of his work lay in his exquisite touch with the lead pencil, which was utterly destroyed by his engravers. Du Maurier, who works with the pen, suffers much less in this way. Doyle, who survived his popularity as completely as Cruikshank, belonged to the past by his incongruous mixture of fancy and folly, of really decorative faculty with the old-fashioned habit of provoking laughter, by parodies of humanity which, in his case, were silly parodies. The replacement of his political cartoons and Leech's by those of Tenniel, whose illustrations to [Thomas Moore's] Lalla Rookh may be consulted by those who wish to see how completely he sympathized with the new demand for "refinement" was another sign of the times. Charles Keene, who lived to make everybody heartily tired of the Leech school of elderly bourgeois, bus-drivers, comic volunteers, and so on, held his own of late years solely by his artistic feeling and his powers of drawing with the pen, which were very considerable within certain limits. From the reprints of Keene and Leech you can still catch the tone of the early period of Philistine fun under the editorship of Shirley Brooks and Mark Lemon.

The editor of the period of so-called refinement was Tom Taylor, whose eminently literary unreality may be studied in the revivals of *Still Waters Run Deep* and *The Ticket-of-Leave Man,* both full of the politest and barrenest ignorance of life and insincerity of speech. Since Taylor was succeeded on his death by Mr. [Francis] Burnand, the era of refinement has been passing away. Tom Taylor would not have appreciated the drawings of Furniss or the admirable studies and burlesques of Anstey: their frank irreverence would have shocked his cautious snobbery. In the work of Furniss and of the later recruits there is often a reversion to the Cruikshank rule of being funny at all costs—more is the pity, since the rule is no longer imposed by necessity. Mr. Burnand does not insist that the pages of Punch shall be handsome and graceful. Provided they are laughable, he is content; and as the first business of a comic paper is undoubtedly to be comic, he can claim that if he neglects half his business it is at least not the

most important half. About twenty years ago Punch gave its contempo-
rary, the Early Closing Association (also born in 1841) a valuable lift by
publishing a startling picture of a lady trying on a dress over which a
woman had been worked to death. This is only one example out of
many of the occasions on which Punch has been faithful to the senti-
ment of Hood's Song of Shirt, which was first published in its pages.
But it generally changes its note if any one suggests that the remedy
for overwork is not sentimental philanthropy. I remember some years
ago, at a period of bad trade and great distress, an atrocious cartoon in
which William Morris, Helen Taylor, and other pleaders on the side of
the people were—but never mind: Punch's jubilee is not exactly the
moment to rake up these matters.

<div style="text-align: right">The Star, 14 July 1891 [C805]</div>

[Nudity and Nakedness in Art]

*[Although the two related letters which follow were not published
until Ray Reynolds included them in his* Cat's Paw Utopia *(1972),
Shaw seems to have written them with a view to publication—by
himself or by the recipient. The letters, which have the air of a Sha-
vian critical essay, were sent to Evacustus Phipson, Jr., a Socialist
who claimed that he wanted to go to the radical utopian colony
planned for the Mexican coastal town of Topolobampo in order to
flee such evils of civilization as art and theater which appealed to
prurience.*

*The less familiar art works to which Shaw refers include the
"Frankfurt Ariadne" of Johann Heinrich Dannecker (1758–1841),
"Ariadne auf dem Panther," created in marble 1812–14 and now in
the Liebig-Haus, the* Museum alter Plastik *of the city of Frankfurt
am Main. In October 1943 it was partly destroyed in a bombing
raid, but restored after the war. The "Hampton Court statue," no
longer there, was described in 1856 by Nathaniel Hawthorne in his*
English Notebooks *as "a marble statue of Venus on a couch, very
lean, and not very beautiful." The "Venus Callipyge" was a second
century* B.C. *Syracusan statue, the Venere Landolina, existing now
only in a Roman copy, its title in Greek meaning "Venus with the
beautiful buttocks."*

*Julio Romano, or Giulio Pippi (1499–1546), was an Italian painter
and architect.]*

29 Fitzroy Square W.
8th March 1892

Dear Sir

I advocate the abolition of the censorship, not because I wish the stage to become licentious, but because, as I have shewn, the effect of the censor's interference is to make the stage worse instead of better than it would be without him. People are not prevented from appearing naked in Regent St by compelling everyone to obtain a license from a censor before going out for a walk. If people abuse free institutions, prosecute them; but don't deny them freedom on the assumption that they will abuse it.

I have not the smallest objection to nakedness myself, either in statues, men and women, or horses and dogs. On any summer evening you may see crowds of naked men and boys on the banks of the Serpentine in full view of the equestrians in the ride and the promenaders on the bridge. No decent person is offended by the spectacle; and at an athletic display women very rightly admire scantily draped young men as openly as men in theatres, music halls and circuses admire scantily draped young women. The boys and girls who misbehave themselves in the way you describe in public galleries ought simply to be taught better, or rather to be left alone on the subject; for no child would ever dream of a statue being indecent if it had not been taught so. In fact, your whole argument, backed by modern researches into the history of clothing and "modesty," goes to show that drapery is a greater evil than the absence of it. People are never curious, much less pruriently curious, about what they see every day. Besides, though I have walked through many a gallery of naked statues, I never noticed anybody undergoing torture; and, frankly, I don't believe they do, except in morbid cases. However, all this has nothing whatever to do with the question of the censorship and I only mention it as a sort of protest against your notion that statues should never be represented as doing anything that is not allowed in Regent St. Would you insist on cages being put round the Trafalgar Square lions? If not, why do you not apply the same argument to the figleaf of Hermes?

Your notion that the indissoluble marriage at present in force prevents 'the men who have the most effrontery and brutality from seducing every girl they can get hold of' is a very extraordinary one. But when you treat the whole affair openly from the old fashioned male point of view, taking it for granted that the great object to be gained is to secure virgins for men, whilst the women are to 'consider the men just as good at second hand,' you take the question off the lines on

which I have discussed it. And you assume, without the slightest warrant, that I am advocating a perpetual saturnalia. I write this without any ill humor; but you pay me a very poor compliment by reading my book without thinking twice about it, rushing to conclusions which are wholly incompatible with my own words. If you want a censorship for statues, make a concrete proposal, and see whether you can suggest anything better than leaving the matter to the good sense of the public. If you are in favor of marriage in its present English form as compared to the greater freedom of the French system or many of the American ones, then say why; but do not absurdly assume that there is no middle course between our system and general prostitution and promiscuity.

Yours truly

29 Fitzroy Square
W 14th March 1892

Dear Sir

Though I protested against your objecting to the public exhibition of a statue in a condition in which a man would not walk down Regent St, I by no means committed myself to the proposition that a statue might be exhibited without offense in any natural predicament whatsoever. Obviously a statue should not disgust people in normal health. To my mind, a male statue which should, as you suggest, have no generative organs at all would be unseemly and ridiculous in the highest degree. On the other hand, a representation of the organ in a state of violent excitement would be almost equally objectionable. A fig leaf is conscious and prudish. The alternatives are such a treatment as you see in a Greek statue, which is entirely inoffensive to me, or else the exercise of a little ingenuity on the sculptor's part so as to avoid the necessity of dealing with the penis at all. As to female statues no difficulty arises, as there are not many attitudes in which a beautifully shaped woman, when naked, scandalizes the spectator. It may be that you are more squeamish than I am; and the question remains whether you are more representative of the general view or I. I am convinced, however, that I am not at all singular in being much more offended by prudery than by frankness in such matters. If you take a noble statue like the Hermes of Praxiteles, in which there is nothing "suggestive," and in which the frankness of the nakedness is perfectly unconscious and decent, then my feeling is that the man who mutilates it, or puts a fig leaf on it, or the woman who looks conscious before it, or puts up her fan, or calls her daughters away, is guilty of a most offensive act of public inde-

cency. On the other hand, there are many draped figures, both in painting and statuary, which are technically decent, but really and obviously lascivious, and nothing else. Such things one passes contemptuously by. Then there are works like a well known statue at Hampton Court which are beautiful enough to be worth looking at, and yet are by no means innocent of an appeal to the passions. For my own part I look at such statues, and when I have sufficiently admired them and had passions appealed to, I walk away and am none the worse. I confess myself unable to draw a line, though your reply thereupon that I might as well at once approve the obscene Parisian confectionery etc., is, if you will excuse my saying so, arrant nonsense. I may be able to accept this extreme and reject that without being able to define a scientific frontier between them. You yourself propose to disallow the generative organs. But the Hampton Court statue and the Frankfort Ariadne, not to mention the Venus Callipyge, all produce the most tremendous effect on sensitive subjects by seductive display of their backsides. Other marble females depend on their breasts. Jan Steen, with whom carnality was a religion, very seldom painted a woman without all her clothes on. Hogarth's 'Lady's Last Stake,' an exquisite picture, but not a pure one in the cant sense of that word, represents nothing that might not be seen in a drawing room. The line which you propose not only leaves these on the guaranteed side but utterly fails to separate the brothel decorations of Julio Romano from the august Medicean tombs of Michael Angelo. Believe me, the common English middle class assumption that abandoned women are distinguished from respectable women by the possession of generative organs and sexual passions is an impossible basis for a censorship. Your line would tie the hands of great artists without hampering a single pander.

It is not true, in my opinion, that women prefer experienced men to novices. Young women do, just as young men are afflicted with calf love, and run after widows, whores, and buxom matrons. Later in life, both men and women change their minds on that point. Therefore there is as much reason to save up the young men for the mature women as the young women for the mature men. I do not yet know how you propose to do either.

I do not believe that the tendency is, as you think, towards promiscuity; but if it is, that is a final argument in favor of promiscuity. For the present, however, nothing more is to be done directly with the marriage laws than to make divorce reasonably easy and private, like marriage.

As to a work of fiction to teach people Socialism, all the sentimental Socialism that can be taught in that way has been taught already; and the ordinary novelist will soon bring their sociology a little better up to

date. For my part I cannot afford to consider such a project even if there were no other objection to it.

<div align="center">

In haste,
which pray excuse,

</div>

Evacustus Phipson, Jr.
79 Cathnor Road W

<div align="center">

G. Bernard Shaw

[NIL]

</div>

Pictures at the People's Palace

[James Hyde (1849–1939), born and died in England, spent most of his life in South Africa; in 1879–92 he was organist and choir-master at King William's Town, Cape Colony. He then transferred his musical activities, including music publishing, to Johannesburg. Francesca Stuart Sindici exhibited two works at the RA 1892–93; her animal pictures were briefly popular, as were her pseudohistorical scenes. Carlo Dolci (1616–86) was a Florentine religious and historical painter; Guido Reni (1575–1642) painted religious and allegorical pictures.

Professor Robert Liston (1794–1847), Professor of Clinical Surgery at the University of London, is remembered for the dexterity with which he employed the scalpel, for his knowledge of anatomy which enabled him to operate successfully in cases from which other practitioners shrank. Shaw has fun with the concept, comparing that talent to that of Anatole Deibler (1863–1939), or Deibler's father or grandfather; all were public executioners.

Francisco Zurbarán (1598–1662), "the Spanish Caravaggio," was a religious and portrait painter. Frederick Major was an English genre painter; Henry Tanworth Wells, seen earlier as a portraitist, also painted genre scenes. William Linnell (1826–1906) painted landscape and rustic genre scenes in England and Italy; Francis William Loring (1838–1905), Boston landscape painter, worked in Europe. Dering Curtois was a Lincolnshire painter of rustic and genre scenes who exhibited in London 1887–92; Edward Roper (1857–91), a Canadian, painted New Zealand as well as Canadian landscape and genre scenes.]

Persons at a loss for a picture exhibition to visit will find one open at the People's Palace until 10 Sept. The aristocracy are admitted on Mondays and Saturdays, from ten to two, at sixpence a head. The

middle classes can come in after two for threepence and stay till ten. On other days the threepenny charge prevails from ten to five; but from five to ten the mob is let loose by electric light at a penny per person. By this ingenious tariff the strong class distinctions between sixpenny Bow, threepenny Mile-end, and penny White-chapel will be turned to the profit of the People's Palace. The *Star* man, representing the world of letters at the West-end, was admitted for nothing, and at once set to work diligently to avoid seeing the pictures, of which he had had quite enough in Bond-st. during the season. He was so far successful that he discovered a winter garden without a single canvas in it, containing a refreshment bar where he obtained for 4d. a meal so satisfying, not so say so stodging, that he has lived on soda-water ever since. Fortunately his digestion was powerfully aided by the minstrelsy of the African native vocal quintet, the ladies of which, who shared a collection of tiger skins, a few dozen necklaces, and one pair of boots and stockings between them, seemed to him so surpassingly attractive that he would have there and then proposed to abandon home, parents, fame, and the habit of dressing for their sakes if he had been acquainted with the Kaffir language.

It is said that the taste for African beauty is an acquired one with Englishmen. All the *Star* man can say is that he acquired it at first sight. After a long and attentive study of the two male members of the quintet, he cannot conscientiously say that he believes them to be real Africans. They are, he is convinced, Englishmen who have devoted their lives to the three ladies, and if he might be permitted to guess at their former standing in their native England, he would estimate the bass as a senior member of the New English Art Club, whilst putting down the tenor as unquestionably a duke at least. One could hear the difference of nationality whenever the Quintet sang out of tune, the two gentlemen doing it in the good old British way, whilst the ladies would drop just half a quarter of a hair's-breath flat in a voluptuous yielding to the languor induced by the heat of the weather and the fascinations of the *Star* man, whose fourpenn'orth of buns had not yet mounted to his complexion. The *pièce de résistance* was "The Big Baboon," concerning which the program stated that it has been "specially composed for the African Choir by James Hyde, Esq., of King William's Town one of the, if not the, first musicians in South Africa, after he had attended one of their concerts given in his town." When the soprano led off the second verse by cooing out "Duzh ennybwoddy heah know de fieath w'ite caat?" the *Star* man quite lost his head, and might have been heard frantically singing "Come live with me and be my love" at the top of his voice but for the din occasioned by the quintet suddenly breaking out into a transport of miaowing, hissing, spitting,

and other demonstrations characteristic of fierce white cats. After this there was an interval, during which the soprano, the delicacy of whose *café-au-lait* complexion made every white woman in the place look wretchedly insipid, went off to look at the pictures. Instantly the *Star* man's sense of duty was aroused; and he set to work on the paintings without further delay. The place of honor was occupied by [Louis] Falero's "Nightmare," a work which every true connoisseur would go a long way to avoid seeing. Close round it were several of Madame Sindici's clever horse pictures. Mr. [Frederick] Goodall has sent acres of canvas in assorted sizes, ranging from his "Sheep Shearing" and "Spinners and Weavers," which are comparatively small but good, up through his "Flight into Egypt" and "Sic transit," which are interesting and graceful, to his huge "By the Sea of Galilee," which made the *Star* man long for death until he refreshed himself by a glimpse of his favorite vocalist. The S. M. desires to add here that Mr. Goodall's dusky beauties fall far short of the real thing. Some of the titles of the pictures have been entered in the catalogue with a view to amusement rather than instruction. "Pygmalion's Prayer to Venice," for instance, is not bad; and "The Waking of Brindhill" is one of those simple touches which the greatest humorist might envy. Some of the pictures have critical and explanatory notes attached to them for the assistance of ignorant East-enders. We are told that Don Quixote's predecessors were "the great knights errant of antiquities"; also that Carlo Dolci's "Cleopatra" is "very high in color and beautifully painted, suitable to the idea we entertain of the personage." In Zurbaran's "St. Francis" we are invited to note the fact that one of the figures "can be removed from view by folding the canvas," a phenomenon not so rare in pictures as the cataloguist seems to suppose. Of Professor Liston we are told that "he thought it quite possible to take off a person's head and replace it with safety." So it is, Monsieur Deibler has often done it with perfect safety. The *Star* man was badly beaten by the following comment on Guido Reni's "Innocence." "Guido has given this picture throughout the whole its value as regards the human form. The spectator, if on viewing sideways, it becomes twice the length and at a certain distance like marble." On the whole, it might be well to have this catalogue looked over a bit before it runs into a second edition, especially as the first will very soon be exhausted by collectors of *facetice*. It is a pity that the best of the modern naturalist pictures of labor in the show suffer a good deal by the bad light, which quite kills Mr. Fred Major's "The Forge," and heavily discounts Mr. Wells's "Purbeck Quarrymen"; whilst on the other hand, the sham pictures of harvesters and hoppers, consisting of Bedford-park models stuck into a Bank Holiday Surrey landscape, are well seen and well hung. There are plenty of pictures

with stories, incidents, and topics which will interest the visitors; but they have hardly any artistic merit, and are, properly speaking, not pictures at all, but simply colored illustrations. The works which have pictorial beauty and artistic feeling are nearly all landscapes—Mr. Alfred East's "Moonrise in Spring," William Linnell's "Weald of Kent" (a really fine example of the master), and Mr. Loring's "Great Bridge of Chioggia" being cases in point. Professor [Leopold] Müller's "Village Nautch Girl," is a first rate specimen of his work. [Miss] Dering Curtois' "Spring Afternoon in the Johnson Ward of the Lincoln County Hospital," a faithful transcript of the prettiest aspect of a ghastly subject, is a piece of realism which will probably not be voted "the best picture." (Everyone who pays for admission has a vote, which is duly counted by the returning officer at the door, who does not, however, return any money). Mr. Edward Roper's sketches of colonial scenery and incidents, which are worth studying by intending emigrants, on show in one of the smaller rooms, and in others there is plenty of black and white work and watercolor. The exhibition is undoubtedly worth all the money it costs, although it is poor in masterpieces combining both strength of subject and beauty of treatment. A really well-written catalogue might take advantage of this fact on open the eyes of the novices of Mile-end to the distinction between pictorial composition and graphic story telling. The *Star* Man would be happy to undertake the job for nothing, if a little purse could be made up just to cover his loss of time.

<div align="right">

The Star, 18 August 1892 [C880]

</div>

The Dudley Gallery

[Sargent's subject, Helen Dunham, afterward Mrs. Theodore Holmes-Spicer, painted in 1892, was the daughter—"one of four blue-stocking sisters"—of a New York friend. His portrait study of Paul Helleu and his wife seated along a riverbank while one sketches and the other reclines on his shoulder was of the French painter and etcher (1856–1927) and his wife, the former Alice Louise Guerin, during the summer of 1889. George Sauter (1866–1937) was a Bavarian-born London painter of portraits and portrait studies. Hugh de Twenesbrokes Glazebrook (1855–1937) was also principally a portrait painter. William H. Bell was a London-based landscape painter who exhibited in the 1890s; Moffatt Peter Lindner (1852–1949) was a London and St.

Ives landscape and marine painter. James Levin Henry (1855–1904)
was a London landscape painter who exhibited from 1877 at the RA;
Arthur Tomson (1858–1905) painted landscapes, genre, and animals,
and wrote art reviews for the Morning Leader *as "N. E. Vermind."*
Robert Anning Bell (1863–1933), ARA 1914, painter and professor of
art (from 1894), had already painted a portrait of Shaw's discarded
mistress, Jenny Patterson.

 Alfred Lys Baldry (1858–1939) painted landscapes and portraits in
oils, pastels, and watercolors, and wrote art criticism. Amy Atkinson,
who exhibited 1890–1916, painted domestic subjects; Amy Draper
(later Mrs. Sumner) is only recorded exhibiting 1892–94, the latter
date at the New English Art Club. Ada R. Holland painted portraits
and genre, exhibiting 1888–1902; Miss G. B. Mackay exhibited water-
colors from 1886. William Brown MacDougall (?–1936) painted land-
scapes and figurative subjects and was an etcher, engraver, and illus-
trator. Hugh Bellingham Smith painted figurative subjects, genre, and
landscapes, exhibiting in London 1891–93.]

 The New English Art Club is holding its ninth exhibition of works by
members and outsiders at the Dudley Gallery. The number of exhibits,
viz., 121, is a little in excess of last year, but allowing for the peculiar
tenets of this society of artists, the merit of the collection is somewhat
of an advance. The portraits, which are not numerous, include two
large examples of Mr. J. S. Sargent, in No. 47, "Portrait Study," and
No. 99, "Miss Dunham," who is seated, handsomely costumed in white
satin. Another study of this class shows us a fair girl seated at a win-
dow, on the sill of which rests one hand, whilst the other supports her
face, and she is gazing contemplatively from "The Window" (78) to
where a boat is seen upon the river. The picture is in all respects a
creditable performance by Mr. George Sauter, and suggests beauty of
both light and life. "M. et Mme. Helleu" (71), which is more of the
nature of a sketch, by Mr. J. S. Sargent, represents the gentleman and
his wife seated on the river-bank, with their both drawn up beside
them. He is engaged painting, with the lady in happy indolence watch-
ing the flowing stream. It is singular how well the likeness of M.
Helleu is secured when so little of his face is seen, as with face bent
down he is hard at work upon his canvas. Mr. C. H. Shannon sends
only one picture, in a portrait of "H. T. Glazebrook, Esq." (19), who, in
front face to the spectator, is seated holding his hands together in what
is doubtless a characteristic posture. Well drawn and painted, one
could scarcely see a better specimen of Mr. Shannon's talent. "Study of
a Girl's Head" (112), by Mr. J. E. Blanche, is executed with a feeling
akin to that of the old Dutch masters, and "June" (95), by Mr. F[reder-

ick] Brown, although it is merely the head in profile of a girl, is a noble study both in colour and masterly technique. As to the landscapes, Mr. Mark Fisher's "Village Street" (65), a picturesque roadway bordered by cottages, with light blue cloudy sky, pleases from its evident truthfulness, whilst it may be objected that the colour is in a degree forced. There are other landscapes having for motive the realisation of tender evening effects, and of these we may specify "Wimbledon Common" (20), by Mr. William H. Bell; "Lingering Light" (111), a view wherein water and sky are warmly lighted up by the departing sun, by Mr. Moffatt P. Lindner; and "Afternoon Glow" (118), cows in the meadows, with warm blue sky, by Mr. James L. Henry. "Between the Showers" (53), by Mr. F[rederick] Brown, is chiefly a sky study, across the blue expanse of which summer clouds are floating and throw shadows on the landscape. Here again the artist realises with happy effect a showery day, when the meadows are lighted up at intervals by gleams of the sun. A cat in a strained position, engaged cleaning itself, the artist, Mr. Arthur Tomson, calls "Toilette" (3); but why, it may be asked, should an animal well known for grace of form be represented in so very ungainly a fashion? Mr. R. A. Bell has ventured boldly on the much-disputed question of colouring sculpture in his "Honeysuckle" (18), a figure of a young girl carrying a basket, whilst she plucks some of the pretty flowers mentioned in the title. The work is in relief, and we think very well and tastefully tinted. Mr. Alfred Lys Baldry sends two extremely clever little landscapes in "September" (10), river scenery, very sweet in colour, and "October" (5), a not dissimilar design. Lady rtists make their presence felt in the exhibition with creditable contributions. A simple subject, a child blowing "Bubbles" (54), is successful both as regards the figure and the effect of sunshine, by Miss Amy B. Atkinson. There is so much shadow in Miss A. G. Draper's "Portrait" (77) of a girl in a hat, that one has some difficulty in judging the picture where it is placed—but it is clearly of more than average merit. A fisherman's wife nursing her baby at "A Window" (102), by Miss A. Holland, is beautiful both in the lighting up and the sentiment of maternity; whilst there is a strong flower study in "Sweet Peas" (49) in a glass, by Miss G. B. Mackay. There are several pictures in the gallery, like "An Idyll" (83), by Mr. W. Brown MacDougall; "A Procession of Yachts" (96), by Mr. P. Wilson Steer; "Chrysanthemum Girl" (115), by Mr. R. A. Bell; and "Boats in Blue" (55), by Mr. Bellingham Smith, that are wholly outside the range of criticism, but Mr. John Ruskin sends a lovely little drawing in "Dawn—Coniston" (32), which, with its picturesque range of hills and sky and other reflections in the water, is one of the gems of the collection.

Daily Chronicle, 21 November 1892 [C904]

[The Spitzer Collection]

[On 11 March 1893 Shaw was asked to come to the offices of The World *to examine a pair of prodigious auction catalogues representing a sale of art in Paris , and to write "Atlas" paragraphs about them. The collector, the late Frederic Spitzer (1815–90), was a Viennese-born Parisian whose collection was to go under the hammer in his own mansion in a series of sales.]*

The catalogue of the great Spitzer sale has just been published. It runs to two folio volumes and a portfolio of nearly seventy photogravures; and even on this prodigal scale it is rather a businesslike than an artistic publication, in spite of its vellum covers and its prefatory essays. It is an extraordinary thing that the sale should be necessary; for the collection, which is nothing short of a complete Cluny or South Kensington Museum ready made, is said to have been offered entire for half a million—a unique opportunity for a millionaire with a native town on hand, or a peerage in his eye. However, the chance has been let slip, and the collection is to be scattered under the hammer. The sale will begin at the Spitzer Hotel in the Rue de Villejust (No. 33) on April 17th, and will last until June 16th.

Spitzer, it may be well to remind the rising generation, was a dealer in works of art, and also an amateur collector. He was born in Vienna in Waterloo year, and made his way to Paris when he was thirty-seven. He died in 1890, having formed a collection which States and Municipalities might have envied if they had had artistic sense enough. Pictures, statues, and carvings, embroidered and woven fabrics, pottery and metalwork—nothing curious or beautiful escaped him; and it is somewhat of a scandal that France is too poor or too stingy to let his work be undone. If anyone in England has half a million to spare, it might easily be put to a worse use than securing the contents of the Hôtel Spitzer for some art-starved English town.

The World, 15 March 1893 [C935]

[Fine Art Society; RA Prizes]

[The three art paragraphs in "Atlas's" column were by Shaw.

Richard Parkes Bonington (1802–28) began exhibiting at the Paris Salon at twenty, beginning with French coastal scenes and, influenced

by Delacroix, moved to romantic historical subjects. He died of apparent sunstroke at the beginning of his artistic maturity. Samuel John Barnes (1847–1901) was a Birmingham landscape painter, largely of Deeside Scottish scenes; Queen Victoria's patronage boosted his stock. Lucien Besché was a miniaturist and watercolorist who exhibited in the 1880s and 1890s.

The art-student son of Sir William Quiller Orchardson was Charles Orchardson (1873–1917), who became a painter of landscapes, figurative subjects, and portraits. He died of war wounds in 1917. Colin Hunter (1841–1904) was a painter of seascapes and coastal scenes; his art-student son, John Young Hunter (1874–1955), began exhibiting genre and historical subjects, portraits and landscapes, in 1895, moving to the United States in 1913, the year before the war. He died in the art colony of Taos, New Mexico, at eighty-one.

John Callcott ('Clothes") Horsley had been Rector of the RA since 1874.]

One or two of the picture exhibitions have been reinforced this week. At the Fine Art Society's galleries there are sixty water-colour drawings made in Sussex, Hampshire, and Scotland, by Mr. A. W. Weedon, some of them very fresh, with great movement and life in the clouds and rushing water; others, especially those representing a wide extent of country, having the distances very skilfully and tenderly handled; and others, again, prosaic and conventional, Mr. Weedon appearing to have no particular preference for the subjects he does best. At McLean's a collection of water-colours, mostly by the old guard, has been added. The most interesting of them are by Bonington, Turner, and James Holland, J. M. Swan, Fortuny, and Rosa Bonheur, with, of course, the inevitable samples of David Cox, Copley Fielding, Prout, &c. Mr. S. J. Barnes has sent some oil-pictures of autumn and winter scenery in the Highlands, old fashioned in technique, but genuine and excellent of their kind, to Dickenson's Gallery. Finally, the Continental Gallery has mounted in high state, on a draped easel, M. Lucien Besché's 'Amor et Vita, a water-colour drawing representing a Royal Marriage of the Middle Ages." The medieval couple, with the bridegroom's grandmother, father, uncles, and so on, are portraits of the Duke and Duchess of York and the present Royal Family. The picture, executed with prodigious pains in the dullest and most laborious German style, proves that if the painter does not get on in the world it will not be his own fault. The catalogue description of the work is amusing, but too long for quotation.

❖

One of the pleasantest gatherings of the winter season to the favoured few who, outside the circle of the Royal Academy, are invited is the distribution of prizes at Burlington House by the President. This took place on Saturday evening in the No. 3 Gallery (where the annual banquet takes place in May). Sir Frederick Leighton entered the room at nine o'clock, followed by a goodly number of the Royal Academicians, who had just re-elected him as their President for the year. Sir Frederick's first announcement to the students, that Mr. Philip Calderon, the Keeper, was on a fair way to recovery from his late severe illness, was received with cheers, for all who know what interest he takes in the schools and the students, and how he devotes the major portion of his time to them, will readily appreciate how much his cheery, kindly presence has been missed of late by all about Burlington House.

❖

Sir Frederick Leighton then gave one of his scholarly addresses to the students upon Teutonic art and its influences upon art in general. At the close the assembly wandered through the galleries criticising the work of the judges, Mr. Alma Tadema piloting Mrs. and the Misses Tadema; Mr. and Mrs. Marcus Stone; Mrs. Orchardson, in the absence of Mr. Orchardson, was with her son, who we hear is one of the coming students at the Royal Academy; Mr. Colin Hunter was with his son, Mr. Seymour Lucas and Mr. Horsley (the treasurer), who is now fully occupied with the collection of works for the coming Winter Exhibition at Burlington House.

The World, 13 December 1893 [C993]

[Pursuing Holbein's Madonna]

[Hans Holbein "the younger" (1497–1543) was one of the great portraitists as well as a master of altarpieces and religious pictures. Born in Augsburg, he worked much of his life in Basel and in London, in 1536 being appointed court painter to Henry VIII.

Shaw's visits to Italy in 1891 and 1894, and in particular his exposure to some of the great Virgin canvases, had an impact upon his "mother play," Candida, begun in October 1894, but even earlier than his second trip to Italy he was deliberately searching out Madonna pictures, apparently having conceived the idea of having a Madonna

reproduction as central to the opening scene of the as-yet-unwritten play. Thus on a trip to Bayreuth to take in the Wagner Festival he detoured to Darmstadt on 17 July 1894 to seek out the "Meyer Madonna," originally in the private chapel of Jacob Meyer zum Hasen some time before Meyer's death in 1531.

The limewood panel, 146.5 by 102 cm, depicts the Meyer family, kneeling, in rapt adoration of a standing Virgin and Child. Shaw's "castle" is the Darmstadt Schlossmuseum. His piece about the picture was written on nine pages of a small pocket notebook and in the persona of music critic "Corno di Bassetto," since Shaw had come to Germany to write about opera in Bayreuth. There was no music in it, and the lines did not emerge into print with his reviews of Lohengrin, Tannhauser, *and* Parsifal.]

There are many excellent but mistaken people who envy me. Now I will not be mock modest: it is doubtless a glorious thing to be Corno di Bassetto; and I have no doubt that I lose much innocent self satisfaction in life from being unable to appreciate myself fully. But this evening I had almost as soon be anybody else. Out of pure devotion to art I have given my train the slip and imprisoned myself in Darmstadt for five hours, all for the sake of Holbein's Madonna. It is just the sort of afternoon to spend in a second class foreign town—too sultry to make even the lightest macintosh bearable, and raining like mad every ten minutes.

The Madonna was a fearful adventure; but it did not last long, as I had to be smuggled into the grand ducal apartments between two relays of private visitors. I do not suppose anybody would believe me if I were to describe how I got there. I first tried the grand ducal picture gallery; and when I could not find it there, I made enquiries of the custodian in German which he, being an uneducated man, could not understand, but to which he replied in common native German, which is altogether beyond me. But after a heated altercation I gathered from him that I was to go through an archway and up a broad flight of steps. I went through the archway; found the steps just as he had tried to say; and found to my horror that a sentinel, armed with a rifle and probably provided with ball cartridge, was looking at me from the middle of the yard with an expression which it would have been a dangerous affectation to pretend to misunderstand.

I rushed up the steps and simply stormed the castle, effecting a lodgment on a landing between two doors. Not wishing to be shot in the back I tried the left hand door. It was locked. I tried the other; it opened; and I found myself, to my unspeakable astonishment, in the kitchen, and in the presence of the Lord High Pastrycook. This man did what I never knew any German do before: he understood me

when I explained myself in his own language. He took off his uniform—by which I mean that he put a tweed coat over his shirt-sleeves, and took me to the grand staircase, where some more of the staff—two charwomen—were assembled.

On being consulted in a whisper as to whether there was anybody inside, these functionaries expressed uncertainty; and the L.H.P. had to lead me through a suite of rooms with excessive caution, going on tiptoe and peeping into each apartment before he entered and beckoned me to follow. These measures were taken in vain: we had come within one room of our goal when a bevy of ladies, evidently come to afternoon tea with the Grand Duchess, came in at one door as we entered at another (there were about six doors altogether); and the L.H.P. said something which was probably German for "Sauve qui peut," and bolted. Fortunately the rest of the grand ducal staff now appeared. He was apparently what we call a "handy man," and he was acting as footman without knowing anything about the business, just as he would have acted as plumber if the drains had gone wrong. His profession had made him a man of resource; and just as I was about to pretend that the last of the Bassettos had come to pay his respects to the last of the Guelphs, or Ghibellines, or Hohenzollerns, or whoever the Grand Duke might be, the handy man shewed me into another room—a mere cabinet, and left me there. I made for the window at once, and was about to put my leg across the sill when I turned to see that nobody was looking. Somebody was looking—Holbein's Madonna.

It is not my business to describe the picture here. The Star sent me here to write about Wagner, not about Holbein; and to the subject of Wagner I intend to stick. Suffice it to say that when the handy man returned and told me that the way was now open for retreat, I felt that my fearful journey to Darmstadt—twentyone hours on end—had been worth taking. When I got out the rain had stopped for a while, leaving the soil, which consists of soft sand, in such a condition that I came to the conclusion that Darmstadt was built, like Venice, in the sea, and that the tide had just gone out. I was proceeding to verify this theory by digging for cockles with the ferule of my umbrella outside the Palace of Justice when a policeman informed me that persistence in the experiment would end in my appearance inside that building in his custody. So I forbore, and looked into Baedeker for a suggestion as to how to amuse myself lawfully. Baedeker suggested going to the top of a facsimile of the Duke of York's column, for the sake of the view. I should have expected more sense from Baedeker on a wet day.

Eventually I went into a colossal Catholic church, copied from the Pantheon, and there found three women, two apparently rich, seated in the pews before the high altar in thoroughly comfortable devotion,

and one, miserably poor, on her knees on the hard flags opposite one of the stations of the cross, which she was toiling through, just as she would have toiled through the task of washing a heavy stone stairway for infinitely meaner wages. Now if I had been the rich women I think I should have knelt on the flags; and if I had been the poor woman I should have taken a pew, for the sake of novelty. But then I do not understand these things; so I left the church, fearing that my presence prowling about might distract the attention of the ladies in the pews, though for the poorer sinner I had evidently no existence.

[Harry Ransom Humanities Research Center,
University of Texas at Austin; unpublished]

A Degenerate's View of Nordau

[Shaw's review-essay excoriating Max Nordau's Degeneration, *which had attacked as decadent the modern movements in the arts, appeared as an open letter to editor Benjamin Tucker in the New York weekly,* Liberty, *27 July 1895. With a new preface and minor revisions, Shaw reissued it as a small book in 1908 as* The Sanity of Art, *the version since reprinted in Shaw's* Major Critical Essays *(1930). Max Simon Nordau (1849–1923) was a Budapest physician who moved to Paris in 1886, where he wrote essays on moral and social questions, and on travel, as well as several novels. The* Musical Courier *article referred to by Shaw is "The Musical Revolution" (C1037), published September 1894. Whistler's portrait of the violinist Sarasate was his 1884 Arrangement in Black: Pablo de Sarasate. George Brandes was the influential Danish literary critic. The footnotes and the idiosyncratic spellings are both Shaw's.]*

My dear Tucker:

I have read Max Nordau's "Degeneration" at your request—two hundred and sixty thousand mortal words, saying the same thing over and over again. That, as you know, is the way to drive a thing into the mind of the world, though Nordau considers it a symptom of insane "obsession" on the part of writers who do not share his own opinions. His message to the world is that all our characteristically modern works of art are symptoms of disease in the artists, and that these diseased artists are themselves symptoms of the nervous exhaustion of the race by overwork.

To me, who am a professional critic of art, and have for many succes-
sive London seasons had to watch a grand march past of books, of
pictures, of concerts and operas, and of stage plays, there is nothing
new in Herr Nordau's outburst. I have heard it all before. At every new
birth of energy in art the same alarm has been raised; and, as these
alarms always had their public, like prophecies of the end of the world,
there is nothing surprising in the fact that a book which might have
been produced by playing the resurrection man in the old newspaper
rooms of our public libraries, and collecting all the exploded bogey-
criticisms of the last half century into a huge volume, should have a
considerable success. To give you an idea of the heap of material ready
to hand for such a compilation, let me lay before you a sketch of one or
two of the Reformations in art which I have myself witnessed.

When I was engaged chiefly in the criticism of pictures, the Impres-
sionist movement was struggling for life in London; and I supported it
vigorously because, being the outcome of heightened attention and
quickened consciousness on the part of its disciples, it was evidently
destined to improve pictures greatly by substituting a natural, obser-
vant, real style for a conventional, taken-for-granted, ideal one. The
result has entirely justified my choice of sides. I can remember when
Mr. Whistler, in order to force the public to observe the qualities he
was introducing into pictorial work, had to exhibit a fine drawing of a
girl with the head deliberately crossed out with a few rough pencil
strokes, knowing perfectly well that, if he left a woman's face discern-
ible, the British Philistine would simply look to see whether she was a
pretty girl or not, or whether she represented some of his pet charac-
ters in fiction, and pass on without having seen any of the qualities of
artistic execution which made the drawing valuable. But it was easier
for the critics to resent the obliteration of the face as an insolent eccen-
tricity, and to show their own good manners by writing of Mr. Whistler
as "Jimmy," than to think out what he meant. It took several years of
"propaganda by deed" before the qualities which the Impressionists
insisted on came to be looked for as a matter of course in pictures, so
that even the ordinary picture-gallery frequenter, when he came face
to face with Bouguereau's "Girl in a Cornfield," instead of accepting it
as a window-glimpse of nature, saw at a glance that the girl is really
standing in a studio with what the house agents call "a good north
light," and that the cornfield is a conventional sham. This advance in
public education was effected by persistently exhibiting pictures
which, like Mr. Whistler's girl with her head scratched out, were propa-
gandist samples of workmanship rather than complete works of art.
But the moment Mr. Whistler and other really able artists forced the
dealers and the societies of painters to exhibit these studies, and, by

doing so, to accustom the public to tolerate what appeared to it at first to be absurdities, the door was necessarily opened to real absurdities. It is exceedingly difficult to draw or paint well; it is exceedingly easy to smudge paper or canvas so as to suggest a picture just as the stains on an old ceiling or the dark spots in a glowing coal-fire do. Plenty of rubbish of this kind was produced, exhibited, and tolerated at the time when people could not see the difference between any daub in which there were shadows painted in vivid aniline hues and a landscape by Monet. Not that they thought the daub as good as the Monet: they thought the Monet as ridiculous as the daub; but they were afraid to say so, because they had discovered that people who were good judges did not think Monet ridiculous. Then, besides the mere impostors, there were a certain number of highly conscientious painters who produced abnormal pictures because they saw abnormally. My own sight happens to be "normal" in the oculist's sense: that is, I see things with the naked eye as most people can only be made to see them by the aid of spectacles. Once I had a discussion with an artist who was shewing me a clever picture of his in which the parted lips in a pretty woman's face revealed what seemed to me like a mouthful of virgin snow. The painter lectured me for not using my eyes, instead of my knowledge of facts. "You can't see the divisions in a set of teeth, when you look at a person's mouth," he said; "all you can see is a strip of white, or yellow, or pearl, as the case may be; but, because you know, as a matter of anatomic fact, that there are divisions there, you want to have them represented by strokes in a drawing. That is just like you art critics, &c,. &c." I do not think he believed me when I told him that, when I looked at a row of teeth, I saw, not only the divisions between them, but their exact shape, both in contour and modelling, just as well as I saw their general color. Some of the most able of the Impressionists evidently did not see forms as definitely as they appreciated color relationship; and, since there is always a great deal of imitation in the arts, we soon had young painters with perfectly good sight looking at landscapes or at their models with their eyes half closed and a little asquint, until what they saw looked to them like one of their favorite master's pictures. Further, the Impressionist movement led to a busy study of the atmosphere, conventionally supposed to be invisible, but seldom really completely so, and of what were called "values": that is, the relation of light and dark between the various objects depicted, on the correctness of which relation truth of effect mainly depends. This proved very difficult in full outdoor light with the "local color" brilliantly visible, and comparatively easy in gloomy rooms where the absence of light reduced all objects to masses of brown or grey of varying depth with hardly any discernible local color. Whistler's portrait of

Sarasate, a masterpiece in its way, looks like a study in monochrome beside a portrait by Holbein; and his cleverest followers could paint dark interiors, or figures placed apparently in coal cellars, with admirable truth and delicacy of "value" sense, whilst they were still helplessly unable to represent a green tree or a blue sky, much less paint an interior with the light and local color as clear as in the works of Peter de Hooghe. Naturally the public eye, with its utilitarian familiarity with local color, and its Philistine insensibility to values and atmosphere, did not at first see what the Impressionists were driving at, and dismissed them as mere perverse, notoriety-hunting cranks. Here, then, you had a movement in painting which was wholly beneficial and progressive; and in no sense insane or decadent. Nevertheless it led to the public exhibition of daubs which even the authors themselves would never have presumed to offer for exhibition before; it betrayed aberrations of vision in painters who, on the old academic lines, would have hidden their defects by drawing objects (teeth, for instance) as they knew them to exist, and not as they saw them; it set hundreds of clear-sighted students practising optical distortion, so as to see things myopically; and it substituted canvases which looked like enlargements of obscure photographs for the familiar portraits of masters of the hounds in cheerfully unmistakable pink coats, mounted on bright chestnut horses. All of which, and much else, to man who looked on at it without any sense of the deficiencies in conventional painting, necessarily suggested that the Impressionists and their contemporaries were much less sane than their fathers.

Again, my duties as a musical critic compelled me to ascertain very carefully the exact bearings of the controversy which has raged round Wagner's music-dramas since the middle of the century. When you and I last met, we were basking in the sun between the acts of "Parsifal" at Bayreuth; but experience has taught me that an American may appear at Bayreuth without being necessarily fonder than most men of a technical discussion on music. Let me therefore put the case to you in a mercifully intelligible way. Music is like drawing in this respect—that it can be purely decorative, or purely dramatic, or anything between the two. A draughtsman may be pattern-designer, like William Morris, or he may be a delineator of life and character, like Ford Madox Brown. Or he may come between these two extremes, and treat scenes of life and character in a decorative way, like Walter Crane or Burne Jones—both of them consummate pattern-designers, whose subject pictures and illustrations are also fundamentally figure-patterns, prettier, but much less convincingly human and real, than Madox Brown's. Now, in music we have these same alternative applications of the art to drama and decoration. You can compose a graceful, symmetrical sound-pattern

that exists solely for the sake of its own grace and symmetry. Or you can compose music to heighten the expression of human emotion; and such music will be intensely affecting in the presence of that emotion, and utter nonsense apart from it. For examples of pure pattern-designing in music I should have to go back to the old music of the thirteenth, fourteenth, and fifteenth centuries, before the operatic movement gained the upper hand; but I am afraid my assertions that much of this music is very beautiful and hugely superior to the stuff our music publishers turn out today would not be believed in America; for, when I hinted at something of the kind lately in the American "Musical Courier," and pointed out also the beauty of the instruments for which this old music was written—viols, virginals, and so on—one of your leading musical critics [Henry T. Finck] rebuked me with an expatiation on the superiority (meaning apparently the greater loudness) of the modern concert grand pianoforte, and contemptuously ordered the middle ages out from the majestic presence of the nineteenth century. Perhaps, however, you will take my word for it that in England alone a long line of composers, from Henry VIII to Henry Purcell, have left us quantities of instrumental music which was not dramatic music nor "programme music," but which was designed to affect the hearer solely by its beauty of sound and grace and ingenuity of pattern. This is the art which Wagner called "absolute music." It is represented today by the formal sonata and symphony; and we are coming back to it in something like its old integrity by a post-Wagnerian reaction led by that greatly gifted absolute musician and hopelessly commonplace and tedious dramatic composer, Johannes Brahms.

To understand the present muddle, you must know that modern dramatic music did not appear as an independent branch of musical art, but as an adulteration of absolute music. The first modern dramatic composers accepted as binding on them the rules of good pattern-designing in sound; and this absurdity was made to appear practicable by the fact that Mozart had such an extraordinary command of his art that his operas contain "numbers" which, though they seem to follow the dramatic play of emotion and character without reference to any other consideration whatever, are seen, on examining them from the point of view of the absolute musician, to be perfectly symmetrical sound-patterns. But these *tours de force* were no real justification for imposing the laws of pattern-designing on other dramatic musicians; and then Mozart himself broke away from them in all directions, and was violently attacked by his contemporaries for doing so, the accusations levelled at him—absence of melody, illegitimate and discordant harmonic progressions, and monstrous abuse of the orchestra—being exactly those with which the opponents of Wagner

so often pester ourselves. Wagner, whose leading lay characteristic was his enormous common sense, completed the emancipation of the dramatic musician from these laws of pattern-designing, and we now have operas, and very good ones too, written by composers like Bruneau or Boito, who are not musicians in the old sense at all—that is, they do not compose music apart from drama, and, when they have to furnish their operas with instrumental preludes or intermezzos or the like, they either take themes from the dramatic part of their operas and rhapsodize on them, or else they turn out some perfectly simple song or dance tune, at the cheapness of which Haydn would have laughed heartily, in spite of its orchestral and harmonic fineries.

If I add now that music in the academic, professorial, Conservative, respectable sense always means absolute music, and that students are taught that the laws of pattern-designing are binding on all musicians, and that violations of them are absolutely "wrong"; and if I mention incidentally that these laws are themselves confused by the survivals from a still older tradition based on the church art, technically very highly specialized, of writing perfectly smooth and beautiful vocal harmony, for unaccompanied voices, worthy to be sung by angelic doctors round the throne of God (this was Palestrina's art)—you will understand why it was that all the professional musicians who could not see beyond the routine which they were taught, and all the men and women (and there are many of them) who have little or no sense of drama, but a very keen sense of beauty of sound and prettiness of pattern in music, regarded Wagner as a madman who was reducing music to chaos, perversely introducing ugly and brutal sounds into a region where beauty and grace had reigned alone, and substituting an incoherent, aimless, endless meandering for the familiar symmetrical tunes in four-bar strains, like "Pop Goes the Weazel," in which the second and third strains repeat, or nearly repeat, the first and second, so that any one can remember them and treasure them like nursery rhymes. It was the unprofessional, "unmusical" public which caught the dramatic clue, and saw order and power, strength and sanity in the supposed Wagner chaos; and now, his battle being won and overwon, the professors, to avert the ridicule of their pupils, are compelled to explain (quite truly) that Wagner's technical procedure in music is almost pedantically logical and grammatical; that the "Lohengrin" prelude is a masterpiece of the "form" proper to its aim; and that his disregard of "false relations" and his free use of the most extreme discords without "preparation," were straight and sensible instances of that natural development of harmony which has proceeded continuously from the time when common six-four chords were considered "wrong," and such free use of unprepared dominant sevenths and

minor ninths as had become common in Mozart's time would have seemed the maddest cacophony.

The dramatic development also touched purely instrumental music. Liszt was no more an absolute musician than Wagner was. He wanted a symphony to express an emotion and its development, not to be a pretty sound-pattern. And he defined the emotion by connecting it with some known story, poem, or even picture—Mazeppa, Victor Hugo's "Les Preludes," Kaulbach's "Die Hunnenschlacht," or the like. But the moment you try to make an instrumental composition follow a story, you are forced to abandon the sound-pattern form, since all patterns consist of some decorative form which is repeated over and over again, and which generally consists in itself of a repetition of two similar halves; for example, if you take a playing card—say the five of diamonds—as a simple example of a pattern, you find not only that the diamond figure is repeated five times, but that each side of each pip is a reversed duplicate of the other. Now, the established form for a symphony is essentially a pattern form involving just such symmetrical repetitions; and, since a story does not repeat itself, but pursues a continuous chain of fresh incident and correspondingly varied emotions, Liszt had either to find a new musical form for his musical poems, or else face the intolerable anomalies and absurdities which spoil the many attempts made by Mendelssohn, Raff, and others to handcuff the old form to the new matter. Consequently he invented the "symphonic poem," a perfectly simple and fitting common-sense form for his purpose, and one which makes "Les Preludes" much plainer sailing for the ordinary hearer than Mendelssohn's "Naiades" overture or Raff's "Lenore" or "Im Walde" symphonies, in both of which the formal repetitions would stamp Raff as a madman if we did not know that they were mere superstitions, which he had not the strength of mind to shake off as Liszt did. But still, to the people who would not read Liszt's explanations and cared nothing for his purpose, who had no taste for "tone poetry" and consequently insisted on judging the symphonic poems as sound-patterns, Liszt must needs appear, like Wagner, a perverse egotist with something fundamentally disordered in his intellect—in short, a lunatic.

The sequel was the same as in the Impressionist movement. Wagner, Berlioz, and Liszt, in securing tolerance for their own works, secured it for what sounded to many people absurd; and this tolerance necessarily extended to a great deal of stuff which was really absurd, but which the secretly-bewildered critics dared not denounce, lest it, too, should turn out to be great, like the music of Wagner, over which they had made the most ludicrous exhibition of their incompetence. Even at such stupidly conservative concerts as those of the London

Philharmonic Society, I have seen ultra-modern composers, supposed to be representatives of the Wagnerian movement, conducting rubbish in no essential superior to Jullien's British army quadrilles. And then, of course, there are the young imitators, who are corrupted by the desire to make their harmonies sound like those of the masters whose purposes and principles of work they are too young to understand.

Here, again, you see, you have a progressive, intelligent, wholesome, and thoroughly sane movement in art, producing plenty of evidence to prove the case of any clever man who does not understand music, but who has a theory which involves the proposition that all the leaders of the art movements of our time are degenerate and, consequently, retrogressive lunatics.

There is no need for me to go at any great length into the grounds on which any development in our moral views must at first appear insane and blasphemous to people who are satisfied, or more than satisfied, with the current morality. Perhaps you remember the opening chapters of my "Quintessence of Ibsenism," in which I shewed why the London press, now abjectly polite to Ibsen, received him four years ago with a shriek of horror. Every step in morals is made by challenging the validity of the existing conception of perfect propriety of conduct; and, when a man does that, he must look out for a very different reception from the painter who has ventured to paint a shadow brilliant purple, or the composer who begins the prelude to his opera with an unprepared chord of the thirteenth. Heterodoxy in art is at worst rated as eccentricity or folly; heterodoxy in morals is at once rated as scoundrelism, and, what is worse, propagandist scoundrelism, which must, if successful, undermine society and bring us back to barbarism after a period of decadence like that which brought imperial Rome to its downfall. Your function as a philosophic Anarchist in American society is to combat the attempts that are constantly being made to arrest development by using the force of the State to suppress all departures from what the majority consider to be "right" in conduct or overt opinion. I dare say you will find the modern democratic voter a very troublesome person, chicken-heartedly diffident as to the value of his opinions on art or science, but cocksure about right and wrong in morals, politics, and religion—that is to say, in all the departments in which he can interfere effectively and mischievously. Happily, the individual is developing greatly in freedom and boldness nowadays. Formerly our young people mostly waited in diffident silence until they were old enough to find their aspirations towards the fullest attainable activity and satisfaction working out in practice very much as they have worked out in the life of the race; so that the revolutionist of twenty-five, who saw nothing for it but a clean sweep of all our institutions, found himself, at forty, accepting and even clinging to them on

condition of a few reforms to bring them up to date. But nowadays the
young people do not wait so patiently for this reconciliation. They ex-
press their dissatisfaction with the wisdom of their elders loudly and
irreverently, and formulate their heresy as a faith. They demand the
abolition of marriage, of the State, of the Church; they preach the divin-
ity of love and the heroism of the man who believes in himself and dares
do the thing he wills; they contemn the slavery to duty and discipline
which has left so many soured old people with nothing but envious
regrets for a virtuous youth. They recognize their gospel in such utter-
ances as that quoted by Nordau from Brandes: "To obey one's senses is
to have character. He who allows himself to be guided by his passions
has individuality." For my part, I think this excellent doctrine, both in
Brandes's form and in the older form: "He that is unjust, let him be
unjust still; and he which is filthy, let him be filthy still; and he that is
righteous, let him be righteous still; and he that is holy, let him be holy
still." This is not the opinion of Nordau, who, with facile journalistic
vulgarity, proceeds to express his horror of [George] Brandes with all the
usual epithets—"debauchery, dissoluteness, depravity disguised as mo-
dernity, bestial instinct, *maître de plaisir*, egomaniacal anarchist"—and
such sentences as the following:

> It is comprehensible that an educator who turns the school-
> room into a tavern and a brothel should have success and a
> crowd of followers. He certainly runs the risk of being slain by
> the parents, if they come to know what he is teaching their
> children; but the pupils will hardly complain, and will be eager
> to attend the lessons of so agreeable a teacher. This is the expla-
> nation of the influence Brandes gained over the youth of his
> country, such as his writings, with their emptiness of thought
> and unending tattle, would certainly never have procured for
> him.

In order to thoroughly enjoy this spluttering, you must know that it
is immediately followed by an attack on Ibsen for the weakness of
"obsession by the doctrine of original sin." Yet what would the passage
I have just quoted be without the doctrine of original sin as a postu-
late? If "the heart of man is deceitful above all things, and desperately
wicked," then, truly, the man who allows himself to be guided by his
passions must needs be a scoundrel, and his teacher might well be
slain by his parents. But how if the youth thrown helpless on his
passions found that honesty, that self-respect, that hatred of cruelty
and injustice, that the desire for soundness and health and efficiency,
were master passions—nay, that their excess is so dangerous to youth
that it is part of the wisdom of age to say to the young: "Be not righ-

teous overmuch: why shouldst thou destroy thyself?" I am sure, my dear Tucker, your friends have paraphrased that in vernacular American often enough in remonstrating with you for your Anarchism, which defies not only God, but even the wisdom of the United States congress. On the other hand, the people who profess to renounce and abjure their own passions, and ostentatiously regulate their conduct by the most convenient interpretation of what the Bible means, or, worse still, by their ability to find reasons for it (as if there were not excellent reasons to be found for every conceivable course of conduct, from dynamite and vivisection to martyrdom), seldom need a warning against being righteous overmuch, their attention, indeed, often needing a rather pressing jog in the opposite direction. The truth is that passion is the steam in the engine of all religions and moral systems. In so far as it is malevolent, the religions are malevolent too, and insist on human sacrifices, on hell, wrath, and vengeance. You cannot read Browning's "Caliban upon Setebos, or, Natural Theology on the Island" without admitting that all our religions have been made as Caliban made his, and that the difference between Caliban and Prospero is that Prospero is mastered by holier passions. And as Caliban imagined his theology, so did Mill reason out his essay on "Liberty" and Spencer his "Data of Ethics." In them we find the authors still trying to formulate abstract principles of conduct—still missing the fact that truth and justice are not abstract principles external to man, but human passions, which have, in their time, conflicted with higher passions as well as with lower ones. If a young woman, in a mood of strong reaction against the preaching of duty and self-sacrifice and the rest of it, were to tell Mr. Herbert Spencer that she was determined not to murder her own instincts and throw away her life in obedience to a mouthful of empty phrases, I suspect he would recommend the "Data of Ethics" to her as a trustworthy and conclusive guide to conduct. Under similar circumstances I should unhesitatingly say to the young woman: "By all means do as you propose. Try how wicked you can be; it is precisely the same experiment as trying how good you can be. At worst you will only find out the sort of person you really are. At best you will find that your passions, if you really and honestly let them all loose impartially, will discipline you with a severity which your conventional friends, abandoning themselves to the mechanical routine of fashion, could not stand for a day." As a matter of fact, I have seen over and over again this comedy of the "emancipated" young enthusiast flinging duty and religion, convention and parental authority, to the winds, only to find herself becoming, for the first time in her life, plunged into duties, responsibilities, and sacrifices from which she is often glad to retreat, after a few years' wearing down of her enthusiasm, into the compara-

tively loose life of an ordinary respectable woman of fashion. The truth is, laws, religions, creeds, and systems of ethics, instead of making society better than its best unit, make it worse than its average unit, because they are never up to date. You will ask me: "Why have them at all?" I will tell you. They are made necessary—though we all secretly detest them—by the fact that the number of people who can think out a line of conduct for themselves even on one point is very small, and the number who can afford the time for it still smaller. Nobody can afford the time to do it on all points. The professional thinker may on occasion make his own morality and philosophy as the cobbler may make his own boots; but the ordinary man of business must buy at the shop, so to speak, and put up with what he finds on sale there, whether it exactly suits him or not, because he can neither make a morality for himself nor do without one. This typewriter with which I am writing is the best I can get; but it is by no means a perfect instrument; and I have not the smallest doubt that in fifty years' time the authors of that day will wonder how men could have put up with so clumsy a contrivance. When a better one is invented, I shall buy it: until then, I must make the best of it, just as my Protestant and Roman Catholic and Agnostic friends make the best of their creeds and systems. This would be better recognized if people took consciously and deliberately to the use of creeds as they do to the use of typewriters. Just as the traffic of a great city would be impossible without a code of rules of the road which not one wagoner in a thousand could draw up for himself, much less promulgate, and without, in London at least, an unquestioning consent to treat the policeman's raised hand as if it were an impassable bar stretched half across the road, so the average man is still unable to get through the world without being told what to do at every turn, and basing such calculations as he is capable of on the assumption that every one else will calculate on the same assumptions. Even your man of genius accepts a thousand rules for every one he challenges; and you may lodge in the same house with an Anarchist for ten years without noticing anything exceptional about him. Martin Luther, the priest, horrified the greater half of Christendom by marrying a nun, yet was a submissive conformist in countless ways, living orderly as a husband and father, wearing what his bootmaker and tailor made for him, and dwelling in what the builder built for him, although he would have died rather than take his Church from the Pope. And when he got a Church made by himself to his liking, generations of men calling themselves Lutherans took that Church from him just as unquestioningly as he took the fashion of his clothes from his tailor. As the race evolves, many a convention which recommends itself by its obvious utility to every one passes into an automatic habit, like breathing; and

meanwhile the improvement in our nerves and judgment enlarges the list of emergencies which individuals may be trusted to deal with on the spur of the moment without reference to regulations; but there will for many centuries to come be a huge demand for a ready-made code of conduct for general use, which will be used more or less as a matter of overwhelming convenience by all members of communities. Oh, Father Tucker, worshipper of Liberty! where shall I find a country where the thinking can be done without division of labor?

It follows that we can hardly fall into any error stupider than that of mistaking creeds and the laws founded on creeds for the applications to human conduct of eternal and immutable principles of good and evil. It sets people regarding laws as institutions too sacred to be tampered with, whereas in a progressive community nothing can make laws tolerable unless their changes and modifications are kept closely on the heels of the changes and modifications which are continuously proceeding in the minds and habits of the people; and it deadens the conscience of individuals by relieving them of the moral responsibility of their own actions. When this relief is made as complete as possible, it reduces a man to a condition in which his very virtues are contemptible. Military discipline, for example, aims at destroying the individuality and initiative of the soldier whilst increasing his mechanical efficiency, until he is simply a weapon with the power of hearing and obeying orders. In him you have duty, obedience, self-denial, submission to external authority, carried as far as it can be carried; and the result is that in England, where military service is voluntary, the common soldier is less respected than any other serviceable worker in the community. The police constable, who, though under discipline too, is a civilian and has to use his own judgment and act on his own responsibility in innumerable petty emergencies, is by comparison a popular and esteemed citizen. The Roman Catholic peasant who consults his parish priest instead of his conscience, and submits wholly to the authority of the Church, is mastered and governed either by statesmen or cardinals who despise his superstition, or by Protestants who are at least allowed to persuade themselves that they have arrived at their religious opinions through the exercise of their private judgment. The whole progress of the world is from submission and obedience as safeguards against panic and incontinence, to wilfulness and self-assertion made safe by reason and self-control, just as plainly as the physical growth of the individual leads from the perambulator and the nurse's apron-string to the power of walking alone, or his moral growth from the tutelage of the boy to the responsibility of the man. But it is useless for impatient spirits—you and I, for instance—to call on people to walk before they can stand. Without high gifts of reason and self-control—

that is, without strong common sense—no man dare yet trust himself out of the school of authority. What he does is to claim gradual relaxations of the discipline, so as to have as much freedom as he thinks is good for him and as much government as he needs to keep him straight. We see this in the history of British-American Christianity. Man, as the hero of that history, starts by accepting as binding on him the revelation of God's will as interpreted by the Church. Then he claims a formal right to exercise his own judgment, which the Reformed Church, competing with the Unreformed for clients, grants him on condition that he arrive at the same conclusions as itself. Later on, he violates this condition in certain particulars, and "dissents," flying to America in the Mayflower from the prison of Conformity, but promptly building a new jail, suited to the needs of his sect, in his adopted country. For all these little mutinies he finds excellent arguments to prove that he is exchanging a false authority for *the* true one, never daring even to think of brazenly admitting that what he is really doing is substituting his own will, bit by bit, for what he calls the will of God or the laws of Nature. The arguments so accustom the world to submit authority to the test of discussion that he is at last emboldened to claim the right to do anything he can find good arguments for, even to the extent of questioning the scientific accuracy of the book of Genesis and the validity of the popular conception of God as an omniscient, omnipotent, and very serious old gentleman sitting on a throne above the clouds. This seems a giant stride towards emancipation; but it leaves our hero, as Rationalist and Materialist, regarding Reason as an eternal principle, independent of and superior to his erring passions, at which point it is easy to suggest that perhaps the experienced authority of a Roman Catholic Church might be better than the first crop of arguments raised by a handful of raw Rationalists in their sects of "Freethinkers" and "Secularists" for the working class, and "Positivists" or "Don't Knowists" (Agnostics) for the genteel votaries of the new fetich.

In the meantime came Schopenhauer to re-establish the old theological doctrine that reason is no motive power; that the true motive power in the world—otherwise life—is will; and that the setting up of reason above will is a damnable error. But the theologians could not open their arms to Schopenhauer, because he fell into the cardinal Rationalist error of making happiness instead of completeness of activity the test of the value of life, and of course came to the idiotic pessimist conclusion that life is not worth living, and that the will which urges us to live in spite of this is necessarily a malign torturer, the desirable end of all things being the Nirvana of the stilling of the will and the consequent

setting of life's sun "into the blind cave of eternal night." Further, the will of the theologians was the will of God, standing outside man and in authority above him, whereas the Schopenhauerian will is a purely secular force of nature, attaining various degrees of organization, here as a jelly fish, there as a cabbage, more complexly as an ape or a tiger, and attaining its highest form so far in the human being. As to the Rationalists, they approved of Schopenhauer's secularism and pessimism, but of course could not stomach his metaphysical method or his dethronement of reason by will. Accordingly, his turn for popularity did not come until after Darwin's, and then mostly through the influence of two great artists, Richard Wagner and Ibsen, whose "Tristan" and "Emperor or Galilean" shew that Schopenhauer was a true pioneer in the forward march of the human spirit. We can now, as soon as we are strong-minded enough, drop the Nirvana nonsense, the pessimism, the rationalism, the theology, and all the other subterfuges to which we cling because we are afraid to look life straight in the face and see in it, not the fulfillment of a moral law or of the deductions of reason, but the satisfaction of a passion in us of which we can give no account whatever. It is natural for man to shrink from the terrible responsibility thrown on him by this inexorable fact. All his stock excuses vanish before it—"The woman tempted me," "The serpent tempted me," "I was not myself at the time," "I meant well," "My passion got the better of my reason," "It was my duty to do it," "The Bible says that we should do it," "Everybody does it," and so on. Nothing is left but the frank avowal: "I did it because I am built that way." Every man hates to say that. He wants to believe that his generous actions are characteristic of him, and that his meannesses are aberrations or concessions to the force of circumstances. Our murderers, with the assistance of the jail chaplain, square accounts with the devil and with God, never with themselves. The convict gives every reason for his having stolen something except the reason that he is a thief. Cruel people flog their children for their children's good, or offer the information that a guinea pig perspires under atrocious torture as an affectionate contribution to science. Lynched negroes are riddled by dozens of superfluous bullets, every one of which is offered as the expression of a sense of outraged justice and womanhood in the scamp and libertine who fires it. And such is the desire of men to keep one another is countenance that they positively demand such excuses from one another as a matter of public decency. An uncle of mine, who made it a rule to offer tramps a job when they begged from him, naturally very soon became familiar with every excuse that human ingenuity can invent for not working. But he lost his temper only once; and that was with a tramp who frankly

replied that he was too lazy. This my uncle described with disgust as "cynicism." And yet our family arms bear the motto, in Latin, "Know thyself."

As you know, the true trend of this movement has been mistaken by many of its supporters as well as by its opponents. The ingrained habit of thinking of the propensities of which we are ashamed as "our passions," and our shame of them and our propensities to noble conduct as a negative and inhibitory department called generally our conscience, leads us to conclude that to accept the guidance of our passions is to plunge recklessly into the insupportable tedium of what is called a life of pleasure. Reactionists against the almost equally insupportable slavery of what is called a life of duty are nevertheless willing to venture on these terms. The "revolted daughter," exasperated at being systematically lied to by her parents on every subject of vital importance to an eager and intensely curious young student of life, allies herself with really vicious people and with humorists who like to shock the pious with gay paradoxes, in claiming an impossible license in personal conduct. No great harm is done beyond the inevitable and temporary excesses produced by all reactions; for, as I have said, the would-be wicked ones find, when they come to the point, that the indispensable qualification for a wicked life is not freedom, but wickedness. But the misunderstanding supports the clamor of the opponents of the newest opinions, who naturally shriek as Nordau shrieks in the passages about Brandes, quoted above. Thus you have here again a movement which is thoroughly beneficial and progressive presenting a hideous appearance of moral corruption and decay, not only to our old-fashioned religious folk, but to our comparatively modern scientific folk as well. And here again, because the press and the gossips have found out that this apparent corruption and decay is considered the right thing in some influential quarters, and must be spoken of with respect, and patronized and published and sold and read, we have a certain number of pitiful imitators taking advantage of their tolerance to bring out really silly and rotten stuff, which the reviewers are afraid to expose, lest it, too, should turn out to be the correct thing.

After this long preamble, you will have no difficulty in understanding the sort of book Nordau has written. Figure to yourself a huge volume, stuffed with the most slashing of the criticisms which were hurled at the Impressionists, the Tone Poets, and the philosophers and dramatists of the Schopenhauerian revival, before these movements had reached the point at which it began to require some real courage to attack them. Imagine a *rechauffée,* not only of the newspaper criticisms of this period, but actually of all its little parasitic paragraphs of small talk and scandal, from the long-forgotten jibes against Mr. Oscar

Wilde's momentary attempt to bring knee-breeches into fashion years ago, to the latest scurrilities about "the New Woman." Imagine the general staleness and occasional putrescence of this mess disguised by a dressing of the terminology invented by Krafft-Ebing, Lombroso, and all the latest specialists in madness and crime, to describe the artistic faculties and propensities as they operate in the insane. Imagine all this done by a man who is a vigorous and capable journalist, shrewd enough to see that there is a good opening for a big reactionary book as a relief to the Wagner and Ibsen booms, bold enough to let himself go without respect to persons or reputations, lucky enough to be a stronger, clearer-headed man than ninety-nine out of a hundred of his critics, besides having a keener interest in science, a born theorist, reasoner, and busybody, and so able, without insight, originality, or even any very remarkable intensive industry (he is like most Germans, *ex*tensively industrious to an appalling degree), to produce a book which has made a very considerable impression on the artistic ignorance of Europe and America. For he says a thing as if he meant it; he holds superficial ideas obstinately, and sees them clearly; and his mind works so impetuously that it is a pleasure to watch it—for a while. All the same, he is shallow and unfeeling enough to be the dupe of a theory which would hardly impose on one of those gamblers who have a system or martingale, founded on a solid rock of algebra, by which they can infallibly break the bank at Monte Carlo. "Psychiatry" takes the place of algebra in Nordau's martingale.

This theory of his is, at bottom, nothing but the familiar delusion of the used-up man that the world is going to the dogs. But Nordau is too clever to be driven back on ready-made mistakes; he makes them for himself in his own way. He appeals to the prodigious extension of the quantity of business that a single man can transact through the modern machinery of social intercourse—the railway, the telegraph and telephone, the post, and so forth. He gives appalling statistics of the increase of railway mileage and shipping, of the number of letters written per head of the population, of the newspapers which tell us things of which we used to know nothing.* "In the last fifty years," he says, "the population of Europe has not doubled, whereas the sum of its labors has increased tenfold—in part, even fiftyfold. Every civilized man furnishes, at the present time, from five to twenty-five times as

*Perhaps I had better remark in passing that, unless it were true—which it is not—that the length of the modern penny letter or halfpenny post-card is the same as that of the eighteenth-century letter, and that the number of persons who know how to read and write has not increased, there is no reason whatever to draw Nordau's conclusion from these statistics.

much work as was demanded of him half a century ago."* Then follow more statistics of "the constant increase of crime, madness, and suicide," of increases in the mortality from diseases of the nerves and heart, of increased consumption of stimulants, of new nervous diseases like "railway spine and railway brain," with the general moral that we are all suffering from exhaustion, and that symptoms of degeneracy are visible in all directions, culminating at various points in such hysterical horrors as Wagner's music, Ibsen's dramas, Manet's pictures, Tolstoi's novels, Whitman's poetry, Dr. Jaeger's woollen clothing, vegetarianism, scepticism as to the infallibility of vivisection and vaccination, Anarchism and humanitarianism, and, in short, everything that Herr Nordau does not happen to approve of.

You will at once see that such a case, if well got up and argued, is worth hearing, even though its advocate has no chance of a verdict, because it is sure to bring out a certain number of facts which are interesting and important. It is, I take it, quite true that, with our railways and our postal services, many of us are for the moment very like a pedestrian converted to bicycling, who, instead of using his machine to go forty miles with less labor than he used to walk twenty, proceeds to do a hundred miles instead, with the result that the "labor-saving" contrivance acts as a means of working its user to exhaustion. It is also, of course, true that under our existing industrial system machinery in industrial processes is regarded solely as a means of extracting a larger product from the unremitted toil of the actual wage-worker. And I do not think any person who is in touch with the artistic professions will deny that they are recruited largely by persons who become actors, or painters, or journalists and authors because they are incapable of steady work and regular habits, or that the attraction which the patrons of the stage, music, and literature find in their favorite arts has often little or nothing to do with the need which nerves great artists to the heavy travail of creation. The claim of art to our respect must stand or fall with the validity of its pretension to cultivate and refine our senses and faculties until seeing, hearing, feeling, smelling, and tasting become highly conscious and critical

*Here again we have a statement which means nothing, unless it be compared with statistics as to the multiplication of the civilized man's power of production by machinery, which in some industries has multiplied a single man's power by hundreds and in others by thousands. As to crimes and disease, Nordau should state whether he counts convictions under modern laws—for offences against the Joint-Stock Company Acts, for instance—as proving that we have degenerated since those Acts were passed, and whether he regards the invention of new names for a dozen varieties of fever which were formerly counted as one single disease as an evidence of decaying health in the face of the increasing duration of life.

acts with us, protesting vehemently against ugliness, noise, discordant speech, frowsy clothing, and foul air, and taking keen interest and pleasure in beauty, in music, and in the open air, besides making us insist, as necessary for comfort and decency, on clean, wholesome, handsome fabrics to wear, and utensils of fine material and elegant workmanship to handle. Further, art should refine our sense of character and conduct, of justice and sympathy, greatly heightening our self-knowledge, self-control, precision of action, and considerateness, and making us intolerant of baseness, cruelty, injustice, and intellectual superficiality or vulgarity. The worthy artist or craftsman is he who responds to this cultivation of the physical and moral senses by feeding them with pictures, musical compositions, pleasant houses and gardens, good clothes and fine implements, poems, fictions, essays, and dramas which call the heightened senses and ennobled faculties into pleasurable activity. The great artist is he who goes a step beyond the demand, and, by supplying works of a higher beauty and a higher interest than have yet been perceived, succeeds, after a brief struggle with its strangeness, in adding this fresh extension of sense to the heritage of the race. This is why we value art; this is why we feel that the iconoclast and the Puritan are attacking something made holier, by solid usefulness, than their own theories of purity; this is why art has won the privileges of religion; so that London shopkeepers who would fiercely resent a compulsory church rate, who do not know "Yankee Doodle" from "God Save the Queen," and who are more interested in the photograph of the latest celebrity than in the Velasquez portrait in the National Gallery, tamely allow the London county council to spend their money on bands, on municipal art inspectors, and on plaster casts from the antique.

But the business of responding to the demand for the gratification of the senses has many grades. The confectioner who makes unwholesome sweets, the bull-fighter, the women whose advertisements in the Chicago papers are so astounding to English people, are examples ready to hand to shew what the art and trade of pleasing may be, not at its lowest, but at the lowest that we can speak of without intolerable shame. We have dramatists who write their lines in such a way as to enable low comedians of a certain class to give them an indecorous turn; we have painters who aim no higher than Giulio Romano did when he decorated the Palazzo Te in Mantua; we have poets who have nothing to versify but the commonplaces of amorous infatuation; and, worse than all the rest put together, we have journalists who openly profess that it is their duty to "reflect" what they believe to be the ignorance and prejudice of their readers, instead of leading and enlightening them to the best of their ability—an excuse for cowardice and

time-serving which is also becoming well worn in political circles as "the duty of a democratic statesman." In short, the artist can be a prostitute, a pander, and a flatterer more easily as far as external pressure goes, than a faithful servant of the community, much less the founder of a school or the father of a church. Even an artist who is doing the best he can may be doing a very low class of work: for instance, many performers at the rougher music halls, who get their living by singing coarse songs in the rowdiest possible way, do so to the utmost of their ability in that direction in the most conscientious spirit of earning their money honestly and being a credit to their profession. And the exaltation of the greatest artists is not continuous; you cannot defend every line of Shakspere or every stroke of Titian. Since the artist is a man and his patron a man, all human moods and grades of development are reflected in art; consequently the Puritan's or the Philistine's indictment of art has as many counts as the misanthrope's indictment of humanity. And this is the Achilles' heel of art at which Nordau has struck. He has piled the Puritan on the Philistine, the Philistine on the misanthrope, in order to make out his case. Let me describe to you one or two of his typical artifices as a special pleader making the most of the eddies at the sides of the stream of progress.

Chief among his tricks is the old and effective one of pointing out, as "stigmata of degeneration" in the person he is abusing, features which are common to the whole human race. The drawing-room palmist astonishes ladies by telling them "secrets" about themselves which are nothing but the inevitable experiences of ninety-nine people out of every hundred, though each individual is vain enough to suppose that they are peculiar to herself. Nordau turns the trick inside out by trusting to the fact that people are in the habit of assuming that uniformity and symmetry are laws of nature—for example, that every normal person's face is precisely symmetrical, that all persons have the same number of bones in their bodies, and so on. Nordau takes advantage of this popular error to claim asymmetry as a stigma of degeneration. As a matter of fact, perfect symmetry or uniformity is the rarest thing in nature. My two profiles, when photographed, are hardly recognizable as belonging to the same person by those who do not know me; so that the camera would prove me an utter degenerate if my case were exceptional. Probably, however, you would not object to testify that my face is as symmetrical as faces are ordinarily made. Another unfailing trick is the common one of having two names for the same thing—one of them abusive, the other complimentary—for use according to circumstances. You know how it is done: "We trust the government will be firm" in one paper, and "We hope ministers will not be obstinate" in another. The following is a typical specimen of Nordau's use of this

device. When a man with a turn for rhyming goes mad, he repeats rhymes as if he were quoting a rhyming dictionary. You say "Come" to him, and he starts away with "Dumb, plum, sum, rum, numb, gum," and so on. This the doctors call "echolalia." Dickens gives a specimen of indulgence in it by sane people in "Great Expectations," where Mr. Jaggers's Jewish client expresses his rapture of admiration for the lawyer by exclaiming: "Oh, Jaggerth, Jaggerth, Jaggerth; all otherth ith Cag-Maggerth, give me Jaggerth!" There are some well-known verses by Swinburne, beginning, "If love were what the rose is," which, rhyming and tripping along very prettily, express a sentiment without making any intelligible statement whatsoever; and we have plenty of nonsensically inconsequent nursery rhymes, like "Ba, ba, black sheep," or "Old Daddy long legs," which please perfectly sane children just as Mr. Swinburne's verses please perfectly sane adults, simply as funny or pretty little word-patterns. People do not write such things for the sake of conveying information, but for the sake of amusing and pleasing, just as people do not eat strawberries and cream to nourish their bones and muscles, but to enjoy the taste of a toothsome dish. A lunatic may plead that he eats kitchen soap and tin tacks on exactly the same ground; and, as far as I can see, the lunatic would completely shut up Nordau by this argument: for Nordau is absurd enough, in the case of rhyming, to claim that every rhyme made for its own sake, as proved by the fact that it does not convey an intelligible statement of fact of any kind, convicts the rhymer of "echolalia," or the disease of the lunatic who, when you ask him to come in to dinner, begins to reel off "Sinner, skinner, thinner, winner," &c., instead of accepting the invitation or making a sensible answer. Nordau can thus convict any poet whom he dislikes of being a degenerate by simply picking out a rhyme which exists for its own sake, or a pun, or what is called a "burden" in a ballad, and claiming them as symptoms of "echolalia," supporting this diagnosis by carefully examining the poem for contradictions and inconsistencies as to time, place, description, or the like. It will occur to you probably that by this means he must bring out Shakspere as the champion instance of poetic degeneracy since Shakspere was an incorrigible punster, delighted in "burdens"—for instance, "With hey, ho, the wind and the rain," which exactly fulfils all the conditions accepted by Nordau as symptomatic of insanity in Rossetti's case—and rhymed for the sake of rhyming in a quite childish fashion, whilst, as to contradictions and inconsistencies, "Midsummer Night's Dream," as to which Shakspere never seems to have made up his mind whether the action covered a week or a single night, is only one of a dozen instances of his slips. But no: Shakspere, not being a nineteenth-century poet, would have spoiled the case for modern de-

generation by shewing that it could have been made out on the same grounds before the telegraph and the railway were dreamt of; and besides, Nordau likes Shakspere, just as he likes Goethe, and holds him up as a model of sanity against the nineteenth-century poets. Thus Wagner is a degenerate because he made puns; and Shakspere, who made worse ones, is a great poet. Swinburne, with his "unmeaning" refrains of "Small red leaves in the mill water," and "Apples of gold for the King's daughter," is a diseased madman; but Shakspere, with his "In spring time, the only merry ring time, when birds do sing hey ding a ding ding" (if this is not the worst case of "echolalia" in the world, what *is* echolalia?), is a sober master mind. Rossetti, with his Blessed Damozel leaning out from the gold bar of heaven, who weeps, although she is in paradise, which is a happy place, who describes the dead in one place as "dressed in white" and in another as "mounting like thin flames," and whose calculations of days and years do not resemble those in commercial diaries, is that dangerous and cranky thing, "a mystic"; whilst Goethe, the author of the second part of "Faust," if you please, is a hard-headed, accurate, sound scientific poet. As to the list of inconsistencies of which poor Ibsen is convicted, it is too long to be dealt with in detail. But I assure you I am not doing Nordau less than justice when I say that, if he had accused Shakspere of inconsistency on the ground that Othello is represented in the first act as loving his wife, and in the last as strangling her, the demonstration would have left you with more respect for his good sense than his pages on Ibsen, the folly of which goes beyond all patience.*

When Nordau deals with painting and music, he is less irritating, because he errs through ignorance, and ignorance, too, of a sort that is now perfectly well recognized and understood. We all know what the old-fashioned literary and scientific writer, who cultivated his intellect without ever dreaming of cultivating his eyes and ears, can be relied upon to say when painters and composers are under discussion. Nordau

* Perhaps I had better give one example. Nordau first quotes a couple of speeches from "An Enemy of the People" and "The Wild Duck."

STOCKMAN: I love my native town so well that I had rather ruin it than see it flourishing on a lie. All men who live on lies must be exterminated like vermin. ("An Enemy of the People.")

RELLING: Yes, I said illusion [lie]. For illusion, you know, is the stimulating principle. Rob the average man of his life illusion, and you rob him of his happiness at the same time. ("The Wild Duck.")

Nordau proceeds to comment as follows:

Now, what is Ibsen's real opinion? Is a man to strive for truth or to swelter in deceit? Is Ibsen with Stockmann or with Relling? Ibsen owes us an answer to these questions, or, rather, he replies to them affirmatively and negatively with equal ardor and equal poetic power.

makes a fool of himself with laughable punctuality. He gives us "the most glorious period of the Renaissance" and "the rosy dawn of the new thought" with all the gravity of the older editions of Murray's guides to Italy. He tells us that "to copy Cimabue and Giotto is comparatively easy; to imitate Raphael it is necessary to be able to draw and paint to perfection." He lumps Fra Angelico with Giotto and Cimabue, as if they represented the same stage in the development of technical execution, and Pollajuolo with Ghirlandajo. "Here," he says, speaking of the great Florentine painters, from Giotto to Masaccio, "were paintings bad in drawing, faded or smoked, their coloring either originally feeble or impaired by the action of centuries, pictures *executed with the awkwardness of a learner* . . . easy of imitation, since, in painting pictures in the style of the early masters, faulty drawing, deficient sense of color, and *general artistic incapacity*, are so many advantages." To make any comment on this would be to hit a man when he is down. Poor Nordau offers it as a demonstration that Ruskin, who gave this sort of ignorant nonsense its death-blow, was a delirious mystic. Also that Millais and Holman Hunt, in the days of the pre-Raphaelite brotherhood, strove to acquire the qualities of the early Florentine masters because the Florentine easel pictures were so much easier to imitate than those of the apprentices in Raphael's Roman fresco factory.

In music we find Nordau equally content with the theories as to how music is composed which were current among literary men fifty years ago. He tells us of "the severe discipline and fixed rules of the theory of composition, which gave a grammar to the musical babbling of primeval times, and made of it a worthy medium for the expression of the emotions of "civilized men," and describes Wagner as breaking these "fixed rules" and rebelling against this "severe discipline" because he was "an inattentive mystic, abandoned to amorphous dreams." This notion that there are certain rules, derived from a science of counterpoint, by the application of which pieces of music can be constructed just as an equilateral triangle can be constructed on a given straight line by any one who has mastered Euclid's first proposition is highly characteristic of the generation of blind and deaf critics to which Nordau belongs. It is evident that, if there were "fixed rules" by which Wagner or any one else could have composed good music, there could have been no more "severe discipline" in the work of composition than in the work of arranging a list of names in alphabetical order. The severity of artistic discipline is produced by the fact that in creative art no ready-made rules can help you. There is nothing to guide you to the right expression for your thought except your own sense of beauty and fitness; and, as you advance upon those who went before you, that sense of beauty and fitness is necessarily often in conflict, not with

fixed rules, because there are no rules, but with precedents, which are what Nordau means by "fixed rules," as far as he knows what he is talking about well enough to mean anything at all. If Wagner had composed the prelude to "Das Rheingold" with a half close at the end of the eighth bar and a full close at the end of the sixteenth, he would undoubtedly have followed the precedent of Mozart and other great composers, and complied with the requirements of Messrs. Hanslick, Nordau and Company. Only, as it happened, that was not what he wanted to do. His purpose was to produce a tone picture of the mighty flood in the depths of the Rhine; and, as the poetic imagination does not conceive the Rhine as stopping at every eight feet to take off its hat to Herren Hanslick and Nordau, the closes and half closes are omitted, and poor Herr Nordau, huffed at being passed by as if he were a person of no consequence, complains that the composer is "an inattentive mystic, abandoned to amorphous dreams." But, even if Wagner's descriptive purpose is left out of the question, Nordau's general criticism of him is an ignorant one; for the truth is that Wagner, like most artists who have great intellectual power, was dominated in the technical work of his gigantic scores by so strong a regard for system, order, logic, symmetry, and syntax that, when in the course of time his melody and harmony become perfectly familiar to us, he will be ranked with Händel as a composer whose extreme regularity of procedure must make his work appear drily mechanical to those who cannot catch its dramatic inspiration. If Nordau, having no sense of that inspiration, had said: "This fellow, whom you all imagine to be the creator of a new heaven and a new earth in music out of a chaos of poetic emotion, is really an arrant pedant and formalist," I should have pricked up my ears and listened to him with some curiosity, knowing how good a case a really keen technical critic could make out for that view. As it is, I have only to expose him as having picked up a vulgar error under the influence of a vulgar literary superstition. For the rest, you will hardly need any prompting of mine to appreciate the absurdity of dismissing as "inattentive" the Dresden conductor, the designer and founder of the Bayreuth enterprise, the humorous and practical author of "On Conducting," and the man who scored and stage-managed the four evenings of "The Niblung Ring." I purposely leave out the composer, the poet, the philosopher, the reformer, since Nordau cannot be compelled to admit that Wagner's eminence in these departments was real. Striking them all out accordingly, there remain the indisputable, objective facts of Wagner's practical professional ability and organizing power to put Nordau's diagnosis of Wagner as an "amorphous," inattentive person out of the question. If Nordau had one hundredth part of the truly terrific power of attention which Wagner must have main-

tained all his life almost as easily as a common man breathes, he would not now be so deplorable an example of the truth of his own contention that the power of attention may be taken as the measure of mental strength.

Nordau's trick of calling rhyme "echolalia" when he happens not to like the rhymer is reapplied in the case of authorship, which he calls "graphomania" when he happens not to like the author. He insists that Wagner, who was a voluminous author as well as a composer, was a graphomaniac; and his proof is that in his books we find "the restless repetition of one and the same strain of thought. . . . 'Opera and Drama,' 'Judaism in Music,' 'Religion and the State,' 'Art and Religion,' and 'The Vocation of Opera' are nothing more than the amplification of single passages in 'The Art-Work of the Future.' " This is a capital example of Nordau's limited power of attention. The moment that limited power is concentrated on his theory of degeneration, he loses sight of everything else, and drives his one borrowed horse into every obstacle on the road. The those of us who can attend to more than one thing at a time, there is no observation more familiar, and more frequently confirmed, than that this growth of pregnant single sentences into whole books which Nordau discovers in Wagner, balanced as it always is by the contraction of whole boyish chapters into single epigrams, is the process by which all great writers, speakers, artists, and thinkers elaborate their life-work. Let me take a writer after Nordau's own heart—a specialist in lunacy, of course—one whom he quotes as a trustworthy example of what he calls "the clear, mentally sane author, who, feeling himself impelled to say something, once for all expresses himself as distinctly and impressively as it is possible for him to do, and has done with it": namely, Dr. Henry Maudsley. Dr. Maudsley is a clever and cultivated specialist in insanity, who has written several interesting books, consisting of repetitions, amplifications, and historical illustrations of the same idea, which is, if I may put it rather more bluntly than the urbane author, nothing less than the identification of religious with sexual ecstasy. And the upshot of it is the conventional scientific pessimism, from which Dr. Maudsley never gets away; so that his last book repeats his first book, instead of leaving it far behind, as Wagner's "State and Religion" leaves his "Art and Revolution" behind. But, now that I have prepared the way by quoting Dr. Maudsley, why should I not ask Herr Nordau himself to step before the looking-glass and tell us frankly whether, even in the ranks of his "psychiatrists" and lunacy doctors, he can pick out a crank more hopelessly obsessed with one idea than himself. If you want an example of "echolalia," can you find a more shocking one than this gentleman who, when you say "mania," immediately begins to gabble Egomania, Graphomania, Megalomania, Onomatomania, Pyromania, Kleptoma-

nia, Dipsomania, Erotomania, Arithmomania, Oniomania, and is started off by the termination "phobia" with a string of Agoraphobia, Claustrophobia, Rupophobia, Iophobia, Nosophobia, Aichmophobia, Belenophobia, Cremnophobia, and Trichophobia? After which he suddenly observes: "This is simply philologico-medical trifling"—a remark which looks like returning sanity until he follows it up by clasping his temples in the true bedlamite manner, and complaining that "psychiatry is being stuffed with useless and disturbing designations," whereas, if the psychiatrists would only listen to him, they would see that there is only one phobia and one mania—namely, degeneracy. That is, the philologico-medical triflers are not crazy enough for him. He is so utterly mad on the subject of degeneration that he finds the symptoms of it in the loftiest geniuses as plainly as is the lowest jail-birds, the only exceptions being himself, Lombroso, Krafft-Ebing, Dr. Maudsley, and—for the sake of appearances—Goethe, Shakspere, and Beethoven. Perhaps he would even except a case so convenient in many ways for his theory as Coleridge sooner than spoil the connection between degeneration and "railway spine." If a man's senses are acute, he is degenerate, hyperaesthesia having been observed in asylums. If he is particular as to what he wears, he is degenerate; silk dressing-gowns and knee-breeches are grave symptoms, and woollen shirts conclusive. If he is negligent in these matters, clearly he is inattentive, and therefore degenerate. If he drinks, he is neurotic; if he is a vegetarian and teetotaller, let him be locked up at once. If he lives an evil life, that fact condemns him without further words; if, on the other hand, his conduct is irreproachable, he is a wretched "mattoid," incapable of the will and courage to realize his vicious propensities in action. If he writes verse, he is afflicted with echolalia; if he writes prose, he is a graphomaniac; if in his books he is tenacious of his ideas, he is obsessed; if not, he is "amorphous" and "inattentive." Wagner, as we have seen, contrived to be both obsessed and inattentive, as might be expected from one who was "himself alone charged with a greater abundance of degeneration than all the other degenerates put together." And so on and so forth.

There is, however, one sort of mental weakness, common among men who take to science, as so many people take to art, without the necessary brain power, which Nordau, with amusing unconsciousness of himself, has omitted. I mean the weakness of the man who, when his theory works out into a flagrant contradiction of the facts, concludes: "So much the worse for the facts; let them be altered," instead of: "So much the worse for my theory." What in the name of common sense is the value of a theory which identifies Ibsen, Wagner, Tolstoi, Ruskin, and Victor Hugo with the refuse of our prisons and lunatic asylums? What is to be said of the state of mind of an inveterate

pamphleteer and journalist who, instead of accepting that identifica-
tion as a *reductio-ad-absurdum* of the theory, desperately sets to work
to prove it by pointing out that there are numerous resemblances—that
they all have heads and bodies, appetites, aberrations, whims, weak-
nesses, asymmetrical features, erotic impulses, fallible judgments, and
the like common properties, not merely of all human beings, but all
vertebrate organisms. Take Nordau's own list—"vague and incoherent
thought, the tyranny of the association of ideas, the presence of obses-
sions, erotic excitability, religious enthusiasm, feebleness of percep-
tion, will, memory, and judgment, as well as inattention and instabil-
ity"; is there a single man capable of understanding these terms who
will not plead guilty to some experience of all of them, especially when
he is accused vaguely and unscientifically, without any statement of
the subject, or the moment, or the circumstances to which the accusa-
tion refers, or any attempt to fix a standard of sanity? I could prove
Nordau to be an elephant on more evidence than he has brought to
prove that our greatest men are degenerate lunatics. The papers in
which Swift, having predicted the death of the sham prophet Bicker-
staff on a certain date, did, after that date, immediately prove that he
was dead are much more closely and fairly reasoned than any of
Nordau's chapters. And Swift, though he afterwards died in a mad-
house, was too sane to be the dupe of his own logic. At that rate, where
will Nordau die? Probably in a highly respectable suburban villa.

Nordau's most likeable point is the freedom and boldness with
which he expresses himself. Speaking of Peladan (of whose works I
know nothing), he says, whilst holding him up as a typical degenerate
of the mystical variety: "His moral ideal is high and noble. He pursues
with ardent hatred all that is base and vulgar, every form of egoism,
falsehood, and thirst for pleasure; and his characters are thoroughly
aristocratic souls, whose thoughts are concerned only with the worthi-
est, if somewhat exclusively artistic, interests of society." On the other
hand, Maeterlinck is a "poor devil of an idiot"; Mr. W. D. O'Connor, for
describing Whitman as "the good gray poet," is politely introduced as
"an American driveller"; Nietzsche "belongs, body and soul, to the
flock of the mangy sheep"; Ibsen is "a malignant, anti-social simple-
ton"; and so on. Only occasionally is he insincerely Pharisaical in his
tone, as, for instance, when he pretends to become virtuously indig-
nant over Wagner dramas, and plays to Mrs. Grundy by exclaiming
ironically: "How unperverted must wives and readers be, when they
are in a state of mind to witness these pieces without blushing crimson
and sinking into the earth for shame!" This, to do him justice, is only
an exceptional lapse; a far more characteristic comment of his on
Wagner's love-scenes is: "The lovers in his pieces behave like tom cats

gone mad, rolling in contortions and convulsions over a root of vale-rian." And he is not always on the side of the police, so to speak; for he is as careless of the feelings of the "beer-drinking" German *bourgeoisie* as of those of the aesthetes. Thus, though on one page he is pointing out that Socialism and all other forms of discontent with the existing social order are "stigmata of degeneration," on the next he is talking pure Karl Marx. For example, taking the two sides in their order:

> Ibsen's egomania assumes the form of Anarchism. He is in a state of constant revolt against all that exists. . . . The psycho-logical roots of his anti-social impulses are well known. They are the degenerate's incapacity for self-adaptation, and the resul-tant discomfort in the midst of circumstances to which, in conse-quence of his organic deficiencies, he cannot accommodate him-self. "The criminal," says Lombroso, "through his neurotic and impulsive nature, and his hatred of the institutions which have punished or imprisoned him, is a perpetual latent political rebel, who finds in insurrection the means, not only of satisfying his passions, but of even having them countenanced for the first time by a numerous public."
>
> Wagner is a declared Anarchist. . . . He betrays that mental condition which the degenerate share with enlightened reform-ers, born criminals with the martyrs of human progress—namely, deep, devouring discontent with existing facts. . . . He would like to crush "political and criminal civilization," as he calls it.

Now for Nordau speaking for himself.

> Is it not the duty of intelligent philanthropy and justice, with-out destroying civilization, to adopt a better system of economy and transform the artisan from a factory convict, condemned to misery and ill health, into a free producer of wealth, who enjoys the fruits of his labor himself, and works no more than is com-patible with his health and his claims on life?
>
> Every gift that a man receives from some other man without work, without reciprocal service, is an alms, and as such is deeply immoral.
>
> Not in the impossible "return to Nature" lies healing for hu-man misery, but in the reasonable organization of our struggle with nature—I might say, in universal and obligatory service against it, from which only the crippled should be exempted.
>
> In England it was Tolstoi's sexual morality that excited the greatest interest; for in that country economic reasons condemn

a formidable number of girls, particularly of the educated classes, to forego marriage; and, from a theory which honored chastity as the highest dignity and noblest human destiny, and branded marriage with gloomy wrath as abominable depravity, these poor creatures would naturally derive rich consolation for their lonely, empty lives and their cruel exclusion from the possibility of fulfilling their natural calling.

So it appears that Nordau, too, shares "the degenerate's incapacity for self-adaptation, and the resultant discomfort in the midst of circumstances to which, in consequence of his organic deficiencies, he cannot accommodate himself." But he has his usual easy way out of the dilemma. If Ibsen and Wagner are dissatisfied with the world, that is because the world is too good for them; but, if Max Nordau is dissatisfied, it is because Max is too good for the world. His modesty does not permit him to draw the distinction in these exact terms. Here is his statement of it:

> Discontent shews itself otherwise in the degenerate than in reformers. The latter grow angry over real evils only, and make rational proposals for their remedy which are in advance of the time: these remedies may presuppose a better and wiser humanity than actually exists; but, at least, they are capable of being defended on reasonable grounds. The degenerate, on the other hand, selects among the arrangements of civilization such as are either immaterial or distinctly suitable, in order to rebel against them. His fury has either ridiculously insignificant aims, or simply beats the air. He either gives no earnest thought to improvement, or hatches astoundingly mad projects for making the world happy. His fundamental frame of mind is persistent rage against everything and every one, which he displays in venomous phrases, savage threats, and the destructive mania of wild beasts. *Wagner is a good specimen of this species.*

Wagner is only named here because the passage occurs in the almost incredibly foolish chapter which is headed with his name. In another chapter it might have been Ibsen, or Tolstoi, or Ruskin, or William Morris, or any other eminent artist who shares Nordau's objection, and yours and mine, to our existing social arrangements. In the face of this, it is really impossible to deny oneself the fun of asking Nordau, with all possible good humor, who he is and what he is, that he should rail in this fashion at great men. Wagner was discontented with the condition of musical art in Europe. In essay after essay he pointed out with the most laborious exactitude what it was he complained of, and how it might be

remedied. He not only shewed, in the teeth of the most envenomed opposition from all the dunderheads, pedants, and vested interests in Europe, what the musical drama ought to be as a work of art, but how theatres for its proper performance should be managed—nay, how they should be built, down to the arrangement of the seats and the position of the instruments in the orchestra. And he not only shewed this on paper, but he successfully composed the music dramas, built a model theatre, gave the model performances, *did* the impossible; so that there is now nobody left, not even [Edouard] Hanslick, who cares to stultify himself by repeating the old anti-Wagner cry of craziness and Impossibilism— nobody, save only Max Nordau, who, like a true journalist, is fact-proof. William Morris objected to the abominable ugliness of early Victorian decoration and furniture, to the rhymed rhetoric which has done duty for poetry ever since the Renaissance, to kamptulicon stained glass, and, later on, to the shiny commercial gentility of typography according to the American ideal, which was being spread through England by "Harper's" and "The Century," and which had not, like your abolition of "justifying" in Liberty, the advantage of saving trouble. Well, did he sit down, as Nordau suggests, to rail helplessly at the men who were at all events getting the work of the world done, however inartistically? Not a bit of it; he designed and manufactured the decorations he wanted, and furnished and decorated houses with them; he put into public halls and churches tapestries and picture-windows which cultivated people now travel to see as they travel to see first-rate fifteenth-century work in that kind; the books from his Kelmscott Press, printed with type designed by his own hand, are pounced on by collectors like the treasures of our national museums, all this work, remember, involving the successful conducting of a large business establishment and factory, and being relieved by the incidental production of a series of poems and prose romances which have placed their author in the position of the greatest living English poet. Now let me repeat the terms in which Nordau describes this kind of activity. "Ridiculously insignificant aims—beating the air—no earnest thought to improvement—astoundingly mad projects for making the world happy—persistent rage against everything and every one, displayed in venomous phrases, savage threats, and destructive mania of wild beasts." Is there not something deliciously ironical in the ease with which a splenetic pamphleteer, with nothing to shew for himself except a bookful of blunders tacked on to a mock scientific theory picked up at second hand from a few lunacy doctors with a literary turn, should be able to create a European scandal by declaring that the greatest creative artists of the century are barren and hysterical madmen? I do not know what the American critics have said about Nordau; but here the tone has been that there is much in what he

says, and that he is evidently an authority on the subjects with which he deals. And yet I assure you, on my credit as a man who lives by art criticism, that from his preliminary description of a Morris design as one "on which strange birds flit among crazily ramping branches, and blowzy flowers coquet with vain butterflies" (which is about as sensible as a description of the Norman chapel in the Tower of London as a characteristic specimen of Baroque architecture would be) to his coupling of Cimabue and Fra Angelico as primitive Florentine masters; from his unashamed bounce about "the conscientious observance of the laws of counterpoint" by Beethoven and other masters celebrated for breaking them to his unlucky shot about "a pedal bass with correct harmonization" (a pedal bass happening to be the particular instance in which even the professor-made rules of "correct harmonization" are suspended), Nordau gives himself away time after time as an authority upon the fine arts. But his critics, being for the most part ignorant literary men like himself, with sharpened wits and neglected eyes and ears, have swallowed Cimabue and Ghirlandajo and the pedal bass like so many gulls. Here an Ibsen admirer may maintain that Ibsen is an exception to the degenerate theory and should be classed with Goethe; there a Wagnerite may plead that Wagner is entitled to the honors of Beethoven; elsewhere one may find a champion of Rossetti venturing cautiously to suggest a suspicion of the glaringly obvious fact that Nordau has read only the two or three popular ballads like "The Blessed Damozel," "Eden Bower," "Sister Helen," and so on, which every smatterer reads, and that his knowledge of the mass of pictorial, dramatic, and decorative work turned out by Rossetti, Burne Jones, Ford Madox Brown, William Morris, and Holman Hunt, without a large knowledge and careful study of which no man can possibly speak with any critical authority of the pre-Raphaelite movement, is apparently limited to a glance at Holman Hunt's "Shadow of the Cross," or possibly an engraving thereof. And, if Nordau were to convince me tomorrow that I am wrong, and that he knows all the works of the school thoroughly, I should only be forced to assure him regretfully that he was all the greater fool. As it is, I have nothing worse to say of his art criticism than that it is the work of a pretentious ignoramus, instantly recognizable as such by any expert. I copy his bluntness of speech as a matter of courtesy to him.

And now, my dear Tucker, I have told you as much about Nordau's book as it is worth. In a country where art was really known to the people, instead of being merely read about, it would not be necessary to spend three lines on such a work. But in England, where nothing but superstitious awe and self-mistrust prevents most men from thinking about art as Nordau boldly speaks about it; where to have a sense of art

is to be one in a thousand, the other nine hundred and ninety-nine being Philistine voluptuaries or Puritan anti-voluptuaries—it is useless to pretend that Nordau's errors will be self-evident. Already we have native writers, without half his cleverness or energy of expression, clumsily imitating his sham scientific vivisection in their attacks on artists whose work they happen to dislike. Therefore, in riveting his book to the counter, I have used a nail long enough to go through a few pages by other people as well; and that must be my excuse for my disregard of the familiar editorial stigma of degeneracy which Nordau calls Agoraphobia, or Fear of Space.

Liberty, 27 July 1895 [C1086]

Must Peterborough Perish?

[Shaw wrote about Peterborough Cathedral with "Anti-Scrape" convic-tion, all the more so because William Morris was now dead.

John Loughborough Pearson (1817–97) was a British architect born in Brussels; he became a restorer as well as builder of churches in 1850. His best-known work is the north transept of Westminster Ab-bey (1860). In the Peterborough affair he weathered much criticism over the tottering central spire and the narthex at the west front, as the Morrisians preferred to save the weathered facade with all the irregularities and distortions of time using hidden structural means. In the end Pearson, supported by other architects of his persuasion, had his way, and the restoration proved actually to be a design based upon conjecture as to what the thirteenth-century structure looked like. He died with the work unfinished and in the hands of his son.

The Rev. Lewis Clayton, excoriated by Shaw as a simpleton, had become Canon of Peterborough in 1887. His sin was to move, in a meeting of Cathedral worthies, that an appeal be made for funds to restore the west front, transepts, and eastern chapel, then to deny that the work would involve major changes. Sir Arthur William Blomfield (1829–99), son of a Bishop of London, was an architect whose major achievement was the London Law Courts (1881). He supported Pear-son's renewal plans. "Baedeker" remains the term for the travel guides initiated by German publisher Karl Baedeker (1801–59). The cele-brated Portland Vase was a prize in the Duchess of Portland's collec-tion, said to be of onyx and of Greek origin, but actually proven to be of

glass. Bequeathed to the British Museum by Josiah Wedgwood (1730–95), it was smashed by a lunatic but skillfully repaired.]

The West Front of Peterborough Cathedral is one of the treasures of thirteenth-century architecture, as famous among West Fronts as the Thirteenth is famous among centuries. There is nothing wrong with it, except that the foundations do not go down to the rock; the Front has come two feet out of the perpendicular at a height of seventy feet in the course of nearly seven hundred years; and the rubble core of the wall, between the wonderfully wrought and beautifully weathered front skin and the back, has become disintegrated and ruinous. There is nothing alarming in this, as the remedy is perfectly well known. The foundations can be carried down to the rock by underpinning; the inclination of two feet does not matter in the least with a wall seven feet thick; and the disintegrated core can be removed bit by bit, and replaced with sound bonded work, without touching or disturbing one grain of dust on the priceless Front which is the glory of the edifice.

These operations are safe and comparatively cheap; and their practicability at Peterborough is vouched for by architects who admittedly have no superiors as authorities on the preservation of medieval buildings. If they are carried out, the West Front will give no trouble for another three hundred years.

The public, as far as it knows or cares anything about the matter, wishes the West Front to be preserved. The Society for the Preservation of Ancient Buildings, familiarly known as "The Anti-Scrape," numbers among its members and friends the best known of our disinterested lovers of medieval building in England, including "master-builders" whose experience is unequalled outside the Society. They have made sound jobs of more rickety buildings than Peterborough without displacing a stone from the outside; and their absolute integrity, personal and artistic, is beyond question. The Anti-Scrape not only told the Dean and Chapter eight years ago to put up the scaffolding that alarmed the public so when it went up the other day, but told exactly what they would find at the top of it as a consequence of the ruinous condition of the core of the wall. The Society of Antiquaries is equally roused, and is ready to contribute handsomely to the expenses. Both Societies are now exhausting themselves in efforts to rouse public feeling on the subject, and are preparing specifications as to the repairs required, in none of which have any of their members the smallest pecuniary interest, even to the extent of their names being mentioned. Every connoisseur in the country is aghast at the idea of the chief ornament of the great Cathedral being "restored." Mr. Ruskin implores us to fight for the West Front as

he would have fought in his prime. And yet the Dean and Chapter and their architect are going to "restore" it.

It may be asked how a building can be "restored" before it is taken away. The Dean & Co. are quite ready for that difficulty. They are going to knock down the West Front to begin with. And then Mr. Pearson (the architect aforesaid) will "restore" it with one of the best sham thirteenth-century fronts the year 1897 can produce.

Residentiary Canon Clayton, simpleton in chief to the Restoration Committee, writes the usual letter to the "Daily Graphic" (21 December), enclosing a modest drawing of the three famous gables, showing that nothing is contemplated but a patch on the crown of the north gable, and explaining that even that bit, when taken down, will be rebuilt "stone for stone." Poor innocent Canon! has he never heard that very old story before; and does he really believe that a mighty medieval wall, 700 years old, can be daintily picked to pieces and piled neatly up again, "stone for stone," even by so eminent a restorer as Mr. Pearson? The disintegrated rubble core of that wall can be taken out safely enough, and replaced invisibly with trustworthy bricks and mortar. But the wonderful front skin of formidable ashlar cannot be unpiled like a child's stack of wooden bricks: it will be either let alone or *smashed* away; and not one stone in five, even though its fragments were cherished like those of the Portland Vase, will ever face the weather again. The guileless Canon, once the Front is broken, will find his Committee meetings enlivened with report after report from the architect, showing how the operations have revealed that the south gable is in a condition not be contemplated without anxiety, and how it is to be desired that further funds should be forthcoming to make sure of the middle gable, and to renew the pillars. And the end will be a new West Front, and sentence in Baedeker: "The West Front was completely restored in 1897," which will elicit from the weary tourist the familiar sigh of relief at having one cathedral less to visit.

Let no man, on reading this, hastily declare that the West Front must and shall be saved. All the powers of destruction are leagued against it. Let it be considered, first and above all, that if the Front is properly preserved, *there will be nothing to show for the money.* The West Front will simply stand as it has always stood, for all the world as if not a farthing had been spent on it. Fancy the feelings of the subscribers who are looking forward to seeing it sandpapered to the raw, with nice new carving, nice statues, nice new stones, and a general suggestion about it that God has moved into a nice new house, with superior arrangements, presented to Him by an influential Committee! Consider the position of the Dean and Chapter if, by yielding to the Anti-Scrape, they give colour to the profane contention of that body

that Deans and Chapters should not be allowed to knock down and rebuild the nation's cathedrals—nay, the world's cathedrals—as they dare not, without leave from their landlords, knock down and rebuild their own villas! Consider, too, the feelings of Mr. Pearson and his called-in consultant, Sir Arthur Blomfield. When Sir Arthur's "restorations" are challenged, he simply says, "Pearson: am I right?" "Of course you are right," replies Mr. Pearson. At Peterborough, Mr. Pearson being challenged, exclaims, "Blomfield: am I right?" "Of course you are," is the reply, which settles the question; for where are two more eminent restorers than Mr. Pearson and Sir Arthur Blomfield to be found?

Let us be just to these eminent "restorers." If their services be called in by Deans and Chapters who, not being experts, must be guided by reputations built on the follies of other Deans and other Chapters, they must propose the methods in which they are proficient, and not those which lie quite outside the profession of architect as now practised. Mr. Pearson can knock down a genuine medieval building and substitute for it a sham one—no man more efficiently. But he cannot *preserve* a building, because that work cannot be done on drawing-boards or imitated from medieval "styles," nor can several such jobs be undertaken and carried out simultaneously. With twenty important works demanding his attention in the year, his art is necessarily an art of designing and then of delegation—consequently, after the design is made, an art of routine by contract. Now the preserver cannot either design or delegate, because he cannot tell from hour to hour how his work ought to progress. Even if he has not to teach jerry-trained workmen how to mix mortar and lay bricks, he must choose at almost every step between what to renew and what to let alone, as well as how to get round unforeseen difficulties and solve all sorts of petty engineering and building problems. He must always be on the spot. In short, the triumphs of the fashionable architect fit him for meddling with cathedral preservation about as well as the triumphs of an operatic tenor fit him for repairing trumpets. His fashionableness and activity as a designer of new buildings are the measure of the necessity for keeping him away from old ones. If any one doubts it, they can look at the nearest "restoration": it is sure not to be very far off. Westminster Abbey exhibits some interesting examples of Mr. Pearson's restorative ability.

However, all this has been said before, officially contradicted before, and subsequently proved before. It is to be regretted that the experts of the Anti-Scrape are not to be shaken in their view that they cannot publicly put their names and achievements against those of the "restorers" without breaking their rule of keeping the activity of the Society

free at all hazards from suspicion of professional advertisement. When William Morris was alive this did not matter so much, since he was not an architect, and could speak out without fear of misconstruction. But now that he is gone, the Dean and Chapter are masters of the situation; and when all is said that can be said, they will have eminent professional authority for preferring new West Fronts to old ones just as sincerely, no doubt, as they prefer new hats to old ones. Being technically and artistically ignorant, and socially mundane and precinctuary, they know no better. Only, the West Front of Peterborough is a terribly heavy price for the nation to pay for their imbecility.

The Saturday Review, 2 January 1897 [C1181]

Madox Brown, Watts, and Ibsen

[Shaw's excuse for an essay largely on art was a review of two new plays, The Mariners of England, *by Robert Buchanan and Charles Marlowe; and* Saucy Sally, *by Francis Burnand. A similar essay on Madox Brown, although not as devoid of mention of the subject ostensibly being reviewed, was Shaw's musical column of 27 January 1892 in* The World *(C837), which critiqued George Henschel's incidental music for* Hamlet *but had at least as much to say about Ford Madox Brown's "Lear and Cordelia," which Shaw described as "a picture in which the epic and dramatic elements have been wrought to the highest pitch."*

Madox Brown's Wycliffe picture was "Wycliffe reading his translation of the Bible to John of Gaunt." The "Jacopo Foscari" represented the young wife of the son of Francesco Foscari, fifteenth-century Doge of Venice, visiting her unjustly imprisoned and tortured husband. "Francesca da Rimini and her lover" pictured the doomed thirteenth-century couple, Paolo Malatesta and Francesca, who had been married to Paolo's brother, Giovanni, rather than to the man she loved.

Antonis Mor (1519–75) was a Dutch portrait painter who became Court painter in England, where in 1553 he was knighted as Sir Anthony More by Queen Mary. (Because of his painting visits to Italy and Spain he was also known as Antonio Moro.)

"Solveig the Sweet" was the gentle, pious heroine of Ibsen's Peer Gynt, *who is attracted to the wastrel Peer but from whom he runs away out of respect for her goodness. Years later he is cared for unto death by the now-blind, and gray, Solveig. "Mr. Smith of Brixton and Bayswater" was Shaw's metaphor for respectability; his "Palmer-*

stonians"—after Henry John Templeton, third Viscount Palmerston (1784–1865), rake, cabinet minister, prime minister—represented early Victorian elegance.]

It has not yet been noticed, I think, that the picture galleries in London are more than usually interesting just now to those lovers of the theatre who fully understand the saying "There is only one art." At the Grafton Gallery we have the life-work of the most dramatic of all painters, Ford Madox Brown, who was a realist; at the New Gallery that of Mr G. F. Watts, who is an idealist; and at the Academy that of Leighton, who was a mere gentleman draughtsman.

I call Madox Brown a realist because he had vitality enough to find intense enjoyment and inexhaustible interest in the world as it really is, unbeautified, unidealized, untitivated in any way for artistic consumption. This love of life and knowledge of its worth is a rare thing—whole Alps and Andes above the common market demand for prettiness, fashionableness, refinement, elegance of style, delicacy of sentiment, charm of character, sympathetic philosophy (the philosophy of the happy ending), decorative moral systems contrasting roseate and rapturous vice with lilied and languorous virtue, and making "Love" face both ways as the universal softener and redeemer, the whole being worshipped as beauty or virtue, and set in the place of life to narrow and condition it instead of enlarging and fulfilling it. To such self-indulgence most artists are mere pandars; for the sense of beauty needed to make a man an artist is so strong that the sense of life in him must needs be quite prodigious to overpower it. It must always be a mystery to the ordinary beauty-fancying, life-shirking amateur how the realist in art can bring his unbeautified, remorseless celebrations of common life in among so many pretty, pleasant, sweet, noble, touching fictions, and yet take his place there among the highest, although the railing, the derision, the protest, the positive disgust, are almost universal at first. Among painters the examples most familiar to us are Madox Brown and Rembrandt. But Madox Brown is more of a realist than Rembrandt; for Rembrandt idealized his color; he would draw life with perfect integrity, but would paint it always in a golden glow—as if he cared less for the direct light of the sun than for its reflection in a pot of treacle—and would sacrifice real color to that stage glow without remorse. Not so Madox Brown. You can all but breathe his open air, warm yourself in his sun, and smell "the green mantle of the standing pool" in his Dalton picture. Again, Rembrandt would have died rather than paint a cabbage unconditionally green, or meddle with those piercing aniline discords of color which modern ingenuity has extracted from soot and other unpromising materials. Madox Brown took to Paisley shawls and magenta ribbons and

genuine greengrocer's cabbages as kindly as Wagner took to "false relations" in harmony. But turn over a collection of Rembrandt's etchings, especially those innumerable little studies which are free from the hobby of the chiaroscurist; and at once you see the uncompromising realist. Examine him at the most vulnerable point of the ordinary male painter—his studies of women. Women begin to be socially tolerable at thirty, and improve until the deepening of their consciousness is checked by the decay of their faculties. But they begin to be pretty much earlier than thirty, and are indeed sometimes at their best in that respect long before their chattering is, apart from the illusions of sex, to be preferred in serious moments to the silent sympathy of an intelligent pet animal. Take the young lady painted by Ingres as La Source, for example. Imagine having to make conversation for her for a couple of hours. Ingres is not merely indifferent to this: he is determined to make you understand that he values her solely for her grace of form, and is too much the classic to be affected by any more cordial consideration. Among Rembrandt's etchings, on the other hand, you will find plenty of women of all sorts; and you will be astonished and even scandalized at the catholicity of his interest and tolerance. He makes no conditions, classical or moral, with his heroines: Venus may be seventy, and Chloe in her least presentable predicament: no matter: he draws her for her own sake with enormous interest, neither as a joke, nor a moral lesson, nor a model of grace, but simply because he thinks her worth drawing as she is. You find the same thing in Madox Brown. Nature itself is not more unbiassed as between a pretty woman and a plain one, a young woman and an old one, than he. Compare the comely wife of John of Gaunt in the Wycliffe picture with the wife of Foscari, who has no shop-window good looks to give an agreeable turn to the pitifulness of her action as she lifts the elbow of the broken wretch whose maimed hands cannot embrace her without help. A *bonne bouche* of prettiness here would be an insult to our humanity; but in the case of Mrs John of Gaunt, the good looks of the wife as she leans over and grabs at the mantle of John, who, in the capacity of the politically excited English-man, is duly making a fool of himself in public, give the final touch to the humor and reality of the situation. Nowhere do you catch the mature Madox Brown at false pathos or picturesque attitudinizing. Think of all the attitudes in which we have seen Francesca da Rimini and her lover; and then look at the Grafton Gallery picture of that deplorable, ridiculous pair, sprawling in a death agony of piteous surprise and discomfiture where the brutish husband has just struck them down with his uncouthly murderous weapon. You ask disgustedly where is the noble lover, the beautiful woman, the Cain-like avenger? You exclaim at the ineptitude of the man who could omit all this, and simply make you feel

as if the incident had really happened and you had seen it—giving you, not your notion of the beauty and poetry of it, but the life and death of it. I remember once, when I was an "art critic," and when Madox Brown's work was only known to me by a few drawings, treating Mr Frederick Shields to a critical demonstration of Madox Brown's deficiencies, pointing out in one of the drawings the lack of "beauty" in some pair of elbows that had more of the wash tub than of The Toilet of Venus about them. Mr Shields contrived without any breach of good manners to make it quite clear to me that he considered Madox Brown a great painter and me a fool. I respected both convictions at the time; and now I share them. Only, I plead in extenuation of my folly that I had become so accustomed to take it for granted that what every English painter was driving at was the sexual beautification and moral idealization of life into something as unlike itself as possible, that it did not at first occur to me that a painter could draw a plain woman for any other reason than that he could not draw a pretty one.

Now turn to Mr Watts, and you are instantly in a visionary world, in which life fades into mist, and the imaginings of nobility and beauty with which we invest life become embodied and visible. The gallery is one great transfiguration: life, death, love and mankind are no longer themselves: they are glorified, sublimified, lovelified: the very draperies are either rippling lakes of color harmony, or splendid banners like the flying cloak of Titian's Bacchus in the National Gallery. To pretend that the world is like this is to live the heavenly life. It is to lose the whole world and gain one's own soul. Until you have reached the point of realizing what an astonishingly bad bargain that is you cannot doubt the sufficiency of Mr Watts's art, provided only your eyes are fine enough to understand its language of line and color.

Now if you want to emulate my asinine achievements as a critic on the occasion mentioned above in connection with Mr Shields, you cannot do better than criticize either painter on the assumption that the other's art is the right art. This will lead you by the shortest cut to the conclusion either that Mr Watts's big picture of the drayman and his horses is the only great work he ever achieved, or that there is nothing endurable in Madox Brown's work except the embroidery and furniture, a few passages of open-air painting, and such technical tours de force as his combination of the virtuosities of the portrait styles of Holbein, Antonio Moro, and Rembrandt in the imaginary portrait of Shakespear. In which event I can only wish you sense enough to see that your conclusion is not a proof of the futility of Watts or Madox Brown but a reductio ad absurdum of your own critical method.

And now, what has all this to do with the drama? Even if it had nothing to do with it, reader, the question would be but a poor return

for the pains I am taking to improve your mind; but let that pass. Have you never been struck with the similarity between the familiar paroxysms of Anti-Ibsenism and the abuse, the derision, the angry distaste, the invincible misunderstanding provoked by Madox Brown? Does it not occur to you that the same effect has been produced by the same cause—that what Ibsen has done is to take for his theme, not youth, beauty, morality, gentility, and propriety as conceived by Mr Smith of Brixton and Bayswater, but real life taken as it is, with no more regard for poor Smith's dreams and hypocrisies than the weather has for his shiny silk hat when he forgets his umbrella? Have you forgotten that Ibsen was once an Idealist like Mr Watts, and that you can read The Vikings, or The Pretenders, or Brand, or Emperor and Galilean in the New Gallery as suitably as you can hang Madox Brown's Parisina or Death of Harold in the Diploma Gallery at the Royal Academy? Or have you not noticed how the idealists who are full of loathing for Ibsen's realistic plays will declare that these idealistic ones are beautiful, and that the man who drew Solveig the Sweet could never have descended to Hedda Gabler unless his mind had given way.

I had intended to pursue this matter much further; but I am checked, partly by want of space, partly because I simply dare not go on to Leighton, and make the application of his case to the theatre. Madox Brown was a man; Watts is at least an artist and poet; Leighton was only a gentleman. I doubt if it was ever worth while being a gentleman, even before the thing had become the pet fashion of the lower-middle class; but today, happily, it is no longer tolerated among capable people, except from a few old Palmerstonians who do not take it too seriously. And yet you cannot cure the younger actor-managers of it. Sir Henry Irving stands on the Watts plane as an artist and idealist, cut off from Ibsen and reality by the deplorable limitations of that state, but at least not a snob, and only a knight on public grounds and by his own peremptory demand, which no mere gentleman would have dared to make lest he should have offended the court and made himself ridiculous. But the others!—the knights expectant. Well, let me not be too highminded at their expense. If they are Leightonian, they might easily be worse. There are less handsome things in the world than that collection of pictures at the Academy, with its leading men who are all gentlemen, its extra ladies whose Liberty silk robes follow in their flow the Callipygean curves beneath without a suggestion of coarseness, its refined resolution to take the smooth without the rough, Mayfair without Hoxton, Melbury Road without Saffron Hill. All very nice, gentlemen and ladies; but much too negative for a principle of dramatic art. To suppress instead of to express, to avoid instead of to conquer, to ignore instead of to heal: all this, on the stage, ends in

turning a man into a stick for fear of creasing his tailor's handiwork, and a woman into a hairdresser's window image lest she should be too actressy to be invited to a fashionable garden-party.

The Saturday Review, 13 March 1897 [C1197]

Delacroix

[Laurence Binyon (1869–1943), English poet and art critic, in his 7 December 1907 column in the Saturday Review *had commented that "whatever opinion we may have of Delacroix' art—and few but fanatics will share Mr. Bernard Shaw's contempt for it—the painter is undeniably a great representative figure. . . ." Binyon may have confused Shaw's writings with those of Oscar Wilde, who did deplore Delacroix. Shaw responded on the letters page.]*

Sir,—What on earth does Mr. Laurence Binyon mean by my "contempt for the art of Delacroix"? In the eighteen-eighties I gave the British Museum library attendants much trouble by my habit of having out the Faust and Hamlet lithographs, and trying them on various people to find out whether the Romantic movement was really dead, or whether there were still young men whom these lithographs could fascinate as they fascinated me. Has any living man done more for Delacroix without being paid for it? I doubt it.

Yours, &c.,

G. Bernard Shaw

Saturday Review, 14 December 1907 [1623]

The Picture or the Baby?
What Mr. G. B. Shaw and Mr. Wells Would Do.
Art v. Humanity

["The picture or the baby" dilemma was a version of a moral choice often touted by newspapers to raise hackles, and thus circulation. Shaw always put humane values ahead of artistic ones, and did so again here. He had raised a similar issue in his Caesar and Cleopatra

(1898), in the burning of the library at Alexandria, and again in The
Doctor's Dilemma *(1907).*

*Sir George Birdwood (1832–1917), trained as a physician, held
posts in the India Office 1871–1902, and became an authority on
Indian and related Eastern art. Colonel Sir Henry Knollys had seen
military service in many Asian countries and written on Chinese and
Japanese culture; Algernon Ashton was a concert pianist and com-
poser of chamber and piano works. Herbert George Wells (1866–1946)
was the novelist and futurist.*

*The "Dresden Madonna" or Madonna di San Sisto, painted by Ra-
phael in 1515, and often considered his greatest picture, was acquired
for Dresden by purchase from the Benedictine monks of San Sisto, at
Piacenza. It was Shaw's original choice for the Madonna picture in his
play* Candida *(1894), but he substituted the Titian Madonna possibly
because there was no babe-in-arms to distract attention from the Ma-
donna figure.]*

The problem in ethics put before Sir George Birdwood by Sir Henry
Knollys, and so uncompromisingly answered by the former, has drawn
forth a host of letters from "Express" readers supplementary to the
views given by various eminent persons in yesterday's issue.

Sir George Birdwood wants to save the famous Temple of Philae on
the banks of the Nile from the devastating effects of the flooding
caused by the Aswan dam, and he puts these historic ruins far in front
of the welfare of the Egyptian peasants.

Sir Henry Knollys put the problem to Sir George Birdwood:—

> Were one in a garret, with a Dresden Madonna on the walls
> and a live baby on the floor, and suddenly it was all ablaze—
> which would one save?

Sir George Birdwood unhesitatingly replied:—

> I would try to save both, but if the direful choice were forced
> on me I should certainly save the Dresden Madonna first.

We print below a selection from the large number of letters received
on this subject:

MR. H. G. WELLS.
To the Editor of the "Express."

Sir. Save the baby certainly; and if the alternative was not a baby but
a kitten, I would save the kitten in the interests of art.

The worship of masterpieces means the suffocation of art and
literature.

Dunmow H. G. WELLS

"G.B.S."

To the Editor of the "Express."

Sir. In reply to your inquiry as to whether, if I were in a burning garret with the Dresden Madonna and a live baby, I should save the Madonna or the live baby, I should certainly save the live baby; but this reply leaves you as wise as you were before, because you can hardly call Raphael's baby, which is getting on for four hundred years old, and is as much alive as on the day of its birth, a dead baby.

What Sir George Birdwood has written on the Philae question is obviously the soundest common sense.

Adelphi-terrace, W.C. G. BERNARD SHAW

ONLY ONE POSSIBLE ANSWER.

To the Editor of the "Express."

Sir. Of course, there can only be one possible answer to this wicked, not to say, contemptible, question.

I reply with a voice of thunder—Save the baby before the Dresden Madonna.

West Hampstead ALGERNON ASHTON

Daily Express, 3 October 1912 [C1838]

Rodin

[Auguste Rodin (1840–1917) was the major French sculptor of his time. Charlotte Shaw, even more than her husband, wanted Shaw immortalized via a Rodin bust, and commissioned the work. Alvin Langdon Coburn (1882–1966) was an American expatriate photographer in London, one of the rare practitioners of his instrument to turn his pictures into art—cityscapes and camera portraiture. At Shaw's suggestion he photographed his subject nude, in the attitude of Rodin's "Le Penseur." It was exhibited to considerable comment in the press.

Pierre Puvis de Chavannes (1824–98) was a French academic painter at the height of his fame in the 'Nineties; Paul Troubetskoi (1867–1938) was a Russian emigré sculptor for whom Shaw was as much a friend as portrait subject. Jacques Offenbach was a German-Jewish composer of opéra bouffe; Neville Stephen Lytton, third Earl of Lytton (1879–1951) was an English painter; Bertel Thorvaldsen (1770–1844) was a Danish sculptor. Giovanni Lorenzo Bernini (1598–1680) was an Italian baroque sculptor and painter; Jean-Antoine

Houdon (1741–1828) was a French classical sculptor. Innocent XI (1611–89) was Pope 1676–89. Morris in Shaw's closing verse is William Morris.]

In Munich once, when I was complimenting a German on the artistic activity of the place (whither I had come to see an enthusiastic but execrable performance of one of my own plays), he replied, "Do not be deceived: this city is a Capua. When an artist settles down here he produces no more art. Our art will be our ruin."

Some time before this, I had written to the greatest artist France or the world has produced for several centuries. I addressed the letter to Monsieur Auguste Rodin, Meudon. If, during one of his visits to London, I had addressed it to Rodin, England, the British Post Office, Philistine as it is, would have delivered it to him within twenty-four hours. It was returned to me by the French Post Office marked *Inconnu.* I naturally exclaimed "God has forgotten this people: they are hopeless." Rodin explained to me afterwards that as he was not a pupil of the Beaux Arts he was not counted as an artist in France, but only as a common mason. I then understood why Germany was the first country to recognize me as a considerable dramatic author, and why France will be the last. Not that I complain; . . . but I am so deplorably lacking in good taste as the French understand it as to know my own value (and perhaps a little more); and I affirm that Europe can be divided into barbarous countries and civilized countries by the simple test of the presence or absence of a Shaw vogue in the theatres.

In the year 1906 it was proposed to furnish the world with an authentic portrait-bust of me before I had left the prime of life too far behind. The question then arose: Could Rodin be induced to undertake the work? On no other condition would I sit, because it was clear to me that Rodin was not only the greatest sculptor then living, but the greatest sculptor of his epoch: one of those extraordinary persons who, like Michael Angelo, or Phidias, or Praxiteles, dominate whole ages as fashionable favorites dominate a single London season. I saw, therefore, that any man who, being a contemporary of Rodin, deliberately allowed his bust to be made by anybody else, must go down to posterity (if he went down at all) as a stupendous nincompoop.

Also, I wanted a portrait of myself by an artist capable of seeing me. Many clever portraits of my reputation were in existence; but I have never been taken in by my reputation, having manufactured it myself. A reputation is a mask which a man has to wear just as he has to wear a coat and trousers: it is a disguise we insist on as a point of decency. The result is that we have hardly any portraits of men and women. We

have no portraits of their legs and shoulders; only of their skirts and trousers and blouses and coats. Nobody knows what Dickens was like, or what Queen Victoria was like, though their wardrobes are on record. Many people fancy they know their faces; but they are deceived: we know only the fashionable mask of the distinguished novelist and of the queen. And the mask defies the camera. When Mr Alvin Langdon Coburn wanted to exhibit a full-length photographic portrait of me, I secured a faithful representation up to the neck by the trite expedient of sitting to him one morning as I got out of my bath. The portrait was duly hung before a stupefied public as a first step towards the realization of Carlyle's antidote to political idolatry: a naked parliament. But though the body was my body, the face was the face of my reputation. So much so, in fact, that the critics concluded that Mr Coburn had faked his photograph, and stuck my head on somebody else's shoulders. For, as I have said, the mask cannot be penetrated by the camera. It is transparent only to the eye of a veritably god-like artist.

Rodin tells us that his wonderful portrait-busts seldom please the sitters. I can go further, and say that they often puzzle and disappoint the sitters' friends. The busts are of real men, not of the reputations of celebrated persons. Look at my bust, and you will not find it a bit like that brilliant fiction known as G.B.S. or Bernard Shaw. But it is most frightfully like me. It is what is really there, not what you think is there. The same with Puvis de Chavannes and the rest of them. Puvis de Chavannes protested, as one gathers—pointed to his mirror and to his photographs to prove that he was not like his bust. But I am convinced that he was not only like his bust, but that the bust actually was himself as distinct from his collars and his public manners. Puvis, though an artist of great merit, could not see himself. Rodin could. He saw me. Nobody else has done that yet.

Troubetskoi once made a most fascinating Shavian bust of me. He did it in about five hours, in Sargent's studio. It was a delightful and wonderful performance. He worked convulsively, giving birth to the thing in agonies, hurling lumps of clay about with groans, and making strange, dumb movements with his tongue, like a wordless prophet. He covered himself with plaster. He covered Sargent's carpets and curtains and pictures with plaster. He covered me with plaster. And, finally, he covered the block he was working on with plaster to such purpose that, at the end of the second sitting, lo! there stood Sargent's studio in ruins, buried like Pompeii under the scoriae of a volcano, and in the midst a spirited bust of one of my reputations, a little idealized (quite the gentleman, in fact) but recognizable a mile off as the sardonic author of Man and Superman, with a dash of Offenbach, a touch of Mephistopheles, and a certain aristocratic delicacy and distinction

that came from Troubetskoi himself, he being a prince. I should like to have that bust; but the truth is, my wife [could not] stand Offenbach-Mephistopheles; and I was not allowed to have the bust any more than I was allowed to have that other witty jibe at my poses, Neville Lytton's portrait of me as Velasquez's Pope Innocent.

Rodin worked very differently. He plodded along exactly as if he were a river god doing a job of wall-building in a garden for three or four francs a day. When he was in doubt he measured me with an old iron dividers, and then measured the bust. If the bust's nose was too long, he sliced a bit out of it, and jammed the tip of it up to close the gap, with no more emotion or affection than a glazier putting in a window pane. If the ear was in the wrong place, he cut it off and slapped it into its right place, excusing the ruthless mutilations to my wife (who half expected to see the already terribly animated clay bleed) by remarking that it was shorter than to make a new ear. Yet a succession of miracles took place as he worked. In the first fifteen minutes, in merely giving a suggestion of human shape to the lump of clay, he produced so spirited a thumbnail bust of me that I wanted to take it away and relieve him from further labor. It reminded me of a highly finished bust by Sarah Bernhardt. . . . But that phase vanished like a summer cloud as the bust evolved. I say evolved advisedly; for it through every stage in the evolution of art before my eyes in the course of a month. After that first fifteen minutes it sobered down into a careful representation of my features in their exact living dimensions. Then this representation mysteriously went back to the cradle of Christian art, at which point I again wanted to say: "For Heaven's sake, stop and give me that: it is a Byzantine masterpiece." Then it began to look as if Bernini had meddled with it. Then, to my horror, it smoothed out into a plausible, rather elegant piece of eighteenth-century work, almost as if Houdon had touched up a head by Canova or Thorwaldsen, or as if Leighton had tried his hand at eclecticism in bust-making. At this point Troubetskoi would have broken it with a hammer, or given it up with a wail of despair. Rodin contemplated it with an air of callous patience, and went on with his job, more like a river god turned plasterer than ever. Then another century passed in a single night; and the bust became a Rodin bust, and was the living head of which I carried the model on my shoulders. It was a process for the embryologist to study, not the aesthete. Rodin's hand worked, not as a sculptor's hand works, but as the Life Force works. What is more, I found that he was aware of it, quite simply. I no more think of Rodin as a celebrated sculptor that I think of Elijah as a well-known *littérateur* and forcible after-dinner speaker. His "Main de Dieu" is his own hand. That is why

all the stuff written about him by professional art critics is such ludicrous cackle and piffle. I have been a professional art critic myself, and perhaps not much of one at that (though I fully admit that I touched nothing I did not adorn), but at least I knew how to take off my hat and hold my tongue when my cacklings and pifflings would have been impertinences.

Rodin took the conceit out of me most horribly. Once he shewed me a torso of a female figure; an antique. It was a beauty; and I swallowed it whole. He waited rather wistfully for a moment, to see whether I really knew chalk from cheese, and then pointed out to me that the upper half of the figure was curiously inferior to the lower half, as if the sculptor had taught himself as he went along. The difference, which I had been blind to a moment before, was so obvious when he pointed it out, that I have despised myself ever since for not seeing it. There never was such an eye for carved stone as Rodin's. To the average critic or connoisseur half the treasures he collects seem nothing but a heap of old paving stones. But they all have somewhere a scrap of modelled surface, perhaps half the size of a postage stamp, that makes gems of them. In his own work he shews a strong feeling for the beauty of marble. He gave me three busts of myself: one in bronze, one in plaster, one in marble. The bronze is me (growing younger now). The plaster is me. But the marble has quite another sort of life: it glows; and the light flows over it. It does not look solid: it looks luminous; and this curious glowing and flowing keeps people's fingers off it; for you feel as if you could not catch hold of it.

Busts outlive plays. In [a] copy of the Kelmscott Chaucer I wrote these lines:

I have seen two masters at work, Morris who made this book,
 The other Rodin the Great, who fashioned my head in clay:
I give the book to Rodin, scrawling my name in a nook
 Of the shrine their works shall hallow when mine are dust by the
 way.

I once wrote that at least I was sure of a place in the biographical dictionaries a thousand years hence as: "Shaw, Bernard: subject of a bust by Rodin: otherwise unknown."

> In Munich. . . . From the preface to the French edition of *Common Sense About the War* (NIL). In the year. . . . From "Rodin," *The Nation*, 9 November 1912 (C1845), complete. Busts outlive plays. . . . *Table-Talk of G.B.S.* (1925), ed. Archibald Henderson (A173).

[The Lane Collection]

[Shaw's letter was read the day before publication at a meeting in the Mansion House, Dublin, which discussed a means of housing the Hugh Lane collection of modern art. Sir Hugh Percy Lane (1875–1915), Irish art collector, would become director of the National Gallery of Ireland in 1914; he was lost at sea the following year when German torpedoes sank the Lusitania. *His personal collection of thirty-nine French Impressionist pictures had been bequeathed to Dublin in a codicil to his will not yet witnessed, which gave the National Gallery in London the legal quibble by which the paintings were held until 1959.*

Henry Edward Doyle (1827–92) had been director of the National Galllery of Ireland 1869–92. Charles Rowley (1840–1933), a member of the city council, founded the Ancoats Brotherhood in Manchester in 1877, perhaps the earliest social settlement house in England, anticipating even Toynbee Hall in London (1884). Shaw had addressed the Brotherhood in 1906. Edward Rimbault Dibdin (1853–1941) was art critic of the Liverpool Courier, *1887–1904, then curator of the Walker Art Gallery, Liverpool. Shaw had known him since 1885. Sir Whitworth Wallis, knighted in June 1912, had been, since 1885, director of the Birmingham Art Gallery.]*

10 Adelphi Terrace, London, W.C.
28th November, 1912

To the Right Honorable The Lord Mayor of Dublin.

My Dear Lord Mayor,—I understand that you have convened a meeting to consider the question of providing a suitable gallery for the collection of works of art brought together by Sir Hugh Lane and now stored in a very handsome dwelling house in Harcourt Street.

I venture to hope that the committee will allow me a word in the matter on the following grounds. Though I am probably known to the committee only as a man of letters, I am not guilty of that want of sense of the vital importance of municipal enterprise and ignorance of its practical difficulties which is unfortunately too common in my profession. I have had six years service as a municipal councillor, not only, I may say, as an ornamental member attending public council meetings, but as a hard working committee man. I know therefore by experience that when public money is to be expended on works of art, the difficulties do not arise through what is called Philistinism on the part of the men of business who compose our municipal committees—indeed, many of the greatest public galleries in Europe owe their existence to

the culture of city merchants—but rather to the fact that unless municipal councillors have made a special study of pictures they find themselves asked to vote large sums for the acquisition or accommodation of works of art which they would not care to purchase for their own private enjoyment, and which do not seem to them likely to be popular with any considerable section of the ratepayers. But as they are aware at the same time that the most highly prized pictures in our great national collections are open to the same objection, and that the pictures which please the ratepayers most or which appear in the annual academy exhibitions and in the shop windows are not the sort of pictures a great civic corporation should buy for its public collections, they are compelled to look for guidance to those who have made a special study of the fine arts.

Let me refer for a moment to the results of this policy of getting the best available advice, and accepting it even without sharing its preferences and enthusiasms. When I was a boy in Dublin I did not know that our Dublin National Gallery was, for its size, one of the very best in Europe: that is, in the world. I found that out only when I had travelled and seen other collections. We owe that eminence practically to the genius of one man, Doyle. Your colleagues will be the first to admit that at no time could such a magnificent result have been achieved by a committee of the Corporation buying what it liked. Turn from our National Gallery to the Manchester Municipal Art Gallery, which has been formed very largely in that way. It is a picture dealer's lumber room, relieved by a few masterpieces which enthusiasts like Mr. Charles Rowley have from time to time forced on the Corporation at the point of the bayonet. The frescoes by Madox Brown in the town hall, which are now the most famous of Manchester's art treasures, would never have existed but for a couple of men who knew Madox Brown's value, and named him as an English contractor who would decorate the walls at the same price per square foot as a Belgian firm which had just tendered for the job. Turn from Manchester to Birmingham. The Corporation of Birmingham found a collector of genius in Sir Whitworth Wallis, and allowed him a free hand to buy pictures which he liked and which the Corporation did not like. It built him a splendid extension of the old gallery under his supervision, and was amazed to find its pictures doubled in value by being at last properly exhibited. And the result is that the Birmingham gallery of modern pictures is almost as famous as our National Gallery. To complete the lesson let me turn to Liverpool. There we find the Corporation trying to make the best of both worlds by clearing out its gallery for several months in the year in order to have an exhibition of popular shop pictures with admission at a shilling a head, whilst its fine permanent collection, nursed by

its curator, Mr. Rimbault Dibdin, is packed away in cellars and wasted. Result: the Corporation of Liverpool is so discredited as far as art is concerned that the Lord Mayor has to countenance public meetings in the gallery to denounce the misuse made of it by the body over which he presides.

Dublin has had the extraordinary good fortune to have had not only a collector of genius in the person of Doyle for its national gallery of old masters, but later on an equally gifted collector of modern pictures. It has not been possible for him to compete with Birmingham and Sir Whitworth Wallis for the masterpieces of the English school which began with the Preraphaelites and ended with Burne-Jones; but Ireland is not concerned with English art as Birmingham is. Sir Hugh Lane, in making a great collection of the modern French school that arose at the same time as the English school, and of the works of those painters, especially Irish painters, who assimilated its technical discoveries and responded to that French audacity of spirit which is so congenial to our own national temperament, has placed in the hands of the Corporation of Dublin an instrument of culture the value of which is far beyond anything that can be expressed in figures by the City Accountant.

I speak on this point with strong personal feeling. The taste and knowledge in fine art which I acquired as a boy in the National Gallery of Dublin not only made it possible for me to live by my pen without discrediting my country, but are built into the fabric of the best work I have been able to do since. I was sometimes the only person in that gallery, except the attendants. If a member of the Corporation with a turn for false economy had looked in on these occasions he might have asked whether it was not monstrous that all the cost of maintaining such a building should be incurred for the entertainment of a single idle boy. But I hope I was not so bad a bargain after all. A few of us must spend our boyhood in this way if Irishmen are to keep and extend their share in forming the mind of the world: a share which we may with just pride claim to be large out of all proportion to our numbers and our opportunities.

Finally, may I say that the house in Harcourt Street will not do for the Lane Collection. It is a very fine specimen of that domestic architecture which lasted in Dublin up to 1830, and which still makes English visitors admire the house-fronts, the windows, the doors, the fanlights, at which no Dublin citizen ever dreams of looking twice. It would serve admirably for an exhibition of domestic furniture of the eighteenth century. But as a picture gallery it is absurd. As a place for exhibiting sculpture it is worse than absurd. Public collections must always depend to a great extent on gifts of works of art from public-spirited citizens. But no real lover of art will give a masterpiece unless he

knows that it will be properly cared for and effectively exhibited. A statue by Rodin is as great a treasure as a fine antique. But suppose someone has a statue by Rodin which he thinks should be dedicated to the public instead of hidden in a private house. At present he can see for himself that if he gives it to the Corporation of Dublin it will be shoved ignominiously into a conservatory on the landing of a dwelling house and treated with less respect than an umbrella stand. Birmingham will make as much of it as the Louvre makes of the Venus of Milo. Naturally he will give it to Birmingham and not to Dublin. The better you treat fine works of art, the more you will get of them. A good gallery is the best of investments, because people will give you pictures for nothing to hang in it which you could not acquire otherwise except by buying them in competition with American millionaires.

I have nothing more to say except to beg you to allow the importance of the subject to excuse the length of this communication. And as your Committee may be curious to know whether I am sufficiently in earnest to back my opinion, I shall be glad, if contributions are invited from private sources to assist the Corporation in providing a suitable gallery, to put down my own name for one hundred guineas.

> I am, my dear Lord Mayor,
> Yours faithfully, G. Bernard Shaw.

Irish Times, Dublin, 30 November 1912 [C1849]

Mr. Roger Fry's [Art] Criticism

[In an obituary essay on Sir Laurence Alma-Tadema in The Nation *(London) on 18 January 1913, Roger Fry downgraded Alma-Tadema's pictures as appealing to only the most mentally lazy in the lower middle classes. Roger Eliot Fry (1866–1934), who trained as an artist but made his living as a critic of art, organizer of exhibitions, and guide to moneyed buyers of art (one client was financier J. Pierpont Morgan), was the missionary of the Post-Impressionists, Paul Cézanne (1839–1906) in particular. He had arranged the first major exhibition of their art in London in 1910.*

Alma-Tadema, Fry argued, considered art as a commodity for shops, with only a shiny surface attraction that left it as nothing more than "dead mechanical art." Art historians in his view would have to recognize two concurrent cultures, existing side by side and ignoring one another—popular commercial art and the art of aesthetic values. It

was one of the earliest statements of a fact that twentieth-century art has since confirmed—that for the first time, an elitist aesthetic was being successfully created by artists who identified themselves as internal exiles within the mass culture, and that mass culture—the taste of the markets which a Rembrandt or a Turner might have satisfied— was no culture worthy of the term.

A debate about Fry's dicta filled the letters columns of The Nation *for several weeks following. Philip Burne-Jones, with whom Shaw had seldom agreed, attacked Fry for attacking the "dead great" in "brutally indecent haste" with a "poison pen." Fry responded that he had used Alma-Tadema as a representative of the other, lower, culture, not as an individual, and insisted that two art standards indeed existed, one of them state-supported through the Royal Academy at Burlington House, ignored by the masses but not by the perceptive few, who would always be few. The state, he argued, should support both, or none. "Let posterity decide."*

Sir William Blake Richmond, one of the surviving Victorian masters, charged Fry with "indecent suicidal egoism," and described his kind as "effete intellectuals [who] caper and gyrate alone." Both Richmond and young Burne-Jones had additional harsh words for the Post-Impressionists, spurring Lytton Strachey to wonder whether the old guard sought a monopoly on censure. The real question, he reminded Fry's attackers, was one of taste—that death did not enable one's escape from evaluation, but imposed a demand for it.

Shaw entered the controversy with some autobiography about his experience as art critic a generation earlier, then responded to Fry's reply.

Giles Lytton Strachey (1880–1932) was then a reviewer and critic, having not yet made his mark as bitchy biographer with Eminent Victorians *(1918). Norman Wilkinson (1892–1934) was a scenic and costume designer for the theater. Edward Gordon Craig (1872–1966), illegitimate son of Ellen Terry and architect-designer Edward Godwin (1833–86), was a stage designer. Shaw's apparent coinage of* inscenation *suggests scene-creation.*

Louisa Ruth Herbert, Jane Burden Morris, and Marie Spartali Stillman were Pre-Raphaelite goddesses—models for Rossetti and his followers. "N.W." refers to the postal zone for Hampstead, one of the artists' sectors of London; Maida Vale was a middle-class neighborhood.

*Zenobia was a third-century (*A.D.*) queen of Palmyra, known for her striking beauty, high spirits, and just reign. Faustine was the consort of a second-century (*A.D.*) Roman emperor; she achieved a posthumous reputation for promiscuity probably fabricated by her husband's political enemies. Miss Ponsonby de Tompkins recalls the George Du Maurier*

Punch *caricatures of his invented family as the incarnation of the aesthetic taste also mocked in Gilbert and Sullivan's comic opera* Patience—*the cult of daffodils, lilies, and sunflowers; of billowing gauzy gowns and electric hair; of plush jackets and plush sofas; of blue-and-white china and Japanese prints. One of Ellen Terry's most popular roles was that of Imogen, the heroine of Shakespeare's* Cymbeline.

Henri Matisse (1869—1954) was a Post-Impressionist artist characterized by bold uses of color within two-dimensional designs; Pablo Picasso (1881–1973), one of the pioneers of Cubism, was the dominating figure in twentieth-century art, already recognized as such in 1913. Pierre-Auguste Renoir (1841–1919) was an Impressionist artist then in physical decline; Phil May (1964–1903) was the cartoonist and caricaturist of East London types, famed for his contributions to Punch. *Joseph Cunningham Harker (1855–1927) was an English painter of panoramic views; Clive Bell (1881–1964) was a Bloomsbury art critic and disciple of Roger Fry. Paul [Kestner] Cinquevalli (1859–1918), a German-born music-hall performer, was an acrobat turned juggler—perhaps the most versatile juggler of all time.]*

Sir,—The controversy between Sir Philip Burne-Jones, Sir William Richmond, and Mr. Roger Fry is so amusing that I hope your columns may long remain open to it. To anyone with a sense of comedy, nothing is more delicious than the spectacle of a virtuously indignant Englishman calling on some other Englishman in the most vituperative terms at his command, to remember that he is a gentleman and not to use abusive language. The spectacle is at its best when the controversy is about Art; for controversy in England always reaches its climax in imputations of lower middle-class tastes; and the lower middle class is the class which produced Hogarth and Turner, the two greatest English painters. The grotesqueness of the present outburst is made complete by the fact that it began with Sir Philip Burne-Jones assailing the Post-Impressionists with an exact reproduction of the invectives which, in the eighteen-seventies, greeted the magnificent series of pictures in the Grosvenor Gallery which gained Sir Philip his title.

Now I, like many other people, would not dare to speak unkindly of Alma-Tadema's work, even if I thought unkindly of it. I should get into trouble with friends of his whom I value much more than I value my reputation as a critic. My object in writing this letter is to call attention to that part of his work which interested me professionally; I mean his stage pictures. His Cymbeline at the old Lyceum Theatre, and his Julius Caesar at His Majesty's were triumphs of his art. There was nothing worth attempting after it, except the change of school effected

by Mr. Gordon Craig, Mr. Norman Wilkinson, and Mr. Granville Barker. If anyone will walk through the Academy rooms with Cymbeline and Caesar in mind, forgetting the Post-Impressionists and the lower middle classes, it will become clearer and clearer, from room to room, that Alma-Tadema was a master of inscenation. And when you think of what those scenes would be if, instead of the ladies who now figure in them, you had Ellen Terry as Imogen, you will perhaps, hit on the secret of our demur to the pictures. Their weakness is the weakness of Alma-Tadema's Dutch judgment of Englishmen and Englishwomen, especially of Englishwomen.

The last thing a foreigner learns—if he ever learns it—is how to class people in the country in which he is a stranger. An Italian trooper or porter, if he can bawl loudly and continuously, will be accepted in Italian opera by English audiences as a perfect gentle knight if only he can be induced to refrain from expectoration until he has left the stage. English noblemen will accept the daughter of a Parisian *concierge* as a duchess. American ladies of fastidious taste cannot place an Englishman within six degrees of his real class, and sometimes make appalling matrimonial blunders in consequence. I myself, an Irishman, was hopelessly at sea in England for the first ten years, though in Dublin I could place anybody to a hair's-breadth by instinct. The foreigner invariably overrates; and difference of sex increases the overrating. You find English Pooh-Bahs saying, and even writing, that "the Latin races are never vulgar," and so forth. No delusion is more universal or more inevitable.

Now, look again at Alma-Tadema's pictures. You see instantly that he has either overrated or misrated all his models, especially his female models. When he wanted something rare, something exotic, something strange and haunting, he found her in the first artsome middle-class girl he met in Maida-Vale. The more typical the model, the more faithfully and lovingly he drew her, emphasizing the suburban type and suppressing the universal individual. Sir Philip Burne-Jones's illustrious father and his friends had wonderful models: Miss Herbert, Mrs. Morris, Mrs. Stillman. Even in real life they stood distinct from other women as a fine Gothic church stands distinct from a modern street. And their painters loved their distinction and heightened their beauty by getting away from their type to their individual charm. But such beauty, such distinction, reminded Alma-Tadema of the Netherlands, or at least took him away from fairy N.W., where every girl was a goddess. He had under his nose models for one look at whom I would have sold all Kilburn into Siberian slavery but he would have thought my taste vulgar: that is, Dutch.

The result speaks only too plainly for itself. Had he painted his god-

desses as a realist, surrounding them with cottage pianos and plush overmantels, or placing them in Surrey cottages, all would have been well: his pictures would have kept the Art Union in prizes for generations. But as to him they were all Zenobias and Cleopatras and Sapphos, he resolved to affect a hitherto undreamt-of combination of the morbidezza of romanticism with the beauty and clearness of classicism, by putting the nymphs of Maida Vale into Roman and Greek scenes and costumes. And so where he saw Faustine, we see Miss Ponsonby de Tompkins; and where nothing but a glimpse of the ornamental water in Regent's Park would have saved Miss P. de T's congruity for us, he gave us the Ionian sea. This is what you cannot get away from in Alma-Tadema. Remove his pictures to Holland, and they will come right; for the women in them will be as rich and strange to all the folk there as they were to Alma-Tadema himself. But never will they be to us what he meant them to be until Miss Ponsonby de Tompkins becomes extinct. And even then she will be incredible. She was always an acquired taste.

Meanwhile, do not let us absurdly suppose that this jar which we feel at the Academy is the jar of incompetence. Alma-Tadema did what he wanted to do, and did it extremely well. You may say that he could not draw, and could not paint (who can, if you put your standard as high as that?); but surely it was a merit in him that he wanted not to draw or paint with a Parisian touch, but quite simply to produce an illusion, and that he did produce it very brilliantly. No doubt this simplicity bores Mr. Fry. He misses the design, the draughtsmanship, the color orchestration of his Post-Impressionists, and thereby provokes Sir William Richmond and Sir Philip Burne-Jones to lose patience with him, even to the wild extremity of denouncing the Post-Impressionists as duffing impostors. Now, whatever else the Post-Impressionists may be, they are certainly not that. If I were to tear a scrap from one of Matisse's lithographs at the Grafton Gallery, and submit it to Sir William in the midst of a desert as something I had just picked up, asking him whether it was the work of a man who could draw, he would tell me, before he had cocked his eye at it for half a second, that only a trained professional hand could get that unmistakable whip into the stroke of his chalk. And if I were to cut a square inch from a canvas by Picasso, and submit it under the same conditions to Sir Philip Burne-Jones, he would say that nobody but a hardened expert could lay on paint like that. The best work in the Grafton gallery is full of skill—even of the insolence of skill. Mr. Fry misses the crepitation of that insolence in Alma-Tadema's work. Being a little in the crepitating line myself, I am on Mr. Fry's side in the general controversy. But I cannot agree that Alma-Tadema was one of the ordinary Burlington House manufacturers of commercial pictures. He stood out among them in his way, quite as much as Watts or Burne-Jones did

in theirs. There was no demand for white marble when he began to paint it: he painted it because he liked it, and because it seemed to him the only substance beautiful enough for Miss Ponsonby de Tompkins to sit on. He did what he liked, and painted what he liked; and we need not grudge him his luck if other people liked what he painted too, and he thereby became popular. Granted that Matisse has designed groups superbly, and that Alma-Tadema can hardly be said to have ever designed a group at all. Granted that Alma-Tadema has painted faces superbly (a very high achievement), whereas in the Grafton Gallery there are faces painted by Matisse which would disgrace a screever! Well, honors are easy. Why recriminate? The Post-Impressionists, stumbling over newly broken ground, naturally give Alma-Tadema little credit for keeping his balance so perfectly on the asphalt; but work on the asphalt takes a lot of doing, as none know better than those who have come to the end of it. When once we recognise the genuine simplicity and enjoyment that inspired Alma-Tadema's technical accomplishments (which, though they would be useless for Mr. Fry's purposes, and therefore don't interest him, were nonetheless rare and real), I think we are bound to admit that he was original and sincere, as well as astonishingly handy with his tools, and that, if there was a marked demand for his work, it was a demand that he created, and not one that he was faithless to himself in following. If all his contemporaries had had half his character, English painting would have been considerably the richer today.

Yours, &c, G. Bernard Shaw
The Nation, 15 February 1913 [C1859]

Crepitation

Mr. Bernard Shaw, with engaging modesty, owns that he is "in the crepitating line," and finds in that a ground of sympathy with my views on Matisse, Picasso, and Alma-Tadema. Now this is the unkindest cut of all. His letter leaves me in doubt as to whether he dealt me this fierce backhander with malicious intent, but as I am certain he would rather be accused of malice than of clumsiness, I must show him how deeply I resent it. An artist can afford to be ungentlemanly, even to be "boycotted by all decent society," but he knows that if he crepitates he is damned. Mr. Bernard Shaw can afford to crepitate; his genius is ethical rather than artistic. To him art is a kind of eloquence, he wants

certain things done for the greater good of mankind, he must induce certain opinions about these things in others, and for this purpose crepitation is a necessary mode of attack. But the artist qua artist does not want anything done; he has nothing to do either with action or opinion. He has to do with feelings which arise out of a detached and irresponsible contemplation of things. He cannot possibly afford therefore to be clever. That is to say, he cannot consciously consider the effect of what he does on others any more than the scientific researcher can consider the effect of truth while he is seeking for it.

Dexterity of hand and eye come, of course, inevitably to those whose life is spent on design; they come in varying degrees, but by no means in proportion to a man's artistic power. The really important thing to remember is that quite adequate skill is attainable by almost any ordinarily gifted person. What is, Alas! rare, and what makes the artist, is the power to feel so intensely about form that a man can create forms entirely corresponding to his feeling. But this has nothing to do with cleverness. The assurance of an artist's touch, that insolence of which Mr. Shaw speaks, is due to his certainty about the form he wishes to make. Now, an artist may have strong convictions about some entirely superficial or vulgar qualities of form. He will then have swagger of touch in a high degree, though his work may have scarcely any artistic value. On the other hand, an artist may have a very profound feeling about form, and yet from some inherent or accidental defect he may be unable to state it with brilliant incisiveness. The very depth of subtlety of his feeling may even interrupt him. Renoir's fingers have for some time been completely incapacitated by rheumatism, but two years ago he painted a large portrait by tying his brush on to his wrist, the canvas being constantly adjusted by an assistant, so as to enable him to get at the part he wished to work on. Now, if one put a Phil May drawing beside this work of Renoir's old age, there is no doubt that the Phil May would be the more assured, would have more of crepitating insolence of touch, but, on the other hand, Renoir's is a great creation, in many ways as great creation, in many ways as great as anything he has ever done. As a work of art, for all its necessary incompetence, it is incomparably greater than anything Phil May ever dreamed of.

I freely admit that Picasso happens to be the greatest virtuoso of modern times. Being the son of an art master, at the age of twelve he had the whole business of academic drawing at his fingers' ends. But I maintain that this is an accident, and not an altogether fortunate one. Picasso is so profoundly an artist that he has never been tempted to make a virtue of virtuosity; on the contrary, he has always plunged into some new adventure whenever he saw accomplishment becoming an obsession. So that although Mr. Shaw is quite right in saying that only

a hardened painter could paint as he does, it is the least considerable of his qualities. Indeed, he has arrived at a point where his sensibility is far more evident than his assurance.

I should rather doubt whether Matisse is so immensely clever. He may be, but what strikes me in his line is not the bravura which Mr. Shaw finds, the "whip" in the stroke of his chalk, but rather the intense, almost tremulous naivete with which his lines follow the contour.

It is quite true that Alma-Tadema also is without virtuosity, but, as far as I can see, this absence is due in his case, not to an extreme anxiety and depth of feeling about form, but to a lack of any special instinctive reaction to it. He liked pretty things, pretty models, silks, marbles, and gilt bronzes, but he liked them with the complex, undifferentiated feelings of the ordinary man, not with the peculiar detachment of the artist. His liking led him to imitate them, but when he came to putting them on canvas he was obliged to proceed by a succession of partial statements, and about each of these partial preliminary statements, such as the contour, the modelling, the play of color, he had no special feeling whatever, and consequently his statements were hesitating and lacked conviction. It was only the final result of a great many complicated and empirical proceedings that gave him satisfaction. He was not interested, so far as one can judge, either in drawing or plastic relief or color, but only in pretty things, and the more or less complete illusion of pretty things. I do not for a moment deny that he pursued this end with great tenacity and conscientious endeavor, nor do I deny that he may have been highly gifted in some ways, or that he admired marble before the power to imitate marble (more or less) became a commercial asset; all I am concerned with is to distinguish between this kind of liking for pretty things and the quite peculiar liking for certain qualities of any or all things, which is the characteristic of artists.

Above all, I want to get clear that is not because Picasso crepitates (if he does) that I admire him, nor because Tadema did not crepitate that I fail to admire his work. It is a misfortune that ever since Giotto's O his skill has generally been the artist's easiest and surest title to the admiration of the public. It is his poorest title to frame, since it is probably never comparable to that of a first-rate billiard player, certainly not to that of a great juggler like Cinquevalli. Its convenience is that, next to the price of his pictures, it is the most measurable and the most demonstrable of an artist's qualities. But in truth all that we need ask about an artist's skill is that it shall be sufficient for his purposes, and I have certainly never yet come across the artist, scarcely ever across the child, who could not frame his hands to make adequately any form that he could clearly visualise. Nor would it perhaps much matter that the public should go on admiring Giotto for his entirely useless power of

drawing perfect circles if it did not unfortunately react on the artist, and too often shift him from his proper functions. It is very serious, therefore, when a man of Mr. Bernard Shaw's brilliant gifts of persuasion comes forward and defends a great artist because of his technical skill. No amount of technical skill would give Matisse his power of coordinating forms with his peculiar amplitude, nor would it give his singular sense of interval or his magical feeling for color. The utmost it can do for him is to free his mind from technical considerations, so that he may concentrate entirely upon the discovery of harmonious and significant relations. It so happens that Matisse himself put this ideal with paradoxical emphasis when he said once, "I want to make my design so absolute that any house painter could execute my pictures."

Yours, &c.,
Roger Fry
The Nation, 22 February 1913

Mr. Roger Fry's Criticism

Sir,—Mr. Roger Fry and I between us have now brought the discussion to a very pretty point. Alma-Tadema, we agree, was an artist; and Picasso and Matisse are drawing masters. In Picasso's case, Mr. Fry points out, the vocation is hereditary.

I should hardly have dared to say as much singlehanded, but there is a good deal to be said for this classification. All advanced movements in art are forced to sacrifice art to propaganda to some extent. Whistler exhibited drawings in which the faces were deliberately spoiled by slashing a pencil three or four times across them, because in no other way could the artist force people to look for the qualities he was teaching them to appreciate, instead of admiring the prettiness of the face, and wondering what the sitter's name was. Matisse and Picasso do the same thing, not by defacing but by omitting the popularities. Far from fulfilling Mr. Fry's definition of an artist as one who "cannot consciously consider the effect of what he does on others," they keep considering it to the extent of violently avoiding all the Alma-Tadema qualities, so as to force us to discover the qualities they are determined to teach us to recognise and value.

This inveterate pedagogy is very French; but it is characteristic of great artists of all nations. It is not the congenial side of art. Mr. Fry does not like it in literature: he tells me, for instance, that my genius is

"ethical rather than artistic." Like Dante's, in fact, or Shelley's, or Bunyan's, or anybody's whose art is worth twopence.

I rather agree with Mr. Fry that what was wrong with Alma-Tadema was that he had no doctrine to preach. Mr. Fry puts is that "his statements were hesitating and lacked conviction"; but surely the root of the matter is that he had nothing to state except that he liked Miss Ponsonby de Tompkins and white marble and cherry blossoms. That was not a statement of "a discovery of harmonious and significant relations." This phrase puts the matter excellently; but I submit that the discovery of harmonious and significant relations is essentially a theological activity, and that it is not lucid to describe it elsewhere as a "detached and irresponsible contemplation of things." Rather would I say that Alma-Tadema was detached and irresponsible; that he sipped every flower and changed every hour, until Polly his passion requited.

Mr. Clive Bell is ingenious; but I wish he would work out his distinction between academic drawing and aesthetic drawing a little further. If he does, he will find there is no such distinction. There is practised professional drawing, and there is unpractised untrained drawing; and it was on this distinction that Sir William Richmond and Sir Philip Burne-Jones seem to me to have gone wildly wrong. Good and bad drawing is quite another matter. It is, as Mr. Roger Fry sees, an ethical matter: the words "good" and "bad" imply as much. If you draw a man's leg and offer it as a drawing of a man's leg, you are doing right. If you draw the leg of a Greek statue and say that it is a drawing of a man's leg, you are doing wrong. But the Greek sculptor may have been quite right to make his statue with that sort of leg, and eight heads high into the bargain. He did it because he wanted to teach something in that highest manner of teaching which is revelation. The academic method is essentially the detached, irresponsible method; or, as I should call it, the ready-made, reach-me-down, art-for-art's-sake method. There is nothing detached, nothing irresponsible, nothing ready-made, nothing reach-me-down about revelation. In short, Mr. Roger Fry is quite right; and so am I; but I am an older hand at straightening the matter out. "*Anch'io son pitsore.*"

Finally, let me dispose once and for ever of Giotto's O. To our gentlemen painters, who despise "trade finish" (which is too hard for them), the feat of Giotto seems a miracle; and whilst their crackle prevails, we shall never hear the end of Ruskin's story. Now listen to my story. One day I was in the studio—about as large as the goodsyard of a big railway company, and not altogether unlike it—of Mr. Harker, the eminent scene painter. Mr. Harker was at work, not with a palette and a dainty assortment of brushes in the thumbhole, but with a broom and a bucket, with which he was converting about an acre of canvas spread

upon the ground into a meadow. He put down his broom to discuss a scene which I wanted; and, presently, to illustrate what he proposed to do, he took a pencil out of his pocket, and drew on an upright flat a perfect circle, the size of dinner-plate, exactly as Giotto did for the Pope's messenger, except that Giotto seems to have considered it something of a feat, whereas to Mr. Harker it was the most matter-of-course incident in his daily routine. I could not resist the temptation to tell Mr. Harker the story of Giotto. Mr. Harker's first impression was, I suspect, that Ruskin must have been a quite abysmal juggins to have been impressed by so simple a matter. Then, the pride of the craftsman rising in him, he called for a piece of chalk, and with one sweep drew a big circle with, as it seemed to me, the accuracy of a lathe, and in a twentieth of the time it would have taken to employ a pair of dividers. But he immediately said: "No: that's not right"; and, with one more sweep, corrected it—painting the lily, I thought. Since then I have dropped the subject of Giotto and his tricks on travellers.

My last word to Mr. Roger Fry is one of thanks for his eager didacticism, his resolute attachment and serious responsibility, and of hope that his appeal for the means of establishing a workshop in London to keep this country in the forefront of European art, and incidentally to gain for his brave band of English Post-Impressionist painters and craftsmen something more succulent to eat than the abuse of Sir William and Sir Philip, will be generously responded to by the millionaires who seem so pitiably at a loss for something really useful and enlightened to do with their heaps of spare money.

—Yours, &c,

G. Bernard Shaw

The Nation, 1 March 1913 [C1861]

Rodin's Bourgeois

[Rodin's famous group statue, cast in at least seven "originals," has a London location near the Houses of Parliament, exactly the location which Shaw promoted. The park setting also faces the Thames.

Raymond Poincaré (1860–1934) was President of France 1913–20.]

The National Art Collections Fund has, from the beginning, proved serviceable beyond all expectation; but it has surpassed itself in procuring for the nation Rodin's Bourgeois de Calais. The question now is

where to put it. The usual plan of dumping a statue in the handiest open space or at the nearest crossroads (a method of disposal formerly reserved for the bodies of suicides) will not suit this extraordinary work, which is not in the conventional monumental form, as it consists of four standing figures placed with an art so well concealed that it is impossible to call them anything as artificial as a group. There is only one place in London worthy of them, and that is Westminster Hall. In artistic and historic fitness this position is ideally perfect, and Monsieur [Raymond] Poincaré's visit affords us just the right opportunity to pay a magnificent compliment to the French nation by offering it to their greatest living genius. We have not been too happy hitherto in giving distinction to Presidential visits—even the echoes of Guildhall banquets do not ring forever down the long corridors of time—and Monsieur Poincaré's threatens to be no exception to the rule unless Rodin's masterpiece saves the situation for us.

The New Statesman, 31 May 1913 [C1893]

Walter Crane

The late Walter Crane, Knight of the Order of St. Maurice and St. Lazarus, and Commander of the Royal Crown of Italy, struck the fancy of England as "an illustrator." And as he illustrated children's books, and literary classics which are presented to children as gift books, he was stamped as a harmless, kindly, beneficent, delightful artist; and all his efforts to impress himself on the British mind as a revolutionary Socialist, at war with society in its most pretentious and solemn aspects, were as vain as the attempts of his friends to make the public analytically aware that he was a born master of decorative design. Crane himself was interested in art of all sorts, and had no notion of concentrating on the thing he did well. He would stop designing to pour forth sonnets which were neither good enough nor bad enough to be memorable, and to deliver lectures which were bearable only when he took up the chalk and shewed what he meant on the blackboard. His extraordinary facility as a designer seemed to have completely dissociated excellence from effort in his mind; he turned his hand to everything he fancied—painting, poetry, and public speaking—with complete confidence that the result would come right with as little trouble as it cost him to fill up a titlepage or the outline of a shield or seal or heraldic lozenge with a perfectly fitted decorative design as few men have been able to do since the Middle Ages.

In this, of course, Crane deceived himself: he was an amateur in all the departments, except that in which he was a master; but he was such a very handy amateur that he was never found out either by himself or other people. He could draw anything quite plausibly and prettily without models or studies; and though it was only when his figures were the materials and the incidents of a decorative design that they became great, he did not seem to value this distinction himself; and, of course, our book buyers at large did not perceive it; they were keen on plausible and pretty "illustrations," and enjoyed decorative design unconsciously when they enjoyed it at all. There was a continual danger of his being offered the wrong work, and of his accepting it. At any moment a publisher might have commissioned him to illustrate Dickens, and one felt that he would have accepted the commission without the smallest hesitation, and with desolating results. He never knew his limitations, because he could do as well as most people outside them, and was therefore never stopped by an incompetence which was only relative to his consummate mastery of ornamental design. He was a Socialist of the best type: a most unselfish and helpful man. Many of his best designs were made gratuitously for magazines, of which he might have said, "In thee there is not half an hour's life." His portrait in the National Portrait Gallery is one of Watts's very best achievements in that kind. It makes him younger and handsomer than he could always contrive to be; but it is more like him essentially than any photograph: his character and expression are there precisely.

The New Statesman, 20 March 1915 [C1997]

The Ugliest Statue in London

[Claude Lorraine (1600–1682), properly Claude Gelée, was a Lorraine-born landscape painter who worked primarily from Rome, where he had papal patronage.

Mrs. Proudie was a large, pompous, priggish evangelical matron in Anthony Trollope's Barsetshire novels; Sarah (Sairey) Gamp was a midwife and nurse in Dickens's Martin Chuzzlewit, *"a fat old woman [with] very little neck" and a face "somewhat red and swollen." Mrs. Betsey Prig in the same novel was a nurse at St. Bart's, "of the Gamp build, but not so fat; and her voice was deeper and more like a man's. She also had a beard." Mrs. Caudle, a popular creation of Douglas Jerrold (1803–57) for* Punch *in 1845, was a plump, talkative, and*

jealous scold in "Mrs. Caudle's Curtain Lectures," where she reproves her husband for minor failings, exhorts him to take her on holidays, and lectures him on the domestic virtues.]

The question "Which is the ugliest statue in London?" is no doubt an interesting one, just like the question "Who is the worst woman in London?" but in the present state of the law concerning libel I do not advise the *Arts Gazette* to print answers to either.

I may, however, seize the opportunity, as an old Victorian, to ask what crime Queen Victoria committed that she should be so horribly guyed as she has been through the length and breadth of her dominions. It was part of her personal quality that she was a tiny woman, and our national passion for telling lies on every public subject has led to her being represented as an overgrown monster. The sculptors seem to have assumed that she inspired everything that was ugliest in the feminine fiction of her reign. Take Mrs. Caudle, Mrs. Gamp, Mrs. Prig, Mrs. Proudie, and make a composite statue of them, and you will have a typical memorial of Queen Victoria. Now if this were a bold republican realism which disdained courtly sycophancy, it would be at least courageous, if unkind. But it is pure plastic calumny. Queen Victoria was a little woman with great decision of manner and a beautiful speaking voice which she used in public extremely well. She carried herself very well. All young people now believe that she was a huge heap of a woman. . . . How could they think anything else, with a statue at every corner shrieking these libels at them? The equestrian statue in Liverpool is the only one that is not an act of high treason, and even it makes her commonplace in size. When I think of the exquisite monument to Claude Lorraine by Rodin in the park in Nancy, where the wonderful little figure on the superb pedestal shews exactly how the thing can be done by a man of genius, I blush for British sculpture, and long for a trip in a bombing aeroplane to remove Victoria's lying reproaches from the face of her land.

Arts Gazette, 31 May 1919 [C2221]

Shaw Would Destroy All 20-Year Buildings

London, Feb. 12—George Bernard Shaw asserts that the old cottages of England should be destroyed wholesale. He told the Society of Arts recently:

"After living in one of these 'literary and artistic' houses with an exalted sense of doing the right thing, one realizes that all the time one has [been] living in a sort of architectural hell.

"I am so far modern that I have come to the conclusion that what is wanted is a law that every building should be knocked down at the end of twenty years and a new one erected. That would get rid of old cottages. We have got into the incorrigible habit of sponging on the past. Every generation ought to be able to produce its own art, and all this worship of the past can only be got rid of by a wholesale destruction of all the monuments of the past.

"If we could avoid the wholesale destruction of human beings involved by a great war I should be glad to have half a dozen great wars in Europe so that all the old buildings might be knocked down, thus forcing us by a sort of starvation to make our own architectural efforts."

Message to the Society of Arts, as reported in *New York American*, 29 February 1920 [C2275]

Epstein's Christ

[American expatriate (Sir) Jacob Epstein (1880–1959) was one of the more controversial of London sculptors, regularly accused of blasphemy and indecency. An exhibition of his statue of Christ led to the usual denunciations from the press, the clergy, and conservative artists' groups. Father Bernard Vaughan (1847–1922) was a notable preacher, the youngest of three brothers who became English Roman Catholic divines, one a cardinal, the other an archbishop. As a social reformer targeting the "sins of society," Vaughan published an attack on Epstein's conception of his subject, "Is It Really Christ?", in The Graphic on 14 February 1920. "I feel ready to cry out with indignation," he wrote, "that in this Christian England there should be exhibited the figure of a Christ which suggested to me some Chaldean or African, which wore the appearance of an Asiatic, American or Hun, which reminded me of some emaciated Hindu or badly grown Egyptian."

Victor Capoul was a French tenor who sang in London in the 1870s. Lord Battersea was Cyril Flower, first Baron Battersea, Liberal M.P. and Cabinet minister under Gladstone. "Henry Dubb" was a generic name for the patient, stolid British workingman. Cecil Phillips was a director of the Leicester Galleries, which had exhibited Epstein's work.

Shaw had written about von Uhde earlier. Dierick Bouts (1415–75)

was a Dutch painter of austere religious pictures; Hans Memling (1440–94) was a Flemish religious and portrait painter. Gerhard David (1460–1523) was also a Flemish religious painter; Ary Scheffer (1775–1858) was a German painter who romanticized his historical and religious subjects in the French style of his time. Shaw's Müller is probably Carl Müller, a Düsseldorf painter of religious subjects in the 1870s and 1880s. Giovanni Cimabue (c.1240–c.1302) was an Italian painter, largely of religious subjects; Sassoferrato, or Giovanni Battista Salvi (1605–85), an Italian religious painter in a sentimental vein, was popular in the nineteenth century.]

Sir,—Father Vaughan is an unlucky man. He has a genius for mistaking his profession. The war tore off his cassock and revealed the spurs, the cartridge belt, the khaki beneath. And now that he is demobilised, his wandering star leads him into the profession of art critic.

When I was last at Lourdes I saw a cinema representation of the Passion. I think that Christ would have pleased Father Vaughan. He looked like a very beautiful operatic tenor. I have seen Victor Capoul and the late Lord Battersea; and he was as Christ-like (in Father Vaughan's sense) as both of them rolled into one. He was more the gentleman than the Christ of Oberammergau, who was in private life a wood-carver. The Church is so powerful at Lourdes that I do not think this exhibition would have been possible without its approval. That the approval was obtained is not to be wondered at. The Church knows its business at Lourdes. And the cinema actor knew *his* business, which was to study the most popular pictures of Christ, and to reproduce their subject in his own person with the aid of his make-up box. He purchased the ambrosial curls and the eyebrows, and put them on with spirit gum. If this nose was not the right shape, he build it up with plastic material. The result was very pretty, and quite satisfactory to those whose ideal Christ is a stage lover. I did not care for it myself. The stage has no illusions (of that sort) for me; and I feel quite sure that Christ was no more like a modern opera singer than he was like Henry Dubb, the modern carpenter.

Now that Father Vaughan is going in for art, many terrible shocks await him. Imagine him in Bruges, looking at the Christs of the Netherland school (he can see some, by the way, in the National Gallery). He will almost forgive Mr. Epstein when he sees how Dierick Bouts and Hans Memling and Gerhard David made Christ a plain, troubled, common man. Or he may go to Tunbridge Wells and walk to Speldhurst Church, where he will see a magnificent Morris stained window in which Burne-Jones, departing utterly from the convention which he himself had so often exploited, made the figure on the cross a glorious Greek God. Michael Angelo did the same in his Last Judgment. Hol-

man Hunt, after representing The Light of the World as an excessively respectable gentleman with a trim beard and a jewelled lantern, knocking at a door with the gesture of a thief in the night, lived to be reviled by the Vaughans of his day for representing Him in "The Shadow of the Cross" as a Syrian—actually as a Syrian Jew instead of an Oxford graduate. Raphael's unique Christ in His Transfiguration is a Tyrolese peasant. Rembrandt's Christ is a Dutchman. Von Uhde's Christ is a poor man who converses with men in tall hats, and women in nineteenth-century bonnets and shawls.

But there is no end to the varieties of type to be found in the Christs of the artists. We are only waiting for an advance in African civilisation for a negro Christ, who may be quite as impressive as any of the Aryan ones. The shallowest of all the Christs is the operatic Christ, just as the shallowest of the Virgins is the operatic Virgin. Father Vaughan, obsessed with the Christs of Guido, Ary Scheffer, Muller & Co., and with the Virgins of Sassoferrato and Bouguereau, was staggered by Epstein's Christ, just as he would be staggered by Cimabue's gigantic unearthly Virgin. He will soon know better. And if he will only read the Gospels instead of the despatches of the war correspondents, he will find that there is not a trace of "tenderness, calmness, and sweetness" in St. Matthew's literary portrait of Christ, and that the operatic Christ was invented by St. Luke.

All the Christs in art must stand or fall by their power of suggesting to the beholder the sort of soul that he thinks was Christ's soul. It is evident that many people have found this in Mr. Epstein's Christ, and that Father Vaughan has not. Well, Father Vaughan will find his Christ in every Roman Catholic Church in the land, and in all the shops that furnish them. Let him choose the statue that is nearest his own heart; and I have no doubt that Mr. Cecil Phillips will place it beside Mr. Epstein's and leave every man to judge for himself which of the two is the more memorable.

Yours, &c.,
G. Bernard Shaw
The Graphic, 20 March 1920 [C2279]

[Ugly Public Buildings]

[Shaw's letter-to-the-editor was published merely as "From Mr. George Bernard Shaw."]

Sir: Why don't you send a competent young man round London to suggest improvements in existing ugly public buildings, and to mark the hopeless ones for demolition? For example, the Houses of Parliament could be made almost presentable by removing the top storey; and a list of the tombs which should be cleared out of Westminster Abbey would be very useful to a Bolshevik leader in the event of a dictatorship of the proletariat being established. That would give a practical turn to much pointless grumbling and sniffing.—Yours, etc.

G. Bernard Shaw

10, Adelphi Terrace, W.C.; Dec. 12, 1922

Architecture: Journal of the Society of Architects,
January 1924 [C2433]

Scene-Painting

[At the request of writer and editor Reginald Pound, Shaw contributed to a symposium on scene design, included in Joseph Harker's Studio and Stage *(London: Nisbet, 1924). Harker, a veteran scene designer, had co-designed and executed the settings for Sir Johnston Forbes-Robertson's production of Shaw's* Caesar and Cleopatra *in 1906.*

William Telbin and his son William Telbin the Younger were both Victorian-era stage designers, the son executing settings for Henry Irving. Philip James de Loutherbourg (1740–1812), a German painter, met David Garrick (1717–79) when visiting London and afterwards was appointed by Garrick to be scenic director at the Drury Lane Theatre. William Poel (1852–1934), English actor and director, founded the Elizabethan Stage Society. John Dryden (1631–1700) was a Restoration poet and dramatist. Dion Boucicault (1820–90), Irish playwright and actor-manager, worked in England and America, sometimes altering the settings of his plays to accommodate changed audiences.

The Phoenix Society was a London group founded in 1919 under the auspices of the Stage Society to present plays by early English playwrights. In its six years of existence it staged twenty-six plays.]

I do not know of any school of scene-painting more advanced than Mr. Harker himself. Mr. Harker does pictorial stage scenery as well as it can be done, and if it were possible to reconcile the conditions of play performance with those of picture exhibition: that is, if Mr. Harker could do as he pleased with the stage and the lights without the least

regard to the actors, the producers, and the authors, and raise the curtain on his painted picture for its own sake solely, there would be nothing for any school to advance on. I have often seen a play in which Mr. Harker's scenery was of a much higher order of art, and enormously more skilled in its execution, than either the play or the acting on which it was wasted. My memory goes back to the scenery of Telbin, and the contrast between the skill of our scene-painters and the bungling of the gentlemen amateurs of the art galleries who refused to recognize them as artists has had plenty of comedy in it.

When you speak of the advanced school of scene-painting, I think you mean an art of play presentation which is not scene-painting at all, and which, when it incidentally employs scene-painting, has to go to Mr. Harker to get that part of its work done for it. This movement was produced in England by the discovery, very slowly realized, that the art of de Loutherbourg, Telbin, and Mr. Harker is incompatible with the art of Shakespear. Shakespear planned his plays to give three or four hours' continuous entertainment; and they cannot be uttered intelligibly on the stage in less time. Now, if they are played with pictorial scenery and elaborate imitative constructions, at least three-quarters of an hour must be cut out of the acting time to set and "strike" the scenes; and what remains of the mutilated play must be divided into acts and re-arranged so as to avoid having more than four changes. When front cloths and flats and wings, which enabled the acts to contain several scenes, were discarded as too absurdly unnatural, the manager of Drury Lane, Chatterton, said that Shakespear spelt ruin. What he should have said was that the attempt to combine scenery and Shakespear spelt ruin.

When Mr. William Poel shewed that Shakespear could be played without anything that Mr. Harker would call scenery, and even without anything that a Shaftesbury-avenue lessee would call a stage, and when Mr. Granville Barker shewed that his could be combined with a stage decoration of unprecedented beauty, the old art of play presentation, in which the stage was a tribune and not a picture, revived; and it is this revival that is sometimes called advanced scene-painting. It is in fact a different art, not developed out of scene-painting, but for the moment struggling violently and occasionally abusively with it in its effort to disentangle itself from the pictorial tradition, and win the public from its enchantments.

During the period when scenery was so supreme that nobody dreamt that a dramatic performance was possible without it, all the plays were written in acts; and the changes of scene made in the course of the act in full view of the audience were contrived in such a way that they could be effected by running on flats or dropping front cloths. From Dryden to Dion Boucicault, authors wrote their plays in this way; and their plays

could therefore be performed as they intended them to be performed. But with the disappearance of the flats after the middle of the nineteenth century, it became impossible to perform even The School for Scandal without rearranging it. For half-a-century, plays were written for one scene to each act; and pictorial scenery was supplanted as to indoor scenes by the building and furnishing of real rooms on the stage. My own plays and those of my contemporaries were written for these conditions; and the pictorial scene-painter would have fared badly but for pantomine, ballet, opera, variety shows, and scenic work in big exhibitions like those at Olympia and the White City.

Now, every play should be performed as its author intended it to be performed. It is no reply to this that Shakespear would have written for scenery if he could. It might as well be said that he would have written for the cinema if he could. The fact remains that he did not, and that the stage for which he wrote his plays is the only one to which they are adapted, and on which they make the effects he planned. This does not mean that the changes of scene in The School for Scandal or Don Giovanni should be made with wings and flats instead of by revolving stages and similar contrivances, nor that the lighting should be by tallow candles needing to be snuffed every ten minutes. The principle must be applied with constant regard to commonsense and knowledge of essential points. Provided that (a) the play is performed without abbreviation or rearrangement and does not last longer than the author intended, (b) the actors are not placed in a less intimate relation to the audience, (c) the attention of the spectators is not divided and distracted by quantities of furniture and appointments greatly in excess of the author's resources, and (d) that the actors do not take advantage of modern contrivances to make effects that the author never contemplated, then it does not matter in the least by what mechanical and optical apparatus these conditions are attained: no producer in his senses will crowd his stage with eighty carpenters, as Irving did, instead of fitting hydraulic bridges and electric lifts and so forth.

Once this is understood, the notion that Mr. Harker's art is going to be supplanted by an "advanced school" is seen to be groundless. It is true that a great deal will be done and is indeed already being done, with a plaster "horizon" and a modern lighting installation, or in village halls with a light cheap drapery and a couple of secondhand modern headlights, that was not believed possible fifty years ago without an expensive and admirably painted mass of pictorial scenery from Mr. Harker's [studio]: But there will always be plenty for him and his pupils and successors to do in reproducing the proper conditions for the old operas and ballets and plays written for the pictorial stage, and carrying that stage on to fresh spectacular triumphs. And, I repeat, the permanent decora-

tions in which classical plays are now performed by The Phoenix and cognate enterprizes, offer artistic opportunities to Mr. Harker and his school which were denied them by the pictorialists, who cared for nothing, and would accept from the painter nothing, except the most literal imitations of natural scenery that paint and canvas could produce. Under the tyranny of such a Philistine demand Mr. Harker was regarded as a tradesman with a flourishing business in the Waterloo-road. Today, thanks to the rediscovery of the art of staging, his position as an artist is recognized by everybody, and not merely by myself and a few others.

Studio and Stage (London, 1924) [B136]

Mr. Epstein's Panel

[In May 1925 a memorial to the novelist and naturalist William Henry Hudson (1841–1922), author of Green Mansions, *sculpted by Jacob Epstein, still an* enfant terrible *at forty-five, was unveiled in Hyde Park by the Prime Minister, Stanley Baldwin (1867–1947). The sculpture, which depicted a flight of birds surrounding the nude figure of Rima, the spirit of the forest in* Green Mansions *(1904), raised anew charges of obscenity about Epstein's work, and campaigns in the sensational English press for the statue's suppression.*

Wembley, to the northwest of London, had been the site of the British Empire Exposition of 1924–25, for which exhibition buildings and cavernous Wembley Stadium were erected. Fay Compton (1894–1978) and (Dame) Gladys Cooper (1888–1971) were two of the leading stage beauties of their time; their photographic likenesses often appeared on popular postcards.]

Sir,—On visiting the Bird Sanctuary on Saturday I found my way by an eloquently trampled path to a crowded railing, where I was confronted with a very remarkable sample—I use the word advisedly—of the great art of monumental wall sculpture which we rather feebly call *bas relief.* It was unquestionably the real thing, with all the power of stone and all the illusion of strenuous passion, and even movement, that live design can give. But it was a sample, and a ridiculously small one. It reminded me of a Quaker cloth merchant in my native Dublin, famous for the imperturbability of his temper. A young English officer, after making him take down every roll in his shop, at last selected a cloth, and gravely said he would take a halfpennyworth of it. The

unmoved Quaker cut out a piece the exact size of the halfpenny, wrapped it neatly in paper, and handed it respectfully to his customer.

It is evident that the Hudson memorialists, having collected what they could, were compelled to go to Mr. Epstein and say, "Please, sir, mother England wants four yards of your best monumental wall sculpture to put up in the Park for one of her famous sons." And Mr. Epstein solemnly delivered the four yards, which bear about the same proportion to what was needed as the Quaker's halfpennyworth of cloth to a suit of clothes. That is what comes of ordering a monument when you have only money enough to pay for a Christmas card. We get a monument to our national meanness in matters of high art. If it had been Wembley now! Next time, if we cannot afford to give Mr. Epstein *carte blanche,* we had better get the job done in the Euston-road in a thoroughly commercial manner.

I have a great deal of sympathy with the people who hate Mr. Epstein sample. Some of them feel the reproach and the inadequacy for which they innocently blame Mr. Epstein. Some of them do not like monumental wall sculpture, and are in the grievous position of people who want a fox-trot and have a Beethoven symphony thrust into their ears. Why should not these people, who have a perfect right to their own tastes, have a monument and a bird sanctuary all to themselves? There is plenty of room in the Park for both. It need not cost much. There is a process called photo-sculpture, with an establishment in the West-End, by which very pretty reliefs can be made by the camera. If Miss Fay Compton or Miss Gladys Cooper would pose as Rima, with a stuffed pigeon on each wrist, the artist who touches up the photo-sculpture could throw in a few swallows, a robin, and a holly branch; and the result would be exactly what is wanted by the honest folk whose sense of beauty is outraged and mocked by Mr. Epstein's powerful proceedings. Why not please everybody when it is so easy?

Yours, &c.,

G. Bernard Shaw

The Times, 17 June 1925 [C2554]

Is the Albert Memorial a Thing of Beauty?
Creator of Rima Laughs

[A follow-up of the "Rima" controversy was to ask the embattled Jacob Epstein what he thought of the Albert Memorial, as the assumption

was that Victorian prudishness was responsible for the unending at-tacks upon Epstein, and that the memorial to Victoria's consort epito-mized the period's tone. The Albert Memorial, built in Kensington Gardens after the prince's death in 1861, was designed by George Gilbert Scott (1811–78) to represent themes suggested in Albert's life, with the top of the ornate obelisk-like structure a bronze seated figure of the prince by John H. Foley (1818–74).

Shaw contributed to the press discussion; also (Sir) Guy Dawber (1860–1938), a leading architect, and writer-controversialist Gilbert Keith Chesterton (1874–1936).]

"*What is the matter with the Albert Memorial?*" asked Mr. Algernon Ashton in the "Daily News" yesterday.

"*A Press writer speaks of its 'ugliness.' I consider it to be one of the most wonderful, gorgeous, and magnificent monuments in the world.*"

A representative of the "Daily News" sought other opinions of the Albert Memorial, with the following results:

MR. JACOB EPSTEIN:

Mr. Epstein burst into loud laughter and intimated that was his reply.

MR. BERNARD SHAW:

Mr. Ashton is entitled to his opinion, and a great deal is to be said for the Albert Memorial being a remarkable work of art. It is not in every respect precisely the sort of thing that I should have built, but Mr. Ashton's opinion is as authoritative as mine.

Very many distinguished artists must have agreed with Mr. Ashton's view, otherwise the Memorial would never have been erected. Some parts of the Memorial are very fine, and if the matter were left to me to decide, I should certainly not pull the Memorial down and build an-other in its place. If the shrine were in stone I should like the Memorial better.

MR. GUY DAWBER, President of the Royal Institute of British Archi-tects in 1925:

The Albert Memorial is typical of the period when it was built. To-day it is rather an anachronism and does not seem to fit in with things. That is no reason, however, why the Memorial should be pulled down and replaced by another. It is a fine example of the Victorian era and its work.

MR. G. K. CHESTERTON:

I agree with Mr. Ashton up to the word wonderful. The Memorial might have been better if one part was not supposed to be Gothic and

another Classical. I have no objections to the Memorial remaining, and if I had the power, I would not remove it, because I don't think it would be worth while.

(London) *Daily News*, 4 February 1927 [C2633]

Thames Bridges

[Shaw was responding to protests that the old Waterloo Bridge was worth saving for aesthetic reasons. Shaw's home at 10 Adelphi Terrace (present site of the Shell-Mex monstrosity) overlooked the Thames Embankment. In 1927 the Shaws moved west along the Embankment to Whitehall Court. John Rennie (1761–1821), Scottish civil engineer, designed Southwark, London, and the old Waterloo bridges, as well as canals, harbors, and breakwaters. Richard Doyle (1824–83) joined Punch *in 1843 and designed its famous cover in 1849; after he left the magazine in 1851 he was a book illustrator and painter, often peopling large canvases with hundreds of fairies.]*

Sir,—The letter addressed to you by the London Society is really more than I can endure in silence. For 30 years I lived with Waterloo Bridge under my study windows; and my hatred of its incurable ugliness and fundamental wrongness increased during all that time. I now live with Charing Cross Bridge under my study windows; and every glance I give at it convinces me more completely that it is a model of what a river bridge should be.

Waterloo Bridge, originally designed as a string of nine canal bridges end to end, is a causeway with holes in it, blocking the view of the river hopelessly, and all but blocking its navigation, which is no doubt its recommendation to people who have no eye for a great river, and so little sense of art that they can write or read themselves into believing that Rennie was one of the great architects of the world. Charing Cross Bridge is a roadway through the air, supported by pillars which do not hide the river, and which reduce the obstruction of the waterway to a negligible minimum. And that, precisely, is what a Thames bridge should be.

All that is needed for Waterloo Bridge is a sufficiency of dynamite, followed by a law making it a capital offence to make perforated causeways across the Thames.

The enthusiasts who are clamouring for its preservation can then find a new subject in those quaint Dicky Doyle fantasies, straight from the titlepage of *Punch,* and painted with all the gay English colours of the Queen of Diamonds, which have sprung up by our dull roadsides to supply us with petrol. The cry for painting them dark green and dirty citrine as a prelude to abolishing them and substituting untidy piles of cans will prove a congenial occupation for our amateur art lectures.

<div style="text-align: right">

Yours, &c.,

G. Bernard Shaw

The Times, 3 May 1928 [C2715]

</div>

[Mr. Shaw on Dear Pictures]

[Flower painter Gertrude Harvey, Shaw claimed, put her paintings up for sale at £5 each to prove his point that art was overpriced. He even wrote a note for the exhibition catalogue which guaranteed the show attention and was itself reprinted, almost in its entirety, in the Daily Mail, *18 September 1929 [C2806]. The sale was held at the home of Shaw's friend, pianist (Dame) Harriet Cohen (1895–1967), 13 Wyndham Place, Bryanston Square. Not only an interpreter of older keyboard music but a concert circuit missionary for modern composers, she was a logical accomplice for making Shaw's point about modern art.*

Frank Winfield Woolworth (1852–1919), the American merchant who had founded the low-price retail chain, was dead; Shaw's comment about going to Woolworth has to be taken metaphorically: the Woolworth management had clearly approved the use of its name as a publicity gimmick. Henry Tonks (1862–1937), a surgeon, gave up medicine for art, primarily portraiture; he was Slade Professor of Fine Art in the University of London 1917–30. Rex Whistler (1905–44) was a designer, illustrator, and muralist; he was killed in World War II. John Butler Yeats, Irish artist and writer (1839–1922), was the father of writer William Butler Yeats (1865–1939) and artist Jack Butler Yeats (1871–1957). George William Russell (1867–1937), who published as "A.E.," was an Irish journalist, economist, poet, and painter.

The title is from the Daily Mail *version.]*

In the economics of fine art there is no more tragic chapter than the history of prices. All my life I have been confronted in picture galleries with price lists conceived in hundreds of guineas attached to pictures for which no sane person, even of the millionaire class, could be expected to sacrifice more than five pounds, and outside the galleries with seedy artists, starving artists, borrowing artists, begging artists, stealing artists, drinking and drugging artists, despairing artists, and dying artists; whilst on the pavement sat the screevers to whom they snobbishly denied the name of artist with pennies enough pouring into their caps to save them quite comfortably from the razor, the pistol, and the gas stove.

Wisely did Mr. [Henry] Tonks say when Mr. Rex Whistler painted the walls of the Tate Gallery at so much per square foot, like any honest tradesman, "Artist your place is in the kitchen."

The Irish poet [W. B.] Yeats, whose name Englishmen sometimes rhyme to Keats (an error excused by a natural association of ideas), has told us how his father, a portrait painter of genius who held his own with G. F. Watts, was led by the hundred guinea mania to believe that he could afford to spend more than three months painting a single landscape from nature. But at the end of the three months spring had changed to summer, which involved repainting for another three months. By that time summer had changed to autumn. Before the necessary readjustments were complete, the snows of winter had changed the landscape out of recognition. Yeats *père* was therefore obliged to live by painting portraits, as the subjects remained fairly stable for comparatively long periods. Only, as they refused to give him sittings (as well as guineas by the hundred) he had to learn his business properly and polish off his job in a reasonable time, as a housepainter must.

Mrs. Harvey, whose works you see around you, is a flower painter. Now there is no nonsense about flowers: they cut down the three months available for the landscape painter to three days or less. Recognising the quality of Mrs. Harvey's work I called her attention to that great American genius Mr. Woolworth, who has given us wonderful shops in which you can buy any article for sixpence. No shop windows detain me in my walks as his do. I reminded her that I, Bernard Shaw, had been glad to receive five pounds for many of the best criticisms I ever wrote, and that George Russell the painter supported A.E. the poet by editing a paper on weekdays, and on Sundays painting an Irish (or Tir nan Oge) landscape of extraordinary quality for which he easily found a purchaser at five pounds. I exhorted her to become the first WOOLWORTH ARTIST, and give London the first one-woman-show of five pound pictures. Miss Harriet Cohen rose to

the occasion and offered her house for the experiment. You may even, she said, announce "Harriet Cohen at the piano."

The result is before you.

> "Note by Mr. Bernard Shaw" in the *Woolworth Exhibition of Pictures by Gertrude Harvey* catalogue, 1 October 1929 [A194]

Mr. Shaw's Retort
Advice to Mr. Nevinson
Sell Paintings by the Foot
"No Good Artist is a Gentleman."
By G. Bernard Shaw
in an interview last night with Charles Graves

[Even before the Gertrude Harvey sale had opened, the advance publication of Shaw's remarks in the Daily Mail *led to remarks from artists that the marketplace was the best determinant of art prices. C. R. W. Nevinson (1889–1946), who had achieved deserved recognition as a war artist in 1914–18, and was now also working as etcher and lithographer, took issue with Shaw and wondered how he would have survived as a playwright if every seat were sold at topmost-row prices. Asked for an interview on the subject by journalist Charles Graves, Shaw replied in unbudging fashion, writing the "interview" himself.*

Nevinson's father, mentioned in the interview, was an old friend of Shaw's. Henry Wood Nevinson (1856–1941) was a retired editor and journalist. Shaw's futurist political satire The Apple Cart *had premiered in Warsaw; it was then a major success on the London stage, and would run 258 performances.]*

Being a further stage of the controversy between Mr. Shaw and Mr. C. R. W. Nevinson, the "Modernist" painter. Mr. Shaw advised artists to sell their works at £5 apiece, and Mr. Nevinson, replying in an article in yesterday's "Daily Mail," declared that he would see Mr. Shaw's plays if he charged 6d. a seat.

Mr. C. R. W. Nevinson shows the most deplorable imbecility in his article in yesterday's *Daily Mail.*

It arose from my advice to artists to sell their works at £5 apiece—provided, of course, they cannot get more for them. And 99 out of 100 are not worth that nowadays.

Goodness knows what happens to the hundreds of pictures which are painted every year! Many of them, hung in the Royal Academy, are priced at ridiculous sums like 250 guineas each. Nobody in his senses is going to pay that for them.

Every artist has one or two pictures in his studio which he has never been able to sell. Why does not he get rid of them for whatever they will fetch? Even if it is only tuppence he is that much to the good.

If he leaves them they remain a humiliation to him—as well as a total loss.

As a matter of fact Mr. Nevinson is quite an able artist, and yet he can talk the nonsense he does. If he behaves like that, what hope is there for the others?

He talks, for example, of giving £5 tips to Italian waiters in the hopes of getting a "thank you." When I was in Italy I gave a regular tip of three halfpence to the waiter who brought in my macaroni. He was perfectly content. If I had given him £5 he would have sent for the police and had me put under arrest as a madman.

What extraordinary ideas of money Mr. Nevinson has, to be sure. His father certainly brought him up very badly. His arithmetic is unsound and his arguments deplorable. I must really talk to his father about him.

The trouble is that everyone thinks that artists are or ought to be gentlemen. This is idiotic.

Artists, of course, need to know about gentility and how to paint a gentlemen. But no really good artist is a gentleman. I am not one myself. I am far beyond that.

Mr. Nevinson ought to realise that painting is a trade. Let him look at the magnificent frescoes in the Manchester Town Hall by Madox Brown. They were ordered and paid for at so much a foot. The authorities had told him that a Belgian firm had agreed to do it at so much a foot. Madox Brown sensibly agreed to do it himself.

Mind you, I entirely agree with the point Mr. Nevinson makes about expensive theatre seats. I should like the world to know that nothing written by Shakespeare or his successor, myself—and my plays are much more entertaining—is worth more than five shillings for one night's entertainment. If I were to build a theatre I should erect a large one with hundreds of cheap seats.

When I was in Poland at the production of "The Apple Cart" the highest price for the best seats was 4s. Naturally everyone rushed to see it.

In London they charge enormous sums for the stalls and the only people who can afford them are idiots—naturally. No wonder the seats are empty or "paper," and serious plays do not last very long.

Doubtless, though, if I made Mr. Nevinson my manager he would charge five guineas and no more would go at all. I myself have always believed in value for money.

Mr. Nevinson accuses me of extracting the last farthing from my publishers. The truth is that my publishers keep on asking why I insist on having, let us say, three plays and two long prefaces put together into one volume instead of having them printed in five.

My answer is that I think books ought to be sold by the pound exactly as they are sold by his Majesty's Stationery office.

I remember before the war telling the manager of a London theatre that a play of mine which he wished to put on could not draw more than £800 a week, although the overhead charges were £1,600 a week. The manager still said he wanted to put it on, as he had nothing else ready and he would lose just as much or more if the theatre were empty. This story shows that I practice what I preach.

Finally, Mr. Nevinson says I am very old. Apart from the fact that if we walked down Bond-street together people would probably take me for his son I can only say this is a relief from the eternal greeting, "Oh, how young you are looking, Mr. Shaw." It is really quite a strain living up to that sort of thing. If anyone said loudly in my hearing, "It is high time that decrepit old man were put in his grave," I really believe I should embrace him. As it is, in the church near my house in the country stands the tombstone of a woman of 70, with an inscription lamenting her short stay on this earth. Indeed, nobody ever seems to die there.

The Daily Mail, 25 September 1929 [C2807]

[Troubetzkoy's Sculpture]

[For an exhibition in December 1931 of Prince Paul Troubetzkoy's sculpture at Colnaghi and Co. in London, Shaw wrote "A Word" for the catalogue. Shaw's superlatives relate less to Troubetzkoy's talents, which were considerable, than to their friendship. He had done a bust of Shaw; they had visited each other; Troubetzkoy had become sufficiently fashionable in his years as émigre from Czarist Russia to convey a cachet upon his subjects.

Antoine-Louis Barye (1796–1875) had been distinguished for his animal bronzes; Richard Burdon Haldane, first Viscount Haldane (1856–1928), had served in several Liberal cabinets. Monarchs referred to are Alexander III (1845–94), one of the more ruthless of many ruthless czars; Charles XII (1682–1718), King of Sweden 1697–1718; and the "Sun King," who was King of France 1643–1715.]

Prince Paul Troubetzkoy is one of the few geniuses of whom it is not only safe but necessary to speak in superlatives. He is the most astonishing sculptor of modern times.

When he models an animal, whether it is the tiniest domestic pet, or an overdriven carter's horse embodying all the sorrows of all the ill-used four-legged drudges that have ever perished without having known human pity, or the colossal brute dominated by the terrible Tsar [Alexander III], which stands irresistibly in the great square at Leningrad amid the vacant sites of the conventional monuments which the Soviet wrath has swept away, the result is so perfect in its truth to nature and its power of conveying some lesson or appeal, that you are rushed to the conclusion that its sculptor, like Barye, was born to model animals and nothing else.

Yet if your first confrontation is with his busts and statuettes of perfectly dressed leaders of society in Paris and London, you would say that his destiny was to extract the quintessence of elegance from the hang of a skirt and the carriage of the head and arms of an archduchess.

Or again, if you knew him only by the monuments which began with that grimly powerful Tsar mastering the horse which is not a gentleman's mount but a great earthy animal that symbolizes all the vast agricultural whole of oppressed Russia under the Imperial Crown, you would class him a supercharged portrayer of force *in excelsis.*

Yet when Troubetzkoy's neighbors on the Lago Maggiore, where his famous Villa Cabianca stands, asked him to commemorate the great war for them, expecting something enormous and intense, he placed on a rock on the esplanade at Pallanza a simple figure of a young mother holding out her baby and asking "Is this what you are going to do with my son?"

For Troubetzkoy is a gigantic and terrifying humanitarian who can do anything with an animal except eat it.

Some of us remember the inaugural banquet in London of the International Society of Painters, at which the late Lord Haldane, presiding, announced, when all the conventional speechmaking was over, that the illustrious sculptor Paul Troubetzkoy desired to address the company, and how a figure of Patagonian stature arose amid polite applause, and began: "Mr. President: is it not a monstrous thing that we,

who are supposed to be artists and civilized men, and not savages, should be celebrating a great artistic occasion by gorging ourselves on the slaughtered corpses of our fellow creatures?"

As I am a vegetarian my withers were unwrung (it is as a faithful vegetarian that I am immortalized in bronze in this exhibition); but for the rest it was merciful that as the speech was in French they only pretended to understand it, and applauded they knew not what.

One sympathizes also with the unfortunate Russian committee of the Fine Arts who were instructed by the Tsar to see that the young Troubetzkoy produced a proper statue of him. They had him before them and admonished him that the statue must be accurate in detail and highly finished, like the statue of Charles XII in Stockholm and Louis XIV on the Pont des Arts.

"Did you say *finished,* gentlemen?" said the youthful sculptor. "Those statues have not even been begun." The puzzled councillors thereupon informed him that they would visit his statue every Monday morning to see how the work was progressing, and dictate any alterations that were necessary to bring it up to their imperial standard of excellence. He replied by a cordial invitation to them all to come when they pleased, adding that they would find delightful company in his two bears and eighteen wolfhounds, so much adored by all his friends. He saw nothing more of the councillors.

It is now many years—more's the pity—since an exhibition of Troubetzkoy's work has been seen in London. It should be welcome because we have for so long seen ourselves reduced to our primitive elements by our modern sculptors, who take a duchess and reveal her as a cave-woman, that a sculptor of such incurable and inbred refinement that he can take even a postwar cave-woman and make her into a duchess, is almost necessary to restore our respect.

However, his work is before you; and I must not trouble you further with my impertinences.

<div align="right">

"A Word," *Sculpture by Prince Paul Troubetzkoy,* London, P. & D. Colnaghi and Co., December 1931 [B206]

</div>

[Walter Crane II]

[Shaw's newest tribute to Walter Crane was titled "An Appreciation" in the May Day 1937 pamphlet distributed jointly by several labor groups. As he often did, Shaw used communism *loosely to describe whatever in*

socialism he approved of. Herbert Morrison (1888–1965), later Baron Morrison of Lambeth, was a Labour Party founder and stalwart, and a Cabinet minister in the wartime coalition government and in the first postwar Labour government. Clement R. Attlee (1883–1967), later first Earl Attlee, who would be Prime Minister in the first postwar government, also served earlier in the Churchill coalition Cabinet. George R. Strauss (b. 1901), later Baron Strauss of Vauxhall, Labour M.P. and Cabinet minister in several governments, would be wartime Minister of Aircraft Production; Sir Richard Stafford Cripps (1889–1952), lawyer, chemist, and economist, and a Labour statesman, would be ambassador to Moscow and then wartime Cabinet minister.]

Walter Crane, born in Liverpool in 1845, was at the top of his powers as an artist when he was caught by the Socialist revival of the 'eighties, and threw himself into it with William Morris and the group of artist-craftsmen who followed him in his thoroughgoing Communism thirty years before Sovietism was invented. By far the best portrait of Crane is that by Watts in the National Portrait Gallery. He was a pleasant soul, without a trace of the quarrelsomeness which did so much harm to the Labour Movement. Now, quarrelsome as labor leaders are, they are angels compared to artists, who are apt to get into little cliques, hating each other personally and disparaging each other professionally with an intensity of which Mr. Herbert Morrison and Mr. [George R.] Strauss, Mr. [Clement] Attlee and Sir Stafford Cripps are incapable. The combination of art clique and labor faction makes their society almost impossible. I never saw a trace of this in Crane. If only the gift of oratory had been among his many gifts he would have cut a figure on the platform. Unfortunately, though he was quite ready to try his hand at public speaking or anything else for the cause, his lectures would have been unbearable but for his habit of having a blackboard on the platform and saving himself the trouble of verbal descriptions by drawing.

Crane was a wonderful decorative designer. I am afraid the comrades, who mostly regarded an artist as a person whose business it was to make pictures of life, plain or colored, never appreciated his special gift. Give him a space to be decorated, and no medieval woodcarver or illuminator could fill it up more fitly than he. It is a thousand pities that Queen Victoria did not know enough to set him to design her coinage and her stamps. As it was, much of his best work was unpaid: he threw away on the Fabian Society designs for note-paper headings, tickets of membership and admission to meetings, titlepages and book covers that we should seek in vain now even if we came with high fees in our hands.

When it came to what people now call pictures, Crane lacked con-

tacts with vulgar reality. To put it exactly, he never had recourse to models. It was said, with what truth I know not, that his wife would not let him. But there are some men who draw so easily without models that they do not want to be bothered with them. Besides, models are useless in designing. They cannot make themselves into chains of flying fairies or into Athenian friezes, and Crane always wanted his figures to do that. When Crane died in 1915 Punch lost its only chance of redrawing Dicky Doyle's famous titlepage for the better.

In those days whenever a young convert asked me what he could do for Socialism I used to say "What are you?"; and if the reply was, say, "A carpenter," I would say "Make yourself the best carpenter in the town, and then let everyone know that you are a Socialist." What Crane brought to the movement was his character and his professional skill, and they were worth a million street-corner speeches to it. I can still, fifty years later, give no better advice.

> May Day Program of the Birmingham Trades Council Labour Party and Co-operative Party, 2 May 1937 [B265]

[Baalbek Architecture]

[Shaw wrote on Baalbek as "Foreword" to the catalogue of the MARS (Modern Architectural Research) Group's New Architecture: An Exhibition of the Elements of Modern Architecture *at the Burlington Galleries, London, 11–29 January 1938. He had seen the ruins, dedicated to the Jupiter-like Syrian thunder god Hadad, the nature god Atargatis, and a youthful vegetarian god equated with Hermes/Mercury, on a Middle Eastern trip. The site, in present-day Lebanon, was unknown before the Greek conquest of Syria in 332 B.C.; excavations were accomplished by a German expedition 1898–1903.*

Sir Christopher Wren (1632–1723), architect of St. Paul's, was very likely England's greatest master in that art. Adelphi Terrace, where Shaw had lived after his marriage to Charlotte Payne-Townshend in 1898, had been razed for an office block. The area is now dominated by the white, clock-topped Shell-Mex art deco building which overlooks the Thames near the Savoy Hotel.]

If you would see how extravagantly architecture has been valued, go to Baalbek. It was there that the Romans set to work to impose their

God Jupiter Ammon on the world as the god of gods. They did it quite successfully (as such efforts go) by building a stupendous temple, the remains of which still impress even American engineers as the handiwork of a superhuman force. For how these colossal monoliths could have been hoisted to the tops of those gigantic columns, or even how they were transported from the quarries in which some of them lie hewn out and still awaiting that transport, is beyond all speculation. Experts tell you calmly that they were lifted by inclined planes. I prefer the explanation that angels carried them up Jacob's ladder as being much more plausible.

There are few of these columns left with their incredible entablatures; but in the great acreage of the temple as the Romans left it there were scores of them. People came from all parts of what was known of the world at the time; and when they saw that humanly impossible temple they knew that Jupiter was indeed varigod. As long as the temple stood there was no resisting him. That was why, when the Arabs came, bearing the standard of Allah (save in Whom is no majesty and no might) they saw at a glance that the great temple must come down, and not one stone of it be left on another, before Jupiter could be dethroned.

Amazing as the building of the temple was, its demolition and desecration must have been at least equally laborious and dangerous. Even Arab fanaticism could not go quite through with it. Or it may be that the destroyers deliberately calculated that a visible wreck and ruin of Jupiter's famous temple would shew how Allah had dealt with him better than an annihilation that could shew nothing. Anyhow there is the wreck for all the world to see. It is easier to get to than the Shetland Isles; and I advise you not to miss it when you visit the Holy Land, as everyone with money enough ought to nowadays.

Yet as pure architecture Baalbek is not, and never was, worth twopence. Its builders relied on magnitudes and apparent impossibility for the effect of their work. The esthetic part of it was conventionally Roman. To anyone who has seen Ely Cathedral, or Chartres, or St. Sophia, or even the Parthenon, it is null and dull. But it illustrates, as no other existing ruin within my reach does, the fact that you cannot destroy a religion until you have destroyed or assimilated what it has built.

Architecture of this kind may be called impressive architecture. It persists from Baalbek to the country seats of our landed gentry, to the terraces, gardens, and squares of Bloomsbury, South Kensington, and Regent's-park, and to the newest fanes of Christian Science. I lived for thirty years in Adelphi-terrace, which was built to reproduce in London the splendors of the palace of Diocletian in Split (çi-devant Spalato),

and for nearly twenty years in Fitzroy-square, where you may still see what the impressive architects call *façades*. As to the Terrace, it has just been razed to the ground and even deeper. I speak with the authority of personal experience when I say that in neither of these residences was there a bathroom, and in both the sanitary arrangements had had no place in the original plans. In impressive architecture it is the outside that matters most; and the servants do not matter at all.

The Mars group represents a violent reaction against impressive architecture. It has no religion to impose, and however it may operate incidentally as an advertisement of wealth and respectability, this is not its object. It considers the health and convenience not only of the inmates but of their neighbors and of the whole town, as far as it is allowed to have its own way, though of course it is often baffled on this point just as Christopher Wren was. To the classical Baalbekian list of building materials, stone and bricks and mortar, it adds concrete with a steel skeleton, glass, and steel without any concrete. I must not say that in using these materials for utilitarian ends it is indifferent to the aspect of the result. Indeed, artistic instinct is at the very root of the matter even if the more fanatical Martians do produce buildings that are staggeringly unlike Adelphi-terrace and Fitzroy-square.

No matter: we shall have to get used to them, even if the only way to escape from their unusualness is to get inside them. At all events they do not keep out the light, and when one considers that the curse of London is the three months of all but Arctic darkness which descends on it every winter, this alone is an overwhelming recommendation.

Martian architecture is part of a new artistic movement. Its unprejudiced search for new beauties of form is in its favor; for the seekers after what Dickens's blacksmith [Joe Gargery in *Great Expectations*] happily called the Architectooralooral always find themselves back again at Lancaster-gate or the Tate Gallery. And we have had enough of that. At least I have.

> "Foreword," *New Architecture: An Exhibition of the Elements of Modern Architecture.* London, Burlington Galleries, January 1938 [B275]

[The Economics of Art]

[Wartime bred benefits of all sorts for war-service organizations, one of them an exhibition in the galleries of the Royal Academy. Since the

*prices eliminated most potential purchasers, Shaw reminded London-
ers in* The Times *of the "Woolworth Exhibition" he had promoted in
September 1929. After criticism of his proposal as tongue-in-cheek at
best, and impractical at worst, Shaw published a rejoinder. D. S.
MacColl (1859–1948), one of the skeptics, was a veteran art historian
who had been keeper of the Tate Gallery 1906–11 and the Wallace
Collection 1911–24. Sir William Rothenstein (1872–1945) was an
English artist who was a gifted portraitist and principal of the Royal
College of Art 1920–35; Augustus John (1878–1961) was famed for
his bold portraits; Philip Wilson Steer (1860–1942) was an English
Impressionist painter in the Whistler manner.]*

Sir,—If the most is to be made for the Red Cross by the present
exhibition of pictures at Burlington House, the Academy must aban-
don the tradition that artists are ladies and gentlemen who must price
their works in tens, hundreds, and thousands of guineas. If any but the
most exceptional pictures are to be sold as well as exhibited, the lec-
tures of Sir Joshua Reynolds must be discarded for the example of Mr.
Woolworth.

I suggest that in every room in the Academy a notice should be
displayed announcing that any colored picture in the exhibition can be
bought for five pounds and any plain picture for two pounds. The
unsold pictures (if any) could be sold in lots by auction.

The plan has been tested in a small way with complete success at a
one-artist exhibition.

<div align="right">

Faithfully,
G. Bernard Shaw
The Times, 20 January 1940 [C3355]

</div>

Sir,—Dr. MacColl and Sir William Rothenstein must think my
Woolworth suggestion over again. The cost of production of a picture
has nothing to do with the price it will fetch. In competition with Sir
William or Mr. Augustus John or Mr. Wilson Steer I can easily paint a
picture on a larger canvas, with more expensive pigments, in a costlier
frame, and in a studio with a higher rent, and ask a proportionately
higher price for it. The result will be a piece of unsaleable junk, while
the John, the Rothenstein, and the Steer will be snapped up eagerly for
three or four figures. The prices a painter commands may dictate the
rent he can afford to pay and the time and money he can afford to
spend on materials and rent, to say nothing of clothes and food; but
these expenses can never dictate the price at which a purchaser can be
found for his pictures.

I am, of course, quite aware that if our eminent painters were to send

pictures to a Woolworthized £5 exhibition the pictures would be instantly snapped up and resold at an enormous profit, in which neither the painters nor the charity would share. But I did not suggest that these famous men should do anything so thriftless. They are under no obligation to contribute to the exhibition. If they wish to contribute to the charity they can lend their pictures as an attraction at the turnstile, but not for sale.

The problem is not how to sell a full-length portrait by a president of the Royal Academy for two thousand guineas, but to sell two thousand other pictures which will be returned to their painters as unsaleable junk if they are priced as high as two thousand pence, though for a modest fiver they would sell like hot cakes. A fiver in the pocket is better than fifty guineas in the air. . . .

<div style="text-align:right">

Faithfully,
G. Bernard Shaw
The Times, 29 January 1940 [C3357]

</div>

Esthetic Science

[An early postwar exhibition by the Council of Industrial Design enlisted Shaw, then ninety, to help call attention to it. His essay, "Esthetic Science," took up two pages of the very substantial catalogue, Design '46: Survey of British Industrial Design as Displayed at the "Britain Can Make It" Exhibition.

Jascha Heifetz (1901–87) was considered the greatest twentieth-century master of the violin, to whom Shaw had written on 13 June 1920, after Heifetz's London debut, "Your recital has filled me and my wife with anxiety. If you provoke a jealous God by playing with such superhuman perfection, you will die young. I earnestly advise you to play something badly every night before going to bed instead of saying your prayers. No mere mortal should presume to play so faultlessly as that." (Sir) Yehudi Menuhin (b. 1916), American expatriate violinist in the top rung of instrumentalists, became a London conductor.

Sir Almroth Wright (1861–1947), English bacteriologist and immunologist, was the prototype for Shaw's Sir Colenso Ridgeon in the The Doctor's Dilemma *(1907). Sir Robert Ho Tung (1862–1956) was an Eurasian millionaire of obscure origins who had a Hong Kong estate. He adopted the manner, deportment, and costume of a Chinese gentle-*

men. His mansion, Idlewild, was used by Shaw (who had visited in 1933) as the interior setting for Act II of Buoyant Billions (1946).

Giovanni Palestrina (1525–94) was an Italian composer of religious music and operas. Edward Jenner (1749–1823), English physician, discovered the vaccination process which wiped out smallpox. Joseph Lister (1827–1912) was the Scottish surgeon who introduced (1860) the antiseptic system into the operating room. Ivan Petrovich Pavlov (1894–1936) was the Russian physiologist famed for his study of "conditioned" or acquired reflexes. The composers referred to are all household words in music.]

Until quite lately architecture, decorative painting, pottery, tapestry, costume, were catalogued as Art, and, as such, not on speaking terms with Science, which was concerned with mathematics, astronomy, all the ologies, and therapeutics and hygiene, popularly represented by bottles, powders, plasters, and inoculations prescribed by magicians called doctors. Politics occupied a very distinct third sphere, difficult to define, as politicians were assumed to be very profound philosophers and economists with encyclopedic knowledge, but without any steps being taken to ascertain whether they could read or write.

The artists, scientists, and politicians were as completely dissociated in the public imagination as if they were distinct species, as indeed to some extent they were. But they dabbled in each other's specialities as amateurs. In this sort of poaching Art was predominantly attractive. Prime Ministers painted in oils, and Field Marshals in water colors. Mathematicians were fiddlers, less skilful than Heifetz or Menuhin, but nonetheless inseparable from their violins. But these were the relaxations of the scientists, whose work was held to be a dry and joyless grubbing among sordid and cruel facts, whilst Art was what is now called Escapist, taking its votaries away from the horrors of real life into a world of happy or exciting dreams in which even the tragedies were enjoyable, and Science only an excuse for pretending that tales of miracles and fairy tale magic were authentic truths.

The iron curtain between Art and Science seemed impenetrable.

One evening I was lecturing at St. Mary's Hospital in London at the invitation of Sir Almroth Wright, professionally England's greatest bacteriologist, whose relaxation was the establishment of a technique of accurate thinking and grammar. In my address I dealt with the modern craze for immunizing inoculations, contending that as the vaccination experiment in the treatment of smallpox, when checked by the control experiments of cholera and typhus, both of which had practically disappeared while smallpox, after years of compulsory vaccination, had ended in two of the worst epidemics on record, we must

conclude that the reduction in its ancient prevalence, on which the whole case for vaccination is founded, was actually delayed by vaccination and effected in spite of it by sanitation.

Wright sprang to his feet and exclaimed impatiently: "I believe that the effect of sanitation is esthetic," and then sat down unconscious of having smashed the iron curtain into smithereens and made Art the most scientific of all the subjects.

Among my many medical acquaintances was a country doctor, now dead, whose children all died within a few days of their births, leaving him prolific but childless. In desperation he tried a senseless experiment. He took the last baby into the garden and shaded it in a little tent of Turkey red. That baby survived. When I last heard of him from his father, he was flourishing in the prime of life in the Antipodes. A spot of pleasant color had made all the difference between life and death where the most intimate doctoring had failed. The suggestion is that all the improvement in our vital statistics that has been credited to doctors' prescriptions, to leeches, drugs, antiseptics, and preventive operations, has been really produced by pleasant colors, pleasant smells, handsome buildings, gracious curtains, furniture and utensils, fine clothes, noble pictures, music, and beauty everywhere.

When I was in Hong Kong, I was entertained very agreeably indeed by Sir Robert Ho Tung. We were both of the age at which one likes a rest after lunch. He took me upstairs into what in England would have been a drawing room. It was a radiant miniature temple with an altar of Chinese vermilion and gold, and cushioned divan seats round the walls for the worshipers. Everything was in such perfect Chinese taste that to sit there and look was a quiet delight. A robed priest and his acolyte stole in and went through a service. When it was over I told Sir Robert that I had found it extraordinarily soothing and happy though I had not understood a word of it. "Neither have I," he said, "but it soothes me too." It was part of the art of life for Chinaman and Irishman alike, and was purely esthetic. But it was also hygienic: there was an unexplored region of biologic science at the back of it. The exploration of it is just beginning, and giving a new charm and a new interest to Science.

Our doctors now stand helpless before those terrible diseases in which the life force slips down from its human level and proliferates horribly as cancer and arthritis. The greatest doctors, when their wives die in this manner, declare desperately that they can cure nothing and can only go through their hocus-pocus and look on while the disease kills or cures itself.

There may come a time when the Council of Industrial Design will take the place of the General Medical Council, and cancer be cured by a course of Palestrina's Masses or Monteverdi's Cantatas in Sir Robert

Ho Tung's temple. Prisons and hospitals will be demolished and replaced by cathedrals. Jenner, Lister, and Pavlov will go to the dustbin or the devil, and Handel, Mozart, and Beethoven, Wagner, [Richard] Strauss, and Sibelius, Elgar, and Vaughan Williams take the places they have usurped. The headquarters of Science may move to the National Gallery.

Whether things happen in these ways or not, the Council of Industrial Design will get its feet on the ground of Science and cure the nation of its habit of regarding Art as a demoralizing variety of debauchery practised only by incorrigible Bohemians and born mountebanks.

Design, 1946 [B307]

Art Workers and the State

[Thomas Babington Macaulay (1800–59), first Baron Macaulay, M.P., was an orator, essayist, and historian; John Stuart Mill (1806–73) was the English philosopher, essayist, and social critic. Richard Cobden (1804–65), M.P., English economist and politician, was one of the most zealous free-trade advocates of his time; Leigh Hunt (1784–1859), English anti-monarchist radical, poet, and essayist, was caricatured by Dickens. The other creative figures Shaw catalogues are recognized names, with the exception of Sir William Sterndale Bennett (1816–75), English pianist and composer who was Professor of Music at Cambridge and later Principal of the Royal Academy of Music.]

Being old enough to have been educated by Macaulay and John Stuart Mill on the subject, all that has lately been written about State selection of budding novelists, poets, painters, composers, scientists, statesmen, and philosophers, with State nurture of them by tax-exemption, prizes, endowments, and so forth, seems to me obsolete. A state department for such selection would be like one for the selection and support of possible Derby winners.

In a Socialist State, with the Marxian class wars between proprietors and proletarians abolished, there will come to the front the conflict between the energetic few who want to work until they must go to bed or for a holiday tour of at least six weeks and retire at forty, having paid scot and lot for their education, subsistence, and pension, into a private life of leisure and experiment, and the easy-going who want to work

four hours a day or less for five days or fewer in the week, and retire at sixty or later.

There will always be such people, and Socialism will have to organize employment for them, just as it will have to organize the lives of those who make docile and useful prisoners and soldiers in a condition of complete tutelage, but, left to themselves, become helpless and incorrigible criminals, beggars, borrowers, tramps; in short, burdensome good-for-nothings. In these last the human stock is not necessarily degenerating: it is in fallow, recuperating for future harvest. It may include brothers and sisters, sons and daughters of the world's greatest geniuses. Mozart's son was only a fair musician like his grandfather. Mendelssohn's father complained that he had begun as the son of his father and ended as the father of his son. Beethoven's nephew was a scapegrace, and none of the kindred of Shakespear or Dickens achieved anything like their eminence. Selection by heredity, the weak point in the feudal system, is thus ruled out under Socialism. So is extermination of the defective.

Nature, which our religious sects rightly call Providence, somehow sees to it that as many geniuses as are socially necessary are born; but under Capitalism most of it is extinguished by lack of leisure from breadwinning. I myself, after five years' commercial servitude, had to burn my boats and sponge upon my parents for my livelihood for nine years of literary apprenticeship, before I could earn my keep by my pen. From commercial habit I worked daily at fiction, like Trollope, day by day, without waiting for inspiration; but the publishers were unanimous in their refusal to select me as an author; and the better I wrote, the more resolved they were to have nothing to do with me.

Their advisers, who included George Meredith and John Morley, knew their business as well as any State department could.

What, then, was needed to tide me over this period had my parents been unable to feed, lodge, and clothe me?

Clearly and simply a bread-and-butter job in the four-hour-five-day-a-week division, leaving the novice daily leisure enough to write fiction as a would-be novelist, to paint pictures, to compose music, to invent machines, to excogitate philosophies or scientific theories, taking the chance of imposing on the world as a professionally self-supporting story-teller, painter, composer, philosopher, inventor, or what not. Rousseau lived by copying music, Spinoza by grinding lenses, Wagner by conducting (and borrowing), Dickens as a clerk, [H. G.] Wells as a schoolmaster, others as journalists or what not. But nowadays few such employments leave sufficient leisure to maintain the natural supply of geniuses. Sterndale Bennett was extinguished by having to teach five-finger exercises to young ladies when he should have been

composing. Newton might have got as far as Einstein if he had not been employed as Master of the Mint.

There is, as far as I can see, no other solution of the problem of original work under Socialism than routine jobs and shorter hours for aspirants. Some business training does no harm to artists and thinkers; on the contrary, it saves them from being the feckless nuisances they now often are, living in an imaginary world and ignorant of the real one. The Harold Skimpole [in Dickens's *Bleak House*] side of Leigh Hunt was an extremely undesirable one.

I must warn the Soot-or-Whitewash Brigade, the All-of-One-Piece-Beginners who make Socialism and every other change so difficult, that I am not renouncing all my Fabian doctrine and advocating the instant and catastrophic discontinuance of all tests of fitness for public employment except the Trial and Error test. All that I have written suggesting that the present promiscuous popular selection of our rulers be restricted to panels of persons with a minimum of education and sanity is as valid as ever. People with the mental scope of villagers should be eligible only as parish councilors, and should at least establish their ability to read an agenda paper, and to have some notion of the surviving items in the ten commandments and the limits of religious and political toleration. For the highest offices of State a grasp of the two elementary laws of political economy (rent and exchange value), and of the scope and importance of the fine arts, physical science, law and the religions, should be exacted. This much is roughly but sufficiently ascertainable, and does not include individual technical accomplishment as distinct from comprehension. Until the popular electoral choice is limited to some such extent, our present system of election of anybody by everybody will continue to operate as a guarantee of mediocrity and reaction interrupted only by paroxysms of Hitlerism.

Socialists who want to have everything socialized, Liberals who want to have everything Cobdenized, Conservatives who want to have nothing changed, and people who are unaware that all civilization is based on a foundation of Communism and a surrender of individual liberty in respect of totalitarian agreements to do or not to do certain fundamental things, should be disfranchised. Some of them should be sent to mental hospitals. Every competent citizen should be Communist in some things, Conservative, Liberal, and even Capitalist in others all at once, before he or she can rank as a competent citizen.

But the social provision for genius will still be leisure for voluntary experimental apprenticeship. No better anthropometry is yet within our knowledge.

The New Statesman, 26 April 1947;
Atlantic Monthly, November 1947 [C3722]

[Art and Socialism]

[Shaw's energies in his declining years were more given over to polemics than playwriting, although he continued to write plays until the end of 1950. He was besieged by journalists, politicians, cranks, and the merely curious, all who wanted words from the world's best-known nonagenarian. Shaw often succumbed, as he stubbornly clung to ideas that were important to him all his life, and felt committed to propagating them further, by whatever means. Thus he replied to Labour Forum, *which printed his reply in holograph facsimile, the shaky hand of a writer now nearly ninety-three. No longer the critic, he was now more interested in how artists could continue to ply their art.*

Sir Thomas Henry Hall Caine (1853–1931), once Dante Gabriel Rossetti's secretary, became a popular novelist.]

? Do you consider that a part-time job which permits would-be artists to try out their talents at reasonable leisure, is the best way for a Socialist state to give its artists a chance?

G.B.S. says . . .

Part-time jobs are not always available. Under Socialism whole-time jobs could be scaled down to, say, a 4 hour day and a 5 day week. That would provide sufficient leisure for the would-be artists to prove their talent and obtain employment, public or private, in their vocation, and live by it. This is the solution for all the cases in which scholarships are not available, either because the candidates cannot pass examinations, or because what he wants to do is not an established practice and therefore there are no scholarships.

At present leisure can be obtained by whole time jobbers by getting up at four o'clock and working until breakfast; but this, as it excludes painting and piano playing; is practically confined to writing, mathematics, and the professions provided for by scholarships. Wells, Hall Caine, Trollope and others worked in the night long after they had no need for it.

The 4 hour day and 5 day week would not suit energetic spirits engaged in work congenial to them. They work 16 hours a day until they drop and then do nothing for six weeks but travel for fun. Napoleon worked until his council could not keep awake, but often dawdled for a fortnight playing with children and dogs. The 4 hour 5 day people should have purely mechanical jobs needing no thought. Equality (meaning intermarriagability) could be adjusted by varying the age for retirement and pension: the lazy and untalented at, say, 65, and the Napoleonic at 45.

Labour Forum, I, April 1948 [C3795]

Victorian Pictures: A Select Source List

Much of the art written about by Shaw, the classics of earlier times as well as his own, is either familiar to the reader or accessible in standard studies illustrating artists and ages. The least familiar is the popular and the academic art of Victorian England, although that itself is returning to critical and collecting favor. For those interested in reproductions of still-obscure Victorian pictures written about in Shaw's columns, the most promising sources are *The Art Journal* (1849–1911) and *The Magazine of Art* (1879–1903). Useful books, with illustrations often in color, are the following, most with extensive bibliographies of their own:

Royal Academy, *The First Hundred Years of the Royal Academy*. London, 1951.

Martin Hardie, *Water-Colour Painting in Britain*. London, 1968.

Luke Hermann, *British Landscape Painting of the Eighteenth Century*. New York, 1974.

Charles Holme, *The Royal Institute of Painters in Water Colours*. London, 1906.

Robin Ironside, *Pre-Raphaelite Painters*. London, 1948.

Bill Jay and Margaret Moore, eds. *Bernard Shaw on Photography*. Salt Lake City, 1989. (Two G.B.S. photography reviews omitted are printed, to complete the record, with S. Weintraub's review of the book in *History of Photography*, October 1989.)

Raymond Lister, *Victorian Narrative Paintings*. New York, 1966.

Jeremy Maas, *Victorian Painters*. New York, 1969.

Huon Mallalieu, *Dictionary of British Watercolour Artists*. London, 1986.

Jean-Jacques Mayoux, *English Painting from Hogarth to the Pre-Raphaelites*. London, 1972.

I. B. Nadel and F. S. Schwarzbach, *Victorian Artists and the City*. New York, 1980.

Christopher Newall, *Victorian Watercolours*. Oxford, 1987.

Richard Ormond and Carol Blackett-Ord, *Franz Xaver Winterhalter and the Courts of Europe*. London, 1987.

Leslie Parris, *Landscape in Britain*. London, 1973.

Benedict Read, *Victorian Sculpture*. London and New Haven, 1982.

Graham Reynolds, *Victorian Painting*. New York, 1967.

David Robertson, *Charles Eastlake and the Victorian Art World*. Princeton, 1987.

J. L. Roger, *History of the Old Water-Colour Society, now the Society of Painters in Water Colours*. London, 1891.

Michael Rosenthal, *British Landscape Painting*. Ithaca, N.Y., 1982.

Dudley Snelgrove, *British Sporting and Animal Prints, 1658–1874*. London and New Haven, 1981.

Allen Staley, *The Pre-Raphaelite Landscape*. Oxford, 1973.

Julian Treuherz, *Hard Times. Social Realism in Victorian Art*. London and Mt. Kisco (N.Y.), 1987.

Christopher Wood, *Dictionary of Victorian Painters*. Woolbridge, Suffolk, 1978.

———, *The Pre-Raphaelites*. London, 1981.

———, *Victorian Panorama. Paintings of Victorian Life*. London, 1976.

Acknowledgments

Implicit in the making of this book is the help of a host of people on both side of the Atlantic, among them Jeffrey Cave (of *The Observer*), Fred D. Crawford, Vivian Elliot, T. F. Evans, Alice Fleischer, Roland Fleischer, Hellmut Hager, Alan Hanley-Browne, Eileen Hanley-Browne, Wendell Harris, Nicholas Joukovsky, Jürgen Kamm, Thomas Kirchner, Heinz Kosok, Dan H. Laurence, Charles W. Mann, Jr., George Mauner, Shirley Rader, Judith Rayback, Sandra K. Stelts, John Trewin, Wendy Trewin, James Tyler, Rodelle Weintraub, Suzanne Wills, Philip Winsor, and Roma Woodnutt.

Museums, libraries, and collections that have rendered assistance include the Bethnal Green Museum; the National Gallery (London); the National Portrait Gallery (London); the Prince of Wales Hotel, Niagara-on-the-Lake, Ontario; the Royal Academy, Burlington House (London); the Victoria and Albert Museum (London); and the Wallace Collection (London). Also the British Library (London) and Newspaper Library (Colindale); the Burgunder Collection, Cornell University Library (Ithaca); the Guildhall Library (London); the Pattee Library, The Pennsylvania State University (University Park); the Harry Ransom Humanities Research Center, University of Texas at Austin; the Staatliche Museen, Preussicher Kulturbesitz (West Berlin); and the University of Wuppertal Library (Federal Republic of Germany).

Index

464 Index